Landscape as World Picture

VOLUME II

Jacob Wamberg

Landscape as World Picture

Tracing Cultural Evolution in Images

VOLUME II

Early Modernity

Translated by Gaye Kynoch

Aarhus University Press |

Landscape as World Picture: Tracing Cultural Evolution in Images
Volume II: *Early Modernity*

First published in Danish as *Landskabet som verdensbillede.*
Naturafbildning og kulturel evolution i Vesten fra hulemalerierne til den
tidlige modernitet by Passepartout, Aarhus, 2005

Graphic design and cover: Jørgen Sparre
Cover illustration: Detail from Jan van Eyck, *Madonna of Chancellor*
Rolin (c. 1433-34), oil on wood. Paris, Musée du Louvre.
Typesetting: Narayana Press
Type: Legacy Serif and Legacy Sans
Paper: Lessebo Design Smooth and Hello Silk
Printed by Narayana Press, Denmark

Printed in Denmark 2009

ISBN 978 87 7934 287 3

AARHUS UNIVERSITY PRESS
Langelandsgade 177
DK - 8200 Aarhus N
www.unipress.dk

Gazelle Book Services Ltd.
White Cross Mills
Hightown, Lancaster, LA1 4XS
United Kingdom
www.gaxellebookservices.co.uk

The David Brown Book Company
Box 511
Oakville, CT 06779
USA
www.oxbowbooks.com

Published with the financial support of
The Aarhus University Research Foundation
The Danish Research Council for the Humanities (FKK)
The New Carlsberg Foundation
The Novo Nordisk Foundation

Contents

VOLUME II

Early Modernity

Mephistopheles:

And had you even swum the trackless ocean,
Lost in its utter boundlessness,
You still saw wave on wave in constant motion,
Though for your life in terror and distress.
Still there were sights. You would have seen a shift
Of dolphins cleave the emerald calm, the drift
Of clouds, sun, moon and stars revolve in harness;
There you see Nothing – vacant gaping farness,
Mark not your own step as you stride,
Nor point of rest where you abide.

Faust:

[...] Within your Naught to find the All, I hope.

GOETHE,
Faust, 2, 1[1]

8

"'Tis All in Peeces, All Cohaerence Gone"

Modern Pictorial Space between
Self-Consciousness and World Picture

Introduction:
breakthrough of the modern
pictorial paradigm

THE THIRD DECADE of the 1400s sees the arrival of a new paradigm in European pictorial space. That which, in the Middle Ages, had required at best a thematic trigger if it was to be rendered pictorially, is now with startling suddenness transferred to the landscape image in its totality: a space stretching effortlessly from the close foreground to distant, misty horizons; a time manifested in indicators such as sunlight, seasons, clouds, atmosphere and ruins; and a ground so softened that, in addition to mountains, it allows for the presence of eroded earth and plains. This crumbling ground creates space both for traces of cultivation such as fields, hedges, fences, roads, bridges and mining as well as their opposite, the sublime wilderness totally devoid of human presence. The new landscape paradigm could therefore be said to be stretched between two poles: *realism*, which focuses on humankind's control of nature via work, and *romanticism*, which highlights the superior forces of nature.

As described in chapter 4, this new landscape paradigm can be seen as structurally equivalent to the second stage of the Paradise and Golden Age myths – respectively, the Fall and the fall to the Silver, Bronze and Iron Ages – for in both domains we find: [1] an unrestricted space (as opposed to the previously restricted); [2] a variable time (as opposed to the previously eternal spring); [3] a nature marked by work (as opposed to the previously work-free nature); [4] a diversity of terrains rooted in the plains (as opposed to the previously mountainous ground). In accordance with practice thus far, I shall therefore view modernity's paradigmatic shift as registering a transformation of *field* applicable to Western culture in its totality – the

[I]

transformation from the antique-medieval to the modern epistemic *field* or, if you like: from Golden Age *field* to Iron Age *field*. As the Middle Ages proceed, the Golden Age *field* assumes the character of a dam that has to withstand increasing pressure of water. Spatially, it is being pressed by infinity, which in late antiquity was displaced to the heavens, but which in the long run seems incompatible with a hierarchical world picture. Temporally, it is being pressed by a continuous-abstract concept of time, which breaks definitively with the supra-temporal thinking of antiquity. And, in terms of work and power, it is being pressed by a new notion of activity which, rather than polarising society into an upper class relieved of work and an under class composed more or less of slaves, levels out the difference between physical and spiritual pursuits, so that the social status of the citizen is not dependent on blood and privileges, but on occupational contribution.

Even though the pressure of water, stemming from these and many other sources, does not lead to a sudden and dramatic bursting of the dam, there is nevertheless a pronounced restructuring of hitherto applicable values in the period here called the Late Middle Ages: the 11th to 15th centuries. It is from this restructuring that the *field* of modernity emerges. The *field*, which has been in the making since late antiquity (cf. chapter 7), reaches a preliminary peak in the 14th-15th centuries (cf. this and the following chapters), but does not culminate until the 18th-19th centuries after a struggle with what I will here regard as a countercurrent: the Renaissance with its revival of antique values (cf. chapter 9 in particular).

That the Renaissance seems to subdue the manifestation of modernity, including that part of modernity which makes its mark in a new pictorial paradigm, is because the Renaissance, like antiquity, has its fulcrum in an ideal and closed cosmos, including this cosmos' pictorial imprint in an ideal and closed human body. The perspectival landscape image, on the other hand, points per definition beyond the closed form, towards space, time, the particular and – in part – the cultivated: all characteristics that burst the Golden Age paradigm. I must therefore count on a pictorial – and altogether cultural – fault line between northern and southern Europe, stretching from the end of the 15th century to the middle of the 18th century. Currents manifested in Italian pictorial art under the aegis of the Catholic rearmament and Counter Reformation – High Renaissance, Mannerism, Baroque – are, despite the habitually emphasised stylistic differences, all characterised by their focus on one or other form of idealised human body. Conversely, Europe north of the Alps, in so far as it breaks away from Italian Renaissance ideals, would seem to be increasingly controlled by a paradigm that points away from the ideal centrality and out towards the particularised environment.

As cultural evolution ensures that the epistemic *fields* are in constant transformation, what is marked out in early-15th-century painting can be seen as merely

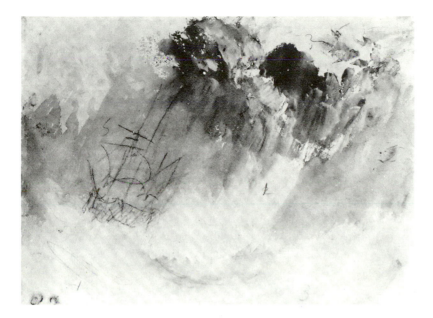

Fig. 8.1. J.M.W. Turner, *Ship in Stormy Weather*
(c. 1825), watercolour and pencil on paper.
London, British Museum.

the first hesitant imprints of modernity's *field*. Its actual pictorial implementation first occurs in a period of which I can here unfortunately only sketch a rough outline: modernity's second and mature phase between 1750 and 1900. Even though the principles of an infinite pictorial space are already built-in to the perspective presented by Alberti in *De pictura* in 1435, they are first put to a thorough investigation in the work of Friedrich, Degas and Monet (FIG. 20). The same can be said of the manifestation of time in the landscape image. We might indeed come across effects such as seasonal features and the darkness of night in standard 15th-century landscape images, but Hugo van der Goes was unlikely to have been in a position to fulfil such an extreme mimetic requirement as that expressed by the realist painter Thomas Eakins in a letter sent to his father from Europe (1868): "In a big picture you can see what o'clock it is afternoon or morning if its hot or cold winter or summer [...]. If a man makes a hot day he makes it like a hot day he once saw or is seeing [...]."[2] Ultimately, the in-depth exploration of the landscape's cultivation, or lack of the same, also belongs to the mature modernity. Turner is the first to visualise a sense of the individual's total insignificance in the face of natural forces (FIG. 8.1); and it is not until Millet, Breton and van Gogh that

[3]

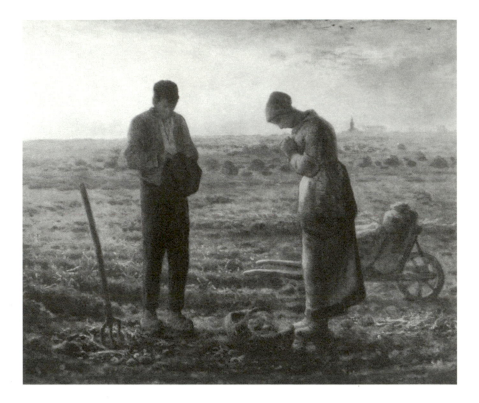

Fig. 8.2. Jean-François Millet,
L'Angélus (1857-59), oil on canvas.
Paris, Musée d'Orsay.

the human being's status in the cultivated landscape reaches its full ideological potential (**FIG. 8.2**).

Were we to clarify this pictorial development in relation to a concept that combines its temporal and spatial consequences, we could say that it concerns an accelerating approach to the *momentary sight*: the transient individual gaze born of the instant and looking from the close here to the distant there. In order to realise this gaze in images, one has to relinquish definitively the hierarchies of feudalism, Renaissance and Catholic Church and instead render visible secularised civil life, be it its everyday sights (realism) or spectacular yearnings (romanticism).

As enjoined by my overarching analytical strategy, the tripartite context model (cf. Interlude), I shall also render visible the landscape image's iconology as regards early modernity by making a structural comparison with the domains of self-consciousness, world picture and socially-determined perception of nature. In

the realisation of the momentary sight in 15th-19th-century Western images, we see, firstly, a structural equivalence to a fully autonomised self-consciousness. The moment at which the pictorial view has retreated to its maximum distance from the surroundings and regards them in unrestricted depth of field occurs simultaneously with the phase in which spirit is finally drained out of nature and looks at it in a keenly separated subject-object relationship. The image's well-defined vantage point, foreshortening and surgical cropping refers back to a subject that is capable of forming its own point of view and reflecting on its own position in the world.

As suggested by the survey of the pre-modern stages in chapter 1, this connection finds more general support via the involvement of Hegel's and Piaget's developmental models of the evolution of self-consciousness, because just as modernity's perspectival pictorial space and corresponding autonomous consciousness harmonise with Hegel's third stage of art history – the romantic – they can also be compared with Piaget's formal operational stage in which the child's perspectival drawing appears as a manifestation of mental independence (cf. FIG. 1.28). Besides being able to elaborate upon this connection in terms of the histories of philosophy and religion by reference to nominalism and Protestantism – two movements leading both to the independence of consciousness – I shall involve that part of the socially-determined perception of nature relating to the urban citizen's distance to nature. For, as Joachim Ritter has shown, the full manifestation of the landscape image can also be seen as a response to the modern individual's corresponding alienation from nature.

If we move on to the cosmological domain, modernity's pictorial space appears as structurally isomorphic to the Copernican world picture. In the Late Middle Ages, the scholastics began to wonder if not just God, but also his material creation might be infinite, and it is in the space cleared by this thought that a new and disturbing world system emerges. As proposed with growing self-assurance by a series of philosophers between the 14th and 16th centuries – Nicole Oresme, Nicholas of Cusa, Nikolaus Copernicus – the earth is neither central nor static, but rather an insignificant globe circling the sun on equal terms with the other planets. The physical basis for a geocentric hierarchy from underworld to heavens is hereby eliminated: the underground is no longer the lowest and fallen sphere, but simply a zone within the earth globe; the heavens are not the domicile of perfection and indestructibility, but simply the atmosphere and the immense void in which the earth follows its trajectory around the sun.

This subversion of geocentricism, then, leads to a quite concrete crumbling away of the foundation for basing the pictorial space on rocks of an underworld quality (cf. chapter 2) and for overarching it with heavens in golden, striped or lapis lazuli-blue colours (cf. chapter 3). The new heavens dawning above the levelled-out terrains are instead made up of atmospheric and temporally marked expanses, which can be

linked with an infinity that is spatially homologous with the one now including the new solar system. Linear perspective – the geometric system which gives the image's infinity its mathematical formalisation – also offers a connecting link to another and more down-to-earth aspect of the new world picture: Westerners' discovery, conquest and colonisation of continents beyond Europe. For, in addition to perspective developing in interaction with a new cartography controlled by grids, the non-Western domains are drawn into the Western cultural sphere in close parallel to the absorption of distant outward views in the perspectival pictorial space. In other words, the horizontal extension of the image not only appears as isomorphic with the spatial expansion of astronomy, but also with that of colonialism.

These sets of image properties and their accompanying homologies in, respectively, the domains of self-consciousness and world picture, will be the main theme of this chapter and will also carry over into the next: chapter 8 thus explores the more unbridled development of subjectivity and infinity in image and culture, while chapter 9 focuses on the complication of this development when it encounters the Renaissance – the idealistic and body-fixated countercurrent to the modernity *field*. If these themes chiefly address the *spatial* aspect of the homologies with the second stage of the Golden Age myth (cf. point [1] in the introduction to this chapter), chapters 10-12 will turn our attention to the domains of *time, cultivation* and *soil* (cf. points [2]-[4]), and consequently also to the last unit of my tripartite context model: the socially-determined perception of nature. Chapters 10-11 will accordingly describe temporal circumstances and agricultural work respectively up to and after the paradigmatic shift in the image in 1420, while chapter 12 will deal with a conflict-ridden relic of the pre-modern pictorial paradigm: the bizarre rock formations in 15th-century painting and their partial opening towards the traumatic Iron Age intervention in the earth – mining and quarrying.

8.1 The pole of vantage point: modern pictorial space and the emergence of self-consciousness

If the problem for any analysis is the separation of elements which in the real world are closely interwoven, if not indissoluble, this problem is acutely exposed when we separate modernity's pictorial space and its structural homologies into two specific segments: the pole of vantage point and the pole of remoteness. For if the two poles are mutual requirements in the perspectival pictorial space of modernity's paradigm – without outward view, no depth; without depth, no outward view – they are no less so in their respective homologies: the infinite Copernican cosmos and

the autonomous subject. It is first when the universe swells to its maximum extent that the capacity is reached in which the individual can finally step back from the world and be screened off in an independent – subjective or objective – position of observer. And it is first when there is an autonomous subject that infinity can be measured against relatively-defined distances, and thereby be substantiated. The context is metaphorically manifested in modernity's mathematics, late-17th-century infinitesimal arithmetic, for here the onslaught of curves on infinity is often defined in relation to a point that is approached indefinitely, but never reached.

This interaction between infinity and autonomous subject can also be traced in Spengler, whose overall definition of Faustian culture (alias my modernity) is based on the primordial symbol *the infinite*. This epistemic structure, which characterises all Faustian products – perspectival painting, instrumental music, capitalism, long-distance weapons, infinitesimal arithmetic – thus not only points outward towards the immaterial wide expanses, but also inward towards what Spengler terms the "awakening of the inner life": an "infinite solitude" and "ineffable sense of forsakenness" that is incarnated in typical Faustian heroes such as Parsifal, Tristan, Hamlet and Faust.[3]

From world cave to eye socket

In order to make this link between heliocentric world picture and self-consciousness comprehensible in evolutionary terms, it could be said that it is conditional on a collapse of Plato's world cave. As shown in chapter 1, the geocentric world hierarchy is salvaged, for a time, by late antiquity's transference of the infinite to the sphere of God, in that the firmament acts as cave ceiling screening against the transcendental. But eventually, on the threshold to modernity in the Late Middle Ages, infinity breaks through the cave ceiling. This breakthrough does not lead to the disappearance of the world cave, rather it shrinks in order to stabilise in a new membrane. The autonomous soul of modernity is embedded on the inner side of this membrane; the Copernican universe is left on the outside.

That the world cave can implode in this way is because both the geocentric and the Copernican world pictures are characterised by a border between an external reality and an inner image. In the geocentric world picture this border comprises the firmament, the cave ceiling around the mortal earth. Reality here is found in the eternity of the heavens beyond the cave ceiling, whereas the image – the reflection of reality – is the entire earthly cavity with its shadows. In modernity the image is still cut off from reality, but now the border has shifted from the firmament and right down to the human mind, which forms notions of a reality that is no longer the heavens, but the whole and infinite environment. The image is now solely

humankind's thoughts or the outward extension of these in language, scientific models, music, images, and so forth.

The properties of structural preservation inherent in this implosion would seem, particularly from a visual standpoint, to be pronounced, as the eye – the instrument through which the mind forms images of the surrounding environment – serves as a faithful miniature copy of Plato's cave. As demonstrated by modernity's new optical science, images of the eye consist, exactly as in the allegory of the cave, of shadows cast from an outer reality onto the back wall of a cavern. In the eye, the cave entrance is formed by the pupil, while the role of cavern wall on which images are projected is fulfilled by the retina. In modernity, the separation of inner from outer is, however, now so absolute that the inner image can just as well be raised to 'reality' as vice versa. At the one pole, the *objective*, reality is based in the exterior world, whereas the thought constructions of the subject appear as more or less successful approximations hereof. At the other pole, the *subjective*, the interior world would rather seem to be the only accessible reality, reality as experienced by the subject, and the exterior world thereby becomes a projection, a reflection, of the mind. Just as the images of the mind can be equated with more or less clean windows onto the surrounding world (objectivity), they can be understood as smeared panes or even mirrors allowing the mind to reach consciousness of itself (subjectivity).

Hegel's romanticism as imprint of consciousness

And with this insight we are approaching a cultural evolutionary line of thought which places my analysis more specifically in relation to the pole of vantage point, the development of self-consciousness – namely the Hegelian aesthetics of the evolution of spirit, which I last explored in chapter 1. According to Hegel, the definitive emancipation of consciousness from matter occurs in the post-antique period and culminates during the philosopher's own day in the early 1800s: in other words, indeed what I have here designated the period of mature modernity. Since the spirit at the *romantic* stage has withdrawn right into the inner sphere of humankind – has reached consciousness of itself and for itself – it can no longer, as had been the case in antiquity, find conclusive expression in material form, in sculpture, but has to be content with mirroring itself in the outer and now separated surrounding environment – a reflection which in visual art can best be realised on the projective surface of the painting. In this arch-modern medium, the spirit finds resonance in transient and subjective agencies of style (light-shadow effects, colour tones, pronounced viewpoints), at the same time as it becomes engrossed in a repertoire of ever more secularised and sensuous motifs (everything from psychological portraits to interesting or ugly genre pictures to banal still lifes and spellbinding landscapes).[4]

In Hegel's view of romantic art, it thereby appears as an expression of the subjective response of consciousness to its surroundings. Even when the painting settles for a depiction of the surroundings in their mere starkness – mountains, valleys, brooks, thickets, sea, clouds, sky, buildings, rooms, and so forth – it must not be regarded as soulless materialism, for that which

> constitutes the core in the content of such works of art is not the objects themselves, but the *vitality* and soul imported into them by the artist's conception and execution, his emotional life in fact, which is reflected in his work, and gives us not merely a counterfeit of external objects, but therewith his own personality and temperament.[5]

Hegel thus makes the interesting observation that the more the spirit has withdrawn from the material surroundings and views them from the detachment of reflection, the more it nonetheless abandons itself to an illusionist semblance (*Schein*) of their purely sensuous qualities: a semblance which achieves its extremes in the figureless genres of still life and my topic, the landscape image. Through a subjectively-coloured interpretation of the objective surroundings, the pictorial gaze approaches momentary sight.

The perspectival vista through a Piagetian lens

Another interpretative framework which allows us to connect the perspectival image bearing indication of time and described in light-shade with the crystallisation of self-consciousness is found in Piaget's ontogenetic development model and its phylogenetic derivatives in Marcussen – and with a few significant changes – Gablik and Blatt (cf. Interlude and chapter 1). Piaget's final stage of child development, the *formal operational* stage from age 12 onwards, is characterised by the child having internalised its experiences of action to such an extent that manipulation and transformation of these is possible independently of concrete objects, since thought representations are acknowledged as hypothetical, i.e. ultimately stemming from and bound to subjective consciousness. In terms of representational space, this autonomy of consciousness is expressed in an abstract, so-called Euclidian space with co-ordinates that are independent of objects, including a perspectival space with foreshortenings and vanishing points, both being effects conditioned by the subjective vantage point.[6]

Most appropriately, it would seem, this stage can be linked phylogenetically with Western modernity between 1420 and 1900. Here, in correspondence with the formal operational stage, the adult, urban individual has developed a consciousness of his or her thoughts as being independent of the physical environment about which

they form conceptions and, as pictorial art testifies, this mental autonomy finds its representational-space manifestation in an image that is indeed characterised by an eventually fully-developed perspectival foreshortening with a homogenising vanishing point and a specifically marked vantage position.

In their phylogenetic translation of ontogenesis' formal operational stage, however, Gablik and Blatt prefer to link it with the late 19th and 20th centuries rather than with the 15th-19th centuries, which are called concrete operational.[7] In Blatt's case, a contributory factor in the latter identification would seem to be his somewhat uncritical appropriation of the Renaissance historical construct: with modernity thought to have its roots in the Renaissance, the revival of antiquity, and with Blatt able to identify those body-fixated features of Renaissance images which derive from this very revival, then it is actually quite logical that the linear perspective ostensibly invented by the Renaissance should be called concrete operational.[8]

As indicated in chapter I, the wider argument for the displacement of the formal operational stage to the 20th century is that the typical pictorial art of this epoch, abstraction with its pictorial space allegedly devoid of referents, has reached a climax of representational autonomy, and furthermore that this can be connected with scientific parallels such as Riemannian mathematics and Einsteinian physics, as both parties, in Blatt's words, involve: "[...] a shift from an interest in systems of relations to a consideration of the relation among systems of relationships."[9] Although I find it an attractive prospect to attempt a further development of Piaget's model, and in particular consider comparisons between abstract art and post-Newtonian mathematics and physics convincing, I have to reiterate that the actual Blatt-Gablikian translation from onto- to phylogenesis, the identification of 20th-century paradigms with Piaget's formal operational stage, comes across as highly problematic. Apart from the fact that it seems ever more strained to describe all forms of abstract art by means of the Greenbergian label 'the climax of autonomy', neither these art forms nor their scientific-mathematic parallels deal with a 'Euclidian', much less perspectival space. As touched upon in the Introduction and Interlude, I should rather prefer to propose an *expansion* of the Piagetian, purely progressionist model by means of a model that is cyclical in its final phases, so that autonomy and spatial homogeneity, having reached their climax in the 17-1800s, are dissolved in favour of various forms of heterogeneous and compound spaces. At the same time as these spaces allow for a reactualisation of earlier phases in cultural – if not pre-cultural – evolution, they would seem to point to culturally-mediated sense perceptions, technological prostheses of the human body; and accordingly, we should perhaps rather be operating with a *posthuman* stage after the year 1900.[10]

Self-consciousness as nominalism, I:
ramifications in religious and natural philosophy

To pursue self-consciousness in a more specifically culture-historical light, as it matures from the Late Middle Ages to the 18th and 19th centuries, a key term could be *nominalism*: an understanding of the world that erects an invincible border between name and thing, between representation of the world's phenomena and these phenomena themselves. For whether the representation is perceived as an organised mental image or its insertion in different outer mediations – language, mathematics, images, and so forth – it appears as the product of an autonomised consciousness, a consciousness that has withdrawn from the world's phenomena and recreates these, independently of their outer location, in the human mind. By this means nominalism becomes the common denominator of such apparently diverse currents in modernity as Protestantism (God as exclusively manifest in the mind), scientific empiricism (theory as pragmatic approximation, but not ontological covering of natural phenomena) and aesthetics (the beautiful and sublime as internal response to a surrounding world that is in itself devoid of quality).

The role of nominalism in an evolution of consciousness model is clarified by its origins in the late medieval discovery – and subsequent writing-up – of the individual mental life. In the 12th century the 'self' appears as a more complex and changeable entity than the either saved or damned soul of the earlier medieval period, and consequently many writers become preoccupied with self-knowledge as the true path to God. The Benedictine Abbot Guibert of Nogent (d. 1123) declares, for example:

> No preaching seems to me more profitable than that which reveals a man to himself, and replaces in his inner self, that is in his mind, what has been projected outside; and which convincingly places him, as in a portrait [*quodammodo depictum*], before his own eyes [...].[11]

In accordance with Guibert's desire for an inner visualisation of the outer self, it is also in this epoch that we find modernity's first images of the individual subject, painted and sculpted portraits as well as written biographies and autobiographies – the latter (by, *inter alios*, Abelard and Guibert himself) with strands back to Augustine's *Confessions*. That making confession – exposure of the self's intentions rather than its actions – signifies a main road to God is also borne out by the 4th Lateran Council in 1215, which made an annual confession obligatory.[12]

It is no great step from this fostering of the self's singularity to nominalism, since Colin Morris points out, the same singularity came to play the role of key

evidence in a new, more general belief in the irreducible particularity of the world of phenomena, including the self (the term *individuum*, an indivisible unit, in fact stems from scholastic logic).[13] According to nominalists such as the Oxford Franciscan William of Ockham (*c.* 1287-*c.* 1349) there is no such thing as actually existing *universalia*, eternal prototypes from which the individual phenomena materialise. In contrast to the beliefs of the contemporaneous Aristotelians, such general concepts could only be understood as *fictiones*, intuitive insights extracted from things by the human individual through experience. Our mental representations of the world – consciousness – thereby become a distillate of the two interacting, but separated sources: the diverse and changeable surrounding environment and the equally turbulent movements of the mind.[14]

For Panofsky, too, nominalism involves a subjective view of the world, and he therefore does not hesitate to detect its pictorial expression in the perspectival interpretation of space that invades European painting in the 14th-15th centuries: "It [perspective] records, to borrow Ockham's term, the direct *intuitus* from subject to object, thus paving the way for modern 'naturalism' and lending visual expression to the concept of the infinite [...]."[15] And in agreement with my idea of a modern connection between *how* and *what*, between paradigm and content, Panofsky also notes that the more specific themes in which perspective materialises are chiefly portrait, interior and landscape – new genres, which all satisfy nominalism's interest for particularity and unlimited variation.[16]

Considering that the perspectival vision and its accompanying empirical details mature into a pictorial paradigm in the 1420s, it is quite logical that at about the same time we encounter the first mature, modern thinking: Nicholas of Cusa's (1401-64) ideas of *learned ignorance*. Even though this German cardinal working in Rome still operated with divine prototypes, *exempla*, which precede the objects of the material world, he is irrevocably nominalist as, unlike Aristotle, he is of the opinion that everything God is able to do is actually also *realised* in what for Nicholas of Cusa is now the infinite world – an idea summed up in the term *possest*, made up of *posse* (to be able to) and *est* (is).[17] Since, however, only infinity covers absolute wisdom, this wisdom is, as he puts it, incomprehensible to every intellect, immeasurable to every measuring, unlimited by every limitation and inconceivable to every imagination.[18] Yet, this fundamental inaccessibility of insight does not mean that the individual should abandon the acquisition of knowledge; on the contrary, the individual should tirelessly aspire to approximate image to reality, approximate *aliud* (otherness) to *idem* (the same): "The image does not settle down, if not in that of which it is an image, and from which it has beginning, middle and end."[19] In this philosophical celebration of an attendance in which the image infinitesimally approaches but never touches its object,[20] the leap does not seem far to a van Eyckian visuality in

which the pictorial gaze from the desiring distance of observation exposes hitherto unseen details in the environment.

Even though it is beyond the scope of this study to pursue nominalism in detail as it branches off into the mature philosophies of modernity, it is of fundamental interest in terms of cultural evolution that the distinction between conscious-ness and world seems to reach its climax simultaneously with the maturation of the modernity paradigm in painting, i.e. in 17th-19th-century philosophy. Obvi-ous examples are accounted for by Hume's empirical scepticism and its further development in Kant's concept of the fundamental inapproachability of *das Ding an sich*, but also such a ratio-centric philosopher as Descartes builds on the basic nominalist premise that the cogito, reflective consciousness, is distinct from its physical environment, an infinite void filled with particles subjected to mechanical laws. However much the individual might aspire to uncover these laws behind the diversity of phenomena, he cannot escape the insight already highlighted by the 14th-century nominalists: that *universalia* such as these can only be traced *through* the sensory experience, while their formulations remain bound to the human consciousness.[21]

Realised in this way, the chasm between mind and world could also be described as a scenario in which the spirit is drained from its hitherto geocentric sites – heaven and its infusion of soul into the earth – ultimately to lose its attachment to any external physical place. Just as punctiformed the concentrated spirit now manifests itself in the inner human, consciousness, just as thinly is it now distributed in its environment, cosmic infinity, in which only the incomprehensible totality, Nicho-las of Cusa's *possest*, adds up to divine intensity. This de-localisation of the spirit could thereby also be perceived as a de-sacralisation of nature, in which no earthly or celestial matter can lay claim to spiritual privileges.[22]

This de-sacralisation finds its fulcrum in the reformative movements of the Late Middle Ages, which oppose relic cult, icon worship and ecclesiastical power in favour of a religious outlook in which God is disengaged from an attachment to specific places, things and institutions and is instead revealed in the spirit, the individual's inner consciousness. Protestantism treats of an emancipated subject's relationship to a God who is found everywhere and nowhere.[23] This Protestant scepticism toward the spirit's attachment to matter provides, paradoxically, a crucial condition enabling the new and more sensory image genres of the Late Middle Ages – portrait, genre, landscape and still life – to be emancipated from their previous status as mere attendant phenomena, backgrounds, to sacred or mythological figure-based painting and instead to become genres in their own right. When 16th-century reformers such as Luther, Calvin and Zwingli cast sus-picion on the sacred figure-based images as more or less idolatrous, artists are

obliged to explore more prosaic themes, which in turn can then be developed with much greater freedom from religious demands.[24]

By depleting nature of a manifest infusion of spirit, the Northern reformed movements also become significant allies of the new philosophy of nature and its followers: empirical experiments and industrial exploitation of nature. According to, for example, the English philosopher Francis Bacon (1561-1626), a distinction should be made between morality, which applies to the person, and science, which is beyond good and evil. Morality applies to values, science to facts. The human being is given a divine right to rule over nature, make it a slave, and this power is realised when it becomes one with knowledge of its object. We are thus not far from witch trials in Bacon's description of the gathering of knowledge: nature "exhibits herself more clearly under the trials and vexations of art [i.e. mechanical art] than when left to herself." As if to suggest that the modern era can be perceived as a new Iron Age – an Iron Age no longer, however, desecrating nature – Bacon appoints the miner and the smith as the natural philosophers' ideal models: "the one searching into the bowels of nature, the other shaping nature as on an anvil."[25] This is as far away as can be imagined from the civilisatory discontents of the Golden Age *field*.

Not least as a consequence of this association with metalwork, Western science gradually saw its goal as identifying eternal natural laws that could describe nature as a gigantic machine, *machina mundi*. Descartes even considered plants and animals, along with the human body, comparable to machines.[26] A culmination of this mechanistic thinking occurs again in the Enlightenment, more specifically in the work of the French mathematician and astronomer Pierre-Simon Laplace (1749-1827) who assumed that, if an independent observer had access to all the parameters of the universe at a single moment, then the conduct of the universe could be predicted for all time.

Self-consciousness as nominalism, II: the aesthetic ramification

It could well seem paradoxical that the epoch responsible for developing this mechanistic world vision also fostered its approximate opposite: an aesthetic sphere in which eternal natural laws have to give way to such unregulated entities as originality, emotion, taste and disinterested gratification. But rather than belonging to two incompatible spheres, science and aesthetics span the extremes within the same epistemic *field*, the modern, whereby cohesion can be ascertained partly through complementarity and partly through common structural features.

As regards complementarity, it should be noted that in practice the mechanist

models were only capable of addressing a limited aspect of the sensory nature. In this respect, mechanics could be said to have pulled the Platonic heaven down to earth – a heaven qualified by eternal natural laws outside historical time. However, beyond the new natural sciences – physics, astronomy, chemistry and, to some extent, biology – we are overwhelmed by that disorder and changeability which was previously the sole province of all things chthonic.[27] At the greatest distance from natural science we find aesthetics, which, with the outer unpredictability as resonance space, appeals to humankind's inner non-rational needs: emotions, intuition, imagination. The aesthetic exposure of the chaos and purposelessness of nature supplies the bourgeois citizen with a metaphysical framework for his emancipation: freedom from an imposed destiny. And by embracing nature with emotion, the aesthetic view of nature simultaneously affords a kind of atonement for the sins of rationality, be these the emotionally neutral formulae of science or industry's cynical exploitation of nature.

As Joachim Ritter remarks in his invaluable study on the sociological stipulations of the aesthetic understanding of nature, this mutually reflective relationship is already fully acknowledged in Alexander Baumgarten's (1714-62) *Aesthetica*, the first attempt at a systematic formulation of this concept, written in 1750-59.[28] According to Baumgarten, essential aspects of the modern human experience evade the domain of reason and science. These aspects are therefore referred to art, which has its own *veritas aesthetica*, the truth of emotion and sense perception. Baumgarten thus considers aesthetic art and logical science to be in a complementary relationship: what is ignored by one finds expression in the other.

This relationship recurs in the work of Alexander von Humboldt (1769-1859) who, in his mammoth undertaking *Kosmos* of 1845-58, attempts a unifying description of the universe, a feat which was no longer obvious in his day. Humboldt also realises that if nature is to be understood in depth, harmoniously and in its totality, it is not enough to know about its external appearances and how the natural sciences describe it in objective terms; rather nature should be presented "as it is reflected in the interior of the individual". Thereby, the reflection of the external image will speak through the senses to "the emotion and the poetically tuned imagination".[29]

Besides the complementarity of science and aesthetics, we should here note that the aesthetic understanding of nature does not apply to nature as such, but to the effect it has on the subject's mind – a characteristic also found in Kant's *Critique of Judgment* (1790), where the sublime feeling (as somewhat distinct from beauty) is independent of any intrinsic quality in the exterior nature.[30] Aesthetics, then, also shows itself to be an unmistakeably nominalist phenomenon, whereby its structural kinship with science should be evident. Both domains can be assigned to the modern individual with his or her independent vantage position in an infinite universe.

The scientist is *objective*, i.e. he emphasises the similarity between his response and the environment. The aesthetician is *subjective*, i.e. she emphasises the distinctive characteristic of her response in relation to what she is reacting to. The former must, however, to the same extent as the latter, exact a clear dividing line between object and description, because were the two to merge then the object would be altered and the description would no longer be objective. It is therefore crucial to both approaches that spirit has been drained from nature and condensed in the human mind.

If we now look at the placing of the modern pictorial paradigm vis-à-vis these extremities, we will see that it covers them both. The rational perspectival construction and its projection on the flat surface, the pictorial window, here appears as an offshoot of the mechanistic world vision, the description of which can be monitored with mathematical accuracy. As writers of a phenomenologist leaning such as Merleau-Ponty and Lacan have noted, this is a way of looking which ultimately breaks free of the subject's optical impression and instead thrives in a Cartesian abstract space that could just as well be perceived by someone who is blind.[31] Outside this obviously linear domain – in areas such as the interplay between light and material, seasons and diurnal rhythms, clouds and undulating terrains, not to mention the representation of these phenomena in the highly unruly medium of paint on canvas – rational calculation loses, however, its grasp and viewing is consigned to a more intuitive form. Through topics such as these, in which the boundlessness of the environment seems hazy and discontinuous, and chance and the passage of time become dominant factors, consciousness is then reflected in its manifold and irrational form. It must be stressed, however, that the two ways of looking – linearity and discontinuity – in practice thrive in close interaction in the paintings of modernity; indeed, as will be shown below in the discussion of the Northern European tradition, they are often inseparable.

Finally, we could question the perception of history that determines the simultaneous emergence of the mechanistic world view and aesthetics. Both approaches probably owe their existence not least to the fact that nature was long untouched by an actual natural history that could be written in concert with the history of humankind. Until Comte de Buffon (1707-88) in the 1770s suggested a drastically expanded period of genesis for the earth and its seas, continents, plants and animals, and Darwin with *The Origin of Species* (1859) followed up by enrolling humankind in the animal section of this evolutionary creation, nature had, on the whole, no history beyond its week-long Biblical creation and subsequent degeneration, which was assumed to have resulted from the Fall, the Flood or Cain's fratricide (cf. Chapter 5). For natural science, this lack of natural history constituted an ideal basis on which to develop the mechanistic world picture with its fundamentally reversible

processes, and a theorist such as Descartes quite logically regarded history as irrelevant in a scientific context.[32] For aesthetics, nature's lack of history was not a case of repeatable rules, but of unrepeatable singularities, and nature could thereby act as suitable otherness for the man-made domain, including human history, which is thus also played out on virgin ground. Because nature, on this scale, seemed random, chaotic and devoid of development, the individual had the opportunity to push through his or her inner will and in aesthetic form enjoy the emancipation from external demands.[33]

Landscape as expression of urban alienation

In making nature accessible in pictorial form, the category of landscape represents a key manifestation of the aesthetic sense of nature. While I have above explained this sense as one of nominalism's many guises – as an expression of consciousness's autonomisation and distance from the infinite cosmos – I shall in conclusion move away from the pole of vantage point and into the middle distance, the socially-determined perception of nature, since I shall also identify it as expressive of the second distance to the surroundings, namely the one due to the urban individual's alienation from nature. Even though this alienation, as shown in chapter I, is active from the very earliest beginnings of culture, when enclosure in the urban space facilitates the first pictorial depth of field, it could be said to culminate in the epoch of modernity between the 15th and 19th centuries, when the urban pictorial culture has become fully perspectival and equipped with landscapes which are manifold, marked by temporal variation and, frequently, overlaid with territorial grids.

This landscape culture has been the focal point for Joachim Ritter, who does indeed regard it as compensation for the modern individual's isolation in the metropolis – a compensation that is not limited to painting or literary exposition, but also chips in as a filter when we seek out nature itself. The beautiful landscape is *picturesque*, meaning that it draws to mind the painterly simulation of nature.[34] Leonardo actually already poses the question in his polemic on poetry:

> What moves you, O man, to abandon your home in town and leave relatives and friends, going to country places over mountains and up valleys, if not the natural beauty of the world [*la naturale bellezza del mondo*] which, if you consider well, you enjoy with the sense of sight alone?[35]

A general definition of the concept of landscape could therefore be: *nature elevated to image*. Ritter writes:

> Landscape is nature which in the eyes of an aware and sensitive beholder has become aesthetically present: neither the fields facing the city, the watercourse as "boundary", "trade route" and "problem for bridge builders", nor the mountains and the steppes of the shepherds (and oil prospectors) are yet "landscape" in themselves. They only become such when a human being turns to them with no practical objective, in "free" appreciative contemplation as though himself wanting to be in nature.[36]

Nature, then, is not landscape in itself, but first becomes so when experienced by a sensitive beholder. And in order to have the right aesthetic dimension, the experience has to be free and elevated above practical purposes. We are, as the Germans say, *im Freien* (in the open; literally: in the free).[37] Even though Ritter's concept of landscape identifies a fundamental property of modernity's view of nature, we could object that this focusses a little one-sidedly on what I have called the romantic part of this view, landscape divested of any utilitarian function. When an artist visualises a landscape through a realistic lens – a lens that highlights traces of cultivation such as roads, fields and canals – this lens might indeed in the first instance be coloured by an aesthetic distance resembling total romantic freedom, and yet this freedom can very well have undertones of nationalism, duty, valour of work, and so forth. These concepts, as I shall develop further in chapters 10 and 11, put the free individual into a social function whereby pure pleasure is moderated by morality.

Nevertheless, it seems to be a fact that the urban dweller's distance is actually requisite in order for a value of beauty to be read into the spatial image of nature, cultivated or not.[38] Leonardo's enjoyer of nature is an urban-dweller who has left the city behind. Conversely, having followed Leonardo's advice, Cézanne could express his doubts as to whether the countryside's residents, the Provençal peasants, understand what a landscape is – that they have seen Mont Sainte-Victoire, that they sense the green of the trees or the red of the soil – apart from their utilitarian, unconscious view of it.[39] The observation was corroborated by Le Roy Ladurie when he undertook his famous study of the Inquisition records made around 1300 relating to the Pyrenean village Montaillou. The closest the villagers got to expressions of beauty were phrases such as "beautiful young girl", "beautiful men", "beautiful fish pâté", "beautiful songs in church" or "beautiful orchards in Paradise". Nor did the villagers use terms for space, but mainly words associated to the body, such as *corpus* and *domus*. The explanation of this form of perception is again that the villagers have nature at too close a hand to be able to take the necessary step back and look at it in a spatial and aesthetic perspective.[40]

8.2 The pole of remoteness: modern pictorial space and the genesis of the open cosmos

Genesis of the Copernican world picture

In the above, I have chiefly explained the modern pictorial paradigm from the perspective of the pole of vantage point, i.e. based on the structural homology between the pictorial space's well-defined vantage point and the autonomised consciousness. This strategy led us from the world reflected in the eye socket to Hegel's romanticism and the Piagetian formal operational stage and on to the various branches of nominalism: Protestantism, scientific empiricism and aesthetics.

I shall now make the contrapuntal leap to the pole of remoteness and show that the infinite wide spaces, towards which the observing gaze is positioned in the same pictorial paradigm, are structurally equivalent with modernity's new world picture: in the first instance, the Copernican infinite cosmos; in the second instance, the colonisation of the earth's surface that takes place in Western culture at the same time as the perspectival landscape image comes to maturity. Thereby, overall, a mutual dependence is extrapolated in which the autonomisation of consciousness is just as fully based on the expansion of the world's boundaries as vice versa.

The homology between infinite cosmos and perspective could appropriately take its starting point in remarks made by the historian of science Pierre Duhem on the extreme continuity characteristic of the development of science: "Science, no more than nature, makes no brisk jumps." And: "Not even the most unforeseen discoveries have ever been made in all detail in the mind which generated them."[41] Both the Copernican universe and the modern perspective are indeed discoveries that go through lengthy incubation periods, and their developments are surprisingly simultaneous.[42]

With regards to the Copernican cosmos, preparations are found right back in the Early Middle Ages, especially in the Islamic sphere. At this time, when antique natural philosophy was suffering straitened circumstances in both the West and Byzantium, its salvation was that its Greek branch from Alexandria was exported to more free-thinking cultural centres in Syria, Armenia and Persia. Here the philosophers of antiquity, particularly Aristotle and Ptolemy, were closely studied by Arab scholars, who wrote commentaries on the works and added new, analytic ideas. In the 11th and 12th centuries this refurbished corpus of scholarship was introduced to the West via translation centres in Spain and southern Italy, border regions to Islam. Used at the new seats of education in the West, the universities, these studies triggered off the late medieval revolution in natural philosophy.[43]

The prerequisite of the modern cosmos is a dissolution of differences between heavens and earth. For as long as the celestial bodies are placed outside time and ascribed particularly perfect movements owing to proximity to *primus mobile*, the unmoved mover, homogeneity is obviously out of the question. As we saw in chapter 1, not even the atomists of antiquity, who toyed with the thought of an infinite void, escaped the idea of isolated worlds controlled by a universal downwardness. The dissolution is assisted, however, by the Church Fathers who distrust the idea of divinity of the stars. In chapter 3 we saw, for example, how Augustine refused to restrict God's presence to any specific place and would rather call him omnipresent.

It is this thought, then, that is intensified in the Late Middle Ages when many scholastics, after a thorough digestion of the newly-imported Aristotle, are offended by his ideas on the closedness of the universe. As far as the Bishop of Paris is concerned – and for this very reason he excommunicated Aristotle in 1277 – God's creative power simply cannot be spatially restricted or curbed to the earth as the absolute centre of the universe. The idea is extended by the Oxford mathematician Thomas Bradwardine, Archbishop of Canterbury (*c.* 1290-1349), as in his opinion there was an infinite void before the Creation. As he made clear in a remark taken from the pseudo-Hermetic *Liber XXIV philosophorum* (*Book of the 24 Philosophers*), written in *c.* 1200: "God is an infinite sphere, whose centre is everywhere and whose circumference is nowhere."[44] And Nicholas of Cusa eventually takes the decisive step of comparing the question of God's locality with the question of the geometry of the physical world itself: "Thus, the fabric of the world [*machina mundi*] will *quasi* have its center everywhere and its circumference nowhere, because the circumference and the center are God, who is everywhere and nowhere."[45]

In the hyper-reflective climate of the 13th-14th-century universities, the world hierarchy is also attacked in its particulars. As a result of the nominalist scepticism of actually existing universals, the Franciscan Oxford nominalists Duns Scotus (*c.* 1270-1308) and William of Ockham question the idea that the celestial bodies are privileged with a special immutability.[46] And, parallel to this, the Parisian Jean Buridan (d. shortly after 1358) turns to the Arabic idea of incorporeal motive energy first advanced by the Byzantine John Philoponus in the 6th century. Aristotle had – somewhat hesitantly – ascribed projectile motion to pressure of air from behind. Buridan, on the other hand, thought that inner energy, which he called *impetus*, had been imparted to the projectile and that the motion could only be arrested by external resistance. In particular, the celestial bodies are not impelled by *primus mobile*, but by the constantly unchanged *impetus* imbued in them by God at the Creation.[47] As Pierre Duhem pointed out, this idea is identical to Newton's First Law (the Law of Inertia)[48] and fuels the Second Law (definition of force):[49]

One day Newton will write on the last page of his *Principia*: "By the force of gravity I have given an account of all phenomena that exist in the heavens, and those which our oceans display" [...]. On that day Newton will announce the full bloom of a flower whose seed Buridan had sown. And the day the seed was sown is, as it were, the day that modern science was born.[50]

The ideas of God's placelessness and *impetus* are both closely linked to the concept of local *relativity* – and thereby also with the observing subject, self-consciousness simultaneously identified by nominalism. The Byzantine philosopher who introduced the concept of *impetus* is also the man who first contradicted Aristotle's idea of concord between place and body and who made the alternative proposal that place is actually identical with the void in its three dimensions.[51] But as the void by definition has no tangible fixed locations, its places can only be described on the basis of arbitrarily – subjectively – selected points of reference. This insight is explicit in the work of Buridan's pupil Nicole Oresme (*c.* 1323-82) as for him, in nominalist fashion, it is purely a question of language, as to where a centre is placed in relation to which something else is being described. As Oresme remarks in his commentary to Aristotle's *On the Heavens* (*Le livre du ciel*, 1377), a man in a sailing boat will not notice that he is moving if his point of reference is another boat sailing at the same speed as his own. And relativity is no different when applied to the cosmos:

> Therefore I say that if the higher [or celestial] of the two parts of the universe [...] were today moved with a diurnal motion, as it is, while the lower [or terrestrial] part remained at rest, and if tomorrow on the contrary the lower part were moved diurnally while the other part, i.e., the heavens were at rest we would be unable to see any change, but everything would seem the same today and tomorrow.

Oresme rejects all counter-arguments to this observation, be they physical, logical or indeed even Biblical. The old objection that things would fly off a rotating earth can, for example, be dismissed by *impetus*: as things have *impetus* from earth, they continue with their speed even when they have lost contact with the earth. Nonetheless, Oresme claims that he does not personally believe in a rotating earth.[52]

Oresme's relativistic thinking resulted in an invention which, in the 17th century, was to revolutionise mathematics: *the system of co-ordinates*. In 14th-century Oxford, scholars had reached the point of describing changes in quality – for example, increase in speed – as a function of time; this theory was named *latitudo formarum* (breadth of forms). Oresme's system of co-ordinates visualises the theory via a division of qualitative changes and time following two axes at right angles, which he calls respectively *longitudo* (length, i.e. the later *abscissa*) and *latitudo* (breadth, i.e.

the later *ordinate*).[53] The system thus has distinct similarities to the agrimensorial orientation via the *kardo* and *decumanus* axes (cf. chapter 4) and, as we will soon see, it is indeed also developed at the same time as cartography introduces the square grid as reference. Like the observer in Oresme's boat experiment, his system of co-ordinates is extremely flexible vis-à-vis the phenomena it describes. It only distinguishes relative changes, and its centre can be freely chosen.

Just under relativity lurks infinity. In order to select one's centre independently, it is necessary to claim a limitless space, because natural limits are inevitably accompanied by naturally imposed – and not subjectively selected – orientation points. The concept of infinity is therefore also an essential ingredient in early modern philosophy. Avicenna (980-1037), one of the Islamic commentators on Aristotle, had already suggested the possibility of an actual, all-embracing infinity.[54] The concept is further developed in 14th-century Parisian physics, both in respect of the infinitely large and the infinitely small, and it has become an essential element of Nicholas of Cusa's philosophy.[55] As Panofsky already remarked in his little treatise on perspective, the result of the breaking up of the geocentric world picture is "an infinity not only prefigured in God, but indeed actually embodied in empirical reality (in a sense, the concept of an *energeiai apeiron* [actualised infinity] within nature)."[56]

According to Nicholas of Cusa, this realised infinity is impervious to an absolute definition in a man-made image: "The infinite identity cannot be received in the otherness, because it is here received with difference."[57] In this passage we sense the mutual conditioning between infinity and subjectivity. The world being infinite, all cognition is referred to limited, subjective consideration. Conversely, this consideration is possible precisely because the world is infinite: the subjective is the relative, and the relative requires, as we have seen, the absence of natural borders. While space expands out into infinity, the viewing mind must contract to a point whose location can be selected with exclusive subjectivity, and from which relative observations can be made. The concept of the outer infinity was also stimulated by the simple feeling of enormousness that followed in the wake of nominalism. By disbanding tradition in favour of sense perception, a new and alien world opened up. In Leonardo's words: "Nature is full of an infinity of operations which have never been part of experience."

As can be seen, these early Copernican shoots were more the product of existential-philosophical than mathematical deliberations. Even though Nicholas of Cusa takes Oresme's ideas on the motion of the earth seriously, they lead neither him nor his predecessor to toy with similar thoughts of placing the sun at the centre of the planetary system. Nicholas of Cusa does certainly stress that the earth, like the other celestial bodies, is in constant motion and, if observed from beyond the fiery sphere, will seem to be a luminous star, just as the sun is for us. And yet he still

includes celestial spheres in his calculations and works out that the earth moves to a lesser extent than the other celestial bodies.[58] Leonardo comes a little closer to a heliocentric system in that, besides declaring the sun immobile, he states firmly, recalling Oresme's remarks above:

> The earth is not in the centre of the Sun's orbit nor at the centre of the universe, but in the centre of its companion elements and united with them. And any one standing on the moon, when it and the sun are both beneath us, would see this our earth and the element of water upon it just as we see the moon, and the earth would light it as it lights us.[59]

Despite Leonardo's early attempt to fix the sun and detach the earth, we actually have to go all the way to Copernicus' *De revolutionibus orbium coelestium* (*On the Rotations of the Spheres of the Heavens*) published in the year of his death, 1543, before the sun is systematically placed at the centre of the earth's – and the other planets' – trajectory. Copernicus, on the other hand, was motivated purely by mathematical dissatisfaction with the old system. The older astronomical theories seemed inconsistent and unsystematic, and they did violence to the principle of regularity.[60] In response to this, Copernicus suggested that the centre of description be moved from earth to sun – not because the sun would then be the new absolute centre, as the earth had been, but solely because it simplified and tidied up the mathematics.

In order to make space for his circular planetary trajectories, however, Copernicus found himself obliged to inflate the diameter of the world at least 2,000 times beyond the 20,000 terrestrial radii to which Ptolemy had already set it. Even if his mathematical sobriety prevented him from letting the fixed-star sphere dissolve into pure infinity – an infinity beyond what he calls *immensum* (immeasurable) – the step was there for the taking. As Koyré remarks: "the world-bubble has to swell before bursting." This bursting of the bubble and entry into the infinite universe, which had already been proposed in the Late Middle Ages, was formalised by Copernicans such as Thomas Digges, Giordano Bruno, Kepler, Galileo, Descartes, Newton and Laplace.[61] As Bruno (1548-1600), for example, writes in his pioneering work *De l'infinito universo e mondi* (*On the Infinite Universe and Worlds*, 1584): "This science does not permit that the arch of the horizon that our deluded vision imagineth over the Earth and that by our phantasy is feigned in the spacious ether, shall imprison our spirit under the custody of a Pluto or at the mercy of a Jove."[62]

Today it has become a cliché that human alienation in a fragmented world is a characteristic specifically resulting from the post-1800 industrial modernity when, according to Marx' view of capitalism, "all that is solid melts into air".[63] But actually this feeling of estrangement is put into words as soon as the philosophical

consequences of the Copernican cosmos are examined. As early as 1611, in John Donne's *An Anatomie of the World*, we read:

> And new Philosophy calls all in doubt,
> The Element of fire is quite put out;
> The Sun is lost, and th'earth, and no mans wit
> Can well direct him where to looke for it.
> And freely men confesse that this world's spent,
> When in the Planets, and the Firmament
> They seeke so many new; then see that this
> Is crumbled out againe to his Atomies.
> 'Tis all in peeces, all cohaerence gone [...].[64]

That all is in pieces, all coherence gone, is, for better or for worse, the prerequisite for cultural evolution's realisation of the free and independent individual. As Giordano Bruno – martyr of the unlimited cosmos – claimed, it is precisely because of the ability to confront an infinite environment at variance with the human identity that the individual is equipped with self-consciousness. In the Copernican universe, the human being is not enrolled in a stable hierarchy, but floats in the void between what Pascal, too, calls the two infinities: the infinitely large and the infinitely small. As Kant notes, these two infinities – made accessible via the new inventions from the science of optics: the telescope and the microscope – have no absolute value, but are exclusively the result of comparison between the individual human being and the items that appear behind the lenses.[65] This relativism is also the prerequisite for Michel Serres' observation that modern matter has become strangely weightless. Rather than matter with numinous or demonic power, it occurs as accumulations of particles without value, metaphysics or capacity to lay foundations.[66]

The image as window on the world

The modern pictorial space can be read as the visual homology of this Copernican universe. If the depth of field is actualised, and no screening has been inserted into the image – in the form of a wall, a rock, a collection of ideal human bodies – the beholder's view will open towards the same infinity as that exposed in the new universe, and furthermore the point of view towards this infinity can be selected just as freely as the centre from which a movement is described. As Thomas Bradwardine wrote: "God is an infinite sphere, whose centre is everywhere and whose circumference is nowhere." The same can be said of the perspectival scrutiny of the infinite plane as, from a centre that can be placed everywhere, the view is of a periphery,

the horizon, which is located nowhere because it is solely an optical phenomenon generated in a subject looking towards infinity.

The connection between the two spheres – world picture and perspective – was brilliantly outlined by the young Panofsky. According to Panofsky, the "perspectival achievement is nothing other than a concrete expression of a contemporary advance in epistemology or natural philosophy."[67] Nor, historically, can perspective be pinned down to a sudden Florentine invention, as Damisch and Kubovy still – quite inexplicably – seem to think.[68] It is far more likely, as adduced by Samuel Edgerton, that it emerged from the same culture that established the new world picture and the new subject: the universities of the Late Middle Ages.[69] Its forum was that with which, in the 15th century, it was still synonymous: *optics*. Influenced by the Islamic Alhazen's (*c.* 965-*c.* 1039) *Optics* – a work that had reformed the ideas of Ptolemy and Euclid – comparative Western studies were made on the anatomy of the eye and the reflection and transmission of light through glass.[70] As early as the 13th century, these studies resulted in the introduction of two quintessentially modern items: *eye spectacles* and the *camera obscura*, both based on vision originating in the individual point of view. While spectacles were a new invention, the camera obscura went back to Alhazen, who refers to experiments with images of candlelight sent through a hole in a screen. When this work is resumed by scholastics such as Roger Bacon, Witelo and John Peckham, the principle is primarily used for the study of solar eclipses.[71] The significance of optics is also stressed by another popular phenomenon, the *mirror*, which inspires many a treatise title in the Late Middle Ages – *Speculum humanae salvationis, Speculum fidei, Miroir du monde, Sachsenspiegel,* and so forth – and which in this usage cannot be traced further back than the 9th century.[72] Reflection is the epitome of subjective consciousness, as it signifies the pondering – speculation – in that Narcissus mirror which, with surgical precision, separates consciousness from environment.

In the first section of this chapter, I described the formation of subjective cognition as a kind of implosion of Plato's cave. The firmament, which separated the ideas from their earthly reflection, here shrank into the membrane separating the infinite environment from the receptive mind. This implosion can also be tracked when focussing on the membrane's visual imprint, the pictorial surface. As described in chapter 1, the medieval icon was seen as an equivalent to the firmament, which also functioned as an area of refraction between the fundamentally unattainable world and us. This firmamental identity of the icon reaches a form of climax in stained glass, a speciality of Gothic architecture going back to, at most, Carolingian time. In the writings of Abbot Suger, the founder of Gothic architecture, we read about the preciousness of the windows, the exquisite workmanship and splendour of stained glass, sapphire glass and ornaments crafted in silver and gold[73] – all of which are materials

associating to the heavens (cf. chapter 3). And yet, the light that makes the panes shine is not extrasensory, but physical; and, furthermore, it breaks through the surface of the glass at a remarkably great distance from the transcendental heavens – in Suger's case in the choir of Saint-Denis, which closes around the beholder in a semicircle. Taking into consideration that the modern image emerges as a projection from the outer world onto a surface – a window – which separates viewer from surroundings, and also bearing in mind that the celestial infinity, in Cusanian fashion, is in the process of absorbing the outer world in its entirety, how great, then, is the leap from Gothic stained glass (the celestial infinity illuminating the earthly icon) to perspectival window (the infinite environment projected into the image plane)?

The connection may be substantiated by an observation I will develop further in chapter 9, namely that Gothic pointed arches anticipate mathematical perspective. In order to create the modern image, the pointed-arch perspective has to be, so to speak, laid down horizontally and placed in front of the window painting. No wonder Suger sees the church pervaded with a *lux nova* and in his meditation feels transported to a new, indeterminate place in the universe beyond the customary duality: "[...] then it seems to me that I see myself dwelling, as it were, in some strange region of the universe [*sub aliqua extranea orbis terrarum plaga*] which neither exists entirely in the slime of the earth nor entirely in the purity of Heaven."[74]

The assumption is also corroborated by the contemporaneous attitude to windows and images as being two equal entities. During the renovation of Salzburg Cathedral in 1127, for example, we learn that Archbishop Konrad "adorned the walls with windows and with a painting shining of gold." And Bishop Egbert of Münster (in office 1127-32) had "illuminated the walls of the House of God with windows."[75] Spengler is, therefore, on the right track when he remarks of Western window architecture that it is one of the most significant symbols of the Faustian experience of depth, the will to force the way from inner to infinite. Of the glass windows in cathedrals, in particular, he states that they comprise a "translucent, and therefore wholly bodiless, painting".[76]

If, on the other hand, we turn to Alberti's early manifesto for the modern painting, *De pictura* (1435), we will also see that his language involves several indications of a link with this Romanesque-Gothic tradition. Besides the window as general metaphor for the image, Alberti also refers specifically to *coloured* windows, which ensure the penetration of the visual pyramid: "when [the painters] draw lines around a surface, and fill the parts they have drawn with colours, their sole object is the representation on this one surface of many different forms of surfaces, just as though this surface which they colour was so transparent and like glass [...]."[77] And when Alberti compares the image with a *veil*, he is following the thread right back to the *Mandylion* and the icon's identification with the firmament (cf. chapter 3).

Perspective between intuition and linearity

As mentioned, there are two aspects to perspectival pictorial space: it more or less intuitively conjures up a feeling of depth through optical impressions such as fore-shortening and atmospheric blurring with distance; and it freezes some of these impressions in the abstract-geometric system of linear perspective. Realisation of linear perspective depends ideally on knowledge of points of reference in the space being described, in such a way that the projection of the space appears as a geometric reconstruction. Less ideally, familiarity with known phenomena in the depicted space – in particular elements of a geometric profile, such as buildings, roads and fields, but also human figures, animals and trees – can lead to plausible hypotheses of spatial behaviour, although it must be stressed that accurate knowledge of space can never be reached via the sense of sight alone.

Landscape, then, is in the outer zone or completely beyond the reach of linear perspective, constructed as it is by nature's amorphous phenomena. Is it a twig or a branch we are looking at; a mound or a mountain? Have we spotted a small cloud or a broad expanse of mist? Where the wilderness begins, clear proportion comes to an end. It is only where cultivation makes for lines of connection across the terrain that the landscape can be calculated in more exact spatial terms. Landscape in modern painting is thus stretched between these two extremes: on the one hand, the proportions extract power over it via the levelling of cultivation; on the other hand, it manifests a chaos, the infinity of which eludes the comparative scale and therefore has to be pinned down through an intuitive rather than a linear perspective.

Regardless of its varying dealings with intuitive perspective, however, I am in no doubt that linear perspective is still the plane-geometric system which comes closest to visual impression – visual impression understood as the momentary sight, *das Augenblickliche*. The linear perspectival eye-point, which gathers the lines leading out to the objects in the environment – what Alberti calls the visual rays – corresponds to the centre of the eye's lens; and the surface, which cuts off this visual pyramid, corresponds to the projection on the retina.[78] There is, indeed, endless discussion as to whether linear perspective is artificial or natural, construed or realistic. One point of argument is that linear perspective is monocular, whereas eyesight is ste-reometric; another, that the perspectival projection is flat, whereas that of the eye is convex, which makes for problems at the sides of panoramic prospectuses. In practice, moreover, we do not register things in a single glance, but piece vision together from many single glances. These objections do not, however, upset the fact that linear perspective operates with momentary sight as the ideal and that, considering its mathematical rigorism, it gets pretty close to this objective.

In the first instance, therefore, we should look at the distinguishing features of momentary sight rather than at the technical methods by means of which it is fixed on the image plane. Momentary sight distils down to two properties: [1] it sees the surrounding environment in an isolated moment; [2] it does this from a specific point of view, which is determined by the momentary element. To isolate this gaze from the broader perception and elevate it to pictorial ideal is – as shown in the Interlude – anything but 'natural'. If in doubt, we should simply bear in mind Aristotle's reasoning as to why a very small animal cannot be beautiful: it cannot because *our perception becomes indistinct when it approaches the momentary* (cf. chapter 1). The primacy of momentary sight in the image is therefore determined by, and inscribed in, an epistemic *field* that breaks with antiquity's ideal of total knowledge – an all-surveying insight before which the objects settle in their ontological essence – in favour of a fragmented cognition satisfied by limited and subjectively-bound aspects of an object.

It is on this basis that the essential quality of modernity can be called nominalism – a property which is actually also embodied in the etymology of perspective. In the perspectival vision we cannot look the world directly in the eye, but have to look *through* something, *perspicere*. This something that we look through is the projected image – cast onto the back wall of the eye socket or its outward extension in the painted image plane – a projection which thereby becomes both mediation and barrier, window and mirror, symbol of liberty and prison. It is only by dint of being enclosed behind the wall of individuality that there is need to open that window which is not merely represented by the modern image but also by the momentary sight. As Leonardo so elegantly – and Platonically – writes of the eye: "The eye is the window of the human body through which the soul views and enjoys the beauties of the world. Because of it the soul in its human prison is content, and without it this human prison is its torment."[79]

The clearest manifestation of the image plane as this kind of window is most probably to be found in the latticework – equivalent to the window's crossbars – which underlies so many painting designs following the emergence of linear perspective and which is also a feature of the new pictorial aid, the latticed perspectograph. In Dürer's famous woodcut illustration from his treatise on perspective, *Course in the Art of Measurement* (1525), the reclining nude is scanned through the grid of this instrument, which in its *Durchsehung* simultaneously offers an opening towards and an appropriate screening from the woman's prominent crotch, an apposite synecdoche for that nature the male viewer wants to control. In this latticework we find, furthermore, an apposite visual parallel to the system of co-ordinates developed by Nicole Oresme 150 years earlier to describe the change of quality as a function of time. Both systems signify, in nomalist fashion, the membrane through which

consciousness reaches cognition of the infinite environment while simultaneously realising its separation from the same.

However, in a wider sense, the *Durchsehung* of perspective also deals with the arrangement of objects out in the spatial surroundings. A significant innovation in 15th-century painting is thus the framings – windows seen frontally or, a particularly bold Netherlandish speciality: as very narrow slots – through which the gaze glides smoothly from dim interiors and out to distant landscapes. This mode of presentation is in sharp contrast to the sacral-idyllic paintings' discontinuous leap between architectural walls and their inserted depictions of landscape (cf. chapter 6). Out there in the landscape expanses, trees are likewise set up with no antique anxiety about what can be seen in the distance behind them, whether it be other trees, remote hills or the clear blue sky visible between the branches. In this ongoing juxtaposition of foreground and distance, landscape becomes one big perspective: everywhere, we move *through* something in order to get further into the depth.

The role of linear perspective in modernity's epistemic *field* is particularly apparent from the fact that it crystallises simultaneously with the new pictorial paradigm.[80] It is still a matter of discussion as to whether its precise mathematical formulation is the work of Brunelleschi in the 1420s, Alberti in 1435 or an *éminence grise* such as Brunelleschi's friend, the mathematician and geographer Paolo dal Pozzo Toscanelli (1397-1482), but Masaccio's use of *costruzione legittima* in his *Trinity* fresco of 1427 or 1428 (**FIG. 8.3**) suggests that at least Brunelleschi, who according to Vasari was Masaccio's teacher, must have been familiar with the method. Manetti's biography of Brunelleschi (*c.* 1480) indeed claims that the architect actually invented or re-discovered perspective and that he demonstrated his method through two now vanished depictions of Florence's Baptistery and Piazza della Signoria. In order to ensure the desired illusion in the Baptistery panel, Brunelleschi drilled a hole at the spot which later became known as the vanishing point. As a manifestation of the correspondence between outlook and remoteness, subject and infinity, this point was now transformed to eye-point, as Brunelleschi stipulated that the beholder should look through the hole from the verso of the panel and observe the reflection of the view as it appeared in a mirror (of identical size) held at arm's length.[81]

But the regime of linear perspective also clearly had its limits given that "he placed burnished silver where the sky had to be represented, that is to say, where the buildings of the painting were free in the air, so that the real air and atmosphere were reflected in it, and thus the clouds seen in the silver are carried along by the wind as it blows."[82] The gold ground of medieval skies is thus transformed to a silver plane no longer symbolising the indestructible celestial sphere but, on the contrary – as a visual counterpart to the literary *speculum* – reflecting the atmospheric sky in all its changeability. In Hubert Damisch's key statement, we are here dealing with

an epistemological emblem [...] to the extent that it reveals the limitations of the perspective code [...]. It reveals perspective as a structure of exclusion, the coherence of which is founded upon a series of rejections, and yet which has to make room for the very things that it excludes from its order.[83]

Even though Damisch has a keen understanding that linear perspective belongs in the urban space with its geometrically-controlled forms and thereby becomes diffident in relation to nature's amorphous chaos, it nonetheless seems to me that he exaggerates the degree of otherness of this chaos. That the hazy sky's reflection

Fig. 8.4. Dirk Bouts, *Last Supper*
(1464-67), central panel from
Altarpiece of the Holy Sacrament,
tempera on wood. Louvain,
St Peter's Church.

defies a linear effect of depth does not actually mean that it is beyond depth, let alone representativity as such, any more than linear perspective is beyond 'mirroring effect'. On the contrary, linear perspective and the reflection of clouds are inscribed in the same epistemic *field*, that of modernity, through the fact that they both signify an infinite remoteness through which the autonomous subject constitutes – reflects – itself; only the former, mathematic, remoteness applies to the rationality of this subject (objectivity), whereas the latter, chaotic, remoteness applies to its intuition (subjectivity).

So saying, it also becomes a less confusing fact that the systematic linear perspective was utilised earlier and more intensely in Italy than in the transalpine North. Whereas the Italians present a mathematical perspective construction in the 1420s, we would seem to have to wait until Dirk Bouts' *Last Supper* of 1464-67 (**FIG. 8.4**) before the Netherlands see an architectonic space assembled with a thoroughly unifying linear perspective.[84] The reason for this difference is decidedly not that the Netherlandish artists had less spatial sense than the Italians for, as will be detailed in chapter 9, their pictorial gaze often opened towards more radically vertiginous horizons than their colleagues to the south. It is rather a case of a Northern nominalist tradition versus a Southern construction-oriented one. The mathematical perspective construction depends upon a precise imagining of the way in which the scene to be painted is built up. If, however, a panorama is evoked

less from construction than from visual impression, the centre of gravity is moved inwards, from objective knowledge of the surrounding environment to subjective visual knowledge or, to put it another way: from rationalism to empiricism.

Despite the differences between South and North, and despite the fundamental divide between linear continuity and hazy discontinuity, there are nonetheless limits as to how far the Netherlanders diverge from linear perspective. Simply because the artificial construction is close to the transference of the visual impression onto the pictorial surface, then even an art that imitates this impression on a purely empirical, anti-constructivist basis will have a 'linear-perspectival' look.

Svetlana Alpers has most thought-provokingly but, as far as I can judge, with only partial success, attempted to separate out these two image regimes – the visually-oriented and the linear perspectival – on the basis of the terms "description" and "narration".[85] In her opinion, the Northern post-medieval pictorial space is fundamentally empirical, what she terms descriptive, whereas the systematic perspective construction is a congenial expression of Italian Renaissance painting, oriented as it is towards narration. Although it appears to be correct that the Italians found immediate comfort in a definable pictorial regime in order better to underpin the figure-based narrative, it seems doubtful that this regime can merely be described by the general term 'linear perspective'. As will be shown in the next chapter, this is most likely a case of *selective* linear perspective, which transforms the field of vision into a kind of theatre stage, on which the figures obviously belong.

Despite the basic soundness of the concept of North European description, Alpers gets into further difficulties when she links description with a kind of 'pure' vision without reference to the beholder, whereas it is conversely claimed that the Italians preferred a view in which the beholder's position is well-defined. It is more accurately a case of the Netherlandish vision-oriented art being inconceivable without the idea of the subjective beholder's position. In fact, Panofsky has established the likelihood of the subjective beholder being far more developed north of the Alps, whereas the Italians tend towards idealised frontal compositions in which the idea of the presence of a beholder is in practise blurred. Panofsky refers, as an example, to the otherwise very Netherlandish-influenced Antonello da Messina, who has to place his Saint Jerome (*c.* 1474; FIG. 8.5) in a study, which is shown closed, parallel with the image plane and with a vanishing point at the centre. In contrast, we could turn to, for example, Jan van Eyck's *Madonna in a Church* (*c.* 1432-34; FIG. 8.6), in which the Gothic church interior stretches diagonally into the depth. We are here, more explicitly, confronted with visual direction and point of view, and can sense that the pictorial field only comprises a section of a larger space.[86]

In keeping with our comments on the subtle boundary between linear and intuitive perspective, linear perspective seems otherwise to be thoroughly absorbed in

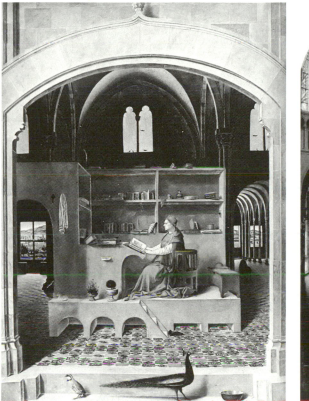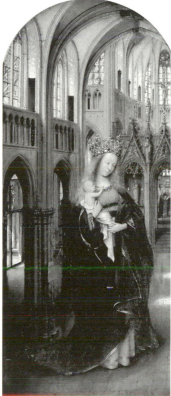

Fig. 8.5. Antonella da Messina, *Saint Jerome in his Study* (*c.* 1474), oil on wood. London, National Gallery.

Fig. 8.6. Jan van Eyck, *Madonna in a Church* (*c.* 1432-34), oil on wood. Berlin, Staatliche Museen.

the post-1500 North. And yet Alpers finds that even this systematised Northern form reflects principles other than those current in Italy. In reading the North's first treatise on perspective, Jean Pélerin Viator's *De Artificiali Perspectiva* (1505), she notes that sight itself, not a window in front of the eye, is the ideal for the image. The result of this vision – a heterogeneous, de-centralised space which pays regard to the movements of the eye – is identified by Alpers in, for example, a plate from Jan Vredeman de Vries' *Perspective*, published in Leiden 1604-05 (**FIG. 8.7**).[87] In this geometric construction of a room, the central vision is indeed challenged by a confusing number of open doors and shutters, and yet it is still a *perfectly homogenous space constructed in systematic linear perspective*. Even though Alpers is addressing a significant point when she identifies sight, rather than construction, as the ideal for Northern artists, this

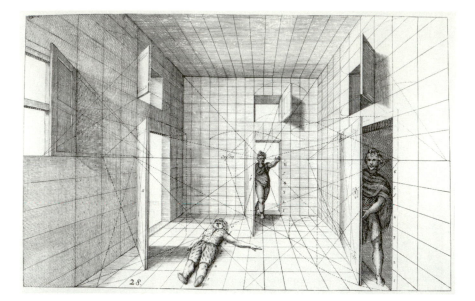

Fig. 8.7. Jan Vredeman de Vries, Plate 28
from *Perspective* (Leiden, 1604-05), engraving.

does not change the fact that sight still occurs on the basis of the same principles as those of the perspectival image in the widest sense. The world does not deposit differently located outlines when projected through a perspectograph than when cast onto the back wall in a *camera obscura*, the mechanical imitation of the eye.[88]

Provisionally, therefore, we could say of Alpers' theory that her key distinction, the difference between Northern description and Southern narration, appears to be extremely precise, but that she follows the wrong track by going on to link description with a subject-less eyesight, and narration with a linear perspective based on subject and window alike. The crucial distinction between the Italy-North correlation is not between window and eye or between linearity and empiricism – categories which will actually often be interwoven – rather it concerns a Southern ideal-oriented perspective versus a Northern subject-oriented perspective. In the ideal perspective, the image is centralised to a scene upon which plastic figures present themselves so self-evidently that consciousness of viewpoint disappears, or rather: is displaced; however, in its subject-oriented counterpart – of which ideal centralism actually constitutes a special case – the image points to itself as a seen fragment of the infinite environment, by means of which the figure's plasticity-based special status is dispelled in the non-hierarchical space.

The gaze from above:
voyages of discovery, cartography, perspective

The modern paradigm's invasion of the pictorial space not only occurs simultane-ously with the development of the Copernican world picture, but also alongside the colonisation of another space: the world beyond the West.[89] At the same time as the space behind the image plane begins to expand, and the universe around the earth is extended, European culture is struck by similar growing pains in a horizontal direction. This expansion begins with crusades on land, is followed up with voyages of discovery by sea and culminates in the systematic colonisation of everything non-Western. None of the three movements can be cut down to single causes, but are controlled by an impenetrable complex of motivations: commerce, overpopulation, missionary zeal, aspiration to conquest, scientific inquisitiveness, love of adventure, restlessness; in brief, a wealth of factors better understood within the epistemic *field* – that of modernity – of which they are a part, rather than in isolation.

The crusades between the 11th and 13th centuries can thus be said to actualise that link to the Orient which at the same time finds intellectual expression in the import of Islamic natural philosophy. As a consequence of this opening, the Venetian Polo family is able to travel to China and Indonesia in the second half of the 13th century and the similarly Venetian Niccolò Conti to journey to Java by land in 1419. In the 14th century, Europeans also begin to extend their sea routes southward and westward, pursuing the incentive of commercial imperialism. The Madeira Islands and the Azores, a third of the way across the Atlantic, already featured on a map in 1351, the Canary Islands were added in 1389. And, in the 15th century, African gold and sea routes to India are prized: in 1433 Gil Eannes, one of Henry the Seafarer's captains, crosses Cape Bojador; Cape Verde is reached by Dinis Dias in 1444; and in 1488 Bartholomeo Dias rounds the Cape of Good Hope, the southern tip of Africa.[90]

These voyages and their climax in Columbus's expedition westward to America in 1492 and Vasco da Gama's eastward to India in 1497-98, were again not experiments in the dark. They took place completely synchronously with and dependent on the change in the *mental* image of the world which affected the birth of the modernity *field*. In J.R. Hale's words, they occurred "in the service of an organized vision of what might be found and an eagerness to relate to it what is known."[91] This organised vision of the world was particularly evident in *cartography*. As we saw in chapter 4, the antique world map only covered Eurasia and North Africa and, what is more, it had been out of proportion. Land surveying did indeed use proportioning grids for the measurement of fields on the local level, just as Ptolemy in his *Geography* had introduced co-ordinates as specification of location, but it would seem that a

Fig. 8.8. Pietro Vesconte, map of the Holy Land (*c.* 1320),

miniature from Marino Sanudo's *Liber secretorum fidelium*

crucis. Paris, Bibliothèque Nationale, ms lat. 4939, ff. 10V-11.

fusion of the two systems – a grid covering the entire world – eluded antiquity, as did a perspectival unification of the visible space in the image.[92]

As with practically everything else in Western culture, the situation changes after year 1000. At this point, what are perhaps the first *regional* maps begin to be drawn, these being the mediating link between the local and the global. If they have precursors, they would seem to be from the 'little modernity' of the 4th-5th century. The 12th century produced maps of Europe and Asia, the end of the 13th century saw harbour maps of the Mediterranean and the Black Sea which, in details and accuracy, surpass all previous maps.[93] And around 1320, Pietro Vesconte, a Genoan living in Venice, draws a map of the Holy Land to be used in Marino Sanudo's *Liber secretorum fidelium crucis* (*Book of Secrets for the Faithful of the Cross*), a work calling for a new crusade (**FIG. 8.8**).[94] This map is remarkable because of its overlaid gridwork specifying, with startling clarity, the position of cities, rivers and mountains. The gridwork is this time possibly imported from China, where it had been used in maps ever since the work of the 3rd-century cartographer Phei Hsiu. Another possible – and possibly mediating – influence is Byzantium as, from the 13th century, several Greek editions of Ptolemy's *Geography* were equipped with grid-covered maps, both regional maps and world maps.[95]

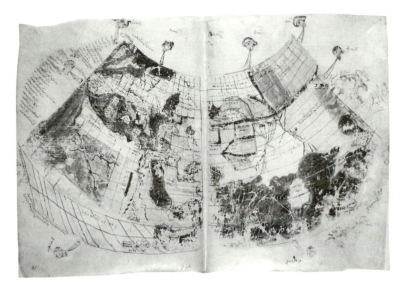

Fig. 8.9. World map (15th century), miniature from
Byzantine manuscript of Claudius Ptolemy's *Geography*.
London, British Library, Add. ms 19391, ff. 17v-18.

For the first time in Western culture, therefore, mapping now transgresses the *agrimensores'* local grid limited by mountains and rivers, and moves on to a fundamentally infinite system of co-ordinates, disengaged from the directives of the terrain. Quite logical, then, that a few decades after Pietro Vesconte produced his map (and evidently more as a result of the epistemic *field* than a direct influence), Nicole Oresme works out *his* system of co-ordinates, but now just, as we have seen, to be used for the calculation of the change of intensity over time.

The idea of overlaying the entire world mass with a grid reaches the West from Byzantium at the beginning of the 15th century, when Ptolemy's *Geography* is translated into Latin for the first time (**FIG. 8.9**).[96] Although the illustrated Ptolemy still only depicts a limited part of the globe – the section from Gibraltar to the Far East – it moves the West to the upper left corner of the map and in so doing signals a new approach to the world – an approach aiming to survey the globe in its totality. This overall inspection is only possible because the map is disengaged from the earth, becomes an independent system with its own points of reference. We will recall that Nicholas of Cusa, the philosopher who stresses the difference between the infinite presence of the world and the limited otherness of consciousness, also envisages how the earth will look if it is viewed from a point outside the

fiery sphere. Moreover, this same Nicholas of Cusa lifts his gaze above his homeland, Germany, and commits its terrain to paper, using cartographic co-ordinates that correct those of Ptolemy.[97]

The voyages of discovery not only take place simultaneously with this approach, they implement it, for, as Hale points out, 15th-century studies in geometry are just as significant for navigation as for cartography.[98] This is proven in spectacular fashion when the Portuguese Crown asks Nicholas of Cusa's friend, the aforementioned candidate for the invention of linear perspective Paolo dal Pozzo Toscanelli, to supply information about the sea routes to the Orient. As Edgerton notes, the Florentine mathematician's reply to the Canon in Lisbon, a letter dated 25 June 1474, can be seen as "one of the decisive letters of history", given that, probably in direct motivation for Columbus's expedition 18 years later, Toscanelli writes, *inter alia*:

> Accordingly I am sending his Majesty a chart done with my own hands in which are designated your shores and islands from which you should begin to sail ever westward, and the lands you should touch at and how much you should deviate from the pole or from the equator and after what distance, that is, after how many miles, you should reach the most fertile lands of all spices and gems [...]. So there is not a great space to be traversed over unknown waters.[99]

That this combined love of adventure, commercial imperialism and hard-headed calculation really does signify a giant leap in cultural evolution – a leap that takes Western culture definitively from the closedness of the Golden Age *field* to the openness of the Iron Age *field* – is apparent if we recall antiquity's terror-stricken remarks on sea voyages beyond the Pillars of Heracles at the Strait of Gibraltar (cf. chapter 1): "All beyond that bourne cannot be approached either by the wise or by the unwise." Since the far more carefree modernity not merely approaches, but definitively transgresses this marker for the closed world, the post-Golden Age horizons are at long last saturated, so that Toscanelli's no longer "unknown waters" realise Ovid's "unknown waves" and winds of which the sailor has scant knowledge, just as the voyage to "fertile lands of all spices and gems" recalls, for example, Tibullus's search for "riches on unknown shores" and ship cargoes with "foreign merchandise" (cf. chapter 4).[100]

Bearing in mind Toscanelli's interest in perspective and optics, indeed, that he was possibly the catalyst who, half a century earlier, had guided Brunelleschi to his famous perspectival view of the Florentine Baptistery, we also clearly sense how inviolable a thread goes from mapping and colonisation of the macroscopic world to the perspectival visualisation of the near and distant surroundings. As Edgerton has vividly shown, the horizontal grid, which in cartography sees the continents

from above, is crystallised synchronously with the vertical grid, which in linear perspective sees the surrounding environment captured from an individual point of view.[101] The conquering journey to the furthest reaches of the globe is thereby inseparable from the journey simultaneously undertaken by the pictorial view across the visualised earth to distant misty-blue mountains. W.J.T. Mitchell's idea of landscape as a kind of 'dreamwork' for imperialist movements can accordingly be corroborated.[102] The conquest potential of the eye in all its facets – cosmological, colonial, scientific, artistic – shines out of this citation from Leonardo:

> Now, do you not see that the eye embraces the beauties of all the world? It is the mas-
> ter of astronomy, it makes cosmography, it advises and corrects all human arts, it car-
> ries men to different parts of the world; it is the prince of mathematics, its sciences are
> most certain; [...] it has created architecture, and perspective, and divine painting.[103]

That cartography and perspective develop so synchronously is because the former is contained in the latter. In my examination of pre-modern space representation, I found that *mapping gaze* and *panoramic gaze* were separated when the depth of field had expanded to such an extent that land formations could create depth of image. With the *agrimensores'* mapping gaze and grid it was possible to survey a larger territory, but not to direct the gaze toward the horizon. With the semi-subjective panoramic gaze it was possible to direct the gaze into the depth, but not to survey the terrain divided by the grid. In order to create a modern landscape portrait, then, the two ways of seeing have to be amalgamated. Without forgoing the over-view and precision of location provided by the mapping gaze, there is, as it were, a zoom-in to selected map details, which are then isolated in spatial images. At that instant – the instant when the overview reaches from mapping gaze and into that oblique gaze which creates the modern image – at that moment the horizon and infinity are exposed.

The mechanism applies regardless of whether the landscape being depicted is fic-tive or topographically accurate. If the latter is the case, we remain in the descriptive sphere of the map. The last quarter of the 15th century sees the first topographical portraits to include the map's overview as well as the new paradigm's perspective. One example is the woodcut view of Florence, called "with chain" (*c.* 1470-85), at-tributed to Cosimo Roselli's workshop (**FIG. 8.10**). The artist, as if not wanting to leave the beholder alone with the floating view, intervenes as agent for our gaze. On a level with the padlock, which secures the chain framing the image, he stays fixed to the ground of the hilltop while his gaze flies from the river boats in the close foreground across the city wall and all the townhouses and on to the fields, hedges and distant mountains.

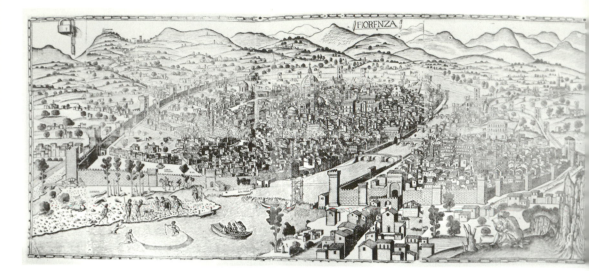

Fig. 8.10. Cosimo Roselli's workshop, *Panorama of Florence ("with Chain")* (*c.* 1470-85), woodcut.

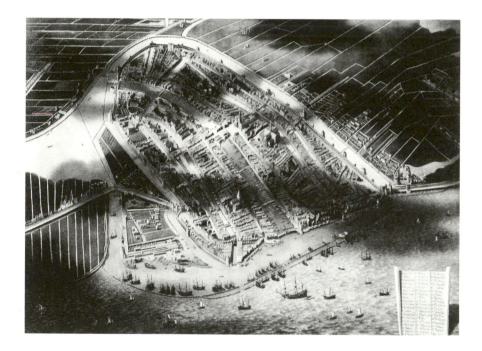

Fig. 8.11. Jan Christaensz. Micker, *View of Amsterdam* (*c.* 1650). Amsterdam, Amsterdam Historical Museum.

But in Jan Christiaensz. Micker's *View of Amsterdam*, painted two centuries later, this connection with the earth has long since been cut (FIG. 8.11). Here the gaze is so high up in the air above the busy merchant city that the flat Netherlandish topography is covered with fuzzy shadows made by the clouds. Bearing images such as these in mind, it becomes strangely tangible that Leonardo should refer to the eye as a means of carrying people to the different parts of the world – and even toyed with the idea of aircraft, which could take the beholder physically up to this viewing altitude.

The triumph of sight and colonisation

As mentioned, the culturally-produced symbiosis between an independent subject and its infinite environment first reaches an ultimate maturation in the 19th century. At the same time as Western landscape painting is emancipated, the subjective gaze could be said to culminate in the photograph – where it also begins its phasing out. This line of thought is summarised in Peter Galassi's excellent essay for the exhibition *Before Photography* held at the Museum of Modern Art, New York, in 1981.[104] The camera can capture the world from odd, random angles, making the images almost absurd fragments of the infinite surroundings. Here, in the actual freezing of the momentary sight, the classical illusion of a closedness in front of the pictorial window ultimately fails.

Galassi cautiously suggests that this gaze is not determined by the photograph, but that, on the contrary, the photograph is triggered by the gaze. As the pre-photographic paintings in the exhibition show, an increasingly 'photographic' pictorial view develops as we move from the invention of perspective in the 15th century and on to the beginning of the 19th century. In Ruisdael's deserted *Bentheim Castle* (c. 1670; FIG. 8.12) the rocks are already given a conspicuously prominent place in the foreground around the rushing river, while the castle itself has to draw insignificantly back on the hill below the broad cloud cover. And yet this spatial displacement is nothing compared with the 'non-motif' that appears in Friedrich Loos' *View towards Salzburg from Mönchsberg* (c. 1829-30; FIG. 8.13). Here, an oblique shadowy mass of rocks and trees hits us straight in the eye before we spot the diminutive, carelessly revealed town in the background.[105] It is not until the exact instant in which the momentary sight is fully realised, as here, that the combination of optics and chemistry able to fasten this sight come together.

The period that initiates light-chemistry's freezing of the momentary sight is also the period that canonises the infinite universe and allows for the culmination of Western imperialism. At the same time as the last white spots on the world map disappear, the 'new' world becomes the last domain of Western longing for freedom,

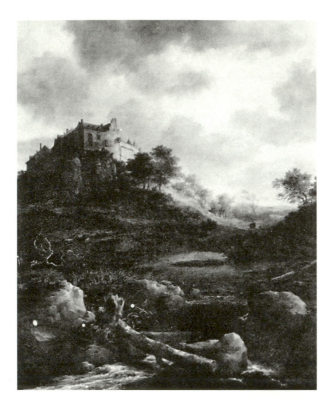

Fig. 8.12. Jacob van Ruisdael, *Bentheim Castle* (*c.* 1670), oil on canvas. Amsterdam, Rijksmuseum.

Fig. 8.13. Friedrich Loos, *View towards Salzburg from Mönchsberg* (*c.* 1829-30), oil on canvas. Vienna, Österreichische Galerie Belvedere.

adventure and possession. In Franzsepp Würtenberger's pioneering essay *Weltbild und Bilderwelt von der Spätantike bis zur Moderne* (1958), we not only read about this connection between expansion of the pictorial space and actual knowledge of the world's continents, but also about the dependence of these spheres on the *concept of time*.[106] Even though Würtenberger does not go into detail, he suggests that 19th-century artists are the first who are able to place their pictorial space in a definable time, because control has been gained of the earth's total surface and it is therefore possible to co-ordinate the sun's changeable positions in a universal time (**FIG. 8.14**).

Nor is this aspect of Würtenberger's ideas difficult to corroborate. Although 15th-century painters might introduce indications of time such as day, dusk, night and seasons, there is still a long way to go before the exact indications of time we encounter in 19th-century images. In 1856, the Pre-Raphaelite John Everett Millais paints *Autumn Leaves* in so temporally precise a fashion that the setting sun burnishes the girls' hair while their faces are indirectly lit up against the blue-black horizon (**FIG. 8.15**). As John Ruskin notes: "It is [...] as far as I know, the first instance of perfectly painted twilight."[107] It is also this visualization of time that we see captured in the photograph, the momentary freezing of a space influenced by time.

Again, we can make a link to the epistemic *field* because, just as the 19th century constitutes the zenith of the colonial period, it is also the period in which global time is co-ordinated and chronometers regulated. Even though, as we will see, mechanical clocks had been in widespread use since the Late Middle Ages, for a long time temporal measurement was purely a local phenomenon. In *Voyage en Italie*, for example, Montaigne writes about the chaos he experienced en route because cities in the 1500s still followed their own time.[108] Thus, it is only after the artist is situated on a globe with a common, homogenised time, that he or she is able to paint a dusk experienced at a specific moment.

This observation is also corroborated by an isolated consideration of light in painting. As Wolfgang Schöne commented, the movement from the painting of the Middle Ages to that of modernity signifies a movement from *self-light* to *illuminating-light*. Whereas light in the Middle Ages is conceived of as metaphysical and transmitted internally from body to body through the world hierarchy, in modernity it becomes an outer entity cast from well-defined light sources and spread in the void between the bodies. Schöne distinguishes between four types of light cast in the images: natural light (from sun or moon); artificial light (from fire or lamps); sacred light (from celestial revelations); and, finally, what he calls *indifferent* light. This last category is a light which can be seen cast onto objects, but which cannot be traced to any specific source. Schöne notes that images between the 14th and 18th centuries always have a portion of this kind of light, and that it first disappears around 1800 in favour of explicit light sources.[109] On the basis of my earlier

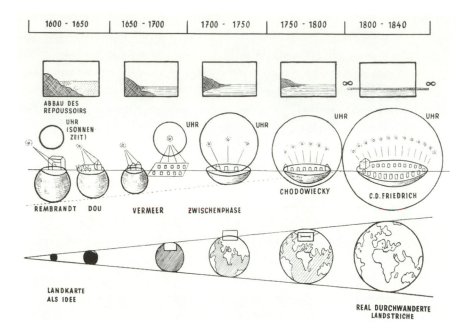

Fig. 8.14. Diagram showing the connection between pictorial landscape, sundial time and knowledge of the earth's surface, 1600 to 1840. From Franzsepp Würtenberger, *Weltbild und Bilderwelt von der Spätantike bis zur Moderne* (1958).

Fig. 8.15. John Everett Millais, *Autumn Leaves* (1856), oil on canvas. Manchester, City Art Gallery.

considerations of the maturation of modernity, I will therefore interpret the indifferent light as a leftover from the pre-modern period – cast light, indeed, but as of yet homeless. The elimination of homelessness requires a fully-developed subjectivity and a homogenised time fixing the sun at a precise point in the sky.

Petrarch on the Windy Mountain

The overview implicit in both the cartography and perspective of modernity can only be achieved by, in an utmost concrete sense, exploding the geocentric world picture. With the heights filled with fire, ethereal bodies and various hierarchies of angels, it is difficult to imagine them being replaced by a human observer. When Nicholas of Cusa considers how the earth might look to an observer beyond the fiery sphere, he is therefore already in the process of dispersing the geocentrism.

This tension between overview and geocentrism is also evident in Petrarch's famous epistle about his mountain ascent on 26 April 1336, addressed to the Augustinian monk Dionigi da San Sepolcro.[110] The humanist, who had already expressed his pleasure over his *vita solitaria* in the Provençal nature, had long aspired to climb Mont Ventoux, the highest peak in the area. The desire was provoked – and legitimised – by an antique precedent, Philip of Macedonia's ascent of Mount Hemus in Thessaly. Could it really be true, as claimed by Livy, that Philip had been able to see both the Adriatic Sea and the Black Sea from the peak of the mountain?[111] For want of a better method, the statement could be tested on the Windy Mountain, which Petrarch now – accompanied by his younger brother – decides to climb.

Before Petrarch reaches the mountain's panoramic platform, however, he has to go through a veritable purgatory of ordeals, mental and physical alike. The daring character of the project is obvious even before he sets off, when he excuses the venture on the grounds that "an ordinary young man" could "do something considered appropriate for an old king." Along the way, he and his brother meet an old shepherd who had indeed made the ascent when a young man, but who warns them against subjecting themselves to its infernal hardships. The warning merely fires Petrarch up, and he even chooses to follow a more complicated route than his brother. When he realizes that the ascent really is incredibly exhausting, he likens it to the journey undertaken by the soul en route to the spiritual sphere. For also "[t]he life we call blessed is certainly located on high, and [...] a very narrow road leads to it."[112]

The view by which Petrarch is overwhelmed on the cloud-encircled peak, however, disperses the geocentric tension. The panorama across the Alps, the Mediterranean and the Rhône is so grandiose that the spatial perspective is coupled with a temporal one. Above the Alps, thoughts fly back a decade, to his young days at the university in Bologna. But Petrarch is also seized by melancholy and doubt

about his ability to love God, and he therefore looks in Augustine's *Confessions*. The passage he chances upon states: "And men go abroad to wonder at the heights of mountains, the lofty billows of the sea, the long courses of rivers, the vast compass of the ocean, and the circular motions of the stars, and yet pass themselves by."[113] Petrarch now frets about having ever admired anything earthly when it is obvious that nothing is greater than the soul, just as inner cannot be found in outer. Our need is "not to achieve a more lofty place on earth, but to trample underfoot our appetites which are exalted by earthly impulses."[114]

Petrarch's letter thus tells us that he has reached the point of isolating the soul from the simple geocentric hierarchy. And yet the soul is still too frail an entity for him to dare mirror it in a view of the outer, expansive world. Nonetheless, the very desire for this view – the aesthetic – shows that Petrarch has become irredeemably modern.

The searching gaze: cross section

And yet: because the modern gaze hovers uncertainly between the large and the small infinity, the distance that inserts itself between the viewer and the object can just as well be diminutive as immense. In the most extreme case, the plane that cuts off the visual pyramid may slice through the very inside of objects. In the sciences of modernity – anatomy, geology, biology, archaeology, architecture, and so forth – this surgical *section* is an important means by which to understand the objects, and its exposure is also traceable in the space in front of the pictorial window. Section understood as a level slice of a mass is, as Maria Fabricius Hansen has pointed out, an unknown phenomenon before modernity. When architects were to set out the plan of a building, they drew the walls as body-less lines – for example, in the ideal *Plan of St Gall* (c. 820; FIG. 8.16). But, in the 15th century, the section is fully-honed as part of the new pictorial paradigm. While Alberti still advises against the use of perspectivistic methods in architectural drawings, Filarete and Francesco di Giorgio present a number of their draft designs as sections, in profile as well as level (FIG. 8.17).[115]

This way of viewing can be traced back to 14th-century images, in which we often look into the architectural interiors as if they were a kind of dolls' house with the facades sliced away.[116] In this extremely non-antique way of viewing, the section appears in its dual role as surgical uncovering and window for the gaze. From the 14th century onward, the buildings were also sliced through as the result of another modern image phenomenon, which I shall examine in more detail in chapter 12: *the ruin*. In the *Miracle of the Cross* in the Upper Church of San Francesco in Assisi (c. 1300), the moral decay has ensured that the walls, tiles and rafters of the church are exposed,

Fig. 8.16. *Plan of St Gall (c. 820),* red ink on parchment. St Gall, Stiftsbibliothek.

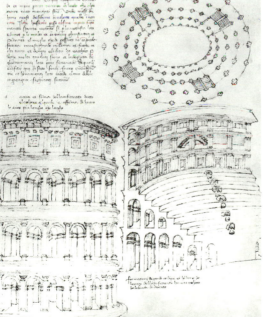

Fig. 8.17. Francesco di Giorgio, *Elevation, Plan and Section of the Colosseum (c. 1486-92),* pen and ink on parchment. Turin, Biblioteca Reale, Codice Saluzziano 148, f. 71.

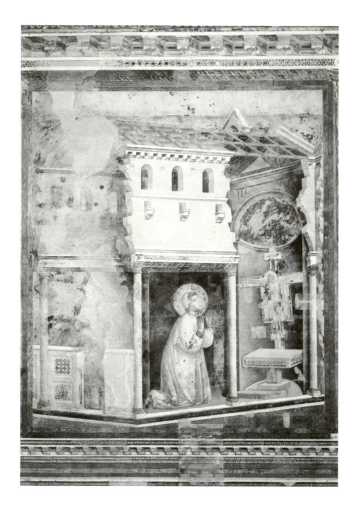

Fig. 8.18. School of
Giotto, *Miracle of the
Cross* (*c.* 1300), fresco.
Assisi, San Francesco,
Upper Church.

revealing a perfect model of its structure (FIG. 8.18). The subversion of time thus ex-
poses the inner structures just as comprehensively as any architectural section. An
illustrative example of this is the drawing of the Colosseum ruin around 1490, in the
anonymous Italian sketchbook *Codex Escurialensis* (FIG. 8.19). The ruin is seen here
for the first time from its difficult, surreal side where decay has sliced through the
circular walkways around the inner wall. The gaze is remarkably similar to Filarete's
drawing of *Casa della Virtù e del Vizio*, in which a comparable structure features, albeit
now the result of a cool mathematical section (FIG. 8.20).[117]

Pointing out a difference between these two methods of exposure – ruination
and section – would again have to depend on the degree of definition. Both ways
of viewing belong to modernity's infinite and homogenous space, but whereas the

Fig. 8.19. Anonymous Florentine artist, *Ruins of the Colosseum* (*c.* 1490), pen and ink on paper. Escorial, Biblioteca Real de San Lorenzo, Codex Escurialensis, ms 28-II-12, f. 24v.

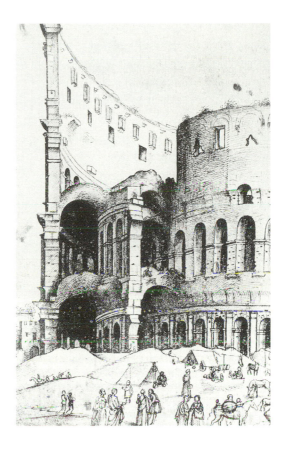

Fig. 8.20. Filarete, *Casa della Virtù e del Vizio* (*c.* 1450), pen and ink on parchment. Venice, Biblioteca Marciana, ms lat. VIII, 2, f. 139.

architectural section belongs to the mathematically definable reality – that of linear perspective – the ruin is located in a space that defies mathematical description, a space of nuances, haze and irregular transitions. This, then, is the unregulated and intuitive space also found in the amorphous landscape phenomena, especially clouds.

In whatever form it takes, we could in conclusion be tempted to believe that the section brings the pictorial view into close contact with matter. The opposite is the case. The section constitutes the triumph of immateriality. The space is now so self-sufficient that it is irrelevant whether its points of reference are placed in vacuum or in matter. In modernity's relative space, the gaze is not to be darkened beyond the eclipse built into the mediation of the viewing process itself, and which does not make any fundamental distinction between dark and translucent matter.

9

Pressure and Counter-Pressure

The Pictorial Paradigm of Modernity and Its Curbing in the Renaissance

Introduction

IN ATTEMPTING TO come to a closer understanding of the early phase of the development of modernity's pictorial paradigm, including the role played by the landscape image, we run into a significant complicating factor which it is necessary to unravel here: the historical movement known as the Renaissance. Since the Renaissance itself – and reinforced by Jacob Burckhardt and the 20th century's conventional cultural history[1] – we have been taught that this movement ushered in a new and enlightened era, the beginning of modernity, and that it did so by supplanting the hitherto dominant epoch, the dark Middle Ages, with a re-actualisation of a past culture, antiquity. Art history in particular accepts that the naturalistic pictorial paradigm of modernity was only possible when artists moved onto the dual track: nature *and* antiquity. But what veracity can be attributed this myth if we take the Renaissance's self-definition as a reawakening of the antique cultural heritage at face value?

In this chapter I shall propose the thesis that the Renaissance's pictorial paradigm only constitutes an idealised subset of modernity's, and that this is because the Renaissance is to be understood more as a conservative time-pocket in an already semi-developed modernity *field* than as a source from which modernity rises. The argument has its fulcrum in the relatively simple observation that the antique pictorial gaze, the Rieglian normal sight – in its original and reawakened form alike – has its focus in a closed and supra-temporal body, whereas modernity's pictorial gaze, the Rieglian distant sight, rather moves attention from this body and out towards the infinite space marked by temporal change, including, in particular, the landscape. In other words, the Renaissance pictorial space appears

as a selective and beautified subset of the paradigm of modernity – a subset which, in accordance with the neo-antique canon, highlights plastic ideality and represses arch-mimetic phenomena such as oblique angles, distant wide expanses, confused compositions, amorphous spots, hyper-definition, fragments, particularities, ugliness, indeed, simply the prosaic in general.

But if the Renaissance is not the origin of modernity, then what is? In accordance with my own overarching evolutionary model, I shall again point to the Middle Ages, especially the Gothic late medieval period, as a likely candidate. While in the previous chapter I brought in arguments pertaining to the histories of consciousness and cosmology, in this chapter I shall rely chiefly on arguments relating to historiography and to internal aesthetic considerations of art. In a historiographical perspective, the idea of the Renaissance as generator of modernity would thus seem to be a peculiarly Italian construction, which despite specifically re-actualising the cultural heritage of the Mediterranean region also manages to spread to the Northern cultures. However, this construction has an element of coup to it, for if we trace the history of the term 'modern', we will find a late medieval link to the Northern Gothic culture.

The Gothic potential for modernity can, conversely, be enlarged upon in an aesthetic and aesthetic-historical analysis, in which its characteristics include phenomena so pregnant with modernity as infinity, myriads of particularities, non-corporeality and naturalism. Interestingly, these ingredients are not just to be found in the castigation to which the Italian Renaissance writers subjected the Northern Gothic, they also reappear as central parts of the aesthetic repertoire of romanticism in the 18th-19th centuries, including the Gothic revival. The romantics' rediscovery of the Gothic was thus not merely a case of more or less detached return to the Middle Ages, but of re-instituting the foundation of modernity and through that to overcome the regressive Renaissance.

Qua fulcrum of modernity's pictorial paradigm, landscape will be a recurring element in this argument. Despite the modern paradigm's trans-European impact in the 15th century, we will note, for example, that Netherlandish landscape images already at this time depart from their Italian counterparts by being more expansive, detailed and naturalistic. And in the 16th-17th centuries it is in the reformed North Europe too that landscape separates off from its ballast of figurative justification to become a motif in its own right.

It is my hope that this redistribution of roles in the play 'the birth of modern art' will reach beyond the narrow sphere of historians of the Renaissance and the Middle Ages and affect the discipline of image interpretation more generally. For the Renaissance annexation of early modernity has had a very unfortunate impact on standard art history in that the two specifically modern pictorial phenomena,

naturalism and perspective, are always interpreted through the Renaissance's distorting concave mirror, namely as inextricably allied to narration and to the plastic figure, and thereby also as adversaries of the amorphous, the expressive and the symbolically ambiguous. If, on the other hand, naturalism and perspective are liberated from the neo-antique hegemony, there should be hope that we can re-uncover their ontological potential as pictorial agents favouring description rather than narration, space rather than figure, subjectivity rather than ideality and brush-worked colours rather than unmediated transparency.

9.1 Modernity versus Renaissance: a historiographical perspective

The Renaissance – mask or face?

According to still prevailing Renaissance art history, the new naturalism of the 1400s emerged through the simultaneous pursuit of two sources: observation of nature and study of antiquity. By this means an art emerged that was ostensibly both more true to nature and aesthetically more satisfying. But as already suggested by Panofsky, there is a possible divide wrapped up in this dual objective: is the most beautiful and most antique-looking also necessarily the most true to nature? Panofsky states that until the end of the Renaissance, the divide was surmounted by the thesis "that classical art itself, in manifesting what *natura naturans* had intended but *natura naturata* had failed to perform, represented the highest and 'truest' form of naturalism."[2] With his characteristic, strategically-placed inverted commas Panofsky suggests that there is something fishy about this form of 'true' naturalism – a naturalism that should rather be understood as its opposite, *idealism* – and yet he elegantly sidesteps having to take an actual stand on the matter. Renaissance devotee that he had by now become, he could at the very most suggest that the Renaissance was a kind of masquerade – but a masquerade that completely changed the girl who wore her grandmother's clothes. Role and personality allegedly became one.

If, however, we isolate Panofsky's equilibristic attempt at conciliation in its subjugated component parts, we are left with the following basic question: does the late medieval pursuit of the pictorial heritage of antiquity really lead to anything that could with any justification be called a more naturalistic pictorial paradigm, or does the antiquisation chiefly involve an idealized pictorial culture masking or even subjugating an already advanced naturalism? The question leaves us with three options increasing in degree of scepticism: [1] when the Renaissance broke through, modernity was so little developed that even a resuscitation of antiquity

would look modern; [2] the Renaissance's self-perception is partly self-deception and its 'antique' ingredients a masquerade of a modernity that does not include resuscitation of antiquity as an essential keystone of its existence; [3] the Renaissance is utterly conservative, a backlash, the outer forms of which are not just masks, but signifiers for inner structures that curb the emerging modernity. In the following section I shall lean mainly in the direction of [3], albeit a dose of [2] and a grain of [1] are necessary for the sake of nuance.

As regards point [1], in chapters 1 and 3 we saw how the pictorial art of antiquity is characterised by a semi-developed perspective with foreshortenings and light/shade representation, and that this perspective was deconstructed in the Middle Ages in favour of a flatter, more diagrammatic pictorial space in which propensities to infinity are only expressed symbolically. Based on that observation, there must then be something or other in the pictorial culture of antiquity that is suppressed in the Middle Ages and 'reborn' in early modernity. Broadly speaking, it could be an acknowledgement of the sense of sight as crucial factor in pictorial representation – even though it has to be repeated that antiquity's concept of visibility is based in corporeality, whereas its modern counterpart looks towards space. It would thus not seem improbable that antique pictorial culture did actually act as a catalyst, optically becoming a guide for the late medieval image, albeit we have to be aware that this catalyst also had its limits, if it did not simply carry over into a neo-antique pictorial idiom.

Should the latter be the case, one interpretation is found in point [2], i.e. that we are dealing with an exterior cladding of an otherwise advanced modernity. Spengler, for example, sees the Renaissance as anti-Faustian in its attempts to repress the musical-Gothic and depth-seeking in favour of the plastic-corporeal, and yet it has no core substance that can justify these stylistic phenomena as anything other than semblance:

> But the Renaissance, when it had mastered some arts of word and picture, had shot its bolt. It altered the ways of thought and the life-feeling of West Europe not one whit. It could penetrate as far as costume and gesture, but the roots of life it could not touch – even in Italy the world-outlook of the Baroque is essentially a continuation of the Gothic.[3]

So, even though Spengler acknowledges the muted existence of the Gothic in Italy, there is still so much of it that it constitutes a core upon which the neo-antique is merely ornamentation. The Renaissance thereby limits itself to an enterprise in taste, an artificial counter-movement, which might indeed be anxious about Faustian supremacy, but at the same time lacks awareness of what it will put in its place.

But is accepting this idea of masquerade not to undervalue the effect of the Renaissance? For if sufficient power is staked behind the masquerade, this power appropriates what there might be of original personality, and we land in point [3], the understanding of the Renaissance as regressive, also in its fundamental structures. According to this model, the Renaissance can still effectively be an illusion at incorrigible distance from its antique prototype, and yet the empathy with antiquity represents a symptom of a cultural regression that radically changes the structures of the epistemic *field* in the 15th-16th centuries.

If not before, this model made itself felt in Italy after 1850 when the *Risorgimento* was unifying the peninsula under a republican form of government, and democratically-minded historians began searching for national antecedents to republicanism. In this quest writers such as Pasquale Villari and Alessandro Wesselofsky were seized by bitterness against Renaissance humanism and its promotion of antiquity, as classicism was seen as camouflage for a 14-16th-century political decline in which the republicanism of the communes was supplanted by the despotism of the *signorie* – antecedents, that is, to the very same mighty nobility which the *Risorgimento* was in the process of neutralising.[4] According to Villari's argument, for example, the communes were the cradle of European democracy since they afforded the third estate a stake in power – as is evident from 14th-century chronicles and diaries, the *volgare* of which is full of chaotic, everyday details. As the despotism spreads, however, the writers are seized by Neo-Latin airs and consequently their images of history become synthesised constructions scorning empirical trifles.[5] It was only with the Dominican monk Savonarola's attempt to re-establish the Florentine republic at the end of the 15th century that the *volgare* culture ostensibly had a final chance to break with the classically-draped absolute rule, in this instance of the Medici, and the 19th-century Italian school of historians itself was therefore given the name *I savonaroliani* or *I nuovi piagnoni* (after Savonarola's followers, 'the crying').[6]

Apart from the aforementioned nuances – the Renaissance's doses of actual modernity and masquerade – this model of regression corresponds quite precisely to what is going to be my concern here. The wealth of detail in 14th-century chronicles thus corresponds with pictorial art's contemporaneous movement towards an unbridled naturalistic paradigm, just like those constructions of history estranged from empirical corpus prevalent in later humanist literature correspond with the focus on the ideal body shunning particularities that is prevalent in pictorial art from and including the later 15th century, the epoch in which the High Renaissance came into being. While the sociological evidence of this will be discussed in chapters 10-11, I will here restrict myself to selected intellectual aspects: history of philosophy and science and, particularly, history of aesthetics and art.

In the history of philosophy, the ambiguous status of the Renaissance in the

creation of modernity can be sensed in, for example, the work of Bertrand Russell, who might indeed believe in the movement's breach with a rigid scholasticism and creation of an intellectual free space, but who nonetheless has to note that it "was not a period of great achievement in philosophy" and "produced no important theoretical philosopher".[7] And Ernst Cassirer, who must take the credit for having identified just such a theoretical philosopher in Nicholas of Cusa, a pioneer in the development of the modern, nominalistic philosophy, runs into problems, on the other hand, when he also wants to categorise Cusanus as Renaissance philosopher, even as the focal point for the thinking of the movement. In practice, he has to note that Nicholas of Cusa stood singularly alone among the antiquity-venerating philosophers of his day and immediately afterwards – the Aristotelians and Platonists – and that he first found company in the work of people such as Copernicus, Kepler, Galileo and Giordano Bruno; and where, then, is the stamp of the Renaissance?[8]

The historian of science, Lynn Thorndike, goes to the heart of the issue:

> The concept of the Italian Renaissance [...] has, in my opinion, done a great deal of harm in the past and may continue to do harm in the future. It has kept men in general from recognizing that our life and thought is based more nearly and actually on the Middle Ages than on a distant Greece and Rome, from whom our heritage is more indirect, bookish and sentimental, less institutional, social, religious, even less economic and experimental.[9]

According to Thorndike, then, the Middle Ages paves the way to modernity, whereas the concept of the Italian Renaissance confuses the understanding of both the character and the genesis of modernity. By expanding the scope of the Renaissance category from a concept just belonging to a posterior historiography into a late medieval practice seeking to transform that concept into reality, we could be even more specific and say: early modernity is curbed and modified by the Italian Renaissance, first regaining its full strength in the 18th century. As a very precise synonym for Spengler's Faustian culture, modernity could thus be understood as an epistemic *field* growing out of the Middle Ages around 1000, reaching its first maturation in the 15th century – the century that ushers in the new paradigm of pictorial art – culminating in the 18th-19th centuries and phasing out with the same paradigm after 1900.[10] Whereas this *field* in the Late Middle Ages, from 1000-1400, is equally distributed between North and South Europe, indeed, in certain respects is most sharply accentuated in Italy, it is, however, muted down here by the Renaissance from the middle of the 15th century, so that the waters are definitively divided from 1500 onwards.

In art history this understanding of the Renaissance as fundamentally different from early Northern modernity was already hinted at by Riegl, for although he

did not comment upon the Renaissance in his *Spätrömische Kunst-Industrie* with its macrohistorical reflections on the evolution of the culture of the gaze, the epoch emerged in *Das holländische Gruppenporträt* (1902) in which the attention is directed to the evolution of pictorial content in early modern visual culture.[11] Here the Italian Renaissance and its ideal, classical antiquity, are considered to be founded in what Riegl designates *will*, a compositional principle which *subordinates* all pictorial ingredients to a narratively-conditioned *inner unity*. In the 17th-century Dutch group portrait, on the other hand, the point of gravity is displaced toward *feeling* and *attention*, qualities which allow the pictorial elements a looser *coordination* and simultaneously, in an *outer unity*, open them toward a completion through the subjectively-conditioned gaze of the beholder. As in Hegel and Spengler, classic images here, once more, appear as closed upon themselves in a plastic self-sufficiency, whereas Dutch images, in a conscious incompleteness (cf. Spengler's Faustian infinity), open toward the gaze of a subjective beholder. In this characterization of Dutch imagery we thus meet a reformulation of Riegl's own category, the optic distant sight, and remembering that this sight is under development throughout the Middle Ages, the possibility here too emerges that the Renaissance could be a conservative island formation in an already advanced flood of modernity.

Without reference to Riegl, Svetlana Alpers has also expertly revealed the many aspects in which 17th-century Dutch painting, and Northern art altogether, escape the Italian Renaissance aesthetics – an aesthetics which art historians have hitherto elevated to an almost universal instrument in the understanding of all pictorial art produced between the Middle Ages and the 20th century. What Alpers observes in Netherlanders, going back to Jan van Eyck, is, as indicated in chapter 8, their *descriptive* method – a method which abandons itself to the pure visual process, to the empirical registration of the surroundings in all their diversity. With its attention to texture and particularity of detail, this way of looking is in striking contrast to the Italian, which cultivates *narration* in accordance with the antique canon, as revived not least in Alberti's *De pictura*.[12]

Even though there are, as mentioned, a few problematic details in Alpers' theory (the coupling narration/linear perspective, the separation between window and eyesight), it is highly profitable in its basic concept. The tendency in Northern art, which Alpers pins down, can be expanded both forward to the 18th-19th centuries and backward to the Gothic, the beginning of modernity. The characteristics of Italian art also have far-reaching consequences, becoming guidelines for *academic* art. The art academies, the new places of education established by the absolute royal houses which from the 16th century onwards replace the medieval workshops, have *history painting* as the norm, i.e. depiction of the heroic human body in narrative or allegorical situations. The art academies could but look down on genres

which moved their gaze away from the symbolically dense ideal body and over to its insignificant surroundings. The further we move out into the chaos of the environment, the lower we are in the genre hierarchy. We are thus flung centrifugally from portrait to genre to marine and animal painting, in order to land at the outermost – and lowest – points, the humble landscape and still life.[13] The reason for the inferiority of these genres was therefore no different in modernity than it had been in antiquity. Rather than guiding the intellect towards grand perceptions, they pulled it down into the darkness of sensuality. That the academic view of art in the 18th-19th centuries was increasingly looked upon as conservative, was therefore due to more than a purely contemporaneous reason. From its very introduction in the 15th-16th centuries, the question could be asked as to how universally it expressed its contemporaries' conception of the world.

One philosopher who could supply the wherewithal for an integrated theory of the iconological properties of the modern art – also in contrast to the Renaissance – is Hegel. As mentioned in the Interlude and chapters 1 and 8, Hegel makes a sharp distinction between classical art and its Christian and modern successor, the art form to which Hegel applies the umbrella term *the romantic*. Where classical art culminates with sculpture based in the ideal and non-subjective, the congenial visual medium for romantic art is painting – a painting which, as expression of the free spirit, emphasises temporality, particularity, diversity, subjectivity, portraiture and the everyday. Even though its changeable environment must always appear as reflection of the inner frame of mind, of mood and emotion, it knows no restriction of subject matter:

> Precisely for the same reason romantic art suffers externality on its own part to go on its way freely; and in this respect permits *all and every material*, flowers, trees, and so on, down to the *most ordinary domestic utensils*, to appear in its productions just as they are, and as the *chance of natural circumstance* may arrange them. [my italics]

Hegel even remarks that romantic art "gives unfettered play to the emphatic features of ugliness itself."[14] In this art form the spiritual is not only drained from nature but also from the context which previously supplied classical art with its meaning: characters, stories, events – in brief: *the narrative*.

Hegel is in no doubt that romantic art is in conflict with its classical forerunner – an art which does not tolerate such an uninhibited presence of empirical observations, randomness and transience.[15] Nonetheless, he is unwilling to take the full consequence of his own theory and draw up the lines between Italian Renaissance and Northern romanticism. He might well note that Italian painters rarely depict their times, reality, national history or landscape, whereas these subjects are

welcome in the North with its focus on the inner mental life. And yet he confirms the widespread prejudice that Italian art expresses "a beauty of form and a freedom of soul"[16] to a greater extent than its Netherlandish counterpart. Even though Hegel does not quite manage to escape the Italophile pitfall, his conceptual structure is nevertheless so solid that it can be used as safeguard against the same.

In more recent scholarship pertaining to the history of literature, the idea of Renaissance conservatism also strikes Hans Robert Jauss, a representative of the Konstanz School of Reception Aesthetics.[17] In his identification of what he calls a "Christian poetics", Jauss demonstrates how the Middle Ages separate out the hideous from the cruel and evil – a disengagement which underlies modernity's interest in the arbitrary, non-ideal and individual. According to Jauss, a closer examination of this liberation ought to show how it became "mitigated and modified" by the Renaissance focus on ideal beauty and how this "excommunication" was then broken at the end of the 18th century with the re-discovery of the Christian poetics, not least as it came to expression in the work of Dante. The Renaissance thus appears, once more, as a regressive bulge between the Late Middle Ages and romanticism.

Having demonstrated that since the 19th century there have actually been many well-qualified attempts to break up the Renaissance monopoly on the definition of early modernity, then we have all the more cause to wonder why these attempts are repeatedly silenced and ousted from the general historical consciousness. Perhaps we are at long last approaching the state of affairs in which we can join Spengler in stating:

> That close inward relation in which we conceive ourselves to stand towards the Classical, and which leads us to think that we are its pupils and successors (whereas in reality we are simply its adorers), is a venerable prejudice which ought at last to be put aside. The whole religious-philosophical, art-historical and social-critical work of the 19th century has been necessary to enable us [...] to begin to realize, once and for all, how immeasurably alien and distant these things are [...].[18]

Gothic modernity, Renaissance conservatism

Until the requisite study is available, revealing how the myth of neo-antique modernity has been maintained right up to our own day, I will settle for identifying certain seeds to the other side of the story: its origins in the Late Middle Ages. This primarily involves an account of how the controversial concept 'modernity' emerged and of how this concept was then appropriated by the Renaissance movement. An obvious problem with the term *modern* and its opposite *antique* is that they can be used – and since the 5th century have been used – about everything that seems

to represent a dialectic between a present and a past state of affairs.[19] And what is worse: in a remarkable paradox, throughout the history of this pair of terms the modern has repeatedly been *equated* with the antique.

Nevertheless, there would seem to be a qualitative structure within the concept of modernity cutting across all differences. Simply the post-antique emergence and dissemination of the term *modern* tells us something of the word's meaning and makes it reasonable to use it in the sense of period: for modernity as era. Its secret is hidden, as so often, in the etymology. *Modernus* means, essentially, 'contemporary', derived as it is from the adverb *modo* which means, among other things, 'now', 're-cently' and 'just'. The latter meaning, however, makes a bridge from the restrictive, recent time interval ('it has just happened') to a more general idea of pinning down in relation to a norm ('just' = 'exactly', 'precisely', 'only'). This wider meaning reflects the root word for *modo* – and thereby also *modernus* – i.e. *modus*, with meanings such as 'way', 'manner', 'measure' and 'limit'; for these terms are indeed different aspects of the norm to which the exact, precise and limited relate.[20]

In the last chapter we saw how modernity is characterised by a nominalistic distinction between the beholder and the infinite environment, between the notions which the individual has of the world and that world itself. These notions could be described on the basis of these very same various meanings of *modus*: 'way', 'manner', 'measure' and 'limit'. 'Measure' could, for example, indicate the objective scientist who measures the world, i.e. compares the independent units of measurement with the infinitely differentiated objects which make up the world. 'Manner' could suggest the subjective artist who interprets the world with the help of an equally independent style (=manner), the expression of his or her original personality. Also on the etymological level, then, modernity could be said to be concerned with the individual's creation of cultural norms that are autonomous in relation to the sur-rounding environment – alongside an assumption that these norms are different from the immediate past. A keyword could therefore be *liberation*: liberation from the dominance of nature as well as from tradition.

Indeed, the term *modernus* does not appear until post-antique periods, when con-sciousness of time changes. Its introduction and first blossoming occurs in late an-tiquity around 500 AD, at a time when, for example, Cassiodorus (*c.* 485-*c.* 585), sec-retary to the Ostrogothic king Theodoric, looks upon antiquity as a bygone Golden Age, which the modern era can only imitate. In a letter to the cultured Roman politi-cian, Symmachus, written around 507, commissioning him with the reconstruction of the Theatre of Pompeius, Cassiodorus praises him for the private residences he has built outside Rome, by means of which he has become "the very careful imitator of the ancients, the very noble founder of the moderns".[21] The pairing of modernity and revival of antiquity can thus even be traced to this early date.

Apart from a prelude during the Carolingian *renovatio* – again, that is, in a neo-antique context – the word 'modern' does not, however, become common until after 1000 AD, the very period during which I have claimed modernity was born. The most well-known area of application is probably the Northern European proto-reformatory movement *Devotio Moderna*, which from the 14th century displaces Christianity's point of gravity from church and monastery to the laity, and thereby actually takes part in the creation of modernity. But, in fact, the use of the term *modernus* already starts escalating in the 1100s. Alain de Lille denounces "modern crudeness" while Walter Map, in *De nugis curialem* (*On Trifles of Courtiers*; 1180-92), celebrates the 12th century, "whose recent and strong memory collects everything which is remarkable [...]. The century which has passed is our modernity [*modernitas*]." Soon again the modern is linked with the revolutions taking place in the universities, first the Aristotelian in the 13th century, and later the *nominalistic* in particular which, as we have seen, breaks with Aristotle and could once more be associated with the birth of modern philosophy. Among the famous representatives of *logici moderni* or *theologi moderni*, apart from natural-philosophy-oriented scholastics such as William of Ockham and Jean Buridan, we also find a proto-reformer such as Wycliff.[22]

Within my own area of study, what we now call visual art, we should pay particular attention to the fact that the first style to be labelled 'modern' was the Gothic – a current whose veritable modern features I shall elaborate upon in the following section. North of the Alps the modern style is associated with Gothic right up until the middle of the 17th century, and even in 1639, when Giovanni Baglione was seemingly the first Italian to swap the usual term *maniera tedesca* with the new *gotico*, there is still so much modernity clinging to the style that he has to use the prefix *antico* in order to highlight its obsolescence (*antico-gotico* or *antico moderno gotico*).[23]

It was, however, an Italian construction to invent the Middle Ages, topple the Gothic in its darkness and then to transfer the Gothic label of 'modern' to the revived antique style. The Goths were the ones who, along with other Northern barbarians, had ravaged the antique culture, the grand Italian past. Therefore, their style, however long after the great migrations it might have been developed, must be primitive. The idea of Northerners who ravage the antique culture and institute their own barbaric building style is presented in Manetti's biography of Brunelleschi (*c.* 1480), and it is further developed in the letter from Raphael and Castiglione to Pope Leo X (*c.* 1519), in which pointed arches are compared with the topos of the wild man who builds bowers: Gothic architecture is "born from trees that are not yet pruned, from which they bend the branches together and bind them to form their pointed arches."[24]

Although the idea of the dark Middle Ages can be traced back at least to Petrarch, and from then on antiquity was the ideal for Italian intellectuals, it was nonetheless a long time before they spotted the Gothic blunders, and at first only in architecture where the clash with antiquity was more immediately visible than in painting and sculpture. Filarete was possibly the first Italian writer to bemoan the Gothic when, in his *Trattato di architettura* (c. 1460-64), he wrote: "I too was once pleased by modern [i.e. Gothic] buildings, but as soon as I began to enjoy the antique ones I grew to despise the modern."[25] It was not until the next century, however, with Vasari's confirmation of Italy as the home and most advanced bastion of the modern art, that the coup with which we still contend took place: the juxtaposition of *moderno* and *la buona maniera greca antica* in its re-awakened form.[26]

Even though Vasari had an instinctive eye for the classical-oriented painters who were part of the Italian current of modernity from the outset – most obviously, as we will see, Giotto and Masaccio, more problematically Leonardo – he saw no conflict between these painters and their typical, Gothic-dominated environment in the 14th-15th centuries. All were forerunners of the classical, 'modern' style culminating with Michelangelo in the 16th century, the classicists just to a more pronounced degree. That Vasari and his predecessors were thus blind to the Gothic features of painting, while at a relatively early stage they were offended by Gothic architecture, can partly be explained by the lack of antique paintings for comparison before the end of the 15th century, the beginning of the Renaissance. Moreover, painting was not scarred by the North-South conflict. While architecture had been ravaged by Gothic, painting had simply stagnated in *maniera greca*, the Byzantine manner.[27] The style which succeeded *maniera greca* in the 14th-15th centuries was accordingly not associated with Gothic, but only with the Renaissance. It is therefore not so strange, as we will see, that far into the 1400s the humanists preferred Gothic painters to Masaccio.

However, by the time the Gothic features of early modern painting were finally spotted during the romantic period and the Gothic revival of the 18th-19th centuries, the Renaissance myth was so well-developed that Gothicism's modern aspects had evaporated. The 15th-century Netherlanders and (to an extent) Italians became 'primitive'. Brueghel was a medieval painter. The argumentation is again the Platonic, which Panofsky went so far as to equip with inverted commas: the 'true' naturalism is that which realises what nature had 'actually' intended, but could not carry out. The beautiful is the true; the ugly is the primitive. In Johann George Sulzer's *Allgemeine Theorie der Schönen Künste* (1792), "Gothische Malerei" is defined, for example, as the painting that precedes the study of nature and antiquity in the late 15th century and which has elongated figures and unnatural movements. "The painters before that time drew according to an ideal that was not a heightened

nature, as was the ideal of the Greeks, but according to a nature that was corrupted in proportion and movement."[28]

Both Panofsky and his predecessor Sulzer thus acknowledge that the Renaissance aspires to a 'heightened' nature, an antiquised nature free of Gothic 'corruption'. And yet it is still the prevailing myth that naturalism is *by and large* a Renaissance invention. But can the same movement embrace nature in its expansive, temporal and particular aspects – all the modern ingredients which literally corrupt beauty – and at the same time aim at beauty with only limited access for these ingredients? It seems far simpler to attribute the new naturalism to the Gothic and instead to look at the Renaissance as a counter- or subsidiary movement to this – a movement which curbs the modern lack of restraint in favour of a more ideal beauty.

Still, however, we are left with the paradox that modernity so often – from Cassiodorus to the Renaissance and neo-classicism to Nazism – has been associated with a re-awakened antiquity. To explain the modern potential in this, we could perhaps focus on the masquerade aspect, the non-antique antique in all these revival movements. For is it not an ongoing phenomenon of modernity all told that it likes to rig itself out in alien robes (apart from all the classicisms, for example, neo-Gothic, Chinoiserie, Orientalism)? Inscribed as it is in an infinite space without proportions, modernity would at heart seem to lack identity. To rectify this, it fluctuates between adventurous longing for foreign shores and times (romanticism) and a prosaic everydayness that tethers it to 'reality' (realism). The modernness of the Renaissance, then, could be said to increase the more it assumes the quality of masquerade, the less its antique norms are actually realised.

Perhaps modernity also needs antiquity because in itself it lacks *body*. As we saw in the previous chapter, matter has become strangely weightless in the Copernican space where the world hierarchy has been eradicated and the beholding mind has isolated itself from the surrounding environment. The Renaissance, then, is able to supply the body with a dignity and substance which modernity otherwise dissolves. The problem, however, is that this dignity and substance becomes forced in step with the increasing development of the modernity *field*. Simultaneously wanting to highlight that the human being has become modern – a liberated individual in an infinite environment – and to heroise this condition via an idealised, muscular body, puts culture in danger of totalitarianism. The extreme consequences of this striving are seen in 20th-century totalitarian movements: Fascism, Nazism and Communism.

9.2 Modernity's pictorial space
and its Gothic origins

Ergon-parergon

As shown in chapter I, antique literature yielded a whole list of curses connected with the illusionist image: detachment from reality, mist, fragmentation, transience, collapse of proportion, deception, particularity, individual arbitrariness, confusion, overcomplicated variation. As the reader will by now have acknowledged, it is precisely these properties that constitute the basic substance in the modern image. To be sure, they are now often evaluated in a totally different and positive light, but this does not alter the fact that their *structures* are unchanged.

That such a preservation of structure is achievable will only become obvious if we bring in the cosmological considerations of the previous chapter: in antiquity, with the celestial soul confined in the earthly prison, beauty and wisdom consist of getting as close as possible to the celestial prototypes, which means slipping off the fetters of an earthly point of view and individual contingency. But as the celestial cavity implodes to the membrane around the individual mind in the Late Middle Ages, there is no longer a celestial universality to strive for. Where the image had before been a microcosmic depiction of the closed macrocosmos, a tight and corporeal *ergon* elevated above the individual point of view and discreetly surrounded by *parergon*, it is now transformed – analogously to the individual of which it is the expression – to an *autonomous work* surrounded by an *infinite environment*. As far as the internal pictorial world – the infinite environment projected onto the image plane – is concerned, on antiquity's terms we could say that *ergon* is overwhelmed by *parergon* since the pictorial field within the individual viewpoint is filled with surroundings, space, landscape and particularities. The climax of this is, of course, the autonomous landscape image, which indeed only consists of that which had previously comprised *parergon*.

But, as Christopher Wood remarks, the conceptual couple *ergon-parergon* has actually lost its meaning as a device by means of which to describe single elements in the modern work of art.[29] In the infinite space in front of the individual field of vision there is no closed form, no *ergon*, and therefore no *parergon* either. What we encounter is rather a web of perceivable objects, in the broadest sense: a landscape. Landscape is no longer of peripheral importance, everything has become landscape. In this all-encompassing landscape there are, of course, no proportions, which in themselves would presuppose closed form; these are instead transformed into an internal relationship on that plane through which the artist chooses to capture the surroundings.

If the relationship *ergon-parergon* is to have any meaning in modernity, therefore,

it has to be displaced from the depicted *single objects* and their connecting link to the world, to *the work in its entirety* and its connecting link to the world. And what is the connecting link between the modern work and the infinite environment other than its frame? Synchronously with infinity breaking down the claim of pictorial elements for the status of *ergon, parergon* is absorbed by the infinitesimal frame that makes this breaking-down possible. This razor-sharp frame is what endows the work with its autonomous aura and makes it an analogous expression of its autonomous creator. As Wood writes: "The frame isolated the work from ordinary objects and from the world in general, just as artists would eventually be distinguished from ordinary people by certain defining myths about them, and by expectations about their behaviour and appearance."[30]

In the pictorial world cut off by the frame, there emerges a completely new space for the particular which now as never before is the bearer of visual meaning. This shifting of meaning towards its earlier periphery is also bolstered temporally, as the frame additionally signifies an incision in a time which is detached from anchorage in particular events. It is by this means that a new aesthetic emerges, based not in narrative but in *description*.[31] Description covers everything that the light allows the eye to see in a space at a given moment and thereby points in the direction of the Aristotelian concept of history as discussed in chapter 1. The historian not only includes the circumstances pertinent to a narrative sequence, but also "all the events (in their contingent relationships) that happened to one person or more".[32] Bearing in mind that, between the 15th and 19th centuries, the advance of depth of field towards infinity brings with it more and more such non-narrative events, we can all in all corroborate a connection already pointed out by Franzsepp Würtenberger: that the symbolic incident, the literary-defined charge of meaning gleaming from the figures, shrinks proportionally with the expansion of the earthly horizon (**FIG. 9.1**).[33]

The transformation I am outlining here is, of course, an ideal model. In reality, the sequence took place over a period stretching from the 11th century to 1900, and the development was far from steady. Even Kant, a champion of the autonomous, aesthetic work of art, demonstrates a still significantly ambivalent attitude to the status and place of *parergon*:

> Even what one calls ornaments [*parerga*], i.e., that which is not internal to the entire representation of the object as a constituent, but only belongs to it externally as an addendum and augments the satisfaction of taste, still does this only through its form: like the borders of paintings, draperies on statues, or colonnades around magnificent buildings. But if the ornament itself does not consist in beautiful form, if it is, like a gilt frame, attached merely in order to recommend approval for the painting through its charm – then it is called decoration, and detracts from genuine beauty.[34]

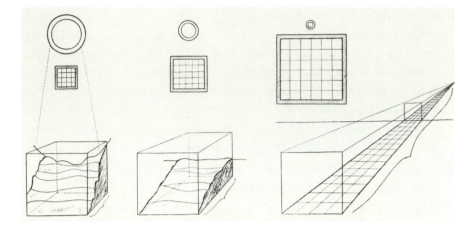

Fig. 9.1. Diagram showing the connection between
1) the shrinking of symbolic incident and 2) the simultaneous
expansion of the earthly horizon. From Franzsepp Würtenberger,
Weltbild und Bilderwelt von der Spätantike bis zur Moderne (1958).

Kant is here still irretrievably influenced by a classical way of looking in which or-
namental frames can be placed around an image in the same way as draperies can
be placed on statues and colonnades around magnificent buildings. But, as Wood
points out, strictly speaking there is no room for this transitional position in the
infinitesimal incision that separates the modern work from its surrounding world.[35]
The ornamentation is swallowed up by the black hole of the incision. And, if the
frame is of any size, there is no intermediate position: either it belongs to the work
or, more usually, it is totally external.

Taking Kant's hesitation and Renaissance primacy into consideration, however,
it is hardly surprising that the classical *ergon-parergon* coupling persists in early mo-
dernity. *Hypnerotomachia Poliphili*, Francesco Colonna's phantasmagorical romance
of *c.* 1467 (published 1499), provides a description of a mosaic frieze on the inside
of an arched gateway decorated with "exquisite details [*perergi*] of waters, springs,
mountains, hills, woods and animals".[36] And in a Latin dialogue written around 1530
by the historian and art collector Bishop Paolo Giovio, we are told very informatively
of the Ferrarese court painter Dosso Dossi (*c.* 1479-1542):

> The gentle manner of Dosso of Ferrara is esteemed in his proper works [*justis operi-
> bus*], but most of all in those which are called *parerga*. For devoting himself with
> relish to the pleasant diversions of painting he used to depict jagged rocks, green

groves, the firm banks of traversing rivers, the flourishing work of the countryside, the gay and hard toil of the peasants, and also the far distant prospects of land and sea, fleets, fowling, hunting, and all that *genre* so pleasing to the eyes in a lavish and festive style.[37]

The "proper works" must be referring to the figurative motifs and *parerga* to their surrounding environment given that Dossi belonged to a culture in which autonomous landscape paintings were as yet unknown. This reading is more than corroborated in the lexicographer Thomas Blount's definition of landscape in his *Glossographia* of 1656:

> *Landskip* (Belg.) Parergon, Paisage or Bywork, which is an expressing of the Land, by Hills, Woods, Castles, Valleys, Rivers, Cities, etc., as far as may be shewed in our Horizon. All that which in a Picture is not of the body or argument thereof is *Landskip, Parergon*, or by-work. As in the Table of our Saviours passion, the picture of Christ upon the *Rood* [...] the two theeves, the blessed Virgin *Mary*, and St. *John*, are the Argument. But the City *Jerusalem*, the Country about, the clouds, and the like, are *Landskip*.[38] [Blount's italics]

We will note that in Blount's classification, a picture's *parergon* – that which lies beyond the body of the argument – is quite simply defined as landscape. And thus landscape is again seen as a marginal zone in a twofold sense: as the zone in which the figurative is disbanded as the body is assigned to space, and as the zone in which meaning is diluted with increasing distance from the argument.

Northern landscape sensibility in the 15th century

Before highlighting the differences between North and South in the pictorial articulation of landscape, it must be made clear that these differences appear exclusively as variations within the same paradigm. In the Late Middle Ages especially, culminating in the international Gothic of the decades around 1400, shared experiences seem conspicuous. Thus the modern landscape image breaks through fully – and suddenly – on both sides of the Alps in the 1420s. In Gentile da Fabriano's *Flight into Egypt* of 1423 (PLATE 6) as well as in Robert Campin's *Nativity* of c. 1425 (PLATE 7), we encounter distant horizons, projected sunlight, an atmospheric sky, roads, hedges and ploughed fields.

Nevertheless, from the very outset there are striking differences in kind between the landscape images from Italy and those from the Netherlands. The Netherlandish gaze takes in more radically remote horizons than the Italian, and the Netherlanders'

zeal to depict detail, texture and effects of light with realistic refinement would seem almost inexhaustible. In comparison, Italian vision seems more general and constructed, and far more dependent on considerations of a well-arranged composition. In Jacob Burckhardt's words: "As a gift from heaven [the Italians] [...] possessed the tact not to pursue the outer reality in all details, but only so far that the higher poetic truth did not suffer from it."[39] Gift from heaven, tact, curbing of realistic details, higher poetic truth – would it be possible to express Renaissance selective ideality more unequivocally?

When referring to Netherlandish painting, it was indeed usually the radical empiricism, including the teeming details, which caught the attention of contemporaneous Italian writers. In 1449, when describing Roger van der Weyden's *Deposition* owned by Leonello d'Este, prince of Ferrara, Ciriaco d'Ancona, the greatest antiquity expert of the time, is stunned by

> garments prodigiously enhanced by purple and gold, blooming meadows, flowers, trees, leafy and shady hills, ornate halls and porticoes, gold really resembling gold, pearls, precious stones, and everything else you would think to have been produced, not by the artifice of human hands but by all-bearing nature herself.[40]

And when Bartolomeo Fazio in his *De viris illustribus* (*On Brilliant Men*, 1456) refers to a Jan van Eyck painting owned by Ottaviano Ubaldini della Carda, nephew of Federigo da Montefeltro (d. 1499), he is particularly struck by, among other things, the incredible feeling of distance. Moving from a scene of women in a bathroom, the gaze takes in what must have been the view through a window:

> In the same picture there is a lantern in the bath chamber, just like one lit, and an old woman seemingly sweating, a puppy lapping up water, and also horses, minute figures of men, mountains, groves, hamlets, and castles, carried out with such skill you would believe one was fifty miles distant from another.[41]

Even though the painting has not survived, Fazio's fascination may be relived in a work such as Jan van Eyck's *Madonna of Chancellor Rolin* (c. 1433-34; FIG. 9.2 and PLATE 28). In the inner courtyard beyond the shadowy interior, the two observers by the embrasure become agents for our own gaze towards the extensive landscape: from the city with its teeming civic life and tiny ant-like people on the bridge, our gaze moves to the boats and island castle reflected fantastically in the river, only to continue towards the diminutive forests, rows of furrowed fields and church spires, the distances between which would indeed seem to be measurable in scores of miles – a visual expansion culminating in the vertiginously distant

Fig. 9.2. Jan van Eyck, *Madonna of Chancellor Rolin*
(*c.* 1433-34), oil on wood. Paris, Musée du Louvre.

snow-clad mountains where the afternoon light fades from tawny to light-blue to a hardly visible grey.

This panoramic-realistic way of looking, with a depth of field stretching all the way to the most remote distance and with a lens that captures the least and most insignificant objects, must generally be ascribed to, indeed identified with, the Northern tradition. Evidence of this is provided both by the observation that the word 'landscape' develops at an earlier stage in Northern Europe than in Italy, and that it is in the North, too, that the landscape image breaks away from its attachment to figurative themes and becomes autonomous, a pictorial motif in its own right.

Etymology of landscape

That landscape belongs to a modern sensibility is evident from the very etymology of the word *landscape*, which does not exist in its current sense before the 15th century – the century that ushers in the new paradigm for pictorial art. As we saw in chapter 6, when referring to areas of the earth's surface or their pictorial representation, antiquity uses words such as *topia* (rural places), *regio* (stretch of land) or *terra* (earth). While these terms relate specifically to the terrain itself, the word 'landscape' signals an elevation of viewpoint: rather than comprising the land itself, landscape is the panoramic totality that emerges when the earth's surface is viewed spatially. As Kenneth Olwig has pointed out, however, this meaning of landscape seems to be derived from an older form denoting a tract of land, a district or a country – the English extinct *landsceap* or *landscipe*, the German *Landschaft* – a designation which more than its antique forerunners evokes a sense of the earth's belonging to and being formed by a community (cf. *-schaft* being etymologically related to *schaffen*=shape or create).[42] In fact, the oldest sense of the German *Landschaft* – first recorded 1121 – refers to the very inhabitants of a country district, and from at least the 15th century the word often denotes geographical units being regulated by particular customs, laws and estates, sometimes regions with a certain political autonomy such as the Schleswigian *landskab* Eiderstedt. In this older sense, then, a landscape was neither the land itself nor a picturesque panorama of it; as Olwig writes, "it was a nexus of law and cultural identity".[43] In other words, we here encounter yet another indication that the modern landscape is indeed founded in the *territory*, the post-paradisiacal earth marked by the utilitarian grid of civilisation.

In the case of painting, the concept of landscape in its more emancipated sense as a panoramic totality is documented from the beginning of the 16th century when, in Germany and Switzerland, there are several references to the *landschaften* to be inserted into commissioned pictures. A contract made in 1518 for an altarpiece in Überlingen on the shores of Lake Constance specifies, for example, that *landschaften* in the scenes on the panels should be painted in the "best oil colours".[44]

Renaissance-dominated Italy is more hesitant when articulating the new concept. Alberti, with an eye to antiquity, uses the term *province* and its Latin translation *regionis*,[45] Leonardo uses *paese* (country), which long remains the predominant term. In a note written around 1515, for example, he refers to "[t]he best method of practice in representing country scenes, or I should say landscapes [*paesi*] with their plants [...]." And in a contract of 1495, Pinturicchio consents to paint "in the empty parts of the pictures – or more precisely on the ground behind the figures – landscapes and skies [*paesi et aiere*] [...]."[46] We must seemingly wait until the 1530s before the word *paese* begins its metamorphosis on the way to *paesaggio*, a word that imitates

the French *paysage*. In 1531, Giorgione's famous *La Tempesta* from the collection of Gabriele Vendramin is thus referred to as "[t]he small landscape [*paesetto*], on canvas, with the thunderstorm, a gipsy and a soldier."[47] However, it is not until Vasari's day in the second half of the century that the future term *paesaggio* enters the canon.[48] This delay in usage could seem irrelevant, were it not for the fact that the Italians are also reluctant to cultivate landscape in their pictorial art practice. Landscape relates to the extensive and particular space, which threatens the dignity of the ideal body, and consequently it is left, by and large, to the Northerners to pursue its more extensive exploration in the image.[49]

Rise of the autonomous landscape image

The autonomous landscape image is an image whose sole motif is landscape, whose justification is the view across the landscape itself. In a way, every modern image can be said to tend towards the autonomous landscape image, for earlier I claimed that everything positioned in front of the picture window became landscape. If, however, we acknowledge the sluggishness of the dissolution of the classical *ergon* concept, and if we maintain the distinction between a zone dominated by culture and one dominated by nature, the autonomous definition is somewhat narrowed down. In that case, the autonomous landscape image is an image whose justification is in the aesthetic pleasure afforded by the natural domain alone, and the figures of which, if there are any, do not take part in narrative actions, but on the contrary are dominated by the wide expanses of this natural setting. To this must be added the requirement that the aesthetic pleasure of landscape takes place in what could be called a presentational medium – a medium not intended for studio purposes or the artist's own personal gratification, but aimed at an audience.

The autonomy could thus be said to be conditioned by the following parameters: [1] extent of the landscape in relation to any human figures present; [2] degree of extrovert presentation; [3] degree of aesthetic pleasure. When all three factors meet in full maturity, the autonomous landscape image takes form: the grand landscape painting produced for the open market. This type crystallises in 17th-century Netherlandish painting and reaches its full maturity in the 19th century. Its forerunners include such different media as: labours of the seasons; all sorts of maps and topographical illustrations, including depictions of private properties and militarily strategic areas; natural science illustrations; studies in preparation for paintings; more or less finished landscape drawings made for the artist's own use; landscape graphics; intarsia panels; outer panels of altarpieces; and, finally, paintings whose landscapes swell up in relation to the figures.

As this list would indicate, there are already many landscape depictions in the

14th-15th centuries without dominant human figures. Nevertheless, these images cannot be called autonomous, because they are either subject to a purpose beyond pure aesthetic pleasure or else this pleasure is constricted to a germinating status in the artist's studio. Advanced examples of the former are found in German and Netherlandish miniatures. A Regensburger manuscript from 1431 of Hugo von Trimberg's didactic poem *Der Renner* (*The Courier*, c. 1300-1313), for example, shows a landscape with crystalline rocks, fields and castles, but no people (FIG. 9.3). The justification for this lack of figures is provided by three larks in the foreground, as the miniature illustrates a moralistic passage on larks.[50] Another example, pointed out by Otto Pächt, is an illustration for a topographical text produced in Bruges around 1470 (PLATE 29). Here we are looking across the Flemish countryside with its fields, roads, hedges, fences, windmills and watermills, and tiny human figures.[51] I will not here discuss this type of illustration any further, for it tells us just as much about the new landscape paradigm *as such* as it does about the specialised genre framing a section of this paradigm.

Since this genre, the autonomous landscape image, is closely connected with the autonomous concept of art as such, it is most likely to be pin-pointed within the aesthetic art domain: painting and fine-art graphics and drawing. In painting, the forerunners to landscape autonomy are particularly of the type 'Landscape with...'. The epicentre is 16th-century Flanders, where painters such as Patinir, Herri met de Bles, Lucas Gassel and Brueghel created such sweeping views across meadows, fields, villages, rocks, forests, bays and high misty skies that it is often necessary to search for the diminutive narrative themes which, after all, still validate these panoramas (FIG. 9.4).[52] When Dürer travels to the Netherlands in 1521 and records a visit to Patinir in his diary, he thus ignores Patinir's figures completely and simply calls him "der gut landschafft maler".[53] This Flemish landscape panorama has very appropriately been given the name *World Landscape*, as each picture seems to synthesise the whole world within a single bird's-eye perspectival view. Realism is thus not manifest in the overall terrain, which still has much of the medieval rock mass to it; it can rather be traced in the details carrying on the development of van Eyckian precision.

A related centre of landscape, which is more concerned with human figures, but on the other hand is more open to the atmospheric value of landscape, is the Republic of Venice. The atmosphere makes itself felt in all pictorial genres, but reaches its peak exposure in the so-called *poesie*, a figurative genre of pastoral appearance, in which the artists consciously make the narrative content ambiguous. In a painting such as Giorgione's *La Tempesta* (c. 1505-10), the relationship between the soldier and the breast-feeding woman is unspecified to just the point (more about this in chapter 11) where it opens to the stormy sky's atmospheric rather than

Fig. 9.3. Regensburg Master, *Landscape with Skylarks*
(*c.* 1430), miniature from manuscript of Hugo von
Trimberg's *Der Renner*. Heidelberg, Universitätsbibliothek.

Fig. 9.4. Herri met de Bles,
Road to Calvary (*c.* 1550?), oil on wood.
Vienna, Akademie der Künste.

Fig. 9.5. Domenico Campagnola (?), *Landscape with
Two Trees and a Group of Buildings* (c. 1517), engraving.
Rotterdam, Museum Boymans-van Beuningen.

narrative expression (**PLATE 30**). No wonder, then, that in 1531 Marcantonio Michiel
puts landscape and storm before figures: "The small landscape, on canvas, with the
thunderstorm, a gipsy and a soldier." Even though the Italians came late to the use
of the actual word 'landscape', Michiel's statement would seem to be the earliest
surviving example of a whole work being categorised as a landscape.[54] In return for
this categorisation and for the dominance of atmosphere, the human figure has to
be given a bigger role than the diminutive one sanctioned in Flanders. As could be
anticipated, however, landscape dominance increases as soon as the Venetians move
towards the periphery of monumentality, to graphics and drawing respectively. An
engraving attributed to Giulio Campagnola (c. 1517), for example, depicts no more
than a collection of rustic buildings with two trees in the foreground (**FIG. 9.5**).[55]

Figureless landscape studies on paper or parchment must have existed at the
time of the paradigm shift around 1420, if not before, albeit we first encounter
extant examples from the 1470s onwards. Such studies, which have chiefly attracted
interest on a level of studio practice, alternate between precise topographical
representations and fictive compositions, and between preliminary studies for

Fig. 9.6. Leonardo da Vinci, *River Landscape*
(1473), pen and ink on paper, Florence,
Galleria degli Uffizi.

paintings and graphics and independent works. In his pen-and-ink drawing of
an imaginary Arno landscape, the 21-year-old Leonardo takes a pronounced step
towards autonomy, in that he introduces the genre of the landscape image which is
at one and the same time devoid of human figures and aesthetic (FIG. 9.6). From a
tree-covered rocky plateau we look across a gorge with a waterfall of almost Chinese
appearance, and from here the gaze moves on towards an extensive plain creating
a staggering sense of remoteness. That Leonardo was conscious of the drawing's
status as a work of art is apparent from his dating in mirror writing, even with
specification of the day, August 5 1473. This is indeed the earliest dated drawing
to have survived at all, and thus Leonardo has committed the very modernity-
pregnant act of elevating both the medium of drawing (the sketchy) and the genre
of landscape (the multivalent) to an autonomous sphere, which now begins to
hold the properties of 'art'.

Even though this tradition of independent landscape compositions on paper
seems initially to crystallise in Central Italy, it goes on to have a richer existence
towards the North: in Venice and, in particular, southern Germany where landscape

Fig. 9.7. Fra Bartolommeo, *Landscape with Farmhouses and Capital of a Column (c.* 1500), pen and ink on paper. Vienna, Albertina.

drawing is cultivated by artists such as Dürer, Albrecht Altdorfer and Wolf Huber.[56] In this respect, the Florentine Dominican monk and follower of Savonarola, Fra Bartolommeo, is an interesting exception. In the decades around 1500 he creates a series of pen-drawn landscapes with monasteries, farms and rocks (FIG. 9.7), which apparently had no other recipient than himself.[57] If the choice of subject and his religious-populist approach points towards the North, the stylistics, however, keep him anchored in the South. Despite topographically precise elements (localities around Tuscan Dominican monasteries) these stylistics focus on the volume of the forms, just as the vegetation and rocks are generalised. The Venetians and, to an even greater extent, the Germans, on the contrary, emphasise irregularities such as foliage, bark and the ruined surfaces of buildings.

In a series of works from the beginning of the 1520s by Albrecht Altdorfer – watercolour-gouache, oil on parchment and etching – this now independent landscape takes a further step in the direction of a cultivated audience (FIG. 9.8).[58] The etchings multiply the line drawing, and the colour pictures bring the landscape closer to painting, the most finished and most official medium. A total merger

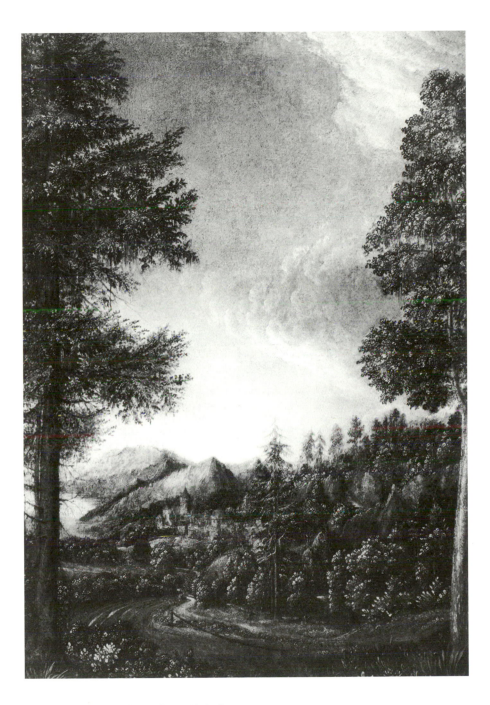

Fig. 9.8. Albrecht Altdorfer, *Landscape with Castle*
(c. 1522-25), oil on parchment, mounted on wood.
Munich, Alte Pinakothek.

with painting has yet to take place, however, as although the oil compositions are mounted on wood, they are actually painted on parchment. Moreover, unlike the etchings, they are kept in a vertical layout.[59]

This vertical layout could be seen as a final hesitation en route to the pure landscape painting. For the new landscape paradigm could be described as the triumph of horizontality. In the antique-medieval Golden Age *field*, the pictorial space is extended in a vertical tension between the heavens and the earth – a tension which is incarnated in the upward-striving rocky ground. When the poles of the heavens and the earth are dispelled in the Copernican infinity, however, verticality is replaced by a horizontal panorama with the level plain as sounding board. Landscape literally gets *horizon*. What the image still retained of sculptural mass is hereby transformed into incorporeal vision: not vertical solidity, but panoramic restlessness. That Altdorfer, in this strategic transitional phase, upholds verticality in his colour images can therefore be seen as manifestation of a desire not to give space free rein. As Goethe notes in his *Italian Journey* (1787), we have to bear in mind that

> [...] when human fantasy wants to think of things as being significant, it always imagines them as larger than life, and thus provides the image with more character, gravity, and dignity. [...] [I]magination and reality correspond to each other as do poetry and prose; the former will conceive of things as mighty and steep, the latter will always spread them out flat. Landscape painters of the sixteenth century, compared to ours, offer the most striking example. A drawing by Jodocus Momper next to one of Kniep's outlines would make the whole contrast evident.[60]

This worldliness-impeding verticality also has an impact on the genre in which landscape devoid of human figures appears for the first time in the large painting format – the outer wings of altarpieces. On the outer wings of Gerard David's *Nativity Altarpiece* of the 1510s, we see a forest interior scene with two oxen, an ass and a building which must be the stable where Christ was born (FIG. 9.9).[61] Despite the probable function of the scene as a kind of 'appetizer' for the middle panel of the altarpiece, such a monumental landscape image with no human figures is highly radical for its day. Legitimacy is provided, then, by the vertical layout, which almost turns the forest into a Gothic cathedral. A similar justification could support the bird's-eye view over the newly-created earth which adorns the outer wings of Bosch's *Garden of Earthly Delights* (c. 1503-04; FIG. 9.10). Despite the glass-like celestial dome, the flat earth and the eerie paradisiacal vegetation growing from the virgin ground – all reminiscences of a pre-modern, dualistic cosmos – the panorama is just as far-sighted and the cloudy sky just as high as in Patinir's world landscapes of a slightly later date. As the triptych even seems to have been made for a private

Fig. 9.9. Gerard David,
Forest Landscape with Stable
(1510s), outer panel of
Nativity Altarpiece,
oil on wood.
Den Haag, Mauritshuis.

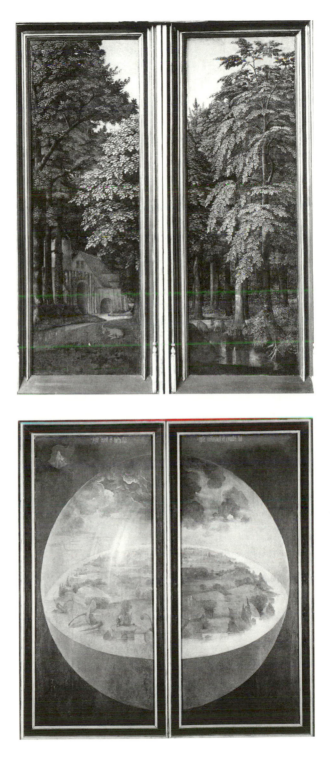

Fig. 9.10. Hieronymus
Bosch, *Creation of the
World* (c. 1503-04), outer
panels of the *Garden of
Earthly Delights*, tempera
on wood. Madrid,
Museo del Prado.

Fig. 9.11. Anonymous German artist,
Langenargen Castle (1486), woodcut from
Thomas Lirer's *Chronik von allen Königen und
Kaisern* published in Ulm. New Haven, Yale
University, Beinecke Rare Book Library.

Fig. 9.12. Anonymous German artist,
Mounts Sinai and Horeb (before 1508-09),
miniature from Hartmann Schedel's
manuscript copy of Felix Fabri's
Evagatorium in Terrae Sanctae, vol. 2.
Munich, Bayerische Staatsbibliothek.

individual's worldly meditation, it has been in great need of the semantic values still attached to the sacral altarpiece.

Another archaic element compensating for the lack of figures in the landscape image is, as in antique painting, *the rock*. As Christopher Wood has noted, the rock is one of the most important motifs in a special category of early deserted and semi-official landscape images. These landscapes are actually substantiated by a semantically well-defined purpose, but all approach an independent pictoriality beyond the purely illustrative. This applies to the woodcut depicting the castle of Langenargen in Thomas Lirer's *Chronik von allen Königen und Kaisern* (*Chronicle of All Kings and Emperors*; 1486; **FIG. 9.11**), and the miniature with *Mounts Sinai and Horeb*, pasted in and framed by Hartmann Schedel in his manuscript copy of Felix Fabri's *Evagatorium in Terrae Sanctae* (*The Wanderings in the Holy Land*; before 1508-09; **FIG. 9.12**). It is also true of Dürer's peculiar chunk of rock which, probably symbolic of the Madonna (cf. chapter 12), is inserted under an otherwise completely separate tondo of *Madonna and Child* from around 1515 (**FIG. 9.13**).[62] That these depictions of landscape in a non-private context approach the autonomous image, is thus – almost like in Roman wall painting – because the solid rock with its numinousity counterbalances the narrative loss inherent in landscape.

As in the early phases, the North is also the fulcrum when, in the decades around 1600, the pure landscape image is presented as actual *painting*, i.e. on wood and canvas. This initially occurs in the forest interiors by Flemish successors to Brueghel, such as Gillis van Coninxloo, Jan Brueghel and Roelant Savery. In their pictures, the dense trees, for a final time, render numinous compensation for the dwindling narration. But, with a new generation of Netherlandish artists – a generation shaped by the Protestant civil republic which, from the 1580s, is built up following the Spanish recapture of the Southern Netherlands – a real breakthrough becomes possible: rather than being surrounded by sheer rocks and dense forest, the gaze opens – and sinks – towards a previously unseen flatness of moorland, dunes, ploughed fields, canals and muddy tracks. In landscapes by Jan van Goyen (**FIG. 5**), Cornelis Vroom, Pieter de Molijn and Salomon van Ruysdael, modernity's surface has at last become presentable in itself.[63]

All that being said, however, it must be stressed that these early examples of autonomous landscape pictures in the North should only be seen as tips of the icebergs of a broader development. Because, on the whole, it can be claimed that Northern artists, regardless of the specific theme, allocate that which is depicted a greater degree of landscape, i.e. a coherent way of looking, than their Southern colleagues. In Wölfflin's incisive words:

What is so characteristic for Romanesque feeling – articulated beauty, the transparent system with clear-cut parts – is certainly not unknown to Germanic art as an ideal, but immediately thought seeks the unity, the all-filling, where system is abolished and the independence of the parts is submerged in the whole. [...] And just in that fact lie the conditions of northern landscape painting. We do not see tree and hill and cloud for themselves, but everything is absorbed in the breath of the one great nature.[64]

So saying, the Northern, autonomous landscape pictures do not so much denote the development of an independent genre, but rather selected incisions in a paradigm that is born landscape-like.

Origins of landscape space: the Gothic-Romantic axis

It is not for nothing that the modern landscape image breaks through during the period of international Gothic. For it seems that infinity and the sensuous diversity of the painted pictorial space were already laid down in the Gothic style, a quintessentially Northern phenomenon.[65] Gothic architecture could thus be seen as the first building style based on panoramic impressions, on the beholder's subjectively generated illusion, and which at the same time, in the details, employs unseen naturalistic devices (precisely observed foliage ornamentation,[66] exact likeness of faces, and so forth). The myth of Gothic emerging from the depths of the forest has, therefore, more than just primitivistic potential; as Spengler points out, it is just as much comprehensive evidence of Gothic architecture's expansive, landscape-like qualities.[67]

In a structural homology to 13th-century university discussions of the closed cosmos' deficiencies, the anthropomorphic closedness that had hitherto made architecture compatible with the geocentric cosmos is thus also problematised. Not only can the slim Gothic columns reach any length whatsoever in the space between capital and base, they can also exceed this space so that such articulations achieve the status of mere markers on infinitely outstretched lines. Furthermore, Gothic doors, windows and statues have a tendency to harmonise with the small human figure rather than with the overall proportions of the cathedral, thus breaching the antique concept of a closed building structure. Panofsky notes, in particular, that the modern pictorial space is pre-empted in the areas around the Gothic statues and reliefs, where canopies ensure that the figures are surrounded by a space.[68]

The climax of this architectural expansion is seen in Gothic pointed arches (FIG. 9.14). When the columns, from the beholder's perspective on the floor, are seen rushing toward the celestial infinity, we forget that they actually meet in the point

Fig. 9.14. Chancel vaulting in Amiens
Cathedral (building begun 1220).

of the arch. In anticipation of mathematical perspective, they would rather seem
to follow an uninterrupted course, only to converge in the celestial remoteness. As
Georg Forster (1759-94) writes in 1790 of Cologne Cathedral's pointed arches:

> In enormous length the groups of slender columns are standing there, as the trees of
> a primordial forest; only in the highest pinnacle are they divided in a top of branches
> which, together with its neighbour, vaults into pointed arches and is almost unat-
> tainable for the eyes which want to follow them. If it is not possible to visualize the
> *immenseness* of the cosmos in the limited space, then in this upward-striving of the
> pillars and walls there is nevertheless that incessantness, which the imagination so
> easily extends into the *unlimited*.[69] [Forster's italics]

That Forster's juxtaposition between the upward-reaching perpetuity of the columns
and the infinity of the universe is not just a matter for the 18th-century reception of
the Gothic, will be evident, for example, by recalling Nicholas of Cusa's nominalistic
possest. In the early medieval world picture, the heavens had had the monopoly on
infinity, but in Cusanus the divine ability has moved into an infinity that includes
everything outside the measuring, human consciousness.

[83]

It was quite natural that the Gothic's infinite features would be the subject of conscious discussion in the 18th century as here, in the second phase of modernity, the infinite, the unfinished and the becoming have become common ideals for the romantics: ideals that are condensed in the key concept of *the sublime*. As formulated by Edmund Burke in his *A Philosophical Enquiry into the Origin of Our Ideas of the Sublime and Beautiful* (1757), this entity is characterised by qualities that point away from the closed and well-defined body, qualities such as enormity, extreme insignificance, infinity, indefinability, coarseness, confusion and lack of substance.[70] The close connection between these qualities and romantic self-awareness in total is highlighted by Schiller, for example, when, in his *On Naïve and Sentimental Poetry* (1795), he compares the naïve, antique poet with the modern, sentimental heir: "The former therefore indeed fulfils his task, but the task itself is something limited; the latter indeed does not fulfil his, but his task is an infinite one."[71]

In relation to my concept of modernity as a *longue durée* developing from the 11th to the 19th century, the point, then, is that this un-antique striving for infinity was not limited to Schiller's own day, for the roots of modernity, which the romantics aspired to re-expose, were to be found precisely in what we still call the Middle Ages, especially the Gothic prior to the triumph of the Renaissance in the 16th-17th centuries. Around 1800 John Milner (1752-1826), for example, like Forster, saw an *artificial infinite* in the Gothic's "aspiring form of the pointed arches, lofty pediments, and the tapering pinnacles", besides the serial repetition of the bays. And when Uvedale Price was seduced by Gothic architecture in his *Essays on the Picturesque* of 1794, it was a consequence of its coarseness, sudden variation and detailed irregularity – all features which were contrary to the classical closed form, and which also made it well-suited to become a picturesque ruin.[72] The feeling of infinity is thus also roused on the microscopic level in the teeming Gothic detail, layer upon layer of tympanum figures, foliage ornamentation, small architectural members, and so forth. (FIG. 9.15). In reference to Milan Cathedral, Goethe even speaks of a "multiplied smallness" (*Multiplizierter Kleinheit*), so the thought could, in Speglerian fashion, lead to Leibniz's and Newton's later integral calculus.[73] Bringing together all these observations, it does not seem strange that by *romantic* Hegel understood post-antiquity in general.

However, the axis from Gothic to romantic – and bypassing the Renaissance – is made truly tangible by the fact that all the terminology with which the romantics rehabilitate Gothic actually goes back to Gothic's own time. For, although in a judgement reversed 180 degrees, the Italian and French Renaissance writers focus on the same characteristics of the Gothic as those highlighted by their romantic successors. As the Italians gradually became convinced of the blessing of the Renaissance and the curse of Gothic – the hitherto modern style – it was precisely the un-proportional

Fig. 9.15. Section of the
west facade (1386-87,
1485 and 1509-14) of
Rouen Cathedral.

throng of detail that caught the eye. Filarete, one of the first declared adversaries of
the Gothic, states in his tract on architecture (*c.* 1460-64) that the Gothic style was
not created by real architects, but rather by painters, stonemasons and especially
goldsmiths, who designed their modern works "like tabernacles and thuribles".[74]
And in Raphael's and Castiglione's letter to Leo X (*c.* 1519), offence is taken at the
Gothic's badly executed and observed small figures and at the "strange animals and
figures and foliage beyond all reason".[75]

Vasari, too, giving *maniera tedesca* the deathblow in the mid-16th century,
thinks that these artists made "a curse of tiny tabernacles, one above the other,
with so many pyramids and spires and leaves, that [...] it seemed impossible that
they could sustain themselves; and they appeared more as if they were made of
paper than of stone and marble."[76] Apart from the confusing hotchpotch, then,

[85]

Vasari is also offended by Gothic's *incorporeality*, its all too slight appearance. This discourse survives undiminished when, in 1642, Giovanni Baglione defines *Gotico* or *Tedesco* as "particular disorder in art and architecture" [*più tosto disordine dell'arte e dell'architettura*],[77] and also when, in 1681, the art historian Filippo Baldinucci refers to the Gothic "infinity of small tabernacles" and its "extremely subtle columns and long distortions [*smisuramente lunghe*], turned and in many ways unnatural".[78]

Thus, even though the Italian Renaissance and Baroque writers find the Gothic style repugnant, and not sublime, they still describe it via exactly the same concepts as those used by the romantics. Both parties are concerned – whatever the assessment – with Gothic infinity, immeasurability, irregularity, coarseness, myriads of detail and incorporeality. If we also add Gothic naturalism to these properties, we are practically left with a recipe for a landscape image. Only the projection onto a surface is missing. This we find in Michelangelo's comment on Flemish painting, reported in *Four Dialogues on Painting* by the Portuguese Francisco de Hollanda:

> Flemish painting [...] will, generally speaking, [...] please the devout more than any painting from Italy which will never bring him to shed one tear, whereas Flemish painting will cause him to shed many; and this is not because of the strength and goodness of the painting but because of the goodness of the devout person. It will appeal to women, particularly the very old and the very young, and also to monks and nuns, and to certain noblemen without sense of true harmony. For in Flanders they paint in order to bind you to the outer view [*pera enganar a vista exterior*], or such things that may cheer you up, and of which you cannot speak badly, such as for instance saints and prophets. They paint materials and masonry, turf of fields, shadows of trees, and rivers and bridges, which they call landscapes [*paisagens*], and many figures on this side and many on that. And all this, although it appeals to some, is done without reason and art, without symmetry and proportion, without clever choice and boldness, and, finally, without any substance and nerve.[79]

In Michelangelo's view, then, Flemish painting is sentimental, over-pious, effeminate, harmless. Its tear-jerking effect should not be attributed to the work's inherent qualities, but rather to the beholder's own, which is to say it appeals to *subjectivity*, nominalistic shielding from the object being looked at. This subjectivity is made possible precisely because it can be reflected in an external vision: a vision that can almost be identified as landscape. For the radius of the landscape not only encompasses the turf of fields, the shadows of trees, rivers and bridges, but also "materials and masonry", plus a plethora of figures, all of which are mentioned in the same breath. This kind of sensory inclusion of pictorial elements obviously impedes the reasoned choice that creates symmetry and proportion, prerequisites of

Fig. 9.16. Michelangelo Buonarroti, *The Fall
and Expulsion from Paradise* (1510), ceiling fresco.
Rome, Vatican, Sistine Chapel.

a closed *ergon* in accordance with antiquity's canon. Without closedness, substance
cannot be created either, and then we are left with exactly the same objections that
the Italian writers had against Gothic architecture: lack of proportions, confusing
myriads of detail, incorporeality.

Michelangelo's comments are so much the more striking in that he is himself
a sculptor and, moreover, when he paints, the Renaissance expert of the figure par
excellence. While the volume of his nude bodies swells to titanic, sometimes gro-
tesque dimensions, the landscape is restricted to an almost forced minimum. Adam
and Eve on the ceiling of the Sistine Chapel (1510) are expelled to a green plateau
without so much as a blade of grass or a stone (**FIG. 9.16**). The thought occurs that
the closed corporeality required in neo-antique art is a problem in the open space of
modernity. It is unlikely to be a coincidence that Gothic human figures are slight,
spindly and ethereal, as if the materiality has been dissolved in the expansive sur-
rounding environment.

That post-Hegelian art history has, however, been blind to the continuity in the Northern tradition is because it has been sliced into at least three parts, each with an isolated discourse: Middle Ages, Renaissance and modernity. As the first two have both done their bit to tie Gothic solidly to the Middle Ages, the only Gothic-romantic axis that historians of modernity have been able to spot is the one that turns the romantics' interest in the Gothic into a question of reception history: the romantics' view of the Gothic as sublime revealed more about themselves than about the nature of Gothic. But, as I have shown here, to a surprising extent *the same* properties come to light when a Renaissance commentator and a romantic discuss Gothic: i.e. infinity, myriads of detail, coarseness, lack of substance, and so forth. The difference between the two discourses is not due to content, but to the *evaluation* of this content.

But how can the same content be regarded with contempt at one point in time and with admiration at another? For the early practitioner of the sublime, Edmund Burke, there is actually no great distance to the undercurrent of difficulty that makes the re-evaluation understandable. Burke sees the sublime experience as rooted in liberation from pain and fear. The subject is confronted with terrifying topics threatening to obliterate it, but because they are placed at an appropriate distance – that of art or of aesthetics – the beholder experiences a feeling of relief, what Burke calls *delight*.[80] For the Renaissance beholder, the Christian experience of painful and base topics were still too close to the body for the Gothic visualisation of them to be regarded with this kind of delight, but once the bourgeois culture in the romantic period had put them at a greater distance this enjoyment could be realised.

For Kant, however, the sublime not only incites delight but also aspiration. The sublime – *das Erhabene* – makes reason aspire to an absolute totality and imagination crave infinite progress. "That is sublime in comparison with which everything else is small", says Kant, but at the same time he stresses it has to remain a subjective category, as nothing is so big that it cannot be microscopic in comparison with something else. The term also predicates, therefore, that nature ultimately remains unattainable as an object for the exposition of ideas.[81] *Das Erhabene*, then, could be perceived as the twofold feeling of omnipotence and impotence that arises when the subject is confronted with the modern, infinite environment. Today, with the romantic repertoire of marvellous topics getting rather worn-out, we are again beginning to sense the alarming aspect of rendering infinity visible. The discomfort has found expression in the French and English concept of *abject*, a sort of negation of the sublime.[82] In her 1980 essay on the abject, Julia Kristeva aptly notes that sublime and abject are bound together by a common denominator: neither of them has an object. Kristeva thus notes that:

"The abject is edged with the sublime. It is not the same moment on the journey, but the same subject and speech bring them into being."[83] If both the sublime and the abject are turned towards the amorphous world beyond the closed body, the sublime depicts what is spellbinding about this world, whereas the abject is more likely to deal with its spleen and identity-threatening vacuity of meaning. Here, then, we are back in the vicinity of the Italian disgust at the Gothic.

9.3 Gothic versus Renaissance in Italian 14th-15th-century painting

Giotto and the Sienese

Right from the modern painting's pioneers in the 14th century – the first stage of Vasari's three-point programme on the way to the ostensible climax, the High Renaissance in the 16th century – there is perceptible tension between the two power centres competing for the pictorial paradigm's supremacy: the classically closed-form body and the Gothic expanding surroundings. A comparison between Giotto – the traditional father figure of Renaissance painting – and the Gothic-oriented Siena should demonstrate this relationship.

Even though Siena is located to the south of Florence, its French trade connections made the city the Gothic centre of Central Italy. The Sienese School provides the 14th century's most extensive pictorial spaces and landscape panoramas, both in absolute fresco-dimensions and within the image in relation to the figures. In Ambrogio Lorenzetti's the *Effects of Good Government in the City and the Countryside* (1337-40), for example, the gaze wanders without interruption across an already broad cityscape and on to the Sienese *contado*, which by the standard of the day comprises a dizzying landscape panorama with fields, hills, forests and rivers (PLATE 13). In this type of Sienese pictorial space, the figures are neither dominating nor voluminous but, on the other hand, in possession of a relaxed, graceful freedom of movement (FIG. 9.17). Similarly, the Sienese images are rich in detail and small episodes, which is presumably what caused Berenson to note "a native tendency of Sienese art toward mere Illustration."[84] This illustration can fittingly be assessed in contrast to narration. Where the narrative action is in itself loaded with meaning, illustration is more of a *supplement* to the story, by means of which it can develop its own space of details.

Narration is, however, what we are offered by Giotto (FIG. 9.18). In spite of his Gothic-realistic elements, Giotto aspires to a monumental body volume which will make his figures heroic. But to accomplish this, he has to sacrifice the Gothic

Fig. 9.17. Duccio di Buoninsegna, *Massacre of the Innocents* (1308-11), panel from the *Maestà*, tempera on wood. Siena, Museo dell'Opera del Duomo.

freedom of movement and gain control of the incipient infinity. He does this by reducing the details so that his figures never get lost in the crowd. Furthermore, he tones down the dimensions of the pictorial space vis-à-vis the figures, so we have the impression that it is a function of these figures. As this is only partially successful, and as the space is almost clinically cleansed of irrelevant detail, Giotto's environment, particularly the architectural surfaces, is strangely, almost eerily, empty. This aspiration to subjugate both the corporeal and its spatial environment to geometrical control shows us the seeds of the tension which, via Renaissance, Baroque and Neoclassicism, culminates in Fascism. To sum up the contrasts: where the Sienese figures are slender, emotional, ethereal and mobile, Giotto's are monumental, self-controlled, substantial and slightly static.

Panofsky, even though he persisted in regarding the Renaissance as modern and the Gothic as medieval, had a brilliant understanding of this mechanism. In a comparison between the Gothic pioneer Abbot Suger and Renaissance man, Panofsky finds that Suger manifests his personality *centrifugally*: "he projected his

Fig. 9.18. Giotto,
Massacre of the Innocents
(1305-06), fresco.
Padua, Arena Chapel.

ego into the world that surrounded him until his whole self had been absorbed in the environment." Renaissance man, on the other hand, expresses it *centripetally*: "he swallowed up the world that surrounded him until his whole environment had been absorbed by his own self."[85] The Sienese ego is thus projected out into the expansive world, which thereby comes into focus, whereas the body is restricted to an airy shell full of graceful movement. The neo-classicist Giotto, on the other hand, attempts to recreate a substantial individual, which involves a loss of movement and a suppression of expansion.

This suppression can also be traced in his landscapes, which remain *parergon* to a greater extent than the spatial totality of the Sienese School. Evidence of this is found in the new cartoon-like phenomenon: the permanence of the surrounding environment in stories that develop over time, but not in space. It requires overt consciousness of the space's independence of the figure to imagine a specific place where the sequence of events is played out and to insist that this place remains unaltered when the image and chronology change. Giotto and Duccio, his slightly older Sienese colleague, are on a par for as long as they are dealing with the temporal stability of the interiors. But as soon as the setting is moved out of doors, Giotto is reluctant. In the Arena Chapel's images of Joachim (1305-06), when moving from *Joachim among the Shepherds* to *Joachim's Dream* the rock formations and the vegetation

Fig. 9.19. Giotto, *Joachim among the Shepherds*
(1305-06), fresco. Padua, Arena Chapel.

Fig. 9.20. Giotto, *Joachim's Dream*
(1305-06), fresco. Padua, Arena Chapel.

Fig. 9.21. Duccio di Buoninsegna, *Entombment* (1308-11), panel from the *Maestà*, tempera on wood. Siena, Museo dell'Opera del Duomo.

Fig. 9.22. Duccio di Buoninsegna, *The Three Marys at the Tomb* (1308-11), panel from the *Maestà*, tempera on wood. Siena, Museo dell'Opera del Duomo.

are replaced even though the wooden hut and rock peak to the right indicate that we are in the same location (FIGS. 9.19-9.20). In Duccio's *Maestà* (1308-11), on the other hand, rocks and trees stay in place for three whole sequences: from the *Nativity* to the *Adoration of the Magi*; from the *Agony in the Garden* to the *Arrest of Christ*; and from the *Entombment* to *The Three Marys at the Tomb* (FIGS. 9.21-9.22).[86]

Masaccio and Gentile da Fabriano

This tension between statuesque figure and expansive space only seems to escalate when we let our gaze move on to the 15th century. We sense this in a strangely back-to-front way in Frederick Antal's *Florentine Painting and Its Social Background* (1947), in which the author's youthful experience from *Budapester Sonntagskreis* – Karl Mannheim's and Georg Lukács' sociological forum (1915f.) – is channelled into that revitalisation of the Renaissance myth, which took place simultaneously with the primacy of the totalitarianisms from the 1930s to 1950s. In a kind of political competition between the two leading players, the Renaissance man Masaccio and the international Gothicist Gentile da Fabriano, the former is thus elected hero, as with his ostensibly hypernaturalistic Renaissance style he is perceived as exponent of a progressive republicanism, whereas his Gothic and correspondingly less naturalistic rival is seen as champion of an aristocratic feudalism. As, *inter alios*, Peter Burke has shown, there is no evidence in support of the political aspect of such a thesis, for although we know that the two painters found their patrons among the same upper middle class, nothing is known about the specific political orientation of these patrons.[87]

I shall here further problematise Antal's argument by simply turning its stylistic observations on their head. Even though it might make sense to do the same with the politics (cf. Pasquale Villari above), I must settle for referring to the macrohistorical argument, which will be developed in the next two chapters, and here restrict myself to the aesthetics.

As Masaccio is the first painter to carry forward Giotto's heroic body cult and thereby the neo-antique project, he must, like his predecessor, forgo energy of movement, grace and landscape abundance. The price of his desired goal – strong and worthy figures – is a certain degree of stasis. And although he is among the first artists to try out mathematical perspective, he uses it in a centralising and simplifying manner, which precludes the richly-stocked landscapes of his ostensibly more conservative colleague Gentile da Fabriano in, for example, the *Strozzi Altarpiece* predella (PLATE 6).

In the *Tribute Money* in the Brancacci Chapel (c. 1425; FIG. 9.23), Masaccio has placed his statuesque male figures in a landscape that might at first sight look fully modern: a plain with more or less withered trees, a bay, and in the background a mountain range so high that its peaks half disappear in the drifting clouds. But more than opening up, the mountains serve as a limiting background, a backdrop for the relief-like figures. And the withered state and sketchiness of the trees would mostly seem to bear witness to lack of interest in this part of the created world. The impression is corroborated by the almost washed-on belts of vegetation on

Fig. 9.23. Masaccio, *Tribute Money* (c. 1425)
fresco (section). Florence, Santa Maria del
Carmine, Brancacci Chapel.

the mountainsides, the only green element in the otherwise traditionally desolate
and massive rocky landscape. In form they look like the new hedges surrounding
Gentile's fields, but here they seem strangely ghostly. It is as if Masaccio intuitively
feels that the modern cultivation of landscape is an enemy of his heroic, neo-antique
art of the body and has therefore chosen to suppress it. "Puro, senza ornato," they
said of him in his day. *Puro* could refer to the body, *ornato* could stand for *parergon*,
including landscape trimmings.

Against the background of these observations, Gentile's pictorial idiom might
seem more chaotic and less monumental, but, for this very reason, also more radi-
cally naturalistic than Masaccio's. That Gentile, being the international Gothicist he
is, has a certain predilection for precious ornamentation – undulating sequences of
lines, touches of gold leaf, stylised cloth patterns – should not entice the beholder
into believing that he can only master the ornamental, because the ornaments thrive

Fig. 9.24. Paolo Uccello, *Battle of San Romano* (c. 1445), tempera on wood. London, National Gallery.

Fig. 9.25. Piero della Francesca, *Battle between Heraclius and Chosroes* (c. 1452-57), fresco from the cycle of the *Legend of the True Cross*. Arezzo, San Francesco.

in close liaison with searching optical observations which out-distance those of Masaccio. What does Masaccio show us, in degree of naturalism, for example, that corresponds to Gentile's variegated flora, gritted tracks, sacral gleams of light in the dark night and hillsides blazing in the sun's head-on rays? There would seem, all in all, to be evidence for the assertion that the unilateral crowning of Masaccio by Antal – and conventional art history – as the pioneer of modernity, and the corresponding consignment of Gentile to the darkness of the Middle Ages, is chiefly

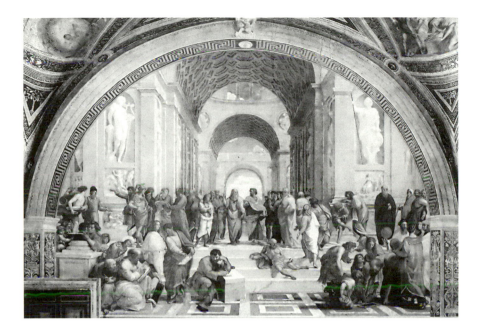

Fig. 9.26. Raphael, *School of Athens* (1510-11), fresco.
Rome, Vatican, Stanza della Segnatura.

the result of a hibernated neo-antiquity, an impeded modernity, favouring the monumental and plastic at the expense of the particular and optical.[88]

After Masaccio and Gentile had divided the waters in 15th-century Italian painting, some painters tried to squeeze it all in anyway: not just neo-Giottoesque corporeality, but also movement plus perspectival and cultivated landscape space. The impossibility of the project is clearly seen in the work of ambitious artists like Uccello and Piero della Francesca. In scenes of violent action, such as Uccello's versions of the *Battle of San Romano* (FIG. 9.24) and Piero's *Battle between Heraclius and Chosroes* (FIG. 9.25), the movement seems strangely postulated and puppet-like – quite the opposite to the work of contemporaneous Gothic artists like Filippo Lippi and Fra Angelico. Uccello's warriors, horses and lances even become prisoners of the centralising linear perspective, as if they were iron filings in a magnetic field, which could only be positioned either parallel with or at right angles to the image plane.

This conflict between the ideal, substantial body and its surrounding space is not resolved, characteristically, until the High Renaissance, when the Italians – temporarily – restrict the expansion of pictorial space and re-establish a closed world hierarchy. In a leading example such as Raphael's *School of Athens* (1510-11; FIG. 9.26),

the barrel vaults can soar high above the figures because these vaults are placed in a symmetrical relationship to the figures and also to their framework. A secure scene is thereby created, in which the figures keep their monumental substance, without this threatening their freedom of movement, which they can now express with relaxed grace.[89]

Pisanello and Guarino da Verona

Since Masaccio (and gradually also Uccello and Piero della Francesca) has been seen as representing the absolutely most advanced achievement of early Italian Quattrocento art, it has been a thorn in the flesh of scholarship that humanists far into the 15th century actually preferred the Gothic painters and generally trained their antennae on the North. Michael Baxandall, who has made a close study of the humanist art commentaries, has to acknowledge:

> It is one of the more disconcerting facts of Quattrocento art history that more praise was addressed by humanists to Pisanello than to any artist of the first half of the century; in this sense – and it seems a reasonably substantial one – Pisanello, not Masaccio, is the 'humanist' artist.[90]

What we would today describe as Gothic pictorial qualities found a strong centre of appreciation in the Guarino School – i.e. Guarino da Verona himself, plus pupils such as Tito Vespasiano Strozzi and Bartolomeo Fazio. In a poem probably from the 1430s, Guarino is impressed by, *inter alia*, the varied landscape in the work of his fellow townsman Pisanello: "[...] you equal Nature's works, whether you are depicting birds or beasts, perilous straits and calm seas; we would swear we saw the spray gleaming and heard the breakers roar." Whereupon Guarino is about "to wipe the sweat from the brow of the labouring peasant" and praises Pisanello for his realistic effects of night and seasons. In brief, just about all the new, modern phenomena of the landscape image are celebrated.[91] Later, in 1456, when Bartolomeo Fazio catalogues the greatest painters of his day in the book *De viris illustribus* (*On Brilliant Men*), he chooses, besides Pisanello, the Gothic painters Gentile da Fabriano, Jan van Eyck and Roger van der Weyden. Of "Jan of Gaul" it is even said that he "has been judged the leading painter of our time" and of Gentile, that he was Roger's favourite among the Italian painters.[92]

Nonetheless, by now we are so far into the Renaissance that landscape and Gothic realism ought to be justified in a neo-antique framework. Key concepts, characteristically borrowed from rhetoric, were *copia* (abundance, plenty, richness) and *varietas* (variety).[93] In antiquity both were used to ensure the appeal of the spoken

word and image to the audience and could therefore be seen as *parerga* adorning *ergon*. Abundance of expression might have been important to the rhetoricians of antiquity, yet it could not be allowed to get out of control, but should be held in check by *compositio*, the internal coherence of the period. Failing this, chaos and disintegration – *dissolutio* – would ensue. In Quintilian's words:

> But plenty [*copia*] should be controlled by moderation [...]. The result will be great-
> ness, not excess; sublimity, not hazardous extravagance; boldness, not rashness;
> severity, not grimness; gravity, not heaviness; abundance, not luxuriance; pleasure,
> not abandon [*dissoluta* [*opera*]]; grandeur, not turgidity.[94]

This very threat is integral to landscape and Gothic variety. Tellingly, Guarino – the humanist who has praised Pisanello for his diverse landscape – is taken to task by his own pupil, the Byzantine George of Trebizond, for cultivating a disjointed style of speaking. As early as 1435, George attacks the many short sentences in Guarino's 1428 panegyrical speech to Count Francesco di Carmagnola, and rewrites it into one long construction.[95] In sentences such as these, which recall Villari's observation of Renaissance humanists' synthesizing constructions, we thus encounter the literary parallel to a pictorial idiom favouring the plastic body over the particular environment.

Alberti's De pictura

De pictura, Alberti's 1435 manifesto for the new painting (which he himself translated into *volgare* in 1436), also attempts the feat of uniting Gothic modernity with neo-antique beautification – putting particularity-filled illusionism in tandem with principles of ideal corporeality. Alberti wants space, realism and profusion *alla tedesca*, but also closedness and moderation *all'antica*. The other side of the coin is apparent from the Renaissance requirement that beauty is at least as important as faithfulness to nature: "The early painter Demetrius failed to obtain the highest praise because he was more devoted to representing the likeness of things than to beauty."[96]

The ideal image is achieved when there is balance between, on the one side, *istoria* and *composizione*, on the other, *copia* and *varietà*. Or, in other words: the *ergon* of the story has to be appropriately decorated with the *parergon* of profusion. The story – the narrative action – should be, as in Aristotle, a closed body, and so Alberti requires everything in the image to be contained within it, a construction put together, borrowing from rhetoric, with the help of composition. In the same way as words are parts of phrases, which are enclosed in sentences, which in turn are set in periods, Alberti concludes that: "Parts of the 'historia' are the bodies, part of the body is the member, and part of the member is the surface."[97] This last, slightly peculiar

term, *surface* (*superficie*), is one of the very few words in Alberti's vocabulary with no precursor in antiquity,[98] and should perhaps therefore be read as his response to a specific visual problem: to build a bridge between the two – increasingly more remote – entities, the sculptural totality of 'bodies', which make up the story, and then the plane – the painting's window – through which these bodies are seen.[99]

This focus on the outer surfaces rather than on the voluminous bodies themselves could be seen as a kind of externalisation of the antique corporeality. When Vitruvius discussed *eurythmia* and *symmetry* in the human body, he regarded them as the result of the interplay between the *individual parts of the body* (cf. chapter 1). As Alberti, however, lives in a period in which vision is transferred from the corporeal to the projection of the image window, he correspondingly shifts the gaze from the body parts to their *outer surfaces*: "From the composition of surfaces arises that elegant harmony and grace in bodies, which they call beauty." Immediately before this, he even claims: "The principal parts of the work are the surfaces [...]."[100]

Even though Alberti thus builds a bridge from the bodies via their surfaces to that surface which is the composition of the painting, he cannot, however, make up his mind as to how many doses of *copia* and *varietà* this bridge can bear. With a Gothic enthusiasm for detail, which levels out *ergon* and *parergon*, he may proclaim: "I would say a picture was richly varied if it contained a properly arranged mixture of old men, youths, boys, matrons, maidens, children, domestic animals, dogs, birds, horses, sheep, buildings and provinces."[101] In this extremely un-antique – and landscape-like – juxtaposition of objects, Alberti gets suspiciously close to Bartolomeo Fazio's aforementioned examination of Jan van Eyck's bathroom scene with its old woman, water-lapping puppy, horses, tiny human figures, mountains, groves, villages and castles.

But once Alberti has let go of this landscapesque view, Renaissance man also has to take a look and call for composure: "I disapprove of those painters who, in their desire to appear rich or to leave no space empty, follow no system of composition, but scatter everything about in random confusion [...]." In the Latin version of *Della pittura*, the maximum number of participants is even restricted to the nine or ten considered by Varro to be the limit for a banquet.[102] Here Alberti is obviously divided against himself, as ten players do not harmonise with a throng in which the human ingredients alone are made up of "old men, youths, boys, matrons, maidens, children". Hardly surprising that he left out the passage in the Italian version.

Just as the painter's gaze should not be overwhelmed by the *parergon* comprising the abundance of the surrounding environment, neither should the gaze, however, move to such a great distance from these surroundings that another type of *parergon*, vacuity, takes over. Alberti thus also warns against too many empty surfaces, what he calls "loneliness". Guarantee that the composition is bound together and

avoids overloading or vacuity alike is provided by the unity of action. Regardless of how many figures appear in the story, they must all react to the same action. As illustration of this, Alberti makes an exception and points to a modern rather than an antique work, Giotto's celebrated fresco *Navicella* in the Old St Peter's: "[...] Giotto represented the eleven disciples struck with fear and wonder at the sight of their colleague walking on the water [...]."[103]

Ghiberti and the Sienese

Whatever Alberti might have thought about the proper dosage of *copia* and *varietà*, there is no doubt that at least one contemporaneous artist, the Gothicist Lorenzo Ghiberti, was struck by the diversity potential of the concepts. Ghiberti was in the middle of modelling his *Gates of Paradise* when *De pictura* was published in 1435, and the last five bronze reliefs for the door show a pronounced change of style, which could be described as a systematised augmentation of *copia* and *varietà* (FIG. 9.27).[104] The first five reliefs for the portal – the sequence up to and including *Isaac* – usually have a manageable number of figures, placed additively so that their individuality is retained. The culmination is reached in the classically-looking *Isaac*, where the figures seem almost sculptural in their high relief and enter into harmony with the Albertian arcade, which could well bring Raphael's *School of Athens* to mind.

From and including *Joseph*, however, the number of figures is drastically increased, while the gaze becomes more summarising. Ghiberti's starting point would now seem to be the throng in its totality, whereas the figures lose their individual corporeal substance. There is also an attempt to control this more overarching gaze by means of a tighter *istoria* in that the number of narrative episodes within each panel is reduced, culminating in *Solomon and the Queen of Sheba*, which only has one episode.

That Ghiberti's change of style was due to influence from Alberti – very likely through reading the newly-published *De pictura* in 1435 – is confirmed by Ghiberti's own *Commentarii*, the compendium of art history written in 1447-48, which was meant to ensure his place among the *conoscenti* of the day. As noted by Henk van Veen, *Commentarii* is full of Albertian terminology,[105] and of his own *Gates of Paradise* Ghiberti writes:

> They were Old Testament stories, very abundant with figures [*molto copiose di figure*], in which I strove with every measurement to respect nature and to try to imitate nature as far as it was possible for me, both with all the line structures that I was able to produce from it [nature] and with excellent compositions rich with a great number of figures. In some stories I put about one hundred figures; in some stories more and in some less.[106]

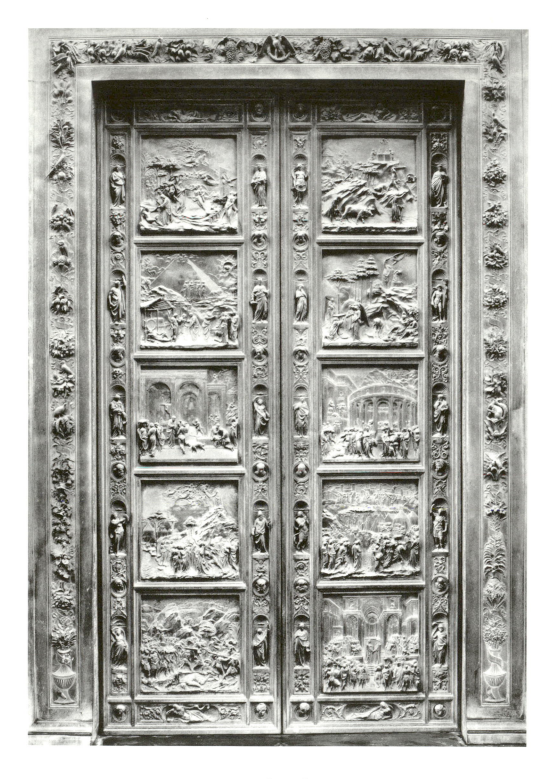

So here Ghiberti compares *copia* with the number of figures and, moreover, sets the number so high that it can only correspond to the last five reliefs on the *Gates of Paradise*.

The impression that Ghilberti had read Alberti is also corroborated by reference in *Commentarii* to Ambrogio Lorenzetti, which is again coloured by Albertian terminology.[107] *Commentarii* is remarkable for presenting the first lengthy discussion of the Sienese tradition, which had otherwise only previously been mentioned a few times in the Florentino-centric literature.[108] By writing this item, Ghiberti shows both his debt to the modern Sienese tradition and, in a broader sense, its correlation with Alberti's concept of *copia*. In his examination of two now lost Ambrogio Lorenzetti fresco cycles in Siena – on the one hand the *Franciscan Mission's Martyrdom*, formerly in the chapterhouse of Sant'Agostino, on the other the *Crucifixion* and *Stories of Saint Catherine*, formerly in the first cloister garth of San Francesco – Ghiberti is struck by a number of telling features. The San Francesco cycle immediately impresses him with its Sienese speciality, size, as it fills an entire monastery wall. In addition, he is impressed by the effect of the throng and the variations within it. Of the San Francesco cycle he writes that the monks "are decapitated, with a very great multitude, mounted and on foot, looking on. There is the executor of Justice with very many armed people [and] there are men and women."[109] And in the Saint Catherine fresco "there are painted many people, [both] inside and out." Indeed, "this story is very rich [*molto copiosa*]".[110] Within this abundance, Ghiberti goes on to note the pronounced variation created by different positions and clothing.

But Lorenzetti is *nobilissimo componitore* as well, so Ghiberti also describes how all those involved in the various episodes, as in Alberti's description of Giotto's *Navicella*, react to the same action. For example, "all the people" have their eyes turned to the naked monks; just as "all the people who go to see" listen to the hung monk preach.[111]

Considering Lorenzetti's sense for descriptive details and subsidiary episodes, this last part of Ghiberti's description could seem to be somewhat influenced by wishful thinking. Lorenzetti has a lot of *copia* and *varietà*, but it seems doubtful that they can be so painlessly subjugated to the neo-classical idea of unity of

Fig. 9.27. Lorenzo Ghiberti, *Gates of Paradise* (commissioned 1425; modelled 1429/30-37; installed 1452), gilded bronze. Florence, executed for the Baptistery, east entrance; now in the Museo dell'Opera del Duomo.

composition and action. The Gothic variety is something experienced purely from a subjective vantage point, which emphasises the window through which the world is beheld; classical corporeality, on the other hand, is elevated above the subjective. The composition and unity which Ghiberti so enthusiastically thinks he has found expressed both in his own work and that of the Sienese is, therefore, perhaps in reality not so much a corporeal unity as a unity dependent on the beholder's gaze – in short, a modern, subjective unity. Ghiberti – and his mentor Alberti – only lacked a vocabulary that could provide words for this alternative unification of the image.

9.4 Supremacy of the amorphous: naturalism without Renaissance

Landscape imagery between wall stains and hypernaturalism

If we acknowledge that the naturalistic image is not necessarily focussed on plastic bodies, but may include all forms of sense impressions determined by the moment (sharply defined, dull, amorphous or completely dark), our attention is split in two opposite directions and the midpoint between them: towards the infinite space in all its diversity; towards the subject appraising this space; and, finally, towards the image plane on which this space's subjectively-determined projection of infinity leaves its imprint. As Alberti states in *Della pittura*, this plane is not merely to be compared with a clean windowpane, but also with a veil or even a mirror for the beholder. In other words, there are extremely fluid transitions from a myriad chaos of objectively-observed individual elements (window) to a totality unified on the image plane, because it is seen from a subjective position (veil or mirror).

Considering the roots of nominalism and subjectivity in the Northern European culture, it is therefore not unexpected that in the post-Albertian period, from the end of the 15th century and further on to the 16th-17th centuries, it is the Northern culture – Venice and the Netherlands – that devises the coherent, hazy, so-called painterly vision that turns the brush-script into an index of original artist personality. Behind the framed plane, alias the artist's retina, lies the autonomised subject, a primarily Northern European mind able to make a free choice as to the degree of purity in which sense impressions will be invoked on the plane which receives them.

As far as this subject is concerned, the objective observation of nature devoid of the trace of an artist's hand (window) is but a sable-hair's-breadth from the subjective vision which allows the brush strokes to emphasise the process by means of which the surrounding world is comprehended by the beholder (veil or mirror).

Both ways of seeing – 'hypernaturalism' and 'impressionism' – are based in the plane separating the individual from the surrounding world. The introverted version, the mirror, is Narcissus' image: "What is painting but the act of embracing by means of art the surface of the pool?"[112] Or, in the words of a popular 15th-century aphorism: "Ogni dipintore dipinge se" ("Each painter depicts himself").[113] In modernity, therefore, the hazy traces of the painter's hand, which to Plato signalled illusion and deception, become a refractive zone between two mutually-dependent areas of reality: the inner personality and the outer world.

Landscape is the epitome of this binocular way of seeing as it represents, to a supreme degree, that which is alien. It is brimming with objects, each with its particular character – rocks, gravel, broken branches, leaves, clouds, etc. – so that there are no limits as to the extent to which it is possible to become absorbed into their illusionistic reconstruction on the image plane. But, at the same time, the grouping of the objects within the whole is raised above predetermined regularities to an extreme degree, and thus the artist can treat them with equally unlimited freedom. We recall how Pliny the Younger, when describing his view from the Apennines in the *5th Epistle*, turned to the words *varietas* and *descriptio* (see chapter 6). By so doing he indicated that the variety of the landscape settled into a pleasant arrangement in front of the beholding gaze. With a modernist turn it could be said that the outer world slots together with the beholder's mind. In this respect landscape, as no other pictorial motif, demonstrates the intimate connection between the objective and the subjective.

But once more there are extremely fluid transitions from the landscape of 'nature' to the landscape that simply appears in front of the beholder irrespective of the objects involved. For again, whatever the motif, the modern way of seeing is landscapesque. The connection is elegantly demonstrated in Leonardo's *Treatise on Painting*. Leonardo shall not fail

to include among these precepts a new discovery, an aid to reflection, which, although it seems as a small thing and almost laughable, nevertheless is very useful in stimulating the mind to various discoveries. This is: look at walls splashed with a number of stains or stones of various mixed colors. If you have to invent some scene, you can see there resemblances to a number of landscapes, adorned in various ways with mountains, rivers, rocks, trees, great plains, valleys and hills. Moreover, you can see various battles, and rapid actions of strange figures, expressions on faces, and costumes, and an infinite number of things, which you can reduce to good, integrated form. This happens thus on walls and varicolored stones, as in the sound of bells, in whose pealing you can find every name and word you can imagine.

And Leonardo continues:

> Do not despise my opinion, when I remind you that it should not be hard for you to
> stop sometimes and look into the stains of walls, or the ashes of a fire, or clouds, or
> mud, or like things, in which, if you consider them well, you will find really marvel-
> ous ideas [...], because the mind is stimulated to new inventions by obscure things.
> But be sure that you first know how to make all the parts of the objects that you
> wish to represent, such as the limbs of animals, and the elements of landscape, that
> is, rocks, plants, and such things.[114]

Subject to a certain previous knowledge of the organisation of the world, and
taking as the starting point the most confused and amorphous forms – stained
walls, motley stones, ashes, clouds and mud – the artist might thus create the most
admirable inventions. Just like their initiators, these inventions seem to transcend,
if not dissolve, the neo-antique horizon, the closed *ergon*. The painted landscapes
are particularly effective in this respect, as the amorphous forms which are their
point of departure – stains, clouds, mud, and so forth – also belong to the variety
of natural objects which the finished landscapes *depict in high definition*. In addition,
the inventions can consist of facial expression (fleeting emotional states), battles
(large throngs of figures), figures ("strange" and in "rapid actions", i.e. beyond
neo-antique decorum) and clothing (by definition a *parergon*), besides "an infinite
number of things". We recall variety, infinite number of things and confusion as
points on the Albertian curve towards increasing dissolution. To the modernist
Leonardo, the prime safeguard against chaos, however, is not composition but
naturalistic studies of individual elements.

Once again, then, we see what a short step it is from lack of proportion to
hypernaturalistic close studies. Hovering in the uncertain space between the large
and the small infinity, the painter has free choice as to the frame and the sharpness
within which he will view the surrounding environment. What at one moment ap-
pears as an amorphous blob in the microworld, proves – under a change of lens –
to constitute a hypernaturalistic landscape in the macroworld. At the same time,
this macroscopic landscape is made up of amorphous objects, each of which is the
entrance to yet other new landscapes. The damp stains of the wall could, therefore,
in themselves be regarded as a metaphor for the painterly style, the painting which
stresses the misty vision and its own genesis.

This vision, which can zoom freely in on and out from the objects of the world, is
in obvious conflict with its classic forerunners. The classical vision only finds beauty
in objects that it can include in a single gaze – if the objects shrink to ant-size, or
expand to giant-size, it is jolted. The feeling is clearly felt in Francesco Colonna's

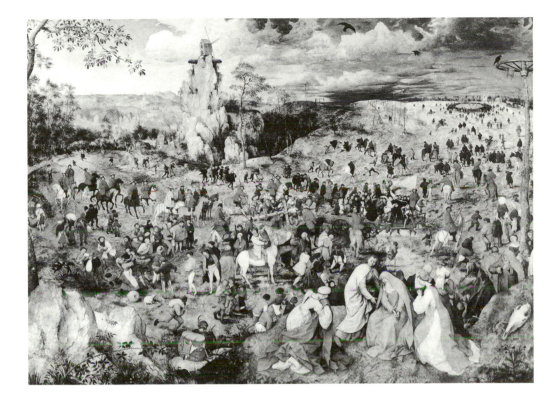

Fig. 9.28. Pieter Brueghel the Elder,
Procession to Calvary (1564), oil on wood.
Vienna, Kunsthistorisches Museum.

Hypnerotomachia Poliphili (c. 1467, published 1499). Having climbed a colossal build-
ing at the base of a rock ravine, Poliphilo cannot bring himself to look down, for
"my eyes, adapted to the ground, could not see again, inasmuch as every object
below me appeared imperfect".[115] The "imperfect" could here be interpreted as the
unclosed amorphousness that transpires in the gaze of distance.

It is precisely this obscene relativism, with its emphasis on unclosed matter,
that is cultivated in the Northern tradition, from Jan van Eyck to 17th-century Hol-
land and on to 18th-19th-century modernity. Brueghel's *Procession to Calvary* (1564;
FIG. 9.28) could be seen as an emblematic image in this respect. The gaze has here
been raised so far above the underlying terrain that the more distant part of the
throng of people looks like the miniscule organisms Aristotle finds so distasteful in
his *Poetics* (see chapter 1). And the terrain itself could resemble the *Poetics*' thousand-
mile-long object, the cohesion of which is lost to the observer.

Naturalism in recent art criticism: some adjustments

If I have by now succeeded in extrapolating naturalism's distance from plastic ideality and its corresponding close connection with the amorphous, this should not only set the scene for reformation of the traditional art history, but also for adjustment of some of the reactions that this art history has already triggered in the post-war period, especially in phenomenological- and semiotic-oriented art criticism. It is thus an ironic fact that post-16th-century prejudices caused by the Renaissance annexation of naturalism actually live on among opponents of the traditional art history. Rather than recognising naturalism's modernity potential by divesting it of neo-antique ingredients, the new art history takes over the whole Renaissance cliché of naturalism as inevitably narrative, olympically overviewing and linear perspectival, with the result that this distorted idea of naturalism is not dissolved but, on the contrary, turned into the antipole of, and thereby – through the logic of negation – into a continued sphere of control for, the new art history. Thereby, we end up in the far too universal 'denigration of vision', the antiocularcentric paradigm, which Martin Jay has identified in numerous areas of 20th-century French thought and which has spread to much of the cutting-edge art criticism since the 1970s.[116]

The unacknowledged neo-antique prejudices concerning naturalism, which thus hibernate as the 'enemy' of an ostensibly more advanced art appreciation, are, in particular: [1] naturalism's ideal is an unmediated, transparent reproduction of reality; [2] naturalism is focused on clearly-defined bodies; [3] naturalism without linear perspective is inconceivable; and [4] naturalism and narration are two sides of the same coin.

The first point has been corroborated by, in particular, Norman Bryson, whose post-structuralist attack on naturalism's iconic aspiration builds on an assumption that this iconicity demands a 1:1 equality between image and environment. Bryson thus assumes that Western painting since the 15th century is gripped by a fallacious longing for absolute transparency, an unmediated access to "the Essential Copy" and that it therefore opposes *deictic* traces, i.e. traces which accentuate the painting's own process of creation (from Greek *deiktikos*=able to show).[117] But if we bear in mind naturalism's nominalistic roots, it should be unambiguously apparent that even a very 'clean' pictorial window still comprises a subject-bound, fragmentary mediation, whereas the term "Essential Copy" leads our thoughts in an extra-subjective, universalistic direction, i.e. towards the Renaissance focus on ideal plasticity. And, unlike Bryson's assertion, the Western pictorial window is actually often transformed into a veil or mirror, with the brushwork miming the subject's impression and assimilation of the environment. The painterly style with

its indexicality of both craft and perception is not, therefore, essentially alien to, but rather symptomatic of, Western modernity.

The attack on naturalism's apparent ideology of transparency can also be turned around so that, instead of firing a broadside against the Western painting tradition, focus is placed on its overlooked pockets of seemingly conscious anti-transparency. This strategy is implemented with considerable effect by Hubert Damisch, who in his semiotic counter-reading of Western pictorial art, *Théorie du /nuage/*, identifies the cloud as an amorphous primary figure for the painterly, picturesque and Baroque. As demonstrated in a manifesto-like manner in Correggio's dome frescoes in Parma (San Giovanni Evangelista (1520-24) and the Cathedral (1526-30)), the cloud evades the domain of the measurable and linear and instead marks out a transcendent zone midway between visible and invisible, representable and non-representable. In Damisch's opinion, the cloud image can actually be driven so far into the supremacy of the amorphous that he finds it useful to distinguish between two types of cloud sign: on the one hand, an italicised *cloud*, the unambiguously denoting *signifiant* for the *signifié* cloud; on the other hand, a slash-flanked /cloud/ representing the *signifiant* itself, the amorphous traces of paint, and with a denotative relation to the representation of the physical environment so consciously unclear that it turns inwards and becomes the index for the artist's, for example Correggio's, style.[118] With the idea of /cloud/, Damisch is thus aiming at the very stuff of which painting is made, and which can only be contained to a limited extent in recognisable figures.

Conversely, the chief instrument of the figure formation is ostensibly linear perspective, which thus, as already indicated in the discussion of Brunelleschi's views of Florence, becomes the absolute anti-pole of the cloud. In Damisch's opinion, not only is perspectival representation inextricably allied with the drawing and the linear, but both parties permeate every form of imitation and *trompe l'oeil*, which accordingly sees colour outdone by line. At the same time, Damisch sees this linearly-controlled and colour-repressing imitation as inevitably concentrated on corporeal figures and their manifestation in Albertian stories, acted out on cubical vanishing-point-oriented scenes.[119] It is in order to disarm this rationally imitative pictorial regime that the hazy *cloud* and its condensation in amorphous blotches of paint – /cloud/ – has to be mobilised, by means of which we are catapulted into the self-representative genesis of style, a seemingly non-naturalistic space filled with paradoxical ruptures and ambiguous connotations.[120]

Despite Damisch's indubitably perspicacious and innovative ideas – the distinction linear/amorphous; the distinction cloud/amorphous traces of paint; and perhaps especially: the alliance between the cloud figure and the picturesque style – we have to note that he again perpetuates all the neo-antique clichés as regards naturalism's modes of operation: that it is necessarily transparent, linear-perspectival,

corpo-centric and narrative. But why should a sharply-focussed *trompe l'oeil* paint-
ing not be able to depict amorphous, colour-glinting clouds just as convincingly
as it can denote ideal bodies on grey, mathematically square scenes? What is more,
in order for the paint to be the index of the artist's stylish brush-writing, these
optically imitative cloud images do not require a change of register to particularly
paradoxical, anti-naturalistic and rupture-filled spaces, because, as suggested by
possibly the most valuable point in Damisch's thesis, the characteristic of the cloud
figure is exactly the fluidity of the transitions between *signifié* and *signifiant*, between
transparency and opacity, between hypernaturalism and painterliness. To defend
nevertheless the idea of a distinction imitation/cloud and simultaneously of a link
between linear perspective and corporeality, Damisch finds himself compelled to
adopt forced, indeed strangely infantile assertions – such as, for example, that the
vanishing point or the optical image of the sky cannot induce a feeling of infinity,
and that infinity is given a better representation in a vertical rather than a horizontal
view.[121] In this endeavour to see infinity as monopolised by the cloud, the amorphous
and the transcendent, Damisch fails to notice that infinity appears in two forms in
the culture of modernity: not only in the domain of incalculability (for example,
in the sublime of aesthetics), but also in that of the calculable (in addition to the
vanishing points and horizon lines of perspective – entities approached infinitely
but never reached – in mathematical differential and integral calculus).

A more specialised articulation of anti-transparent phenomena in Western
art history is moreover put together by Georges Didi-Huberman who, in a rein-
terpretation of Fra Angelico, highlights the "dissemblant" quality in this artist's
brush-writing, i.e. its equally indefinite relationship to bodies, narrative and spatio-
temporal relationships (cf. all the four abovementioned points).[122] Didi-Huberman
concentrates on a more material form of 'cloud' – i.e. certain recurring colour zones
in the frescoes in the Florentine San Marco which, just like the Correggio frescoes,
seem to play on their dual identity as figurative signs and completely amorphous
blotches – for example, the small red colour-stains which, in the *Noli me tangere*
fresco, alternate between denoting flowers and stigmata, or the strikingly large
marmo finto panels found both inside the figure scenes and in separate spheres below
them. In Didi-Huberman's reading, these colour sections are still *figures*, however
in a different sense than the Renaissance 'volgar', which deal with plastic bodies
in well-defined *istorie* seen in linear perspective. In accordance with the medieval
exegesis tradition, pursued in the Dominican monastery, this is more a case of signs
miming the mystery of incarnation and therefore seemingly displaced (*déplacées*) in
relation to time, space and the domain of the visible altogether.[123]

Like Damisch, Didi-Huberman certainly provides a much-needed attack on the
Renaissance annexation of the late medieval, Gothic-influenced image, identifying,

furthermore, highly potent pieces for a persuasive alternative interpretation. None-theless, his attack is again distorted by the Renaissance-governed notion that the narrative and plastic-corporeal are inextricably built-in to the perspectival and naturalistic, and so he too, to an exaggerated degree, has to distance himself from the domain of the visible *in toto*. What he unwittingly reawakens as the agency of this distancing, however, is not merely a certain anti-ocular medieval mysticism, but nothing less than the roots of nominalistic naturalism, i.e. the notion that the visual process and its fixing on the image plane *from the ground* is partly uncertain in its relationship to the surroundings, inasmuch as it is entrusted to mediations such as darkness, mist and amorphous forms – in brief, the entire chaotic repertoire which, according to Leonardo, is the starting point for even the most hypernaturalistic image creation. So why cut the painting's figures away from time and space when the late medieval physical cosmos has already absorbed God's infinity, and this infinity in any case – as Nicholas of Cusa, Fra Angelico's contemporary, recognised (cf. chapter 8) – can only be embraced via otherness, i.e. through signs which only leave traces of it to a limited extent and with ambiguous symbolic meaning?

In other words, Didi-Huberman's 'dissemblance' appears as an iconically rather one-sided nominalism, which displaces the pictorial signs' slightest structure-pre-serving response to the environment, as this nominalism's sole conceivable iconic-ity is the Renaissance-determined caricature: the total likeness, Bryson's "Essential Copy". This does not mean, however, that the surrounding environment as a whole is excluded from Didi-Huberman's thinking, because at the same time he is of the opinion that there should be an inverted proportionality of sorts between iconic-ity and indexicality, so that the less Fra Angelico's figures resemble the visible phenomena in the environment in terms of form, the more they are 'touched', not, as in Correggio's work, by the artist's style, but by the mystery of incarnation.[124] Apart from the problematic correlation of the fundamentally incomparable entities of iconicity and indexicality, it would seem precipitate to attribute Fra Angelico's pictorial signs with special indexical properties vis-à-vis environmental phenomena. Irrespective of how amorphous the colour stains might look, there is no getting away from the fact that they are constructed, just like the linear perspective, via Fra Angelico's hand and are thereby bound to a nominalistic genesis.

Both Damisch's and Didi-Huberman's assumed link between formlessness and indexicality are clearly influenced by the French phenomenological tradition, in that Merleau-Ponty and Lacan similarly consider non-linear visual phenomena such as colour stains and light refraction to constitute a perceptual field which evades the rational perspectival construction – here in favour of more direct, corporeal dealings with the world.[125] Even though I agree with the fundamental benefit of differentiating between, on the one hand, play of colour and light and, on the other

hand, rational linear perspective, Merleau-Ponty and Lacan would also seem to be ensnared by the Renaissance plastic interpretation of the latter, and so they must similarly exaggerate the alien relationship between form and non-form in modernity. However, if the North European pictorial tradition is again brought into the discussion, we will recall that its colour- and light-play often enter into so close an interaction with the linear-appearing but not necessarily mathematically-constructed perspective, that this looks as if born of and borne by the colours. Moreover, as with Didi-Huberman's stains, it is important to stress that the play of colour and light in this pre-photographic era is no less nominalistically based than is perspective, since it is similarly constructed on the image plane through a purely iconic – and not indexical – contact with the environmental phenomena it represents.

If, on the one hand, we elevate the light-colour-play to mediate an extra-rationalist, almost sacred proximity to reality, while, on the other hand, we demarcate the linear perspective to a quasi-fascist, subject-governed environmental control, we are not in my opinion settling accounts with modernity – on the contrary, we are perpetuating a demonised version of its later dogma of two incompatible cultures: the aesthetic rule-less and the rationalist rule-bound. A genuine postmodern horizon ought to set the scene for considering this differentiation with the insight of historical distance and recognise that its rational part has been distorted through its unrecognised annexation by Renaissance idealism. Exculpated from this idealism and its glorified subversion, the divide no longer concerns a 'progressive' versus a 'reactionary' modernity, but points out two complementary sides of the same epistemic *field*.

That it seems fundamentally unbeneficial to isolate the amorphous layers of paint from the naturalistic pictorial tradition in its entirety, is finally suggested by the fact that the *amorpheans* Damisch and Didi-Huberman even prove to be closely allied with a scholar who, from a conventional point of view, might be misunderstood as their antithesis: the *naturalist* Svetlana Alpers. Where the two parties meet is again in the case against their shared defendant: the Renaissance's clearly-defined history painting with its narration and linear perspective. Damisch and Didi-Huberman could simply be said to attack the accused *from the inner side of* the pictorial window (veiled or mirrored), through the chaotic mediation of the paint, which dissolves the clear plasticity and denotation, whereas Alpers goes into action *behind* the same window (the clean one), through the myriad empirically-recorded particularities, which likewise subvert the overview and predefined literary point. Both positions therefore show themselves to be enrolled in the same nominalistic pictorial paradigm, that of modernity which allows for a wide spectrum of paint definitions – sharpness and blurredness, glaze and opacity, brightness and darkness – to act as iconic signs for the optically-perceived

space and light conditions of the environment. While these paint formations – in the special case of Renaissance pictorial space – *can* be manipulated to centre on plastic figures denoting well-defined iconographic meanings, they will most often spread their references to the optically-perceived boundlessness, with a corresponding displacement of meaning – a gemmation of connotations – to follow. Thus, again, neither the materiality of the pictorial sign nor the ambiguity of its iconical meaning should be sought in a special pictorial space that is estranged from imitation and stylistically isolated; on the contrary, they both thrive at the heart of naturalism, the pictorial idiom of nominalism.

Wölfflin's principles: a reappraisal

These observations could be further clarified by bringing in Heinrich Wölfflin's celebrated *principles of art history* from 1915.[126] Even though these principles are tremendously useful in a pragmatic way, Wölfflin did not succeed in developing an explanation of *why* they were as they were and which context of cultural history supported them – a lack of context presumably resulting from the art history discipline seeing itself compelled to throw any such deliberations overboard after, in the second half of the 19th century, it had liberated itself from its origins in aesthetic philosophy.[127] Since, however, the art history discipline has recently approached a reconciliation with its former partner, these principles – like their kin: Riegl's haptic-optic spectrum (cf. chapter 1) – could be considered as being a perceptual fine-tuning of Hegel's aesthetics; albeit, that is, a Hegelian aesthetics now so concentrated on form and so limited in its temporal overview that any consciousness of its progenitor and his ideas pertaining to the philosophy of history has evaporated.[128]

Wölfflin sees, as is well known, a dichotomy between Renaissance and Baroque, particularly Italian Renaissance and Northern Baroque – a dichotomy described by the following pairs of terms: *linear/painterly; plane/recession; closed form/open form; multiplicity/unity; absolute clarity/relative clarity*. This entire dichotomy can be described as a specification of Hegel's contrast between *classic* and *romantic* – and thereby also of Riegl's last two levels of the pictorial history: the *haptic-optic normal sight* of antiquity and the *optical distant sight* of late antiquity and modernity. Linearity, plane, closed form, multiplicity and absolute clarity are thus all features caused by Renaissance eagerness to return to the classical *ergon*, in which the subjective vantage position is moderated. Placed in the perspectival field, we see objects that: appear in relief-like parallelism with the image surface (plane); accumulate into an articulated whole, the outline of which relates to and in a way becomes one with the pictorial frame (multiplicity and closed form); and, finally, are sharply-drawn, by means of which the visual process is displaced (linearity and absolute clarity).

In the Northern 'Baroque' (actually, more like naturalism and realism), however, modernity flares up again and attention shifts from the objects in front of the field of vision to the process of perception itself (painterliness, relative clarity and unity); by this means, the image becomes a frame randomly cutting off the gaze towards the infinite environment (open form and recession). To the question of where the 15th-century painters, *the primitives,* fit into his scheme, Wölfflin is interestingly rather undecided as, on the one hand, their "craftsmanlike" and therefore sharply-drawn images could be seen as an undeveloped Renaissance art; on the other hand, they are marked by 'Baroque' features such as space-creating and complicated compositions, which explode the Renaissance idiom of closedness. However, even though the point is underplayed, Wölfflin himself supplies the beginnings of an explanation:

> There is a Germanic imagination which certainly passes through the general development from plastic to painterly, but still, from the very beginning, reacts more strongly to painterly stimuli than the southern. Not the line but the web of lines. Not the established single form, but the movement of form. There is faith even in the things which cannot be grasped with hands.[129]

Had Wölfflin now gone on to clarify that the painterly stimuli, i.e. the web of lines and the movement of form, might just as well be fixed on the clean window as on its veiled counterpart – since both forms of appearance point to the perceiving medium more than to plastic objects independent of it – the primitives would seem to be sheer early 'Baroque', and the Renaissance would thereby shrink to my requisite image of it: an island formation in a more or less unbroken trans-European tradition flowing from the Gothic period up through the 17th-19th centuries.

Wölfflin's thoughts thus, once more, corroborate that modernity demonstrates no epistemologically interesting contrast between a pictorial idiom focussed on the empirical phenomena of the surrounding environment (cf. Alpers) and one oriented toward the materiality of the image plane (cf. Damisch and Didi-Huberman). Both converge towards Wölfflin's concept of the Baroque, the friction of the eyesight, and both are at a distance of his Renaissance, the smoothness of the ideal body.

The last bastion of neo-classicism:
Panofsky's iconography

Finally, it must be stressed that the points concerning the optical primacy in the modern pictorial paradigm are not restricted to considerations of form, but also have far-reaching interpretative consequences. Inasmuch as the depth of field's flight towards infinity displaces focus from the body to its spatial surroundings,

and from supra-temporal presence to subjective observation, the centre of meaning is also displaced on several levels: from object-bound narrative to environmental translation; from the motif itself to the agencies through which this motif is captured; and from denotation to connotation.

To the story of the lengthy afterlife of the Renaissance, however, we must add that this interpretative strategy has also had problems finding favour in art scholarship dealing with the early modern image. For if the romantics came a long way in their formulation of an aesthetics of formlessness, this aesthetics continued to thrive alongside the antique notion of closed form. The idea lives on in the romantic notion of the *beautiful* – an entity which, unlike the chaos of the sublime, is characterised by limitation, well-defined outlines and clear surfaces, and which in its capacity as *ergon* can still be the bearer of conceptual meaning.[130] The extent to which this closed – and therefore continually antiquating – concept of beauty has actually held its own in relation to its amorphous companion, is not least apparent from its success in 20th-century art history, where it is elevated to a – albeit partly unacknowledged – cornerstone in Panofskian image interpretation (cf. also Interlude).[131]

In close agreement with art academy norms, Panofsky turns his iconographic searchlight on what he calls *images*, *stories* and *allegories* – visual forms charged with so-called *intelligible concepts*. If this has a Platonic ring it is by no means accidental, as the intelligibly-charged forms Panofsky calls for are precisely the closed *ergon* forms which are re-instituted with the Renaissance. Iconographic meaning is here welded together with the plastic body, whereas it evaporates in the infinite space beyond that body – the open space of genre, landscape and still life. Renaissance historian that he was, Panofsky had to make these genres, as mentioned, the exception in his master schema.

However, if the Renaissance and its academic offshoots are understood as a countercurrent in the epistemic *field* of modernity, then rule and exception change roles. Here the iconography-less genres are no longer to be understood as isolated meaning-deprived cracks in a space of otherwise iconography-dense bodies; rather they comprise specialised aspects of the modern pictorial vision – a vision which gradually reduces the domain of iconography to scattered condensations in the paradigm. Despite his sceptical attitude to the concept of realism and its connection with optical perception, Bryson supplies a precise semiotic analysis of this very circumstance.[132] What the "reality effect" supplies, according to Bryson, to the meaning determined by convention – the iconography or denotation – is a budding growth of particularities, which with their surplus information about physiognomy, atmosphere, light conditions, and so forth, trigger off a chain of connotations. Interested as he is in the Renaissance logocentric regime, Bryson

certainly considers the connotations to be agencies chiefly employed to make the denotation self-evident – "natural" – in that they seem to be revealed by perception rather than the socially-determined conception. But, nevertheless, he outlines the way in which they actually lead in the opposite direction: to the periphery of denotation, and thereby to Panofsky's displaced genres, in which meaning is multilateral and uncontrollable.[133]

Therefore, if Panofsky's method has reached a crisis point, this should not be attributed to a postmodern scepticism as regards a truly modern strategy; rather, it signifies the discovery of a classicist's problems with modernity.

Time, Territory and Wilderness
in Early Modern Landscape Images, I

Before the Paradigm Shift 1420

Introduction

FROM THE PREVIOUS TWO CHAPTERS, the following observations, *inter alia*, should now appear quite clearly: within the perspectival pictorial space of modernity, a boundlessness is released which not only bursts the shallow spatial depth of medieval pictorial art but also impedes the return of antique pictorial culture, the reawakening of the plastic-bound forms. It has been shown, moreover, that this expansion of space is structurally equivalent to a two-sided cosmological breach of boundaries: the Copernican world picture's transgression of geocentricity; and the geographical and colonial conquest of land areas beyond the European continent.

If we again compare these expansive movements with our fundamental mythological framework – the Golden Age and Paradise myth – we will recall (cf. chapters 4 and 8) that they correspond structurally with the spatial disruption that occurs during, respectively, the Fall and the fall to the Silver, Bronze and Iron Ages. In the post-paradisiacal world, humankind is no longer encircled by a womb-like garden nature, but is scattered to the winds in cultures which are compelled to make use of agriculture, territorial divisions, tree felling, mine-work, shipping and trade in order to procure the necessary – or superfluous – natural goods. This opening-up of the world was both pre-empted and displaced by the pre-modern epistemic *field*, the Golden Age *field*, inasmuch as this *field* nominated the substitute Paradise as its ideal society: the bipartite and yet closed social body with an unbroken lifeline between place of production and consumer, whereas the post-paradisiacal circulation of goods was encompassed by the antique horror-concept: infinity.

While I have so far illuminated the spatial expansions of modernity from mainly natural-philosophical and aesthetic angles – corresponding to the pole of

remoteness: world picture; and the pole of vantage point: self-consciousness – in this and the next chapter I shall demonstrate that these expansions also redeem the sociological dimensions of the Fall, the focus area of the middle distance. As Plato cautioned, the society that produces the new hyper-illusionist images is precisely a society that has submitted itself to the free market: from the 12th-15th centuries a proto-capitalist economy was developed in Europe, the proliferation of which can already be seen as a structural equivalent to the contemporaneous development of perspective and infinite universe alike. The sociology of the Fall is more specifically paralleled if we zoom in from the pole of remoteness to the middle distance of the image, for here the Golden Age paradigm's *terra*, the primordial virginal rocks, is displaced by a new combination: partly the 'Iron Age paradigm's' *territory*, civilisation's controlled terrain, which from plains to mountains is scored with controlling indicators such as roads, cornfields, fences, hedges, watercourses, bridges and mines; partly by a wilderness which has been left untouched, in a more radical sense than formerly, by human hand. The emergence of the cultivated part of this terrain in monumental art is dependent on a pervasive rehabilitation of an ethic of work – the one which, as Max Weber has demonstrated, is catalysed by capitalism.

As was the case in chapter 7, dealing with the medieval prelude to modernity, I shall also here deal with the last aspect to disband the Golden Age *field*: *time* and its pictorial traces in connection with work. For at the same time as the pictorial view admits cultivation of the landscape, it also allows for a viewing determined by the moment – a temporality manifested in weather, diurnal fluctuations and seasons. In the cultural practice – waged work – time is also interwoven with the notion of labour and it can be argued in general that time, in diametrical opposition to the understanding of classical antiquity, is a fundamental component in modernity's perception of existence: in changeability as the basic condition of life. Two phenomena from the complex of concepts applying to time and work, namely the *ruin* and *mine-work*, will however be left until chapter 12, when the gaze will sink below the landscape's newly-eroded soil – to its hard and in many ways still archaic foundation: the rock.

My examination of the thematic cluster of time, territory and wilderness will be divided into two chronologically separate chapters, because that which has its breakthrough in the overall landscape paradigm around 1420 was first introduced in contexts requiring specific thematic justification: labours of the months, health compendia, topographic studies, patriotic landscape portraits, and so forth. These iconographic currents, which eventually flow together in a paradigmatic high tide, are the subject, then, to be studied in this chapter.

10.1 Capitalism, work and pictorial space

The period that prepares the way for the new landscape paradigm of the 1420s is one of the most revolutionary in the evolution of Western culture. In the three centuries before the gaze is directed towards a cultivated landscape in painting, actual landscape is exposed to what today would be called an ecological rape. At the end of the 11th century the greater part of Europe was still covered with forest and marshland. It is estimated that in the Low Countries and Germany two-thirds of the land was uncultivated, in the British Isles four-fifths, in France half or more. But from the 11th century onwards, chiefly at the instigation of monastic orders such as the Benedictines and their offshoots, the Cluniac order and the Cistercians, large-scale clearance and drainage projects were started during which the greater part of the continent's wilderness was transformed into agricultural land. The old farm lands were extended; moors drained; plains irrigated; and, above all, vast tracts of forest were felled to make way for new ploughed fields with attendant villages.[1] During this transformation of nature, which had already reached its saturation point by the 14th century, many of the landscape contours laid down stayed intact until the 19th century. This terrain, structured around the cornfield, thus comprises the physical framework both for the modern epistemic *field* and its complementary pictorial paradigm – a paradigm that precisely exposes the intervention of work in the surface of the earth.

Environmental change was, on the face of it, determined by a population that doubled or tripled in the period from the beginning of the 11th to the middle of the 14th century – the infamous plagues of the time were possibly triggered by over-population and the consequent famine and deterioration in standards of sanitation. But as is always the case in cultural evolution, no change can be traced to a single cause, but interacts with a larger ensemble of transformations. Both the extension of arable land and the population explosion would accordingly be inconceivable without the concurrent technological and economic revolutions. The centuries following year 1000 see the development of technological innovations such as the three-field system, wheeled ploughs, spinning wheels, better carts, improved harnesses and, in particular, water- and windmills which, besides milling grain could also tan, full, irrigate, saw and produce the new underlay for writing and drawing: paper.[2] The economic historian Wilhelm Abel concludes that the 13th and 14th centuries witnessed Europe's first industrialisation: "The only analogous occasion was during the 'second industrialization' in the nineteenth century – admittedly on a very different scale."[3] The new technology and exploitation of water- and wind-power makes for a radically more effective relationship between work input and results achieved than was possible in antiquity. For that reason alone, the slave

labour which shored up antique society and was part of its theoretical justification would seem to be rendered superfluous.[4]

The technology therefore fits hand-in-glove with the other new development of the time, *capitalism*, which provides labourers and peasant farmers with the beginnings of economic freedom. Even though the feudal system continued to be widespread for a long time, by the end of the 12th century Europe already has an international economy with banks, financial loans and letters of credit. The word *capitale* emerges around year 1200 in Italy, the late medieval stronghold of capitalism, and by the 14th century the term is commonly used by many writers, such as Boccaccio, Giovanni Villani and Donato Velluti.[5] It is in this economy that the modern division between employer and wage earner is established. Even though the system of hiring labour is thus a child of the capitalist economy, we must still agree with Heitland that it would be inconceivable without the intervention of the Middle Ages, when labourers enjoyed an embryonic freedom.[6]

Despite their position at the bottom of society, even peasant farmers thus became players in this new market economy. Whereas previously they had only had dealings with the lord of the manor, whom they paid in kind and in service, they now also began to do business with the citizens in capitalism's new control centres, the cities. This leads to a reduction of the services paid in debt to the feudal lord and an increase of payment made by money, which gives the peasant farmers greater autonomy.[7] While regretting the continuation of serfdom, Eike von Repgow praises this new trend in *Spiegel der Sachsen* (c. 1220), the first German document to deal with the legal rights of peasant farmers.[8] Of the peasantry between the 12th and 14th centuries, F. Lütge even goes so far as to remark: "Its economic and social position had never been better, and would never be better thereafter."[9]

That it is worth mentioning these new economic and work-related developments in our nature-representational context is, firstly, because capitalism could be said to be structurally equivalent to the incipient perspectival image.[10] From the chief medium of antiquity, sculpture, to the medieval ditto, the icon, to modernity's perspectival depiction, the image could be said in Hegelian fashion to be increasingly incorporeal. At the same time as its representational space is extended from local surroundings (sculpture) across a flat middle distance (icon) to infinity (perspectival image), so the artistic material phases out any kind of magic or divine environmental trace, index, in favour of pure, abstract reference. If any index has been left in this final evolutionary phase, it is at most from the painting subject that deposits its gestural traces on the wood or canvas.

A similar separation between sign and reality can also be deciphered in the capitalist economy. While the purchasing power of money in the early Middle Ages was dependent on the metal value of the coins, the early days of capitalism saw the

introduction of trading in securities, with purchasing power solely dependent on the value to which they refer. In this respect, securities are just as devoid of value per se as the perspectival image is vis-à-vis environmental influence. And, like the image, this value shrinkage is dependent on increased depth of space, i.e. in the way that securities refer to goods circulating in what is theoretically an unlimited market.

Economic history and the modern image can, secondly, be linked together when viewed through a Max Weberian lens[11] – i.e. in the way that the emergence of capitalism acts as a catalyst for a new and more positive notion of work, at the same time as work and traces of work become worthy of depiction in late medieval images. Hegel and Kojève have already shown us how, during the early medieval foundation of the feudal system, the slave took over the master's leading role in the evolutionary drama, humankind's struggle for recognition, and how in consequence work became visible in societal ideology, *inter alia*, with its penance status in the monasteries (cf. chapter 7). This feudal development culminates at the end of the 11th century, when a number of writers regard society as divided into three groups: *oratores* (those who pray), *bellatores* (those who fight) and *laboratores* (those who work), and at the same time introduce the category *artes mechanicae* as a supplement to the *artes liberales* of antiquity, arts which were free because they were pursued without physical exertion.[12]

Having reached an appreciation of physical labour, however, yet another step is taken: the category 'work' is no longer limited to physical toil, but includes any kind of activity designed to enhance society. The Augustine provost Gerhoh of Reichersberg (d. 1169) states that "every profession [...] has a rule adapted to its character, and under this rule it is possible by striving properly to achieve the crown of glory." The anonymous *Libellus de Diversis Ordinibus* (*Booklet on Diverse Orders*) of the mid-12th century even protests against the special status of work in an interpretation of 2 Thessalonians 3: 10: "And let not him who works with his hands vaunt himself above the man who works seated, for there is labor in both."[13] As Max Weber has shown, this line of thought supposes that work is regarded as a vocation issued by God – a *Beruf*, *beroep* or *calling* first taken up within the monastery walls, but spreading out onto the streets via the *Devotio Moderna* movement and eventually becoming indistinguishable from a societal duty.[14] This development of work towards such a communal requirement is illustratively reflected in the new councils of free men, the communes, which dominate the Italian city states from the 11th to 14th century.[15] Etymologically, *comune* derives from *cum* (with) and *munus* (task), by means of which access to government is thus the communally imposed work. This practice again goes directly against classical philosophy, in which it is precisely freedom from work that makes the individual fit for administrative office, and which has no equivalent to the term *Beruf*.[16]

If we again make a comparison with the development of pictorial art, we will see that this reevaluation of work in early modernity finds a particular echo in the rapidly growing number of illustrations for the *labours of the months*. As I noted in chapter 7, the Carolingian period would seem to have afforded a breakthrough for this genre, as it was here that manuscripts apparently provided the first illustrations of active labours of the months since the 3rd-4th centuries. While miniatures continued to feature these active labours for the ensuing two centuries, they only did so sporadically and often as breakaway experiments in the dominant image type: standing personifications of the months, the only reference to work being via their attributes.

It is not until the 12th century that the calendar labours become dominant, but now with explosive diffusion. Besides privately commissioned manuscripts, where in a few instances the scenes might even involve several figures at a time (cf. *Queen Mary's Psalter*, London (?), c. 1310-20),[17] we come across the labours under public management on the new churches' portal reliefs, especially in France and Italy. The 12th-century reliefs in San Zeno Maggiore, Verona, show, for example, the following manual, predominantly agricultural activities: tree pruning (February), fruit picking (June), grain harvest (July), coopering (August), grape harvest (September), pig feeding (October), pig slaughter (November), tree felling (December). In addition, we notice a few illustrations away from work: a man warming himself by the fire (January), a bugler (March), a flower carrier (April), a warrior on horseback, with shield and spear (May).[18] Evidence of the labours of the months' connection to actual practice and also of their patriotic value can be found in their regional differences. The bugler and the cooper, for example, only appear in Italy, whereas Burgundy's speciality is wood gathering in October and November. Moreover, the further north we travel the later the harvest is scheduled.

To a more pronounced degree than in the 4th century and the Carolingian period, agricultural labours also spread beyond the context of the calendar. As Michael Camille has shown in a searching socio-historical study, they appear, for example, in the margins and decorated initials of psalters and books of hours. A particularly spectacular instance is the *Luttrell Psalter* (c. 1320-45), an English commission by Sir Geoffrey Luttrell, in which grain-growing sequences from tilling to harvest form part of a wider spectrum of border scenes of everyday life.[19] Although these margin decorations are often prompted by single words in the psalm texts, they are characterised by the mendicant friars' wider application of the psalms, where work, especially agricultural work, is advocated as the path to redemption.[20] And yet, by being displaced to the margins, the images reflect an attempt to reinforce the feudal hierarchy – a reinforcement that felt urgent in England at the time, with famine and agrarian crises leading to the first peasant risings of the Late Middle Ages.[21]

10.2 Sienese beginnings

Trial run for the modern landscape image: Ambrogio Lorenzetti's portrait of Siena

For the first few decades of the 14th century, the depiction of landscape as such remains impervious to these iconographic innovations, which are predominately exercised in contained, niche-like pictorial spaces. This changes dramatically in what could be called the trial run for the 15th-century landscape image: Ambrogio Lorenzetti's fresco decoration of Sala della Pace (also known as Sala dei Nove) in Siena's Palazzo Pubblico (1337-40).

Here the calendar labours have become ingredients in a hitherto unseen panoramic view (**PLATE 13**).[22] Rather than, as is usual in medieval art, looking towards a fictive or mythical landscape, in the *Effects of Good Government in the City and Countryside* we are confronted with a landscape in its first late medieval sense as a geographical region regulated by certain laws and customs: namely, the republic of Siena and its rural territory. The setting forms part of a double allegory which, through the three hall walls without windows, juxtaposes good and bad government and their effects on the city and the countryside. At the time of the commission, the hall served as the meeting place for *I Nove*, Siena's oligarchic nine-man council composed of members from the most influential families, and it is therefore probable that the decoration was designed to remind them of their duties as regards the common good as well as to warn them against the harmful effects brought about by administrative corruption: decline into the tyrannical form of government with which the communes were in competition. To this end, the artist and his advisors have compiled an encyclopaedically wide-ranging allegory of the moral-political ideas of the time, including fragments from Brunetto Latini, Aristotle and his exegete Thomas Aquinas, besides presumably local legal texts.[23]

The warning image, the *Bad Government*, on the west wall takes up the least space, but on the other hand it catches the observer's attention immediately upon entering the hall (originally by the window). The allegorical part comprises a devil-like tyrant surrounded by vices (**FIG. 10.1A**). However worldly the context and aim might be, the horns, plaited locks and golden cup point in the direction of Babylon, the mother of harlots (Book of Revelation 17: 3-4), so perhaps the tyrant's regime is made up of a social inferno à la Albertus Magnus' Babylon, where no one could find employment and where, in consequence, everything disintegrated. Lorenzetti's only active participants are the weaponsmith making arms and the warriors plundering and raping while the buildings fall into decay (**FIG. 10.1B**). And in the countryside, the farms that have not already been destroyed are burnt

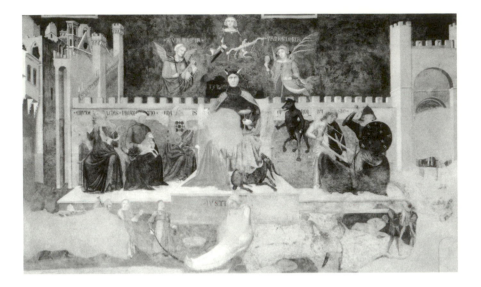

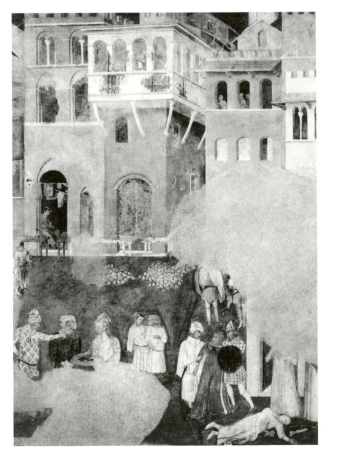

Fig. 10.1a. Ambrogio Lorenzetti, *Allegory of Bad Government* (1337-40), fresco. Siena, Palazzo Pubblico, Sala della Pace.

Fig. 10.1b. Ambrogio Lorenzetti, *Effects of Bad Government in the City* (1337-40), fresco (section). Siena, Palazzo Pubblico, Sala della Pace.

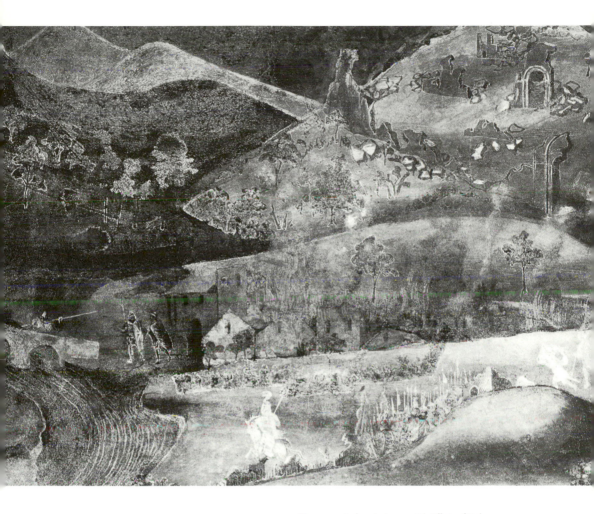

Fig. 10.1c. Ambrogio Lorenzetti, *Effects of Bad Government in the Countryside* (1337-40), fresco (section). Siena, Palazzo Pubblico, Sala della Pace.

to the ground (**FIG. 10.1C**), while *Fear* (*Timor*), an old woman clad in rags, hovers beyond the city walls.

At the other end of the scale, the *Good Government* of the north and east walls, Siena's democratic *comune*, can be seen as an earthly counterpart to the New Jerusalem. The *Comune* itself, a man holding sceptre and shield, is attended by the Christian virtues of *Faith, Hope* and *Charity* above his head, and is flanked by various civic virtues (**FIG. 10.1D**). *Justice*, an enthroned female figure further to the left, has *Wisdom* above her and is flanked by a Thomistic pair of concepts: the *Exchanging*

Fig. 10.1d. Ambrogio Lorenzetti, *Allegory of Good Government* (1337-40), fresco. Siena, Palazzo Pubblico, Sala della Pace.

Fig. 10.1e. *Allegory of Winter* (1337-40), fresco (section). Siena, Palazzo Pubblico, Sala della Pace.

Justice (*Comutativa*), who is handing out (and receiving?) two spears and an unidenti-
fied object (a money chest?), and the *Distributing Justice* (*Distributiva*), who is crowning
a kneeling figure with her left hand while beheading another figure with her right
hand.[24] Under *Justice*'s throne, the republic's Consiglio Grande is lead by *Concord*
(*Concordia*), whose thread goes from hand to hand throughout the assembly. These
and other ingeniously devised figures emphasise the way in which earthly govern-
ment has to be regulated by superior principles – the constitutional beginnings of
the subsequent nation states.

The fruits of the commercial republic, especially the newly-rehabilitated *artes
mechanicae*, are displayed on the third, east wall (PLATE 13). From the city with its
buildings, construction workers, zebra-striped cathedral, school, taverns, workshops,
wedding procession, dancing women and peasants on their way to and from market,
the eye is led through the city gate and out into the widespread *contado*. As a sign
of the new interaction between city and country, the steep road up to the city gate
is very crowded. Heading for market, peasants hurry along with their wares, pack
mules and even a dressed boar. Heading in the opposite direction, affluent nobles
(or citizens?) on horseback are riding off to hunt with falcons, an activity underway
in the stubble fields further down. As if to indicate the potential for conflict in the
city-dwellers' encounter with the countryside, hunters armed with crossbows are
similarly busying themselves among the vines outside the city gate while a farmer
looks on (in resignation?).

The overriding characteristic of the Sienese hinterland, however, is coopera-
tive harmony. While the most distant hills in the left background are covered by
a mosaic of hedged-in vineyards and, further out, by olive groves, the valley area
in the middle is taken over by cereal culture. Farmers till, sow, harvest and thrash.
All these activities, which in actuality are spread throughout most of the year, are
here scheduled to spring and summer, the personifications of which embellish
the border above *Good Government*. Conversely, the opposite border – above *Bad
Government* – has to settle for *Autumn* and *Winter* (FIG. 10.IE).[25] All in all, many of
the activities shown in the pictorial panorama of the frescoes can be seen as a way
of bringing out the medallions on the borders which, besides the seasons, depict
planets, liberal arts and, in the case of *Bad Government*, infamous emperors such as
Nero and Caracalla – predecessors of the contemporaneous despots ruling the city
states. However, the republican landscape panorama also has its tyrannical traces:
when one tributary of the most remote winding river flows into a bay guarded by
a citadel, it is a reference, confirmed by an inscription, to Siena's ambitious new
port, Talamone, annexed to the republic in 1303. Talamone could, of course, not
be seen from the Siena of reality, but is included because of its patriotic-militant
significance.

The activities in the Sienese *contado* are not taking place at a particular point in time. Rather, they are representative of a stable and peaceful *everyday life* at a distance from narrative happenings. In order to maintain this work-dependent stability, they have been allocated *Securitas* as their tutelary spirit. The beautiful, semi-naked, winged woman airborne above the city gate is holding out a banner on which we read: "Without fear every man can travel freely, and all can till and sow, as long as this commune keeps this Lady (*Justice*) sovereign, for she has stripped the evil ones of all power." And *Securitas* means business, because in her left hand she is holding a gallows from which a troublemaker dangles. This form of modern idyll with its security, work and steady everyday life is also the model later celebrated in a ballad by the French court poet Eustache Deschamps (1346-1406):

> I only ask of God to give me
> That I may serve and praise him in this world,
> Live for myself, my coat or doublet whole,
> One horse to carry my labour,
> And that I may govern my estate
> In mediocre style, in grace, without envy,
> Without having too much and without begging my bread,
> For this day is the safest life.[26]

That this message is a typical representative of the 14th-century work ethic is corroborated by its reappearance in the English *Piers Plowman*, William Langland's series of dream visions written in 1378-79. This socially critical poem is innovative in that the hero of the piece is not a knight or a saint, but a ploughman, and the saintly deed again consists of stable, humble toil:

> Truth's command to Piers was to stay at home and plough his fallow lands. And
> to everyone who made any useful contribution to his work, helping him to plough,
> plant, or sow, Truth granted pardon along with Piers Plowman.[27]

An overall evaluation of Lorenzetti's landscape image leads to the conclusion that it is located at a midpoint between old and new. The sky remains, in medieval fashion, lapis lazuli blue and smooth; the ground is rocky-grey and, at the river, still ruptures into the abyss of the Byzantine terraced rocks. And yet the theme – the portrait of the enterprising republic – sees to it that the mountains are eroded to rounded hills and a valley that is amenable to yellow cornfields, ploughed furrows, rows of vines, hedges, bridges, forests, not to mention paved roads. These zones no longer see a quantum-like leap from rock to vegetation, but evoke a sense of the softened earth

that can organically connect the underground to its growing offspring. Moreover, the plant life is painted with light, sketchy strokes which abandon the medieval focus on individual leaves in favour of an optical overview, a Rieglian distant sight. As a consequence of this same distant sight, the gaze is now finally allowed to venture further out into the space than the atmosphere-less sky would seem to motivate. In a panoramic vista, which has quite a lot in common with Petrarch's only slightly earlier view from Mont Ventoux and which anticipates Jan van Eyck and the 16th-century world landscapes, the gaze is lead across vineyards, rivers and bays to a wilderness with series of hills, scattered trees, occasional castles and a dense forest in the dip of a valley.

As Uta Feldges so rightly observes, without the specific republican commission it would not have been conceivable "that Ambrogio could break with a thousand-year-old tradition of rock landscapes and, in the sense of a modern concept of genius, independently develop wholly new forms."[28] At the same time, however, the didactic and moral aim of the work – corresponding to the oldest sense of the landscape concept – by no means precludes the admission of a more general natural beauty. The land that yields the harvest is also the land on which the aristocracy (or the bourgeoisie?) hunt for pleasure and go for outings. To these social classes, the land with its panoramic expanses is something other and more than simply utilitarian terrain. It becomes landscape in the picturesque sense. Furthermore, we noted that the work, despite the allegorical meaning of individual episodes, has no unifying narrative because it is depicting the new collective phenomenon: everyday life. The landscape panorama is able to display its vast – and beautiful – expanse precisely because there is no story to undermine. We are thus witnessing the birth of *description* in a landscape that is almost autonomous – not a landscape serving as background for figures, but a landscape in which figures can appear and disappear.

Portrait of conquest:
Simone Martini's Guidoriccio da Fogliano

The portrait of *ager senensis* is part of a large sequence of images dealing with Siena's land possessions. Like other Italian communes, Siena was keen to acquire land so as to ensure economic and political autonomy for the republic, and in the 13th-14th centuries not only had neighbouring communes such as Grosseto, Massa Marittima and Montalcino been conquered but also strongholds and land owned by local noble families, the Aldobrandeschi's town of Montemassi, for example.

The degree of pride in these conquests is apparent from a document of March 12 1315 in which it is stated that the Consiglio Grande proposes that all hitherto and future conquests made by the republic should be depicted in Palazzo Pubblico.

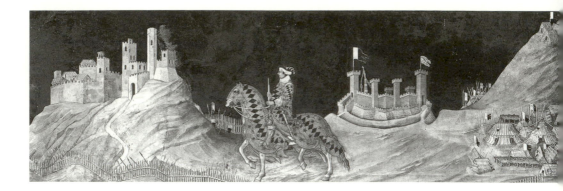

Fig. 10.2. Simone Martini, *Guidoriccio da Fogliano*

(1328), fresco. Siena, Palazzo Pubblico.

According to this document – the earliest extant evidence of a policy devised by political leaders to illustrate their land possessions – a number of conquered citadels had already been depicted and the cycle was to be continued with the citadel of Giuncarico, captured in 1314. Perhaps this is the fenced fortification featured in Memmo di Filippuccio's fresco, uncovered in 1977, on the west wall of Sala del Consiglio.[29]

The project certainly continued in 1330-31 as we know that Simone Martini depicted the four castles of Arcidosso, Castel del Piano, Sassoforte and Montemassi. That he approached the assignment with topographic accuracy was already obvious from a written record of payment dated September 6 1331, in which it is certified that "Simone, painter" on horseback and accompanied by a servant had visited Arcidosso and Castel del Piano (plus Scansano).[30] In the only extant representation from this cycle, the commander Guidoriccio da Fogliano seen against the background of his conquest, the castle of Montemassi, the actual contours of the landscape are thus mirrored in the fresco's two hilltops (**FIGS. 10.2-10.2A**). Besides the city on the hilltop to the left, Simone has also depicted the renowned *battifolle*, the stronghold built by the Sienese during the eight-month siege in 1328, and furthermore: two-three military tent camps, two small fenced vineyards, a sharply defined road winding down from the Aldobrandeschi family's town, and a long fence against which leans a row of spears.

As a consequence of the demands of territory portraiture, we therefore here see the insertion of terrain-dividing elements which are otherwise alien to medieval art. The road and vineyards provide a more general indication of the surveyed landscape, whereas the fence is specific evidence of military purposes. *Ager senensis*

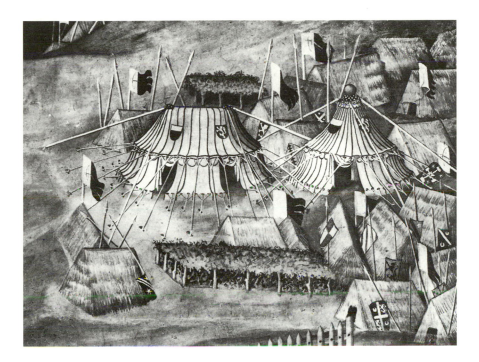

Fig. 10.2a. Detail of
Guidoriccio da Fogliano, fig. 10.2.

and the Montemassi portrait could thus be said to approach the depiction of territory from two different angles: the first deriving from the civic and work-related sphere familiar from the labours of the months; the second originating in the imperialist sphere with forerunners in the Neo-Assyrian and Late Roman reliefs. The two spheres are, however, closely connected, with patriotism and control of land as common denominators. Nevertheless, the extensive rocks in the Montemassi image seem strangely bare, as if the traditional forms are exposed unexpectedly in the glaring topographic light. Unlike Lorenzetti, but similar to the Neo-Assyrian reliefs, the military angle thus fails to get to grips with the ground itself and fill it with a latticework of fields.[31]

Considering the Sienese patriotic fascination with themselves and their conquests, it would seem only logical that they would eventually lift their gaze to a bird's-eye perspective and declare the little Tuscan republic the centre of the world. This occurred in 1345 in a now vanished circular world map on wood placed below the Guidoriccio da Fogliano portrait and above Memmo di Filippuccio's aforementioned fresco. If we are to believe testimony from 17th-18th-century sources,

Ambrogio Lorenzetti built this *mappamondo* upon concepts of the New Jerusalem as he placed Siena with accompanying fortresses and territory at the spot where the Christian world's primordial city otherwise nailed the terrestrial disc.[32] A completely legitimate gesture, taking into consideration the fact that Paradise in modernity's void can be located wherever might be so desired. For is the centre of the world not everywhere and nowhere?

10.3 Landscape-promoting themes

Time

In tandem with Petrarch climbing his mountain, the scholastics puzzling over *impetus*, spatial relativity and infinity, and Lorenzetti and Martini unveiling their vistas of the distant hills around Siena, a striking transformation of the *concept of time* was taking place. The transformation corresponds to and qualifies the new space, for in the same way as space is measured out with a subjective yardstick, time is now also measured out independently of the event. To the question "does time exist outside the mind?" the scholastic Pierre Auriol responds that time is nothing but "a being in the mind (i.e., a concept)". And Ockham, the Franciscan nominalist, is of the opinion that Aristotle's definition of time as "the number of motion" is not a "definition according to the thing" but a "definition according to the name".[33]

This nominalist concept of time leads to the modern historical sense of placing events in relation to one another and to epochal thinking – which, in brief, introduces a temporal perspective analogous to the spatial. In Spengler's words, "[w]ithout exact time measurement, without a *chronology of becoming* to correspond with his imperative need of archaeology (the preservation, excavation and collection of *things-become*), Western man is unthinkable."[34]

The groundwork for this temporal transformation had been prepared, as we saw in chapter 7, all the way through the Middle Ages. The carefully measured-out temporal rhythm cultivated as the ideal in monasteries and convents could therefore be absorbed by the enterprising city of the Late Middle Ages, not just in the case of the liturgy, but also where work was concerned.[35] *None*, the middle of the day, which was first set at two o'clock and later at midday (hence: *noon*), for example, divides the working day into two parts. There are numerous reports from 14th-century France providing evidence of workers who wanted the working day to be divided into such well-defined intervals, resulting in a fixed correlation between payment and hours worked. This demand is again connected to work as a common calling, an abstract activity detached from the products generated.

Parallel with the more rigorous work rhythm was a need for an improved method of time measurement. Work, liturgy, defence and administration were first rung in by metal bells, later, from the end of the 13th century, also by mechanical clocks. In the same way as modernity's infinite space was captured through the eye-glass, the perspectograph, the camera obscura and the mirror, so the new time was also allotted its own instrument.[36] A report of August 15 1335 states that in Aire-sur-la-Lys a special bell had been constructed as a result of the "cloth trade and other trades which require several workers each day to go and come to work at certain hours [...]".[37] Time spent working became part of an all-encompassing everyday time, which also included the liturgy, for the work clock could be painlessly installed in churches, as in, for example, York Minster between 1352 and 1370. Everyday time could also be State time, as in the Paris of 1370 when Charles V declared that all clocks should be set by the clock in the Palais Royal which struck every quarter.

Ultimately, time was not merely a common necessity, but a treasure that ennobled the individual. Bernhard of Clairvaux (1090-1153) had already declared: "Nothing is more precious than time".[38] In *Disciplina degli spirituali*, the Dominican Domenico Cavalca (d. 1342) deals with measuring, wasting and saving time, and the time-waster is avowed to be at a lower developmental stage than animals. The humanists were pioneers in the utilisation of time, and in the second half of the 14th century the Florentine humanists insisted on a clock in every workroom. In *Libri della famiglia* (1437-38), Alberti is able to declare that humankind has three possessions: destiny, body and time; and he advises: "never waste a single hour of time."[39] This line of thought also informs Lorenzetti's cycle: among the virtues surrounding the *Comune*, *Moderation* is symbolised by a woman holding an hourglass (FIG. 10.1D).

Against the background of this obsession with time, which increasingly marks the epistemic *field*, it is therefore no wonder that time and its synonym *weather* also make their presence felt in pictorial art – albeit these themes, like their frequent companion, work, must provisionally be limited to the heightened situations of iconography. Ghiberti refers to, for example, Ambrogio Lorenzetti's spectacular weather phenomena in his aforementioned frescoes in San Francesco (see chapter 9): following the decapitation of the martyrs, "a turbulence of dark weather stirs, with much hail, lightening, thunder, and earthquakes. It seems, to see it painted, that it endangers the sky and the earth [...]."[40] The weather effects in Ghiberti's *ekphrasis* are in all probability not exaggerated, given that Sala della Pace's personification of *Winter* comprises a man standing with a snowball in his hand while the snow pelts down around him and forms a white layer on his shoulder (FIG. 10.1E); and Ambrogio's *Allegory of Redemption* shows a sky that has turned partially grey-blue as darkness descends upon the crucifixion of Christ (FIG. 10.3).[41] Ambrogio's brother, Pietro, is also open to the new sense of time, for in his *Last Supper* (1330s?; FIG. 10.4)

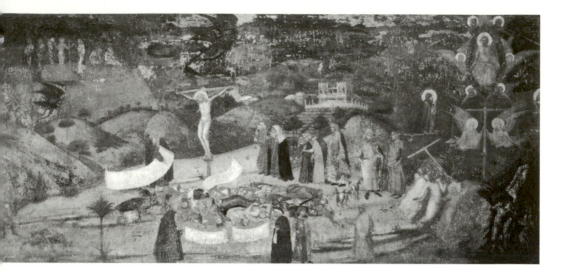

Fig. 10.3. Ambrogio Lorenzetti, *Allegory of Redemption* (1330s), tempera on wood. Siena, Pinacoteca Nazionale.

in the Lower Church, Assisi, we see what is possibly the first European pictorial night sky since the late 4th-century Vatican Virgil. Against the backdrop of a dark-blue plane with crescent moon, stars and a shooting star, the interior seems almost to be illuminated by the flames in the fireplace to the left, albeit no shadows are cast.

Light effects in contrast to actual darkness are, however, to be encountered in Florence of the period. In Taddeo Gaddi's *Annunciation to the Shepherds* in Santa Croce's Baroncelli Chapel (1332-38), the announcing angel is revealed in an illusionistic halo, a luminous cloud (**PLATE 31**).[42] The middle of the cloud behind the angel emits so strong a radiance that it casts golden light onto the rocks, shepherds, trees and sheep, and one of the shepherds has to use his right hand to shade his eyes against the light. The depiction is sited at a crossroads between supernatural and ominous natural light. Precisely which dangers this new light, modernity's cast light, might activate – from immodest curiosity to blindness – we learn from an exchange of letters between the painter and his friend, the Augustinian preacher Fra Simone Fidati. That Fra Simone considered it worth keeping the correspondence is presumably due to its educative potential – a potential that is on a par with Petrarch's almost contemporaneous letter to another Augustinian monk, Dionigi da San Sepolcro, after the momentous mountain ascent in 1336 (cf. chapter 8).

What Taddeo has been improperly attracted by is, however, not a downward

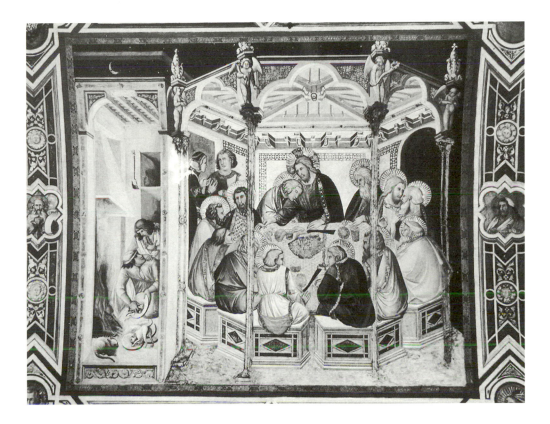

Fig. 10.4. Pietro Lorenzetti,
Last Supper (1330s?), fresco. Assisi,
San Francesco, Lower Church.

view, but an upward view, namely a *solar eclipse*. Presumably it was the solar eclipse
of May 14 1333 that motivated Taddeo's radiant halo, given that during a later solar
eclipse on July 7 1339, shortly after completion of the fresco cycle, he stares at the
sun until half blind. As he laments in his letter to Fra Simone in Rome, this act of
folly has clouded his eyes and given him problems with his vision, plunging him
into the deepest abyss of melancholy. Rather than strengthening his inner eye,
the disability has darkened everything. Would it not be possible for his friend to
intercede on his behalf and send him a few words of comfort?

The reply, written by Fra Simone on New Year's Day 1340, covers the whole
spectrum of regrets we remember from Petrarch and his re-reading of Augustine's
Confessions:

You should have looked upon that eclipse which removed the eclipse of the human race, [i.e. the eclipse during the crucifixion of Christ] and which would then have cleared your eyes and sharpened the sight of your intellect. But you have suffered a total eclipse because you looked at the failure of the sun's light not only rashly but with curiosity [...]. For curiosity never leaves her author unavenged, so that the kind of pain with which you must be punished may make the point for you, since you presume to look so rashly upon what it is not permitted to desire [...]. Your eyes are weakened because you looked surmisingly into the heavens; yea, they are affected and darkened because you lifted your face with pride toward the heights, not toward your Creator and not to praise His majesty or the wonders He has made, but so that you might understand those things which there is no usefulness in knowing.[43]

Taddeo's sight has thus been clouded by the solar eclipse because he has repeated the cardinal sin of Adam and Eve: curiosity. Rather than looking with an eye to intellectual purification – looking toward God and the solar eclipse that redeemed humankind during the crucifixion of Christ – he has, like Petrarch on Mont Ventoux, looked with covetousness at forbidden matters in the heights.

It would therefore be an obvious assumption to read the shepherd in the Baroncelli Chapel as being the artist's alter ego, covetously directing his gaze toward naturalism's new, incisive light as it breaks through behind the angel's body like a veritable corona, but also having to raise his hand and shade his eyes against the light since this recognition is still too dazzling. The gaze towards the world's cast light cannot happen until the eye is understood as analogous to the camera obscura, an instrument that was indeed often used in the Late Middle Ages to view solar eclipses. Through this artificial eye the bedazzling look towards the insufficiently shaded fire in front of Plato's cave is displaced to an optical dialectic in which image formation is, in a more modern manner, *mediated* – from the dazzling cave opening to the projection against the dark back wall of the camera.

And yet, the solar eclipse motif in its most ominous connotations is resurrected in Andrea Orcagna's now fragmented *Triumph of Death* (1340s; **FIG. 10.5**) in the same church. The black ball above the deep darkness, as seen on this fragment of the fresco, is now among the signs presaging the Second Coming of Christ and the Last Judgement. Again, two men are seen looking towards the ball, right hands shading their eyes, while a third man bends away in pain, a hand to his eye – presumably another reference to Taddeo's experience. The sinners to be punished at the Last Judgement will quite evidently include those whose curiosity has led them to be attracted by the celestial light.

In fact, the contemporaneous solar eclipses were considered to be just such ominous signs. In Florence, both eclipses were followed by fierce storms and flooding,

Fig. 10.5. Andrea Orcagna,
Solar Eclipse (1340s), fresco,
fragment from the *Triumph*
of Death. Florence, Museo
dell'Opera di Santa Croce.

and with reference to the second eclipse, the Florentine merchant and historian Giovanni Villani wrote in his *Cronaca* (*c.* 1300-48):

> All these things were signs of future evils for our city, such as followed soon after-
> wards. As the ancient experts in astrology have written, every obscuration of the sun
> in Cancer, which takes place once in about a hundred years [such was the solar eclipse
> of July 1339], is of great significance with regard to evils to come in this century.[44]

Considering the forecasting reputation of the solar eclipses and the sinful associa-tions of gazing at them, it is remarkable that the new naturalistic developments in art are actually temporarily curbed by reality's equivalent of the Last Judgement: the Black Death in 1348.[45] It is as if the entire epistemic *field* of the early 14th century ascends towards an evolutionary culmination, but the pressure becomes too intense and it therefore ruptures in overpopulation, plague and accompanying cultural regression. Out of chaos, however, the fluctuation pattern rises again, refreshed, and now with such high evolutionary potential that it, *inter alia*, makes its mark in the new image paradigm around 1420.

Fig. 10.6. Jean Pucelle,
December (c. 1323-26), miniature
from the *Belleville Breviary*.
Paris, Bibliothèque Nationale,
ms lat. 10483.

Another forum in which passage of time found expression via landscape images was that of calendar scenes in the *book of hours*. The specifically private successor to the *breviary*, this genre developed at the beginning of the 14th century as an appendix to the psalter. Like the breviary, a book of hours contains the *horae canonicae*, the canonical offices consisting of eight daily prayers as instituted by Saint Benedict in the 6th century, but while the breviary is, at least in principle, designed for ecclesiastical use, the book of hours becomes an important status symbol for the aristocratic laity.[46] The weather is almost physically tangible in Jean Pucelle's *Belleville Breviary*, a book of hours painted between 1323 and 1326, possibly for Jeanne de Belleville. Although *December* is the only month illustration to have survived, the original design of the series can be reasonably well reconstructed from later books of hours such as the *Hours of Jeanne II de Navarre*, executed at the Pucelle workshop, 1336-49, and Jacquemart de Hesdin's *Petites Heures du Duc de Berry* of c. 1380-85. However, the *December* scene (**FIG. 10.6**) in the *Belleville Breviary* is atypical in that it

Fig. 10.7. Workshop of Jean Pucelle,
February (1336-49), miniature from the *Hours
of Jeanne II de Navarre*. Paris, Bibliothèque
Nationale, ms nouv. acq. lat. 3145.

Fig. 10.8. Workshop of Jean Pucelle,
March (1336-49), miniature from the *Hours
of Jeanne II de Navarre*. Paris, Bibliothèque
Nationale, ms nouv. acq. lat. 3145.

shows the bare winter trees in the company of their user, a forest worker, whereas
the other months were apparently illustrated by means of autonomous landscape
vignettes, which do not even refer consistently to the labours of the months: bare
trees in *January*, rainfall on trees and land in *February* (FIG. 10.7), budding branches
in *March* (FIG. 10.8), flowers in *May*, a ripe cornfield in *July*, falling leaves in *October*,
hogs finding acorns in *November*. Moreover, the progression of the year is followed
by the yellow sphere of the sun moving along the bordering arch, the symbol of the
firmament.[47] The book of hours is indeed, as we will soon see, one of the warmest
incubators for the hatching of the modern landscape paradigm.

Topography

Topography is closely linked with landscape. Both concepts converge on the idea of
viewing a specific place at a specific time. But while the landscape image can raise
a purely fictive place, the topographic depiction is always obligated to geography.
This obligation means that a topographical portrait of nature does not need to
have 'landscape' qualities even though it is always, by definition, a landscape image.

Topographic portraits, just like the category of which they are a specific case,
the spatial landscape image, are also part of the new formations of the Late Middle
Ages. In the Early Middle Ages an image can well visualise the contours of named,
usually Biblical, places: for example, Paradise, Hell, Babylon, Zion, Calvary, Bethle-
hem or the New Jerusalem. But if these places have actual rather than just mythical
existence, they are depicted with features that refer only vaguely or not at all to their

Fig. 10.9. Isidore of Seville's world map (7th century), miniature from an 11th-century manuscript. Munich, Bayerische Staatsbibliothek, ms Clm. 10058, f. 154v.

optical appearance. If seeking precursors of architectural and landscape topography, we should rather look at the *cartographic* tradition. Maps were so rare in the Middle Ages that there was no specific word for them; a map was either called "diagram" or "picture".[48] The schism is distinctive because, like their antique forerunners, medieval maps could be said to span two types of vision: mapping gaze and panoramic gaze. As we have seen in chapters 1 and 4, the mapping gaze only catches spatial displacements in the horizontal plane – for example, river channels and coastlines. Displacements taking an up-down direction, particularly mountains and buildings, are attended to by the panoramic gaze, but now in profile or at most a slight perspective. As a consequence of this rupture in viewpoint, they are put into the map without any tangible connection to the ground, which is thereby cleared of its customary materiality. An 11th-century copy of Isidore of Seville's 7th-century world map shows the buildings and mountains spread out like flat pieces placed on the light-coloured continents around the Mediterranean, the centre of the world map (**FIG. 10.9**). Only the tops of the mountains are given illusionist profiles, while they are cut off at the base by linear segments.

Fig. 10.10. Andrea da Firenze, *Triumph of the Church* (*c.* 1365-67), fresco. Florence, Santa Maria Novella, Cappella degli Spagnuoli.

Maps like this, either of the world or specific locations such as the St Gall monastery (**FIG. 8.16**), would seem to be the most important medieval medium for the storage of topographic data in visual form. In order to create a topographic portrait seen from a pictorial view, it is thus necessary in a very concrete sense to zoom in on selected map details and isolate them in spatial images. An image such as the Guidoriccio portrait has not quite reached this point because, like the medieval maps, the topographic portraiture is only accounted for by the mountain profiles.

With its well-defined form, architecture would seem to be a more tangible indicator of place than the mere terrain profile. In any case, the architectural portrait would seem to have been common at an earlier stage than the terrain portrait as seen in the work of Simone Martini and Lorenzetti. When city plans, the Roman in particular, become more pictorially precise,[49] fragments of them also appear outside the maps themselves: for example, in the work of Cimabue in Assisi. A section of a pendentive in the Upper Basilica of San Francesco d'Assisi shows a city view, *Ytalia* (*c.* 1280-90), with Roman monuments such as Torre delle Milizie, the Pantheon, Pyramid of Cestius and Castel Sant'Angelo. Up until the mid-15th century, however, such precise topographic motifs remain a comparative rarity.[50] Besides the Rome iconography, which is the most widespread type, other examples are: Andrea da Firenze's portrait of Florence Cathedral (*c.* 1365-67; **FIG. 10.10**); Simone Martini's alleged portrait

of Siena's Duomo and Campanile on the façade of the Opera del Duomo;[51] and the Avignon cartographer Opicinius de Canistris' drawing of Pavia Cathedral (c. 1330).[52]

Among the many motivations behind the creation of such portraits, an important one is undoubtedly emerging nationalism, including the specific Italian variety, the Renaissance. To visualise *Ytalia* in a Christian fresco cycle, as Cimabue does, is patriotism, and to do so with a portrait of Rome that focusses on the monuments of antiquity (Torre delle Milizie was considered to be antique right up until the 15th century) is to give patriotism the attributes of renaissance. It is also patriotism, just of a local brand, when Andrea da Firenze paints Santa Maria del Fiore, when Martini paints Montemassi and when Lorenzetti paints the enterprising Sienese hinterland. The latter examples are illustrative because they show the connection between patriotism and ownership. The topographic portrait is here the picture of the national possessions, not *terra* (as was still the antique *topos* image) but *territory*. And yet, Lorenzetti is already beginning to turn possession into longing, to convert the conquered into the coveted, if not unattainable; in brief, turning the landscape from its original territorial to its later picturesque sense. This ambivalence, making that which is familiar unfamiliar and that which is alien known, turning the domestic exotic and the exotic domestic, is deeply embedded in the topographic – and altogether the modern – gaze.

The encyclopaedic tradition, I: landscape images in mirabilia collections and encyclopaedias

The topographic portrayals border on a broader medieval trend for proto-landscape images, identified by Walter Cahn in a brief, groundbreaking essay as "the encyclopedic tradition".[53] The material going by this term in the medieval literature is a heterogeneous, partially antiquity-derived corpus stretching from large moralising syntheses to straightforward accounts and descriptions of selected subjects – clarifying notes on the Creation as presented in Genesis. From my point of view, particular attention should be paid to the descriptive tendency which itemises properties of the world's phenomena independently of stories constructed via a narrative because, in a way that leads the thoughts to Alpers' later descriptive category, it is precisely here that the setting emerges for landscape illustrations, framed sections of distinctive spaces.

At the more fantastical end of the spectrum, the *mirabilia* tradition, it should be mentioned by way of example, that the earliest known illuminated version of *Marvels of the East*, an English manuscript from *c.* 1025-50, not only contains images of monstrous creatures but also a figureless landscape square illustrating a miraculous balsam tree, which is one of four references to fantastical trees and plants.

Fig. 10.11. *Balsa Trees*
(*c.* 1025-50 (?)), miniature from
Marvels of the East. London,
British Library, ms Cotton
Tiberius B.V, f. 83.

Prompted by the text "In this place [*in hoc loco*] trees grow which resemble laurel and olive trees" the artist has painted in a rocky knoll with three large-leafed trees of such potent fertility that they transcend the frame (**FIG. 10.11**).

However, the encyclopaedia par excellence that can be linked with landscape images is the widely circulated *De proprietatibus rerum* (*On the Properties of Things*), a Parisian work executed by the Franciscan Bartholomeus Anglicus around 1225-50. Of the 19 books of the manuscript, the following occasion later landscape illustrations: matter and form (10), birds (12), the earth (14), areas of the world (15), precious stones and metals (16), trees and plants (17), plus the various species of animal (18). In the illustrations, of which the earliest extant example is from around 1400, but which were presumably begun with Jean Corbechon's 1372 French translation for Charles V, the illuminators were evidently guided by just one of the main sources for the text, the foremost encyclopaedia of the early medieval period, Isidore of Seville's *Etymologiae* (7th century); in at least one 12th-century version of this encyclopaedia there are initials embellished with simple landscape vignettes: for example, a tree-clad rock to illustrate *De montibus* and a stronghold for *De civitatibus*. In the Jena University Library copy of *Livre des Propriétés des Choses*, these initials are now transformed into autonomous squares with more emphatically spatial views. Particularly in the

Fig. 10.12. *Areas of the World ("Pays")* (c. 1400),
miniature from Bartholomeus Angelicus' *Livre des
Propriétés des Choses* (originally Paris, c. 1225-50).
Jena, Universitätsbibliothek, ms El. f. 80, f. 217v.

miniature accompanying the section on the areas of the world, *pays* would seem to
be undergoing a mutation into its successor, *paysage*; for we are here located above a
panoramic rocky terrain where a premature billowing cloud frieze forms the back-
drop for cities, castles, churches and even a windmill and a watermill, the fruits of
the late medieval 'little industrial revolution' (**FIG. 10.12**). In Cahn's words, what we
have here is "not a raw slice of geography but a piece of nature that has been socially
invested and structured in particular ways by implicit human agents"[54] – in short, a
landscape in its first territorial, late medieval, sense.

The encyclopaedic tradition, II: landscape images
in animal, medical and health compendia

We have now seen several instances of how the soberly registering overview con-
tributes to the genesis of the landscape image. Another concise gaze is just as
imperative – the one directed towards the naturalistic detail. Among the traditions
occasioning visual detail studies of natural phenomena, the Islamic scientific corpus
introduced into southern Italy from the end of the 11th century is further developed
under the 13th-century Hohenstaufen court and reaches a provisional culmination
in northern Italy during the International Gothic period of the decades around
1400. Taking into account that antique natural philosophy lay dormant in the Is-
lamic world, it might seem tempting here to speak of a renaissance; more precisely,
however, it is a case of an Islamic-Gothic ripening of antique seeds.

The reasons that the Hohenstaufen court was such an important intermediate
station for the nature-observing illustration in the Late Middle Ages were, firstly,
because it had overtaken the Norman southern Italian culture in which so many Is-
lamic studies of natural science had been translated and, secondly, because Freder-
ick II himself was, among many other things, a rationally-minded scientist. To the
frequent irritation of his contemporaries, he would only lend credence to informa-
tion that could be verified by first-hand experience. He owned a number of zoologi-
cal gardens and his illustrated treatise on hunting, *De arte venandi cum avibus* (*The
Art of Falconry, c.* 1244-50), presents a wealth of new observations which are often at
variance with Aristotle's zoological writings.[55] This is the tradition continued by In-
ternational Gothic artists such as the Lombardian school's Giovannino dei Grassi
and Michelino da Besozzo, and the Veronese school's Stefano da Zevio and Pisanel-
lo, when they fill their sketch books with naturalistic animal studies, from which
some are selected to ornament monumental works – as is the case with, for example,
Giovannino's border illustrations in the *Visconti Book of Hours* (FIG. 10.29).

Another forum for nature studies, but with a more direct link to the landscape
image, is the *herbarium*, a plant manual derived from antiquity.[56] As is apparent from,
for example, the renowned *Wiener Dioscorides* of 512, this genre was one of the few
slots of the Middle Ages in which the antique disposition to naturalism survived,
simply because the properties of medicine depended on a correct identification
of the plant. Following importation from the Islamic sphere and development in
Salerno and surrounding centres, the herbarium is also given a naturalistic facelift
at the Hohenstaufen court, after which it similarly culminates in the International
Gothic style of Northern Italy under titles such as *Compendium Salernitatum* or *Secreta
Salernitana* (the latter with an alphabetically-listed collection of herbaria texts). In
the *Carrara Herbarium* from Padua, for example, minutely observed plants meander

Fig. 10.14. *Apothecaries Picking Herbs*
(12th century), miniature from the
German *Apuleius-Dioscorides*,
Eton College, ms 204, f. IV.

Fig. 10.13. Anonymous Italian artist, *Ears of Corn*
(*c.* 1400), miniature from the *Carrara Herbarium*.
London, British Library, ms Egerton 2020, f. 21.

across whole pages (**FIG. 10.13**). The particular factor in the significance of this genre to the development of the landscape image is that the herbaria also, as a continuation of antique or Islamic tradition, offer small genre scenes which form a bridge to the spatial image: for example, picking the plant in its original environment (**FIG. 10.14**), pharmacists preparing medicines, or doctors curing patients.

In the search for sources of the modern landscape image, another Islamic import must be studied: the *Tacuinum Sanitatis* manuscripts.[57] This genre was given its Latin adaptation at Manfred's court after the mid-13th century and, like animal illustrations and herbaria, also reached its peak during the International Gothic period when, between *c.* 1380 and the beginning of the 15th century, it was refined in the scriptoria of the Po valley. With the *Tacuinum* genre we are moving into another quintessentially modern area, *health*, for in the manuscripts the Baghdad physician Ibn Botlân (Latin form Albulkasem; d. earliest 1068) presents his proposals for the necessary components of a healthy daily life. According to the introduction, this is a matter of six types of phenomena: [1] *air*, concerning the heart; [2] *food* and *drink*;

Fig. 10.15. *Southerly Wind (Ventus meridionalis)* (*c.* 1380-90), miniature from manuscript of Ibn Botlân's *Tacuinum Sanitatis in Medicina,* executed in a workshop on the Po plain. Paris, Bibliothèque Nationale, ms lat. 6977A, f. 101v.

Fig. 10.16. *Sage (Salvia)* (*c.* 1395-1400), miniature from manuscript of Ibn Botlân's *Tacuinum Sanitatis in Medicina,* executed in a workshop on the Po plain. Rome, Biblioteca Casanatense, *Theatrum Sanitatis,* ms 4182, f. 68.

[3] *movement* and *rest;* [4] *sleep* and *wakefulness;* [5] *body fluids;* and [6] *joy, anger, fear* and *pain.* Very diverse phenomena – plants, foodstuffs, sexual intercourse, dance, vomiting, winds, seasons, for example – were discussed on the basis of these categories and the same questions were applied to each. The *Southerly Wind* (*Ventus meridionalis*), illustrated by the flapping capes of two knights walking through a leafy landscape (**FIG. 10.15**), is accompanied, for example, by the words: "*Nature*: Warm in the second degree, dry in the first. *Optimum*: The kind that sweeps across favourable regions. *Usefulness*: Good for the chest. *Dangers*: Weakens the sense. *Neutralization of the Dangers*: With baths."⁵⁸

Of the many landscapes filling the illustrations, a few are generated by the herbarium tradition. Rather than being portrayed on their own, the plants are set free in small nature sections, which might either be totally autonomous or show how the plant can be gathered. Sage, for example, is accompanied by a woman carrying a basket and plucking leaves from a plant growing behind a wattle fence (**FIG. 10.16**). The vignettes actually have the quality of landscape, for even though

Fig. 10.17. *Harvesting Rye (Siligo)* (*c.* 1390-1400), miniature from manuscript of Ibn Botlân's *Tacuinum Sanitatis in Medicina*, executed in a workshop on the Po plain. Vienna, Nationalbibliothek, ms Series Nova 2644, f. 47.

they are still grounded in Byzantine rocks, the spreading of the plants provides a fine quantitative effect. Inasmuch as the plants are not simply there for the sake of pleasure, but have a practical purpose – i.e. to facilitate wellness in everyday life – it seems obvious that they should be obtained by means of an everyday activity: work. It seems particularly logical that the most laborious farming activity, the harvesting of cereals, has become fully worthy of depiction. It is not only featured as an illustration of the *Summer* season, but also in depiction of the different varieties of cereal: wheat, barley, rye, spelt, rice (**FIG. 10.17**). The cereal harvest – the result of the Fall – is, however, still but one of the many gathering activities, which include the picking of paradisiacal vegetation such as oranges, grapes, olives and roses. Work is thus integrated into the depiction of nature at exactly the same time as the vegetation of the Fall is put alongside the Paradise flora in the same all-embracing category of utility plants.

In addition, we also see that the *Tacuinum* genre releases time into nature. This transpires in portraits of the *seasons* by means of the picking of roses in the spring and the harvesting of grain in the summer.[59] It also occurs in portraits of the four winds, with fluttering scarves, trees bent by air pressure and torrential rain forcing

a woman to pull her shawl over her head (PLATE 32). And the subject heading "Snow and Ice" not only produces one of the first snow landscapes in Western culture, but also one devoid of human figures: Byzantine white-speckled rocks sombrely enclosing a frozen grey lake (PLATE 33).[60]

However, it also seems symptomatic that this book, which is the first to release weather and time into the Western landscape image, is also a book dealing with human moods (6) and body fluids (5). The body fluids – yellow and black bile, blood and phlegm – were in themselves determining factors in states of mind inasmuch as they regulated the four temperaments (alternatively known as *humours*) and, as we will see in the next chapter, one of the most important tasks of the future landscape painting is to turn the changeable weather situation, *atmosphere*, into an external expression of the no less changeable state of mind, *mood*.

The forest

Yet another forum to advance the dawn of the modern landscape image is found in *the forest* and its visual depiction. Right up until the aggressive deforestation carried out in the Late Middle Ages, West and Central Europe were still covered by the dense forests that had earlier incited the Romans' awe. In a darkness of trees, thickets and marshes, the villages and their fields were like islands at the mercy of a mighty ocean. The forest provided firewood, timber, game, fruit, fungi and herbs, but it also represented that which was strange and threatening: wild animals and savage humans, phantom creatures, robbers. With its overwhelming presence, the forest constituted both the physical and psychological framework of medieval Western Christianity.[61]

I will not here examine medieval forest mythology, but merely note that the forest image is first given spatial attire in the Late Middle Ages; indeed, in a way, that this is where it makes its entrance in pictorial art. As we saw in chapter 6, antiquity was not able to amalgamate the image of the single tree with the image of the thicket, but took a quantum-like leap from the lone figure surrounded by space to the enclosed mass. The leap is already smoothed out to a continuity of openness and closedness in certain 14th-century images: for example, *The Enchanted Garden*, an illumination in a manuscript of Guillaume de Machaut's *Le Dit du Lion* (c. 1350-55; FIG. 10.18). Here the illuminator shows us a Paradise garden with an opulent flora and fauna in the antique tradition of mixed forest, but rather than being blocked, as in Livia's garden fresco (PLATE 5), the eye is led across an extensive flower-bedecked meadow to a background of trees, between which we can walk in and be absorbed by the deep darkness. Unlike the closedness of the garden frescoes, this is essentially a landscape image with spatial view, a *Durchsehung*, which leads the gaze through a succession

Fig. 10.18. *The Enchanted Garden*
(*c*. 1350-55), miniature from French
manuscript of Guillaume de Machaut's
Le Dit du Lion. Paris, Bibliothèque
Nationale, ms fr. 1586, f. 103.

of objects. The more remarkable, then, that the forest scene retains its absence of human figures. It thus approaches the status of autonomous landscape image.

Pointing out the physical significance of the forest in medieval culture is valuable because its occurrence at this late point in the evolution of culture could actually have contributed to the development of the conception of infinity. As mentioned in chapter 9, the Italians linked Gothic architecture with "trees that are not yet pruned, from which [the Germans] bend the branches together and bind them to form their pointed arches." In my own description of Gothic architecture, we saw that the branches might indeed have been bent, but that their binding was in a way postponed boundlessly to the celestial infinity. We also noted that the infinity effect was embedded in the serial repetition of the architectural bays. Might the Italians' myth actually have something to it, in the sense that visualisation of the forest in all its spatial, two- as well as three-dimensionality, not only stems from a general spatial awareness, but from the specifically medieval approach to the forest?[62]

We have seen how the paradisiacal flora in *Tacuinum* became utility plants on equal terms with the cereal crops. A similar process of secularisation, then, is seen when Paradise is converted into the modern, spatial forest. The agoraphobic thicket is hereby broken up into an open collection of trees with a base levelled to a flat and softened landscape.

10.4 On the threshold to the paradigm of modernity

The Labours of the Months around 1400

If we return to the *Labours of the Months*, we will notice that they reach a first monumental synthesis with the regular landscape image in Torre dell'Aquila, Trento. Here, sometime between 1390 and 1407, and in all probability around 1400, anonymous artists make the first actual calendar landscape in Western culture. Due principally to the fact that the frescoes are located at the crucial moment of the modern landscape painting's genesis, there is intense discussion as to whether they are the fruit of Northern or Italian artists. The monumental fresco technique itself seems to be related to North Italian, particularly Veronese and Lombardian, traditions. The iconography, on the other hand, appears to be thoroughly Northern: the architecture is Gothic, the humans blond, storks build nests on roofs, ploughs are pulled by horses, scripts used for the few inscriptions are German; and, not least, the farming rhythm seems to be slow, inasmuch as the cereal harvest is still going on in August (albeit starting in July). Even though there is the possibility that the cycle could have been executed by local artists on the basis of Northern source material, it would

Fig. 10.19. Anonymous Bohemian artist
(? [from workshop of Meister Wenzlaus?]),
April and *May* (*c.* 1390-1407), fresco. Trento,
Torre dell'Aquila.

seem most probable that it is the work of peripatetic Bohemians. The leader could
be a certain Meister Wenzlaus, given that the books of the Brotherhood of Saint
Christopher in Arlberg refer to this master as coming from Bohemia along with the
commissioner of the fresco cycle, Prince-Bishop George of Liechtenstein. George
was Bishop in Trento from 1390-1419, and his key role in the creation of the cycle
is clear from the inclusion of his coat of arms embellishing one of the frescoes.[63]

In the frescoes' skies, which are for the most part traditionally dark-blue, the
sun can now break through: a white circle with fiery rays (**FIG. 10.19**). And in *Janu-*
ary, winter is so well-established that a lightly-clouded sky tops off a snow-covered
landscape in which the aristocracy enjoy a snowball fight (**FIG. 10.20**). Even though
the landscapes are still based in Byzantine rocks, these are disrupted by sections
of forest and meadow, hedges and wattle fences, fields, rocky tracks and bridges.
Moreover, it should be noted that there is no attempt to camouflage social stratifi-
cation; although the landscapes are qualified by the various labours of the months,

Fig. 10.20. Anonymous Bohemian artist
(? [from workshop of Meister Wenzlaus?]),
January (c. 1390-1407), fresco (detail).
Trento, Torre dell'Aquila.

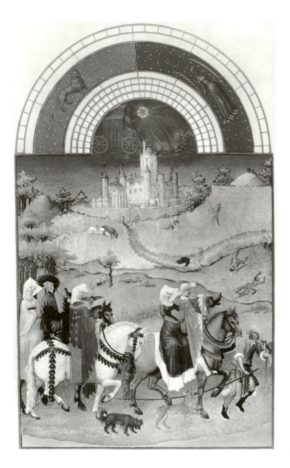

Fig. 10.21. Limbourg brothers, *August* (*c.* 1410-16), miniature from *Les Très Riches Heures du Duc de Berry*. Chantilly, Musée Condé.

these tasks are consigned to the backgrounds while the foregrounds are allocated to the leisure pursuits of the aristocracy. Besides the snowball fight, we can watch such pastimes as hunting, flirtation, festivals, tournaments and outdoor meals. The more laborious activities going on in the backgrounds include cutting grass, forging scythes, picking grapes, grinding grain, ploughing and sowing.

This sharp class division is also found in the high point of labours of the months, and what could be considered the threshold to the modern landscape image, *Les Très Riches Heures,* executed between *c.* 1410 and 1416 by the Flemish Limbourg brothers for the French duke and patron of the arts Jean de Berry.[64] In line with surviving evidence of the Duke's stringent taxation of his copyhold farmers – the contemporary chronicler Jean Froissart called him "the most avaricious man in the world"[65] – scenes of the nobility enjoying their leisure pastimes are acted out at a safe distance from the farmers' work. Festivities and the exchange of gifts in

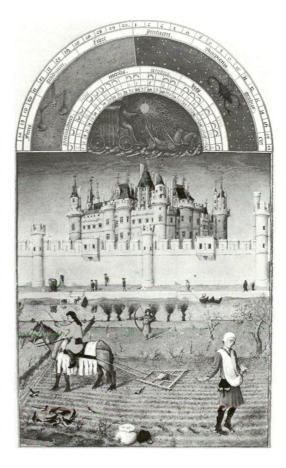

January, the betrothal of the young couple (Bonne de Berry and Charles d'Orléans
(?)) in *April*, and the spring pageant in *May*, are all scenes exclusively reserved for
the nobility. And when, for once, aristocracy and peasants feature in the same field
of vision - *August* - the gathering of the hay (and the peasants swimming in the
river) is removed to a distant background, while falconry and flirtation occupy the
foreground (FIG. 10.21).

In extension of the social hierarchy, the landscapes are usually crowned by a
castle which, if not belonging to the Duke himself, is at least owned by the royal fam-
ily, given that Jean was brother to the deceased king, Charles V (reigned 1364-80). The
October tilling and sowing scene is presided over by a Louvre depicted in such detail
that in the 1980s it was used for a reconstruction of the royal palace (FIG. 10.22).[66]
And the diagonal road in *March* runs past a ploughed field, a vineyard and a meadow
with herdsmen, to reach the gates of Château de Lusignan in Poitou, one of the

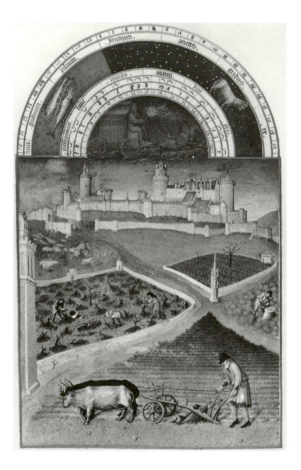

Fig. 10.23. Limbourg brothers, *March* (c. 1410-16), miniature from *Les Très Riches Heures du Duc de Berry*. Chantilly, Musée Condé.

Duke's favourite residences (**FIG. 10.23**). The effect is reminiscent of Lorenzetti's portrait of the Sienese territory, but laterally reversed: rather than casting the gaze from architecture to land, the gaze is here enclosed by the architecture. Feudalism versus republic? The new landscape images might indeed be based in an emerging capitalist and more democratic culture, but as depicted here the peasants are still the Duke's serfs and must therefore be subject to the authority of the castle.[67]

Regardless the feudalism, the calendar illustrations in Jean de Berry's book of hours constitute a pinnacle in early modern realism. The sky is blue and atmospheric and turns whitish towards the horizon. In *December* the trees have yellowed leaves and bare trunks, while broken-off branches and a tree stump lie on the ground. *February* (**PLATE 34**) presents a snow landscape with a heavily-clouded, greyish sky and such transient phenomena as footprints in the snow, freezing breath and smoke from the chimney (the first since the Dominus Julius mosaic, **PLATE 26**). In this and

other miniatures from *Les Très Riches Heures* we have to wait until Brueghel's *Seasons* 150 years later before the Limbourg's innovations are followed up. Even though the few background rocks may still have a Byzantine appearance, they are used on completely equal terms with the other landscape elements. The calendar landscapes are essentially flat – a flatness that falls iconographically into place with their loosened soil. Never before in Western art has the grass-covered ground been transformed into ploughed top soil, as we see it in *March* (FIG. 10.23). Rather strikingly, it is also in *March*, behind the man at the plough, that the first post-antique painted shadow is cast (shadows are also visible in *October* (FIG. 10.22) and *December*). And another effect of light is explored in the *October* river running between the Louvre and the fields: reflections cast by the boats and the people walking alongside the water. Even optical distortions of limbs seen through water are explored in the depiction of the peasants swimming in *August* (FIG. 10.21).

In considering and comparing all these visual innovations, there is a real sense of closeness to the stuff of which Western realism is made; an understanding that this style is not simply a case of a new way of seeing an indifferent surrounding environment, but that it is released by specific subject areas – work, traces of time, infinite particularity – which, despite their apparent individuality, all gain sustenance from a common epistemic *field*: that of modernity.

The landscape paradigm around 1400

My discussion so far of late medieval landscape images has chiefly concentrated on heightened situations: specific iconographic contexts which have provoked progressive shifts in the depiction of nature. Even though the shifts are particularly apparent here – and in a context that puts the implications of their content into relief – it must be mentioned, in conclusion, that they are also to be encountered with increasing frequency in the *standard* landscape image; that is: contexts in which there is no local semantic pressure, but which lead directly to the paradigm. It is by making a comparison between the heightened situations and this transitional paradigm that we realise precisely how far there is to the fully-accomplished paradigm shift in the third decade of the 15th century. The modern paradigm is thus formed in a synthesis between the two categories.

The medieval symbolic sky is already showing signs of atmospheric disorder in Jean le Bon's mid-14th-century *Bible Moralisée*. Here the otherwise blank vellum backgrounds are topped-off with small, dark-blue feathery clouds (FIG. 10.24).[68] In the Master of the Boqueteaux's illuminations for Guillaume de Mauchet's poetic works of around 1371-77, *Nature Introduces her Children to the Poet* and *Love Introduces his Children to the Poet*, these dark-blue skies have gathered into a complete cover

Fig. 10.24. *Scenes from the Life of Saint Paul,*
miniatures from Jean le Bon's *Bible Moralisée*
(mid-14th century). Paris, Bibliothèque
Nationale, ms fr. 167, f. 285v.

Fig. 10.25. *Nature Introduces*
her Children to the Poet
(c. 1371-77), miniature from
Parisian manuscript of
Guillaume de Machaut's
poetic works. Paris,
Bibliothèque Nationale,
ms fr.1586, f. E.

Fig. 10.26. *Visitation* (c. 1390), miniature from *Les Heures de Bruxelles*. Brussels, Bibliothèque Royale Albert Ier, ms 11060/61, f. 54.

Fig. 10.27. *Flight into Egypt* (c. 1390), miniature from *Les Heures de Bruxelles*. Brussels, Bibliothèque Royale Albert Ier, ms 11060/61, f. 106.

of cloud above panoramic landscapes full of details (**FIG. 10.25**).[69] On the hilly but no longer rock-like ground, we also find the kind of detail indicative of productivity such as a farm worker carrying a sack of grain on his shoulder as he walks along a proper road towards a windmill. If we move on to *Les Heures de Bruxelles*, a Flemish manuscript painted around 1390, we see that not only does the artist reintroduce a road – now cobbled – running through the landscape, but also that the monolithic aspect of the rocks is in the process of being broken up into flakes of a more naturalistic appearance (**FIG. 10.26**). Furthermore, the branches of the trees are shown to have lost their leaves in the wintry *Flight into Egypt* (**FIG. 10.27**). In Melchior Broederlam's altar cupboard lid of slightly later date, 1394-99, adorned with the *Presentation in the Temple* and *Flight into Egypt*, the rocks are again flake-like and, what is more, overgrown with green moss and grass (**FIG. 10.28**).

In the climate of International Gothic holding sway during the last two decades of the 14th century, there seems to be a symmetry between Italy and Northern Europe as regards iconographic contributions to the genesis of landscape. The scriptoria of the Po valley yield the *Tacuinum Sanitatis* and *Compendium Salernitatum*

Fig. 10.28. Melchior Broederlam, *Presentation in the Temple* and *Flight into Egypt* (1394-99), altar cupboard lid, tempera on wood. Dijon, Musée des Beaux-Arts.

manuscripts, Bohemian artists paint the first proper calendar landscapes in Torre dell'Aquila, Trento. Intermittently, as with the small fence in Giovannino dei Grassi's Paradise landscape in the scene of the *Creation of Eve* (shortly before 1395-98)[70] from the *Visconti Book of Hours*, modernity also breaks through in the Italians' standard landscape depiction, the paradigm (**FIG. 10.29**). It is still clear, however, that from the middle of the 14th century the paradigm-determined frontline in the genesis of the landscape image is located in the North. And after 1400 the North assumes an unequivocal lead. Quite specifically, the new landscape paradigm crystallises in Franco-Flemish manuscript illuminations executed during the first two decades of the 15th century.

In the Boucicaut Master's book of hours (c. 1401-05) the golden rays of the sun break through the firmament – and with such force that they are reflected in the lake behind the *Visitation of Mary and Elizabeth* (**PLATE 35**).[71] It is fitting that the rays should bless the holy women and, by so doing, at that moment gain a form of iconographic justification in their company; and yet the scene opens up for a type of lighting – cast light – which, iconography notwithstanding, will characterise painting for the following five hundred years. Behind the rays another firmament is revealed, an atmospheric blue sky sprinkled with light fluffy clouds and toned down with white towards the already distant horizon. Although still alternating with the

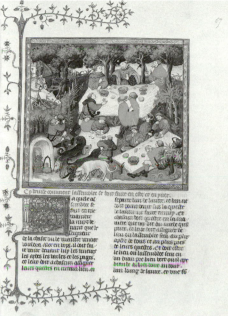

Fig. 10.29. Belbello da Pavia, initial with the *Creation of Eve* (1430s); workshop of Giovannino dei Grassi (shortly before 1395-98), elaborated by Belbello da Pavia, *Landscape*, miniature from the *Visconti Book of Hours*. Florence, Biblioteca Nazionale, ms Landau-Finlay 22, f. 46v.

Fig. 10.30. *Gathering before the Stag Hunt* (c. 1407), miniature from a Parisian manuscript of Gaston de Phébus' *Hunting Book* (1387-88). Paris, Bibliothèque Nationale, ms fr. 616, f. 67.

medieval, symbolic sky – with rinceaux, cubes or other patterns – this sky soon frees itself from golden sunbeams. This type of fully-mature naturalism can be observed in manuscripts such as the *Works by Christine de Pisan* and the *Hunting Book* of Gaston de Phébus (FIG. 10.30), made between 1405 and 1407.[72] John Ruskin fully understood the significance of this shift in the skies of early-15th-century manuscripts:

> The moment the sky is introduced (and it is curious how perfectly it is done *at once*, many manuscripts presenting, in alternate pages, chequered backgrounds, and deep blue skies exquisitely gradated to the horizon) – the moment, I say, the sky is introduced, the spirit of art becomes for evermore changed, and thenceforward it gradually proposes imitation more and more as an end, until it reaches the Turnerian landscape.[73] [Ruskin's italics]

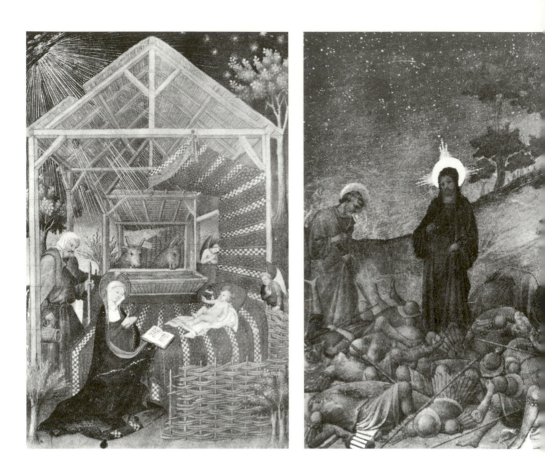

Fig. 10.31. Boucicaut Master, *Nativity* (*c.* 1401-05), miniature from the *Boucicaut Book of Hours*. Paris, Musée Jacquemart-André, ms 2, f. 73v.

Fig. 10.32. Limbourg brothers, *Agony in the Garden* (*c.* 1410-16), miniature from *Les Très Riches Heures du Duc de Berry*. Chantilly, Musée Condé.

The star-studded night sky, too, has its – second – breakthrough in the *Boucicaut Book of Hours* (we recall Pietro Lorenzetti's Assisi *Last Supper*, presumably from the 1330s). It features as background to the ray-casting star of Bethlehem in the *Nativity* and the *Adoration of the Magi* (**FIG. 10.31**). However, while the darkness in these virginal night scenes is still limited to the sky itself, the Limbourg brothers allow it to absorb the space in its entirety; this happens in the *Crucifixion* in *Les Belles Heures du Duc Berry* (*c.* 1408-09) and again in the same scene and also in the *Agony in the Garden* in *Les Très Riches Heures* (**FIG. 10.32**).[74] In the Gethsemane scene, the stars have a naturalistic variation in size and are distributed randomly across the black-blue sky, while lanterns and burning torches cast an orange gleam to illuminate the immediate surroundings.

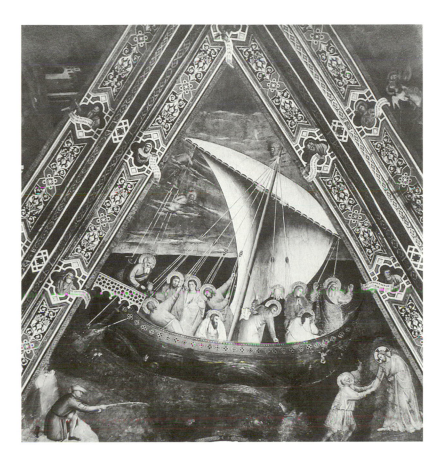

Fig. 10.33. Andrea da Firenze, *Christ Calming the Storm* (c. 1365-67), fresco. Florence, Santa Maria Novella, Cappella degli Spagnuoli.

Unlike these versatile temporal and meteorological effects in early North European 15th-century manuscripts, the Italian counterparts seem to be restricted to scenes of stormy weather. When Andrea da Firenze adapts Giotto's *Navicella* to his own version of *Christ Calming the Storm* (c. 1365-67), he already has his wind gods appear from an authentic cloudy and greyish sky (**FIG. 10.33**). And, again, when Lorenzo di Niccolò di Martino (documented 1391-1411) paints *Saint Fina Saving a Ship in a Storm* (San Gimignano, Pinacoteca) in 1402, the usual gold base is replaced by a cloudy sky.[75] The dark-blue clouds are here shaded towards the horizon, going from a reddish blush to white. According to Bartolommeo Fazio, ten years later Gentile da Fabriano paints: "a whirlwind [*turbo*] uprooting trees and the like, and

Fig. 10.34. Limbourg brothers,
Annunciation to the Shepherds (c. 1410-16),
miniature from *Les Très Riches Heures du
Duc de Berry*. Chantilly, Musée Condé.

Fig. 10.35. Limbourg brothers, *Saint
Michael Fighting the Dragon* (c. 1410-16),
miniature from *Les Très Riches Heures du
Duc de Berry*. Chantilly, Musée Condé.

its appearance is such as to strike even the beholder with horror and fear."[76] The
image was painted at an unidentified location in Venice and possibly reflects the
notorious storm that hit the city on August 10 1410.[77]

A further difference between the Northern and Italian landscape images at this
time can be seen in the way the Italian images limit their temporal effects to the
sky, whereas their Northern counterparts also include innovations in the grounds.
The landscape that receives the first pictorial sunrays in the Boucicaut *Visitation*
is thus a green landscape with windmill, a farm wall enclosing a hillside, two tree
stumps that are evidence of forestry, and even some tiny fields surrounded by

hedging. It would seem, however, that we have to wait until *Les Très Riches Heures* of the following decade before the cultivated landscape again breaks through beyond specific agricultural themes. In the background of the *Annunciation to the Shepherds* (FIG. 10.34), we see a patchwork of yellow, green and brown furrowed fields, and they appear again as part of the world Christ is offered by the Devil in the *Temptation of Christ*.[78] In the paradigmatic landscape images of *Les Très Riches Heures*, we also meet innovations such as withered trees (*Nativity, Annunciation to the Shepherds, Entry into Jerusalem*) and something as unprecedented as a sandy coastline with almost van Goghesque beached boats (*Saint Michael Fighting the Dragon*; FIG. 10.35). Here the ploughed fields are thus complemented with another tangible expression of the levelling out of the Byzantine rocks.

Thus, the depiction of landscape in Western pictorial art has now reached a cataclysmic threshold, a hyper-unstable state in which the antique-medieval pictorial paradigm, the Golden Age paradigm, is filled to satiety by modern trends, not just iconographic themes such as labours of the months, seasons, winds, snow, plant gathering, and so forth, but also fragmental images of territory or simply optically observed bits of nature. The theme of the next chapter will therefore be the period during which this satiation finally collapses and all these trends crystallise into a new dynamic equilibrium, the imprint of a dissipative structure: the modern paradigm.

Time, Territory and Wilderness in Early Modern Landscape Images, II

After the Paradigm Shift 1420

Introduction

ASSERTING THAT THE modern paradigm breaks through in the Western landscape image around 1420 is the same as saying that what previously could be generated only via specific thematic motivation – weather, time, cast light, cultivation, and so forth – now spreads from particular iconographic contexts to the landscape image *in general*, independently of what might otherwise be going on in terms of figurative events. Simultaneously with the view expanding through an atmosphere now characterised by time, the formerly so dominant rocks have to make way for a softened earth that can be ploughed into fields, dissected by roads and form gently sloping shores for lakes, rivers and oceans. In this landscape, the forest has also been balanced with the territory as a whole, for whereas before it appeared in agoraphobically isolated units it can now absorb the space in its mass and spread out across the ground.

Looked at cosmologically – and vertically – this image transformation depends, as already mentioned, on a dissolution of the geocentric tension: as the magnetic field between heavens and underworld is weakened by the Copernican infinity, the segregation of Paradise in an elevated garden is penetrated, at which its forests and meadows can slide down in the simultaneously levelled rock masses of the inferno. Looked at socially – and horizontally – the transformation involves a displacement along the *field* framework of the Golden Age and Paradise myth: the fulcrum slides from the *terra* of the Paradise mountain to the *territory* of the plains of the Fall. Just as I, in chapter 2, concluded that the rock formations of pre-modern images found resonance in the geographical environment of their commissioners, the mountains of the Mediterranean area, the same argument can be applied to the geographical

setting of their successors, the landscape formations of a more plains-like character. For could it not be said that the fulcrum of Western civilisation towards the end of the Middle Ages has been moved from the mountain-dominated Mediterranean culture to the transalpine, plains-like and increasingly territorially re-mapped Northern Europe: the British Isles, Holland, Flanders, France, Germany? Having once expanded my optical instrument with the lenses of the paradigms and their associated *fields*, and having recognised that there is no such thing as a 'pure', unmediated pictorial view, I can then actually allow myself a certain measure of realistic and mimetic pictorial reading: the rocks in pre-modern images are those of the Mediterranean region; the fields in their modern successors are those of Northern Europe. In a temporally very wide-ranging sense, Europe's tangible terrain thereby functions as part of a macrohistorical attractor, a structure of forces that control Western cultural evolution; and the paradigms of the landscape image can be read as a fixing, an imprint of this attractor.

But the couplings of opposites, territory/wilderness, realism/romanticism, do not take over the landscape image by means of a smooth development. Reminiscences of the pre-modern Paradise/underworld duality live on far into the 15th century, and from the end of that century the Renaissance puts the lid on the modernity paradigm. What we ascertained in chapter 9 about space, diversity and particularity in relation to the reawakened antique canon can thus here be extended with the factors of time, topography and work. In my analysis of the antique landscape image

Put succinctly, the flattened-out terrain of the landscape image spreads between two poles, those of territory and wilderness, which could simultaneously be said to correspond with two extremities of the naturalistic visual spectrum, those of realism and romanticism. In the realistically beheld utilitarian nature of the territory, the human being is master and through his or her own efforts has made the landscape purposive. In the romantically beheld expanses of the wilderness, on the other hand, nature takes over and shows that it has no pact with humankind. Ultimately, this is the pathless landscape in which the human being is inspired with sublime emotions upon contemplation of the indomitable forces of nature, from which, however, this subject simultaneously finds him- or herself at a reassuring distance guaranteed by the non-visible, but nonetheless indispensable urban civilisation. Despite the polarisation, these landscape types are thereby an expression of the same approach to nature, for whether the human being has control of nature or has, in his imagination, commended himself to its forces, the situation is qualified by a rift between humankind and nature – the nominalist rift that has shaped humankind's self-volition with regard to a nature that is in itself infinite, changeable and devoid of *telos*. Whether the human being wishes to relinquish passively to this nature (romanticism) or actively conquer it (realism), is entirely a question of free will.

But the couplings of opposites, territory/wilderness, realism/romanticism, do not take over the landscape image by means of a smooth development. Reminiscences of the pre-modern Paradise/underworld duality live on far into the 15th century, and from the end of that century the Renaissance puts the lid on the modernity paradigm. What we ascertained in chapter 9 about space, diversity and particularity in relation to the reawakened antique canon can thus here be extended with the factors of time, topography and work. In my analysis of the antique landscape image

I observed that such phenomena were not represented, and it would therefore seem understandable that they must also be moderated in modernity's neo-antique version. Apollo cannot wander among windmills, cornfields, logs or quarries, nor can he play his lyre in front of a roadside inn or a city hall depicted with topographical accuracy. Narcissus does not look at his reflection in the surface of a frozen lake on which children are skating, and Venus does not go ashore on a beach flanked by autumnal trees.

But whereas timelessness, spatial limitation and absence of work in the sacral-idyllic landscape were deeply embedded in the pre-modern pictorial paradigm, the Golden Age paradigm, these conditions now have to be recreated as a pocket in the modernity paradigm. While Northern Europe's images increasingly give way to time, topography and cultivation, the Italians put a sordine on the new effects, an enterprise that culminates in the *ideal landscape* of 16th-17th-century pictorial art. In other words, Renaissance art is amazingly consistent in its neo-antique endeavours. Not only does the devotion to the ideal body take place in a tamed pictorial space which reduces details, pulls the heavens back to the earth and limits ideality-threatening time; this space also shuns the cultivated nature of the territory because this nature, just as in antiquity, is reminiscent of an existence in which there is not sufficient leisure time for the heroic deeds involved in the devotion to the ideal body.

As to the cultivated and temporally-determined landscape, this reaches a provisional climax in 17th-century Dutch art. Not least with Renaissance ideology in mind, the degree to which Carel van Mander refers to farm work in *Het Schilder-Boeck*'s section on landscape painting (1604) is striking. As the painter expands his view across the landscape, he must

> skilfully divide the expanse of land in fields. While we can see the blond-haired Ceres at one side, the other field is filled with unripened oats. It is here that Eurus floats in, who passes the time by turning the fields into a sea of green waves and whispering sounds. [...] There are also red and blue flowers among the corn and wheat and the useful, sky-blue flax. Ploughed fields, too, hatched with furrows, or here and there fields, with harvested crops; then too, fields and meadows with the ditches, hedges and winding paths belonging to them.[1]

Nor does van Mander find any fundamental difference between agriculture and other forms of rural activity. Immediately after the passage just cited, he refers to strange shepherds' huts and peasants' homes in caves or hollow trees. And of the small figures in the landscapes, he urges: "Show them either ploughing or mowing, or loading up a cart further away. Elsewhere you may show them in the act of fishing, sailing, catching birds or hunting."

In particular, van Mander sees no difference between this new land iconography and that of antiquity. The Augustan Ludius would almost seem to have been painting van Mander's contemporary Netherlands: "In landscapes without water he would paint fully laden carts and asses in the fields and paths, near the houses and farmyards, and other agricultural implements." And: "The achievement for which he received the highest general acclaim at that time was his depiction of a marshy low-lying piece of land in which he painted a couple of farms and muddy, almost impassable, slippery roads. He showed this very explicitly by painting women slipping and falling down."[2] When reading these mildly distorted paraphrases of Pliny, slipping in territorial fields, paths, roads and agricultural implements which were not there in the original, we can understand how hard it has been to define modernity in relation to antiquity.

In the light of my contention in the previous chapter that the introduction of fields into the landscape image was facilitated by a reappraisal of physical work, indeed of work all told, the obvious question now has to be asked: is the retreat of the fields – and the pictorial conservatism of the Renaissance in general – connected to a corresponding regression within work philosophy and politics, i.e. to a revival of antique aristocratic politics? It is beyond the remit of the present study to pursue this question in depth, but I must however point out a few principal trends that would seem to bear out a connection.

In his famous study of the religious roots of capitalism, Max Weber emphasised the special status of this form of production in a world historical perspective. Not only is there no capitalism outside, or before, the Western modernity; within the European area it should be specifically located to the Protestant settings, which thus means that commercial, technical and industrial work is mainly developed in North European areas such as the Netherlands, England, certain parts of Germany and Northern France (and later, with colonisation: the US). Among religious communities such as Calvinists, Pietists, Puritans, Baptists and Methodists, the teaching was that one should lead an industrious, regulated and ascetic life, should not waste time and should earn money; in brief, a profusion of qualities that stimulated – and were stimulated by – the development of modern market economics and standardised production.[3]

Having, in chapter 8, mentioned the connection between the Copernican world picture, colonisation of the non-Western world and expansion of the pictorial space, all predominantly Northern European phenomena (Spain and Portugal being more complex hybrids), it would thus not seem unreasonable to extend the effective radius of the *field* and connect the equally Northern European phenomena of capitalism and Protestantism to the Northern pictorial art's corresponding temporally-dominated and cultivated terrains. The connection is particularly pertinent

in the 17th-century Netherlands, Europe's first fully bourgeois, commercial, non-aristocratic, non-Catholic and democratic republic, which, as we have seen, is also where the gaze is first lowered down to the flatness of the fields under the high misty skies. If this is correct, then it is still, however, a case of the mature fruit of a lengthy evolution, for as Weber also points out, the communal space between capitalism and worldly religion can be traced far back to the *Devotio Moderna* movement in the 13th-15th centuries, and this in turn is nourished by the culture of the monasteries and convents.[4]

If, however, we focus on Italy, the Catholic culture that fosters the Renaissance and the neo-antique ideal landscape, we find, in keeping with the 19th-century republican historians, *I nuovi piagnoni* (cf. chapter 9), that it is characterised by an escalating process of aristocratisation in the 15th-16th centuries. Machiavelli writes *Il Principe*, the formula for total princely power, in 1513, at the same time as his desired host city, Florence, the 15th-century's symbol of inviolable republican liberty,[5] is in the process of being transformed into the capital city of a duchy – a process that is completed in 1530. According to Le Goff, the Renaissance also seeks to revive Roman law and Aristotelian politics, even though the antique vocabulary – for example, the term *opera servilia* – is often at odds with social progress.[6] In particular, the Italians do not plunge into the same kind of trade and colonial ventures that are undertaken by Northern Europeans, the Spanish and Portuguese. The Italians do not yearn outwards, but inwards towards their own past. After Charles VIII's Italian passion catalyses his conquering expedition to the country in 1494, this nostalgia is enlarged upon by the Northern Europeans' craving for all things Italian. The otherwise highly expanding world picture of modernity has to be provisionally curbed by, if not directly implode in, the concentration on Italy and the neo-antique culture.

All in all, the period from the end of the 15th century to the late 18th century seems to incorporate what Le Roy Ladurie calls an "immense multi-secular breath of a social structure", a re-feudalisation in which previously free farmers are now again serfs or reduced to day-labourers, while power is concentrated in the hands of absolute rulers. Braudel even refers to the "second serfdom", a comprehensive European trend that has its fulcrum in Italy, Germany, France and Eastern Europe.[7] This countercurrent in cultural evolution, then, occurs at the same time as the revival of antique imagery during the Counter Reformation, and it is therefore extremely tempting to see the Renaissance style as, to a large extent, the manifestation of absolute monarchy. As far as the production of art is concerned, it is particularly of note that the art academies, the Renaissance's new centres of education, are indeed aristocratic institutions under the auspices of the powerful elite. Their forerunners, the workshops of the Late Middle Ages, were, on the other hand, independent institutions, the leaders of which were organised in guilds.

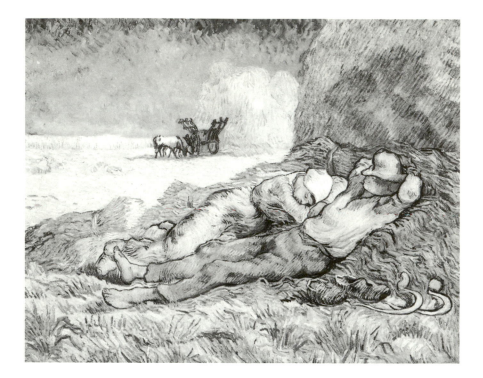

Fig. II.I. Vincent van Gogh, *The Siesta*
(after Millet) (1889-90), oil on canvas.
Paris, Musée d'Orsay.

Even though I acknowledge the considerable complexity of the development, I must therefore trust that in relation to the modern epoch it would make a certain degree of sense to couple the following concepts: on the one hand, images with ideal landscapes, Renaissance, Catholicism and aristocratism; on the other hand, images with cultivated or romantic landscapes, modernity, Protestantism and republicanism.

Like the traces of time and the infinite pictorial space, agricultural iconography could be said to culminate in the work-fixated 19th century, if not the 20th century. In the work of painters such as Bastien-Lepage, Jules Breton, Millet and van Gogh, farm workers become more or less martyr-like heroes fighting a daily and gruelling battle to put food on the table (**FIG. II.I**). The range of motifs is clearly qualified by the nationalistic movements' accelerating affection for the ancestral turf, and by an expanded awareness of the workers' circumstances. The iconography not only continues to flourish during the Communist revolutions in Russia and China,

but also during late-capitalist culture[8] and its totalitarian extremes, fascism and Nazism. As the totalitarian regimes also, however, revive the antique notion of the heroic human being, a disastrous and destructive coupling occurs: comprising, on the one hand, modernity's anti-heroic everyday life and fixation on physical work, and, on the other hand, the Renaissance cult of the ideal body, an aristocratic cult in which heroism is actually rooted in freedom from work. This ominous totalitarian constellation could be said, then, ultimately to stem from the self-deception that we have yet to put behind us: the idea that modernity is a rebirth of antiquity.

II.1 Time as weather and light

Scanning the paradigm

In diametrical opposition to the Golden Age paradigm's timelessness, from its very earliest beginnings the modern landscape paradigm draws nourishment from time. Time drained of events, *tempus*, can be equated with weather, the atmosphere's changeable constellation of water and air that determines the way in which light from the sky is spread across trees, plains, mountains and seas. And as can be illustrated by, for example, Pieter Brueghel the Elder's *The Harvesters* (1565; New York, Metropolitan Museum of Art) and *Hunters in the Snow* (1565; Vienna, Kunsthistorisches Museum), the modern landscape paradigm is easily condensed in conditions that offer a pictorial representation of Ovid's post-paradisiacal weather: "Then first the parched air glared white with burning heat, and icicles hung down congealed by freezing winds."[9] Unlike the classical culture, this inconstancy is, however, no longer unequivocally negative; in the instantaneous atmospheric condition, nature would rather seem to have a tender effect on the observing mind, transporting it to a mood. Indeed, atmosphere has even become synonymous with mood, so it seems logical that when the German landscape painter, physician and Schelling pupil Carl Gustav Carus is to define the main task of landscape art in his *Neun Briefe über die Landschaftsmalerei* (1815-24), he describes it as "[r]epresentation of a certain mood in the life of the mind (perception) through the depiction of a corresponding mood in the life of nature (truth)."[10] This strong correspondence between inner and outer mood can also be clarified in musical terminology if we bring in the concept of *tempering* (from the Latin *temperare*), the slight deviation from absolute mathematics which is necessary in order to establish the modern major and minor scales. The term, which actually means to mingle or proportion properly, is indeed also, like, for example, *tempesta* (weather, storm), derived from *tempus*, and again it points both outwards towards meteorology's *temperature* as

well as inwards towards the mind's *temper* (Latin: *temperamentum*), the mingling of bodily fluids (*humours*) that determine the state of mind.

This intimate connection between weather and state of mind could be used as further evidence of modernity's air of original sin, for just as the Fall involves a shift from eternal spring to unstable weather, it also entails a shift from a harmonious person to someone at the mercy of the rages of moods. According to a doctrine developed in the 12th century, original man was free of sin or death because he was in perfect balance with himself and his bodily fluids. In the words of Hildegard of Bingen: "had man remained in Paradise he would not have noxious fluids in his body." The Fall thus leads to an imbalance in which the warped distribution of bodily fluids not only causes death, illness and sin, but also the disharmonious personality types called temperaments – with the melancholic temperament generated by the black bile, the phlegmatic by the white, the choleric by the yellow and the sanguine (despite everything, the most desirable) by the red. It is these four temperaments – in the shape of elk, ox, cat and rabbit, respectively – which, as emblems of the post-paradisiacal fluctuations in state of mind, accompany Dürer's engraved Adam and Eve (1504).[11]

A god who invariably features as tutelary spirit for the mental as well as the landscape changes in mood is Saturn, alias Cronus. Although host of the Golden Age, the eternal cloudless spring, he is also, as the god of lead, the epitome of its cessation, the epoch in which time and depression take over. Melancholy transpires when the *otium* of the Golden Age changes into idleness. The Middle Ages used the same word for both concepts: *accidia*. In pre-modern times melancholy is chiefly seen as an illness, linked to the black bile, albeit Aristotle had already remarked that great minds are usually melancholics.[12] This notion becomes all-important in modernity, in which melancholy and mental instability are considered marks of genius, a necessary illness that is reflected aesthetically in changeable external matters such as, for example, temporally-marked landscapes. The tutelary spirit is, of course, Cronus, as Cronus-Saturn was associated with time, the epitome of inconsistency, and was also said to have introduced time measurement.[13]

The topicality of the link between external and internal lability in the wake of the 1420 shift in pictorial paradigm, the fall from the Golden Age paradigm, is evident in Alberti's dialogue *Theogenius*:

> Look, how the earth is now dressed in flowers, now heavy with apples and fruits, now naked without her foliage and hair, now squalid and horrid through ice and snow which make the sides and tops of mountains and lonely places white-haired. And do we not, when we are ready, see anything now, no moment follows, as the poet Mannilius says, which is like the previous, not only in the minds of humans,

who are now happy, then sad, next angry, then full of suspicion and similar pertur-
bances [*perturbazioni*], but also in the whole universal nature, warm in the day, cold
at night, bright in the morning, dark in the evening, recently windy, suddenly calm,
then clear, then full of rain, splendour, thunder, and thus incessantly with variation
upon variation [*varietà*].[14]

We notice that the word *varietà* is here used in the temporal sense, in that it is part of
the changeableness of the world. The leap to spatial diversity, in reference to which
we have heard Alberti use the term before, is, however, obvious. Both the temporal
and spatial aspects of the word concern a fundamental feature of modernity and
its representations in landscape imagery.

During the period of the Golden Age *field*, this changeability and unrestrained
variation is considered a degeneration of beauty, but in modernity it becomes the
basic element of art. If the weather is due to the instantaneous attuning of atmo-
spheric elements, and the mood is created by the momentary mingling of bodily
fluids, then correspondingly a degree of non-harmonious, but well-moderated
constellation of tones is necessary before the music rings. It is hardly accidental
that polyphonic music is born in the Late Middle Ages alongside the growth of
the modern pictorial paradigm, and that this music's modern ('classical') successor
matures and culminates at the same time as the highpoint of the landscape paint-
ing in the 18th-19th centuries.[15] Both parties reflect fluctuating, dissonant frames
of mind by means of pure sense perception, the former aurally, the latter visually;
both are inextricably bound to the passage of time. Michel Serres even considers
music to be the absolute antithesis of sculpture: while sculpture is hard, solid, silent
and has kinship with death, music is gentle, buoyant, audible and roams the non-
differentiated space.[16] In general, we can thus conclude that the well-tempered blend
that comprises mood, weather and music is located at the focal point of modernity.
Modus, the mode determined by the instant, is its approximate synonym.

It would therefore be no trouble at all to install landscape painting in the place
of music. Hegel corroborates the objectless, hovering and sonorous quality of the
romantic vision:

The inner, thus pushed to extremes, is the uttering without externality, invisible, as
if perceiving only itself, a sounding as such, without objecthood or form, a hovering
over waters, a ringing over a world, which, in and by its heterogeneous apparitions,
can only receive and reflect one reverberation of this in-itself-being of the soul.[17]

As a consequence of this internalised resonance, Hegel alleges that the romantic
disposition, also when expressing itself visually, is musical and lyrical. This line of

thought continues with Spengler who, like Serres, considers music to be the Faustian archetypal art form. The nuances of light, shadow and colour in painting are basically dealing with musical matters and, conversely, music is a spatial art form. At its culmination in 18th-century instrumental music, we are offered

> bodiless realms of tone, tone-intervals, tone-seas. The orchestra swells, breaks, and ebbs, it depicts distances, lights, shadows, storms, driving clouds, lightning flashes, colours etherealized and transcendent – think of the landscapes in the instrumentation of Gluck and Beethoven.[18]

The engine driving the atmospheric visions of painting and music alike is, again, time: time in the form of unburied death. We recall that the seasons made their renewed entrance into the West's understanding of the world when winter was excavated from the land of the dead and thus released its shadows, winds, stenches and diseases. According to Lucretius, it is the very clouds or fogs that bring plague and disease:

> Therefore when a sky which is alien to us happens to set itself in motion and [...] when it has come to our sky, it corrupts it, making it like itself and alien to us. Accordingly this new plague or pestilence either falls on the waters suddenly, or settles on the corn itself, or other food of mankind or fodder of beasts, or even remains as a force suspended in the air itself.[19]

In whatever way this airborne epidemic might choose to reveal itself, it once more has its origins in Saturn since besides incarnating melancholy, the contamination of bodily fluids by the black bile, in the landscape environment this sluggish god was also linked to clouds, which brought plague. In *Genealogia deorum gentilium* (*On the Genealogy of the Gods of the Gentiles*; begun c. 1350) Boccaccio states:

> Finally, when standing thus irresolutely, it seemed to me that I saw a slow and cloudy star, blurred by Stygian steam, rising from the Eastern sea as if it were from hell. While I observed this cloud-enveloped sight, I remembered the precepts of the venerable Andalò and knew that it was the hated and harmful star Saturn.[20]

As we are, after all, on our way into the epistemic *field* of modernity, we must however note that what here, on its threshold, is still regarded as infernal and contaminating, becomes, in its more mature state, uplifting and inspiring, an outer reflection of the slightest emotions in the depths of the soul. In Carus' *Neun Briefe über die Landschaftsmalerei*, the now transformed Saturnian steam cladding, the ordinary

clouds of landscape painting, is praised for its ability to encapsulate this connection in particular:

> Everything which resonates in the human breast, a brightening and eclipsing, a developing and dissolving, a making and destroying, everything hovers before our senses in the delicate images of the cloud regions; and perceived in the right way, inspired by the spirit of art, it reaches wonderfully the very mind which these apparitions pass by unnoticed in reality.[21]

In 1821, John Constable also has to put the case for the way in which the upper parts, the celestial regions, speak to the beholding mind:

> Sir Joshua Reynolds speaking of the "Landscape" of Titian & Salvator & Claude – says *"Even their skies seem to sympathize with the Subject."* [...] It will be difficult to name a class of Landscape, in which the sky is not the *"key note"*, the *standard of "Scale"*, and the chief *"Organ of Sentiment"* [...]. The sky is the *"source of light"* in nature – and governs every thing.[22] [Constable's italics]

That the atmosphere of the sky can be de-demonised in this way and instead become the subject's sympathiser, the chief organ of emotion and the principal tone for the modern landscape image – and the landscape all in all – is perhaps because it has the characteristic of a medium: it lies *between* the beholder and the objects in the environment. Along with foreshortening, it determines how things appear from the instantaneous point of view. In its way it could thereby be regarded as part of the modern visual process itself. Plato's statement that "distance has the effect of befogging the vision of nearly everybody",[23] could both be read as the fog of the world cave getting in the way of vision, given that objects are removed to a distance, and as vision itself becoming foggy *because* it is directed towards that which is at a distance. To look far out into the environment is to shroud it in atmosphere.

It therefore also seems characteristic that Leonardo, the artist who makes sight the empirical sense par excellence, is also the artist who invents *sfumato*, the dark smokescreen that veils the surroundings in indefinable shadows. And, later, Jan Vermeer's soft, imperceptible gradations can be seen as reflecting the experience of using the camera obscura: captured as light-projections in the darkness, the houses of Delft are not razor-sharp and plastic, but appear as ambiguous expanses with a relationship to reality that is a question of interpretation. Here we understand the etymological kinship between *nuance, nuer* (to shade) and *nuage* (cloud), as it is in the rims of the shadows and in the clouds that we find the subtle gradations of colour that are the ideal for the modern painting.

As Damisch has pointed out, the gap from exposition of atmosphere and vision to so-called *painterly* styles is therefore not so big.[24] If the soft brushstrokes do not directly imitate the atmosphere or the haziness of vision, they are indicative of the painting process itself: sight becoming brushstrokes. And, since sight itself is a case of assimilating the world *through* something, the version of sight that has been filtered through the brushstrokes also comes close to the act of seeing.[25]

From its very beginnings in Venice around 1500, the painterly style was characterised by anti-classical propensities. While the classical, Florentine *disegno* aims for the plastic representation of the human body's *ergon*, the Venetian *colore* shifts attention to the way of seeing itself and to the *parergon* of the fleeting qualities: mood, atmosphere, light, environment. The mere fact of their speed and sketchiness would seem to put the brushstrokes in harmony with these qualities. With the possible exception of Rubens, the mediator between North and South, the classicist painting has thus always had problems with the painterly style; we need only think of all the Italian painters South of Parma, of Poussin, David, Ingres and 19th-century academic painters generally. Conversely, painterliness is congenially suited to the antithesis of classicism: landscape painting. This applies to the Venetians, Rubens and a number of 17th-century Dutch painters; it is true of romantics such as Turner, Constable and Corot; and it applies to the Impressionists. The surface of the painting, too, can often accommodate stylistic distinction between figure and landscape. While the *ergon* of the figure usually requires a degree of clear-cut drawing, the *parergon* of the landscape setting is more easily resolved in fleeting strokes.

Nevertheless, the painterly style's harmonisation with qualities of the moment does not mean that it has a monopoly on them. As shown by, for example, Caspar David Friedrich, they can still be attended to by its apparent opposite, the sharp definition of hypernaturalism (**PLATE 2**). Just how intimately the two pictorial languages, hypernaturalism and painterliness, are connected is demonstrated by romantics such as Turner and Moreau, or by realists like Menzel, Courbet and Sargent, not to mention masters of abstraction like de Kooning or Gerhard Richter. Hypernaturalism and painterliness are kith and kin, classicism is their mutual antithesis.

Bearing in mind the structural similarities binding together every epistemic *field*, we must ask a final and pressing question: is it a coincidence that the culture which makes atmosphere the pictorial mood-bearing element is also a culture which procures physical energy from devices that exploit the atmosphere: pressure from wind and water in mills, pressure from gunpowder explosions in firearms, pressure from steam in steam engines; furthermore, all manner of combustibles: wood, coal and oil? The first Western image to show frost breath and the grey winter sky, the *February* picture in *Les Très Riches Heures*, is also the first image to

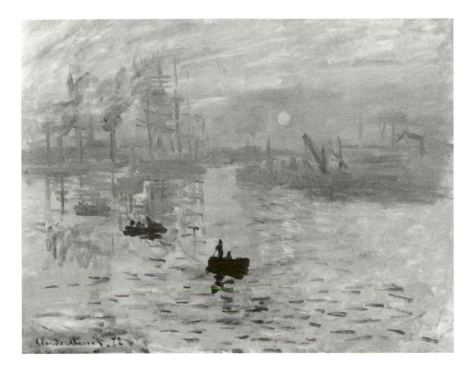

Fig. 11.2. Claude Monet, *Impression,*
Sunrise (1872), oil on canvas. Paris,
Musée Marmottan.

revive the late antique ground-breaking motif: smoke from the chimney (PLATE 34).
From this point and on to the first paintings to systematise mood by means of
this very smoke, Leonardo's *sfumato* paintings (FIG. 11.22, 12.31 and PLATE 36), the
gaze can glide on to the latest progeny of the tradition: a large share of the ambi-
ence in Monet's atmospheric paintings of the mist-swathed River Thames comes
from the *smog* which was the result of fog mixed with smoke emanating from the
factory chimneys, the industrial version of Saturnian plague-laden air emanating
from hell (FIG. 11.2).

Similarly, it should be noted that Turner succumbs to the movements of the
atmosphere at the same time as the industrial application of steampower becomes
widespread (FIG. 8.1). According to the logic that turns aesthetics into a chaos-
cultivating complementary phenomenon to rule-based natural science and tech-
nology (cf. chapter 8.1), the common denominator here thus comprises turbulence,
which in aesthetics is given free rein, whereas its cascades of atmospheres are tamed
in the turbine. And the turbulent unbridledness must again, as shown earlier, be

interpreted as an expression of the inner emotions: given that Ghiberti referred to Ambrogio Lorenzetti's turbulence of dark weather (*turbatione di tempo scuro*), and Fazio mentioned Gentile da Fabriano's root-pulling whirlwind (*turbo*), in terms of visual communication they became counterparts to Alberti who compared the changeableness of the weather with the inner disturbances (*perturbazioni*).

To this tradition, which allows the modern soul with its fluctuations of temperament find reflection in smoke and steam, we could ultimately add *tobacco smoking*, a stimulant imported from Europe's New World and often depicted in 17th-century Dutch genre paintings. To heighten the mood, smoke from the burned tobacco is inhaled, and then, by being puffed out, this same mood is transposed in a picturesque atmosphere.

Weather between 1420 and 1500: sunshine without sun

Even though, post-1400, genres such as *Tacuinum Sanitatis* and the *labours of the months* furnished a rather advanced repertoire for iconographically-determined depictions of time, it has to be noted that, strangely, this repertoire is not given unfettered freedom as soon as the new pictorial paradigm makes it technically possible, but is in fact curbed and enters into a kind of compromise with the timelessness of its predecessor, the Golden Age paradigm. The result in the typical image between 1420 and 1500, both North and South of the Alps, is a landscape bathed in sunshine, where the sun is rarely seen; where there might well be modulations of light and shade, but few fully-drawn shadows; where the universal noon and summer blooming is seldom contravened; and where the sky is usually a cloudless blue that becomes whiter towards the horizon.

An exception to this tendency is found, however, in the immediate wake of the paradigm shift when some of the most naturalistic-minded – Gothic – artists carry on with experiments begun in manuscripts such as *Les Très Riches Heures*. In pioneering works of the 1420s, such as Gentile's *Flight into Egypt* and Robert Campin's *Nativity* (PLATES 6 and 7), the artist cannot resist showing the otherwise rarely depicted sun: Gentile, so that the hills to the left flare up in gold-leaf rays; Campin, so that trees and human figures cast full-sized shadows. Illustrating December, moreover, Campin's trees are leafless. For the *Nativity* scene in the Strozzi predella, Gentile also provides a fully-mature night scene with stars and light cast from the angel and the radiant infant Saviour. In Flanders, this early realism culminates in the school of Jan van Eyck's now partially burnt *Turin Hours* (1430s (?)), which presents several landscapes that have no parallel right up until the 17th century, if not even the 19th century: a coastline with waves washing up onto a flat beach (*Prayer on the Shore*; FIG. 11.3); a strait with foaming and yet reflecting waves (*Saint Julian Conveying Our*

Fig. 11.3. School of Jan van Eyck, *Prayer on the Shore* (1430s). Miniature from the *Turin Hours*. Formerly Turin, Biblioteca Reale; destroyed 1904.

Fig. 11.4. School of Jan van Eyck, *Saint Julian Conveying Our Lord across a River* (1430s). Miniature from the *Turin Hours*. Formerly Turin, Biblioteca Reale; destroyed 1904.

Lord across a River; FIG. II.4); a dusk scene in which the setting sun can be glimpsed behind misty cloud formations as it throws the hilly horizon and windmill into silhouette (*Betrayal of Christ*; FIG. II.5).[26]

In the Italy of the time, the closest the general landscape image gets to this realism is probably in paintings by Fra Angelico. His 1434 *Deposition* presents an evocative sky in which the deep-blue air, like a vestige of the darkness at the crucifixion, is covered by greyish, partially stacked clouds, while beautiful sunlight streams down from the left (FIG. II.6).[27] Shortly after the Flemings' innovations, light at daybreak is explored by Jacopo Bellini, Gentile da Fabriano's Venetian pupil. In *Madonna of Humility with Donor (Leonello D'Este(?))* from *c.* 1441, the rising sun casts its light on

Fig. 11.5. School of Jan van Eyck, *Betrayal of Christ* (1430s). Miniature from the *Turin Hours*. Formerly Turin, Biblioteca Reale; destroyed 1904.

the clouds, mountaintops, city walls and the treetops in the hedge surrounding the Madonna (**FIG. 11.7**).[28]

This, along with the other paintings mentioned, leads the paradigmatic effects interestingly into an iconographic junction, for in the literary discussion about the competitive relationship between painting and poetry, temporal traces were a favourite topic of dispute. Thus, in Angelo Decembrio's *De politia litteraria* (*On Literary Polish*), a dialogue written in 1462 and set in the court of the presumed commissioner of the Bellini painting, the Marchese of Ferrara Leonello d'Este (reigned 1441-51), sunrises are among the subjects listed as being beyond the scope of painting. In his dialogue, the court humanist places poetry above painting, leading Leonello to ask:

> For what painter could ever depict thunder and lightning, clouds and winds and the other elements of tempests as well as the poet does? What painter could draw the hissing of snakes, the concert of birds, the roar of men fighting, the groans of men

Fig. 11.6. Fra Angelico, *Deposition*
(1434), tempera on wood. Florence,
Museo di San Marco.

Fig. 11.7. Jacopo Bellini,
*Madonna of Humility with Donor
(Leonello D'Este?)* (*c.* 1441),
tempera on wood. Paris,
Musée du Louvre.

dying. [...] Or the colours of dawn, one moment red, the next yellow? Or the rising and the setting of the sun? [...] Who will ever show through skill in colouring the darkness of night, or shining moon, the many different movements of the constellations, the changes of the time of day or of the seasons? But let us say no more of the genius [*ingenium*] of writers: it is a divine thing and beyond the reach of painters.[29]

In an epoch which had just reached a stage where it could in fact visualise these effects of the passage of time, it must have been an agreeable challenge for Bellini to contradict this attitude, whosoever might be expressing it.

An earlier text, Leonardo Giustiniani's (d. 1446) letter to a certain Queen of Cyprus, is differently disposed in favour of painting. Like writing, in some aspects painting surpasses nature, because where nature can only make flowers in the spring and fruit in the autumn, "the art of painting may produce snow even under a blazing sun, and abundant violets, roses, apples, and olives even in winter tempests."[30] Guistiniani's teacher, Guarino Veronese, does not differ in his assessment when in his 1430's praise of the International Gothic artist Pisanello, another of Gentile da Fabriano's pupils, he states:

When you paint a nocturnal scene you make the night-birds flit about and not one of the birds of the day is to be seen; you pick out the stars, the moon's sphere, the sunless darkness. If you paint a winter scene everything bristles with frost and the leafless trees grate in the wind. If you set the action in spring, varied flowers smile in the green meadows, the old brilliance returns to the trees, and the hills bloom; here the air quivers with the songs of birds.[31]

This statement is located at an interesting midway spot between actual description and non-observing *ekphrasis*. On the one hand, traces of time had become a spectacular effect in the new painting and even though no nighttime scenes from Pisanello's brush have survived, it is quite likely that they once existed. On the other hand, the landscape paradigm had, as mentioned, consolidated itself in such a position that conspicuous seasonal effects, especially winter scenes, were again not featured in the contemporary paintings. The closest we get to snow landscapes are scenes illustrating legends such as Masolino's *Founding of Santa Maria Maggiore* (c. 1423; FIG. II.8), in which a swarm of low-hanging clouds – against, incidentally, a medieval gold ground – have deposited their snow in the shape of a ground plan of the church; or Fra Angelico's *Martyrdom of Saint Mark* (from the *Linaiuoli Triptych*, commissioned 1433), in which dry-looking hail falls from a dark sky.[32] The two humanist statements thus become more like prophetic manifestos, given that seasonal effects are at the heart of the future landscape painting.

Fig. II.8. Masolino, *Founding of Santa Maria Maggiore* (c. 1423), tempera on wood, from the *Santa Maria Maggiore Triptych*. Naples, Museo di Capodimonte.

Even though it might at first seem unlikely, Sienese painting is also a telling example of the pioneering spirit after the paradigm shift. Having comprised the 14th-century European avant-garde, Sienese painters enter the 15th century with a strangely conservative outlook. The paradigm in total is lost on the grey Byzantine rocks, and the gold ground is often preserved. In the midst of this conservatism, the modern *concepts* nonetheless make their presence felt, and often with considerably more selective strength than in the rest of Italy. In works by Sassetta (d. 1450) and the Master of the Osservanza (documented until 1450), the hilly horizons curve as if they are illustrating the spherical shape of the globe and the skies are filled with extraordinary, refractive clouds (**FIG. II.9**).[33] In Giovanni di Paolo's *Flight into Egypt* (1436?), the radiant sun casts fully-grown shadows from the trees and

Fig. 11.10. Giovanni
di Paolo, *Flight into
Egypt* (1436?), tempera
on wood. Siena,
Pinacoteca Nazionale.

Fig. 11.11. Donatello, *Miracle of the Irascible Son* (1446-53),
bronze relief. Padua, Sant'Antonio, high altar.

Fig. 11.12. Dirk Bouts, *Altarpiece of
the Deposition* (c. 1445), oil on wood.
Granada, Capilla Real.

Fig. 11.14. Paolo Uccello, *Flood* (c. 1445-47), fresco (detail). Florence, Santa Maria Novella, Chiostro Verde.

Fig. 11.13. Piero della Francesca, *Constantine's Dream* (c. 1455), fresco. Arezzo, San Francesco.

farm (**FIG. 11.10**) – a direct gaze towards the sun, which otherwise only re-appears in Donatello's bronze relief of the *Miracle of the Irascible Son* (1446-53; **FIG. 11.11**).[34] Characteristically, Sienese temporal effects were also complemented on the surface of the earth. The terrains are distinguished by dense forests and stony tracks, and in Giovanni di Paolo they are furthermore covered with rigidly geometric field grids (**FIG. 11.30**).

However, after this hectic overture, the indefinite sunlight of noontime takes over both south and north of the Alps. Up until the last third of the century, this is generally only breached when so demanded by a specific iconography: night, storm, the rising or setting of the sun – themes which, unsurprisingly, are most frequently and thoroughly explored in the Netherlands. The nighttime theme is

Fig. 11.15. Giovanni Bellini, *Transfiguration of Christ* (late 1480s), tempera on wood. Naples, Museo di Capodimonte.

generated chiefly by the *Nativity* and episodes from the Passion such as the *Last Supper*, the *Arrest* and the *Crucifixion*. The earliest extant Netherlandish work to transfer night and sunset effects from the miniature to the painting on wood panel is Dirk Bouts' *Altarpiece of the Deposition* (c. 1445; FIG. 11.12):[35] under the ink-black sky of the centre panel, the trees darken against the luminosity of the sunset, and in the *Resurrection* of the right-hand panel, the rocks on the horizon glow in the Easter dawn. The nocturnal effects reach an interim culmination in Geertgen tot Sint Jans' *Nativity at Night* of about 1490, a virtuoso study in the diffusion of light through dense darkness.[36]

Confronted with this realism, the Italians' darkest nocturnal image, Piero della Francesca's fresco of *Constantine's Dream* (c. 1455), seems more subdued in its effects, as if Piero feels uneasy about turning darkness loose across his imposing figures (FIG. 11.13).[37] Besides being caused by the absence of the sun, the Italian skies also darken in stormy weather, as is the case in Uccello's *Flood* (c. 1445-47) where the clouds are gashed by a conical flash of lightning (FIG. 11.14), or Fra Angelico's *Saint*

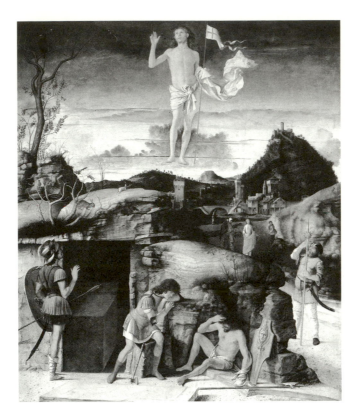

Fig. II.16. Giovanni Bellini, *Resurrection
of Christ* (*c.* 1480), tempera on wood.
Berlin, Staatliche Museen.

Nicholas Saving a Ship during a Storm (1437), where the blue sky shades into black.[38] A
more muted form of darkness – the one in which the transfiguring light of heaven
shines down on Christ – can be seen in Giovanni Bellini's *Transfiguration of Christ*
from the late 1480s (FIG. II.15).[39] Here the discreet celestial rays shine down from
blue-grey clouds laden with rain, while breezier white clouds can be seen floating
further away in the background of the overcast grey sky. This could be a perceptive
portrait of April weather, and thus it comes as no surprise that Bellini is also the
painter to carry on with his father's sunrise motif. It is taken up again in works
such as *Agony in the Garden* (*c.* 1460; London, National Gallery) and *Resurrection of
Christ* (*c.* 1480; FIG. II.16) and, as we will see, Mantegna, Giovanni's brother-in-law,
takes it to Mantua in his *Christ as the Suffering Redeemer* (*c.* 1495-97; PLATE 38).

While the 15th-century landscape image might, then, occasionally admit to

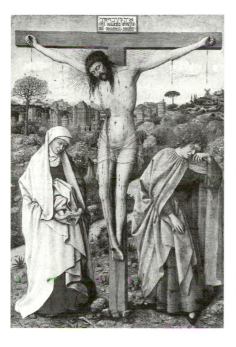

Fig. 11.17. School of Jan van Eyck, *Crucifixion* (1430s), oil on wood. Berlin, Staatliche Museen.

Fig. 11.18. Hugo van der Goes, *Donors and Saints* (late 1470s), oil on wood, right panel from the *Portinari Altarpiece*. Florence, Galleria degli Uffizi.

variations of the diurnal cycle, it is a different story with the annual equivalent. The flora is mostly evergreen and in flower, but, if not, then it leaps straight to an unspecified and total withering. As we saw exemplified in Piero's *Resurrection* (cf. Interlude), the withered or dead flora can be prompted by the theme (PLATE 10). A corresponding symbolism with a dead tree contrasted to a flowering one can be seen in the background of the Jan van Eyck school *Crucifixion* (FIG. 11.17). But apparently there is no need for any iconographic compulsion given that the 15th-century landscape image acquires an increasing number of dead trees, which appear among the thriving ones.[40] On the other hand, Robert Campin's wintriness is only followed up a few more times during the 15th century, the most striking example being Hugo van der Goes' *Portinari Altarpiece* where all three panels depicting the *Adoration of the Shepherds* (late 1470s; FIG. 11.18) are filled with bare trees and ravens.

Post 1470: overcast skies

While the landscape images in the wake of the paradigm shift are controlled by sunshine and blossoming, their successors from about 1470 onwards, and especially in the 16th century, become more complex: the sky might be overcast, the light might be that of dusk, and among the evergreen trees there are now not only leafless trunks but also trees with faded brown leaves. Situations involving weather and time, which formerly required specific iconographic justification, are now part of the general landscape paradigm. However, while North and South share the clouds and more complex times of day, they gradually drift apart in their approaches to the subjects of weather and seasonal traces. Whereas the Italians have little inclination to go beyond the unspecified withered leaves and twilight, the seasons and the weather are more manifest North of the Alps from and with Brueghel.

The newly-overcast pictorial sky could be said to behave like the clouds of reality, which increase the temperature at night, but lower it in the day. In Italy, we thus encounter a 'nocturnal' cloud cover which, while admitting a new kind of mood, also supports the closed, geocentric world picture that is in the process of re-establishing itself. Just behind the clouds we can feel the presence of the Counter Reformation's down-to-earth sky, which seems to be permanently ready to slash them open in a revelation. These are the nocturnal clouds that will frame the Baroque realm of *chiaroscuro*. The 'daytime clouds' of the North, however, hold the source of rain, snow and seasons, and their skies are at a greater distance from the underlying earth. These clouds have to be able to pile up to dizzying heights above the flat soils of the Netherlands.[41]

The darkness which may, increasingly, appropriate the pictorial space in its entirety, does not, of course, kick in without warning, but has a number of forerunners, all of which are, however, conceived of and determined by the modern paradigm. In addition to variations in the diurnal and seasonal cycles, we can spot two in particular: *locally-qualified shadows*, especially indoor dimness; and outdoor *mist*. Right from the paradigm shift of 1420, figures can be placed in surroundings where they appear against a dark background. It could be van Eyck's donor in his semi-dark architectonic niche (*c.* 1432; FIG. II.19), or it could be Cosmè Tura's Madonna in her shadowy garden (*c.* 1452; FIG. II.20). As darkness gradually loses its tie to such delimited locations, it can be conditional for the landscape space as a totality: for example, overcast skies or twilight. In *Saint George and the Dragon* of 1469, for instance, Tura manages both to darken his figures with sooty shadows and to make these shadows a convincing expression of the scene's yellow-toned gloaming.

If the shadows thus move from the close-up to the distance, the mist moves in the opposite direction. Earlier in the 15th century, the mist is exclusively a feature

Fig. 11.19. Jan van Eyck, *Donor* (*c.* 1432), oil on wood, from the *Ghent Altarpiece*. Ghent, Cathedral of St Bavo.

Fig. 11.20. Cosmè Tura, *Madonna and Child in a Garden* (*c.* 1452), tempera on wood. Washington, National Gallery of Art, Samuel H. Kress Collection 1952.5.29.

of the distant horizons. It is the white haze stretching some distance up into the blue firmament, turning the mountains light-blue and softening their outlines. The shift of atmosphere around 1470 could accordingly be described as an expanded radius of action for this haze: on the one hand, it can absorb the sky in its entirety (overclouding) and, on the other hand, it can spread via the darkness to the immediate space (*sfumato* and painterliness). While the atmosphere and interplay of light/dark in *sfumato* still keep to the other side of the image plane, which consequently seems whitewashed and sharply delineated (window), through painterliness they have taken possession of it, sullying it by traces of brushstrokes (veil or mirror). In Damisch's terminology, the brushstrokes have here changed function from denotative *cloud* to connotative /cloud/.[42]

The extent to which painterliness on the image plane is caused by atmosphere and light from remote space becomes clear from the work of the inventor of

Fig. II.21. Giovanni Bellini, finished by
Titian, *Feast of the Gods* (1514/1529), oil on
canvas. Washington, National Gallery of
Art, Widener Collection 1942.9.1.

painterliness in the modern era, Giovanni Bellini. Even such a divine motif as the
Feast of the Gods – his late work for Alfonso d'Este's Camerino di alabastro, finished
by Titian – is lowered into terrestrial time to such an extent that a pale-yellow glow
breaks through between the trunks of the forest trees (1514/1529; **FIG. II.21**). At the
same time, the castle atop the shadow-swathed rocky outcrop is struck by a ray of
sun, causing it to glow against the deep-blue sky. This landscape also features trees
with dead foliage and trees whose green leaves show the first spots of brown. It is
not for nothing that a devotee of the picturesque such as Uvedale Price could regard

Venetian painting, particularly the works of Giorgione and Titian, as being based on autumnal colours, even calling autumn "the painter's season".[43] These picturesque innovations are thus also soon to be seen among the customary features in Italian landscape images, from Dosso Dossi to Beccafumi.

Sfumato too is a phenomenon that throws a bridge from the stylistic *how* to the thematic *what*. Even though Leonardo does not provide a straightforward recipe for *sfumato*, his notes are full of deliberations as to atmospheric and temporal influence on light. To linear perspective he adds two further kinds of perspective, both of which relate to the behaviour of objects in the atmosphere. The one, *colour perspective*, deals with "the variation and loss or diminution of the essential character of colours" when they are pulled away from the eye. The other, *aerial perspective*, pertains to the explanation as to how things seen at a distance have to be less defined and more similar to the colour of the atmosphere.[44] Notice here the use of "less defined" (*meno profilato*), which clearly turns aside from plasticity and closedness, and instead towards the projection of infinite space.[45]

In addition, Leonardo also writes about the light itself. Bearing in mind the typical manner in which trees in 15th-century paintings are lit through by the blue of the sky, it can come as no surprise that he has to recommend the midday sun in order to achieve this particular effect. Otherwise he prefers moments in time when the light is muted and distributed more softly: cloudiness, sunrises or sunsets. Works executed with this light are "sweet and every kind of face acquires grace". The reddening of the clouds at the horizon gives rise to a mixed tone between red and blue "which renders the countryside very gay and cheerful." The twilight glow that endows Ginevra de' Benci's face with a graceful ivory luminosity would seem to be a case of theory put into practice (*c.* 1474; FIG. 11.22). Leonardo goes on to assert that objects not struck directly by the sun "appear to be enveloped in obscuring mists [...]." He also discusses various forms of smoke and vapour and recommends that a landscape should be made "with smoke in the manner of a thick mist, so that clouds of smoke are seen in various locations [...]. And the highest parts of the mountains will be more evident than their bases [...]."[46] From such comments, it is not such a very great leap to the phantasmagorical, mist-enveloped mountains seen in works such as *Mona Lisa* and *Virgin of the Rocks* (FIG. 12.31 and PLATE 36; see also chapter 12).

True to form, Leonardo was also the first to study atmospheric forces on the very large scale. In a drawing showing stormy weather breaking over a mountain valley (FIG. 11.23),[47] the point of view is so high that we see both the downpour of rain falling on the smaller mountains under the clouds and a mountain ridge rising above these clouds. When, in *On Painting*, Leonardo advises how to depict this kind of storm, he uses the term *fortuna* because, like its synonym the temporally-derived *tempesta*, this stormy weather was the epitome of the unpredictable events

Fig. II.22. Leonardo da Vinci, *Ginevra de' Benci* (*c.* 1474), oil on wood. Washington National Gallery of Art, Ailsa Mellon Bruce Fund 1967.6.1.a.

Fig. II.23. Leonardo da Vinci, *Storm in an Alpine Valley* (*c.* 1500), red chalk on paper. Windsor, Royal Library.

occasioned by time.[48] The connection is elaborated in an alarming manner in Leonardo's well-known 'deluge' drawings, where the ruthless power of the storm cleaves the very mountains.

How innovative these themes relating to weather and light might have seemed in an age which was otherwise well under way with re-instituting the closed body as the foremost yardstick of art, becomes apparent if we move northward and look at Erasmus' praise of Dürer in the dialogue *De recta Latini Graecique sermonis pronuntiatione* (*On the Correct Pronunciation of Latin and Greek*; 1528).[49] In making a comparison with Apelles, who achieved his results by the use of colour, Erasmus is impressed by the graphic artist Dürer because by means of the mere black line he not only produces proportions and harmonies: "Nay, he even depicts what cannot be depicted: fire, rays of light, thunderstorms, sheet lightning, or even, as the saying is, the clouds upon a wall [*nebulas, ut aiunt, in pariete*]." With this slightly paraphrased citation from Ausonius (cf. chapter 3), Erasmus is alluding to the 'undrawable' par excellence, as in his *Adagia* he makes it clear that such a cloud is "something most similar to nothing or a dream" and consequently too

incorporeal to express in colour.[50] In modernity, however, it is this incorporeal matter that comprises such stuff as images are made on, and Dürer's wall clouds, the already *re*-presented mists, thus become indistinguishable from Leonardo's still unformed wall stains, those "obscure things" which under the influence of imagination can be included in the domain of the figuration, for example that of the landscape (cf. chapter 9).

In the contemporaneous Florence, Piero di Cosimo is also an artist working at the intersection between the stylistic potential of the paradigm and its condensation in themes related to meteorology. At the same time as using, in *Perseus Freeing Andromeda* (*c.* 1515; Florence, Uffizi), for example, a form of misty brushwork that is midway between *sfumato* and Venetian painterliness, between *cloud* and /cloud/, he is exploring subject matter such as: being dazzled by the light of celestial rays (*Incarnation with Saints* (*c.* 1505-10), Florence, Uffizi); storm clouds (*Portrait of Simonetta Vespucci* (*c.* 1501); FIG. II.24); and, not least, forest fire – his paintings of primitive humankind, commissioned by the wool merchant Francesco del Pugliese in the 1490s, show smoke and clouds working together to bring about a darkness against which the flames light up (FIG. II.25).

According to Vitruvius, forest fire, a topos in the depiction of hard primitivism, is triggered by friction between closely-packed trees during stormy weather.[51] After their initial fear, people discover that heat makes their bodies feel good and they

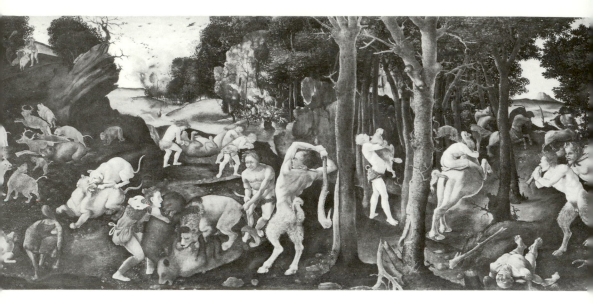

Fig. II.25. Piero di Cosimo, *Hunting Scene* (1490s), tempera and
oil transferred to masonite. New York, Metropolitan Museum
of Art. All rights reserved, The Metropolitan Museum of Art.

learn to keep it alight. The discovery of fire leads to the institution of civilisation,
because people now gather around it and then learn to speak, walk upright and,
eventually, to build huts. And for Lorenzo il Magnifico, Piero's contemporary, storm
and forest fire are made into another aspect of the Fall, passionate love:

> But, if Aeolus frees from the cave fierce and violent winds, not only the green branches
> break, but whole aged pines fall to earth: the infuriated sea menaces the miserable
> wood of the pointed prow, and seems to despair; the air of dense clouds assumes a
> veil; so mourns earth, sea and sky.[52]

Lorenzo goes on to describe how the wind transforms a spark into a forest fire,
so that the formerly so homelike forest expels its residents: the animals and a
shepherd. Forest fire is thus linked to a whole register of features from advanced
civilisation: language, craft, warmth as protection from the cold, passionate love,
raging of the elements. And, as such, its pictorial rendering can be seen as a form
of condensation in the modern paradigm – the very paradigm which renders visible
the post-paradisiacal era and makes inner passion and outer weather slot together.

In the contemporaneous Venice, Giorgione's *La tempesta* (c. 1505-10; PLATE 30)

Fig. II.26. Giovanni Antonio Amadeo,
God Admonishing Adam and Eve (*c.* 1472-73),
marble relief. Bergamo, Cappella Colleoni.

is a particularly striking example of this the motif being absorbed into the style, of narration being lifted into the paradigm. If the weather theme contributes to the painting's pioneer status, it is not so much because of the newsworthiness of stormy weather and lightning, but because of the manner in which these phenomena become part of the general mood of the painting. Who would have suspected that a gathering storm could arouse such gentle, melancholy yearnings?[53] The overcast sky makes the trees, lit-up by the lightning, stand out against the green-grey background, and it casts the whole foreground landscape and its three figures in mysterious shadow. But this is still not, as a number of art historians have wrongly assumed, a case of sheer *poesia*, an image devoid of defined narrative, for, as Salvatore Settis has convincingly shown, the painting shares its figurative arrangement with a relief by Giovanni Antonio Amadeo, *God Admonishing Adam and Eve* (*c.* 1472-73; FIG. II.26).[54] What the painting is so discreetly referring to is a situation after their expulsion when a staff-holding Adam and a nursing Eve rest against a background of the lost Paradise, a New Jerusalem in the shape of a modern Italian city.[55] The broken columns and wall ruins in the middle distance thus become emblems of the post-paradisiacal decline. Seen through this lens, which naturalises the allegory by absorbing it in a contemporaneous landscape, the lacerating lightning of the stormy

sky can be specifically understood as a figure which is otherwise very conspicuous by its absence, namely the admonitory God of the relief. The consequent transformation of the incarnated deity into a vanishing flash is emphasised in the fallen world below, where the serpent of the Fall, Satan, is also seen, in a reflection of the lightning's sinuous flight, darting into a cave under the rock. *La tempesta* thereby becomes a Southern offshoot of the North European proliferating image type which reduces the narrative – and its associated moralising – in unison with the opening up of the wide expanses of the landscape. In the large void between Adam, Eve and Cain, God fades away to infinity, a sublime intimation in the sultry thunderstorm atmosphere. Paradise has been, in the most profound sense, forsaken.

If weather is an indispensable compensator for Venetian *poesie*'s breakaway from narrative, it is obviously even less dispensable for the autonomous landscape image – the landscape image holding so much 'content' in itself that it can be enjoyed purely at face value. In Albrecht Altdorfer's autonomous landscape images from the 1520s, the first to be produced in the West, a significant element of this content indeed comprises the mist and light into which the land has sunk. In two instances, the mist is even wrapped around a sunset.

Post-1500: nocturnal clouds to the south, diurnal clouds to the north

But, as already mentioned, the weather of the images does not open the way for the same route to modernity north and south of the Alps. If the greying clouds in Italy entail a new landscape mood, a 'nocturnal' aspect nevertheless makes sure that the heat is retained – heat understood as pre-modern, geocentric animation. Their emergence thus coincides with the High Renaissance, as if they were to prevent a leakage of that volume which neo-antique plasticity re-injects into the body. In the Gothic style, the body was elongated under the expanding sky; in the High Renaissance it becomes muscular, because the firmament is again closed.

This epistemic climatic change can be detected in an amazingly concrete manner from a pictorial genre that sprouts up in Italy after 1500: scenes in which the sky meets the earth – revelations, visions, transfigurations, ascensions, expulsions, and so forth. The genre not only substantiates that the divine heavens still exist, but also that they are at an approachable distance to earth, since the celestial figures are always depicted on the same scale as the mortals. In Raphael's *Disputà* (1510-11), the clouds bearing the celestial assembly have sunk down to a level immediately above the heads of the disputing theologians (FIG. 21). At the same time, the landscape view with building and trees has been moved to a distant background, as if it is them, and not the heavens, that belong to the hereafter. Close juxtapositions of

Fig. II.27. Albrecht Dürer,

Sojourn of the Holy Family

in Egypt (*c.* 1502), woodcut

from the *Marienleben* cycle

(published 1511).

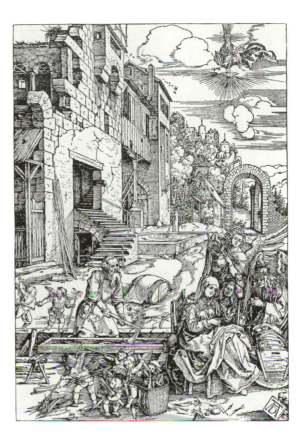

heavens and earth such as this do not occur nearly as frequently in Northern art because, as in Giorgione's *La tempesta*, the sky here has slipped out to the distance delineated by the landscape's horizon. In a revelation scene such as Dürer's woodcut of the *Sojourn of the Holy Family in Egypt* from *c.* 1502, the perspective is ruthless in ensuring that God is kept back in a distant sky (FIG. II.27). From far away, on a cloud, He looks down upon the large foreground figures.

Nor are the Italian revelations restricted to Christian contexts – no more than the neo-antique abundance of figures is a speciality of antique themes. Raphael releases cherubs from the clouds in his *Triumph of Galathea* (1513, Rome, Villa Farnesina). Giulio Romano lets the giants fall from the antique Parnassus (*c.* 1532-34, Mantua, Palazzo Te). Correggio lets Io be embraced by the cloud-clad Jupiter (*c.* 1532; FIG. II.28). We are here dealing with a Catholic epistemic *field* which, be it called Renaissance, Counter Reformation or Baroque, re-installs humankind in a celestial hierarchy – a hierarchy that would seem to be definitively dismantled in the Protestant – and proto-Protestant – culture.[56] Mannerism might be a disruption

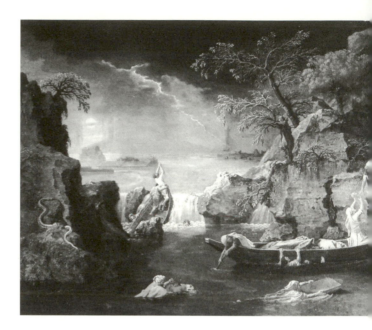

Fig. 11.28. Correggio,
Jupiter and Io (c. 1532),
oil on canvas. Vienna,
Kunsthistorisches Museum.

Fig. 11.29. Nicolas Poussin,
Winter, or The Flood
(1660-64), oil on canvas.
Paris, Musée du Louvre.

within this archaic tendency, a protuberance from the chaos of the Gothic style. Like the Gothic, here we see the reappearance of both the figurative elongation and the mixture of extreme naturalism and affected artificiality. And yet here, too, everyday life, physical labour, weather and ugliness are kept at a suitable distance.

In relation to the closedness of the Renaissance image, the 17th-century ideal landscapes by Poussin and Claude Lorrain, both Frenchmen residing in Italy, nevertheless signify an opening. Particularly in Claude's case, the figures become diminutive under an extensive sky, which now also admits a sinking afternoon sun. And yet, the spatial expanses and the temporal changeableness are still muted. The figures never leave the landscape setting which surrounds them in the same manner as a mount embeds a jewel. The sun never seems to reach the horizon, and late summer never turns into autumn. Just how alien changeableness is for these landscapes is starkly illustrated when the ageing Poussin atypically depicts the *Four Seasons* (1660-64). Even though snow is absent in *Winter*, it is already non-classical in its rainy darkness (**FIG. 11.29**).[57]

The absolute contemporaneous antithesis of the ideal landscapes is to be found in the Netherlands, where temporal phenomena such as snow, heavy rainclouds and nocturnal light are common occurrences (FIG. 22). In his *Het Schilder-Boeck* (1604), Carel van Mander praises sunrises and adds that "you cannot show the distance too vaguely" because of the mistiness of the air, thanks to which the "hazy landscape in the distance begins to look like the sky, and almost merges into it. Solid mountains seem to be moving clouds." Even though he considers extreme weather conditions to be the exception, a thunderstorm sky should be "monstrously ugly", and the path of lightning through the dark stormy sky should frighten the mortals. Furthermore: "One should try to express in paint, the snow, hail, rainy squall, ice, hoar frost, and impenetrable fog. These are all needed to show gloomy winter days, for when we try to see distant spires, houses and towns, we realize that we cannot see further than a stone's throw." Nonetheless, van Mander feels called upon to grumble that certain nations accuse the Netherlanders of never painting good weather.[58]

In contrast to the Italian Baroque painting, in which the sacredness of the sky prevents it from being viewed in large sections devoid of figures, the North European dispersal of God in an infinite Copernican space causes the sky and the overall landscape expanses to undergo a pictorial extension, possibly leading to a total displacement of the figure. Above the flat terrains in 17th-century Dutch landscape paintings, we see a misty sky which can easily take up three-quarters of the image plane. From such a de-sacralised sky it is unthinkable that a band of angels would be able to burst through in a golden radiance, descending effortlessly down to earth. In order to experience this still geocentric sky, we have to go to the conservative pocket of modernity, Italy of the Counter Reformation and the Renaissance. Is it possible to imagine that Descartes, the philosopher of the mechanical world picture, could have developed his ideas in Italy rather than the Netherlands, or that Giordano Bruno, martyr to the infinite cosmos, could have been burnt at the stake in Amsterdam rather than Rome?

II.2 Territory and wilderness

Scanning the paradigm

In the same way as the paradigm of modernity breaks with the timelessness of the Golden Age paradigm, it also challenges the unexploited *terra* of this paradigm, the wild mountains. A multiplicity of terrains enters pictorial art after 1420 – besides the now more peripheral mountains: plains, forests, marshes, bays – all of which are potential objects for the Fall's territorial control, especially the control that stems

Fig. II.30. Giovanni di Paolo, *Saint John the Baptist Entering the Wilderness* (c. 1453-64), tempera on wood. Chicago, Art Institute.

from agriculture. As in Ovid's Silver Age, now, for the first time, Ceres' "seeds of grain were planted in long furrows", and, as in Ovid's Iron Age, it is quite safe to say that "the ground, which had hitherto been a common possession like the sunlight and the air, the careful surveyor now marked out with long-drawn boundary-line."[59] (cf. chapter 4)

As in the perhaps key iconographic forerunner of the modern paradigm, the land surveying treatises of late antiquity, here we can again trace a connection between use and measuring. Just as in chapter 10 I was able to show that it was principally secular utility contexts – health compendia, labours of the months, encyclopaedias, property portraits – which led directly towards the genesis of the modern landscape image, I can also here, in the network of fields, trace a type of constructive interference, a reciprocal reinforcement between the earth's use in particular and the new pictorial space in general. For if the hard and undulating rocks of the Golden Age paradigm were impervious to the plough, while in their chaos they thwarted spatial definition and in their verticality hindered the view towards the horizon, the viewpoint is now displaced to the plains, which can be ploughed, measured and surveyed. It is the triumph of geometry – tellurian surveying – where the Latin *limes*, the border between two ploughed fields, is transformed into that *limes* which in differential calculus, the mathematics of the system of co-ordinates, designates the marginal value for a function that goes towards infinity. In effect, the measure to which *modus*, the mother word of modernity, refers (cf. chapter 9), could, also in the Roman period, be a surface measure, especially an agrarian unit.[60]

This movement, in which agriculture's land marks are transformed into the incorporeal spatial lines of mathematics, can be read with sensuous tangibility in several 15th-century landscape images. In Giovanni di Paolo's *Saint John the Baptist Entering the Wilderness* (c. 1453-64) the wilderness is represented by mountains, whereas civilisation, which the holy man leaves behind, is indicated by a flat grid of fields (FIG. 11.30). From the almost aerial-photographic angle whence the fields are viewed, this grid looks just as much like a dizzying albeit somewhat awkward study in perspectival foreshortening. A similar effect can be observed in Leonardo's drawing of the imaginary Arno landscape (1473), in which the distant, foreshortened grids are positioned in an ambiguous zone between fields and a perspective that measures out the plain (FIG. 9.6). The section on landscape painting in Carel van Mander's later *Het Schilder-Boeck* actually includes advice on this effect: "Notice how the ditches and furrows in the field taper and converge at the same vanishing point, looking just like a tiled floor. Do not get bored taking it all in, as it will give a convincing sense of space to your own background."[61] Although the tract results from a period in which the cultivated landscape blossomed in Dutch art, van Mander's idea of boredom suggests a slight insecurity about this effect, as if it exercised force on untamed nature.

The boredom could, however, indicate another point at which the fields become symbolic of the culture that depicts them in landscape images: modernity's *plainness*, i.e. its uniformity and mediocrity. Fields are areas where the soil is evened out and, in the actual space of the Later Middle Ages, this plainness reached a hitherto unseen extent. The fields crept further up the mountains than they had before and, in the modern *field's* centre of gravity north of the Alps, wetlands such as marshes, bogs, lake shores and rivers, which had previously been too waterlogged to cultivate, became cultivatable as a result of drainage and the new deep-digging wheeled ploughs.[62] At the same time, plainness is a keyword in modern, popular culture. In *rota Virgilii*, an interpretative schema systematised by the Parisian scholastic John of Garland (b. *c.* 1190), but with roots back to Donatus (*c.* 350), the writing styles, *artes poeticae*, are arranged in order of precedence in concentric circle segments corresponding to Virgil's three works: one for the high, serious style (*gravis*) represented by the *Aeneid*; one for the mediocre style (*mediocris*) represented by the *Georgics*; and one for the humble style (*humilis*) constituted by the *Eclogues*.[63] Thus the peasants do not represent the lowest soil, *humus*, but are evened out, via their occupation, to a middle position in the cosmic wheel, which at the same time makes neighbours of shepherds and heroes. This is modernity in its social aspect, in which the individual is not isolated, but appears in a homogenised common mass, *vulgus*. The *vulgata* version is the Bible for everyone; *volgare* is the common language spoken by the people; the *comune* is government based on collective work. As the earth is evened out in the ploughed furrows of the fields, then so is society homogenised towards the mediocre norm – the very same middle way that was celebrated by Eustache Deschamps' worker (cf. chapter 10).[64]

And, as such, it again has Saturn as tutelary spirit. While I earlier pointed out that Saturn, god of time, was intimately linked to the atmospheric changes in the landscape image, his influence similarly extends to its territory. It is part of his peculiar dual nature that just as much as he presides over the agriculture-less Golden Age, he also protects its successor, civilisation, which sows, reaps and divides. A recurring attribute is thus a sickle or a scythe, and in astrological illustrations, for example in 15th-century block books, his crippled, criminal and forest worker *Planetenkinder* are accompanied by farm workers (**FIG. 11.31**).[65]

Saturn also gives us a sense of how closely the perceptions of space and time are connected. His measurement of time forms part of an overall personification of every type of measurement, including land surveying.[66] Similarly, there are hazy boundaries between his harvesting and temporal activities: the sickle and scythe, which gather in the grain, turn into the scythe with which his alter ego, Death, reaps his souls. In truth, working in the fields was so gruelling in itself – grinding to death – that the Grim Reaper had no need to strike here, but could make do

Fig. 11.32. Hans Holbein the Younger, *Ploughman* (1523-25), woodcut made by Hans Lützelburger from the series *Totentanz* (*Bilder des Totes*). Dresden, Staatliche Kunstsammlungen, Kupferstich-Kabinett.

Fig. 11.31. *Saturn* (c. 1480), pen and black ink, from the *Master of the Housebook Manuscript*. Aulendorf, Fürstlich zu Waldburg-Wolfeggsches Kupferstichkabinett, f. 11.

with pushing at the yoke and egging on the oxen. This is how, running exuberantly, he is portrayed in one of the sheets from Hans Holbein's woodcut series *Totentanz* (1523-25) depicting the *Ploughman* (**FIG. 11.32**).[67] Rather than the disastrous and suddenly fatal hour, our common destination has here been extended in time, a time that is indicated by the ploughed furrows' relentlessly perspectival sweep towards the vanishing point, the setting sun. The Hebrews had also employed this personification of Death as the reaper, and here it had already provided presentiments of time, in that it was specifically linked to the unburied dead: "The dead bodies of

men shall fall like dung upon the open field, like sheaves after the reaper, and none shall gather them". (Jeremiah 9: 22) And: "[...] they shall not be gathered or buried. They shall be as dung on the surface of the ground." (Jeremiah 8: 2)

The circle is thus, once more, complete – the modern landscape paradigm's morbid circle of which one half is comprised of the vaporous atmosphere, the realm of the dead converted into temporal restless weather, and the other half is comprised of the ploughed fields, the consumed earth manured by its own unburied cultivators.

Farm land as park: territory and wilderness in the 15th-century landscape image

If we now turn our attention more specifically towards the 15th-century landscape image, we have to note that, in the same way as it toned down temporal inconsistency, nor is it actually intrusive when it comes to its work associations – just as the wilderness is similarly restrained. If the 15th-century image has a typical landscape, then it is made up of a green terrain, the components of which enter into a pleasantly harmonious blend against the summer-blue sky. We see grass-covered hills, trees and copses, fields, meadows, hedges, meandering streams and rocks. We see cities, castles and farms; and tracks, gravel roads or the occasional bridge conduct the imaginary visitor through the terrain. Any scenes of sea, bays or mountains are generally located towards the distant, slightly misty horizon. The landscape is domesticated, but not over-eager to display its utility function. It is an agricultural landscape camouflaged as a park.

Elements associated with fertility include: fields, pastures, orchards, fences, hedges, tree stumps, roads, bridges and, as we will see in chapter 12, quarries. In the 15th century, however, none of these elements make a show of their working function, and field cultivation in particular goes through a noticeable curve, both North and South of the Alps, reminiscent of the curve followed by weather and light: high at first, quickly flattening out, and rising again at the end, after which, in the 16th century, it divides into North and South.

As can be seen in, for example, Gozzoli's *Adoration of the Magi* (1459; FIG. 11.33) or Botticelli's little panel of *Judith's Return to Bethulia* (1470s; FIG. 11.34), fields and ploughed furrows feature whenever the opportunity arises. Nonetheless, what lies between the hedges in the images is seldom precisely defined, be it mature fields, fallow fields or pastures. Surprisingly, the impression of a park is particularly dominant in the Netherlands, from Roger van der Weyden onwards. The muted utility function of the landscape is signalled by the temporary disappearance of the windmill – the corn milling machine. While they still leave their mark on the horizon in

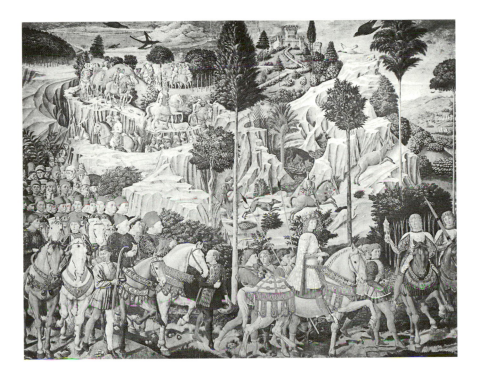

Fig. 11.33. Benozzo Gozzoli,
Adoration of the Magi (1459),
fresco. Florence, Palazzo
Medici Riccardi.

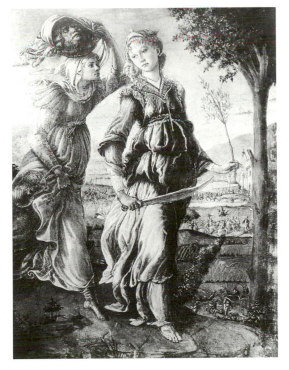

Fig. 11.34. Sandro Botticelli,
Judith's Return to Bethulia (1470s),
tempera on wood. Florence,
Galleria degli Uffizi.

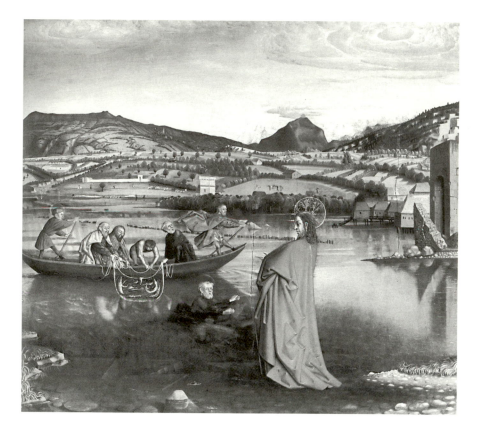

Fig. 11.35. Konrad Witz, *Miraculous Draught
of Fishes* (1444), oil on wood. Geneva,
Musée d'Art et d'Historie.

pioneering works such as the Jan van Eyck school *Crucifixion* (1430s; FIG. 11.17) and
the *Turin Hours' Betrayal of Christ* (FIG. 11.5), they then slip out of sight and do not
reappear until around 1500 in Bosch (*Temptation of Saint Anthony*; Lisbon, Museu
Nacional de Arte Antiga).

In the wake of the paradigm shift, distinct specifications of fields are to be found
in Robert Campin's *Nativity* (c. 1425; PLATE 7), in Jan van Eyck's *Madonna of Chancellor
Rolin* (c. 1433-34; FIG. 9.2 and PLATE 28), in Konrad Witz' *Miraculous Draught of Fishes*
(1444; FIG. 11.35), in Gentile da Fabriano's *Strozzi Altarpiece* (1423; PLATE 6) and in
Domenico Veneziano's *Adoration of the Magi* (1439-43; Berlin, Staatliche Museen).[68]
Uccello's depictions of the *Battle of San Romano* (c. 1445; FIG. 9.24) also take place
against a background of brown ploughed fields,[69] and in his later *Saint George and*

Fig. II.36. Paolo Uccello, *Saint George and the Dragon* (1456-60), tempera on wood. Paris, Musée Jacquemart-André.

the Dragon (1456-60; FIG. II.36), the city, Selena, is surrounded by flat fields. In addition to being made possible in the modern paradigm, these fields are endowed with a particular thematic import in that 'George' means 'earthworker'.[70]

The agricultural workers themselves are illustrated in the pictorial theme of *the flight into Egypt*. According to a legend, which apparently did not become tradition until the 13th century, during their flight to the granary of the Roman Empire, Mary and the infant Jesus encountered a peasant sowing wheat. Jesus reached into the seed basket and threw a handful of seed corn onto the ground where, by morning, it had grown into ripe ears of corn. When Herod's soldiers heard that the peasant has last seen Jesus at sowing time they abandoned their search. The tale is presumably a symptom of the late medieval development in which Mary became more overtly identified with the goddess of corn; through Christ's sacrifice the corn can rise again.[71] Seen in this light, the otherwise primarily paradigmatically-determined ploughed fields in Gentile's interpretation of the theme are perhaps endowed with an extra iconographic weight – a matter that should be corroborated by the following comparisons: in the *flight* scene in the early-15th-century *Rohan Book of Hours*, i.e. before the paradigm shift, the peasant is in the process of harvesting the newly-ripened corn when the soldiers appear (FIG. II.37); in Giovanni di Paolo's version (*c.* 1440) there are no soldiers, but, then again, two field hands are working

Fig. 11.37. The Rohan Master, *Flight into Egypt* (early 15th century), miniature from the *Rohan Book of Hours*. Paris, Bibliothèque Nationale, ms lat. 9471, f. 99.

Fig. 11.38. Joachim Patinir, *Rest on the Flight into Egypt* (*c.* 1520), oil on wood. Madrid, Museo del Prado.

with spade and hoe, while a third is ploughing in the background (**FIG. 11.10**); and in several 16th-century Flemish depictions of the *Flight* narrative, by Patinir for example, the field hands have been put to work out in the panoramic world landscape (**FIG. 11.38**).[72] These scenes are all interesting because they provide a rare illustration of the agricultural activities behind the 15th-16th-century paradigm's otherwise invisibly cultivated fields.

Fig. II.39. Michele
Pannonio, *Thalia*
(1456-59), tempera
on wood. Budapest,
Szépmüvészeti Múzeum.

The pressure of agricultural work on painting was also manifested more indi-
rectly, as we have seen, in Guarino's Pisanello-*ekphrasis* from the 1430s. Pisanello's
manner of painting was so lifelike that Guarino "put out a hand to wipe the sweat
from the brow of the labouring peasant".[73] Agriculture again makes its presence felt
when, in 1447, the Ferrarese court humanist is designing the first monumental work
of modernity with a thoroughly antique content, the now only partially extant cycle
depicting the *Muses* for the *studiolo* in Belfiore Castle.[74] In late antiquity, Boethius
(*c.* 480-*c.* 525) had accused the arts of the muses – *inter alia* poetry, song and music –
of being frivolous and in conflict with theology and philosophy. The humanists
of a more modern era – Petrarch, Boccaccio, Salutati – had therefore done what
they could to rehabilitate them, not least by highlighting poetry as the source of
theology. Guarino now gives the inspirational power of the muses a simultaneously

more useful and fecund slant when he resorts to a Byzantine Hesiod tradition in which two of the muses become tutelary spirits for agriculture.[75] According to a letter written by Guarino to Leonello d'Este in 1447, Thalia's customary comedy is replaced by "one part of agriculture, that which concerns planting the land". And Polyhymnia did not discover the writing of hymns, but the cultivation of fields: "[...] let her be girt up and dispose hoes and vases of seed, bearing in her hand ears of corn and bunches of grapes."[76]

This agriculture is thus the late medieval all-embracing variety which puts grain and wine cultivation on an equal footing, a juxtaposition that is also seen in Michele Pannonio's free interpretation of Thalia from *c.* 1456-59, an enthroned women crowned with corn and holding a rose and a vine (FIG. II.39). The admission of agriculture to this princely private cycle, which otherwise focuses on the more 'musical' arts, could be seen as a sign of a despotism trying to create a more civically legitimate, quasi-republican image. Activities appreciated by Leonello d'Este lead to, *inter alia*, the Good Government in the countryside, while also stimulating the fertility of the soil – thus providing justification for otherwise extravagantly erotic gestures such as unlacing the bodices of several of the muses.[77]

The accuracy of the first part of the reading is confirmed by the fact that the Good Government is also the one later celebrated in Palazzo Schifanoia's *Frescoes of the Months* (1469-71) under the rule of Leonello's brother, Borso.[78] In Sala dei Mesi's cycle it does not, however, appear in the shape of muses, but as the plain agricultural labours of the months of the late medieval tradition. Taking inspiration from the antique *planisphere*, a circular zodiac chart, each month is divided into three bands. Uppermost, the Olympian god of the month exults; in the middle lingers the star sign accompanied by three star demons, known as *decans*; and at the bottom we see various episodes centred on Ferrara's good regent, Borso d'Este. Among the many activities distinguished in the now somewhat ruined frescoes – besides Borso's feats and leisure pursuits, also mythological episodes, plus assorted seasonal labours and amusements – there are quite a few farm labours: in *March* the vines are pruned, in *May* the hay is cut and the trees are pruned, in *June* the grain is harvested, in *August* the land is ploughed and sown (FIG. II.40). Despite this iconographically-determined cultivation, we nonetheless search in vain for agricultural divisions among the green parts of the frescoes.[79] In return, we encounter bizarre rock formations whose si-multaneously growing and artificial qualities would in themselves seem to develop the theme: the fertility of the earth (more about this in chapter 12).

If we again look at the more general traces of work in the 15th-century landscape images, I must also mention the phenomenon *tree stumps*, i.e. vestiges of tree felling. As we saw in chapter 4, trees in the antique and medieval landscape images as often as not bear evidence of pruning in the shape of branch stumps with sharp-edged

Fig. II.40. Anonymous artist, *August* (1469-71), fresco (section). Ferrara, Palazzo Schifanoia, Sala dei Mesi.

surfaces. These traces represent the Golden Age paradigm, in that they can be perceived as a result of horticulture, a gentle shaping of trees that are allowed to carry on growing. The tree stumps, on the other hand, seemingly attest to a more radical intervention in nature, an intervention that is not restricted to adapting the tree, but kills it so that the stump is left mutilated and dead, while the trunk, as in Ovid's Iron Age, "now leap[s] insolently over unknown waves" (cf. chapter 4).

We have already noted the tree stumps in the Boucicaut Master's *Visitation of Mary and Elizabeth* (c. 1401-05; PLATE 35). Later, in Filippo Lippi's adoration scenes, they appear in rocky forest settings among sound and dead trees (c. 1463; FIG. II.41). Mantegna places them in several types of environment: along the winding road in the *Agony in the Garden* (c. 1460; FIG. II.42); on the rock plateau behind *Saint George* (c. 1467; Venice, Accademia); on the flat tract in front of the forest in *Pallas Expelling the Vices from the Garden of Virtue* (c. 1499-1502; FIG. 12.77).[80] In the latter case, they become part of the depraved world beyond the garden, because the trees inside the garden are not hacked down. The tree stumps' link to felling is unequivocally demonstrated in an anonymous Venetian painting of *Saint Jerome in the Wilderness* (c. 1500-20; FIG. II.43). A few men in the background are here in the process of felling trees and collecting branches.[81]

These traces of the exploitation of nature could be seen in context with a typical figure of late medieval literature: the woodcutter. When youths such as Aucassin

Fig. 11.41. Filippo Lippi, *Adoration of the Child with Saints* (*c.* 1463), tempera on wood. Florence, Galleria degli Uffizi.

Fig. 11.42. Andrea Mantegna, *Agony in the Garden* (*c.* 1460), tempera on wood. London, National Gallery.

Fig. II.43. Anonymous Venetian artist, *Saint Jerome in the Wilderness* (c. 1500-20), oil on wood. Toledo (Ohio), Toledo Museum of Art.

or knights such as Lancelot have gone astray in the forest, they encounter this late mutation of the savage man, a semi-monster with unkempt hair.[82] The forest is thus no longer more comfortable than that even its most primitive inhabitants have to procure warmth via the systematic felling of trees. A such diminutive forest worker signifies the kind of nature in question when Altdorfer, around 1522, makes one of the first independent landscape images in the West.[83] Even the Venetians' otherwise so pastoral 16th-century landscapes are not free of tree stumps.[84]

The field *of work ideology*

The utility landscape, which becomes a part of 15th-century painting's new pictorial paradigm, can be said overall to incorporate two contradictory inclinations: on the one hand, a clarification of the origins of fields, hedges, fences and tree stumps in arduous work on the land; on the other hand, an obscuring of these origins in favour of a more park-like appearance characterised by the pursuit of leisure. The admission of utility traces in the general paradigm herewith resembles, as already mentioned, that which was also the fortune of the traces of time and weather, in that the paradigm provisionally postpones the adoption of the more extreme thematic potential (snow, rain, close-up portraits of fields, etc.) – a potential which, in more specific iconographic circumstances, was otherwise already displayed in precursors such as *Tacuinum Sanitatis* and *Labours of the Months*.

Would it be hasty to connect this initial toning down of the landscape images' temporal and work-related potential with the aforementioned "multi-secular breath" in the social structure which, according to Le Roy Ladurie, is underway in this very period – a breath which, in many European regions, is re-strengthening the feudal structure and thereby the polarization between the upper and lower strata of society? Even though I have argued that this re-feudalisation finds its mature paradigmatic pictorial expression in the neo-antique work-free and pastoral landscape image, the ideal landscape, between 1500 and 1700, a certain prelude to this would seem likely, and this prelude, then, could comprise the transformation of agricultural land into parkland in the pictorial paradigm between 1420 and 1500.

Certainly, it is a fact that what in the 12th-13th centuries had constituted a relatively unambiguous liberation process for the peasantry and workers in general, gradually turns into an intense class struggle in the 14th-15th centuries. The conflict is manifested in social unrest such as the 1358 Jacquerie peasant revolt in France, the 1381 peasant uprising in England and the Hussite movement in Bohemia following the death of religious reformer Jan Hus in 1415. As an indication of the upper classes' reaction to this, for example, Rodríguez Sanchez de Arévalo (1404-70), a learned bishop and close ally of the pope, wrote a widely-read analysis of the relations between the social classes, *Speculum vitae humanae* (1468). Whereas in the olden days the peasants turned weapons into tools, it is now the reverse, writes Arévalo, and therefore they must be punished. The good society requires an upper class.[85]

This late medieval deflection of peasant liberation could then find correspondence in the preliminary park-characteristics of the landscape paradigm. But, at the same time, a perceptible countercurrent is also beginning to take shape in Northern Europe: a current which does not go along with the period's "multi-secular breath" on its way towards a re-strengthened feudalism, but which prefers to stress a work

Fig. II.44. Anonymous
artist, *Bailiff and Peasant*
(*c.* 1490-1500), woodcut from
a German edition of Pier de
Crescenzi's *De commodorum
ruralium libri XII* (*c.* 1305).

ethic. A positive evaluation of the peasantry is accordingly detectable in the engravings of peasants which begin to appear after 1470 in the work of the Master of the Housebook, Martin Schongauer, Dürer and the Beham Brothers – interestingly, all artists from areas (respectively, Oberrhein, Alsace and, in the case of the last three, Nuremberg) in which the peasants rose in rebellion, and where a degree of support from the urban middle class, the social stratum to which the artists belonged, could therefore be expected.[86]

This attitude is also apparent in many German woodcuts from the decades around 1500; for example, in a late-15th-century German edition of Pier de Crescenzi's widely-distributed agricultural treatise *De commodorum ruralium libri XII* (*12 Books on the Rural Arts*; *c.* 1305). Crescenzi (Latin: Petrus de Crescentiis), a Bolognese lawyer, was indeed a conservative feudalist of the opinion that peasants were the property of the lord of the estate, but a critical attitude can be sensed in the German illustrations. One of them shows, for example, a stern-faced bailiff harrying the stooped peasant as he hoes (FIG. II.44).[87] An unambiguous critique of feudal society is simultaneously produced by Johannes Lichtenberger (d. 1503), a German astrologer, who in the similarly woodcut-illustrated *Prognosticatio* (1488, imprint 1499) advanced a prophetic vision of the undoing of the social order: "The rich will be overthrown, the poor, however, rise and attain riches." Although Lichtenberger upholds the social stratification, he considers humankind to be one big community.[88]

Fig. II.45. Anonymous artist, *Allegory of Society* (1520), woodcut from Petrarch's *De remediis utriusque fortunae* (publ. Augsburg 1532)

A similar inversion of the social hierarchy is found in a 1520 woodcut illustration for the Augsburg edition of Petrarch's *De remediis utriusque fortunae* (*Remedies Against Luck and Bad Luck*; published 1532). In the text, Petrarch claims that there is no difference between the blood of noblemen and that of peasants, and that nobility is achieved through deeds alone. The woodcut illustrates this outlook by making peasants both the root and the top of feudal society, symbolised by a fir tree (FIG. II.45). The three sets of branches in between hold a hierarchy of, respectively: craftsmen and merchants; bishop, cardinal and princes; pope, emperor and kings.[89]

Faced with illustrations such as these, we get a clear sense that an interest in and compassion for the lower social strata is beginning to gain credence and become part of the emerging Protestant culture. Still in the 15th century, we also come across compelling Italian examples of a work ethic, for example in Lorenzo Valla who declares that work with its potential to transform nature is the means by which

Fig. II.46. Domenico
Veneziano, *Saint John in
the Desert* (c. 1445-50),
tempera on wood, from
the predella of the
Santa Lucia Altarpiece.
Washington, National
Gallery of Art, Samuel
H. Kress Collection.

humankind fulfils its destiny.[90] But, as Max Weber shows, the cultivation of work as a common calling gradually becomes a speciality of North Europe, intensified by the reforming faith of Luther, Calvin and others.[91] In painting, the first results of this alliance probably comprise the secular genres, which make their debut in painting's monumental scale after 1550. For Netherlandish artists such as Aertsen, Beuckelaer and Brueghel, lives of the peasants have become a valid autonomous subject – a subject which often supersedes the religious and mythological themes, relegating them to inconsequential backgrounds or complete withdrawal.[92]

Paradisiacal rudiments of the landscape image

However, as implied, the new landscape formations in painting are not only made up of fields. During its dissolution in the Copernican infinity, Paradise can just as well be transformed into gardens, thickets or forests. While this procedure goes along quite homogenously in 15th-century Netherlandish images, the process of change in Italy would seem to be up against a greater degree of inertia and is therefore more conflict-ridden. The Byzantine rock formations are tougher to stamp out and do not seem prepared to undergo a levelling with the Paradise nature coming down from above, which in its turn retains something of the pre-modern agoraphobic look. Far into the 15th century the turf thus still floats around as detached rugs on the rock formations, as if plant life and underground continue to live their mutually independent lives (**FIG. II.46**).

Fig. II.47. Sandro
Botticelli, *Primavera*
(*c.* 1482(?)), tempera
on wood. Florence,
Galleria degli Uffizi.

Fig. II.48. Anonymous
artist, fresco from Sala
della Donna del Verzù
(*c.* 1350). Florence,
Palazzo Davanzati.

Just such an agoraphobic carpet of flowers spreads relentlessly, for example, under the screening orange trees in Botticelli's *Primavera* (*c.* 1482 (?); FIG. II.47). Venus and her entourage have a curiously weightless appearance since all the flowers and plants distributed so generously by Flora seem to be rooted in an obscure void – a typical effect of meadow floors for the period. Botticelli even reinforces the paradisiacal enclosure by means of Mercury turning away a little flock of clouds with his staff – a gesture recalling Marsilio Ficino's idea of Mercury as a force driving out the clouds from the light of intellectual beauty.[93] And, in this, as we shall soon see, the meadow

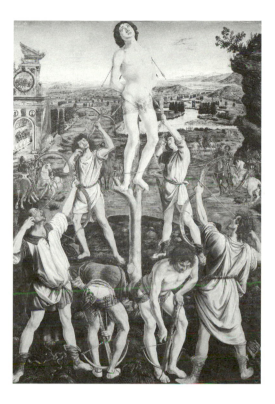

floor takes on the aspect of Venus' cloudless garden of love as depicted in Claudian's *Epithalamium de nuptiis Honorii Augusti* (*Nuptial Poem to Emperor Honorius*; 398 AD).

Indissoluble paradisiacal remnants in 15th-century Italian landscape images are also sensed in the many sequences of assorted trees gathered behind walls or spread across the wide expanses of the landscape (FIGS. 11.6 and 11.33). Are these series of trees not a kind of spatially-reconciled successors to the agoraphobic antique mixed forest as found in the Pompeian garden frescoes or in the House of Livia (PLATE 5)? Immediate forerunners can be seen in the interior decoration of 14th-century palaces, for example in the Florentine Palazzo Davanzati where assorted trees are spread across the flat space between the illusionistic arcades (*c.* 1350; FIG. 11.48).[94]

Were we to identify a watershed where the Italians dissolve the Paradise/underground gap and reach right into the central ground of levelled soil, which the Northerners had already reached with *Les Très Riches Heures du Duc de Berry* (FIG. 10.23), it would have to be the Pollaiuolo brothers' *Martyrdom of Saint Sebastian* from 1475 – a work that is characteristically set on the flattest plain imaginable (FIG. 11.49). In this image, it is as if Giovanni di Paolo's infinite latticework of fields (FIG. 11.30) has slipped from clear-headed concept to an illusion of the senses. Put a hand into

Fig. II.50. Francesco Traini (?), *Triumph of Death*
(1330s?), fresco. Pisa, Camposanto.

the green-brown plain and it really would come out green from grass and brown from soil.

If we look closer at the 'un-dissolved' meadow floors, they would seem to be just as tangibly produced by the garden notion as are the series of trees. Quite to what an extent is apparent from comparison with an earlier example such as the *Triumph of Death* (1330s?; FIG. II.50).[95] The Garden of Vanity is here a flourishing plant environment floating around in the bare rocky landscape in the same way as the abovementioned sections of turf. However, this garden also demonstrates just how ambiguous the concept of Paradise has become in the transience-conscious Late Middle Ages. The flower carpet with its orange trees has here become the meeting place for a group of well-dressed ladies and gentlemen who are making music, conversing and flirting in the company of their pets: a dog and two falcons – the latter undoubtedly there to assist in the hunt, the favourite sport of the nobility. In the rocks of the wilderness beyond the garden – and apparently at a safe distance from it – a far more macabre scene is unfolding: against a background of the hermits' penitential life, an aristocratic retinue on horseback comes across three semi-decomposed corpses, while elsewhere angels and demons fight over the souls flying upwards from a large pile of bodies: the corpses of merchants, scholars, monks, nuns and beautiful ladies. The garden, however, will soon also become part of this hell, for Death, a hideous be-winged woman, has swung her scythe over her shoulder and is just about to harvest the carefree gathering in the garden. She is

the antithesis of another flying woman, Securitas in the *Effects of Good Government in the Countryside* (PLATE 13). Whereas the agricultural workers achieve security by swinging the scythe, the garden guests have brought themselves into the greatest possible danger by putting it away. The repressed work has here re-emerged in the figure of the Grim Reaper.

The Paradise garden is thus no longer protection from death but, on the contrary, is turned into the image of frailty. Although the idea of the garden of immortality continues to thrive, the very possibility of its fall marks a volte-face in relation to the *locus amoenus* image of the Golden Age *field*. In the Judeo-Christian culture, classical antiquity and Mesopotamia, Paradise gardens might well be guarded by demonic forces (Paradise itself by the serpent, the Garden of the Hesperides by the dragon Ladon, the Cedar Forest by the monstrous Humbaba, and so forth), but in itself the *locus amoenus* milieu – fruit trees, flowers, meadows – would seem to be quite unequivocally linked with that which is good, beautiful and imperishable. The Late Middle Ages challenges this sanctity from two angles in particular: partly, as indicated, the garden incarnates *accidia* (sloth), one of the seven deadly sins; and partly it appeals to the senses, the epitome of frailty. At the beginning of the 12th century, for example, Saint Anselm states that the harmfulness of things is proportional to the senses they gratify. This is especially true of the garden with its roses which appeal to sight and smell, and song and stories which feed hearing.[96]

This idea is also unambiguously present in Camposanto's Garden of Vanity, for among the border figures under the garden we encounter a grinning skeleton which, in *volgare*, asks: "O soul, why, why, do you not consider that Death will tear from you that vesture in which you feel corporeal delight through the power of the five senses?"[97] The garden and its party are thus confronted with death in the form of time. The advent of time amid the fragrant plant life pushes the garden down from its elevated pedestal and out into the landscape. So saying, it could be noted that time is not just something added to the landscape from the realistic pole, cultivated nature, it is just as much input from the romantic pole, work-free nature.

The advent of time in Paradise is also depicted in *Il Tesoretto*, Brunetto Latini's unfinished poem begun shortly after 1262. The writer is on pilgrimage in *Natura* and, having left the beautiful land of the Virtues, curiosity drives him to visit a strange realm:

As it was in May time, after traversing vales and mounts, woods, groves, and bridges, I came to a fine meadow, sprinkled with flowers on every side. But now it seemed like a circle to me, now like a square; now its air was obscured, now clear and shining; now I saw great crowds, now I saw no one. [...] Thus on every side I saw both joy and sorrow.[98]

The inconstancy is due to the circumstance that the garden is dedicated to the Goddess of Love, called *Piacere* (pleasure) by Latini. According to the author, to be in love, i.e. to seek pleasure, involves constant changeability of the soul, a changeability which, as in Lorenzo il Magnifico's poem on the passionate love, is projected out into the environment. The condition is considered dangerous and, not unlike Petrarch after his enjoyment of the view from Mont Ventoux or Taddeo Gaddi after staring at the solar eclipse, Latini has cause to regret his curiosity and must do penance.

The ultimate model for such inconstant gardens of love is the one in Claudian's abovementioned nuptial poem in honour of the Emperor Honorius. Venus' pleasure garden on the Cypriot mountain is an almost flawless Golden Age landscape in which a golden surrounding hedge ensures eternal springtime, perpetual youth and groves saturated with love. The harmony is fractured, however, by the two fountains in which Cupid dips his arrows. While one is honey-sweet, the other is bitter and poisonous. Love is a mixed pleasure, as is also evident from the other deities in the enclosure: Licence bound by no fetters, easily moved Anger, Wakes dripping with wine, inexperienced Tears, Pallor, trembling Boldness, happy Fears, unstable Pleasure, lovers' Oaths.[99] Despite the presence of these deities of inconstancy, it is worth noting, however, that the *garden itself* is unaffected. Instability fluctuates in an eternal springtime. What makes Latini modern, then, is the fact that he also draws the actual garden into this inconstancy – by means of which it is transformed into landscape.

The garden of love is, furthermore, a recurring motif in late medieval literature. We encounter it in Guillaume de Lorris' *Roman de la Rose* (c. 1230), in Petrarch's *Trionfo d'Amore* (1338-43, later revised), in Boccaccio's *Decameron* and *Teseida* (shortly before 1343).[100] In pictorial art the motif is particularly widespread from the end of the 14th century onwards. Regular ingredients are: a fountain, possibly topped by a statue; a flower carpet; clusters of trees; and young lovers making music, dancing and flirting. The setting can be open country among rocks or an enclosed garden (*hortus conclusus*).

As depicted in 14th-15th-century painting, work seldom gains access to the garden or its extension outwards in the landscape. Any practical utility activities are, as in antiquity, of the lighter variety: hunting, pastoralism, fishing. Part of the repertoire is displayed in Avignon's Papal Palace, where Simone Martini's workshop executed a fresco cycle around 1343-44 (**FIG. II.51**).[101] A dense thicket of trees in the House of Livia tradition here forms the setting not just for fowlers, anglers and falconers, but also for men hunting rabbits, deer and monkeys. Of these pursuits, falconry accounts for the epitome of aristocratic pastime: in Lorenzetti's land panorama, the *August* image in *Les Très Riches Heures* as well as Palazzo Schifanoia's *March*, the well-to-do are engaged in falconry while the peasants attend to agricultural matters.

Fig. 11.51. Workshop of Simone Martini,
Fowlers in Forest (*c.* 1343-44), frescoes.
Avignon, Papal Palace.

Nevertheless, late medieval work ideology is still so prevalent that there is never an absolute distinction between work- and grace-landscape in 15th-century painting. By the same token as the forest bore evidence of tree felling, we must also note that pastoralism, the prime occupation of primitivism, can be a feature of standard peasant farming. When the shepherds receive the Christmas message in Sano di Pietro's *Annunciation to the Shepherds* (1450s), they have enclosed their animals within a tight polygonal fence (**FIG. 11.52**).[102] And in Giovanni Bellini's *Saint Francis in Ecstasy* (*c.* 1485) even the sheep pasture behind the rocks of Mount Alverna is enclosed by a

Fig. 11.52. Sano di Pietro, *Annunciation to the Shepherds* (1450s), tempera on wood. Siena, Pinacoteca Nazionale.

Fig. 11.53. Giovanni Bellini, *Saint Francis in Ecstasy* (c. 1485), oil and tempera on wood. New York, Frick Collection.

fence of wood stakes (FIG. II.53). Such enclosures would never be found in an image from antiquity. And their renewed removal in 16th-17th-century Italian painting thus presupposes a conservative current, the Renaissance.

Return of the chthonic: Mary as earth goddess

If nature in the garden of love signifies transient pleasure, the imperishable Paradise is nevertheless within its immediate vicinity. The same *hortus conclusus* that encloses the sensuous flirtation can just as well form the setting for the humble Madonna on bare ground (*madonna humilitas*). In Stefano da Zevio we find her seated amid fragrant roses, music-making angels, singing birds and a trickling fountain (early 15th century; FIG. II.54). The ease with which this replacement occurs is attributable to the fact that both Venus and Mary represent aspects of the goddess of earth. As the etymological origin of the Christian genre, *humus* (Latin=earth), suggests, it acknowledges the Virgin Mary's chthonic identity, her incarnation of the life-giving earth.

In chapter 2 we saw that this identity was, in a way, a built-in component of the Mary figure right from the hesitant beginnings of Christianity, but that it was kept in check by the Church, which wanted to stamp out the pagan fertility cults. However, as the West after the year 1000 takes a renewed interest in the material aspects of the universe, Mary is more overtly linked with nature in pictorial depictions. In an example of this, the Byzantine *Homilies of Jacob* from the beginning of the 12th century, the pregnant Virgin, on her way to visit Elizabeth, has come to a halt in a Paradise of a striking earthly nature (FIG. II.55).[103] The surroundings might well be full of sumptuous plant life, but Mary's throne consists of a soil mound and, at her feet, *Terra* peeps out from a chasm between two hills. However, Terra – here a bare-breasted woman of savage appearance – is not accompanied by her usual attributes of the serpent and cornucopia, an omission which highlights an Early Church comparison between her and Eve.[104] Similarly, *Mare*, the man on the right pouring out a River Jordan from his pitcher, alludes to Adam. That the juxtaposition Terra-Eve can also be extended to Mary is here evident from Mary's appearance as the New Eve who, in a lateral reversion of the Fall, will redeem humankind: she accepts a fruit from the boy in the tree. As it says in the accompanying praise from Terra to the Virgin, written by the monk Jacob of Kokkinobaphos (c. 1050-1100): "Look at this, my gloriously flowering branch, see the fruit of my fertility, [...] through which all those thorns I have had to bear since the damnation will be torn out. [...] This fruit brings forth the one who will deliver me from the errors of humankind."[105] Jacob's poem thus conjures up a whole Tree of Life where Terra's fruit is not only transformed into the one who consumes it – i.e. Mary, the New Eve – but where the fruit also feeds the saviour who will make Terra paradisiacal again by releasing her

Fig. II.54. Stefano da Zevio,
Madonna of the Rose Garden (early
15th century), tempera on wood.
Verona, Museo del Castelvecchio.

Fig. II.55. *Mary and Terra*
(early 12th century), miniature from
the Byzantine *Homilies of Jacob*. Paris,
Bibliothèque Nationale, ms grec. 1208, f. 200.

from the burden of the original sin. The distance between the earth and its fruit is obviously reduced by the association Terra-Eve-Mary.

However, it takes another quarter of a millennium before the pictorial culture in more devotional contexts will venture an enthronement of Mary on the bare ground. An intermediate stage, highlighting her corporeal fertility with no explicit link to the soil, is found in *Madonna lactans*, the nursing Madonna. And when the Madonna is finally released into nature, after 1375, she is initially limited to a protective enclosure, the closed Paradise garden.[106]

What does the garden actually shield her from? The subterranean inferno? More likely the surface as cultivated after the Fall, because when the Madonna can again be found out in the open, after the 1420s' paradigm shift, she is surrounded by a garland of paradisiacal fruit trees, a hedge patently designed to keep the background fields out of the meadowland where she is sitting. In Jacopo Bellini's *Madonna of Humility with Donor (Leonello D'Este(?))*, from the early 1440s, the fields are specified by fine hatching (FIG. II.7), in Giovanni di Paolo's version by the customary chessboard

Fig. II.56. Giovanni di Paolo, *Madonna of Humility* (1440s?), tempera on wood. Siena, Pinacoteca Nazionale.

pattern (FIG. II.56). The screening feels imperative as the *humus* incarnated by the Madonna is *ager bonus*, the sacred virgin ground,[107] which gives birth to Christ without strain or the agency of human semen, in exactly the same way as the clay of Paradise gave birth to Adam, touched only by God. In more secular contexts, the principle is reflected in *Comedia delle ninfe fiorentine*, Boccaccio's pastoral poem written in 1341. The beautiful nymph Agapes (*non-sexual love*), whose parents have forced her to marry a hideous old man, cries out after the wedding night:

O nymphs, have now compassion with my aggravations. Having dragged out most
of the night with [...] gossip, he toils futilely to cultivate the gardens of Venus; and
by using an old coulter [*vecchio bomere*] when trying to cleave the earth on those who
wish the graceful seeds [*i graziosi semi*], he works in vain.[108]

So rather than fertilising the nymph's womb with divine sperm, the old man trans-
forms it into a mere ploughed field which takes strenuous effort to be cultivated.

Against this background of toil in the fields, Venus and Mary become kindred
spirits. Mary is clad in the earthly ground, whereas conversely the graceful seeds
bring Venus from sensuality to the divine world. This association impedes the
garden of love from disintegrating into pure sensuality. Its merger with Paradise is
asserted by Lorenzo de'Medici:

> For "Paradise", to one who wishes to define it correctly, means nothing other than
> the loveliest garden, full of delightful and pleasant things, of trees, apples, flowers,
> living and running waters, birdsong, and, as a result, all the good things of which
> the human heart may dream; and this verifies that Paradise was where there was
> a beautiful woman, for here was every amenity and every sweetness a gentle heart
> might desire.[109]

Later, however, Mary relinquishes the protection of Paradise. When Giovanni Bellini
places his *Madonna and Child Holding a Swallow* (c. 1510) on the bare ground, there
are no longer barriers between the soil of the Virgin's seat and the furrowed fields
behind, even though we still do not doubt the virginity of the seat (**FIG. II.57**).[110]
And in his *Madonna of the Stonecutters* (c. 1488-90), Mantegna has made the Madonna

Fig. 11.58. Giovanni Britto after Titian, *Landscape with a Milkmaid* (*c.* 1520-25), woodcut. Venice, Museo Civico Correr.

a goddess of the earth by placing her immediately in front of a cave, an extension of her womb (FIG. 12.56). As we will see in chapter 12, the stonemasons who have transformed this cave into a quarry highlight her virginal status because, unlike her, they must resort to labour in order to create their progeny: idolatrous works of art.

11.3 The Renaissance and the ideal landscape: prelude

The corporeal swelling, reduction of details and darkening of the sky that occur with the post-1500 emergence of the High Renaissance in painting are accompanied by the disappearance of fields, hedges and fences from the Italian landscape paradigm. At the same time, the extensive 15th-century plains are displaced in favour of a renewed undulation in which tracks are restricted to sporadic traces. The traditional term for the terrain, *the ideal landscape*, could not have been better chosen, for this is the landscape parallel to the triumph of ideality that typifies the figures.

The changes that occur in the landscape image are just as comprehensive and persistent as the other Renaissance features I have discussed earlier, and they cannot be understood without them. It is therefore of no advantage simply to analyse the usual star model, 'the pastoral landscape' in Venice (FIG. 11.58), and then go on to talk of its 'influence'. For rather, it has to be said that the Renaissance paradigm, wherever it is operational, involves a suppression of the landscape image's territorial markers, and that the uncultivated landscape thus exposed provides the opportunity to accentuate the already built-in iconography known as 'the pastoral landscape'.[III] The ideal landscape is, exactly like its antique predecessor, *born*

pastoral, and there is nothing special about the Venetian iconography beyond the emphasis on shepherds and a focus on the purely scenic. And as is the case with the other Renaissance aspects, the uncultivated landscape is not restricted to antique iconography. The landscape surrounding a Venetian 16th-century Madonna or a saint in the wilderness is neither more nor less pastoral than an equivalent *poesia* imbued with antique inspiration.

Conversely, the ideal landscape's tolerance does not preclude antique motifs feeling particularly at home here. For one thing, the landscape is essentially neo-antique, and for another, the antique gods must presumably feel most comfortable in an uncultivated nature beyond historical time. Early antique motifs such as Botticelli's from the 1480s are thus also set on untouched ground. The contention that the ideal landscape thrives in a time pocket and has features of artificial regression is supported by the circumstance that the period in which traces of agriculture are displaced is also the era which makes explicit pictorial representation of the untouched, pre-civilisation earth. As early as the 1490s, Piero di Cosimo was already making his series dealing with life in primordial times (FIG. 11.25). And on the outer panels of Bosch's *Garden of Earthly Delights* (1503-04; FIG. 9.10) we are looking down across the flat earth as it appeared on the third day of Creation, with water, trees, meadows and strange capsules but as of yet no animals or humans. Landscape images such as these point beyond the meaningful ideality of the Renaissance towards a nature that has no experience of humankind's comings and goings, a sublime romantic nature. The ideal landscape thereby simply represents one choice among many for the pictorial rendition of more or less exotic, untouched terrains, a choice which, however, unlike Bosch, makes the presence of humankind inevitable, albeit suitably primitive.

Alberti's landscape genres

The many paths leading to the genesis of the ideal landscape include Alberti's deliberations on the decoration of buildings as presented in his treatise on architecture *De re aedificatoria*, written around 1450. As the passage is of great significance and, moreover, reveals conflicting forces at work, I shall quote it in full:

> Since painting, like poetry, can deal with various matters – some depict the memorable deeds of great princes, others the manners of private citizens, and still others the life of the simple farmer [*aratoriam vitam*] – those first, which are the most majestic, will be appropriate for public works and for the buildings of the most eminent individuals; the second should adorn the walls of private citizens; and the last will be particularly suitable for gardens [*ortis*], being the most delightful of them all.

We are particularly delighted when we see paintings of the amenities of the areas [*amoenitates regionum*] or harbors, scenes of fishing, hunting, bathing, or country sports, and flowery and leafy views.[112]

For the sake of clarity, it would be appropriate to schematise Alberti's genres and compare them with two similar hierarchies, Vitruvius' classification of theatre scenery and *rota Virgilii*, the late antique scholastic revision of literary genres:

Vitruvius (stage scenery genres)	Rota Virgilii (literary genres)
Tragedy – royal buildings	*Aeneid* – gravis (princes)
Comedy – private buildings	*Georgics* – mediocris (peasants)
Satyric plays – pastoral land	*Eclogues* – humilis (shepherds)

Alberti (pictorial genres and their application)
Memorable deeds of great princes – to be set in public buildings and buildings of eminent individuals
Manners of private citizens – to be set in private homes
Life of the simple farmer (particularly pastoral landscapes) – to be set chiefly in gardens

The three hierarchies share a categorization that looks from the noblest to the simplest, from the centre of civilisation to the distance of the wilderness, from *ergon* to *parergon*. On the face of it, the hierarchies might seem to correspond, as if in some virtual hall of mirrors. If the royal subjects of literature are transferred to the theatre, they ought to take place against a background of royal scenery, and when the same subjects are depicted in decorative painting, the pictures should be hung in actual royal or at least prominent buildings. The mirroring is, however, darkened in the nether – or outer – levels, because in the middle of *rota Virgilii* we find peasants rather than the private individuals specified by Vitruvius and Alberti. And Alberti, for his part, cannot quite decide whether he will have toiling farmers or playing primitives at the bottom. Still influenced by late medieval work ideology, he blithely declares that the third category should deal with "the life of the simple farmer". But in the more detailed commentary, the neo-classicist rears his head and slips over to Vitruvius' satyr land: of *special* preference are paintings of "the beauties of the areas" (read: *loci amoeni*), a genre which because of its "delightfulness" is *particularly* appropriate for gardens and which, furthermore, includes the leisurely pursuits we recall from Pliny's description of the sacral-idyllic paintings (see chapter 6): harbours, fishing, hunting, bathing, country sports, along with flowery and leafy views.

Not unlike *Libri della famiglia* (1437-38), in which Alberti praises the idyll and health of life on the land at the same time as deriding the farmers for their stupidity and poor character,[113] he here shows himself to be under the influence of the antique ambivalence vis-à-vis the countryside: everything rural is good, and yet the work-free earth is preferable to the utilised one. He thereby disregards the attractor of the *field* of modernity which engulfs all types of occupation towards the same mediocre middle, not just citizens and farmers, but also the outer edges of the former hierarchy: shepherds and aristocracy. All these types, exposed to the requirements of time and particularity, are the ones emerging in the figure-filled counterpart to the landscape painting in the secularised culture: the genre picture. At the bottom of his hierarchy, Alberti could thus just as well have placed what is brought to fruition in the 17th-century Netherlands: farming scenes hung on the walls of farmhouses.

Arcadia

If pastoral iconography ever disappeared to the extent that it could be said to be resuscitated with the Renaissance, then this resuscitation certainly has its roots far back in the Late Middle Ages. It develops in tandem with the garden of love, with which it is finally united. It can be spotted in one of modernity's first secularised allegories of poetry: the title page painted by Simone Martini for Petrarch's *Virgil* manuscript, after the two had met in 1339 at Avignon's papal court (FIG. II.59).[114] In this work Martini has taken a revolutionising step in relation to conventional medieval practice: rather than depicting the poet indoors, he has moved him out into the open air, in keeping with Petrarch's enjoyment of the outdoor life at the source of the Sorgue river in Vaucluse. On the other hand, in front of Servius, the interpreter pulling aside the curtain from his subject, we again meet, as in Alberti, a toned-down *rota Virgilii*: a spear-carrying Aeneas, a vine-cutting peasant and a shepherd milking. The landscape that brings inspiration to Virgil – and Petrarch – is that of viticulture and pastoralism, not that of grain-growing. There are several pieces of evidence bearing witness to how not only intellectuals but also the rulers of the day presented themselves as shepherds. A lost late-14th-century relief by Claus Sluter showed, for example, Philip the Bold of Burgundy and his duchess, Margaret of Flanders, as shepherds resting with their flock. According to a poem by the Burgundian court poet Chastellain, the literature-loving René d'Anjou (1409-80) was also fond of thus cultivating the joys of pastoral life with his wife.[115]

Pastoral iconography eventually became linked to a specific location, Pan's domicile of Arcadia. The connection had a core of realism, because in the actual world Arcadia was a wild Peloponnesian mountainous region far beyond the control

Fig. II.59. Simone Martini,
*Servius Pulling aside the Curtain
for Virgil* (*c.* 1339), miniature,
title page of Petrarch's
Virgil manuscript. Milan,
Biblioteca Ambrosiana.

Fig. II.59. Simone Martini, *Servius Pulling aside the Curtain for Virgil* (*c.* 1339), miniature, title page of Petrarch's *Virgil* manuscript. Milan, Biblioteca Ambrosiana.

of civilisation. Like the Swiss later on, the Arcadians of antiquity were suppliers of tough mercenaries, but otherwise they mainly provided for themselves by keeping flocks of sheep and goats. They had a reputation for hospitality, for equality between masters and slaves and for their music culture.[116] The Romans saw *Arcadia* as, *inter alia*, a symbol of the new Golden Age to be instituted under Pax Romana. A fresco from Herculaneum personifies the name by means of a Tellus-like mother goddess carrying a bulging fruit basket, a satyr at her side.[117] The Arcadians also appear in the pastoral landscapes of Virgil and Ovid. Even though *Fasti* dates the origins of the Arcadians to pre-Jupiter, their non-farming Golden Age still comprises a hard rather than a soft primitivism, where heavy showers pelt against the naked bodies.[118]

Arcadia as exclusive incarnation of the ideal landscape is, however, a modern phenomenon. The concept is rendered visible in Jacopo Sannazaro's *Arcadia*, a pastoral romance in prose and verse written in 1489-91, which sets the agenda for most of the pastoral writing and much of the painting during subsequent centuries.[119] Here

Arcadia is a landscape in which the shepherds abandon themselves to the bittersweet emotions of romantic love. When love is not lived out in practice, it is described in elegiac songs to the accompaniment of the syrinx. The shepherds also yearn for a vanished past, a Golden Age in which humankind lived from the abundance of nature, watched over their flocks and sang like gods, because even though the Arcadian life is still related to that of the Golden Age, it is but a pale reflection. It is tempting to read into this yearning a metaphor for the Renaissance's own nostalgia for antiquity. For example, the antique Golden Age is given an emblem in Pan's lovely syrinx, which is discovered in a pine wood by the main character, Sincero (ch. 10): no one has played it since its last two owners, a shepherd from Syracuse (Theocritus) and – after him – Tityrus from Mantua (Virgil). But the Renaissance juxtaposition of antiquity and Golden Age is also more than metaphor since, as I pointed out in chapters 4-6, the upper classes of antiquity actually endeavoured to reconstruct the Golden Age themselves, including, in an imaginary form, its manifestation in nature. The Arcadian landscape therefore appears as a reflection of the Golden Age via something which is already in itself the reflection of this age, namely the antique work-free phantasm of nature.

A case story: Pan Saturnus Medicea and Signorelli's School of Pan

If the pastoral iconography had in this way proved proficient in shoring up the power of the upper classes in antiquity, then it must also be reusable when it came to the consolidation of autocratic power in the present. A telling example of how is given in Florence, the initial centre of the Renaissance movement. In response to the post-14th-century gradual decline that befalls the city's banking and trading empire,[120] after the mid-15th century its unofficial ruling family, the Medici, is overcome by a perceptible yearning for the *vita contemplativa* of rural life – a yearning which characteristically also involved an intensification of the family's power symbolism. By means of a presumptuous play on the word 'cosmos', the head of the family, Cosimo de' Medici (d. 1464), not only allows himself to be associated with Saint Cosmas, but also with Pan, the pagan goat god, in his capacity of controller of the universe. Since Pan's domain, the rural idyll, is also characterised by melancholy, *Pan Medicea* is additionally linked with Saturn, the tutelary deity of the Golden Age.

The centre of the Pan Saturnus cult was Careggi, a town just outside Florence and its answer to Arcadia. Here, not far from his own country palace, Cosimo had given a mountain villa to Marsilio Ficino, which the court humanist had then converted into a Neoplatonic academy. In a letter of 1480 sent to Cosimo's grandson Lorenzo il Magnifico, Ficino describes how, when taking an early morning walk to

the tree-clad summit of the mountain, Monte Vecchio, he suddenly realised it was the feast day of Saints Cosmas and Damian. The voice of an oracle was now heard coming from a tall oak tree and declaring that, seeing as Lorenzo was taking care of the festival celebrations in the city, then so Ficino should celebrate it here in the forest. Like a veritable *genius loci*, Cosimo's spirit – a spirit which Jupiter "with no limit has granted the civil power" – had taken domicile in an oak, the same tree with which Augustus had been associated in ancient times. The oracle went on to claim that as Phoebus and Saturn were today in conjunction in the heavens, so Marsilio should let the same powers meet on earth, because: "Happy is humankind should Pan Saturnus' flute harmonise with Phoebus' citar which governs in the cities." And Ficino concludes: "And so I organised an Apollonian, that is to say philosophical, feast for the Saturnians, that is to say the oldest of the peasants [*senioribus agricolis*]." To Ficino, the festival signifies that from now on not only this pair of gods should be worshipped, but also Apollo's accompanying muses, by which means god and muses will be brought "from the havoc of the city to Ceres' fields and Bacchus' hills".[121]

It is quite clear from Ficino's epistle, then, that the Medici regime's attempt to gain legitimisation on a combined Christian-pagan foundation leads to a displacement of the centre of power from an urban to an urban-rural context. This displacement not only supplements the Apollonian with the Pan-Saturnalian, *vita activa* with *vita contemplativa*, the civic spirit of the city with the body of the land (the oak tree as Cosimo's abode); ultimately, it ushers in the Le Roy Ladurie-esque "multi-secular breath" of around 1500, when power is transplanted from republican to autocratic soil.

That it is here worth dwelling on Ficino's astute articulation of this development is because parts of it reappear in pictorial form in Signorelli's painting *School of Pan* (c. 1490; destroyed 1945; FIG. 11.60). This monumental pagan allegory, which presumably decorated il Magnifico's Careggi residence, is fashioned, in best Neoplatonic manner, like a Christian *sacra conversazione*: in an Arcadian afternoon landscape, the sun casting long shadows, a minor court of figures, including two shepherds and a trio of pipe-players, have gathered around the goat god on his throne. Armed with his syrinx, Pan seems to be instructing the assembly in the art of playing the pipe. That we are again dealing with Pan in his role of controller of the universe – and thus with Pan Saturnus Medicea – is apparent from his crescent halo (instead of horns), his star-sprinkled cape, the *uroboros*-like handle of his shepherd's crook, and the division of the syrinx itself into seven, echoing the seven heavens. In addition, both more subtle and more dramatic, the exact centre of the painting – the point of intersection of the diagonals – is located in Pan's exposed genitals, thus indicating that the central force in the cosmos is of an erotic nature and originates in Pan's crotch.[122]

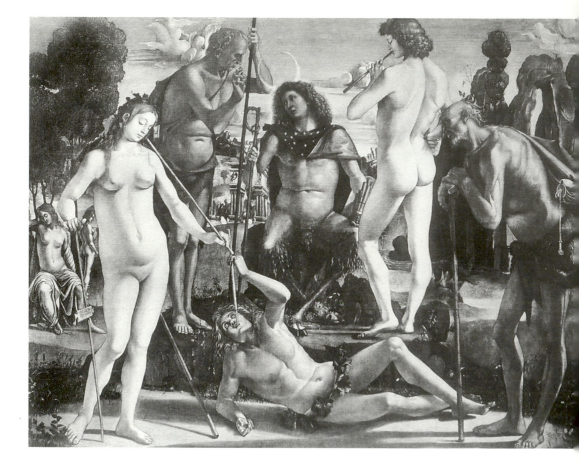

Fig. II.60. Luca Signorelli, *School of Pan* (*c.* 1490), tempera on wood. Formerly Berlin, Kaiser-Friedrich-Museum, destroyed 1945.

Fig. II.60a. Signorelli's *School of Pan*: diagram showing transmission of the cosmic forces. Illustration: author.

The symbolism incarnated in the marble-like figures of the allegory was certainly a mystery for a long time, but after Pochat's discovery of a number of visual and conceptual connections to the so-called *Mantegna tarocchi*, two series of engraved cards executed in Northern Italy *c.* 1450-85, there have been grounds for a more coherent interpretation (FIGS. 11.61A-11.61C).[123] In the same way as the figures on the cards span a cosmic hierarchy – from the celestial spheres to virtues, art forms and muses and on to humankind – the painting can be seen as relating to a *scala paradisi* on which the most wretched of humans, the shepherd, might through Pan's agency be fecundated by the cosmic breath. Signorelli's bowed shepherd leaning on his stick on the lowest ground to the right thus becomes the humble beginnings for this transformation – in the cards (FIG. 11.61A) he is called *Misero* and is given the number "1", in contrast to the "50" given to *Prima causa* at the top of the celestial hierarchy. Taking into consideration that Saturn's children generally include cripples and peasants, and that the Saturnalian guests at Ficino's aforementioned forest festival are specifically made up of "the oldest of the peasants", the case would seem to be clear-cut: in keeping with the Renaissance revival of the practice of antiquity – already seen as premonition in Alberti's ambivalent genre hierarchy – agriculture is displaced to the pastoral wilderness, and thus it is the shepherd, not the farmer, who becomes representative of Pan Saturnus' admirers.

The reference to Ficino's epistle also reaches the other shepherd in the painting – the one with hand raised in a gesture of blessing to Pan, on the right side of him, and now level with the throne. Can he not be seen as fertilised by the Apollonian spirit and thereby as an agent of *philosophia*? On a level more related to portrait, this philosopher-shepherd could be interpreted as *alter ego* of the elderly Ficino, Lorenzo's intellectual mentor. For the scene is already set in il Magnifico's pastoral poem, *Altercazione*, for a similar *locus amoenus* encounter: the lyre-playing mountain dweller Marsilio who typically comes across his friend, the ancient and sage shepherd Alfeo, alongside the spring or under a shady beech tree.[124] Rather than being two different shepherds, however, these two old men ultimately represent two phases through which *the same person* passes while climbing *scala paradisi*. Through Medici patronage, the extension of Pan's primordial power, the unblemished shepherd is elevated to a philosophical poet who can then in turn bless his benefactor.

Two routes – two sides of Pan – lead towards the philosophical transfiguration. One route, the Saturnalian, traverses contemplation and would seem to be incarnated in the left background by a melancholic Urania, who, according to Plato, is the lower of the two muses of philosophy.[125] Meanwhile, another and brighter route goes via Pan's father, Hermes *psychopompos* ('leader of souls'), because according to the humanists Pan was created from a mixture of Saturn's contemplation and Hermes' eloquence. In Signorelli, the Hermetic *eloquentia* is propagated via an

Fig. II.61a. *Misero* (*c.* 1450-85),
engraved card from northern Italy.

Fig. II.61b. *Calliope* (*c.* 1450-85),
engraved card from northern Italy.

Fig. II.61c. *Mercury* (*c.* 1450-85),
engraved card from northern Italy.

ingenious – and apparently hitherto only halfway explored – network of lines which describes a form of loop between heavens and earth, and which is alternately realised in flute music and cleansed sexual power (FIG. 11.60A).[126] Hence, a network of lines transporting the energy from Pan's genitalia.

If we now look at Hermes, the naked figure standing with his back turned to Pan's left (cf. FIG. 11.61C), we will see that the reed pipe this god is playing points down at the crotch of the forward-facing naked woman, Calliope, who is the other – and higher ranked – of the two muses of philosophy (cf. FIG. 11.61B). This is a reference to the muses' traditional involvement with the celestial spheres: by setting the bodies of the heavens in motion, the muses produce celestial tones, *music*.[127] In the common tradition, which coupled tones and muses with the planets, Hermes was indeed brought together with Calliope,[128] but Ficino also considers Calliope to embody the harmony of the celestial spheres, the world soul.[129] Therefore, that which the messenger's pipe music plants in the womb of the muse in Signorelli's painting could be understood as the celestial breath of air that can be transposed into the harmony of the world soul.

Translated into Signorelli's pictorial imagery, this harmony is represented by three reed pipes positioned symmetrically so as to form a further system of rays: the middle ray goes from Calliope's crotch down to the ground; the upper ray is sent from her mouth down to the vineleaf-covered genitals of the recumbent Dionysus, the deity of the earth;[130] and the lower ray has a label attached, on which is written the artist's signature – as if the rendition in painting of the allegory itself is also a result of the pan-Hermetic power. This entire transmission from heaven to earth is, of course, elaborated via the interplay between body positions and differences in height: Hermes, heaven, is standing on the throne dais; Calliope, the world soul's union of heaven and earth, is standing on the ground; and Dionysus, god of the underworld, is lying on the ground, in the same position as the conquered Cupido in illustrations of Petrach's *Trionfi*.[131]

Taking into account that the three-stage ladder is based in Dionysian ground, but ends in pan-Hermetic eloquence, it would seem obvious to view it as a visualisation of the inspirational power of *locus amoenus* – what the Renaissance comprehended as *furor divinus*. On one level *locus amoenus* can be understood as Cosimo's oak tree, and on another level – one which stresses the transmission from nature to human mouth – as the source site which leads Socrates to eloquence in Plato's *Phaedrus*. Besides already being an appropriate model for Ficino, in this dialogue Socrates also points out that his dithyrambic speech is elicited by the deities of the site, i.e. particularly Pan and his mouthpiece, the nymphs, and in Ficino's Plato commentary these two sources of inspiration are extended by the addition of Dionysus and the muses.[132]

Ficino views Socrates' poetic ecstasy as an inevitable consequence of *furor divinus*, for "no one possessed by *furor* is satisfied with normal speech, but bursts out in shouting, in songs and poems."[133] If we earlier found it surprising that Signorelli could render celestial breaths of air, sexual powers and reed pipe music as manifestations of one and the same primordial force – that of Pan Saturnus – a passage such as this proves enlightening, given that here there are similarly extremely hazy borders between religious conduits (prophesies, mysteries), aesthetic expression (song, poetry – and in extension of this: philosophy) and love. Being a fusion of sensuous music and intelligible words, it was *carmina*, song, that Ficino considered to be the key medium leading to the spheres: from *musica instrumentalis* (external music) to *musica humana* (music of the inner ear) and on to *musica mundana* (cosmic music). And this very progression could be seen reflected in the trio Dionysus-Calliope-Hermes.[134]

Since the poetic *furor* is transmitted from *genius loci* to the philosopher's mouth, it could be presumed that it makes its way back along the same route – more specifically, via the usual soundtrack of *locus amoenus*, "the shrill summery music of the cicada choir".[135] Besides the fact that the cicadas stem from the same primordial root as the muses, Socrates goes on to say of them: "To the eldest [muse], Calliope, and to her next sister, Urania, they [the cicadas] tell of those who live a life of philosophy and so do honor to the music of those twain whose theme is the heavens and all the story of gods and men, and whose song is the noblest of them all."[136] This line of thought is corroborated in Ficino's *Phaedrus* commentary (*c.* 1484-93) when, having evoked a spiritual connection from muses to virtuous demons of the air and on to cicadas, he states: "In that way, the divine spirit of the philosopher really is taken back to the heavens."[137]

Signorelli represents this return of the cosmic powers in the figure of the conquered Dionysus who, having received the cleansing of his genital force by Calliope's ray, now returns the purified ray to the heavens via his own reed pipe.[138] Having passed by the shepherd in his act of blessing, Socrates-Ficino in poetic ecstasy, this flute-ray ends in a phantasmagoric cloud formation shaped like a winged horseman. A second cloud formation in the upper-right corner, shaped like another pipe-player, seems to be driving the horseman forward by means of its wind pressure. These cloud figures take us directly into the periphery of the allegory's significance, into a *parergon* zone where meaning is constructed and disintegrated. As Pochat, inspired by Edgar Wind, observes, they presumably refer to two of the three passages in the Neoplatonic concept of cosmic breath, i.e. *emanatio* (emanation) and *remeatio* (returning) – the middle passage, *conversio* (conversion), is thus covered by the reclining Dionysus. The pipe-player in the clouds must therefore, again, be perceived as Hermes, since apart from being master of wind and cloud (cf. the link: soul-breath-air), this swift god primarily incarnated the contemplative spirit that was believed to have taken

over as the soul left the world. The horseman, on the other hand, is his symmetrical counter-image, Zephyr, the fervent puff of air on entry. As Wind states apropos Botticelli's *Primavera* (**FIG. II.47**), the outer sides of which are closed by precisely these two gods: "To turn away from the world with the detachment of Mercury, to re-enter the world with the impetuosity of Zephyr [...]."[139]

As places where the celestial spirit disconnects and connects to its material casing – i.e. as grey zones between chaos and form – these clouds ultimately relate not just to that which is poetic-musical but also to the driving force of pictorial creation. In his *Phaedrus* commentary, Ficino notes that the intellect can appear in the soul in a multiplicity of forms, a variation that is compared to the way in which sunrays are refracted by the cloud in a spectrum of colours.[140] Bearing in mind the abovementioned bridge between heavens, demons of the air and cicadas, Signorelli's clouds must refer more specifically to an 11th-century treatise on demons, written by the Byzantine Michael Psellus, from which Ficino had translated excerpts in 1488 – just before the painting was made. For in his treatise Psellus refers to the demons' ability to adopt a variety of forms with the same ease as clouds can assume a likeness to humans, bears, dragons, etc.[141]

Indeed, looking at the upper – skyward – third of the painting, it is as if Signorelli is exploring and playing with the reciprocal kinship of the forms, so that it is unclear as to whether the amorphous masses of paint are drifting between various referents or, rather, if these referents themselves out there in the landscape expanses are actually the object of material identity shifts. The tall billowing tree and the rock arch in the upper right corner, thus have the same semi-turbulent appearance as the cloud image behind them and, conversely, the shepherd in his act of blessing and Hermes simply look like clearer-cut versions of the clouds that seem to be lingering in their immediate background. As we will see in the final chapter, visual puns of trees, clouds and, not least, rocks is a quite widespread practice in the contemporaneous painting, and they must therefore be seen in context with general trends in natural philosophy and alchemy at the time, as well as reflections on the inherent nature of pictorial art.

Here I will confine myself to a single interpretative key, a Hermetically-coloured letter of complaint, in which Ficino bemoans the reluctance of his friend, the Florentine chronicler Giovanni Cavalcanti, to meet him in the Careggian hills.[142] Even though Ficino himself would seem to have relocated into this contemplative Paradise in Hermetic-Zephyresque manner, "moved by some breeze", he has to use harsh transformative measures in order to entice Cavalcanti, "who has more weight than the rocks themselves".[143] First he implores Apollo to make his lyre play those "songs of Orpheus and Amphion with which they in days of old moved oaks and rocks, so that I thus could attract you, who in my opinion is such a wooden and rocky man,

out to me."[144] But Apollo discovers that Cavalcanti is in fact made of iron, and so he advises Ficino to lure him by means of Zoroaster's art of transformation, which is able to "transform the big rock on Monte Vecchio to a magnet".[145] In Ficino's epistle, the states of the soul are thus again seen as various forms of material attire (breezes, rocks, trees and iron) and, not unlike the strange landscape formations in Signorelli's painting, the Hermetic art consists of controlling the movement as well as the transformation of these substances.

Even though it is framed in an erudite and cryptic symbolism which could only have been comprehended by an informed elite, the commissioner of the painting has thus managed to inscribe the entire cosmic orbit, including the transformation of the soul into various material attires, within the Medici sphere of power. This megalomania can but corroborate the thesis of *I nuovi piagnoni* that the neo-antique Medici supremacy was an obstacle to the development of civic liberty, and that Savonarola's short-lived republic, established in the immediate aftermath of the Medici's expulsion by the French in 1494, was a final desperate attempt to thwart the growing countercurrent in modernity's epistemic *field*, the aristocratism of the Renaissance.

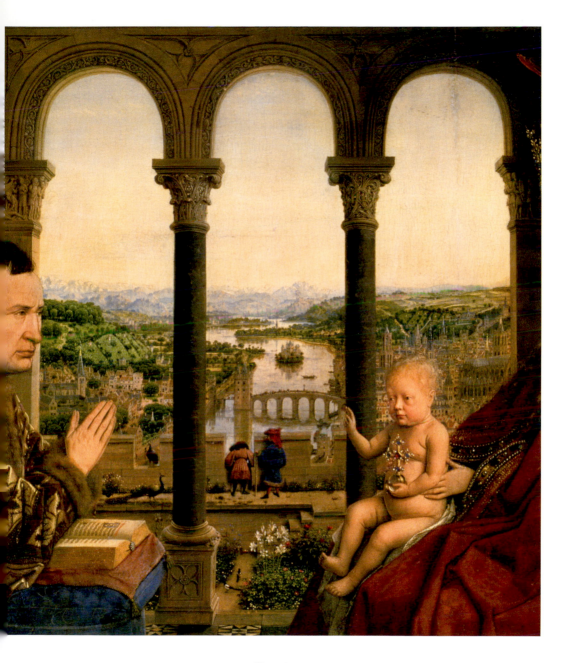

Plate 28.

Detail from Jan van Eyck,

Madonna of Chancellor Rolin (*c.* 1433-34),

oil on wood. Paris, Musée du Louvre

(whole painting: see fig. 9.2).

Plate 29.

Anonymous Flemish artist,

Flemish Landscape (*c.* 1470), miniature.

London, British Library,

ms Cotton Aug. A. V., f. 345v.

Plate 30.

Giorgione,

La Tempesta (*c.* 1505-10),

oil on canvas.

Venice, Galleria dell'Accademia.

Plate 31.

Taddeo Gaddi,

Annunciation to the Shepherds (1332-38),

fresco. Florence, Santa Croce.

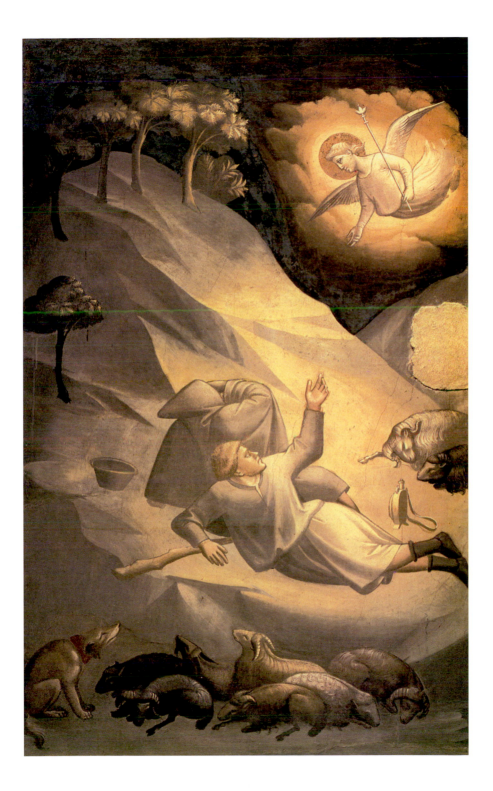

Plate 32.

Easterly Wind (Ventus orientalis)
(*c.* 1390-1400), miniature from
manuscript of Ibn Botlân's
Tacuinum Sanitatis in Medicina,
executed in a workshop on the Po plain.
Vienna, Nationalbibliothek,
Codex Vindobonensis,
ms Series Nova 2644, f. 57.

Uentus orientalis.

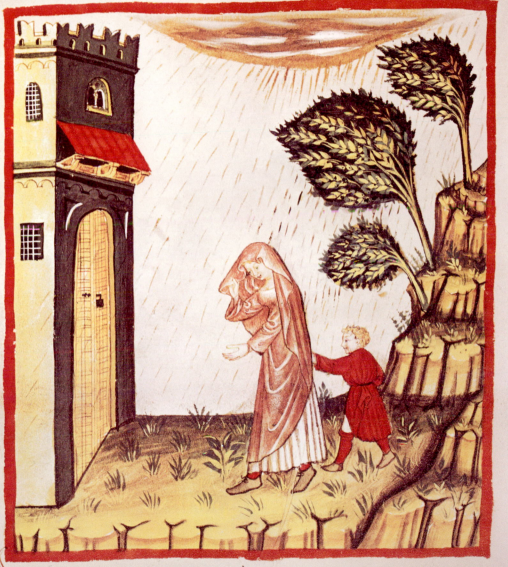

Uentus orientalis. cpto tpate cal. in 2. Electo transies p prata 7 loca pluuioza. uiuantur multi-
plicar sps. Nocumentum nocet obtalmie. 7 coze. Remo. cum aqua florum. ouest tpatis omi
etati. in uere orientali regioi.

Nix et glacies.

Nature f. 7 b. in 2º. melior ex eis. et aqua dulci existêre unameuru. Di
gestione meliorat nocumêtum. tusim mouêt remotio nocumêti.
bibendo aqua modice.

Plate 34.

Limbourg brothers, *February*

(*c.* 1410-16), miniature from

Les Très Riches Heures du Duc de Berry.

Chantilly, Musée Condé.

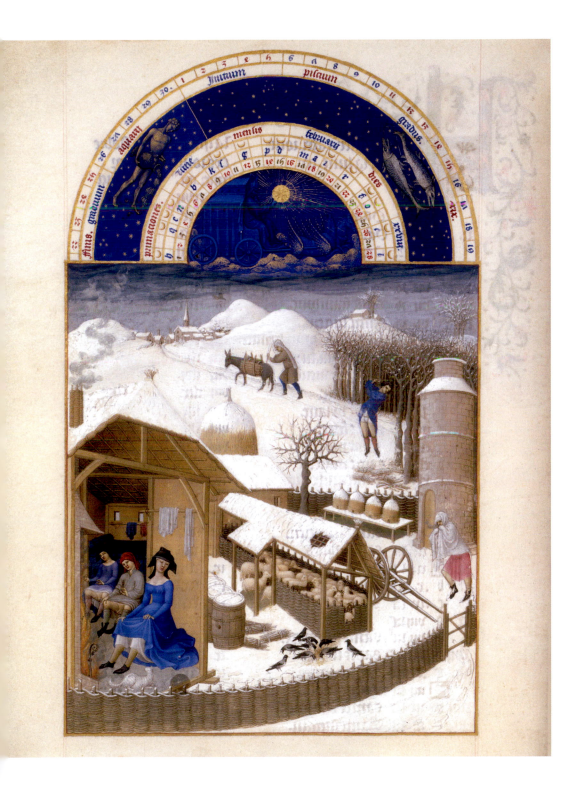

Plate 35.

Boucicaut Master,

Visitation of Mary and Elizabeth

(*c.* 1401-05), miniature from the

Boucicaut Book of Hours.

Paris, Musée Jacquemart-André,

ms 2, f. 57.

Plate 38.

Andrea Mantegna,

Christ as the Suffering Redeemer (c. 1495-97),

tempera on wood. Copenhagen,

Statens Museum for Kunst.

Plate 39.

Filippo Lippi,

Saint John the Baptist Preaching

in the Wilderness (1452-65), fresco.

Prato, Cathedral.

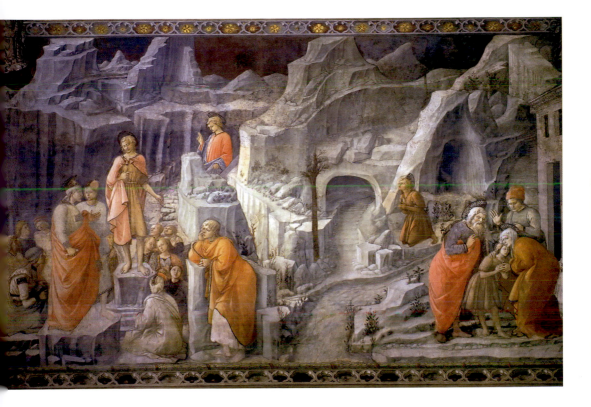

Plate 40.

Jacopo Filippo d'Argenta,

initial 'I' (1480s), miniature.

Ferrara, Museo della Cattedrale,

Corale No. 9, f. 44v.

Plate 41.

Pietro Guindaleri, medallion,

miniature from manuscript

of Pliny the Elder's *Naturalis historia*

(begun *c.* 1475, completed after 1489).

Turin, Biblioteca Nazionale,

ms J.I. 22-23, f. 45v (min. 25).

Plate 42.

Mining Scene (*c.* 1490),

frontispiece miniature in the

Kuttenberger Kanzionale

from Bohemia. Vienna,

Österreichische Nationalbibliothek.

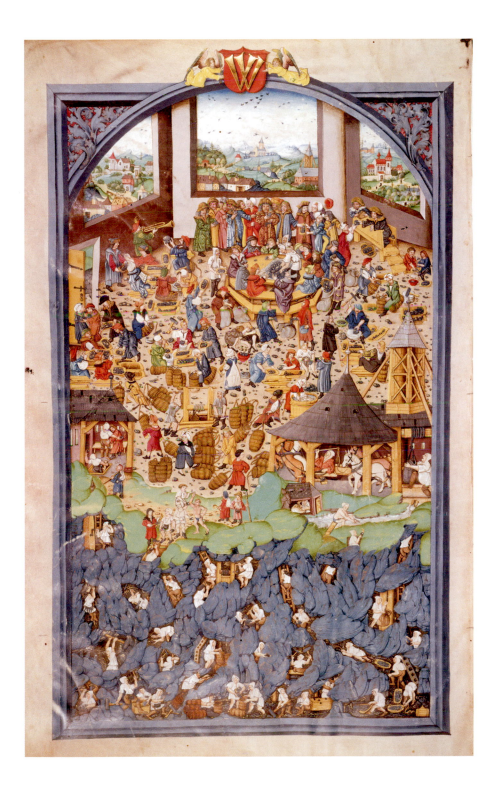

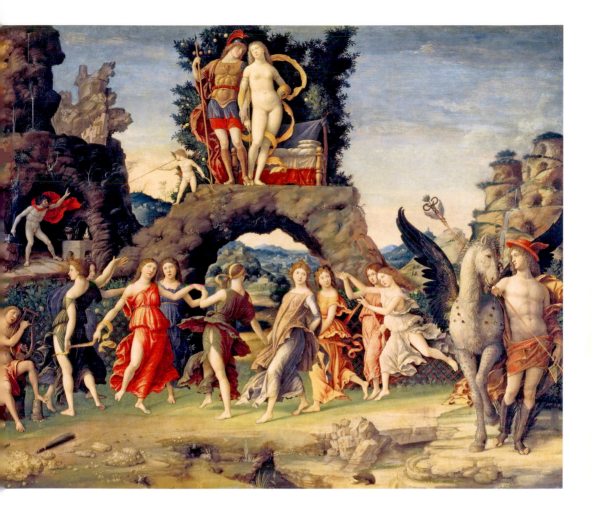

The Architecture of the Underworld

15th-century Pictorial Rocks in a Field of Conflict between Middle Ages, Modernity and Renaissance

Introduction

AS THE CONCLUDING operation in my survey of the early modern landscape image, I shall look down into the depths, towards the rock-solid subsurface and its eruptions into the light through the earth's surface layer of soil and grass. If anything, the rock masses appear as zones of conflict for the cultural tensions of the 15th-16th century, a virtual epicentre, in which the collisions between the three continental plates of fading Middle Ages, emerging modernity and regressive Renaissance would seem to have left clear and often paradoxical scars in the geology of the stone formations. For even though the key trend of the modern paradigm confronts the absolute rule of the rocks in pre-modern painting – eroding them, covering them with plains, displacing them to distant horizons – the rocks also offer a notable resistance. As Kenneth Clark observes of the 15th-century successors to the Byzantine and Gothic "irrational" mountains:

> When, later in the century, they appear in more classical designs, they have obviously been left over from another style. They shoot up surprisingly out of the flat, prosaic landscapes of Patenier; and Breughel, that master of natural observation, puts into the background of his *St. John Preaching*, a rock as crazily improbable as any in a Byzantine mosaic, but modelled with an air of truth [...]. It is one of the last survivors of the landscape of symbols.[1]

But if the rocks really are the last representatives of a "landscape of symbols", it must also be possible to attribute them significance beyond Clark's more stylistically-qualified label "crazily improbable". Despite the hitherto unseen visual features elicited from the stony masses by the new naturalism, this significance is at least

partially made up of the subterranean chaos we met in the post-Egyptian pre-modern images (cf. chapter 2). Paradoxically, naturalism re-exposes the chthonic forces in the broadest sense, not merely the dynamic, catastrophic and growth forces, but also the potential of design inherent in *prima materia*, the chaotic substance at the bottom of the world hierarchy.

If we enlarge upon Clark's 16th-century Northern examples by means of material from the late Italian 15th century, however, it becomes clear that the pictorial rocks not only repeat a medieval tradition, but also go beyond it – into the zone of tension between modernity and resuscitated antiquity, or to use terms from my analytical viewpoint of middle distance: between the work-influenced nature of the Iron Age paradigm and the demonstratively work-free nature of the Golden Age paradigm. Numerous rocks in the Italian Quattrocento images would thus seem to represent a form of primeval architecture, rudimentary monuments halfway between nature and culture. In Mantegna's *Agony in the Garden* (*c.* 1460), for example, one of the rocks is twisted spirally like a Tower of Babel, while an adjacent rock has markedly cubic blocks as if it had been hewn with an enormous chisel (FIG. II.42). And in an extreme case such as the background of the *Saint Peter* panel from Francesco del Cossa's *Griffoni Polyptych* (*c.* 1473-75), a rock sprouting from a partially ruined arcade looks like a variety of growing crystal (FIG. 12.4A). As we can already see from this example, the artificiality is typically clad in such ambiguous visual information that we promptly feel ourselves entangled in a speculative riddle as to the actual origin of these stone formations. As Lauro Martines, one of the surprisingly few scholars to have commented on this phenomenon at all, writes:

> [...] one of the most salient and persistent motifs of Italian painting in the second half of the fifteenth century [is] the imagery of strange rock formations – architec-tonic, fantastic, lovingly delineated. [...] Again and again we find on close scrutiny that we cannot tell whether the oddly mannered constructions are natural geological formations or the ruins of ancient structures and urban sites. The guiding vision is intensely urban, the forms often resembling or suggesting bits of city.[2]

Martines thus feels caught between two explanatory regimes: an internal, in which the architectonic aspect derives from the rock itself; and an external, where it is due to humankind's purposive shaping succeeded by the blind ruination wreaked by time. Although these two explanatory regimes, architectonic rock and ruin, incorporate conflicting arrows of genesis – pointing to, respectively, nature in trans-formation into architecture and architecture in the process of being returned to the embrace of nature – their visual appearance, then, is almost interchangeable. As if Martines' complexity were not enough, the spectrum of possible origins can

actually be expanded with three more: are the rocks' elaborate surfaces the vestiges of quarrying or mining; are they part of a planned landscape design; or are they perhaps simply the result of the beholder's imagination?

An analysis of this ambiguity and its fractures will benefit from the application of my sociological developmental framework, the evolution going from Golden Age to Iron Age paradigm, and an investigation of the position of the rocks herein. In the Golden Age myth, the rock masses represent, after all, the final frontier of the ages of the world, the domain where the Iron Age invades Mother Earth and cuts away forbidden minerals for the purposes of technology and art (cf. chapter 4). When the rocks in 15th-century painting partially exhibit signs of architectural forms, which seem to exist latently in the stone, do they thus appear as a last bastion against the Iron Age – i.e. as a Golden-Age-like nature that creates art autochthonically and thereby renders mine-work superfluous – or do they, on the contrary, represent the final surrender of the Golden Age to the era of technology, a Faustian vision of the rocks as automatons for the technological wishes of humankind? A branch of knowledge that mediates between these two outer poles, and which will accordingly prove significant for the interpretation of the architectonic rocks, is alchemy. While retaining the pre-modern belief in a cosmos endowed with spirit, including ideas of minerals growing in the womb of the earth, alchemy takes issue with the Golden Age *field*'s criminalisation of mine-work and quarrying and, in contrast, sees mining and refining as assistance to nature's urge towards perfection.

Even though the content of the architectonic rocks is, to a large extent, transferred to the paradigm with its assorted and, by definition, flimsier meaning, fortunately it can also be condensed in acute iconographic situations, which can cast their light back on the paradigm – albeit in practice we will often find ourselves in an unspecified spot between paradigm and iconography. In a wilderness motif such as Leonardo's *Virgin of the Rocks* (begun 1483; PLATE 36), it will be shown, by way of example, that the virginity of the otherwise so ingenious-looking rocks is crucial to the iconography, a nest of Chinese boxes that interconnects the immaculate wombs of the Virgin Mary and Elizabeth with John the Baptist's wilderness, the forecourt to Hell and Francis of Assisi's La Verna rock. But, in accordance with society's incipient work ethic, landscape images of the late medieval period also see the beginnings of a turning away from virginity towards the mining and quarrying of the Iron Age. In the paintings of Mantegna, for example, which will be a recurring topic of interpretation in this chapter, quarrying appears to be extremely ambivalent – on the one hand, the indispensable prerequisite of the Gonzaga prince's opulent building activities (PLATE 37), on the other hand, an earth-raping, Iron-Age-marked idolatry which is played off against Christ's both work- and sexuality-free – and therefore Golden-Age-marked – origins in the womb of the earth (PLATE 38).

The 15th-16th-century rock thematics thus ultimately provides the opportunity for a contemplation of the essence of art – art understood both in its antique sense as all forms of technological cultivation of nature (*ars*, *techné*), and in its modern meaning as sublimated, autonomous representation (*fine art*). At the interpretative pole that sees architectonic forms as inherent in the rocks (natural architecture and growing crystals), we are still in the vicinity of the Golden-Age-marked philosophy of antiquity, in which forms are the result of the heavens' fertilisation and impregnation of matter. The pole of external influence, on the other hand, points primarily in the direction of a modern, Iron-Age-infiltrated universe, in which nature is drained of spirit and blind (ruination wreaked by time), and in which humankind can therefore either consume it at will (mine-work, quarrying and technological design) or fantasise about its randomly generated forms (subjective visions reproduced in the fine art of painting). Even though the compass of analysis is complex and often ambivalent, for the sake of manageability I shall make these two poles the fixed points of my exposition, so thus we will ideally move from a neo-antique to a modern reading of the architectonic rocks.

Using the same framework, I shall in conclusion venture an expansion of the corpus of fossil themes and generally analyse examples of early modern pictorial phenomena in the zone of tension between nature and art. This does not just mean images set within stone and clouds ('images made by chance'), but also the figurative counterpart to the rock landscapes – namely, the strangely statue-like figures which populate so many Northern Italian images in the second half of the 15th century.

12.1 Self-grown architecture

Exposing the tensions of the paradigm-shift:
Filippo Lippi's rocks versus those of the Ferrarese

Although the 15th-16th-century artists are handed a new paradigm – a paradigm with the potential to reproduce the surrounding environment in its optical, instantaneous form of appearance – the pictorial motifs do not all behave with equal smoothness in their adherence to the demands of the paradigm. Especially in pre-High Renaissance Italy and north of the Alps in the latter period, the pictorial rocks display an idiosyncratic conflict between way of seeing and object being seen, as if the naturalistic lens taking in the rocks gets embroiled with a hibernated pre-modern content. The rocks seem phantasmagorical, monumental, artificial, ruin-like, organic or just strangely insistent.

A good example of this tension can be observed in Filippo Lippi's landscapes.

Fig. 12.1. Francesco del Cossa,
Triumph of Minerva (1469-70), fresco,
upper section of *March*. Ferrara,
Palazzo Schifanoia, Sala dei Mesi.

The wilderness landscape surrounding John the Baptist in Prato Cathedral (painted 1452-65; PLATE 39) is, in a way, but a hair's breadth from Giotto's Byzantine-derived terraced rocks (FIGS. 9.19 and 9.20). But whereas Giotto's land formations still seem compatible with the partially pre-modern way of seeing through which they are apprehended, the rocks look decidedly bizarre in Lippi's now more zealously naturalistic lens that transforms the hitherto monolithic masses into fantastic accumulations of strata and blocks. Behind the preacher we see a towering rock formation that could well be the corner of a ruined building. In the right foreground, the rocks are cleft by a groove whose identity is uncertainly located between hewn-out path and natural chasm. And what about John's cave, in the depths of which a similar 'path' wedges its way in: is it natural or hewn out? Is it possibly a quarry or mining cave, the architecture of which appears in the negative as residual forms from the hewn-away stone? The answers are uncertain since the whole landscape seems to fluctuate between chaos, natural architecture, ruin, quarry and purposeful

Fig. 12.2. Cosmè Tura, *Triumph of Vulcan* (1469-70),
fresco, upper part of *September* (section). Ferrara,
Palazzo Schifanoia, Sala dei Mesi.

hewing out. This ambiguous attitude to orderliness can only be highlighted by the right-hand side where Lippi has wedged the Baptist family's house in between the thickset rocks. Architecture is here confronted with its origins in chaos.

The sceptical reader will now object that Lippi's landscape was not intended to be anything other than 'ordinary' stony wilderness, and that the anomalies I have read into it are purely the vagaries of style caused by the movement from conventional rock formations to a more consistently naturalistic style. In response, we could move our gaze across to painting in the contemporaneous and slightly later Ferrara, a city which could be hailed as the centre of bizarre rocks in the 15th century.[3] What can we make of the artists' intentions when we see the throng of fantastic rock formations in Palazzo Schifanoia's cycle of the months (1469-70)? In the *Triumph of Minerva* from Francesco del Cossa's *March*, brick houses are built into the rocks, creating peculiar hybrids (**FIG. 12.1**); and behind Mars' and Rhea Silvia's couch in Cosmè Tura's *September* scene we see a rock structure penetrated by caves and a natural arch and, furthermore, divided into veritable storeys separated by protruding segments (**FIG. 12.2**). Cossa manifestly brings the rock fantasia to its

Fig. 12.3. Detail from
Francesco del Cossa's
Saint John the Baptist,
plate 8.

culmination, focussing intensely on the paradoxes of creation in his *Griffoni Polyptych* from *c.* 1473-75. Behind the saints we see rocks growing from otherwise perfect walls or balancing on partially ruined arcades (FIGS. 12.3 and 12.4A). In other instances they seem to be half-way transformed into architecture and, indicative of the dark foundations of the whole spectacle, the ground is penetrated by black holes into the underworld (FIG. 12.4B and PLATE 8).

Fig. 12.4a. Francesco del Cossa, *Saint Peter* (*c.* 1473-75) (detail), tempera on wood, left panel of the *Griffoni Polyptych*. Milan, Pinacoteca di Brera.

Fig. 12.4b. Francesco del Cossa, *Saint Vincent Ferrer* (*c.* 1473-75) (detail), tempera on wood, central panel of the *Griffoni Polyptych*. London, National Gallery.

Fig. 12.5. Pietro Guindaleri, miniature from the opening of Book 30 in Pliny the Elder's *Naturalis historia* (completed after 1489) (detail). Turin, Biblioteca Nazionale, ms J.I. 22-23, f. 425 (min.20).

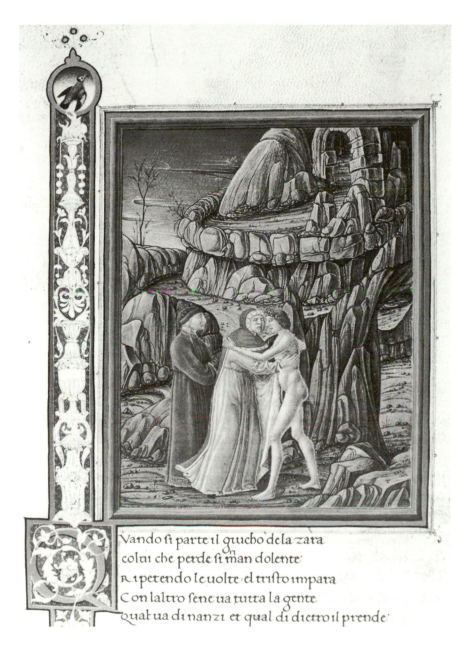

Vando si parte il giucho dela zara
colui che perde si man dolente
Ripetendo le uolte el tristo impara
Con laltro sene ua tutta la gente
Qual ua dinanzi et qual di dietro il prende

Fig. 12.6. Franco de' Russi and Guglielmo
Giraldi, initital Q (*c.* 1480), miniature
from manuscript of Dante's *Divine Comedy*,
Purgatory 6, 72. Rome, Vatican, Biblioteca
Apostolica Vaticana, ms Urb. lat. 365, f. 112.

In images by the Ferrarese artists, no one can be in any doubt that the rocks treat of something thematic beyond their own pure and innocent existence – a theme pertaining to the relationship between unfinished and finished, nature and art, underworld chaos and architectonic order (see also FIGS. 12.5 and 12.6).[4] But the Ferrarese visions, then, are not transferred on a *tabula rasa*, a stylistic language that is wiped clean of meaning, because in Filippo Lippi's wilderness we see exactly the same tendencies, just in a more tacit form. Lippi's visions can only be explained away as stylistic accident if seen in isolation. In other words, the Ferrarese painters only articulate the tensions that arise when the rock forms handed down from the Golden Age paradigm are exposed in the new and more naturalistic landscape paradigm of the period. Any rock formation in the contemporaneous Italian painting will be marked by these tensions, however implicit they might seem. As the tensions of the paradigm thus condense, in terms of meaning we move into a borderland between what is describing and what is being described, between language and content, between paradigm and iconography. Where does the paradigm stop and where does the iconography begin?

Natural architecture

If we want to pin down the significance of the rock forms more specifically, we must first accept that it remains open and ambiguous. We can, at most, sketch in the structures around which meaning can be condensed. To begin with, the rocks perpetuate the entire complex of meaning I discussed in the pre-modern section, the rocks as signifiers of Mother Earth, the chthonic, *chora*, the underworld. If matter is understood as Mother Earth, then the architectonic character of the rocks could be linked with their function as denoting special sacred places or primordial architecture, the protective building of the depths of the earth. As we saw in the section dealing with sacral-idyllic painting (chapter 6), projecting or conspicuous rocks have often had a sacred function because the essence of the earth was concentrated in their solid and yet clear-cut forms. They were the site for visions, protection or cure.[5]

Such rocks were the obvious resort of ascetic saints renouncing the world and seeking contact with God. Athanasius describes, for example, how an inner voice leads Anthony through the desert of Thebaid and on to his new place of abode, a high mountain at the foot of which there is fresh, cold water and a plain with a couple of uncultivated palms.[6] Similarly, in Jerome's letter to his friend Eustochium (*c*. 384 AD), we read: "[...] and, stern and angry with myself, I used to make my way alone into the desert. Wherever I saw hollow valleys, craggy mountains, steep cliffs, there I made my oratory, there the house of correction for my unhappy

Fig. 12.7. Marco
Zoppo, *Saint Jerome
in the Wilderness*
(1460-70), tempera on
wood. Madrid, Museo
Thyssen-Bornemisza.

flesh."[7] Many of the fantastic rock formations in 15th-century painting appear in depictions of just such a hermitic life in the wilderness, be it with all the saints in the Thebaid or with saints John the Baptist, Anthony, Jerome or Francis of Assisi on their own (**PLATES 4, 36** and **39**, **FIGS. 11.53, 12.26, 12.44** and **12.47**). In one of the more spectacular examples, Marco Zoppo's *Saint Jerome in the Wilderness* (**FIG. 12.7**), the rock is a natural arch constructed of stone blocks which look both organic and architectonic.[8] Proof that formations such as these are not simply the figment of an imagination can be gathered by ascending the Tuscan La Verna, the mountain where Saint Francis lived and where his stigmatisation took place. To a visitor today, too, the rock looks like a bizarre piece of natural architecture with flat-walled chasms, stone pillars, plateaus, tracks and caves. And, indeed, how deeply it is loaded with meaning will be examined in my analysis of Leonardo's *Virgin of the Rocks*.

In the subterranean zones, with their labyrinthine cavities, we find the primordial forms of architecture: vaulting, columns, arches, openings.[9] In antique theories of

Fig. 12.8. *Punishment of Dirce*
(1st century BC), fresco from
Pompeii, Casa del Granduca. Naples,
Museo Archeologico Nazionale.

the origins of architecture, the protective cavity, the grotto, in particular played an important role. Vitruvius believes, for example, that the first humans lived in caves, a practice that continues with the treeless Phrygians who cannot, as others, build wooden huts, but have to dig out earth mounds instead.[10] Like the sequence followed by the Golden Age myth, this belief also refers to actual practice, given that Neolithic burial mounds could actually be said to reconstruct the caves which had for millennia, before the agricultural revolution, served as humankind's primary place of abode. A form like this – which goes under names such as barrow or dolmen – occasionally features in the landscape painting of antiquity; for example, in the *Punishment of Dirce*, where a flat capstone has been placed across the top of two upright stones (**FIG. 12.8**).[11] Apparently without recourse to the paintings of antiquity, the 15th century revives this form: examples can be seen in Filippo Lippi's *Madonna and Child with Two Angels* (c. 1450; **FIG. 12.9**) or Jacopo del Sellaio's *Pietà with Scenes of Hermit Life* (1480s?; **FIG. 12.10**) where the 'dolmens' are even divided into several levels.[12] The natural arch in 15th-century painting also has forerunners in Roman painting; for example, in the *Odyssey Landscapes* where some blocks by the sea are riddled with holes.

Fig. 12.9. Filippo Lippi, *Madonna and Child with Two Angels* (*c.* 1450), tempera on wood. Florence, Galleria degli Uffizi.

Protected by such forms of natural architecture, humans found shelter in the womb of the earth. Catacombs were placed in the depths of the earth, because Christians could thereby gain sustenance from the subterranean, chthonic energy. And, later, persecuted Christians sought safe haven in the earth's womb when, from the 8th century onwards, the tufa rocks of the Göreme dale in Cappadocia were converted into a veritable beehive of chapels and monk's cells (**FIG. 12.11**). Innumerable sacred caves far and wide have gained the status of such chapels, either in their

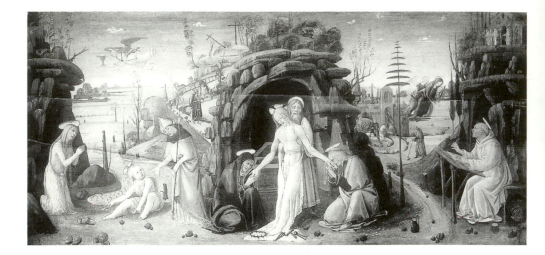

Fig. 12.10. Jacopo del Sellaio, *Pietà with Scenes of Hermit Life* (1480s?), tempera on wood. Berlin, Staatliche Museen (earlier cat. no. III. 97).

Fig. 12.11. Rock chapels in Göreme, Cappadocia (8th century onward).

undressed form or with architectonic elaboration. This is the case with the Grotto of the Nativity in Bethlehem, Santa Maria de Praesaepio (*præsæpio*=enclosure, stable, manger), and it is the case with the many cult grottos in Italy dedicated to Santa Rosalia, the Virgin Mary or Saint Michael, subjugator of the subterranean dragon.

This entire cult tradition has to be borne in mind when looking at the architectonic rocks of Quattrocento painting. Besides hermit themes, they can be generated

Fig. 12.12. Cosmè Tura, *Saint George Slaying the Dragon* (1469),
tempera on canvas, organ shutters. Ferrara, Museo della Cattedrale.

by cave motifs such as Saint George (for example, Cosmè Tura's organ shutters with
Saint George Slaying the Dragon (1469; FIG. 12.12)), the birth of Christ (for example,
Mantegna's *Adoration of the Magi* (c. 1462; FIG. 12.13)) or the resurrection of Christ
(for example, Giovanni Bellini (c. 1480; FIG. 11.16)). The descent to hell is also fertile
with spectacular natural architecture, as can be seen in the school of Mantegna
engraving (1460s; FIG. 12.14)[13], where Christ is forcing a sturdy stone gateway in the
raw rock.

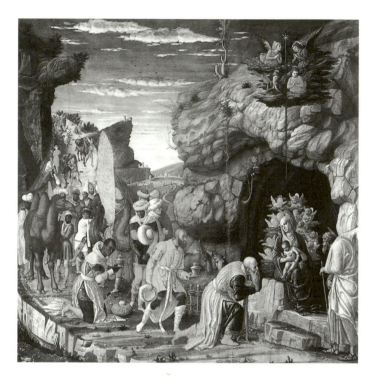

Fig. 12.13. Andrea Mantegna,
Adoration of the Magi (*c.* 1462),
tempera on wood. Florence,
Galleria degli Uffizi.

Fig. 12.14. School of
Andrea Mantegna,
*Christ's Descent
into Limbo* (1460s),
engraving.

The art-philosophical and alchemical context

A tradition born of this millennia-long experience of rock dwellings and chthonic relief, and at the same time providing the rocks in 15th-century painting with a more conceptual framework, is the philosophy of art. How does art come into being and what is its relation to nature? Ronald Lightbown remarks incisively of Mantegna's rocks:

> Indeed it might almost be said that for Mantegna mountains were rude monuments and that he saw in their irregular heaps of rock, which sometimes he echoes in irregular piles of man-shaped stones, heaped up from the ruins of antiquity, a sort of natural architecture, interpreting literally the Renaissance concept of 'fabrica mundi'.[14]

To regard the rocks as kin to the art of humankind, because the world edifice is in itself an elaborate work, is perfectly in keeping with pre-modern, geocentric thinking in which art is inscribed in the total work of creation. Nature was not only perceived as an organism of divine origin, it was also believed to be controlled according to principles similar to those found in art. As it says in Plato's *Sophist*:

> I will only lay it down that the products of nature, as they are called, are works of divine art, as things made out of them by man are works of human art. Accordingly there will be two kinds of production, one human, the other divine.[15]

That man-made works, like nature's organisms, can be included in the overall phenomenon 'art', is due to the circumstance, as shown by Aristotle (cf. chapter 4), that both are characterised by a process in which the male precept of motion transfers nature's form to the passive and female matter. As ratified by the Dominican Aristotelian Thomas Aquinas, the form in the woodworker's soul belongs just as much to nature as does the form residing in the semen, because art is part of the creative force of nature.[16] The role of art in relation to nature is formulated more explicitly by, for example, the Neoplatonist Marsilio Ficino in 1474: "In sum, man imitates all the works of divine nature, and perfects all the works of lower nature, correcting and emending them."[17] Antiquity's belief in the extreme meaningfulness of nature is hereby rekindled: that nature does not create works of art by itself is merely due to a failing power of implementation given that works of art, no less than organisms, are part of nature's intention.

But even though works of art thus complete and perfect nature, they are still not the "divine art" of the virgin works of nature. While nature gives birth, i.e. produces in the closest relationship between form and matter, art is obliged to

construe, i.e. via the strenuous intervention of the hand to assemble and design scattered materials. As already suggested in chapter 4, the distance between nature and art is particularly conspicuous when it comes to mining-work and quarrying, the violent removal of materials from the interior of Mother Earth. Painting could be said to be at a plausible distance from this encroachment, inasmuch as its pigments, the pulverised stone, constitute a kind of sublimation of the gravitational bedrock, a transfer to a more ethereal and thereby spiritual sphere. Architecture and sculpture, on the other hand, are kept much closer to the body of the earth, the tangible materiality of which is retained in the stone and metal, while their form-inducing moulding extends the process through which they are violently wrested from the living rock.

A Renaissance example of the reawakened resistance to mining-work and quarrying, the mark of the Iron Age, is found in, for example, Alberti's dialogue *Theogenius*: "Nature has hidden away [...] the gold and the other metals under enormous mountains and in deserted places. We brisk small humans [...] collect it from the outermost and most extreme regions and cut it apart, giving it new polishing and form." Furthermore:

> The marble lies resting in the earth: we place it on the fronts of temples and above our heads. And so displeased are we by the natural freedom belonging to every created thing, that we dare subjugate it to our own service. And countless artificers were born from and believed in this misery, clear signs and arguments for our foolishness. Add to this the poor concord man has with all the created things and with himself, almost as if he swore to observe the utmost cruelty and monstrosity. His stomach wished to be a public grave for all things, herbs, plants, fruits, birds, quadrupeds, worms, fish; nothing above earth, nothing under earth, nothing that he does not devour.[18]

This citation implies a whole chain of mortal sins brought about by the infringement on the earth. Number one, pride (*superbia*), arrogance in having subjugated creation to the service of humankind in the first place. Next, greed (*avaritia*), lust (*luxuria*) and gluttony (*gula*): covetousness of the treasures found in the terrestrial caves, an obvious parallel to sexual lust, leads to unnecessary architectonic luxury – by means of which these treasures are, as it were, ruined, devoured into the same grave as the food at the very moment they are brought to light. Lastly, this sexually-tinged desire and waste leads to disagreements between people, i.e. anger (*ira*).

In order to establish how this distrust of mining-work and quarrying was gradually transformed into affirmation of the same – how Golden Age *field* was turned into Iron Age *field* – it is necessary to involve a more esoteric, but therefore no less crucial, agent: *alchemy*. At a time when the desacralisation of nature had only just

Fig. 12.15. *The Licorice Plant* and *Growth and Mining of the Lapis Lazuli stone* (*c.* 1320), miniatures from Provençal herbarium. Florence, Biblioteca Nazionale.

begun, and it was still possible, like Alberti, to lament the Iron Age encroachment of the earth, alchemy took on an alleviating role since, unlike the main thrust of the Golden Age *field*, it did not look upon mineral extraction as a symptom of the criminalisation of culture, but on the contrary as a measure on the way towards its perfection. Fertilised by celestial seed, metals and minerals lay in the earth's womb and slowly grew towards more perfect phases, with gold as the ultimate objective. As can be seen from writings on alchemy such as, for example, *Bergbüchlein*, the first book in German on the secrets of metallurgy, published in Augsburg in 1505, every metal, whether it went on with the transformation towards gold or remained in a less noble, 'miscarried' state, was controlled by a planet: silver grew under the moon, gold under the sun, iron under Mars, lead under Saturn, and so forth.[19]

A visual testimony to this belief in the growing and also benign character of minerals, and in humankind's corresponding right to wrest them from earth, can be seen in, for example, a miniature of lapis lazuli mining in a Provençal herbarium (*c.* 1320; **FIG. 12.15**).[20] The precious, sparkling stone, which was of value both in pictorial art (as pigment) and medicine (such as a cure for blindness and fever), apparently grew from the depths of the earth under the influence of the rays of the sun. The

Fig. 12.16. Cave with mine-work and
alchemist, frontispiece engraving from
J.B. von Helmont, *Opera omnia* (1682).

miniature accordingly shows a miner swinging his mattock in front of a sunlit blue
solid block, from which additionally a demonic claw is sticking out – the claw of
the stone's protective dragon, which in a wider sense means the chthonic dragon.
If this dragon can be vanquished, then the earth's store will be released.

Alchemy, with its artificial means of intervention, was now assigned to accelerate
and refine that transformation of matter which is naturally underway in the depths
of the earth. In *Summa perfectionis*, a 14th-century alchemical treatise, it is said that
"what Nature cannot perfect in a vast space of time we can achieve in a short space
of time by our art".[21] This collaboration between nature and art is later rendered
pictorially in engravings such as the frontispiece to van Helmont's *Opera omnia* (1682;
FIG. 12.16), which juxtaposes cave and alchemical work (*labor*),[22] or an allegory from
the *Musaeum Hermeticum* compendium (1627; **FIG. 12.17**). In the latter, the growing
metals are depicted as muses around a lyre-playing Apollo – Gold – in a cave, while
their designers, the alchemists, sit in state on the earth immediately above the cave.
The Philosophers' Stone, the *lapis* of alchemy, which can transform metals to gold,
here appears as a star made up of two triangles: one pointing downwards, earthly,
for water, and one pointing upwards, celestial, for fire.[23]

If the alchemists thus clad their ideas in an often esoteric symbolism, it has to
be stressed that their basic vision is part of the Aristotelian world hierarchy with
its aspiration to perfection and a buoyancy in which the more perfect bodies at-
tract the less perfect. This attraction is principally due to the upper spheres, i.e. the
divine heavens including *primum mobile*, the intelligences and celestial bodies. But
not only: as Thomas Aquinas mentions, objects in the earthly world also influence

Fig. 12.17. Principles of alchemy:
the 'designers' sit in state above the earth
while the growing metals make music in the
cave; in the spandrels, the four elements.
Engraving from *Musaeum Hermeticum* (1627).

one another,[24] an upward urge summed up in the idea of *potential* and *action*.[25] Every
body has the inherent potential to become more perfect, and this vanishes in step
with the fulfilment of this perfection. In turn, the body becomes an *agens* that can
influence other, less perfect bodies.[26] All this thinking around the aspiration to
perfection and the mutual attraction of bodies is also fundamental to alchemy,
not least the idea of pure potential, the totally unstructured *prima materia* at the
bottom of the world hierarchy.

Returning to the architectonic rocks of Quattrocento painting, I would now suggest that on one level of interpretation, at least – the one rooted in the Golden Age *field* and its reformation in alchemy – they can be read as a visual homology to this nature's aspiration to perfection, an aspiration that would here seem to be so irresistible as to break forth without the mediation of work. The architectonic features hover tensely between Iron Age and Golden Age: architecture belongs to the Iron Age, humankind's most cultivated epoch, and yet it crops up Golden-Age-like in the solid rock, as if under the direct influence of the upper spheres. That the forms should emerge from the rock itself would seem logical given that this earth's most concentrated state is akin to, if not identical with, *prima materia*, the matter with the greatest potential and the basis for alchemical transformation. In alchemical texts, *prima materia* is often referred to as "our stone", which "is a stone and yet not a stone",[27] and it is also called "the Chaos of the Wise" as it recalled the unity before Creation.[28] A German poem, *De prima materia lapidis philosophorum*, written in 1598 at the latest, presumably based on an earlier Latin original, says *inter alia* of *prima materia*:

> It is a stone, and yet not a stone,
> In this lies the art alone:
> Nature has made it so,
> Not brought it to perfection, though:
> On earth its equal will not be found,
> It grows on mountains and in ground,
> *Materiam Primam* its name should ring:
> He is quite wise, who knows this thing.[29]

The emergence of architecture in natural forms is made so much the more logical when Aristotle actually discusses the idea of a house produced by nature: "The operation is directed by a purpose; we may, therefore, infer that the natural process was guided by a purpose to the end that is realized. Thus, if a house were a natural product, the process would pass through the same stages that it in fact passes through when it is produced by art."[30] That this idea should be understood in an organic light is emphasised by Frederick Woodbridge: "[...] if a house came into being as a plant grows, we should call a house natural and a product of nature, and if a plant came into being as a house is built, we should call it artificial and a product of art."[31] The juxtaposition of mountain and architecture is perhaps particularly pertinent in an alchemical context since the alchemical synthesis container, the artificial womb in which the vein completes its gestation, went under the name *domus* and could also be symbolised by the mountain itself.[32] The house is, like the mountain, a container that both protects and nourishes.

Fig. 12.18. Francesco del Cossa, *Triumph of Venus* (1469-70), fresco, upper section of *April*. Ferrara, Palazzo Schifanoia, Sala dei Mesi.

But if the stone in 15th-century painting aspires to the higher perfection through growth, it is an obvious step to couple this aspiration with the rocks' 'ordinary' capacity for growth (also cf. the alchemical poem's mention of *prima materia* as *growing* on mountain and in ground). Growing towards the light then becomes identical with aspiration to perfection. There are actually many instances in 15th-century painting of architectonic rocks that also grow. One spectacular example is the Pesaro *Saint Francis Receiving the Stigmata* (PLATE 4), mentioned in chapter 2. Here the Byzantine rocks grow into natural arches, and the middle rock has also moulded a narrow window framed by cubic ashlars. In Palazzo Schifanoia's *Triumph of Venus* in the *April* section, we see the same coupling, only now in a more illusionistic light (FIG. 12.18). Both of the pink rock formations flanking the triumphal vessel have small plant-like peaks at the bottom, while their structural division into storeys is striking, especially in the natural arch rising over the left formation's capstone. Their fecundity, appropriate to the month of love, is substantiated on the right-hand side where rabbits, the classic symbol of fertility, sniff small 'rock shoots'.[33]

Other examples of natural arches resulting from peaks growing towards one

Fig. 12.19. Carlo Crivelli, *Saint George and the Dragon* (c. 1490), tempera on wood, predella panel from the *Odoni Altarpiece*. London, National Gallery.

Fig. 12.20. Vittore Carpaccio, *Sacra conversazione* (c. 1500), oil on canvas. Chantilly, Musée Condé.

Fig. 12.21. *Saint John the Baptist Bearing Witness to Christ* (c. 1315-21), mosaic. Istanbul, Kariye Church (Kora).

another are Crivelli's *Saint George and the Dragon* from the *Odoni Altarpiece* (c. 1490; FIG. 12.19) and Carpaccio's *Sacra conversazione* (c. 1500; FIG. 12.20). The architectural potential of the latter arch is confirmed by the fact that is has become the dwelling place of hermits. As we can see from the Kariye Church (Kora) in the former Constantinople (decorated 1315-21; FIG. 12.21), growing natural arches such as these go back at least to the Middle Ages. The arches call to mind Diana's previously mentioned cave in Ovid, where nature "had shaped a native arch of the living rock and soft tufa".[34] (Cf. chapter 2)

The idea of growing stone indeed thrived in the Renaissance. Alberti devotes a whole page of his *De re aedificatoria* to the phenomenon.[35] Here we read about, for example: marble growing in its quarries; small pieces of Tiburtine stone that grow together as if they were nourished by time and the earth; enormous, still growing stalactites by a waterfall; stones that turn into soil and soil that turns into stone; and large stones born in the bowels of the earth, later to be brought

to light on a riverbank in the Cisalpine Gaul.[36] Leonardo, too, mentions the strata in the "living stone" cut through by the northern rivers of the Alps;[37] and in a letter to Titian, Pietro Aretino writes about the view across the Canal Grande: "As I describe it, see first the houses which, although of living stone, appear to be of some artificial substance."[38]

Lastly, considering the continued belief in fertility of rocks, it should come as no surprise that the mountain masses of Quattrocento images not only swell with architectural forms, but also with precious minerals. While these minerals can be dug out from earth cavities in special iconographic contexts such as Mantegna's *Meeting* scene or *Madonna of the Stonecutters* (more on this later), they can also be spread all the way to the surface of the earth without further reason, i.e. determined by the paradigm. In Mantegna, the thickset rocks often gleam as if they were quite generally made of precious materials. And a number of Ferrarese images, for example Palazzo Schifanoia's *June* and the Guglielmo Giraldi workshop's miniatures, show small red or blue stones lying on the bare ground with no specific – i.e. iconographic – explanation.[39]

Mountain alchemy

In seeking further substantiation that the architectonic rocks in 15th-century painting comprise locations where the alchemical transformation towards perfection might be contemplated, we could turn to a structuralist argument highlighting the tension between upper and lower strata in the mountain. An appropriate iconographic condensation of such a reading can be found in the 1475 wedding festivities held in Pesaro, which are recorded both in an unsigned description and a miniature by Lionardo da Colle.[40] The festivities, which brought together Constanzo Sforza and Camilla of Aragon, had been orchestrated by the Ferrarese duke Ercole d'Este's Jewish dance master, Guglielmo Ebreo, and included a pair of rolling mountains made of painted wood. As an indication of their fecundity, the mountains were covered with plants and trees plus wild animals such as hares, goats, deer, bears and rabbits. The aim of the pageant was partly to disseminate Ercole's pro-Jewish policy, for the Queen of Sheba on a mock elephant and King Rehoboam on a "Monte delli ebrei" made speeches to the newlyweds in which they requested tolerance for the couple's Jewish subjects. In this campaign, Guglielmo obviously drew on *kabbala*, the Jewish mystical teachings, because the mountain proved to be full of fantastical persons. Through two holes in one of the mountains, "the Mountain of Humans", the following emerged: "the Saved Man" fighting a lion, plus fourteen Moors. "The Mountain of Hebrews", for its part, contained an old Hebrew man accompanied by twelve Moors, and at its

Fig. 12.22. Lionardo da Colle,
Monte delli ebrei (c. 1485),
miniature. Rome,
Vatican, Biblioteca
Apostolica Vaticana,
ms Vat. Urb. 899, f. 91.

summit there was a tower housing "a spirit". In Lionardo da Colle's miniature of the *Monte delli ebrei*, an illustration for a c. 1485 account of the wedding, this spirit takes the form of an angel (**FIG. 12.22**).[41]

Although the symbolism of the pageant is not explained in the surviving description, and might seem quite cryptic for a present-day analyst, there can be no doubt as to its use of alchemy and the related astrology. The roof of the ceremonial hall was decorated to resemble a firmament with signs of the zodiac, and the entourage accompanying "the Mountain of Humans" included figures of the seven planets, guides of the metals. Perhaps Guglielmo Ebreo made use of a specifically Christianised alchemy, so that each of the mountains comprised a *domus*, alchemy's artificial womb, and the Jews and the Moors in their interiors comprised a form of religious *prima materia*, potential Christians en route to perfection. Beyond seeing metals represented as human figures in **FIG. 12.17**, we could also consider the hypothesis corroborated by Titus Burckhard who, writing about the alchemical mountain in general, states that it contains "an indefinite collection of uncreated things".[42] The popular belief was maintained, quite literally, that the mountain mines were protected by spirits, genies and phantoms such as, for example, the Monk of the

Fig. 12.23. Miners hewing their way into a mountain; below, subterranean hall with figures from the Book of Esther. Miniature (1582, based on an original from *c.* 1525-30) in the manuscript of Salomon Trismosin's *Splendor Solis*. London, British Library, ms Harley 3469.

Mountain (Master Hoemmerling) or The White Lady who warned of landslips.[43] The angel at the summit of "the Mountain of Hebrews" could thus be the spiritual outcome of this, when the volatile substance, Christian faith, was released via heating. In the illustration for Lambspringk's "De lapide philosophico" (1678), discussed in chapter 2, a winged Hermes has been placed on a mountaintop alongside the "son of the king", precisely as symbols of Soul and Spirit respectively, metaphors for the volatile substances of the heating process (FIG. 2.40).

And as far as the Jewish and Moorish identity of the figures is concerned, it is further parallelised by a miniature in *Splendor Solis*, an alchemical treatise by Salomon Trismosin, allegedly teacher to the alchemist physician Paracelsus (1493-1541) (FIG. 12.23).[44] The 1582 miniature, derived from a German original of *c.* 1525-30, shows two miners working their way into a mountain via two caves. Under the mountain, in the underworld, we again encounter a hall with figures, this time from the Book of Esther: besides Esther herself, Mordecai, Ahasuerus, Bigthan, and Teresh. The scene might again be dealing with Jews as Christian *prima materia* and could also have links to kabbala given that Trismosin claims to have translated kabbalistic and magic books from Egyptian to Greek and Latin during his years of wandering after 1473.[45]

Fig. 12.24. Lorenzo Leonbruno or his school,
Gonzaga Mountain (*c*. 1510), fresco. Mantua,
Palazzo Ducale, Sala dei Cavalli.

Although I cannot here deliver a rigorous decoding of the alchemical iconography of 15th-century art, we can at least note that a hierarchical mountain was also part of the Gonzaga dynasty's symbol repertoire. When rewarding Federico II Gonzaga (b. *c*. 1500) for his efforts in the 1525 Battle of Pavia, Charles V gave him an *impresa* decorated with Olympus Mons and with the accompanying motto "Ad montem duc nos" ("Lead us to the mountain"). This emblem, which can be traced back in the Gonzaga dynasty to at least 1457-58, can also be seen depicted in a fresco in Palazzo Ducale's Sala dei Cavalli, decorated around 1510 by Lorenzo Leonbruno or his school (FIG. 12.24).[46] In the fresco, the Olympus mountain rises from the middle of a circular labyrinth located out in a bay. A spiralling track winds its way from a city gate up towards the top of the mountain. Given that the labyrinth is an underworld symbol, this mountain too must deal with the ascent from fallen matter to purity of spirit. The labyrinth plays a similar role in an illustration for Filarete's treatise on architecture: here it encircles an earth surrounded by water, with King Zogalia's pleasure garden in the middle, "the garden of the new taste".[47] It would seem probable that this hierarchical symbolism lurks in many of the contemporaneous more iconographically-determined depictions of rocks. A striking example would be Cosmè Tura's *Pietà* in Museo Correr (*c*. 1460; FIG. 12.25). Here the Golgatha rock is also wound round by a spiralling track and rises up on a sort of peninsula in an underworld-like labyrinth of a bay. The rock thus becomes a Mountain of Life with the Cross as the Tree of Life.[48]

Fig. 12.25. Cosmè Tura, *Pietà* (c. 1460), tempera on wood. Venice, Museo Correr.

In symbol-laden rocks such as these, we thus see the same tension that can be perceived in the 15th-century general pictorial paradigm, the tension between chaotic matter and elaborate form. On the paradigmatic level, this duality is not merely rendered visible by the rocks being marked with artificial features, but also by architecture and raw foundation being juxtaposed in a contradictory and yet cohesive manner. An arresting phenomenon in landscape images of the period is thus the many castles and cities lingering on the ridges of rocks in the backgrounds, as if they had grown from their foundation like a kind of bud. Obviously Italy actually teems with installations such as these located on dizzying heights, often constructed for reasons of defence, but this does not strip the visual impression of its art-philosophical connotations. An anthropomorphic consolidation of such connotations can be seen, for example, in Roman sculptures of Cybele in which the earth goddess is crowned by a wreath of turrets and thereby avows that cities have their foundations in the body of Mother Earth and will be protected by Cybele.[49]

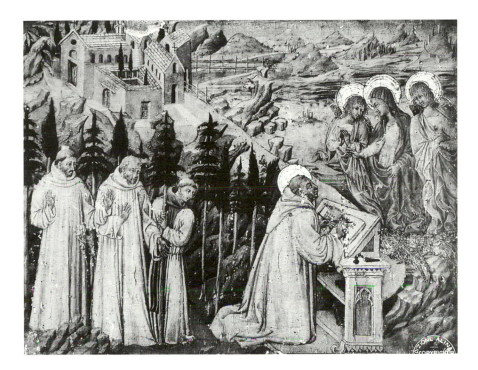

Fig. 12.26. Giovanni di Paolo, *Saint Galganus
and Female Hermit* (1450s?), tempera on wood,
predella panel from the *Saint Galganus Polyptych*.
Siena, Pinacoteca Nazionale.

The annular city wall crowning the spherical mountain in Camera degli Sposi could
be seen as just such a crowning of the earth (PLATE 37).

The 15th-century artists would often seem, moreover, consciously to bring the
castles into a sort of semantic border zone, a *parergon* field, where distance is trans-
formed into thematic ambiguity. Giovanni di Paolo utilises, for example, the fact
that their turrets are so distant that they can be described with single, slightly irregu-
lar brushstrokes, by means of which they resemble disturbing, spiked stone forma-
tions and thereby continue to develop the idea of natural architecture (FIG. 12.26).[50]
Other examples of this semiotic game in the border regions of the eye's power of
resolution are found in Ferrarese manuscripts such as the *Bible of Borso d'Este* (1455-61;
FIG. 12.27) or in Pietro Guindaleri's illuminations for Pliny's *Naturalis historia* (begun
c. 1475, completed after 1489; PLATE 41). In Guindaleri's otherwise so peaceful sunlit
landscapes, the game becomes almost surreal in the way it lets the gaze stumble
between sturdy rock ramparts and raw fortress walls.[51] With sights such as these

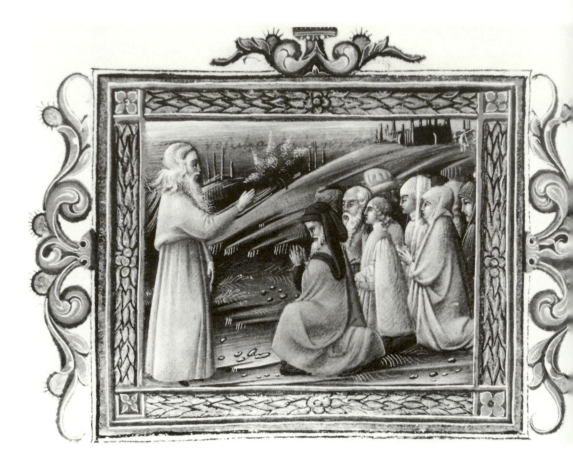

Fig. 12.27. Taddeo Crivelli, Franco de' Russi
et al., *Joshua Speaking to the People* (1455-61),
miniature from the *Bible of Borso d'Este*. Modena,
Biblioteca Estense, ms V. G. 12=Lat. 429, f. 96v.

we are approaching the chaos-born forms in Leonardo's contemplation of stained
walls, and with it also the tradition for naturally-created images in stone as evolved
from the Late Middle Ages up into the time of the *Wunderkammern*. Among the
forms semi-growing from such *pietre fiorentine*, architectural phenomena such as
cities, turrets and ruins indeed featured prominently (**FIGS. 12.28** and **12.29**).[52]

A type of role reversal between architecture and rocks – with architecture keeping
its form intact, but, on the other hand, with emphasis on the rocks' closeness to
prima materia – is seen in *Liber secretorum fidelium crucis* of *c.* 1320, Marino Sanudo's
previously mentioned call for a new crusade (cf. chapter 8). As already stated, this

Urbs Turrita

Fig. 12.28. *Urbs turrita* (natural image in marble), engraving from Athanasius Kircher's *Mundus subterraneus* (Amsterdam 1664), vol. 2, p. 30.

Fig. 12.29. *Marble from Ferrara* (1703), engraving. Amsterdam, private collection.

Fig. 12.30. Border illuminations from an Avignon manuscript (1321-22) of Marino Sanudo's *Liber secretorum fidelium crucis*. Rome, Vatican, Biblioteca Apostolica Vaticana, ms Vat. lat. 2971, f. 159.

work is remarkable for including one of the first maps in Western culture to be overlaid with a gridwork, Pietro Vesconte's map of the Holy Land (FIG. 8.8). But there is an area still beyond the control of land surveying: rocks spread across the otherwise so clean mesh like the indigestible remains of chaos. As an indication of this indigestibility, a number of borders in the Avignon edition of 1321-22 have jettisoned the mesh in order solely to be the forum for these amorphous rocks along with small castles, the maps' specification of cities (FIG. 12.30).[53] As the two parties – chaotic rocks and clear-cut architecture – here float around in the book's own indeterminate semantic zones, sometimes linked, sometimes scattered, they seem to comment on the mysteries of creation. Is it possible to imagine a more illustrative image formation, according to which Plato's *chora*, the primordial receptacle, approaches Kristeva's semiotic namesake, the linguistic primordial chaos, where the indexical meaning is shaped and disseminated in a perpetual process?[54]

Rocks and pictorial space

The architectonic game that 15th-century art channels into its rocks eventually flows over into a game with the pictorial space as such. The landscape in its entirety here becomes a variety of architecture that can be perforated, stacked up or subjected to absurd displacements. The game is familiar in a gentler form from backdrops to portraits, such as the rock landscape in *Mona Lisa* (1503; FIG. 12.31) in which the left half seems to be countersunk in a montage-like way in relation to the right half. But probably the most radical landscape experiments in this respect are again carried out by Ferrarese painters in the 1470s. In the lower part of Cossa's *March* scene in Palazzo Schifanoia, the pruning of vines and Borso's ride take place on something that, at first glance, could look like a natural arch since the rock opening underneath allows for a view of a distant landscape (FIG. 12.32). But on the upper plateau the houses are also displaced perspectively towards the background, as if there was a boundless supply of space. The 'natural arch' curves itself into sheer nothingness.[55]

Even though this absurd effect is exposed in a pictorial space that employs the most advanced illusionistic language of the time, it is not merely 'modern'. If anything, it could again be said to appear in the fracture between modern and archaic, between the homogenous space of naturalism and the aggregate space of antiquity and the Middle Ages. In the Gothic *villes sur arcatures*, the diminutive architecture is used to crown arcades and alcoves, which otherwise serve as the surroundings for human figures of a quite different and larger size.[56] The jump in scale from the large foreground figure to the minor architecture above is accepted here because the space is still determined cumulatively. However, when Cossa subjects it to a naturalistic

Fig. 12.31. Leonardo da Vinci, *Mona Lisa* (1503), oil on wood. Paris, Musée du Louvre.

Fig. 12.32. Francesco del Cossa, *Scenes from the Life of Borso d'Este* (1469-70), fresco, lower part of *March*. Ferrara, Palazzo Schifanoia, Sala dei Mesi.

treatment, in the *March* fresco or in the *Griffoni Polyptych,* it appears absurd and fragmented. It is the underworld being forced up into the sober light of naturalism, so that the black caves are penetrated and become gateways to nothingness.

The mirror image of the abyss: Leonardo's Virgin of the Rocks

In Leonardo's *Virgin of the Rocks* (c. 1483-90; **PLATE 36**) we find an illuminating example of how 15th-century architectonic rocks can be condensed to a complex iconography. The thickset, artificial-looking rocks have led art historians to suggest that the setting was based on the quarries in Monte Ceceri, the source of *pietra serena,* the 'Firenzuola stone'.[57] A closer analysis will nonetheless give an indication of just how paradoxical the artificiality of 15th-century rocks actually is, in that Leonardo's landscape points as far away from the production sphere as is imaginable – on one interpretive level to the uncorrupted wilderness, if not to a distant geological primeval time, on another level to the fecund and yet virginally untouched womb.

Precisely because the most generally prevalent 15th-century landscapes featured as green parks (cf. chapter 11), Leonardo could here produce a desolate wilderness, a body of the world laid bare and, as Alexander Perrig writes, without "the idea of an invisible gardener".[58] In Perrig's opinion, the rocks growing mirage-like in the watery wilderness of the background allude to ideas about the origins of the earth, the primeval time after the floods when the continents began to emerge little by little. With reference to the mountaintops in this process, Leonardo remarks in his writings that they "for a long time rise constantly."[59] In the background of the *Virgin of the Rocks,* however, the rocks seem to have been jutting out into the blue-tinted mist for so long that they are being eaten into by the early stages of erosion.

Yet, in order to gain an impression of how Leonardo activates this scientific, almost geological, understanding of the rocks in a context that is in other respects religious, we must look closer at the requirements of the commission. The painting was commissioned by a Franciscan order in Milan, the Confraternity of the Immaculate Conception, and was to form part of an opulent altarpiece in its chapel, constructed in San Francesco Grande in the years following 1475. As Regina Stefaniak and Joanne Snow-Smith have demonstrated in two ground-breaking articles, the painting is steeped in Franciscan iconography, with the doctrine of the Immaculate Conception, the Confraternity's speciality, as the main catalyst.[60] The question of whether Mary was free of original sin from her very conception or if she was not purified until later, by means of the Annunciation for example, was the object of an intense debate during the Late Middle Ages, in which the Franciscans emerged as sworn immaculists and the Dominicans were just as inveterate advocates of a

later redemption. Even though the *Virgin of the Rocks* was painted at a time when the immaculist doctrine had spread – in 1476, Pope Sixtus IV recognised the feast of the Immaculate Conception of the Virgin Mary – the discussion was no less heated, and it is therefore likely that the painting's iconography, including the allegorical traits of the rock landscape, has been influenced by and comments on some of the tensions in the debate.[61]

That the landscape held meaning for the painting's Franciscan commissioners as something other and more than decorative background, is already evident from the contract made in 1483, which refers meticulously to "le montagne e sassi lavorati aolio divisati de piu collori".[62] The primary function of these "mountains and rocks" was apparently to render visible *abyssus*, the primordial abyss, as it was pervaded by Wisdom, here associated with Mary's immaculate spirit. For, as pointed out by Stefaniak, the landscape has striking similarities with the Bible text approved by Sixtus IV as the introductory reading for the Mass of the Immaculate Conception, a passage about Wisdom taken from the Book of Proverbs (8: 22-25):

> The Lord possessed me at the beginning of his work, the first of his acts of old. Ages ago I was set up, at the first, before the beginning of the earth. When there were no depths I was brought forth, when there were no springs abounding with water. Before the mountains had been shaped, before the hills, I was brought forth [...].

As the divine light that was created before anything else in the world, the female Wisdom (Greek: *Sophia*, Latin: *Sapientia*) became an obvious alter ego for the immaculately conceived Virgin, for through the archaic understanding of the womb as the womb of Mother Earth, Wisdom could permeate the depths of the earth in the same way as Mary's pure spirit made Saint Anne's womb fertile.

The primordial geological era invoked by Leonardo is thereby in a very real sense primordial biblical time in which Wisdom pervades the just-formed mountains, hills, springs and depths of the earth. This iconography is not only supported by pictorial elements such as the rocks themselves, the deserted waters of the right background and the plant life projecting from the otherwise bare stone as if fertilised by a spring; in addition, Mary has lowered her eyes – a lingering gaze directed, via the figureless passage between Saint John and Christ, towards something invisible to the observer in the darkness under the rock bank along the bottom edge of the painting. What could she be looking at other than *abyssus*, the bottomless depths of the earth which was, according to myth, the source of all water on the earth and at the same time the place whereto water returned through hidden channels (cf. chapter 2)?

In order to validate that this must in fact be what she faces, we can start by

turning to a medieval tradition revived, in particular, by the Franciscans, which not only saw Mary permeating the abyss, but also defining it. In consulting a contemporaneous Franciscan thinker such as the Milanese Bernardino de' Busti (1450-c. 1513), a prominent Mariological exegetic scholar who is also known to have been involved in the 1506 judgement on the extended dispute concerning Leonardo's altarpiece, we find in his *Mariale* (1480-93) a passage such as this:

> All the doctors [say] that [the Latin name] *Maria* is derived from the [Latin word for] 'sea' [nominative plural *maria*], because as all rivers enter into the sea, and go out from it, according to Ecclesiastes 1, so all divine graces enter into the blessed Virgin. [...] Remarking on this derivation Albertus Magnus says: 'She is called *Maria* because just as there is in the sea [*mare*] a congregation of all waters, so there is in her a union of all graces.'[63]

Leonardo thus evokes a dual image of a Mary who lowers her gaze towards *abyssus* and from the immaculate position of distance pervades it with her wise graces, and yet is also identical with the object of her gaze, by means of which the cyclical function of *abyssus* and the sea – the place from which the water goes out and to which it returns – is substantiated. An obvious explanation of this identification with otherness would be that Mary is quite simply looking at her reflection in the depths of the rock spring – a reading that is made plausible by the narcissus growing on the edge of the rock to the left in the London version of the painting.[64]

This, in a literal sense, deep self-reflection enlarges, moreover, Mary's incarnation of Wisdom for, justified by a remark in the Book of Wisdom (7: 26) about how nothing contaminated can come close to Wisdom since "she is the refulgence of eternal light, the spotless mirror of the power of God", *speculum sine macula* became a recurrent emblem of the Immaculate Conception. In response to geographical locations of Wisdom such as the one in the apocryphal Book of Ecclesiasticus (Jesus Syrach) (24: 39) – "For her thoughts are more vast than the sea and her counsels more deep than the abyss" – Sixtus IV, in his sermon on the Immaculate Conception, was therefore able to state that: "No one has penetrated the depths of divine Wisdom like the Virgin."[65]

Could it be possible that this embrace of Wisdom, via the Virgin Mary's profound contemplation of her own reflection, entails a meta-commentary on the genesis of painting and, more generally, on the scrutiny of the mysteries of nature? Alberti, after all, described painting as "the act of embracing by means of art the surface of the pool",[66] and what the beholder sees in Leonardo's painting is surely almost a laterally reversed rendering of Mary's unseen reflection in the surface of *abyssus'* water. If Mary alias Wisdom knew "the structure of the world and the activity of

the elements; the beginning and end and middle of times, [...] [s]uch things as are hidden [...] and such as are plain" (Book of Wisdom 7: 17-21), then Leonardo poaches on her preserves in his dual role of painter and natural scientist, inasmuch as both roles derive from the profound eye, that organ which, according to Leonardo, is "the master of astronomy [and] cosmography", whose "sciences are most certain" and which has created "divine painting".[67] By, like a new Luke, portraying the source of her wisdom, the reflection on the water mirror, Leonardo is in a position to reconstruct the whole of Mary's immaculate knowledge. It could thus be argued that the theme of Leonardo's painting is the source point of art itself, a source point, however, not found in virgin nature, but shifted in the direction of a more auto-referential – and thereby modern – form of creation, namely Wisdom's self-reflection in the bottomless *abyssus*. Literally, a *mise en abyme*.[68]

Through her connection with the depths of the world and its spring source, Mary can also be interpreted in a more pagan direction – as the foam-born Venus or as a graceful nymph. The moist, plant-covered rocky setting hereby becomes a more surface-related *locus amoenus* along the lines of the satyric cave. Considering the dripstone-like rocks along the left cave entrance, our thoughts are led in particular to Virgil's description of the Libyan nymph cave with its "hanging rocks [,] [...] fresh waters and seats in the living stone".[69]

The basis on which the Immaculate Conception could be understood as Wisdom's permeation of the depths of the world was, as suggested, a comparison between the damp cavity *abyssus* and Saint Anne's womb. This topicalises the entire pre-modern understanding of the depths of the earth as a maternal womb, including Isidore of Seville's coupling of *abyssus* and matrix (cf. chapter 2) and the late antique Calcidius' commentary to the creation myth in Plato's *Timaeus*, where the womb concept, *gremium*, is linked with considerations of the nature of matter.[70] The associations are indeed so supra-temporal that the abyss-like setting also alludes to the Virgin Mary's own womb, *beatus venter*, by means of which the connection is bound to the painting's two male infants exchanging gestures: the blessing Jesus and the worshipping John the Baptist. For these two met for the first time in an unborn state during the Visitation when the Holy Spirit fills Elizabeth and causes the foetus to leap in her womb.[71]

This womb identity is emphasised by the placing of the Infant Jesus on the bare ground and, moreover, by the crossing of his legs, a posture that replicates the foetal position as drawn in Leonardo's anatomical studies (FIG. 12.33). Additionally, with her right arm and ample cloak, Mary seems to be drawing the infant John into a secure cavity marked on her left side by a gesture of blessing, an open hand hovering above Christ's head like a veritable dove of the Holy Spirit. In a metonymic identification, which again points back to the Immaculate Conception, this airborne

Fig. 12.33. Leonardo da Vinci, *Foetus in Womb* (*c.* 1510-12), pen and ink on paper. Windsor Castle, Royal Library, 19102r.

hand could possibly refer to the beloved in the Song of Songs: "Arise, my love, my beautiful one, and come away. O my dove, in the clefts of the rock, in the crannies of the cliff."[72] Finally, as Stefaniak perspicaciously suggests, the markedly sinusoidal folds of Mary's cloak, winding across her stomach with the golden lining turned out, also presumably entail an allusion to the womb and the chaos partially impregnated with forms. In *Timaeus* the formations in the recipient primordial nature are thus similarly compared with those patterns, for example triangles, that appear and disappear when a person has to make many kinds of forms in gold[73] – a metaphor which elegantly links up with the Virgin Mary's bodice via the assorted allusions of the Latin word *sinus* to twisting, fold, cavity and womb.[74]

The specific arrangement of the figure group is additionally legitimised by another and more 'real' interpretative level, which again changes the rock setting's referent from vertical *abyssus* to horizontal wilderness. According to an apocryphal legend, John the Baptist was sought out in the wilderness by the Holy Family when, on their way back from Egypt, they heard about Elizabeth's death and wanted to

comfort him. The 14th-century Pseudo-Cavalca version describes how the Baptist is here blessed by Christ and embraced by Mary: two gestures that have both found their way into Leonardo's painting. Serapion's late antique *Vita* (written 385-95) provides an added explanation as to why there is an angel present, and why this angel is pointing towards John: "Here is also Gabriel, the head of the angels, whom I have appointed to protect him [i.e. John the Baptist] and to grant to him power from heaven."[75]

This multilayered symbolic structure – linking, that is, Anne's, Mary's and Elizabeth's wombs with *abyssus* and John the Baptist's wilderness – is even extended with two further levels. Given that the painting is a Franciscan commission, there is also a requirement to portray aspects of Saint Francis's life, particularly his retreat on the Tuscan rock massif La Verna, which render him an *alter Ioannes*. Late medieval painting often brings Francis and John together,[76] and in Dante's *Paradiso* John assumes the highest position in Empyreum after Mary, while Francis, at his feet, is at the head of Benedict and Augustine, two other founders of monastic orders.[77] Francis's life on the wild rock can also, more particularly, be connected with John's life in Elizabeth's womb, for in Thomas of Celano's *Vita* (*c.* 1246-47) we find the following passage: "John prophesied enclosed within the hidden places of his mother's womb; Francis prophesied future events enclosed within the prison of this world while he was still ignorant of the divine counsel."[78] The rock cave on La Verna is thus here to be understood as both a womb and a Platonic world cave.

Whatever kind of screening from an external reality the *Virgin of the Rocks* might allude to, it is a screening with many openings. To the left, the hanging rocks open onto a view of a distant mist-wreathed stony wilderness; to the right, an opening provides a view of a solitary rock peak; and above, there would seem to be an open view towards the blue sky. On a Christian level, these openings must be interpreted as entrances to the celestial light that broke through when "the earth shook, and the rocks were split" and "[t]he tombs [...] opened" at the moment of Christ's death.[79] The link to John the Baptist's mission as pioneer for Christ is thereby established. For according to the *Gospel of Nicodemus*, a 2nd-3rd-century apocryphal scripture, the dark regions were bathed in a vast light when Christ yielded up the ghost, and among patriarchs and prophets John the Baptist stepped forward and declared:

> I am the voice of one crying in the wilderness, John the Baptist and the prophet of the most High who went before his coming to prepare his way [...]. And now while I was going before him I came down hither to acquaint you, that the Son of God will next visit us, and, as the dayspring from on high, will come to us, who are in darkness and the shadow of death.[80]

As Francis was an *alter Ioannes*, it was similarly revealed posthumously to the Franciscans that every year, on the anniversary of his death, Francis has the privilege of descending to Purgatorio and releasing some souls.

As the host setting for Francis, then, the La Verna rock has a similar function to that of the passage to Inferno, the split Golgotha rock. In the anonymous Franciscan *Le considerazioni sulle sacre stigmate*, an appendix to *I Fioretti di San Francesco* (*c.* 1370-85), we read the following:

> [...] St. Francis was standing beside that cell, gazing at the form of the mountain and marvelling at the great chasms and openings in the massive rocks. And he began to pray, and then it was revealed to him by God that those striking chasms had been made in a miraculous way at the hour of Christ's Passion when, as the Gospel says, "the rocks split." And God wanted this to be manifested in a special way here on Mount Alverna in order to show that the Passion of Christ was to be renewed on that mountain in the soul of St. Francis by love and compassion and in his body by the imprinting of the Stigmata.[81]

Besides the chasm-pitted La Verna mountain being thus endowed with the same renewing function as the rocks that split at the moment of Christ's Passion, it should be noted that both Christ and Francis display a fluid transition between tortured body and rock; the wounds of the stigmatisation, which penetrate the saint's body, can therefore be compared with the chasms that open up La Verna, his dwelling in the womb of the earth. This connection, which thus shifts Leonardo's rocks from womb to martyred body, from vagina to wound, is corroborated in the widely read *Liber de conformitate vitae beati Francisci ad vitam Domini Jesu*, a work written by Francesco Bartolommeo di Pisa:

> The said Mount Alverna was prepared for the Blessed Francis so that he might receive the Stigmata on his own person. This mountain is exalted to the heights; it is greatly cherished both because in its simplicity and naturalness it is completely set apart from all the other mountains that have been eroded by the weather and because it was singularly ruined as a sign of the Passion of Christ. Since at the time of the Passion, as is revealed in the Gospels [Matthew 27: 51] "the rocks were split," an event which is revealed in a unique manner on this very mountain. Thus it is divided continuously from the top downwards in order that we might see for ourselves, verily, the rocks were rent one from the other.[82]

Could it be that Leonardo had wanted to emphasise the La Verna rock's exceptionally fresh ruination, simplicity and naturalness by setting it in contrast to "all the

Fig. 12.34. Leonardo da Vinci, sketch (*c.* 1506-08) of stage set from a production of Poliziano's *Orfeo* in Mantua 1490, pen and ink on paper. London, British Library, Cod. Arundel, f. 231v.

Fig. 12.35. Leonardo's stage machinery for *Orfeo* (reconstruction by R. Guatelli and C.A. Pedretti).

other mountains that have been eroded by the weather"? If so, these mountains could be accounted for by the distant, misty peaks visible through the two openings in the foreground. These rocks would have been fresh at the Creation, whereas now they have been worn down by the humid air. Conversely, the crumbling rocks in the foreground are a sign of the mythical renewal that is first generated by the Passion of Christ, later by Francis's stigmatisation. Hence, there could be a point in Perrig's symbolic reading of the one opening as paganism and the other as Judaism.[83] In any event, the mist increases the gap between present and past, foreground and distance. The aerial-perspective vanishing point is also the point where oblivion engulfs the past and positions it beyond the renewals of Christ and Saint Francis.

That Leonardo was happy for the cave's subterranean symbolism to fluctuate unproblematically between a Christian and a pagan context is corroborated by his stage scenery for Poliziano's contemporaneous drama *Orfeo*. The play was originally written to be performed in Mantua around 1480 (if not earlier), but was restaged in the same city in 1490, when Leonardo was working for Lodovico il Moro in Milan. Two later drawings show that Leonardo – with striking traces of antique stage scenery – had set the play in a mountain landscape with two or three caves (FIG. 12.34). The middle and largest of these opened to the underworld and could only be seen when a semi-circular disc revolved 180 degrees and opened the mountain (FIG. 12.35). According to Leonardo's notes, this gave access to a "Pluto's Paradise" with devils, Furies, Cerberus, a horde of naked, weeping children and a variety of coloured flames. As this was the "Paradise" from which Orpheus rose again, Leonardo's

stage setting was a reinterpretation of the contemporaneous *sacre rappresentazioni*, the mystery plays about the birth of Christ which also used the cave as setting.[84]

The damaged and yet elaborate rock formations in the *Virgin of the Rocks* thereby corroborate the cyclical connection between destruction and renewal. The image above the right-hand corner, with its two-three crossbars making a bridge between two rock sections, would seem to be particularly close to those architectonic tendencies of Quattrocento painting's standard rock formations I discussed earlier. It is hardly coincidental that this form generation is part of the miraculous aura surrounding a cave seen and described by Leonardo a few years before starting on the painting: "And driven by my craving desire, eager to see the great wealth of different and strange forms made by artful nature, which were partially hidden from me among the dark rocks, I entered the opening of a big cave [...]." Leonardo is struck, however, by amazement and bewilderment, and he tries in vain to distinguish something in the darkness. "And [...] suddenly two things arose in me, fear and desire: fear of the threatening and dark cave, desire to see if something miraculous should be in there."[85]

The *Virgin of the Rocks* is thus the domicile of a force that is not only capable of immaculately creating humans, but also – like the primordial container in Plato's *Timaeus* – fantastical art shapes. And it thereby, on the iconographic level, condenses the autochthonic tendency to create formations found in so many of the Quattrocento painting's rocks exclusively promoted by the paradigm. Accordingly, as Patricia Emison has pointed out, the rock's virginity can also be seen in contrast to the consumed state caused by human greed and rape of the interior of the rock. This rock, victim of the Iron Age, is actually touched on by Leonardo in his writings: "On money and gold. From the cave-like grottoes will emerge that which will exhaust all the peoples of the world, with huge efforts, fear, sweat, in order to be helped by it." Conversely, he declares: "Wild is that which is preserved [intact]."[86]

Just such a rocky wilderness – preserved for the Iron Age intrusion of the earth and the corroding weather alike – is, then, at the heart of the *Virgin of the Rocks*.

12.2 Hewing, mine-work and quarrying

Between autochthony and cultivation

So far I have chiefly focused on rocks in 15th-century painting on the basis of the epistemic *field* they were in the process of leaving: the Golden Age *field*. The architectonic and fertile look of the rocks was mainly seen as being the result of nature's inner impetus, an autochthonic power pregnant with forms. This interpretation

was made more rigorous by involving an undercurrent of the Golden Age *field*, alchemy, which considered the unearthing of bedrock materials to be part of nature's intention rather than running counter to it. In the following two sections I shall shift the reading of the fantastical rocks towards a more naturalistic lens that primarily perceives their architectonic character as being the result of forces out in the world, meaning either enterprising design (man-made construction of nature), residual forms after mining and quarrying (man-made destruction of nature) or ruination (nature's destruction of the work of man). Even though the first two of these forces are still compatible with an alchemical ideology that perceives of human enterprise as naturally validated, they can also be symptoms of the new epistemic *field*, modernity, which is characterised by human separation from nature and by the desacralisation of nature. This is how the ruin, especially, with its traces of nature's blind, destructive forces, must be categorised.

As self-consciousness matures, and humankind cuts the last ties to nature, its art can obviously no longer be seen as a fulfilment of nature, as a transfer of celestial ideas to matter. Freedom of the soul is more a case of nature being drained of purpose, so that its cultivation becomes the result of humankind's free will. The first outcome of this rise of alleged human sovereignty is competition between nature and humankind. William of Malmesbury (c. 1094-1143) is already in a position to call the art of gardening a "competition between nature and art – what the former does not generate is created by the latter".[87] This train of thought reaches extremes in Ficino's *Neoplatonic Theology* (1474), which, to be sure, includes a lengthy paraphrase of Aristotelian philosophy of art, but gradually turns into a delirious celebration of human abilities. Apropos the Archimedian celestial model, he states: "Since this person sees the order of the heavens, [...] who will deny both that he has almost the same genius, so to speak, as the author of the heavens, and that he is capable in a way of making the heavens, should he ever obtain the instruments and the celestial material?"[88] The idea of the human being as rival to God is perhaps particularly prominent in the aesthetic branches of the arts. In 1480, the humanist Cristoforo Landino cautiously voices the opinion that the poet is creative, a sort of mortal god, whereas Leonardo is more smug when calling the painter a "signore et Dio".[89]

Seen in this light, the artificiality of the rocks therefore also has touches of megalomania, of a dream about reducing nature to an unresisting servant to human will. In his reference to the rocks' ruinous appearance (cf. the opening of this chapter), it is to the Renaissance princes' self-assurance and zeal to master nature that Lauro Martines turns:

When it looked to the rural space outside cities, this taste drew away from endowing it with an air of naturalness. Rather, the countryside had to be altered to hint at the grand surroundings of princes and oligarchies, with their great masses of cut and shaped and arranged stone, the proud *palazzi* and churches under their possessive patronage. This was self-confidence of a sort prepared to remake the face of nature.[90]

Ferrara, the centre of pictorial culture's bizarre rock formations, provides an actual example of this eagerness to create nature from scratch. In January 1471, Borso d'Este suddenly decided that a place called Monte Sancto beyond the Porta San Georgio should be extended by means of a mountain – a man-made mountain. All the farmers in the area were put to forced labour; carts, carriages and ships were put to work fetching soil. This exploit led to suffering and complaint as the farmers could not cultivate their land while the work was going on and, moreover, they thought the whole enterprise useless.[91] What was the point of the mountain? Apart from demonstrating Borso's infinite – albeit not completely tranquil – capacity to give nature a makeover and inject the flat Po Plain with undulations, the name of the spot, Monte Sancto, indicates that the location was sacred beforehand. Hence this artificial mountain might perhaps be one of the series of symbolic rocks the ascent of which makes for purification. Whether the mountain also related to Saint George, the patron saint of the city gate, is uncertain. If it did, it might be kin to the mountain pictured in the background of Tura's just two-years-younger Saint George's battle in the cathedral, a tall, cone-like peak wound round with as many as three circular city walls (FIG. 12.12).

The artificiality of the painted rocks could therefore also be understood essentially as an actual belabouring such as this, so that the rock nature itself is embraced by the modern, cultivated landscape. Doubt as to the extent to which a cave is the result of nature's or man's hand strikes a pair of shepherds in *Arcadia*, Sannazaro's pastoral novel of around 1489-91: "And upon entering the holy pine wood we found, under a hanging bank between ruined rocks, an ancient and big cave, I do not know if it was hewn in the hard mountain naturally or by manual artifice [...]."[92] In the work of artists such as Mantegna and Cosmè Tura, then, this ambiguity can be said to be extended to the landscape in its entirety. Their roads do not appear merely as levelled out parts of the surface of the earth, but wedge themselves into the rock mass as deeply countersunk components which, provided they are read as man-made, testify to extensive hewing and extraction. In Mantegna's Louvre *Crucifixion*, the Golgotha rock's large ashlars almost seem to be a continuation of the road winding down along the rock wall from Jerusalem (FIG. 12.36). The dizzying, perspectival curves carving their way across its spherical surface could be suggestive of the headway made by the horsemen on the road. Hence, in this cutting

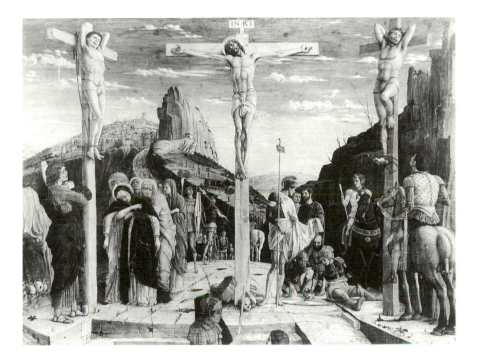

Fig. 12.36. Andrea Mantegna, *Crucifixion* (1459-60), tempera on wood, predella panel from the *San Zeno Altarpiece*. Paris, Musée du Louvre.

out of the landscape's rocks we again find ourselves in a transition zone between paradigm and iconography, gaze and manufacture.[93]

The working-up effect in the rocks of the general landscape image is condensed to actual iconographies in the manuscripts of the Sienese engineer Mariano Taccola (1382-after 1453) (FIGS. 12.37-41). The Gothic republic, which turns its cultivated territory into images (cf. chapter 10), also ushers in the first European visions of the impact of machines on the landscape formations. The visions are rooted in practice since Siena was famous for its technological projects, particularly those dealing with hydraulics. In the high hills around the city there were many natural mineral springs and the Sienese connected them with the city centre via a network of underground aqueducts, what were known as *butini*. The network supplied water in quantities only surpassed by the contemporary Roman aqueducts and could provide for the needs of, among other institutions, Spedale di Santa Maria della Scala, which was one of the largest complexes in Siena at the time. Only

Fig. 12.37. Mariano Taccola, *Water Mill Supplied with Water by a Spring*, drawing from *De ingeneis* manuscript (1433), book III. Florence, Biblioteca Nazionale, ms Pal. 766, f. 22.

Fig. 12.38. Mariano Taccola, *Transporting a Column from Quarry*, drawing from *De ingeneis* manuscript (1433), book III. Florence, Biblioteca Nazionale, ms Pal. 766, ff. 14v-15.

Fig. 12.39. Mariano
Taccola, *Aqueduct*, drawing
from *De ingeneis* manuscript
(1433), book III. Florence,
Biblioteca Nazionale,
ms Pal. 766, ff.29v-30.

Fig. 12.40. Mariano Taccola, *Underground Mine Causing a Fortress to Collapse*, drawing from *De machinis* manuscript (1449). Munich, Staatsbibliothek, ms Clm. 28800, f. 48v.

Fig. 12.41. Mariano Taccola, *Saint George and the Dragon*, drawing from *De ingeneis* manuscript (1433), book III. Florence, Biblioteca Nazionale, ms Pal. 766, f. 76.

envious neighbours such as Dante mocked the Sienese frequent construction and reparation of the water pipes.[94]

This delight in controlling, working and intervening in the earth mass has patently spread to the drawings in Taccola's manuscripts *De ingeneis* (1433) and *De machinis* (1449).[95] The manner in which "Siena's Archimedes" places his inventions among the Byzantine terraced rocks would not have disappointed the American land artists of the 1960s. The raw mass of the rocks looks like a playground of nature, in which Taccola has a free hand to build bridges, set up mills (FIG. 12.37), lay out ports, drill holes, carve columns out of quarries (FIG. 12.38), install aqueducts to fishing reservoirs (FIG. 12.39) or explode fortresses with gunpowder barrels placed in underground mineshafts (FIG. 12.40). Even the chain and the pillar securing the princess in a scene of Saint George's battle with the dragon look like an enterprising intervention in nature (FIG. 12.41). In order to justify his mechanical devices as free intellectual art, Taccola expressed in verse his opinion that mechanical power (*ingenio*) was a direct extension of mental power (*ingenium*), and that ingenuity was a superior quality in a ruler than brute strength.[96] In his drawings he would seem to entertain a predilection for artificial, often round-arched, openings in the rock, be they access to canals, mineshafts or recesses for watermills. All in all, his worked rocks bear a striking resemblance to the rocks that feature in the ordinary landscape images – with the one difference that he displays the tools where they are otherwise concealed.

Quarrying and mining

If we look to Taccola in particular as our witness, the artificiality of 15th-century rocks not only indicates positive cultivation, but also negative matrices left by quarrying and mining, the primary processes of construction. Mineshafts become architectonic gateways, the imprints from excavated blocks turn into architectonic expanses. Landscape thus becomes a ravaged wilderness along the lines of Pliny's lament: "We quarry these mountains and haul them away for a mere whim; and yet there was a time when it seemed remarkable even to have succeeded in crossing them."[97] (Cf. chapter 4.) The rocks' quarried impression might also allude to ruins in the physical world given that throughout the Middle Ages, indeed culminating in the 15th century, Roman relics were stripped of raw materials for use in new buildings.[98]

As we saw in chapter 4, the Golden Age yearning for virgin soil impeded minework, the aberration of the Iron Age, in finding anything more than a sporadic foothold as pictorial motif in pre-modern post-Egyptian time. Apart from the small wave crests in Greek archaic and Late Roman time, it is not until the Late Middle Ages with its new work ethic and corresponding industrial boom that the motif begins to assert itself – but then again, and like the agrarian motif, it has come to stay.[99]

Fig. 12.42. Anonymous artist, *Mine* (1480s), pen and watercolour, inserted in the *Master of the Housebook Manuscript* (c. 1480). Aulendorf, Fürstlich zu Waldburg-Wolfeggsches Kupferstichkabinett, f. 35.

After trial runs in the 13th-14th centuries when mine-workers appear on corbels or, like peasants (cf. chapter 10), as donors in the lower sections of glass paintings, the motif reaches an initial independent try-out in what is known as the *Kuttenberger Kanzionale* (c. 1490), a manuscript of hymns from mine-rich Bohemia (**PLATE 42**).[100] In the frontispiece miniature we are looking across a divided landscape teeming with people, which could be seen as a secularised version of the Day of Judgement, transforming the sinners into initiators of an overall process of refinement. At the bottom there is what resembles a sectional view of an underworld full of cavities, in which small cowl-clad mountain folk are energetically working to relieve the bluish bedrock of its riches. Above ground, where a panoramic view takes over, the gaze is led not to a gem-studded New Jerusalem but to a courtyard where a buzzing crowd of people are processing the blue stone for its core of silver. Even if we are looking

for the Doomsday trumpeters, we can identify a successor in an encouraging little trumpet player next to the entrance.

Behind images such as this and its more factually illustrative 16th-century descendants – the woodcuts in Georgius Agricola's *De re metallica* (1556), for example – there is clearly an enterprising spirit at work, that of modernity, which is no longer weighed down with scruples about intruding into the earth. The growth of this spirit did not occur painlessly, however, but was to the very last accompanied by primitivist voices underpinned by the neo-antique movement, the Renaissance. The aggressive consequences of the Iron Age are subjected to critical treatment in, for example, an image that was almost a contemporary of the *Kuttenberger Kanzionale*, a drawing made in the 1480s and inserted into the Wolfeggian *Master of the Housebook Manuscript* (c. 1480; FIG. 12.42).[101] Like in the Bohemian miniature, a mountain has here been perforated with caves in which miners hack loose the nuggets of mineral. The felled trees from the mountain are either found scattered across its flanks, used to shore up the mineshafts or included in the building of a house in the foreground. As an indication of the alarming aspect of this entire exhaustion of nature, four labourers in front of the house have come to blows with iron swords, the end product of this exploitation.

But the Renaissance could not, of course, make do with a rebirth of the self-hatred of antiquity. Antique architecture, the end product of mining, also represented *magnificentia*, grandeur, and furthermore it could be justified by the less primitivist components of antique philosophy. Even though Pliny certainly often complained about the invasion of the earth, he could also – with a typically antique paradox – be appropriated as an example of the opposite standpoint: that he nonetheless writes his art history as a direct extension of the section of natural history dealing with quarrying and mining, bears witness to his belief in the connection between nature and art. As mentioned earlier, according to classical, non-primitivist thought, design constituted an elevation of the basis material, whether originating from celestial, preordained ideas (Plato), or tied to the material in which it grew (Aristotle).

Fascination with the architectonic effect of quarrying was expressed as early as Pausanias. Of the Pentelic quarries, he writes:

> Here the rock has been quarried away so as to leave a smooth perpendicular wall. [...] The marks, delicate and regular, of the ancient chisels may be seen in horizontal rows on the face. The marks show that the ancients regularly quarried the marble in rectangular blocks, first running a groove round each block with the chisel and then forcing it out with wedges. The effect of this has been to leave huge rectangular cuttings in the side of the mountain.[102]

Fig. 12.43. Albrecht Dürer, *Quarry*
(*c.* 1495-96), watercolour and gouache on
paper. Formerly in Bremen, Kunsthalle
(whereabouts unknown since 1945).

Quarried rocks such as these are the subject of several of Dürer's nature studies
(**FIG. 12.43**).[103] With an unprejudiced gaze approaching the photographic, Dürer
draws the raw hewn surfaces that expose the interior of the earth so that trees and
roots balance vulnerably along the upper rim of the quarry. But again: despite the
searching, almost excruciating naturalism, in the shapes of the quarried rock we
recall the artificiality that moulds so many rocks in the paradigmatically-determined
landscape image. In fact, these stone blocks often look just like that, a sectional view

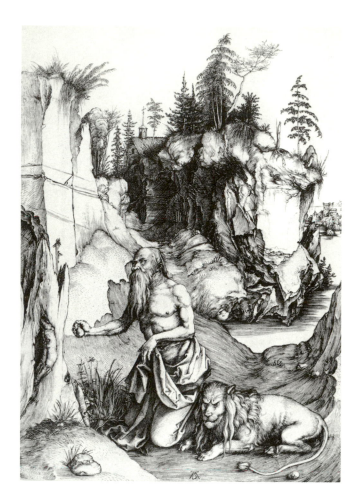

through the earth – with a layer of vegetation and roots at the top and raw stone masses underneath. It would seem that we are here faced with an archaeological investigation, which for the first time lays bare the underground, in the same way as doctors slice through the human body and architects cut sectional views of the body of buildings (FIGS. 8.17 and 8.20). Dürer's quarry studies are therefore just as much examples of the literally in-depth probing of the modern gaze as they are explorations of industrially exploited slopes in front of that gaze.

The full potential of these studies is, however, first exposed when one of them is put into an engraving of *Saint Jerome Penitent in the Wilderness*, *c.* 1496 (FIG. 12.44).[104] Here the wound left by civilisation's most drastic infringement of nature, quarrying, is thus paradoxically turned into the virgin mountains which bring the saint into contact with God. That this is a case of more than a merely superficial visual

coincidence would seem to be indicated by a frontispiece woodcut of the Crucifixion in Johannes von Palz's mining treatise *Celifodina* (Erfurt 1502; FIG. 12.45), in which the Golgotha death cave itself is transformed into a mineshaft around which two monks are swinging their mattocks.[105] As we move into the vicinity of professional mining and its legitimisation in alchemy, we notice that the Iron Age rape of the earth is here ostensibly blessed, in that the minerals originate from the same depths of the earth as the resurrected Christ and are processed in a way which is analogous with Christ and his successors' – the monks – spiritual route. Might it be possible that just as in Leonardo's *Virgin of the Rocks* we witnessed how the freshly ruined underworld becomes restorative – a parallel to both Christ's and Saint Francis' scratched and nail-pierced bodies – so we here encounter a plaidoyer for the redeeming function of an industrially exploited earth? When in another portrait of the penitent Jerome, by

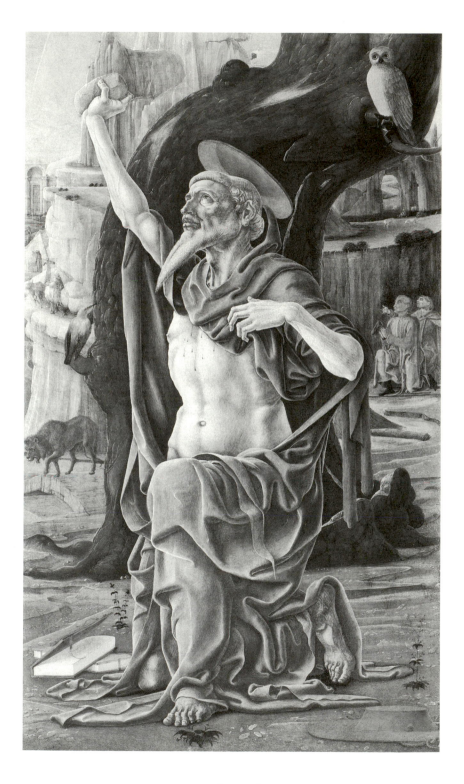

Cosmè Tura (*c.* 1474; FIG. 12.46), our gaze moves to one of the typically bizarre rock formations in the background and here, on the narrow rock path, spots yet another of these monks with a mattock on his shoulder, we have again but to believe that he is on his way to some kind of hewing work – possibly the work that has cut free the knowledge-evoking stone with which the hermit is beating his breast.

The implementation of this kind of pictorial short-circuiting between reclusive shelter and quarry is possibly assisted by actual shared physical experiences. Since antiquity, it was normal that mineshafts also served as – not particularly comfortable – dwellings for the mine workers;[106] and the catacombs, places of prayer for the early Christians, emerged, as we saw in chapter 2, as a huge mine complex prepared by professional *fossores.* Even though it would take further research to provide proof, it seems not unlikely that in the Late Middle Ages there was a common culture for mine workers and monks, a culture that may have produced, *inter alia,* the aforementioned Monk of the Mountain, Master Hoemmerling.

How far the visual play on the anchorite and mining milieus can be driven is apparent, for example, from a comparison between Bernardo Parentino's *Christ Carrying the Cross with Saint Augustine and Saint Jerome* (*c.* 1480; FIG. 12.47) and a later mining scene such as *Mining of Diamonds,* Maso da San Friano's illustration of *terra* from a cycle of the four elements for the *Studiolo* of Francesco I (completed 1570-72; FIG. 12.48).[107] Both show sheer rocks with openings, paths and various arrangements of wooden slats for safety purposes. But whereas Maso's rocks serve as work area, Parentino's function as a habitation complex for the dozen or so hermits who lead there lives here. A structurally-related observation can be made in the 16th-century Netherlandish world landscape. The rocks in Herri met de Bles' mining scenes are riddled with caves (FIG. 12.49), but the same beehive-like perforated rocks are also to be found in a variety of contexts in the contemporary Flemish landscape backgrounds, sometimes given over to the anchorite milieu and at other times with no iconographic label.[108] We thus again find ourselves in a borderland between paradigm and iconography.

Francesco del Cossa, whose father was a stonemason and builder,[109] would also seem to play with mining iconography. To the right in his *Saint John the Baptist* (from the *Griffoni Polyptych,* (*c.* 1473-75; FIG. 12.3) there is a rock passage which bears a striking resemblance to open-pit mines – such as those we see in, for example, the woodcut illustrations for Georgius Agricola's *De re metallica* (1556; FIG. 12.50). And the

Fig. 12.46. Cosmè Tura, *The Penitent Saint Jerome* (*c.* 1474), oil and tempera on wood. London, National Gallery.

Fig. 12.47. Bernardo Parentino,
Christ Carrying the Cross with Saint
Augustine and Saint Jerome (detail)
(*c.* 1480), tempera on wood.
Modena, Galleria Estense.

Fig. 12.48. Maso da San
Friano, *Mining of Diamonds*
(1570-72), oil on canvas.
Florence, Palazzo Vecchio,
Studiolo of Francesco I.

Fig. 12.49. Herri met de Bles, *Landscape with Mining Scenes* (1540s [?]), oil on wood. Florence, Galleria degli Uffizi.

fox-like animal which, in the same panel by Cossa, is on its way into an underground passage, is echoed much later in a engraving in J.E. Boeck's *Uraltes chymisches Werk* (1760; **FIG. 12.51**).[110] Here, against the background of the legendary rabbi Abraham Eleazar, it would seem to be a weasel, the fleetness of which corresponds to the dry process of alchemy, i.e. the secret salt-flame's short, yet hazardous route, involving, *inter alia*, saltpetre. If there is an alchemical symbolism lurking throughout Cossa's many earth apertures, it is particularly evident in the arch of the drain pipe seen above the flowing water in the *Miracles of Saint Vincent Ferrer* (also part of the *Griffoni Polyptych*, but possibly painted by the assistant, Ercole de' Roberti; **FIG. 12.52**). On a number of occasions in alchemical treatises of a later date, a stream such as this is to be seen in front of a cave entrance – one example being again the abovementioned illustration from Boeck's alchemy (**FIG. 12.51**), where the watercourse represents the long process of alchemy, the wet, but sure route involving many distillations.[111]

Although these and many other 15th-century pictorial landscape riddles await

Fig. 12.50. *Mining*, woodcut from Georgius Agricola, *De re metallica* (Basle, 1556), Book 6. Bochum, Deutsches Bergbau-Museum.

Fig. 12.51. *The Legendary Rabbi Abraham Eleazar*, engraving from J.E. Boeck, *Uraltes chymisches Werk* (Leipzig, 1760).

Fig. 12.52. Ercole de' Roberti, *Miracles of Saint Vincent Ferrer* (*c.* 1473-75), tempera on wood, predella panel of the *Griffoni Polyptych* (section). Rome, Vatican, Pinacoteca Vaticana.

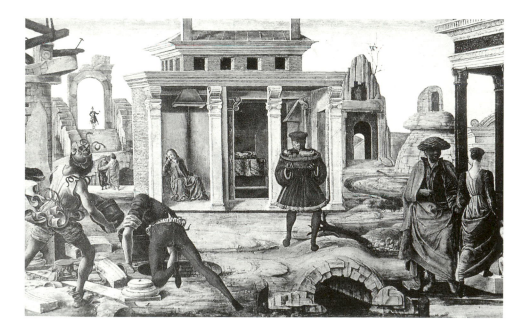

further deciphering – to the extent that their deliberate ambiguities can be unravelled at all – it is at least undeniable that the artists often produce almost surreal visions based on underworld symbolism, dealing with the entire spectrum from alchemical creation to architectonic rock and on to ruin.

Mantegna I: Camera degli Sposi

A defence for mountain encroachment finds iconographic condensation in Mantegna's decoration of Camera degli Sposi in Mantua, Marquess Lodovico Gonzaga's commission, executed 1465-74. In the background of the scene *Lodovico Gonzaga Meets Cardinal Francesco Gonzaga, His Son*, we see a huge hemispherical mountain (PLATE 37). The upper half of the mountain is covered with a mighty city encircled by a wall, and below the city, in the bare rock, various work activities are taking place. To the right, below a hunter running across a meadow with his dogs, three stonemasons are sitting in front of their quarry, a dark cave, chiselling a column and a block (FIG. 12.53A). To the left, the rock is perforated by smaller caves, out of which lumps of minerals are being carried away on a kind of stretcher (FIG. 12.53B). They will be carried via narrow paths up to the building on the plateau above, a temple complex surrounded by an as of yet unfinished arcade.

As Rodolfo Signorini has shown, the setting in which the *Meeting* takes place can be connected with the Gonzagas' undertakings in 1461-62, when Francesco was appointed cardinal by Pius II.[112] In the summer of 1461, just before this politically crucial appointment, Pius had been engaged in a war with the Neapolitan kingdom, supported by, *inter alios*, the Lazionian Baron Giacomo Savelli and the Ghibelline-oriented Tivoli. In July, with assistance from Alessandro Sforza, a brother of the Gonzaga-family friend Francesco Sforza from Milan, Pius won a victory at Tivoli and decided to spend the summer there in order to supervise the building of Rocca Pia, his new fortress intended to prevent further insurrection. The Gonzaga agent Bartolomeo Bonatto, who was working energetically for Francesco's appointment to the rank of Cardinal, also resided in Tivoli. In preparation for the ecclesiastical welding together of Rome and Mantua, Bonatto turned to geography. In a letter to Lodovico, he vows that the prince's villa Cavriana, which was in the process of being built, is not only at the same distance from Mantua as Tivoli is from Rome (*c.* 31 km), but that it eclipses Tivoli's beauty.

As Signorini demonstrates, this and other letters must have informed the programme behind the Camera degli Sposi's landscape. As indicated by the Hercules statue in front of the unfinished temple, and the small seated Hercules Victor figure in its tympanon, this is the Temple of Hercules in Tivoli – the place in whose gateway Emperor Augustus had often meted out the law. This identification is extended in

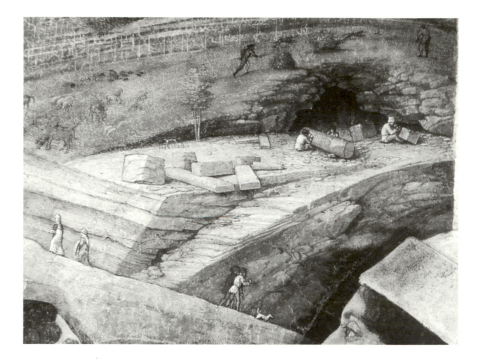

Fig. 12.53a. Detail of Andrea Mantegna's
Lodovico Gonzaga Meets Cardinal Francesco
Gonzaga, His Son, plate 37.

the fresco sections with their grooms and putti on the left, where in addition to a Rocca Pia under construction we spot, *inter alia*, the gigantic Temple of Fortuna in Palestrina. As to the big city, its Rome identity is apparent from elements such as the Pyramid of Cestius, the Colosseum and Castel Sant'Angelo. That all this architecture also alludes to Cavriana-Mantua is apparent from the Gonzagas' coat of arms, a cross, which is inserted into the square tower immediately to the left of the Temple of Hercules and is also a feature in the tower above the antique-looking city gate. With meticulously differentiated texture, Mantegna shows that in both cases the coat of arms is an element of a new building constructed on a ruined foundation. By so doing, we are presented with a tangible statement that the Renaissance princes' new buildings are restoring the Rome of antiquity. The binding substance in this synthesis is, of course, Christianity incarnated in Francesco's appointment as Cardinal. The event is reflected in the foreground where Lodovico, on New Year's Day 1462, immediately after his appointment, meets Francesco outside Bozzolo, midway between Mantua and Milan.

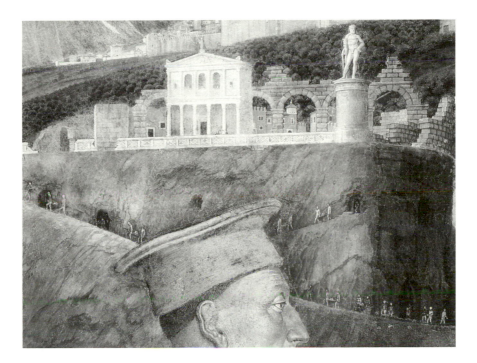

Fig. 12.53b. Detail of Andrea Mantegna's
*Lodovico Gonzaga Meets Cardinal Francesco
Gonzaga, His Son*, plate 37.

The play on the topography continues as we look from city and temple down to the mountain caves below. According to Strabo, a writer the Gonzagas demonstrably have read, the area around Tivoli was known for its quarries: the river Anio

> flows out through a very fruitful plain past the quarries of the Tiburtine stone, and of the stone of Gabii, and of what is called "red stone"; so that the delivery from the quarries and the transportation by water are perfectly easy – most of the works of art at Rome being constructed of stone brought thence.[113]

The stone that is dug out is patently red, and thus their quarrying symbolises nothing less than *the main source of works of art in the Rome of antiquity*. The motif of the stonemason cave near the city belongs, as shown in chapter 7, to a late antique Virgil tradition in which Carthage is built under the vigilant eye of Aeneas (**FIG. 7.29**). The motif is given a further patriotic slant in Lorenzo Valla's *Oratio in principio sui studii*, the opening address given on a course in rhetoric, Rome 1455. Here it is claimed

Fig. 12.54a. Pietro Guindaleri, *Sculptors* (finished after 1489), miniature from manuscript of Pliny the Elder's *Naturalis historia*. Turin, Biblioteca Nazionale, ms J.I. 22-23, f. 496 (min. 9).

Fig. 12.54b. Pietro Guindaleri, *Copper Mining* (finished after 1489), miniature from manuscript of Pliny the Elder's *Naturalis historia*. Turin, Biblioteca Nazionale, ms J.I. 22-23, f. 469 (min. 28).

that the arts, for example urban construction as depicted in the *Aeneid* Carthage episode, derive benefit from competition, and that Roman culture united the many competitors so as not to end up with a Babel. By contrasting Babylon, the all-time stock nightmare vision of the perverted city, the legitimacy of Roman-Mantuan quarrying is thus put into further relief.[114]

What architecture in tandem with quarrying scenes symbolises, then, is the intimate connection between nature and art prescribed in non-primitivist antique philosophy. Art not only completes the raw material provided by nature but, in the most literal of senses, it is nature's superstructure, because architecture, the city surrounded by ring-wall, crowns a hierarchy built up from a base of quarry caves.

How closely Pliny in particular lurks in the background is apparent from an-
other of the Gonzagas' commissioned works: the large, now unfortunately partially
burned, Pliny manuscript in Turin, attributed to Pietro Guindaleri of Cremona
(completed after 1489).[115] In the art history section of this manuscript we find both
a medallion showing sculptors working in a workshop (**FIG. 12.54A**) and a medallion
illustrating copper mining (**FIG. 12.54B**).[116] Like the paths below Mantegna's Temple
of Hercules, the miners here are carrying lumps of minerals on stretchers – a visual
similarity that corroborates the conceptual kinship between mining and quarry-
ing. The area around Tivoli was particularly suitable for visualisation of a Plinian
iconography since in the ancient Tiburtine cult Hercules Saxanus was both tutelary

deity for the quarrymen and for the caves themselves.[117] The Gonzagas could thus scarcely have rooted their city state more effectively in the earth's womb.

A thematic parallel to the building activity and stonemasons of Camera degli Sposi can be seen in the background of *Saint Barbara*, an unfinished painting from 1437 by Jan van Eyck (FIG. 12.55). Like the Camera degli Sposi, the motif concerns the conversion of a pagan to a properly Christian architecture. According to legend, Barbara's father, wealthy Dioscorus, was opposed to her marriage and had therefore locked her up in a tower where she secretly converted to Christianity. Wanting to turn the tower into a chapel, she had another window added to the two already there, as a symbol of the Trinity. However, even though the three windows dominate the second storey in the painting, van Eyck's labourers have evidently built the Gothic tower-chapel from the base up. All in all, it looks like a sacred forerunner to Brueghel's Tower of Babel, a motif with more direct references to the pagan Rome (Colosseum). Albeit no rock caves, but only heaps of rough broken stones, are to be seen in van Eyck, the work of his stonemasons is, like that of Mantegna's, to be understood as being closely linked to the earth; for, besides protecting soldiers, artillerymen and weapon smiths, Barbara is also the patron saint of mine-workers. Having been prosecuted by her father and the prefects, she flees to a rock which opens and envelops her in its protective embrace – in the same way as the earth shelters the miners.[118] For this reason, the van Eyckian Barbara is also placed, like a veritable *Madonna dell'umiltà*, on the bare ground, stone's place of origin.[119]

Mantegna II: Madonna of the Stonecutters *and* Christ as the Suffering Redeemer

In Camera degli Sposi and the Barbara panel, the stonemasons' work is blessed. The iconography is, however, charged with ambivalence, and it takes literally nothing before it fluctuates and turns into its opposite, the demonic art production associated with *luxuria*. Sitting on the bare earth against a background of stonemasons, Barbara can quite reasonably lead us on to two other Mantegna pictures in which the same disposition of a seated *humilitas* foreground figure and stonemasons is split into an antagonistic tension. This is the case in *Madonna of the Stonecutters* (FIG. 12.56), possibly painted during Mantegna's stay in Rome 1488-90, and *Christ as the Suffering Redeemer* (PLATE 38), most likely painted in Mantua in the mid 1490s. Nothing more is known, however, of the paintings' early provenance.[120]

As Frederick Hartt has pointed out in a somewhat neglected article written in 1952,[121] the two paintings are related in terms of genre. The Madonna and Child and the Pietà motif were often put on an equal footing in 15th-century Passion theology, given that the support the Infant Jesus received from his mother was akin to

Fig. 12.56. Andrea Mantegna, *Madonna of the Stonecutters* (*c*. 1488-90), tempera on wood. Florence, Galleria degli Uffizi.

Fig. 12.56a. Detail of Andrea Mantegna's *Madonna of the Stonecutters* (*c*. 1488-90), fig. 12.56.

that which *post mortem* fell to his lot in the Pietà situation after the Crucifixion. And whereas the child Jesus had just left the mother's womb, his adult counterpart also, as in a mirror image, is on the point of being taken back into the rock tomb, Mother Earth's womb. It is therefore an obvious inference to interpret the rock caves in the pictorial backgrounds as essentially the same cave: the mystic nativity grotto whence Christ was born, descended to the dead and rose again (**FIGS. 12.56A** and **12.57**). This

Fig. 12.57. Detail of Andrea Mantegna's *Christ as the Suffering Redeemer* (c. 1495-97), colour plate 38.

idea, juxtaposing Mary's body and that of Mother Earth has, as discussed in chapter 2, a rich tradition in Christianity. A line in an Ambrosian Easter hymn reads, for example: "Thou who were before born of a virgin, art born now of the grave."[122]

Furthermore, in both paintings Christ is shown with open mouth, as if he is singing. In the Copenhagen picture he even seems to be doing so in chorus with the two supporting angels. If we consult a source which was much read in the Late Middle Ages, the 9th-century Abbot Hrabanus Maurus' *Allegoriæ in sacram scripturam*, under the word *carmen* (song) we find a reference to the following passage in the Book Of Psalms (40: 2):

He drew me up from the pit of destruction,

out of the miry bog,

and set my feet upon a rock,

making my steps secure.

He put a new song in my mouth

a song of praise to our God.[123]

Even though in *Madonna of the Stonecutters* it is the Virgin Mary, and not Christ, who has her foot placed on the exposed rock, both paintings would seem to resonate with this kind of song of praise about being drawn out of the rock cave, the pit of destruction. The symbolism is particularly purposeful in the Copenhagen painting since the Suffering Redeemer, most unusually in an Italian art context, seems to be getting up, a movement that is highlighted by the pale-yellow glow of the rising Easter sun. In fact, this full-figure breathing Suffering Redeemer is unique in Italian art.[124] The Easter symbolism is possibly enlarged upon by the four small women walking in the direction of the crosses on Golgotha. They might include the three Marys who find Christ's tomb empty.

But parallel to the aforementioned title page in *Celifodina*, where mining monks have made a metal mine out of the Golgotha death cave, the cave tomb here is invaded by stonemasons. In the Uffizi painting, the area in front of the cave is being used to work on a column shaft, a capital, a sarcophagus lid and, on a rock plateau further down, the sarcophagus itself. In front of the Copenhagen painting's tunnel of a cave tomb, workers are struggling with a column shaft, a statue and what looks like a sarcophagus, while the sarcophagus lid and a large hemispherical bowl with pedestal have already been finished. The scenes are formally identical with their counterparts below the city in Camera degli Sposi, but have now changed agenda. What we are looking at is not material provision for the civilised city state, but rather the greedy Iron Age people assaulting the earth. As he embarks on the gold and silver section in his *Natural History*, Pliny for example laments:

We trace out all the fibres of the earth, and live above the hollows we have made in her, marvelling that occasionally she gapes open or begins to tremble – as if forsooth it were not possible that this may be an expression of the indignation of our holy parent! We penetrate her inner parts and seek for riches in the abode of the spirits of the departed, as though the part where we tread upon her were not sufficiently bounteous and fertile. [...] How innocent, how blissful, nay even how luxurious life might be, if it coveted nothing from any source but the surface of the earth, and, to speak briefly, nothing but what lies ready to her hand![125]

Is it possible to imagine a more evocative pictorial rendition of this seeking for wealth in the realm of the dead than Mantegna's, which turns Christ's freshly-hewn tomb into a quarry? Once the earth has been subject to rape by greed, its protective function as grave, in particular, will cease. It is therefore an insult akin to Jezebel's bared remains upon the field in Jezreel when Isaiah condemns the King of Babylon to the quarry: "[...] but you are cast out away from your grave, like a loathed branch, clothed with the slain, those pierced by the sword, who go down to the stones of the pit, like a dead body trampled underfoot."[126]

That Mantegna is actually referring to the Golden Age topos – and thereby condenses my standard reference of cultural evolution – is apparent from the fact that both quarries are part of a split landscape structured according to the myth's narrative sequence. The raped cave tomb, civilisation's ultimate decadence, is thus found to the left of Christ, a side traditionally linked with furtiveness (cf. *sinister*). To his right, conversely, we see landscapes characterised by all the surface activities renounced by the Iron Age stonemasons. Alongside the road in the Copenhagen painting, we see an idyllic meadow with resting and pipe-playing shepherds and their flock; and the meadow is bounded by a field with sparse vegetation, possibly arable land. On the same side in *Madonna of the Stonecutters*, we see shepherds and peasants harvesting stacks of green grass.[127] These landscapes thus depict a space spanning from the completely virgin Golden Age soil to a Silver and Bronze Age agriculture which might well process the earth but which as of yet stays on its surface. That agriculture, the work of the Fall, is registered in the 'good' side of the picture testifies to the incipient rehabilitation of farming introduced by the modernity *field*. The division is emphasised in the Copenhagen painting where Christ is supported on his left-hand side by a seraph dressed in blue, while his right side is attended to by a cherub in red. The seraph, originally a serpent monster, was lower down the celestial hierarchy than the cherub, and so is shown by Mantegna with a hopeful upward gaze. The cherub, on the other hand, can look downwards from a superior position.

Having been abused by the stonemasons, the entrails within the cavity of the tomb are not transformed into flesh that rises again, but to stone which through the pains of endeavour is converted into art works. On the spectrum of iniquity to which these art works correlate – *luxuria*, idolatry, aggression – the latter, destructive, aspect features because the works can be read, at least in part, as *Arma Christi*, instruments of torment used in Christ's Passion. The column and the statue could therefore allude to flagellation, for in Piero della Francesca's *Flagellation* (FIG. 12.58), for example, Christ is bound to a column topped with a golden idol. It was actually normal practice to surround the Pietà motif (in Venice also the Madonna and Child) with these instruments, so here the pictogram is, as it were, absorbed by the landscape setting.

Fig. 12.58. Piero della
Francesca, *Flagellation*
(1450s), oil and tempera
on wood. Urbino, Galleria
Nazionale delle Marche.

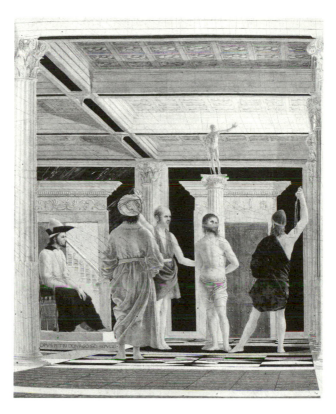

Fig. 12.59. Bartolomeo di Giovanni, *Saint Clement's Penal Work in a Quarry* (c. 1485), tempera on wood, predella panel from *Madonna Enthroned with Saints* (detail). Florence, Galleria degli Uffizi.

But, more generally, the art works represent *luxuria*, and the culmination of materiality: the pagan idolatry which Christ upturned.[128] The column, which was also seen in Camera degli Sposi, was the epitome of antique culture, and the hewing of it and its capitals is thus also conspicuous when Bartolomeo di Giovanni depicts Saint Clement's penal work in a Roman quarry (**FIG. 12.59**).[129] In the more specific choice of objects, particularly those in the Copenhagen picture, Mantegna was influenced by a source that was just as influential for his own art as for the Paduan-Venetian art in general: the sketchbooks of his father-in-law, Jacopo Bellini. Jacopo's sketchbooks are not merely full of ruined relics and idols of antiquity,

Fig. 12.60. Jacopo Bellini, *Baptism of Christ* (1440s), metal stylus on parchment, later reworked with pen and ink, from the *Louvre Sketchbook* (f. 25). Paris, Musée du Louvre, Département des Arts Graphiques.

lingering in contrapposto on Corinthian columns or smashed on the ground, as in two Christian wilderness scenes (**FIG. 12.60**).[130] The stonemasons themselves, in the process of making the idol, can be traced to this source: in the *Louvre Sketchbook*'s *Christ Carrying the Cross* the familiar symbol of pride, the fallen horseman, is coupled with one of these idolmakers working on a column, a capital and a supine statue with a cornucopia slung across its loins (**FIG. 12.61**).[131] The large bowl of the Copenhagen painting also features in Jacopo's works, sometimes as a basin in pagan fountains with Corinthian columns crowned by idols (**FIG. 12.62**).[132]

Whether or not Mantegna's stonemasons planned on assembling one of these fountains, it is certain that the idol and the bowl are to be confronted with the Suffering Redeemer on the sarcophagus. A confrontation between *Idolatry* and *Faith*, mounted on tall columns, had already greeted Borso d'Este, Duke of Ferrara, when he arrived in Reggio d'Emilia in 1453 and received homage in various spectacles. As

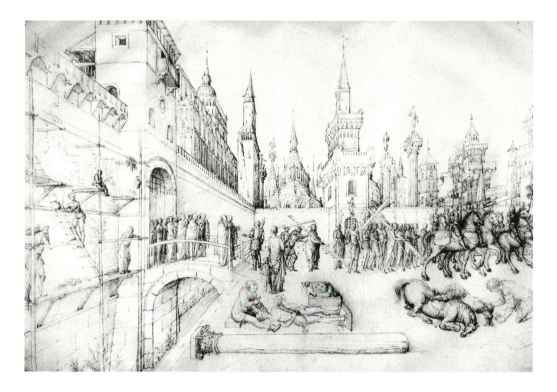

Fig. 12.61. Jacopo Bellini, *Christ Carrying the Cross* (1440s), metal stylus on parchment, later reworked with pen and ink, from the *Louvre Sketchbook* (f. 20). Paris, Musée du Louvre, Département des Arts Graphiques.

Fig. 12.62. Jacopo Bellini, *Presentation of Christ in the Temple* (1440s), metal stylus on parchment, later reworked with pen and ink, from the *Louvre Sketchbook* (f. 7). Paris, Musée du Louvre, Département des Arts Graphiques.

soon as *Faith* had recited a salutation, the idol column collapsed.[133] As to the Suffering Redeemer, an 11th-12th-century Byzantine motif, he is the incarnation of the Eucharist. Stretched out in an indefinable time span between burial and resurrection, he represents the corporeal force that renews the believer upon consumption of the host and wine. The sarcophagus from which Christ rises again can therefore be compared to the chalice that catches the life-giving blood. This symbolism is emphasised, for example, by Vecchietta who, in his ciborium for the Sienese Spedale di Santa Maria della Scala (1467-72; FIG. 12.63), has mounted another resurrected figure, known as the *Eucharistic Redeemer*, on the top of a chalice.

That this symbolism was also close to Mantegna's heart might be deduced from his placing of Christ on an imperial porphyry sarcophagus rounded with volutes in preference to the usual cubic coffin. In the first instance, the volutes allude to *sella curulis*, the folding chair used in antiquity as a seat for men of power, and in the Middle Ages also used to bear the sarcophagus. The sarcophagus hereby appears as the throne for the triumphant Christ.[134] But the voloutes also associate to the chalice, by means of which the throne becomes the source of the life-giving blood. In comparison with the pagan fountain idol, Christ thus appears as the true life-giving source. The symbolism is given a further sexual slant, for just like Signorelli placed the world-governing Pan's genitalia at the exact centre of the picture (cf. chapter II), so Mantegna has arranged Christ's shroud at the centre in a conspicuous knot that cannot be anything but a veiling of an erection. Considering that Bellini's aforementioned supine statue was equipped with a phallic cornucopia, there can be little doubt that Christ's bandaged member is to be interpreted as yet another attempt to surpass the pagan idol: the bodily fluids emanating from the Eucharist are life-giving in every sense, so that the stiffness of physical desire – *rigor mortis*, as it were – is also transformed into divine sexual ecstasy, just as the blood sacrifice of circumcision becomes a fertilizing ejaculation.[135]

However, to gain a more precise understanding of why Mantegna contrasts Christ with art works *in the process* of being made, we must again turn to the fundamental structure of the Golden Age myth. To begin with, we could draw in the Book of Wisdom, an apocryphal 1st-century book which the Middle Ages assigned to the Old Testament.[136] Here we read about the potter and his suspect earthenware products. "[W]ith misspent toil" and "lawless hands" he makes brittle vessels and graven images, even though these objects remain dead, and the clay of which he is himself made will soon be just as soulless.[137] Contrary to the stonemasons' dead idols, Christ must therefore be supreme, given that his clay is not only endowed with spirit but is, moreover, in the process of vanquishing death.

In addition, we can consult another Judaic variant of the Golden Age myth, found in one of Nebuchadnezzar's dreams in the Book of Daniel:

Fig. 12.63. Vecchietta
(Lorenzo di Pietro), bronze
ciborium with the *Eucharistic
Redeemer* mounted on top
(1467-72), from Spedale di
Santa Maria della Scala.
Siena, Cathedral.

You saw, O king, and behold, a great image. This image, mighty and of exceeding brightness, stood before you, and its appearance was frightening. The head of this image was of fine gold, its chest and arms of silver; its middle and thighs of bronze, its legs of iron, its feet partly of iron and partly of clay. As you looked, a stone was cut out [from the mountain] by no human hand, and it struck the image on its feet of iron and clay, and broke them in pieces. Then the iron, the clay, the bronze, the silver, and the gold, all together were broken in pieces, and became like the chaff of the summer threshing floors; and the wind carried them away, so that not a trace of them could be found. But the stone that stuck the image became a great mountain and filled the whole earth.[138]

In the subsequent verses, this shattering of the idol is interpreted as the Kingdom of God's destruction of the fourth kingdom, the kingdom of iron, which follows on from the kingdoms of gold, silver and bronze. That Christianity regarded the

mountain from which the stone is cut to be the Virgin Mary's body, is corroborated, for example, in a hymn to Mary written by the Constantinopolitanian Saint Germanus in the 8th century: "Hail, bountiful and sheltering mountain of God: where the redeeming Lamb was nourished Who bore our sins and infirmities, the mountain whence descended that stone, cut by no hand, which crushed the altars of the idols, and was made 'the capstone, marvellous in our eyes!'"[139] This reading also emerges if we, as Hartt recommends, again consult Hrabanus Maurus. Under the words *mons* and *lapis* it is asserted that the mountain is the Virgin Mary, and furthermore that the stone which detaches itself from the mountain without the agency of human hands, and having crushed the idols fills the entire world, is Christ born without "conjugal labour" [*sine opere conjugali*] and "without male semen" [*sine virili semine*], later to "fecundate" [*fecundeverat*] Jews and pagans with the words of his doctrine.[140]

If we return now to the two paintings – and beyond Hartt's observations – we come to an understanding of why Christ must be superior to the idols: he evades work in every sense. Both Christ and the art works originate in the Golgotha rock, alias the Virgin Mary's body, but whereas art derives from an excessive penetration of Mother Earth and is formed from the stonemasons' laborious craft – both being analogous to fallen sexuality – Christ bypasses the labour of matrimony and hand alike. The Holy Spirit descends directly into the earthly matter, whereupon Christ is born by means of a Golden-Age-like autochthony, the stone spontaneously detaching itself from the body of the earth and, completely in accordance with Christ's conspicuous erection, fecundating Jews and pagans.

Mantegna is presumably alluding to this detachment in the strange crystalline formations jutting out of the rock above the quarry in *Madonna of the Stonecutters*.[141] Here the archaic notion of the growing rock is transformed into a sacred autochthony in the same way as it was in the stone-generating paradise of the Caucasus where Zarathustra was born (cf. chapter 2). According to Eliade, the idea of Christ's birth from stone is also well-known in Christian folklore, such as in some Romanian Christmas carols.[142] Mantegna, furthermore, brings to mind Pliny's words about marble actually growing in its quarries so that the scars on the mountainsides fill up of their own accord (cf. again chapter 2). After the stonemasons' rape, the mountainside is thus healed by means of Christ's resurrection, which will break up the idols. Even the upward pointing rock in the 'good' side of the Copenhagen picture could be included in this symbolism. In that case it should be read as the idol-crushing stone in the process of becoming a world-spanning mountain since it follows the direction of the sunrise, the birth of the Kingdom of God.

In the light of the number of interpretative levels here intended for Christ along with dynamic and fertilising stone, it would seem obvious also to connect him with alchemy's miracle agency, the all-transforming Philosophers' Stone. Right from the

time alchemy was imported to the Western sphere from the Islamic world in the 12th century, focus is on the correspondence between alchemy's wonderful stone and the living stone, the spiritual rock, that is Christ.[143] In the same way as Christ descended to the dead in order to become immortal, the Philosophers' Stone is made of *prima materia* which passes through the *nigredo* stage, the lowest form of earth, in order to be cleansed. And just as Christ through his example changes pagans into believers, the Philosophers' Stone converts impure matter into gold. In support of an analysis that this exegesis must be intended, it should be noted that the *Madonna of the Stonecutters* was later housed in Francesco dei Medici's aforementioned *Studiolo*, a *Wunderkammer* and room in which to contemplate nature's secrets, which, not unlike the cutting out of Christ's tomb in the mountain, was carved into Palazzo Vecchio's thick walls. The panels painted by the Vasari workshop specifically for the *Studiolo* included Jacopo Zucchi's *Gold Mining* and the *Mining of Diamonds* by Maso da San Friano mentioned earlier (**FIG. 12.48**). The *Madonna of the Stonecutters* could here be part of the same meditation on art's nature as applied to the mining scenes. In the words of the planner behind the cycle, the learned Benedictine Vincenzo Borghini: "[S]imilar things are not created completely by nature nor completely by art, but we have two parts helping each other – as, to give an example, nature gives her diamond or carbuncle or crystal and similar unformed material, and art polishes, hews and carves it, etc. [...]."[144]

In this later, art-reflexive context, then, it is clear that the stonemasons' activities were not exclusively denounced, and indeed it is likely that in Mantegna's setting they were also enveloped in mixed values, for which reason the leap to *Celifodina*'s frontispiece with its affirmation of mining is perhaps not so very big after all. In Mantegna's *Madonna della Vittoria* (1496; Paris, Musée du Louvre), the Madonna's throne pedestal is, at all events, equipped with three bronze and stone reliefs with motifs taken from Genesis, of which one – on the left, an illustration of God sculpting Adam from the earth – allows us a glimpse of a hand holding the chisel carving a half-finished marble statue.[145] Mantegna thus takes the biblical idea of Adam being created from the dead clay completely literally, and in so doing highlights that God himself is a common sculptor who has to make use of his hands in order to transfer the form to the material. It is a fine line between divine and human art.

Also the Copenhagen painting could be read as just such an allegory of art's nature and the preconditions for depicting Christian motifs.[146] Even though Christ appears as superior to the idols, he is himself endowed with a strangely sculptural and marble-like body which, in its paleness, detaches itself from his greyish head and throat. By means of this body picture, which is again very concretely highlighting Christ's identity as stone, Mantegna is possibly paraphrasing the Hellenistic *Torso Belvedere*, which he might have seen on Monte Cavallo during his recent stay

in Rome (FIG. 12.64), for the two works share the seated motif, the slant of the body and the direction of the spread thighs. In any event, he composes a montage similar to those in the gatehouses of Camera degli Sposi: an antique ruin is restored with a Christian superstructure. Is this montage thus a sign that Christianity now rises again with its head on an ancient body? And that the corporality of antiquity is hereby made acceptable? If so, the rebirth still does not mean victory to the idolaters since it takes place in a painting.

Thus, the Copenhagen painting could be a contribution to painting's contemporaneous struggle to become a liberal art, an art created by spirit as opposed to the stonemasons' craft.[147] As Michael Camille and Joseph Koerner have demonstrated, the image made without the work of human hand, known as *acheiropoietos*, is a widespread myth in a number of pre-modern cultures, including Western antiquity and Byzantium.[148] Daniel's prophecy of the Messiah as a stone thus cut out without the work of hands is quite tangibly realised by Mantegna, for Christ's body is indeed a stone which is not hewn but re-created in paint. This quasi-stoniness is but strengthened in an alchemical light since Christ's alter ego, the Philosophers' Stone, is often described, like *prima materia*, as "a stone and yet not a stone", implying a spiritual just as much as material metamorphosis of matter. Additionally, Mantegna recalls Alberti's assertion that "[p]ainting possesses a truly divine power in that not only does it make the absent present [...], but it also represents the dead to the living [...], so that [...] the faces of the dead go on living [...]",[149] by means of which he again holds his own against the potters in the Book of Wisdom. Through the painting, Mantegna repeats the divine act of creation in that he *almost* enables the dead Christ to rise again from the rock. Also, if the act of creation is understood as a resuscitation of antiquity, it is made clear that it cannot take place in sculpture, antiquity's principal medium of survival, but in painting. As Filarete remarks, a sculpture is irredeemably damaged if something breaks off; in painting, on the other hand, flaws can be corrected "a thousand times" with more painting.[150] Christ's painted head on the broken sculptural torso is just such an addition. The sculptural closedness of antiquity is not dead, but merely ruined, for which reason it can only be repaired with the flexibility of the modern painting.

Allowing for Mantegna's play on antique sources, it is in conclusion not improbable that the seated, singing figure of Christ alludes to ancient god-musicians such as Orpheus or Apollo.[151] These gods are often – as we will see shortly – depicted making music in a sitting pose similar to that assumed by Christ (PLATE 43), but their song also implies a spiritual power in the broadest sense, from genesis of form to poetry and philosophy and on to fertility (cf. my analysis of Signorelli in the previous chapter), which corroborates the Suffering Redeemer's erotic strength. In Propertius' *Elegies*, Orpheus' animal- and river-taming lyre playing is principally

Fig. 12.64. Apollonius (?), *Torso Belvedere* (1st century BC), marble. Rome, Vatican, Musei Vaticani.

illuminated on the basis of a legend in which "the rocks of Cithaeron, they say, stirred by a Theban's art, joined together of their own accord to form a wall [...]."[152] As Christ's effortless birth could earlier be compared with a stone that was cut out from the mountain without the aid of human hands and then went on to fill the whole earth, the leap cannot be so very big to a metaphor for his creative force according to which the song of Orpheus-Christ drives rocks to form a wall on their own. And besides, the idea of such a rock-born wall must be said to be strikingly close to that autochthonic tendency which, on a paradigmatic level, marks the rocks of Quattrocento painting as a whole.

Mantegna III: Parnassus

The Copenhagen picture's reference to ancient musician-gods, and accordingly to the power of poetry in the broadest sense, makes for an appropriate bridge across to the last of my Mantegna case stories for the moment, the antique allegory *Parnassus* (c. 1496-97) painted for the Mantovian marchesa Isabella d'Este's *Studiolo* (PLATE 43).

In this monumental painting Apollo strikes up his lyre for the Muses' dance, the poetic unsullied power of which again spreads to the surrounding natural formations and on to the making of the image itself. And in the same way as in both *Christ as the Suffering Redeemer* and *Madonna of the Stonecutters*, the corrupting power contrasted with this pure source is once again concentrated on an Iron-Age-like rock cave, where the art works are produced with sweat and toil.

To ensure an appropriately learned atmosphere in the *Studiolo*, the *Parnassus* and its later counterpart *Pallas Expelling the Vices from the Garden of Virtue* (c. 1499-1502; FIG. 12.77; see also the forthcoming discussion) were presumably devised in collaboration between Mantegna and the meddlesome Isabella, plus the latter's humanist adviser Paride da Ceresara (1466-1532), a nobleman knowledgeable in languages and astrology. The picture can in itself be read as an allegory on the mysteries of Creation, more precisely the balance of gender forces necessary for poetry – and in extension of this: image making – to spring pure and unsullied. According to Lucian's defensive *Astrology*, Homer's poetry – primordial poetry itself – is a result of the conjunction between Venus and Mars, and in a form of self-referential loop, Mantegna has taken his starting point in the *Odyssey*'s own reference to their affair, where Aphrodite's (Venus's) disabled husband, Hephaestus (Vulcan), is cuckolded while Olympus shakes with laughter.[153] Just as Homer's poetry is thus born of a love encounter contained within the same poetry, I shall show that Mantegna's picture contains the conditions for its own creation, a source from which the picture crystallises autochthonically.

In Mantegna's free adaptation of the story, however, we are not on Mount Olympus but in a mixed scene that places Parnassus and Mount Helicon as the background setting for a natural arch on which Mars and Venus meet.[154] Similarly, the lyre-playing bard Demodocus, who is singing about the love couple while a troupe of boys dance, is transformed into one of the commentators on the love rendezvous, an again Orpheus-like Apollo seated on a tree stump (cf. Christ's pose in the Copenhagen painting) and accompanying his usual companions, the nine Muses, as they all the while sing and dance in a circle in front of the natural arch.[155] In the left background, however, in front of his cave forge, the deceived husband Vulcan shakes his hand threateningly at the amorous couple. Additionally in the background, from the crater in the dark-brown Etna – here moved to Greece and merged with Parnassus – a chaotic mass of grey crystals spout into the air, recalling those in *Madonna of the Stonecutters*. In antiquity, volcanic eruption was understood to be Vulcan's anger, and so it is tempting, as Edgar Wind has suggested, to interpret the formations as being the result of a cuckold's rage.[156]

On the opposite side of the painting, Pegasus paws the ground alongside his keeper, Mercury, another commentator at the Homeric love rendezvous. As

mentioned in chapter 2, the winged horse's stamping causes the Hippocrene spring, the home of the Muses, to rise on Mount Helicon, so it must be this spring that can be seen trickling out between the porous rocks in the foreground of the painting. A Renaissance topos saw poets drinking from Hippocrene when they wrote verse. For example, with a little play on words, the poet Cariteo calls his Anconian colleague Marco Cavallo (1475-1524) "a new Pegasus at whose feet a flowing spring rises from arid ground".[157] When requesting Francesco Gonzaga's favour in a letter dated August 3 1490, the poet Francesco Roello even proclaims that the prince is "very learned, that he has been at Mount Parnassus and at the spring of Pegasus", and furthermore that he is "totally dedicated to the Muses".[158] In Mantegna, however, the Hippocrene spring does not feature on its own, but is accompanied by a small layout of discreet springs: besides a diminutive one in the left foreground, there are also the narrow waterfalls in the two background mountains. As Andreas Hauser has convincingly argued, this discretion of physical springs highlights the intention that the main poetic source should be read, in a more spiritual fashion, into the Muses' dance itself, which, with its flowing movements, makes comprehensible the frequency with which the Muses decorate fountains.[159]

A more explicit exposition of the conditions for the fertilising activities of the Muse spring is given by the affair between Mars and Venus. The mythological lovers are positioned in front of their bed of passion on the natural arch behind the Muses, and their union is indicated via a subtle play of lines comparable with that seen in the contemporaneous *School of Pan* by Signorelli (**FIG. 11.60**; see chapter 11). Firstly, the two Muses on the right form a coitus sign: a thumb passing through the hole made by the thumb and forefinger is aiming – reinforced by another forefinger and, displaced on the parallel, by Mercury's staff – in the direction of Mars' genitals.[160] Even though Venus is thus unfaithful to her husband, Vulcan, it is apparent from another play of lines that infidelity is here more noble than marriage. Anteros, the son of infidelity, has aimed his blowpipe at Vulcan's genitals. Anteros (Anti-Eros) was the chaste half-brother of Cupid, the arouser of desire, and his triumph over this half-brother is apparent from Cupid's golden arrow, which Venus has confiscated, and from the rods, to be used for Cupid's punishment, on the ground to the left. The line extending from Anteros' blowpipe in the opposite direction ends in Venus' crotch.

Being the metalworking god labouring in the heat of the underworld, Vulcan represented the sultry, Iron-Age-like sexuality, conjugal labour, but in being struck by Anteros' arrows, the cleansed sexual force from Venus' crotch, his potency is lifted into that purer and more Golden-Age-like sphere incarnated in the embrace between Mars and Venus.[161] In accordance with one of Neoplatonism's key texts, Plato's *Symposium*, Venus on the natural arch, then, represents the celestial Venus

superior to her married terrestrial counterpart. Here Mantegna is addressing the tradition according to which the amorous encounter produces the daughter *Harmonia*, the ultimate harmony between loving gentleness and aggressive strength. This progeny of Mars and Venus is omnipresent in late medieval astrological treatises, and it received further metaphysical interpretation by Florentine Neoplatonists such as Ficino and Pico della Mirandola.[162] That it is superior to the more prosaic offspring of conjugal labour is corroborated by Leone Ebreo who, in his *Dialoghi d'Amore* notes that: "when this union of the two parents occurs regularly in nature, it is called marriage by the poets, and the partners are called husband and wife; but when the union is an extraordinary one, it is styled amorous or adulterous, and the parents who bring forth are styled lovers."[163] Despite infidelity, coitus is thus again most beautiful when it – like hierogamy's coupling of heaven and earth – can be performed with love, an attraction free of the fallen and dreary toil of conjugal labour.

If we now turn to the Hippocrene spring in the painting's foreground, we will see that crystal formations also grow alongside this spring, in the countersinking between the porous rocks. An interspersion of yellow gems attests to their preciousness and in so doing makes them apposite symbols for the poetic fecundity of the spring. That they really are growing can be confirmed by Nicander's assertion that the Muses' singing made Helicon rise towards heaven, a growth that was not stopped until Pegasus stamped his hoof.[164] In the rocks to the left, there is another accumulation of pebbles, which could perhaps be interpreted as fossilised shells. Whatever the case, the deposit of fossils in mountains had been noted since antiquity and was usually explained with reference to the Flood. Mantegna's fossils would, in that case, testify that Deucalion and Pyrrha sought refuge on the twin peaks of Mount Parnassus after the Flood[165] – the peaks, through which another of the Muses' streams, the Castalia cascade, flows, and which are riddled with caves, are seen in the right background. Given that Deucalion and Pyrrha recreated humankind by throwing the stones of the earth, "the bones of your great mother",[166] over their shoulders, the crystals with their fecund appearance thus assume a broader function. Exactly like the crystals in *Madonna of the Stonecutters*, they are charged with autochthonic forces.

If we compare these precious minerals with the crystalline formation growing up from Vulcan's mountain, then it acquires a symbolism that is almost the opposite of the formations in *Madonna of the Stonecutters*. Vulcan's genitals have yet to be cleansed by Anteros' arrows, and so the crystals grow chaotically and in vain. Far greater fertility is manifest in the crystals which are called forth by the Muses' singing, and whose growth is curbed by Pegasus' stamping hoof, which in turn releases Hippocrene's source and thereby fertilises the crystals with poetic creative

power. That they really are more noble than those of the volcano is apparent from the latter's uniform grey colour, whereas the former are interspersed with yellow gems. The crystals of the Hippocrene spring are consequently a representation of the free art inspired by the Muses, communicated without the agency of exertion and desire.

The painting thus focusses on the same natural force, the Muses' poetic inspiration, that we see in Signorelli's *School of Pan* and, in a Christianised version, in Mantegna's *Christ as the Suffering Redeemer*. That Mantegna, exactly like Signorelli, also embeds image-making and thereby the painting itself within this force becomes apparent if we turn to the following Pliny anecdote concerning a famous *acheiropoietos*, a myth repeated in the late Middle Ages by Marbode of Rennes and Alberti:

> [King Pyrrhus] is said to have possessed an agate on which could be seen the Nine Muses with Apollo holding his lyre. This was due not to any artistic intention, but to nature unaided; and the markings spread in such a way that even the individual Muses had their appropriate emblems allotted to them.[167]

Might it not be the case that *Parnassus*, in itself a detailed portrait of the lyre-playing Apollo and the Muses, should be understood as an evocation of this image-breeding agate? At the Hippocrene spring, the poetic power centre, Mantegna has, after all, interspersed the rocks with yellow gems; and, geologically, agate is just this kind of filling in cavities. If we zoomed in on one of these yellow stones, we might therefore imagine that we would come across the very painting that depicts the landscape in which the stones are found: i.e., a painting that contains a landscape with an agate with a painting that contains a landscape with an agate with a painting... and so on and so forth in endless self-reflection. The agate is consequently no longer, as it was in antiquity, conceived by a virgin nature, but within the self-same artificially manufactured painting it has itself 'produced' – a painting that has already displaced poetry's origins in nature's springs to a depiction of the Muses' flowing dance. Mantegna therefore shows himself to be an unmistakeably modern artist – an artist who places the power of conception, the natural source of art, in an art that sets up nature as a mirror for the beholding consciousness. When Leonardo suggests that the painter should devise images in, *inter alia*, "stones of various mixed colors" (cf. chapter 9), Mantegna can then add that this devising in the most literal sense is made real via the agency of self-reflection. Just as Leonardo displaces Wisdom's source of insight in the *Virgin of the Rocks* to her self-reflection in the bottomless deep, a literal *mise en abyme*, so too Mantegna stages the Hippocrene spring's picture-making and picture-made crystal image as an auto-referentiality without limits.

12.3 Ruins

If we now zoom out again from these case stories and into the bird's-eye perspective of the paradigm, we can shift the interpretation of the common theme, the architectonic rock, another fraction – not as self-grown architecture, not as the result of conscious design, nor as residue from mining or quarrying, but purely and simply as ruin. Here it is thus a case of an original man-made structure which, with the gradual affects of time and weather, perhaps aided by deliberate destruction, has reached such a state of decay that it has become almost indistinguishable from geological formations – even though the never quite vanished artificial mien attests to some kind of over-and-above-natural genesis.

Given that the ruin appears as the specific result of the influence of the modern paradigm – the eating-away of time (cf. chapters 10 and 11) – a more comprehensive particularisation could appropriately take the renowned quotation from Walter Benjamin's late history theses as its benchmark:

> There is a picture by Klee called *Angelus Novus*. It shows an angel who seems about to move away from something he stares at. His eyes are wide, his mouth is open, his wings are spread. This is how the angel of history must look. His face is turned toward the past. Where a chain of events appears before *us*, *he* sees one single catastrophe, which keeps piling wreckage upon wreckage and hurls it at his feet. The angel would like to stay, awaken the dead, and make whole what has been smashed. But a storm is blowing from Paradise and has got caught in his wings; it is so strong that the angel can no longer close them. This storm drives him irresistibly into the future, to which his back is turned, while the pile of debris before him grows toward the sky. What we call progress is *this* storm.[168]

The debris – ruins – hurled at the feet of the angel of history could thus be said, for the first time, to be depicted in the painting of modernity. In the civilisation that has taken on the Fall and made it its own motive force, the visual rendition of the eating-away of time is a permanent phenomenon of its art. The storm, which drives the angel backwards from Paradise and towards the future, is a laborious wind that erodes, destroys, pulverises. It is the weather-time when not merely manifested as day-and-night variations and seasons, but also shows that there has been a past before the moment. This past is depicted via the traces deposited by time on the object, by means of which we can see that it once existed in a more complete, more virginal state. Were I to supplement this with Serresque terminology, the extended catastrophe that piles wreckage upon wreckage could then be understood as the unburied dead, death stretched out in time.

This ruination makes itself felt in all sorts of pictorial ingredients after 1420. Clothing fades, trees wilt, faces wrinkle and become weather-beaten, fruit rots, walls crumble and get overgrown, mountains erode. The decay is particularly welcome in the expanses of the landscape. In van Mander's *Het Schilder-Boeck*, landscape paint-ers are quite simply advised not to depict buildings in their pristine state: "Roofs and walls ought not to be shown with bright red bricks, but rather in turf, reeds, or straw, holed and patched. You can also plaster them in a fantastic manner, and show moss growing on them."[169] With ruination we are at the heart of the modern pictorial gaze. Where the rock as self-grown architecture bears witness to a still intentional nature, nature with a semi-innate art, the ruin on the other hand bears witness to a nature that has broken every contract with humankind and works in defiance of its projects – to indomitable, blindly destructive forces that are realised by the simple passage of time. "Time has deformed everything" declares Pius II in his *Commentarii* at the sight of the ruined architecture of antiquity.[170] And in the letter from Raphael and Castiglione to Leo X (*c.* 1519), time is said to be "envious of the glory of mortals" and is equipped with "gouging file and poisonous bite".[171] The ruin thereby becomes a visible manifestation of entropy, the thermodynamic term for the steadily spreading disorder in a closed system.

The strongest manifestation of the entropy of weather-time in modernity's pictorial paradigm is seen, as mentioned above, in the expanses of the landscape, more specifically in the main topic of this chapter: *the stone*. It is precisely because stone contains the hardest and most imperishable materials in nature that its transitoriness makes such an impact. Stone also mirrors the lengthy duration and permanence of the process of disintegration: that it can be so broken down attests to the length of time since it was virginal. In post-1420 painting, this ruined stone is seen in battered buildings, from antiquity as well as later, in sculptural fragments, and in the eroded flanks of distant, air-blue mountains – i.e. mountains shrouded in the very same medium which, in the course of time, wears them away.

This latter mode of appearance signals an aesthetic appreciation that bursts the pre-modern reins on pictorial space. Rather than, as in the Middle Ages, being made up of claustrophobic piles of chaotic stone, the mountains move out into the wide expanses of the landscape, the grandeur of which they incarnate. As a sign that this transformation is not confined to the mountains' projection on the surface of the painting, but amounts to a general shift in the sensibility of the times, we can see how Petrarch's solitary 14th-century mountain ecstasy is transformed two centuries later into a minor trend. Numerous Alpine peaks are consequently ascended, some even for the first time, and men of letters such as Erasmus, Johannes Secundus and Montaigne extol the Alps for their beautiful views. The Swiss themselves were especially enthusiastic. In a letter written in 1541 to the physician Jakob Vogel, the

naturalist Conrad Gesner describes the Alps as "Theatre of the Universe". "What delight for the soul [...] to admire the spectacle offered by the enormous mass of these mountains. [...] Without being able to explain it, I sense my spirit struck by their astonishing heights and ravished in the contemplation of the Sovereign Architect."[172] Even though the new panoramic mountain vision tendencially breaks with every ideal derived from an iconographically meaningful, closed art, here we see how the classical ideas of nature as theatre and architecture are still reproduced. As is the case with so many other modern phenomena, appraisal of the mountains first matures in earnest with the birth of romanticism around 1700 when Northern poets and painters vie to represent mountain magnificence. In her eminent study, Marjorie Hope Nicolson links this breakthrough to the emergence of Newtonian physics, by means of which mountain homage becomes the expression of "the aesthetics of the infinite".[173]

Erosion, the gradual decomposition by weather and water, is acknowledged as a key designer of these new mountains, those of reality as well as the pictorial ones. Avicenna (980-1037), a forerunner of modern geologists, thought that fossils in the mountains meant the earth had originally been completely covered with water, and that many mountains emerged as the water receded, so that the clayey seabed was fossilised "during ages of which we have no record". But because most of the mountains by his day had lost contact with this water, they were now in a state of decay and disintegration.[174] This theory later finds resonance with Leonardo, the pioneer of sublime landscape depiction. He also thought the earth's plains in ancient times had been "covered up and hidden by salt water", and that later the water contributed both to the formation and decomposition of the mountains. At one point he notes "that the rocks and promontories of the sea are constantly being ruined and worn away".[175] The Dutch Carel van Mander pronounces the wind an unequivocal part of these erosive forces, for in his art history the Alps are referred to as the target of the north wind, just as streams splash through the "weathered" rocks.[176]

Not least as contrast to the hard rocks' dominance of the pre-modern landscape images, it is tempting to see the new ruining forces also reflected in the gravel and the soil depicted in the modern landscape image. Here, however, the thoroughly pulverised stone, evidence of nature's destructive powers, is simultaneously reshaped through its opposite, the constructive territorial division of the landscape into fields and roads.

The forces that wear down landscape's macrostructures, the mountains, are thus the same forces that cause humankind's architectonic structures to converge towards small mountains and rocks, and make them confusable with self-grown architecture. That this nature's recapturing of art must be seen as one of the modern painting's chief emblems is evident from the mere fact of its relative absence

in pre-modern painting.[177] As suggested in chapter 6, only Roman wall painting displays single, rare candidates of temporally worn-down buildings. What might lurk of ruins in the pre-modern painting is predominantly concentrated in the rocks, fragments left by calamities such as floods, earthquakes and subterranean winds. Here the underworld still adheres to death, whereas the above-ground is structured by the Golden Age paradigm and accordingly by closed, integrated and supra-temporal forms. In this paradigm, where the reconstruction of Paradise by the Golden Age *field* is dominant, and the angel of history has yet to be blown out of the evergreen and closed garden, depiction of the ruin – the temporally worn-away and un-closed object – is impossible. Consequently, items of fruit in the Roman still lifes remain intact and show no signs of decomposition, unlike those in the 17th-century Netherlands.

The taboo in pre-modern painting is thus depiction of the worn-away or collapsed building, destruction of which is due to unspecified forces in the past, particularly the effect of time itself. If the buildings are to be destroyed before modernity, then the overriding norm is that they are done so by a tangible cause in the present

Fig. 12.66. Bartolo di Fredi, *Earthquake
Destroys Job's House*, fresco from *Stories of
Job* cycle (1367). San Gimignano, Collegiata.

or the immediate past. This might be a case of cities demolished by God or man –
Babylon, Sodom and Gomorrah, Jericho or Troy;[178] or buildings that collapse on top
of innocent people, who are then restored to life by means of a miracle performed
by a saint. And, what is more, these episodes of ruination always take place in a
remarkably well-ordered manner.[179] Now and then, as in Cimabue's *Fall of Babylon*
(*c.* 1279-84; Assisi, San Francesco, Upper Basilica), the buildings are simply slanting;
or they are turned upside down, as in the *Fall of Babylon* scene from the *Bamberg
Apocalypse* (11th century; FIG. 12.65) – inversion, also familiar from fallen idols, is
in itself a powerful sign of rejection.[180] And if the buildings should finally fall to
pieces, the fragments are never infinitesimal, just as they are always confined by
sharp-edged and not too irregular cracks (FIGS. 8.18 and 10.1B). In a scene of collapse
such as Bartolo di Fredi's *Earthquake Destroys Job's House* from the *Stories of Job* (1367;

Fig. 12.67. Maso di Banco, *Saint Sylvester's Miracle* (c. 1340), fresco. Florence, Santa Croce.

FIG. 12.66), there are no transitional zones, but a quantum-like leap from intact to destroyed. In W.S. Heckscher's apt words: "The actual outlines of those scattered pieces could be rejoined as if they were pieces of a jig-saw puzzle."[181]

This well-defined destruction must therefore be read as a manifestation of the fundamental closedness of the pre-modern pictorial vision, the Golden Age paradigm. Even in the breaking-up process, the gaze refuses to catch the infinitesimal, which is considered unsightly and incomprehensible. Rather than disintegrating in a shapeless infinity, the building is split into an aggregate of smaller self-contained units, which correspond structurally to the aggregate in the pre-modern space as such.[182]

In modernity, however, visual continuity emerges at exactly the same time as destruction is stretched indefinitely backwards in time. The ruined building is brutally fragmented and exposes sections that are otherwise concealed, but simultaneously, with the gradual erosion of time, its parts merge in a mellow continuum. In this the mathematical sectional view, with its measurable lines and surfaces, turns into an incalculable chaos. Through the wear and tear caused by air mist to the surface, this surface is itself endowed with misty transitions attesting to the transformation that it is in the process of undertaking: the temporally infinite is transformed into the spatially infinite. Just as the well-defined fragments in the pre-modern ruin reflect

the closedness of vision, so the continuous fragments in its modern successor refer to the openness of vision. *Sfumato* is not content to be embedded between gaze and object, but is etched into matter so that the object itself is transformed from closed body to open image. The ruin thereby becomes a prototype of the painterly sight, of the sketch, of what is fundamentally incomplete in modern pictorial production. It attests to the consumption of the perspectival gaze, to the ferocity of oblivion. It attests to the fierceness of isolation from the world as the individual is blown backwards towards the future.

This new ruin is almost materialised in Maso di Banco's *Saint Sylvester's Miracle* (c. 1340; FIG. 12.67). The miracle of the saint rendering the dragon harmless takes place in Constantinian time and, as paganism also fell in this period, there is a rationale for depicting the imperial forum as already bearing signs of the ravages of time. Several of the antique walls are half-collapsed and traversed by weed-covered cracks, and in the foreground there is a heap of rubble. Although the decay is portrayed with a degree of realism that is otherwise unseen at the period, the transitions from destroyed to whole are still very abrupt. Through decay, the ruins become an upward extension of the dragon's infernal hollow. Pagan Rome becomes a destroyed Babylon or Edom as described by Isaiah: "Thorns shall grow over its strongholds, nettles and thistles in its fortresses. It shall be the haunt of jackals, an abode for ostriches. And wild animals shall meet with hyenas; the wild goat shall cry to his fellow [...]."[183] Rather than wild animals and satyric wild goats, the dragon here assumes the role as representative of the underworld. In this vision of Rome, it is not such a great leap to Lorenzetti's contemporaneous *Bad Government*, in which buildings are also transformed into ruins as a consequence of Lucifer's regime (FIG. 10.1B). Lucifer can here be described as the absence of an organised society. As soon as maintenance qualified by work lapses, chaotic nature takes over.

Like most other modern pictorial phenomena, however, the ruin is not explored in earnest until after the paradigm shift around 1420. Gentile da Fabriano and Robert Campin agree that their nativity stables should be made up of ruined buildings: a round-arched stone building and a tumbledown wooden hut (PLATE 7), respectively.[184] And both artists pitch into the building, into the ashlars and into the fillets behind the crumbled plaster. Motifs involving the holy family – the *Nativity*, the *Adoration of the Magi* and the *Adoration of the Shepherds* – constitute a generally dominating forum for the early representation of the ruin. The iconographic reason for this is a proximity of the underworld similar to that seen in Maso, for, as shown in chapter 2, in accordance with Jacob's and Matthew's pseudo-gospels, Byzantine tradition located the nativity in a cave. The tradition actually lives on in Italy far into the 15th century, as demonstrated by Gentile, for example, who has the ass and the ox placed in a cave right next to the ruin. Whether it appears alone or as

Fig. 12.68. Roger van der Weyden, *Nativity* (*c.* 1452-55),
oil on wood, centre panel from the *Bladelin Altarpiece*.
Berlin, Staatliche Museen, Gemäldegalerie.

an extension of the birth cave, the ruin becomes an index of the matter from which Christ is born.

But Maso's pagan connotations also play a role, for it soon becomes the rule that the stable is a former monumental edifice, often a temple or palace. Especially north of the Alps, for example in Roger van der Weyden's *Bladelin Altarpiece* (*c.* 1452-55; FIG. 12.68), the architecture is quite unequivocally Roman, for, in contrast to the usual pointed arches, an indication of the modern and reverential architecture, the windows are circumscribed by semi-circular arcade arches, the formula for its antique forerunners. The architecture is thus not merely stating that Christianity arises from fallen matter, but also that this matter comprises the ruins of pagan

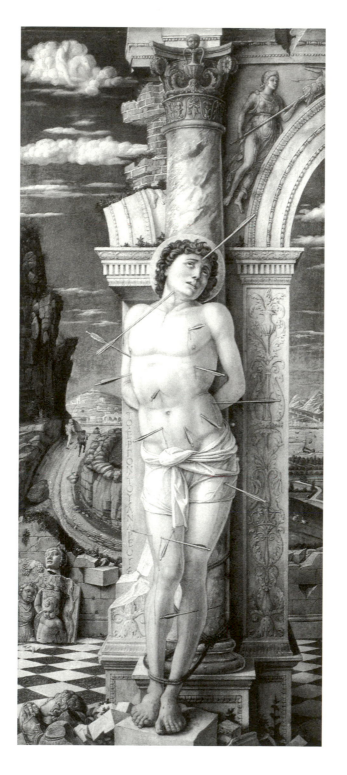

Fig. 12.69. Andrea
Mantegna, *Martyrdom of
Saint Sebastian* (*c.* 1458-59),
tempera on wood. Vienna,
Kunsthistorisches Museum.

Fig. 12.69a. Detail from
Martyrdom of Saint Sebastian,
fig. 12.69: horseman in clouds.

civilisation. Even though paganism is primarily clad in architecture associating to Rome or antiquity, it also takes in Judaism, the period *sub lege*. The new era, which destroys the buildings of the past, thus becomes *sub gratia*.

Another 15th-century theme setting the scene for ancient ruins is found in the Martyrdom of Saint Sebastian. As this saint, who lived under the rule of Diocletian, was punctured by arrows in the Colosseum itself, the heart of Rome, there is every reason to place him among all sorts of broken down monumental architecture: arcades and a column (Mantegna, *c.* 1458-59; **FIG. 12.69**); a triumphal arch (Pollaiuolo Brothers, 1475; **FIG. 11.49**); a triumphal arch and an amphitheatre (Signorelli, *c.* 1500, Città di Castello, Pinacoteca).

However conducive to ruins these themes might be, they should still not be read as anything other than powerful incentive, condensations, in a broader paradigm, for the ruin appears with increasing frequency in a variety of motifs, and after 1500 it can be said to have vanquished the paradigmatic landscape backgrounds both north and south of the Alps. The following few examples will demonstrate the prevalence of the motif. In Petrus Christus' (?) *Friedsam Annunciation* (1450s; **FIG. 12.70**), not only is the wall around the *hortus conclusus* ruined and overgrown, but the weeds and decay have also started to invade the very church where the Madonna is receiving the annunciation. Flowers are growing on the buttress to the left, and the doorsteps are quite battered. In the nominalistic and proto-Protestant

Fig. 12.70. Petrus Christus (?), *Annunciation*
(*"Friedsam Annunciation"*) (1450s), oil on wood.
New York, Metropolitan Museum of Art. All rights
reserved, The Metropolitan Museum of Art.

Fig. 12.71. Andrea Mantegna, episode from the
Triumphs of Caesar (*c.* 1484-92), tempera on canvas.
London, Hampton Court Palace, Royal Collection.

countries north of the Alps, not even the communal Judeo-Christian building can any longer be considered "indestructible", as Panofsky would have it.[185] Faith may rather seek refuge from the passage of time in a spiritual building, the as of yet immortal soul of humankind.

Mantegna's *Triumphs of Caesar* (*c.* 1484-92; FIG. 12.71) is another example of unruly ruination. Although the motif takes place at the very climax of pagan antiquity, there are still ruins in the background. And in Patinir's *Landscape with Saint Jerome* (*c.* 1516-17; FIG. 12.72) there is a group of ruined buildings immediately behind the rock within which the saint lives; they are now a standard element in the world panorama surrounding the saint. Making a generalisation, it could perhaps be said that whereas the Italians mainly concentrate the ruination on selected pieces of antique architecture – as a kind of emblem of the nostalgia in the midst of the reawakened ideality – the painters north of the Alps spread it out into a general

Fig. 12.72. Joachim Patinir, *Landscape with Saint Jerome* (c. 1516-17), oil on wood (detail). Madrid, Museo del Prado.

patination that effects all buildings. This patination represents a broader particularised picturesqueness of which antiquity alone is a special case.

Nonetheless, it was difficult for the Italians to restrict the ruin simply to emblem status. The ruins were too intrusive in the landscape for that. Over large areas of Italy, fragments of architecture and sculpture lay on or stuck out of the earth like unburied corpses. The ruin was, quite tangibly, the unburied dead, death stretched out indefinitely in time. In so saying, it also becomes clear just why the Renaissance was ultimately impossible to realise. In order for a rebirth to be able to generate an integrated resurrection, its subject must have been properly descended to the dead. But this is exactly what the new concept of ruin rendered impossible since it did not, as before, connote definitive death but, on the contrary, a death displaced by indeterminate past, i.e. a past whose vestiges extended into the present. Panofsky wrote: "The Middle Ages had left antiquity unburied and alternately galvanized and exorcized its corpse. The Renaissance stood weeping at its grave and tried to

resurrect its soul."[186] This characterisation is particularly correct if the range of the Middle Ages is extended up to modernity, the period that is aware of having abandoned antiquity to the past so that it features as a half-decomposed corpse. The characterisation also tallies well with the Renaissance, because the self-deception of the Renaissance is specifically to look upon antiquity as being so dead that it could be resuscitated. The Italians might do what they could to realise the Renaissance, but the ruin represents the futility of the project, not because antiquity was dead, but because it belonged only to the past.

Consequently, it also becomes clear why the ruin is by no means a 'Renaissance invention' inevitably requiring the Middle Ages as a fence over which to look. A significant reason for the great frequency with which the ruins can be identified as antique is simply that antiquity constituted the past par excellence, the time before the modernity of Christianity. In that sense, even Robert Campin's thatched stable becomes 'antique' inasmuch as it was presumably executed in the pagan period before the birth of Christ. Conversely, the reason that church architecture is only rarely seen to be crumbling in early modern images is not the theoretical unfeasibility of this decay, but that the church, by definition, represents the viable present.

When the ruin first appears in pictorial art, it is connected with negative feelings. It represents the underworld, the fallen paganism or Judaism, the transitoriness that takes over when the Good Government fails. Even in connection with the dawning appreciation of Roman culture in Petrarch, Giovanni Dondi, Giovanni Rucellai and others, the connotations are still negative: so sad is the decline of the grand classical culture. As Maria Fabricius Hansen has shown, it is not until a surprisingly late date that it becomes possible to demonstrate an unambiguous aesthetic appreciation of the ruin for its own sake, a nostalgic cult that emerges at the same time as the ruin's diffusion in the general landscape backgrounds.[187] Nevertheless, the ruin has to be seen as a coherent phenomenon within the modern paradigm. Its developmental process is strikingly reminiscent of that undertaken by the stormy sky: first a demonic phenomenon tied to specific themes and then later, around 1500, a positive entity creating atmosphere in the general landscape image. Neither ruin nor storm can be said to 'arise from' specific themes whence they then spread; rather, these themes are midwives for a motif that is pushed out by the most comprehensive forces conceivable in the paradigm, indeed in the epistemic *field*.

Despite the ruin's emblematic connection to the new paradigm, the concept of ruin as unburied corpse should also be taken quite literally. As we saw in chapter 1, it was a topos of classical theory to compare the building – a re-organised part of Mother Earth's body – with an organic body. Even Alberti often compares architecture with the bodies of humans and animals and talks of bone, flesh, muscles and nerves.[188] Manetti does the same in his biography of Brunelleschi: "a certain

arrangement of members and bones".[189] This line of thought logically leads to the ruin as body in decomposition. Pius II refers to a ruined gateway as "denuded of its marble". In the letter to Leo X, Rome's ruins are quite simply called "cadaver" and – in an actualisation of the archaic understanding of stone as the bones of Mother Earth – "the bones of the body without flesh". In a particularly evocative manner, in 1448 Poggio Bracciolini refers to Rome as being "stripped of all decency, as it lies overthrown on the earth as a rotting, gigantic corpse".[190] With this stripped and rotting appearance, the buildings are not only robbed of their external cladding; their identity could be said to be displaced from an antique to a Gothic sensibility. For just as the infinity and immeasurability of the ruins are characteristics of the Gothic style, so too is the case with their rawness and decay (cf. chapter 9).[191]

That Poggio even used the term "indecency" could be linked to the aforementioned fact that in pre-modern time it was considered a curse not to be buried. After Jezebel has been thrown down and trodden underfoot by her subjugator Jehu's horses, he decides that she should be buried, given that she is, after all, a king's daughter. All that remains, however, are her skull, feet and palms of her hands, which are therefore spread on the Jezreel field as manure, "So that no one can say, This is Jezebel."[192] Rome's punishment was that it ended up thus unburied. Ruins therefore crop up as a kind of visual manure for the landscape image, which also depicts the fields, the thoroughly crumbled stone. Ruins are consumed by the modern gaze, which in a nominalistic way lives from that which is fundamentally unidentifiable, objects in the process of being devoured by Cronos. It comes, therefore, as no surprise when, around 1398, Pier Paolo Vergerio the Elder reports that some people find the air in ruined Rome downright unhealthy.[193] These comments about air and putrefaction place the ruin in relation to the corroding atmosphere rendered visible by painting alongside the ruin itself. The air of weather-time is poisoned by the unburied dead.

The architecture as it was found in this horrendous decay would have to awaken ambivalent feelings. The body was what had been disowned throughout the Middle Ages, and here it appeared broken down as if it had been punished for hybris. At the same time, the somatic dimension occasioned intense fascination and a desire to reawaken it in the new contemporary culture, the Renaissance, not least as a protest against the Gothic 'incorporeality'. But the corporeality of the Renaissance – architectonic as well as pictorial – did not actually become more somatic than its Gothic equivalent, it merely became ideal, heroic and weighty. The apparent enormity of the blocks of stone from antiquity was therefore considered particularly impressive. Pius II refers to ancient walls with "square stone of an almost incomprehensible magnitude".[194] And according to Alberti, ancient peoples, especially the Etruscans, used "vast, squared stone for their walls [...]."[195]

The architectonic rock, then, can be seen as a borderline case of the ruin, a zone in which the work of nature has intervened to such an extent in the structure that it is impossible to determine how far it is a matter of art on its way to becoming nature, or nature being converted into art. In practice, it seems for the most part possible to distinguish between the authentic ruin and the idiosyncratic phenomenon of the architectonic rock, but, obviously, we can never be completely certain. And, at all events, the ruin – both in its visual mode of appearance and in the associations connected with its hybridity – constitutes an indispensable premise for the architectonic rock.

12.4 Latent images in nature

In relation to the interpretation of architectonic rock, the ruin signified an outward shift of forces: rather than understanding the hybrid features as being innate to the rock, they were seen to be the result of the impact of external forces, human-induced forms surrendered to weather and time. This simultaneously denotes an evolutionary inflection in the direction of modernity, inasmuch as nature is no longer seen as being allied to humankind's projects, but as being their unsighted destroyer. The topic of my final section, latent figurative images in nature's matter, expands these interpretative possibilities whilst simultaneously clarifying another stratum in the movement towards the modern era: artificiality not as a result of forces *out there* – internal or external natural forces around the object – but as determined by forces *in here*, viz. the beholder's own conception. In Peircean terms, attention hereby turns from the sign's *object* towards its *representamen* and *interpretant* – towards those ambiguous forms traced by the paint and the conceptual images these raise in the human *fantasia*.

This shift of fulcrum from architecture to sculpture and painting, and at the same time from external world to internal consciousness, inevitably invokes Hegel's aesthetics. The sequence architecture, sculpture, picture can be said, as does Hegel, to comprise a development towards decreasing materiality and increasing consciousness. Architecture encloses in the same way as the body of the earth, sculpture denotes a section of this body, and the picture regards the body from a distance. Having been inside, we step out into the open – the free reflection undertaken by self-consciousness. Having mainly looked at the innate architecture in the mountains of 15th-century paintings, we thus let the gaze glide towards the more 'exterior' art forms, sculpture and picture, since forms like these can lurk latently in the chaos of the landscape image, be it in the rocks, trees or clouds. By reflecting on these primarily human- and animal-like forms, we are approaching the question of the

make-up of image creation in early modernity. In this respect the clouds, the least material forms, are particularly eloquent, given that their transience in itself gives them kinship with modernity's fluctuating self-consciousness and its projections in painting (cf. chapter 11).

The pre-modern sacralisation of rocks or trees was due to a conception of them as possessed by *numen*. If this attribution was because the rock or tree looked like an animal or a human, then it is an understandable assumption that the likeness should be conceived as an identity. The natural form *was* the creature it resembled. The similarity was not a 'coincidence' from nature's side, and it existed before it was beheld. However, this is no longer the case when Leonardo sees landscapes and battle scenes on the stained wall. These apparitions stem from the beholder's *fantasia*, an imagination able to work precisely because the surroundings are so suitably form-less and chaotic that the inner visions can be projected out onto them. Despite the essentially modern character of these apparitions, they do have precursors in antiquity. Pliny, for example, cites the anecdote about Protogenes who only succeeds in making a lifelike depiction of the steaming breath of a dog when, in desperation, he throws a paint-soaked sponge at the picture.[196] For the classic artist, however, the formlessness of vapour is an extreme instance in the making of an image, a phenomenon that has to be depicted with just as extreme a medium, the sponge's index.[197]

But as the fulcrum of visual art is displaced from plastic to optic in modernity, this extremum is sucked from periphery to centre, from *parergon* to *ergon*. When Botticelli, according to Leonardo, revives Protogenes' trick and throws a multicoloured sponge at a wall, he is thus not just trying to make a lifelike representation of the close encounter of the steam, but the landscape in all its spatial abundance.[198] Leonardo might certainly censure Botticelli for his lack of finish, but, as Leonardo's own wall-stain-gazing bears out, there is actually the subtlest of distinctions between the totally amorphous paint smudge and the pinnacle of finicky illusionism, the landscape image (cf. chapter 9). Conversely, pre-modern cultures' inability to depict the landscape pictorially could be said to stem from the lack of an eye for amorphousness. They still consider the natural elements to be numinous and therefore circumscribed by their inherent corporeal, i.e. closed, forms.

Allowing anthropomorphic forms to appear in the chaos of the landscape image – a chaos that can first be depicted by means of the new illusionism – is thus, *inter alia*, to inscribe them in an evolutionary charged field: do they lie latently hidden within nature, or do they first occur – as puzzle pictures – when the painter's *fantasia* is projected out onto the surrounding environment?

The potential of the puzzle picture is so much the more urgent that in even the keenest illusionistic representation there will be parts that resist predetermined definition. One topos along these lines, a remembrance of chaos, is the multicoloured

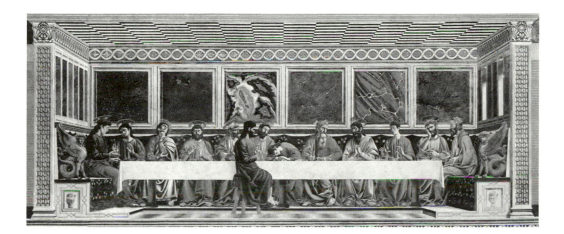

Fig. 12.73. Andrea del Castagno,
Last Supper (1447), fresco. Florence,
Sant'Apollonia, Cenacolo.

stone panel found on the walls in so many 14th-15th-century Italian paintings, including, as Didi-Huberman discusses, those by Fra Angelico.[199] It is only because the gigantic stone squares in Andrea del Castagno's *Last Supper* (1447; FIG. 12.73) are circumscribed by rectangular frames and, moreover, inserted in a well-defined pictorial space, that we can ascribe them significance in terms of form. Seen in isolation, they could almost be taken for abstract expressionism.

Images in stone, trees and clouds

The new illusionism's chaos repertoire of turbulent folds, gnarled trees, peeling walls, rugged rocks and hazy clouds would seem to comprise a whole meditative sphere for the genesis of forms. This repertoire reconstructs amorphous matter, which in its real version, especially stone, was also considered to be pregnant with forms. Until late in the 1700s, the princes' *Wunderkammern* were thus filled with precious stones and pieces of marble impregnated, by the mediation of demons, stars or chance, with images.[200]

Even though 15th-16th-century landscape images normally leave such apparitions to the beholder's imagination, now and then the visual pun is more explicit. In this the North Europeans' rocks are a particularly susceptible forum because they seem more turbulent and less angular than those of the Italians. Just to mention two examples of the most common latent form, concealed faces: in Dürer's

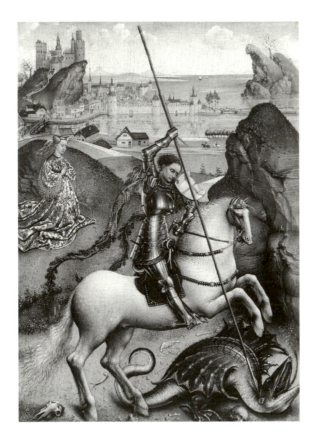

Fig. 12.74. Roger van der Weyden, *Saint George and the Dragon* (c. 1432-35), oil on panel. Washington, National Gallery of Art.

engraving, the *Penance of Saint John Chrysostom* (c. 1497), a male profile with a heavy jaw is concealed in the shaded left-hand side of the rock; in Roger van der Weyden's *Saint George and the Dragon* (c. 1432-35; FIG. 12.74) there is one, if not two, profiles in the rock section to the right of the horse's neck.[201]

Anthropomorphic rocks such as these would seem to be rarer in Italian art of the time. One example is Mantegna's *Adoration of the Magi* (c. 1462; FIG. 12.13) in which the left-hand corner above the nativity cave contains a skull-like mask, possibly an allusion to the death aspect of the cave.[202] Another, iconographically abundant, example is Cosmè Tura's *Annunciation* on the organ shutters from the cathedral in Ferrara (1469; FIG. 12.75). Among the architectonic rocks here, the massif behind the messenger Gabriel assumes a sphinx-like form, as if it were a half-finished version of the Great Sphinx of Giza. As Stephen Campbell has argued convincingly, the immediate iconography is presumably Hermetic.[203] Hermes Trismegistus, the Egyptian figure of legend associated with alchemy, astrology and Neoplatonism, experienced a vigorous revival in humanist circles of the 1460s when Marsilio Ficino translated

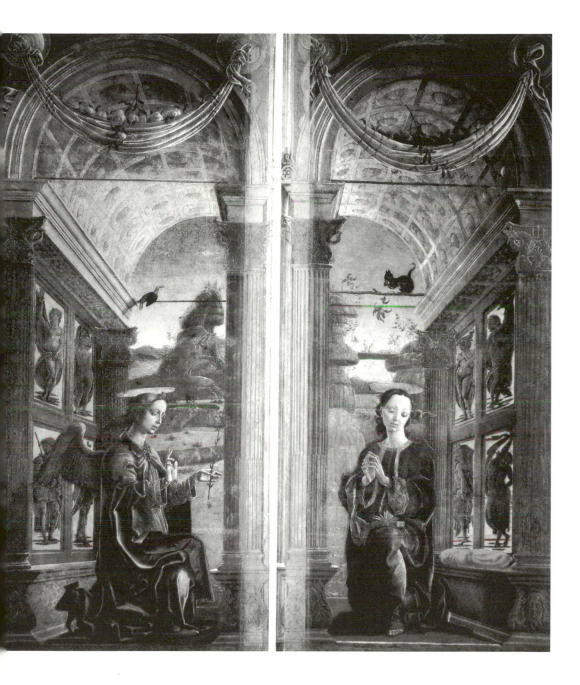

Fig. 12.75. Cosmè Tura, *Annunciation*
(1469), tempera on canvas, organ
shutters from the Cathedral of Ferrara.
Ferrara, Museo della Cattedrale.

the writings attributed to Hermes into Latin and circulated them under the title *Pimander* [*De potestate et sapientia Dei*]. His influence on the design of the sphinx-rock is due to the fact that Hermes, in the text *Asclepius*, states that the Egyptians invented the art of creating handmade gods at the same time as religion.[204] In *Della pittura* the Hermetically-influenced Alberti reworks this passage to make a general description of the origins of sculpture and painting.[205] The reason the origins are assigned specifically to the Great Sphinx of Giza is apparent from Pliny's description in which, besides the local population worshipping the sphinx as a deity, it is "fashioned from the native rock".[206] Tura's sphinx-mountain must thus be understood as this living rock, the shape of which has already been half-developed by the stone itself, and which consequently initiates the worship and creation of the deity. It is present in the *Annunciation* scene because Egypt often incarnated the pagan culture in its entirety, and Hermes Trismegistus, in the *Asclepius* passage mentioned, heralds the overthrow of Egypt.

The half-finished images of the stones also harmonise with Alberti's other ideas about the origins of sculpture. In the introduction to *De statua*, he states:

> Those [who were inclined to express and represent the bodies brought forth by nature] would at times observe in tree trunks, clumps of earth, or other objects of this sort certain outlines [*lineamenti*] which through some slight changes could be made to resemble a natural shape. They thereupon took thought and tried, by adding or taking away here and there, to render the resemblance complete.[207]

Michelangelo's later reference to "liberating" the figures that are "hidden" or "imprisoned" in the block of marble,[208] can therefore be read as a continuation of this notion of the pre-existence of forms in the matter.

As mentioned in my analysis of Mantegna's *Parnassus*, the stones were also assumed to hoard images of a more two-dimensional character. In his defence of painting in *Della pittura* (Book Two), just before he mentions Pyrrhus' gem and its innate images, Alberti states that "nature herself seems to take delight in painting, as when she depicts centaurs and the faces of bearded kings in cracked blocks of marble."[209] Alberti's sources include Pliny and Albertus Magnus, both of whom mention natural pictures in split marble of, respectively, a silen and a bearded king.[210]

As Maria Fabricius Hansen has pointed out, Camera degli Sposi might well also contain a reference to literature's discussion of natural images. In a simulated marble panel in the window recess to the right of the *Meeting*, the artist has inserted the date on which he began the fresco cycle, June 16 1465. With this graffito, which has an undulating and chaotic appearance like the coloured veins of the background and would therefore seem to indicate that the work was 'born' of the cloven marble

Fig. 12.76. Andrea Mantegna, *Trivulzio Madonna*
(1497), tempera on canvas. Milan, Castello
Sforzesco, Civico Museo d'Arte Antica.

on that very day, Mantegna surpasses Alberti, whose *Della pittura* is stated to have
been finished on July 17 1436. By being, so to speak, one day, one month and one
year ahead of Alberti, Mantegna suggests that the practice of art – 'born' as it is of
nature's matter – precedes its theory.[211] The word born must nonetheless be fur-
nished with modernist inverted commas because, like the *Parnassus* agate with its
innate pictures, the marble block itself is already imitated by art. Who gives birth
to whom? The awareness that it would take more than simply the forces of nature
to create art had already been corroborated by Cicero. For it might well be the case

that random images, for example of Pan in a block of marble, could be lifelike, but "we may be sure that it was not so perfect a reproduction as to lead one to imagine that it had been wrought by Scopas, for it goes without saying that perfection has never been achieved by accident."[212]

The other main forum for images created by nature, clouds in the sky, is charged with pictorial representations as it is. The icon marked the barrier between heaven and earth, and by means of cloud, mandorla and halo, the celestial bodies assumed material form. In the discussion of Carolingian miniatures in chapter 3, we also saw how the clouds could become the material of which entire landscapes were made. The extent to which this tradition is active in the 15th century can be seen from, for example, the mandorla in Mantegna's *Trivulzio Madonna* (1497; FIG. 12.76); here we see putto heads depicted in every phase from misty grey cloud to fully-formed pink flesh.

It is the same theme, just with a more self-referential twist, that we encountered in Signorelli's *School of Pan* (FIG. 11.60). Here the gradual clarification of the cloud forms not only signified their ingress into the earthly sphere, but also their encounter with the artist's craft and *fantasia*. The theme is presumably developed by Piero di Cosimo, whose gnarled primeval trees already look as if they are bearing anthropomorphic tendencies (FIG. 11.25). In the *Portrait of Simonetta Vespucci* (FIG. 11.24), the woman's likeness seems thus to be but the final crystallisation of forms pending in the white and black clouds around her. Indeed Vasari also verifies that Piero – just like Leonardo and Botticelli – found battles of horsemen, fantastical cities and gigantic landscapes in clouds and stained walls.

The cloud images, too, were phenomena that had been discussed since antiquity. Were they caused by chance, demonic forces, the influence of the heavens on matter, or the beholder's imagination? As late as the 13th century, Albertus Magnus quotes Avicenna for the following model: exhalations from the earth can, influenced by the stars, create perfect, albeit lifeless, animal bodies; such a calf-shaped form was even once reported to have fallen to earth.[213] Although antiquity had never developed a theory about imagination, the late antique Philostratus was, however, of the opinion that cloud pictures were not of divine origin, but were more likely created by humankind's instinct to make things credible – which in turn means that they are located in modernity's mutually dependent field of external accident and internal *fantasia*.[214] This proto-nominalistic stance was re-strengthened by 14th-century individualism, for in Poem 129 of the *Canzoniere*, Petrarch mentions how he finds his beloved Laura's face again, not just in a white cloud, but everywhere in the wilderness: in the clear water, on the green meadow, on a beech tree stump and again – particularly – in a rock, where "with all my mind I etch her lovely face". However, when "the truth" – not unlike Petrarch's aesthetic experience on Mont

Ventoux – "dispels that sweet mistake", Laura's identikit picture looks back with a kind of Gorgo gaze, and the poet finds himself sitting "cold as dead stone set on living rock [...]."²¹⁵ The cost paid by the artist for being able, like some kind of God or Pygmalion, to breathe life into the stone, is that he himself becomes petrified by modernity's disease of the genius: leaden melancholy.

Mantegna IV: Pallas Expelling the Vices from the Garden of Virtue

As was the case with the architectural forms' marking out of the rocks, the anthropomorphic outlines in the clouds are also afforded generous treatment in Mantegna. In the *Bearers of Trophies and Bullion* from the *Triumphs of Caesar* (*c.* 1484-92; FIG. 12.71), a cloud becomes a circular face (albeit re-traced with little sensitivity). In the topmost cloud in the Vienna version of the *Martyrdom of Saint Sebastian* (*c.* 1458-59; FIG. 12.69*a*), a small horseman comes into view. And in the clouds off the side of the mountain in *Pallas Expelling the Vices from the Garden of Virtue* (*c.* 1499-1502; FIG. 12.77), Mantegna's second painting for Isabella d'Este's *Studiolo*, we see the profiles of two, perhaps three, large male heads.²¹⁶

If we take a closer look at the *Pallas* clouds, it is no great leap to the assumption of an allusion to Albertus Magnus' ideas about earth exhalation, for Mantegna plays on the ambiguity of whether the clouds are *behind* the mountain or if they are actually exuding straight *from* it. Given that the painting is composed following the same structural principles as the *Parnassus*, this mountain seems to parallel Etna with its growing crystal formation. In *Pallas*, too, the mountain is in eruption. Above a greyish lower section, where a cave entrance can just be made out above the garden hedge, the mountain changes abruptly into light-brown and then, a little further up, it throws out a growing magma-like mass. This lava-like quality is pointed up by the black peak behind, which might suggest a crater. It is from this growing mass that the cloud is born, or, more exactly, *transformed*, for the line between rock and cloud is completely fuzzy.

This softening could play on the fact that seen towards the horizon a mountain will merge with the atmosphere, and that clouds per se can look like mountains. Not least the sight of the glittering sunset light in the painting brings to mind Leonardo's slightly later observation as recorded in the Codex Leicester (*c.* 1506-09):

> And lately over Milan towards Lago Maggiore I saw a cloud in the form of an immense mountain full of rifts of glowing light, because the rays of the sun, which was already close to the horizon and red, tinged the cloud with its own hue. And this cloud attracted to it all the little clouds that were near.²¹⁷

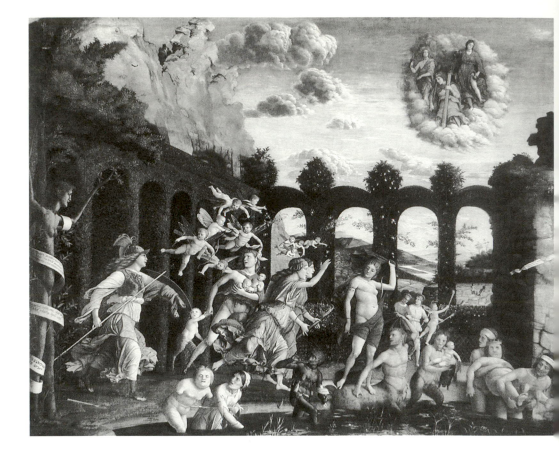

Fig. 12.77. Andrea Mantegna, *Pallas Expelling
the Vices from the Garden of Virtue* (*c.* 1499-1502),
tempera on canvas. Paris, Musée du Louvre.

This mountain aspect of clouds, and their delivery of faces, is a topic of discussion
as early as Lucretius:

> [Images] which formed in many ways are carried aloft and melting incessantly change
> their shapes and turn themselves into the outlines of all manner of figures: as we
> often see clouds quickly massing together on high and marring the serene face of
> the firmament, while they carress the air with their motion. For often giants' counte-
> nances appear to fly over and to draw their shadow afar, sometimes great mountains
> and rocks torn from the mountains to go before and to pass by the sun, after them
> some monster pulling and dragging other clouds.[218]

In fact, even the shadows left by the giants' countenances seem here to be directly translated into Mantegna's paint, and his fuzzy retinue of mountain-lava-cloud must refer to Lucretius' cloudy "rocks torn from the mountains".

Again we recall the stone cut out from the mountain without the aid of human hand, for the growing magma that goes on to be transformed into clouds could be interpreted on the same conceptual basis as its kindred crystal formations in *Madonna of the Stonecutters* and *Parnassus*. The faces in the clouds are thus to be perceived as painting's image generation, the free art produced when the artist's *fantasia* is transferred to nature's randomly generated forms. The clouds, with their buoyancy, pliability and changeability, and their capacity to capture all the colours of the rainbow, thereby become an image of painting's basic matter, the Damischian /cloud/ or smudge of paint that can be shaped and mixed and which is superior to sculpture's hard stone. The latter is presumably signified in the grey part of the rock where there is an opening, which could be a forge or a stonemason's cave as in the two other pictures. Again, then, a montage of hard, ruined antiquity and its soft, modern superstructure. The soft contour smoothing out the difference between rock and cloud could be perceived in particular as a comment on Mantegna's own late style, saturated as it is with sunset light and a milder atmosphere influenced by the new trends in Venice, advocated by his brother-in-law Giovanni Bellini. A farewell to the hard rocks and statuesque human figures.

This interpretation of the mountain seems to fit in beautifully with the rest of the iconography in the painting.[219] In accordance with Isabella d'Este's virtue-seeking ideology, the theme is closely related to that of *Parnassus*, albeit the scene is more conflict-ridden. As a consequence of the Vices' invasion of the Garden of Virtue, symbol of the human mind, lustful materiality has temporarily taken over. Chasteness, in the figure of Daphne, is petrified in an olive tree, Pallus Athene's sacred plant, while the four cardinal virtues are distributed between the sky and the square rock to the right. An inscription on a fluttering banderole intimates that the Mother of Virtue, *Prudentia* (Prudence), is imprisoned behind the brick wall.[220]

However, the painting depicts that hopeful moment when the trio of Justice, Strength and Moderation have again broken through a cloud mandorla in the sky, so that the whole crowd of monstrous Vices – cupids, Venus Impudica, a satyr carrying Cupid, a hermaphrodite monkey (wickedness), the stump-armed *Accidia* (sloth), etc. – have to take flight, some through the pond in the foreground. This expulsion fulfils a vision expressed by of Battista Spagnoli, one of Isabella's court poets. In the elegy *Contra impudice scribentes* we read: "All true poetry loves chastity. Helicon is a virgin: a virgin too is Peneian Daphne, and they say the daughters of the Castalian fount were sprung of a virgin mother. Depart, ye poets of Venus, from the river of Helicon: your mouth pollutes the virgin waters."[221] The vices in the pond can thus

be understood as the obscene poets' words, which sully Helicon's virginal waters. Similarly, the rock prison to the right is an inverted Parnassus, which entraps the free soul, *Prudentia*, rather than giving birth to the Castalian fount, river of the Muses. In the background mountain, on the other hand, pure poetic creation rises again as an echo – in terms of composition as well as iconography – of Pallas' conduct.

Mantegna V: the Martyrdom of Saint Sebastian *in Vienna*

The issue of the origins of art is also raised by the cloud horseman at the top of Mantegna's *Martyrdom of Saint Sebastian* (*c.* 1458-59; FIGS. 12.69 and 12.69A). Sebastian was the patron saint of plague victims – the plague had been associated with arrows since antiquity[222] – and in 1456-57 Padua had been ravaged by the plague.[223] It would seem likely that the painting plays on this epidemic at a number of levels because, although we know nothing about who commissioned it, Mantegna himself both suffered from and survived the plague.

The cloud horseman is thus presumably an allusion to Saturn, the instigator and conciliator of the plague, for, as we saw in chapter 11, Saturn was the clouded star, in Boccaccio's words a "cloud-enveloped sight".[224] The cloud picture's more precise representation of a horse and rider is partly due to the legend of Saturn changing into a horse when he was paying court to Philyra and thus fearful of Rhea's jealousy.[225] In addition, Gregory the Great makes a relevant comment apropos Isaiah's Prophecy about the fall of Babylon. In the Book of Isaiah, Babylon dreams of storming heaven and ascending "above the heights of the clouds, [...] like the Most High", but the "Day Star, son of Dawn" is going to be overthrown.[226] Gregory juxtaposes this fall – somewhat cryptically – with Job's remark about the ostrich who blithely rushes away when the gamekeeper arrives: "she laughs at the horse and his rider".[227] This ostrich laughter makes mockery of the rider's arrogance, and thus in a wider sense this becomes an allegory of the world that disappears into vapour during the flight of time.[228] That the cloud picture only shows the front part of the horse bears out Gregory's influence on Mantegna, for according to Gregory, the vanished hindquarters of the horse, being in the act of falling backwards, should be understood as sudden death and ignorance about the torments which life deals out to the individual. These torments could readily be interpreted as the plague.

To distil a more coherent interpretation from this somewhat cryptic line of thought: Babylon, who ascends to the clouds only to be destroyed during the rushing flight of time – Cronus-Saturn, who consumes his children – must of course be compared with Rome, among whose ruins Sebastian is placed.[229] Time – Raphael's "gouging file and poisonous bite" – devours Rome's proud edifices and sculptures just as thoroughly as it wears down the cloud picture, and could it be that it also

(viz. the metaphor intersection of Saturn-plague/plague-arrow) pierces Sebastian's – and in an identification with this: the plague-ridden Mantegna's – body? As Andreas Hauser has pointed out, however, the architectonic decomposition is concentrated on Sebastian's right side – the domain towards which his uplifted eyes are also directed – whereas the decoration to his left is relatively intact. Hence a two-part landscape is again constructed, one part being the Christian era, whose eroding weather surmounts the proud architecture of the other part, antiquity (whose spandrel's Victoria sculpture is thus only provisionally exultant).[230] Saturn's work is thus no more destructive than it is also good for something, and in a further meta-comment to painting's modus operandi, the cloud image could in fact also be seen as the result of the recurring artist infliction – and one Mantegna was known to have suffered – Saturnal melancholy. The poisoned weather-time, which rises like steam from ancient Rome after it has ruined its hard art forms of architecture and sculpture – the clouds seem again to be almost smoking from the ruins' brick sections via the sprouting grass – is consequently so opportunely chaotic that it allows the softer art form of painting to take over. As the flexible paint mass reacts to the chaos of the clouds, it becomes receptive for visions from the artist's *invenzioni*, here, as was the case with Petrarch, governed by his melancholy temperament. If it is a fact that time consumes its own offspring, this offspring is nevertheless retained in painting, the frozen time which, via its flexibility and higher degree of spirituality, Christianity's revenue, is superior to the fragile ancient stones.[231]

The Gorgo gaze of the Po Plain: stone guests in 15th-century painting

As a final point, it would be quite apposite to turn my analytical gaze from the landscape image and into the figures that inhabit it. For during the culmination of the rock landscape in 15th-century Italian art, it is a disturbing fact that not only nature but also the human body is infected by stone.

Although rocks are ubiquitous in late Italian 15th-century painting, and everywhere might be marked by architectonic and organic features, the stone *fantasias* must nonetheless be said to culminate within a specific area and a specific generation. The area is the eastern Po Plain, from Venice across Padua and on to Ferrara, Mantua and Bologna. And the generation is that of the painters born around 1430: Mantegna (1431), Tura (*c.* 1430), Cossa (1435/36), Zoppo (1433), Crivelli (*c.* 1430/35) and also, as far as the early phase is concerned, Bellini (1431). The quantity of fantastic rocks in the works of these artists seems to be almost inversely proportional to the flatness of the terrain across which they looked.

In fact, they do not restrict the stone to the setting, for the figures within it are

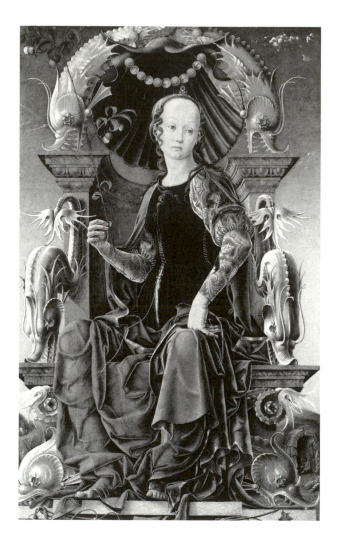

Fig. 12.78. Cosmè Tura, *A Muse (Calliope?)* (*c.* 1455-60), tempera and oil on wood. London, National Gallery.

also strangely petrified, as if the rocks have entered an equilibrium of sorts with the living creatures: while the rock is characterised by an inner vitality, the bodies seem to be encapsulated in stone or metal. The artistic gaze is that of the Late Gothic style with its sharp definition of material particularity, but here it functions as a Gorgo gaze before which everything, in being perceived, turns to stone. Crivelli's hyperrealistic figures would make a metallic clang if struck on their shiny surfaces. And although the fabric around Tura's London *Muse* (*c.* 1455-60; FIG. 12.78) drapes in an absurd number of folds, these folds do not divest the figure of its essentially petrified quality, as if it were made of the same precious stones and metals that make up the throne with its prickly, vaginal dolphins. The painful, idiosyncratic sensation

emanated by so many of Tura's figures could thus be seen as the convulsive battle of the soul against its hard mortal frame.

This petrified characteristic can no more be regarded as simply the product of reception by a posterity than can the rocks' fantastical quality. Francesco Squarcione, Mantegna's Paduan teacher, was struck by this when he saw his former pupil's frescoes in the Ovetari Chapel of the Church of the Eremitani (decorated 1448-57, almost totally destroyed in 1944). In Vasari's retelling, 1568, derived from a 15th-century source, we read:

> Hearing this [i.e. that Jacopo Bellini, his rival, had forged an association with Mantegna by, in 1453, giving him his daughter's hand in marriage], Squarcione fell into such disdain against Andrea that they were enemies ever afterwards; and in proportion as Squarcione had formerly been ever praising the works of Andrea, so from that day onward did he ever decry them in public. Above all did he censure without reserve the pictures that Andrea had made in the said Chapel of S. Cristofano, saying that they were worthless, because in making them he had imitated the ancient works in marble, from which it is not possible to learn painting perfectly, for the reason that stone is ever from its very essence hard, and never has that tender softness that is found in flesh and in things of nature, which are pliant and move in various ways; adding that Andrea would have made those figures much better, and that they would have been more perfect, if he had given them the colour of marble and not such a quantity of colours, because his pictures resembled not living figures but ancient statues of marble or other suchlike things.[232]

However much Squarcione's criticism might have been fuelled by resentment, it is essentially precise. Mantegna paints statues, not living human beings. But is this simply due to flaw, an unthinking imitation of those hard ancient works which Squarcione had, incidentally, let him copy in paint at his school? The style employed by the Ferrarese and Crivelli has often been called mannerism, and this is exactly how the petrifying manner of painting should be read: a play on style.

This stylistic game deals with modernity's first conflict-ridden encounter with the Renaissance. Flat Northern Italy was the centre of the Late Gothic hypernaturalistic style focussing on wealth of detail, texture and temporal signs. It was here that Giovannino dei Grassi, Gentile da Fabriano, Pisanello and Jacopo Bellini worked and thrived. How was the Renaissance, with its emphasis on the ideal, the closed form and the timeless, meant to take root here? The statue-like aspect could be seen as a self-aware response to the artificiality of the project. Rather than penetrating the principles behind the classical style and recreating them convincingly, the artists focussed on the external, on sculpture, because by the chance of time this constituted

the one medium in which the ancient pictorial art survived prior to the excavation in the 1490s of Nero's Domus Aurea. The statues represent the corporeality which modernity lacks, but through their literal reproduction the flesh is petrified and the project exposed as a construction.

When the figures are converted into statues, they are, moreover, of one piece with another rudiment from the past: the selfsame rock landscape in which they are set, and from which the stone and the metal that makes up their bodies is derived. The rocks incarnate the pre-modern landscape image, the material underground, which prevents the landscape from being at an infinite distance from a correspondingly self-conscious beholder. Along with the statuesque bodies, they draw attention to the actual weighty substance of which things are made.

Florence was already too idealising for this kind of self-ironic strategy, and north of the Alps the artistic culture was too naturalistically-minded and still too far removed from Renaissance pressure for it to be implemented. The petrifying mannerism required a head-on clash between Late Gothic nominalism and dawning Renaissance, and there was only one area that had the necessary conditions for this collision, the eastern Po Plain in the second half of the 15th century.

When looking for the more specific roots of this vision, we should not expect to find an 'inventor' who then went on to 'disperse' it. At most it is possible to pin down a milieu in which the abovementioned temporal forces wrestled with particular vigour, so that the style reached a marked degree of maturity. This milieu is the axis between Padua and Venice in the years around 1450. The central figure would have to be Mantegna, for besides the fact that he has to be considered the most prominent artist personality of the time, he had links to Venice and from 1447 also to the Bellini family, and it is known that in 1449 he was in Ferrara.[233] Ironically, a Paduan node was to be found in the very man who had scornfully put the petrified style into words, this being the hyper-ambitious Francesco Squarcione, in whose school Mantegna and Zoppo are documented as having been pupils (1441/2-48 and 1442-55, respectively), and where, due to stylistic common denominators such as fruit garlands, it is assumed that Tura and Crivelli possibly also studied.[234] Discussion continues as to whether such a weak painter as Squarcione can have borne any responsibility for his pupils' innovations, but, via his collection of drawings, medals, statues, reliefs and casts, he certainly introduced them to both the art of antiquity and the Florentine avant-garde art. Considering the dominance of the sculptural media in Squarcione's studio, it is not improbable that they actually acted as a catalyst to the development of the petrified style.

Given that Paduan mannerism unites nominalistic observation with conscious artificiality, we also have to ask if the artists might have been influenced by the milieu around the University of Padua, the stronghold of Aristotelianism in the 15th

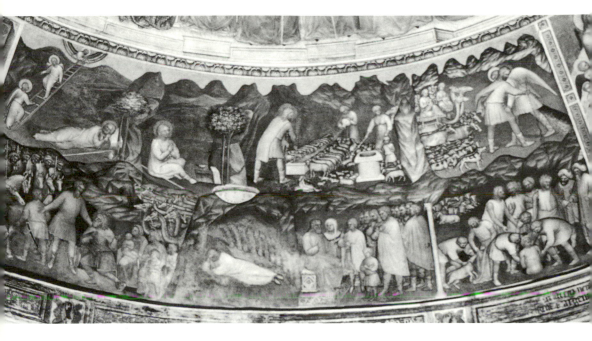

Fig. 12.79. Giusto de' Menabuoi, *Stories of Jacob*
(late 1370s), fresco. Padua, Baptistry, tambour.

century.[235] In Padua, humanism was apparently closer to Aristotelian scholasticism
than it was elsewhere in Italy.[236] In view of the Aristotelian thought pertaining to
the architectonic rocks, it is certainly interesting to see that the issue of the pro-
duction of a house is among the topics discussed by Gaetano de' Thiene, professor
in philosophy 1429-65 at the Paduan university, in his commentary on Aristotle's
Physics (1439). Gaetano, however, sees the production of a house as a mixed business.
The purpose of the materials is not necessarily the building, which is primarily the
work of the architect.[237] So, again, in the midst of Aristotelianism: an anti-idealistic,
nominalistic viewpoint. However that may be, Paduan fascination with rocks can
be traced back to the 14th-century painters Altichiero and Giusto de' Menabuoi. In
the latter's decoration of the Baptistry of the Cathedral (late 1370s; **FIG. 12.79**), many
of the drummer's scenes are separated by rock embankments so that the entirety
would seem to be taking place in a gigantic nature-architectonic complex.

Mantegna's Copenhagen *Christ as the Suffering Redeemer* with its montage of
marble body and fleshy face is, as intimated, emblematic of the whole issue. In a
single image, and triggered by a specific iconography, Mantegna impeccably pins
down the attempt to resuscitate the ruined foundation of antiquity by supplying

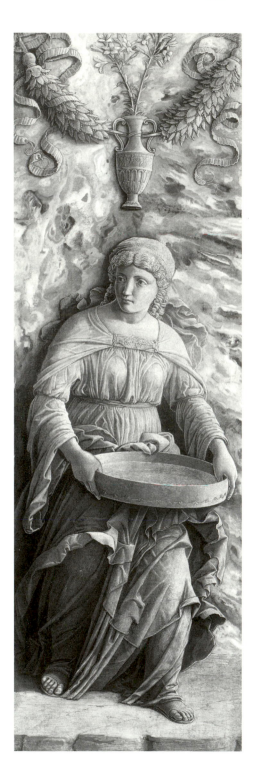

Fig. 12.80. Andrea Mantegna,
The Vestal Virgin Tuccia with a Sieve
(1505-06), tempera on wood.
London, National Gallery.

it with a superstructure of painted frail flesh. An even more sharply-defined illustration can be seen in his *trompe l'oeil* reliefs from the 1490s, presumably installed in Isabella's *Studiolo* (FIG. 12.80). Here Mantegna has, doubtless with subtle irony, realised Squarcione's proposal vis-à-vis replacing the flesh- and cloth-colours of reality with those of the statue: the paintings depict, in the most literal sense, the relief figures in grey marble or gilt bronze placed against some of the aforementioned square panels of amorphous, multicoloured stone. If we are not dealing with a case of random images in split blocks of stone, at least the origin of the carved image in the heart of the earth is underscored.

But, to make a link from here to the Po-artists' paintings in general, it was of course not a question of imitating the ancient statues with archeological accuracy and then transferring them precisely to painting. The statuesque aspect related to the fundamental issue of creating a renaissance art, an art based on the body. *Rilievo* (relief) is one of the qualities on which the Renaissance was judged, and in the works of these artists it was realised tangibly. Perhaps it was the consciousness of the problems of this realisation that led them eventually to shift the focus from the surface of the relief to the very act of painting that captured it. The atmosphere emanating from the *Pallas* picture's mountain carries over into the painterly style, which it was to be the assignment of Venice and Northern Europe to cultivate. The rock is milled to pigment, which is applied with wet strokes – by means of which the modern paradigm may overcome the Renaissance.

Conclusion

Following the final submersion in 15th-century rock iconology and its condensation
in various iconographies, it is time to assess the avenues forging the route to that
locale and to the modern paradigm in general. At this juncture, where we will thus
again pull the vantage point back to the bird's-eye perspectival view and allow the
gaze to pan from modernity's delta back along the forked river with which, despite
the erosion of postmodernity, large tracts of history can still be compared, I will con-
centrate on the following recognitions vis-à-vis the evolution of the landscape image
and its tripartite developmental contexts: self-consciousness, socially-determined
perception of nature and world picture.

Firstly, I should reiterate that the central thesis linking the various subject
areas of this project and opening up for its evolutionary dimension, comprises the
following observations: that the spatial depth of the Western image, what I have
with a photographic metaphor termed its depth of field, expands step-by-step over
the course of time in tandem with a clarification of its vantage point. From the
transparent Palaeolithic clusters of fragmented animals with no other setting than
the bare rock wall, we move across the more coordinated Neolithic accumulations
of figures and on to the Egyptian framed near space on now artificial ground, the
later Mesopotamian landscape backgrounds, the quasi-perspectival architectural
and landscape space of classical antiquity, and the deconstructed but brilliant ce-
lestial space of the Middle Ages, finally arriving at the fully-developed perspective of
modernity, where the subjective vantage point provides a view across surroundings
diminishing towards the infinite distance – surroundings which are gradually able
to dispense with the human figure altogether. The depth of field's expansion, and
inclusion of more and more surroundings along this historical route, is particularly
perceptible in the landscape image, for also the backgrounds of the landscapes are
incorporated in a sequence from close to distant: first the earth formations (Meso-
potamia), then the sky (antiquity) and finally infinity (modernity).

This development, which thus implies a constantly increasing depth of field and
a correspondingly clarified vantage point up until the Western 19th century, after

which it disintegrates in the polyfocal space of postmodernity, exhibits such a high level of regularity and directional impetus that I have no hesitation in characterising it as 'evolution'. This term has, certainly, long been unwelcome within the sphere of the humanities which, cautioned in particular by 20th-century totalitarianisms, has disputed evolutionism and consequently carved up cultures and historical epochs into an archipelago of autonomous parts that can only be linked via differences. But of what use is this line of thought in explaining empirical facts that do not pursue a chronology of disconnected fragments (for example, a full perspective in the Palaeolithic period, a framed near space in the Neolithic period, a quasi-perspective in Mesopotamia, transparent animal clusters in modernity, etc.), but, on the contrary, a developmental logic that is quite apparent even before we have considered by which theory it can be processed? In this I would assume that the anti-linear thought is actually relevant to post-1900 cultural experience, but has overlooked the fact that this experience has occurred precisely because an earlier evolutionary historical sequence has reached saturation point and is in the process of bursting and re-coordinating in a new hyper-dynamic state, that of postmodernity.

The evolutionary concept has all the stronger entitlement to the role of explanatory model inasmuch as the expansion of depth of field constitutes but the most conspicuous of a series of characteristics within the development of the landscape image which prove to have a morphological and content correlation with a number of models pertaining to cultural evolution devised at an earlier date – not just within the spatially-oriented parts of older art history (Riegl, Panofsky), but also within the areas of consciousness modelling (child psychology and philosophy of aesthetics), cosmology (Jungian history of religion and history of science) and, the most comprehensive, sociology (the Marxist tradition). In order to give these morphologic correspondences methodical justification and demonstrate that they are indicative of actually interacting cultural phenomena – and thus prevent them from simply appearing to be 'analogies' between otherwise separate cultural domains – I turn to a number of options within structuralist theory. Via the idea of definable societal stages, sociological evolutionism already operates with a notion that at a given time various cultural domains are subject to a common horizon of experience (as in Talcott Parsons and Jürgen Habermas); and this notion is fine-tuned synchronically by Pierre Bourdieu, who introduces the idea of *field* – a system of social forces that determine all cultural actions – and, moreover, influenced by Foucault's notion of *episteme* and Panofsky's of *mental habits* and *symbolic forms*, formalises the idea of homologies between different cultural domains. My analysis amalgamates these ideas with Thomas Kuhn's concept of *paradigm*, here understood as the mere set of rules demarcating the surface of the *field*, and also with my own Foucault-influenced notion of *epistemic field*, an overarching *field* binding together culture's

many sub-*fields*. Furthermore, I dynamise the *fields* by merging them with Oswald Spengler's theory of the cyclical sequence of cultures, so that cultural evolution is seen as a chain of cyclically waxing and waning *epistemic fields* while it is also, looked at overall, characterised by escalating self-consciousness, expanding world pictures and increasing urbanisation.

That this structuralist methodology has proved to be particularly useful in the interpretation of landscape images is because landscape constitutes an area of the image where significance is thinned out and breaks away from that theme which is often the justification of the image: the iconography. Expressed in terms of linguistics, the significance is not bound to the individual utterance, but rather to the language – what I here call the paradigm – by means of which this utterance is articulated, a level of interpretation which I additionally associate with Panofsky's iconology. Even though this does not necessarily mean that landscapes are always devoid of iconographic characteristics, without a mediatory agency it is not possible to short-circuit from iconography to paradigm and iconology, as it is more a question of using comparative studies to examine the extent to which a given landscape iconography can be taken for condensation (intensifying) or pocket (transversing) in the enveloping paradigm. The iconological interpretation of a given paradigm can thus be pinned down from two angles: a worm's-eye perspective comparing the various iconographies into which the paradigm can be condensed, and a bird's-eye perspective which, by means of a comparison with homologous paradigms and their corresponding *fields* in other cultural domains, surveys a horizon of experience.

It is through familiarity with the inter-cultural correlations and their system-atism in the dynamised theory of *fields* that I have developed the tripartite context model in which evolutionist theories are structured in accordance with the key poles encountered as we wander through a landscape space, and through which different aspects of the cultural-evolutionary significance of the landscape image are thus revealed: [1] the pole of vantage point: *self-consciousness*; [2] the middle distance: the *socially-determined perception of nature*; and [3] the pole of remoteness: the *cosmological world picture*. That the idea of the pole of vantage point may reveal a morphologi-cal correspondence between the specification of vantage point in pictorial art and self-consciousness in general is immediately evident from the realisation that a certain degree of self-reflection is needed in order to signal whence an image is viewed, and that a greater degree of self-reflection facilitates a clearer indication of the viewing position. Several disciplines have indeed fostered the theory that human self-consciousness increases over the course of history, at the same time as a number of these disciplines are correlated with evolutionist art theories in which the development of perspective plays a major or minor role. This is the case with the first major synthesising theory of the evolution of consciousness, that

formulated by Hegel, where consciousness alias spirit becomes independent while it is drawing back from the pictorial media through which it manifests itself, from the symbolic architecture (matter's dominion over spirit), to classical sculpture (matter as expression of spirit) and on to the romantic painting (spirit reflected in matter). The same approach, only now without the consciousness-philosophical ballast, is given a visually sophisticated form by Alois Riegl in the movement from haptic near sight (Egypt) to haptic-optic normal sight (classical antiquity) and on to optic distant sight (Middle Ages and modernity).

From my own studies, I can corroborate the fundamental effectiveness of both these theories, particularly their recognition of antiquity's focus on the plastic ideal body which, besides being substantiated via Spengler's homologies between antique art and mathematics, is also found in, for example, Aristotle's centripetal poetics, Plato's aversion to perspective controlled by vantage point, and the antique image's supra-temporal landscape space and resistance to panoramic pictorial space devoid of figures. As regards Hegel's romantic painting and Riegl's optical distant sight as guiding visual manifestations of post-antique culture, these connections are substantiated by the disintegration of corporeality in the medieval pictorial space, especially as analysed by Panofsky, and also by the perspectival paradigm between 1420 and 1900 in which the optical eyesight configures image making and arranges it according to the subjective vantage point. That the perspectival paradigm is morphologically related to a now independent self-consciousness can be illuminated in terms of cultural history by means of a comparison with the emergence of nominalism. In this movement, which has roots in the late medieval period but gradually develops into a unifying epistemology of modernity, a distinction is made between the infinite world and the mental representations that consciousness makes of it, a distinction which both characterises the subjective (aesthetic) and the objective (scientific) dealings with the world, at the same time as the individual psyche is perceived as being unique (*individuum*). Nominalism thrives, moreover, in the same North European cultural sphere as the Gothic visual style with its emphasis of the openness of the cosmos and architectural profiling of the subject's vantage point against the celestial remoteness of the pointed arches, anticipating the perspectival vanishing point. The nominalist-Gothic cultural sphere also fosters a particularly landscape-oriented painting, which renders visible distant views, a multiplicity of details and the changeability of time, and which, around 1500, opens up for a developmental branch, the autonomous landscape picture, making independent sections of what had previously been panoramic landscape backgrounds. It is logical that against this backdrop the Renaissance, the conscious revival of antique cultural values, would seem in part to be a regressive countercurrent in modernity's epistemic *field*, a resuscitation of Riegl's normal sight, inasmuch as this particularly

Italocentric movement tones down the dominance of setting and changeability in favour of focus on an idealised and plastic human body. This Renaissance resistance to sanction of a landscape image totally devoid of figures is also characteristic of a general law pertaining to the relationship figure/landscape image in that the landscape loses its figure-compensatory *numen*, the original immanent force of nature, in tandem with the expansion of depth of field, and for this reason it will only expand without figures in relatively secular contexts. Hence, when we come across pre-modern landscape images devoid of figures, they are either part of a pre-antique paradigm with low depth of field or else, if the potential depth of field is higher, as is often the case in antiquity, they only exhibit a low actual depth of field – i.e. the view is blocked by thicket or rocks.

Another significant theoretical tradition to reveal the connection between pictorial culture's increased depth of field and the evolution of self-consciousness is the one delimited by Piaget's original ontogenetic model. Piaget's studies of the child's psychological development find that physical and social interaction with the surrounding world leads the child to develop a consciousness in which earlier physical experiences are converted gradually in interiorised representations, from the sensorimotor and preoperational stages to the concrete and formal operational stages. Furthermore, Piaget establishes that this autonomization of consciousness leaves its mark in the child's spatial representations, moving from a topological space, a fragmented and haptic near space characterised by basic elements such as proximity, separation, sequence, enclosure and continuity, to a more abstract space independent of the body, the Euclidian, which is less robust in terms of deformations, but on the other hand is sensitive to distances, curves and angles. As a sub-area, moreover, the Euclidian space contains the projective space which subordinates the representation to the subjective viewpoint, the manifestation of self-consciousness. As first Suzi Gablik and since, and in more detail, Sidney J. Blatt and Lars Marcussen have pointed out, Piaget's thinking can profitably be applied to the phylogenetic development, which displays the same overall tendencies, from the Neolithic period's additive clusters of figures as manifestation of a fully-developed topological space and a preoperational consciousness to modernity's perspective as manifestation of a Euclidian space and a formal operational consciousness (albeit both Gablik and Blatt, mistakenly, shift the Euclidian space to the 20th-century's abstractions).

In my own studies I combine Piaget's stages with the stages of the expanding depth of field, and find additional support in Parsons' and Habermas' social-evolutionary models, of which the latter in itself depends on a phylogenetic, sociological translation of Piaget's ontogenetic models. Parsons' primitive stage (Palaeolithic, Piaget's sensorimotor + preoperational) is thus characterised by additive clusters of

separate figures; his advanced primitive (Neolithic, Piaget's preoperational) by clusters of co-ordinated figures; his archaic intermediate (Egypt, Mesopotamia, Piaget's preoperational + concrete operational) by framed figures in near space, possibly with the beginnings of backgrounds; his advanced intermediate (antiquity, Piaget's concrete operational) by a quasi-perspective; his feudal (Middle Ages, still Piaget's concrete operational) by a deconstructed quasi-perspective with pronounced skies; his modern (Piaget's formal operational) by perspective. Furthermore, a survey of non-Western cultures shows that the space-representational evolution from low to greater depth of field and from a topological to a more projective space is apparently a universal phenomenon, which can again be linked with the evolutionary social stages of sociology from hunter-gatherers and slash-and-burn method users (unframed clusters of figures; for example, the indigenous populations of Europe and Australia), to theocratic city states (framed images with earth formations but no landscape backgrounds; for example Egypt and pre-Columbian America) and on to civilisations with a quasi-autonomous class of intellectuals (projective space with backgrounds; for example, Western antiquity and China). Ultimately, via consideration of the development of children's drawings in the West, I demonstrate that the connection ontogenesis-phylogenesis can also be established on a tangible design level. In order to make this seemingly rather peculiar – and extremely politically incorrect – connection understandable on something other than a purely empirical level, I bring in biological evolution where the embryo's development displays a similar correspondence between onto- and phylogenesis, thereby suggesting a general modus operandi for evolutionary systems.

If we now move on through the theoretical landscape and jump from [1] the pole of vantage point, *self-consciousness*, to [3] the pole of remoteness, the *cosmological world picture*, I should again underline the close connection between these two poles. In the same way as the remoteness in an image is only meaningful in relation to the vantage point against which it is set, the cosmological world picture is inextricably woven together with the 'I' inhabiting its centre. It is here that we enlarge the account of the formation of self-consciousness along gender lines, more precisely its entrenchment in psychoanalysis, inasmuch as the Jungian historian of religion Erich Neumann and his feminist-oriented successors Anne Baring and Jules Cashford have envisioned the first phases of cosmological development as a macroscopic version of Freud's account of the genesis of self-consciousness, from the non-differential fusion with the mother to the Oedipus complex's separation via identification with the father. Thus, the Jungian story of the incipient embedding of consciousness in the self's – in the opening phase, at least – masculine husk means that the cosmos has correspondingly been conceived as a gigantic body, the head of which, alias the masculine heavens, has gradually made itself independent

of its torso, alias the feminine earth. The incipient expansion of depth of field can therefore be perceived as evidence of this gradual division in which the heavens, the extension of the self, become disengaged from the earth's cyclical and self-fertilising embrace, instead to become an indestructible power that fertilises the now chaotic and passive matter. By this means, the non-framed and additive clusters of figures in the Palaeolithic and Neolithic periods correspond with a predominantly feminine and self-fertilising cosmos, whereas the framed images from the Egyptian near space to the quasi-perspective of antiquity are equivalent to a cosmological development in which the celestial powers increasingly take over and ultimately become the animating prototype for the earth's passive matrix. Antiquity's opening towards a quasi-perspective can be linked, in particular, with the new perception of the earth as round rather than, as earlier, flat, whilst the quasi-perspective is nevertheless controlled by a focus on the closed body, a centripetality which cosmologically finds structural equivalence in Aristotle's closed world picture and geographically in *oikoumene* (the inhabited earth, Eurasia) as the only accessible area. As regards the medieval 'deconstruction' and flattening out of perspective, I perceive it as structurally equivalent to the antique firmament now being burst into a new infinity, yet one that is concurrently the preserve of God, for which reason infinity's sensory manifestation – perspective – must logically be drained from the image.

This cosmological development is not only traceable in the *how* of the pictorial space – the way in which it is constructed – it is also rendered tangible in its *what*, the actual materiality in which its landscapes are clad. In this manner, the first stable remoteness encountered by the depth of field in its expansion is made up of earth formations charged with testimony to the material otherness from which the self must necessarily be delimited in order to see into the depth. I am here referring to the virgin rocks and mountains that characterise the landscape grounds all the way from Mesopotamia to the Late Middle Ages. These stone masses and their numerous caves allude to Mother Earth and her oral, vaginal and anal bodily orifices, and they are therefore laced in all the ambivalence of fecundity and demonism that continues to affect the earth goddess. In a kindred imagery, the rocks could be compared with the first material condensation of *chora*, the maternal primordial container in Plato's *Timaeus*, which Kristeva couples ontogenetically with the child's pre-conscious symbiosis with the mother, and they are broadly representative of *terra*, the uncultivated earth at the bottom of that cosmos which gradually becomes hierarchical. If the significance of the rocks is here clarified in a vertical respect, in the field of suspense between formative heaven and chaotic matter, it can also be approached in a horizontal respect, in the field of suspense between civilisation and wilderness, by which means, then, the cosmological angle [3] is supplemented with that of the middle distance, the socially-determined perception of nature [2].

As apparent from, for example, the Dionysus cult's affiliation to both the land and the underworld, pre-modern cultures had particularly fluid boundaries between concepts of wilderness and underworld, just like Dionysus's schizophrenic transformation into Christ and the Devil is in turn symptomatic of the ambivalence of these terrains. Besides being the province of barbarians, the mountainous country also represented unspoilt nature, ultimately Paradise and the realm of the Golden Age.

This complex significance, then, is embedded in the paradigmatic level of the rocks and can be further illuminated via iconographic condensations such as hell, the fallen angels, the *Thebaïd*, Saint John the Baptist wandering in the wilderness and the birth of Christ. Another level of meaning, where the pictorial rocks reveal their qualities, is in the very way in which they are made. Fluctuating and fluid traits in the Western High Middle Ages indicate affiliation to the primordial chaos as displayed in *chora*, and, similarly, terraces, abyss effects and rugged cave edges in the Byzantine sphere point to the gaping, labyrinthine underworld of *abyssus* and *chaos* and also allude to hierogamy and earthquakes – a chthonic identity that additionally characterises the many representations of cave-like water reservoirs. However, by means of their likeness to dripstone formations in caves, the terraced rocks also seem to be growing, and they thereby form part of a widespread tendency, going as far back as at least Minoan-Mycenaean culture, in which rock images allude to ideas of a living earth where even the minerals and metals are born of the subterranean womb – a tendency bolstered by the pre-modern idea of life on earth as a life lived on the bottom of a cave and with celestial seeds as form-initiators. Even though the idea of mineral life thrives among more rational 'geochemical' or 'mechanical' explanatory regimes, this belief in a lithic biology is widespread in pre-modern times and is outspoken in, *inter alia*, classical Roman literature.

While the exposure of rocks in the pictorial depth of field bears testimony to cosmology's most archaic cast member, Mother Earth, the visual depiction of the still more remote reality, the sky, ushers in victory for its rival, an indestructible and eventually infinite divine sphere which, at the same time as it forces its way into the pictorial backgrounds, is initially only revealed in symbolic form, be it in the neutral colours of antiquity or the sparkling planes, strips or patterns of the Middle Ages. Unless requiring a particular iconography – for example, a deity revealed in the earthly-celestial transitional medium of the cloud – the skies from antiquity to the Middle Ages thus bear no trace of optically recordable phenomena such as clouds, atmosphere, cast sunlight, diurnal cycles, seasons or weather per se in the form of rain or snow, for example – phenomena that could also be read as a manifestation of the passage of time (cf. *tempus* = both time and weather). A structural cosmological equivalence to the absence of cast light or, as in antiquity,

its extremely sporadic form, is a perception of light as being a spiritual force ema-
nating through the world hierarchy, as seen in Plato for instance and passed on
to medieval theology. The medieval precious celestial colours, not least the gold
grounds, are equivalent to the priceless materials – precious stones, metals, mirrors,
crystal, ice, fire – that were thought to make up the heavens, at the same time as
they are only, however, a symbolic manifestation of an infinity which, as mentioned
above, cannot be given sensory accessibility. As corroborated by a comparison with
iconographically-determined beam phenomena such as celestial spheres, mandorlas,
nimbi, clipei and rainbows, the strips of the celestial grounds in particular might
allude to the transmission of spirit through the heavenly spheres, just as there are
often references to a cloth symbolism that alternates between veiling and unveiling.
The latter finds iconographic condensations in, *inter alia*, Carolingian illuminated
manuscripts, which prove to be a stronghold of exploration into the significance
of clouds given that many Carolingian images, presumably based on an idea of
God's absolute detachedness from the earthly and visible celestial domains, play
on the visual ambiguity vis-à-vis: do clouds constitute landscapes, or do landscapes
constitute clouds?

 A concluding evolutionary stage, in which pictorial space and its material mani-
festation, the landscape image, can be interpreted in a cosmological respect, finally
emerges in modernity, where my focal period is again made up of the introductory
phase in the Late Middle Ages and the 15th and 16th centuries. The key event here
is the simultaneous breakthrough of the perspectival way of looking and the pan-
oramic landscape – a combined *how* and *what* ushering in the dissolution of the
hierarchical cosmos. In the nominalist milieus at the northern European universities
of the Late Middle Ages, Aristotle's closed cosmos is contested in favour of a theory
that not only regards God but also the world as infinite, and that thinks in relative
movements which both break with the idea of the earth's static and central position
and bring in the subjective observer position as indispensable. Via Nicholas of Cusa
and Leonardo, this thinking prepares the foundation for Copernicus' heliocentric
system (1543) and its philosophical-physical justification by Descartes and Newton –
a world picture which places an independent observer in an infinite universe. The
cosmological development from antiquity to modernity could thus be described,
all in all, as an implosion of Plato's world cave, where the divine reality alias the
heavens first swells to infinite dimensions (Middle Ages), and then also absorbs into
its infinity the mortal earth (modernity). During this infinite levelling-out of the
cosmos, the firmament that previously separated the destructible world cave from
the indestructible world of ideas, collapses and is compressed into the membrane
separating self-consciousness from the new non-differential infinite surrounding
world – a metaphor that is particularly graphic in relation to visuality, inasmuch

as the eye serves as a faithful miniature copy of Plato's cave (with cave opening = pupil, and the shadows on the back wall of the cave = the retina's projections).

Pictorial art's perspectival paradigm can thereby also be seen as structurally equivalent to Copernican cosmology, given that the task of perspective, in a more or less comparable fashion to the eye, is to fix projections from an infinite environment onto a surface. Whether these projections are chiefly fixed in accordance with mathematic principles (as in 15th-century Italy) or more intuitively (as in 15th-century Netherlands) is, as I demonstrate, not crucial for the innovative quality of the image; on the contrary, the Netherlandish images often get closer to a subjective vantage point oriented towards distant horizons than does the Italians' more corpo-centric and idealistic vision. And, in any case, it makes no sense on the one hand to forge an ontological alliance between linear perspective and narration, and on the other hand to delimit the intuitive way of looking either to a hypernaturalistic view alien to linear perspective (Svetlana Alpers) or to a blatantly anti-naturalistic mysticism (Damisch, Didi-Huberman, Lacan). Regardless of its specific shape, perspective contains an anti-narrative tendency, so the contrast ought more accurately involve a Renaissance-determined ideal-plastic and narrative interpretation of perspective (cf. Wölfflin's Renaissance parameters and the Renaissance as reawakening of Riegl's normal sight) vis-à-vis a naturalism more concerned with perception, viewpoint, mediation, framing and detail, be it construed in a linear-perspectival mode, intuitive or – perhaps most often – mixed (cf. Wölfflin's Baroque and Riegl's distant sight). That the Renaissance, the revival of antique cultural values, does not have a monopoly on the initiation of the modern, but, on the contrary, can be regarded as a partially regressive pocket in the modernity *field*, is finally alluded to historiographically, in that the very concept of modernity is not linked unequivocally with the neo-antique until a late stage and otherwise has roots in proto-modern movements such as *Devotio Moderna*, nominalism and Gothic style.

As the antique vision was structurally equivalent to the geographic dependence on the *oikoumene*, so the perspectival paradigm ultimately possesses a structural affinity with the expansive geographic space accumulated in conjunction with the voyages of discovery and colonisation of non-Western domains. From the 14th century onwards the map is controlled by the same grid through which perspective sees the world, and perspective's grid develops an increasingly flexible mobility between close and distant, at the same pace as Western colonisation arrogates power around the globe. The culmination of this flexibility, the invention of photography, simultaneously denotes a structural parallel between image as absolute freezing of time and Western synchronisation of the globe's time zones.

If we now perform the final – loop-like – movement in the theoretical landscape and move from the above-discussed outer position, [3], the pole of remoteness,

the *cosmological world picture*, and back towards [2], the middle distance, the *socially-determined perception of nature*, we can, firstly, return to the expansion of depth of field and look at it in a sociological light. Just as the image's view towards distance and nature extends simultaneously with the encapsulation in the husk of self-consciousness, it also expands synchronously with humankind's isolation in another enclave: the artificial enclosure of the city. In other words, Joachim Ritter's specifically modern observation that an aesthetic understanding of nature depends upon urban alienation and isolation from an otherness, nature, may, *mutatis mutandis*, be extrapolated to a general condition of cultural evolution – with a Palaeolithic culture devoid of cities as well as images of space and landscape being the borderline case in terms of origin, and a post-medieval high-urban culture promoting perspective and landscape being the ultimate culmination.

However, apart from that, my attention as regards this sociological angle has been particularly focussed on the question: to what extent do landscapes of the various pictorial epochs contain traces of cultivation, and how does this relate to the cultures' understanding of work and its connection to nature, including the cosmic creative force which I have designated the power of conception? In this respect, taking the bird's-eye perspectival view of pictorial evolution, I identified a three-unit structure in which a lengthy central phase was flanked by two symmetrical outer phases. While landscape backgrounds in the long period from Mesopotamia through antiquity and on to the Middle Ages are thus dominated by unspoilt rocky grounds without traces of use (*terra*), in the epochs before that – the Neolithic and Egyptian – and also in the epoch after – modernity – we encounter depictions of terrains upon which networks of utilitarian traces, such as tracks, fences, hedges, cereal fields, bridges, watercourses, mines and quarries, may encroach (*territory*). In order to make this pattern comprehensible in a sociological respect, I investigate the status of physical work among the elite classes of these societies based on the thesis that work (especially the penetrations of the earth perpetrated by agriculture and mining) in pre-modern times was perceived as a component of sexuality (penetration of the body) and as such was correlated with the cosmological evolution described above.

When, for example, the pictogram-like images in Çatal Hüyük (*c.* 6000-5800 BC and Valcamonica (*c.* 2000 BC-*c.* 0) include depictions of fields and tracks, and Egyptian images, which are otherwise devoid of proper backgrounds, teem with descriptions of physical work – cereal agriculture, management of cattle, hunting, etc. – it should be seen as expressive of cultures in which the fecund, male celestial forces are only semi-liberated and enter into a strenuous reproductive-cycle with the bearing, female earth, while the societal body is still, in structural equivalence to this, coherent and not divided into fixed differentiated classes. That work thus – as

part of the power of conception and common duty, respectively – bestows prestige, at least in ideal terms, can just as well be corroborated by the modern anthropological observation that in the advanced primitive slash-and-burn-method society it was possible to become a Big Man via hard physical toil, as well as by extant contemporaneous testimony to the Egyptian paradise, the fields of Earu, that still had to be cultivated by their inhabitants. If these observations are to be detailed more explicitly in terms of space representation, it has to be acknowledged that they concern cultures in the preoperational and topological phase, with a subjective vantage position that still allows the two modes of viewing, *mapping gaze* (the gaze that looks downwards from above) and *panoramic gaze* (the gaze that looks outwards), to occur simultaneously, albeit often in incoherent montages as in, with particular tension, Egypt.

Characteristically, traces of work are ousted from pictorial art synchronously with the introduction of a more outward-looking, panoramic pictorial view, which for the first time supplies actual backgrounds – the recurring rocks of Mesopotamia, antiquity and the Middle Ages – while this pictorial view by and large brackets off the depiction of territory and its mapping gaze to a new independent and less monumental genre: the topographical map. It is thus only in markedly secularised contexts, where rulers chronicle their campaigns of conquest – as in the neo-Assyrian palace reliefs and Trajan's Column of late antiquity – that a survey of divided, albeit field-free terrains finds its way into the panoramic monumental art. However, specifically cultivated terrains with grids of fields, tracks, fences, hedges and watercourses are exclusive to the specialised utilitarian genre, the Roman *agrimensores'* maps chiefly characterised by the mapping gaze, in which the abstract system of measurement also anticipates modernity's system of coordinates and thereby a representation of infinite space.

In expanding to a trackless middle distance in the post-Egyptian era, the depth of field thus principally looks across and beyond the flat territory with its networks of traces of use, and these do not return to the landscape image until the coming of modernity. The sociological-cosmological conditions making for this combined expansion of depth of field and displacement of traces of use involve the emergence of a more hierarchical society, Parsons' advanced intermediate and feudal stages, during which urban-based elites control a rural underclass, while these elites also have privileged access to a new cleaving-off from the formerly cyclical world picture, an indestructible heaven whose masculine forms, in homology with the dualised society, control and animate a now passive and increasingly demonised feminine matter. Besides work here becoming inferior, because it is displaced to classes with no access to the intellectual life of the urban elites, it also loses its prestige given that the power of conception becomes a masculine and celestial monopoly which

should preferably, as seen in nature's organisms, have a direct effect on matter, whereas work with its exertion and assembling of scattered materials becomes, exactly like sexuality, a necessary evil inextricably linked with the dirt of matter. It is as a consequence of this that the post-Egyptian pre-modern elites prefer their pictorial depictions of various mythological or historico-political themes to be set against a background of wild and unspoiled rocks, these being land formations which in themselves, due to their remoteness and hardness, resist civilisation's utilitarian infringements.

My specific designation of the epistemic *field* covering this cultural evolutionary middle phase as the Golden Age *field*, and its imprint in pictorial art as the Golden Age paradigm, is due to the homology between the untouched quality of the landscape backgrounds and a new both spatial and temporal longing for a beyond that could appropriately be termed primitivist. As manifest in key instances such as Mesopotamia's myths of the Flood and Gilgamesh, through the Greco-Roman Golden Age myth and on to the Judeo-Christian Paradise myth, this epistemic *field* is characterised by a partial glorification of mountain life with its ostensibly more undemanding and primordial occupations such as pastoralism, hunting and fruit picking, whereas life on the plains with its farming, and extension into the mountains, mining and quarrying, is looked upon as signifying the decadence of civilisation – albeit, as we have seen, this projection of organic celestial forces on rural phenomena is extremely unstable, given that they are just as likely to turn into the opposite of the celestial forces: matter's barbarity and demonism, by means of which civilisation's plains become the bulwark against chaos. The extent to which this ambivalent primitivism influences pictorial art's post-Egyptian pre-modern landscapes is apparent from the very fact that the rural occupations here portrayed are more often than not precisely of the primeval variety, and, accordingly, iconographic condensations of the paradigm. Indeed, the entire pictorial paradigm can be taken as structurally equivalent to the limits which, in the mythical cosmos, characterise the primordial world prior to the Fall or the emergence of the Silver Age. Thus in both places – Golden Age/Paradise and pictorial paradigm – we encounter [1] a spatially restricted world (viz. local self-sufficiency vs. as of yet undeveloped perspective), [2] a timeless world (viz. eternal spring vs. light and flourishing landscapes), [3] a world devoid of work (viz. directly available food vs. terrains devoid of territories), and [4] a world based in the mountains (viz. the Paradise mountain vs. rocky grounds). As we will soon recall in more detail, modernity's post-1420 pictorial paradigm is inversely structurally equivalent to the bursting of the limits that occurs in the state of original sin following the termination of Paradise and the Golden Age, by means of which it is thus predicated that modernity rejects the elite primitivism of the Golden Age *field* and embraces the Fall with its world marked by time and work.

As the Golden Age *field* is thus actually implemented in a world that has long since been engulfed by nature's fallen state, the Golden Age must here be artificially reclaimed – that is, by means of the justified subjugation of slaves who, via the necessary evil, labour, recreate the lost energy of the Golden Age for the urban elite. The primordial state of affairs under Cronus' regime is therefore proclaimed the model for Plato's ideal state, but, as Aristotle makes clear, the advanced city-state must inevitably build upon a foundation of naturally-subdued human tools, slaves, whose activity, *poiesis*, is subject to a purpose external to themselves. This downwards displacement of work ensures that the urban elites can indulge in heroic, self-fulfilling actions, *praxis*, if not in pure leisure-time activities: politics and philosophy. And thus that symmetry is again achieved whereby the urban elites can be mirrored in the primitive *bioi*, Aristotle's primary occupations, which are predominately coincident with the rural activities of classical art's iconographic repertoire. However, as a close reading of the sacral-idylls in Roman wall paintings in particular substantiates, these pursuits are diametrically opposed to real life on the land, given that although agricultural commentators such as Xenophon and Columella wish for the return of freeholder farmers, the dominant reality constitutes large estates, *latifundia*, staffed by slaves.

The elite paradisiacal yearning characteristic of Golden Age paradigm landscape images is so strong that it is not only condensed in recurring iconographic figures such as the *Tree of Life*, *locus amoenus* and the *sacred grove*, but can be linked with the strange schizophrenic tendency preventing plants and grass from spreading in any great quantity into the rock-dominated pictorial space, while concentrations of plant growth are restricted to narrow spatial compartments, images with only potential depth of field. The more advanced Judeo-Christian patriarchal world picture thus saw mountains and rocks as post-paradisiacal or post-diluvian excrescences defiling the originally flat and thereby good earth, and the pictorial culture's condensation of plant life in rock-excluding enclaves – unadulterated Paradise images – could then be perceived as a structural equivalence of this.

Even though the Golden Age paradigm is predominant until 1420, during the Middle Ages it is interspersed with iconographic pockets in which time, weather and farm work are represented and gradually, from the Carolingian era onwards, construct a counter-tendency. These scattered iconographies, which are found in new motifs such as the *Seasons* and the *Labours of the Months* stemming from late antiquity, must be seen in context with the formation of the feudal system and its closer alliance between lord of the manor and peasant, with the penance status labour in monastic culture, and also with the irreversible and more linear timeline brought in by Christianity. In a wider overview of cultural evolution, I went on to show that the transformation of time and work as perceived from antiquity to the

Middle Ages could be elucidated on the basis of Hegel's and Kojève's sociological parameter for the liberation of spirit throughout history: the human struggle for recognition. While thus in classical antiquity the master acquired recognition via the suppressed slave, whose labour made nature permanently accessible – paradisiacal – to this master, recognition in the Middle Ages becomes an internal slave matter where the slave achieves self-esteem via the new transcendent and egalitarian God and sublimates time via work, converting it into a progressive history.

Around 1420, however, these medieval tendencies have become so satiated that they cause a paradigm shift in pictorial art: the shift from the Golden Age paradigm to that of modernity. If we again make a structuralist comparison with the course of the Golden Age myth, then in the epochs following the cessation of the Golden Age and also in modernity's pictorial paradigm we will find: [1] a spatially open world (viz. institution of trade vs. perspective directed towards infinity); [2] a changeable world (viz. emergence of time and weather vs. landscapes marked by time and weather); [3] a world marked by work (viz. invention of agriculture and mine-work vs. landscapes marked by territory); and [4] a multifarious world rooted in the plains (viz. emergence of civilisation rooted in the plains vs. cessation of the rocky grounds' monopoly). I traced the more specific cultural conditions causing the paradigm shift to the late medieval 'little industrial revolution' between the 11th and 14th centuries, when improved technologies such as mills and wheeled ploughs, a new work ethic, a proto-capitalist market economy and incipient civil democracy lead to a thorough cultivation of the actual European landscape. Apart from being traceable in the speedily expanding *Labours of the Months* and on to their culmination in *Les Très Riches Heures du Duc de Berry* (*c.* 1410-16), this new enterprising culture is perceptible in the iconographic genres that include landscapes, such as health compendia, encyclopaedias, *mirabilia* collections and topographic portraits, of which Ambrogio Lorenzetti's panorama of Siena's grid-divided territory (1337-40) would almost seem to be a dress rehearsal for the modern paradigm. In Simone Martini's contemporaneous description of Siena's military conquests, on the other hand, the Byzantine rocky ground is not affected by cereal fields, but only by roads and military camps, which recall the militant contexts in the Neo-Assyrian palace reliefs and Trajan's Column. The abovementioned genres demonstrate, all in all, that the modern landscape image springs principally from secular contexts in which qualities such as matter-of-factness, military control, republicanism and work ethic are dominant.

If the geographic sequence from mountain to valley spans an attractor, a structure of forces directing the evolution of culture, then it must be noted that the post-1420 cultural fulcrum has moved from mountain (ideal projection of the Golden Age *field*) to valley (sounding board of modernity, or Iron Age *field*), which is consistent

with my thesis that the driving force of cultural evolution actually shifts from the mountain-dominated Mediterranean area to the plains-dominated northern Europe. It is up in the North, in the homelands of the Reformation, capitalism, industriali-sation and, to a large extent, colonialism, that panoramic and temporally-marked landscape images occur, whether they look at the territory's cultivated and controlled areas (realism) or terrains completely untouched by human hand (romanticism). The flattening out of territory produces a structural correlation to modernity's equalised society, just like its grid division is homologous with the perspective by which it is surveyed. In the Renaissance-dominated, Counter-Reformatory, re-feudalised and more introverted and retrospective Italy, on the other hand, the end of the 15th century onwards sees a reawakening of a neo-antique landscape image in which ideal human bodies are set in supra-temporal and pastoral surroundings. The tightness of the link between this neo-pastoral tendency and an aristocratic culture was demonstrated by means of a detailed study of Signorelli's *School of Pan*, in which Pan Saturnus was equated with Cosimo de' Medici and placed at the centre of a cosmological orbit of erotic forces.

The modern paradigm's homology with a post-paradisiacal state is not least visible in its incorporation of the synonymous phenomena weather and time (cf. Latin *tempus*), given that these can also be perceived as manifestations of a similarly original-sin-qualified inner imbalance in the bodily fluids (cf. Latin *temperament*) – an imbalance that in turn seems emblematic of modernity via its association with Saturn, the melancholy genius and polyphonic music. Yet, in the same way as traces of work are placed discreetly in 15th-century painted landscape images, which have predominantly park-like qualities, so too the traces of time are mostly of an indeter-minate summer-like quality. Effects such as dead leaves, mist, darkness and *sfumato* first appear after 1470, many of them external atmospheric phenomena which, in their softening of the bodies' solid forms, prove themselves to be indispensable to the painterly style developed around 1500 in Venice and become characteristic of styles north of the Alps, culminating with Impressionism. And I could, moreover, establish a post-1500 division between Southern European 'night clouds', which with their revelatory potential are equivalent to a restored geocentric cosmos, and Northern European 'day clouds', which in their remoteness correspond to a de-sacralized Copernican sky.

The vantage position of the middle distance, the socially-determined percep-tion of nature, would seem to find its most distinct synthesis with the pole of remoteness, cosmology's world picture, in the final focus of this study: the rocky ground in 15th-century landscape images. The peculiar, fantastical features of the rocks – architectonic, ruined, mine- or quarry-like, organically growing – could be partially perceived as a relic from the Byzantine rocks' chaotic-organic underworld

tendencies, but in the new paradigm with its potentially exploited earth they are additionally part of a field of suspense dealing with the genesis of art. In a more archaic reading, that of the Golden Age *field*, the architectonic forms can be perceived as innate to the rocks and impregnated by celestial seeds (natural architecture and growing crystals), whereas a modern reading, that of the Iron Age *field*, displaces the forces of genesis outwards – towards a soulless and sightless nature (ruination caused by time), towards industrial exploitation (evidence of mining and technical design), if not towards the beholding subject's imagination (projections from the artist and/or the viewer).

Art even has an ambivalent relationship to nature in the Golden Age *field*, given that its forms are perceived, on the one hand, as celestially sanctioned and, on the other hand, as being dubious because of the brutal penetration of nature perpetrated by mine-work. On an iconographic level, this ambivalence was seen manifested in Mantegna's stonemason and mining scenes, which in Camera degli Sposi appeared as part of a blessed cosmological hierarchy with Mantua-Rome as the obvious crowning of labour, whereas in *Christ as the Suffering Redeemer* and *Madonna of the Stonecutters* they alluded to the Iron Age and its rape of Mother Earth – in sharp contrast to the autochthonic nativity of Christ. The ambivalence is surmounted, however, in alchemy, the furthest pre-modern culture gets in the development of a philosophy in which art in all its stages – from mining to completion – is seen as part of nature's intentions. In this light, the paradigmatic-determined architectonic features of 15th-century rocks are perceived as allusions to unfinished, autochthonic monuments, manifested by the rocks' innate growing tendencies.

As Filippo Lippi and the Ferrara painters in particular were shown to substantiate, this study also stressed that the pictorial rocks are ambiguous and idiosyncratic, and that specifically modern contexts such as ruination, industrial exploitation and projections of the imagination have to be taken into consideration. The epoch-making characteristic of the paradigm's eroding forces in the landscape image was corroborated by the observation that actual ruins – ruins broken down by the ravages of time and not by instantaneous forces – are absent in images from antiquity and the Middle Ages, periods during which the Golden Age paradigm exacts stagnation and relatively unified wholes, even in the moment of decomposition. In the modernity paradigm, on the other hand, the ruins feature as melancholic-aesthetic objects of contemplation, the debris of a past that will not die to such an extent that it can rise again as fully-developed Renaissance. Besides showing signs of this eroding force – with iconographic condensation in the background of Leonardo's *Virgin of the Rocks*, where it is contrasted with the curative penetration of the foreground rocks – the 15th-century rocks might also associate to utility-oriented encroachments in the earth, such as those iconographically condensed in Mariano

Taccola's manuscripts, just as they might allude to projections of the imagination in the same way as the cloud images in Mantegna's *Pallas Expelling the Vices from the Garden of Virtue* and *Martyrdom of Saint Sebastian*. All in all, we came across many examples of 15th-century images contemplating, in a particularly self-assured manner, the genesis of art: from the image-generating agates in Mantegna's *Parnassus* and the abyss-reflection in Leonardo's *Virgin of the Rocks* – natural phenomena that create the images of which they are themselves an element – to the strangely stone-like figures generally populating the later North Italian 15th-century painting and showing, through their actual statue-likeness, the fundamentally artificial character of the Renaissance project.

This book, taken as a whole, demonstrates that even though landscape images belong to the domain of depth of field – those surroundings in which the narrative and allegorical meanings of images are diluted – this is far from synonymous with an absence of significance per se. In order to make contact with at least one layer of the significance that exists in these outer edges, the study has claimed that we have to forsake the widespread dogma of the humanities that proper scholarly analysis is only permissible on a microhistorical level. This layer of significance has namely proved to involve a shift in focus from *what* to *how*, to paradigms that are manifested through large numbers of images and through many different contexts. Given that these paradigms also find structural resonance in other cultural domains, and given that the paradigms as well as their homologies can be arranged according to a developmental logic, an evolution, my interpretation of Western landscape images can be described overall as an iconological project that beholds the landscape images as indicator not merely of self-organising forces in history, but of forces that at least on one analytical level move in a non-random, i.e. teleological, direction.

Notes

Chapter 8
"'Tis All in Peeces, All Cohaerence Gone"

1 Goethe (1962), v. 6240-6256, p. 334: Mephistopheles: "Und hättest du den Ozean durchgeschwom-
 men,/Das Grenzenlose dort geschaut,/ So sähst du dort doch Well auf Welle kommen,/ Selbst
 wenn es dir vorm Untergange graut./ Du sähst doch etwas! Sähst wohl in der Grüne/ Gestillter
 Meere streichende Delphine,/ Sähst Wolken ziehen, Sonne, Mond und Sterne;/ Nichts wirst du
 sehn in ewig leerer Ferne,/ Den Schritt nicht hören, den du tust,/ Nichts Festes finden, wo du
 ruhst."/ Faust: "[...] In deinem Nichts hoff ich das All zu/ finden." English translation from Goethe
 (1976).

2 Here cited from Harrison and Wood (1998), p. 421.

3 Spengler (1972), pp. 238-39. English translations from Spengler (1971), p. 186.

4 Hegel (1988), especially pp. 57-156; Hegel (1970), especially vol. II, pp. 351-74 and vol. III, pp. 11-83.

5 Hegel (1970), vol. III, pp. 25. English translation from Hegel (1999), vol. 3, p. 232.

6 Piaget and Inhelder (1956), pp. 301ff.

7 Gablik (1976), pp. 40-47, pp. 66ff. and 80ff.; Blatt (1984), pp. 97, 235-36 and 333-34.

8 *Ibid.*, pp. 202, 216 and 231-41.

9 Blatt (1984), p. 362.

10 Cf., for example, Hayles (1999). For an account of the situation of art at this stage, see Wamberg
 (1999a).

11 *Commentary on Genesis*, introduction (Migne, *Patrolgia Latina*, 156, col. 27B), cited in Morris (1972),
 p. 67. For this section, see also *ibid.*, pp. 64-95.

12 On self-exposition as Faustian phenomenon, see also Spengler (1972), pp. 330-40.

13 Morris (1972), pp. 64-65.

14 Panofsky (1951), pp. 12-16; Nardi (1966), p. 22.

15 Panofsky (1951), pp. 16-17. Antal (1924/25), pp. 209-39, also maintains that late medieval Italian
 culture – painting, poetry, philosophy, religion – springs from a subjectivism oscillating between
 realism and fervour, i.e. again the extremes of nominalism.

16 Panofsky (1951), pp. 18-19.

17 Described in the discourse *De possest* (1460), see Cusano (1965ff.).

18 "De sapientia", from *Idiota* (1440-50), I-II, *ibid.*, p. 68.

19 *Ibid.*, p. 76.

20 Cassirer (1927), p. 23.

21 René Descartes, "Discourse on the Method of Rightly Conducting the Reason and Seeking Truth in the Sciences" [1637] (trl. J. Veitch), in *The Rationalists* (1960), pp. 63 (on cogito) and 45, 47, 68 and 92 (on experience).

22 Merchant (1980).

23 On this God's lack of fixed place in the Reformation, see Weber (1920), pp. 94-95 and 114. Calvin stated, for example, that miracles occurred in early Christian times in order to spread Christianity, but that God no longer intervened in the material world; see Sheldrake (1990), p. 20.

24 For an empirically-based account of this argument, see Moxey (1977).

25 Merchant (1980), p. 171.

26 Descartes (1960), p. 80; Sheldrake (1990), p. 41.

27 On the limitations of the geometric understanding of the world, see Kojève (1980), p. 128.

28 Ritter (1989), pp. 155-56.

29 *Ibid.*, p. 153: "wie sie sich im Inneren der Menschen abspiegelt [...]" and "das Gefühl und die dichterisch gestimmte Einbildungskraft".

30 Kant (1974), especially §§ 23-24, pp. 164-69.

31 Merleau-Ponty (1964), pp. 37, 57 and 72-74; Lacan (1994), pp. 93-97.

32 Toulmin and Goodfield (1965), pp. 80, 101-03 and 143-47.

33 On this issue, see Cassirer (1927), p. 45.

34 See also Cosgrove (1998), p. 17.

35 *Trattato della pittura* 1, 42 (f. 12), see Leonardo (1956): "Che ti move, o homo, ad abbandonare le proprie tue habitationi della cita e lasciare li parenti et amici et andare in lochi campestri per monti e ualli, se non la naturale bellezza del mondo la quale se ben consideri sol con senso del vedere fruisci?"

36 Ritter (1989), pp. 150-51: "Landschaft ist Natur, die im Anblick für einen fühlenden und empfindenden Betrachter ästhetisch gegenwärtig ist: Nicht die Felder vor der Stadt, der Strom als 'Grenze', 'Handelsweg' und 'Problem für Brückenbauer', nicht die Gebirge und die Steppen der Hirten und Karawanen (oder der Ölsucher) sind als solche schon 'Landschaft'. Sie werden dies erst, wenn sich der Mensch ihnen ohne praktischen Zweck in 'freier' genießender Anschauung zuwendet, um als er selbst in der Natur zu sein." On the beholder's significance for the spiritualisation of the landscape, see also Spengler (1972), p. 369.

37 Mitchell (1994), p. 15, also stresses freedom from economic-utilitarian purposes as crucial for the landscape's modus operandi.

38 See also Cosgrove (1998), pp. 18-20.

39 Reported in conversation with Joachim Gasquet (*c.* 1900), cited in Busch (1997), p. 322.

40 Le Roy Ladurie (1975), pp. 446 and 432. The conclusion about the villagers' lack of distance to nature is made in Fechner (1986), pp. 74-75 and 180-81.

41 *Études sur Leonardo da Vinci*, I, I, p. 56; *Les origines de la statique*, I, ii, p. 156, cited in Jaki (1984), pp. 386 (citation) and 390.

42 Blatt (1984), pp. 275-89, notes this connection as well and provides an excellent description of the emergence of the modern world picture, based particularly on Koyré (1957), who can also serve as substantiation for the following.

43 Toulmin and Goodfield (1960), pp. 154-60.

44 "Deus est sphaera infinita cuius centrum est ubique et circumferentia nusquam." On the use of the phrase in the Late Middle Ages, especially in Neoplatonic circles after its initial appearance in *Liber XXIV philosophorum*, propositio ii, see Wind (1958), p. 183. The 14th-century debate about the void and infinity was explored by Koyré in 1949; an account of his study is found in Edgerton (1975), pp. 19-20.

45 Koyré (1957), p. 17. Citation from *De docta ignorantia*, 2, 12. Spengler (1972), p. 95, sees Nicholas of Cusa's concept of an infinite God as the germ of infinitesimal arithmetic.

46 Cassirer (1927), p. 26.

47 On John Philoponus: Duhem (1913-59), vol. 1 (1913), pp. 317 and 374-87; on Buridan: *ibid.*, vol. 8 (1958), pp. 200-214; also, Toulmin and Goodfield (1960), pp. 221-23.

48 An object not acted upon by a force will either be at rest or moving at a constant velocity along a linear path.

49 Net force = mass x acceleration.

50 "Un jour, à la dernière page du livre des *Principes*, Newton écrira: 'Par la force de la gravité, j'ai rendu compte des phénomènes qu'offrent les cieux et de ceux que présente notre mer – *Hactenus phænomena cælorum et mari nostri per vim gravitatis exposui.*' Ce jour-là, il annoncera le plein épanouissement d'une fleur dont Jean Buridan avait semé la graine. Et le jour où cette graine fut semée est, peut-on dire, celui où naquit la Science moderne." Duhem (1913-59), vol. 8 (1958), p. 340. See also Jaki (1984), p. 429, and *idem* (1990), p. 39.

51 Duhem (1913-59), vol. 1 (1913), p. 317.

52 Clagett (1968), p. 12 (Latin); Kuhn (1985), pp. 115-18 (with English translation); Toulmin and Goodfield (1960), pp. 164-68.

53 On precursors in Oxford, see Schmitt (1988), p. 592. On Oresme's system of co-ordinates, see Clagett (1968), particularly pp. 34-35, 56, 64 and 271 (II, 1).

54 Duhem, vol. 7 (1956), pp. 6-7. The Islamic commentators otherwise chiefly believed in an infinity reserved God, see Cohn (1960), p. 69.

55 On the infinitely large and the infinitely small in the 14th century, see Duhem, vol. 7 (1956), pp. 3-157.

56 Panofsky (1991), p. 65.

57 "De sapientia" from *Idiota*, Cusano (1965ff.), p. 82.

58 Koyré (1957), pp. 14-15 and 20, citation from *De docta ignorantia*, 2, 12.

59 Leonardo (1939), No. 886 (Windsor, Royal Library, ms W., f. 12669a (1489-1506)): "Il sole non si
 move". *Ibid.*, No. 858 (Paris, Institut de France, ms F., f. 41v (*c.* 1508)): "Come la terra non è nel mezzo
 del cerchio del sole, nè nel mezzo del mondo, ma è ben nel mezzo de'sua elementi, conpagni e
 uniti con lei, e chi stesse nella luna, quand'ella insieme col sole è sotto a noi, questa nostra terra
 coll'elemento dell'acqua parrebbe e farebbe ofito tal qual fa la luna a noi." (Cf. also *ibid.*, Nos.
 893 and 898.) In Leonardo (1939), Nos. 945 and 1218, the earth is compared to a machine: "Questo
 corpo della terra, questa machina" (945).

60 For this and the following: Koyré (1957), pp. 28-35.

61 *Ibid.*, pp. 35-36, 39, 52, 96 and 275-76.

62 Cited in *ibid.*, p. 43.

63 Berman (1983), pp. 87-98.

64 Donne (1994), p. 177.

65 Kant (1974), § 25, pp. 171-72.

66 Serres (1989), pp. 37-40, 97 and 105-06.

67 Panofsky (1991), p. 65.

68 Hubert Damisch's title for his book (1987), *L'Origine de la perspective*, is not exactly a correct descrip-
 tion of the subject matter; Kubovy (1986).

69 Edgerton (1975), pp. 64-78. With particular reference to Giotto's frescoes in the Arena Chapel in
 Padua, this connection is also stressed by Blatt (1994), pp. 365-93. It appears to me, however, that
 Blatt (pp. 383-84) exaggerates the potential of infinity in the frescoes' azure skies, which are called
 more illusionistic than the ostensibly more traditional gold grounds. As shown in chapter 3, the
 two grounds are, if anything, equivalent in terms of significance; and the blue, as mentioned in
 chapter 3 too, is a requirement of fresco painting, which cannot bind gold.

70 Edgerton (1975), pp. 64-78.

71 See Hammond (1981), pp. 1-9. In *Problems* Aristotle already refers to how solar eclipses cast imprints
 through holes in leaves, strainers, crossed fingers and baskets but, characteristically, he does not
 indicate any systematic utilisation of this screening effect in antiquity.

72 In pre-1500 late medieval literature we can find more than 200 titles dealing with the mirror. See
 Grabes (1973), pp. 21 and 25-32. On the significance of mirroring, see also Jay (1993), pp. 31-33 and
 37-38.

73 Panofsky (1946), "De administratione" XXIX, p. 53, and XXXIV, p. 77.

74 *Ibid.*,"De administratione" XXVIII, p. 51, and XXXIII, p. 65: "[...] videor videre me quasi sub aliqua
 extranea orbis terrarum plaga, quæ nec tota sit in terrarum fæce nec tota in coeli puritate." See
 also Gage (1993), pp. 69-71.

75 Cited in Schöne (1954), p. 78. Of Konrad: "[...] fenestris etiam et pictura auro rutilante parietes
 afine usque ad finem opere mirabili ornavit." Of Egbert: "[...] qui primus tecta ecclesiae plumbo
 stabilivit et parietes templi vitreis illuminavit."

76 Spengler (1972), p. 257. English translation from Spengler (1971), p. 199.

77 Alberti (1975), I, p. 48.

78 *Della pittura*, I.

79 Leonardo (1956), I, 34 (f. 16): "Questo è finestra dell'human corpo per la quale l'anima [in ms: la sua via] specula e fruisce la bellezza del mondo, per questo l'anima si contenta della humano carcere, e sanza questo essa humana carcere è suo tormento."

80 See Cosgrove (1998), p. 27.

81 Manetti (1970), pp. 42-47. See also Edgerton (1975), pp. 61-63 and 124-52, and Kubovy (1986), pp. 32-38, with discussion of earlier literature. Kubovy is of the opinion that Brunelleschi used an intuitively rather than a rigorously construed perspective, but does not ask where, if this is the case, Masaccio learnt his construction.

82 Manetti (1970), pp. 43 and 45: "[...] e per quanto s'aveva a dimostrare di cielo, coe che le muraglie del dipinto stanpassono nella aria, messo d'ariento brunito, accio che l'aria e cieli naturali vi si specchiassono drento e cosi e nugoli, che di vegono in quello ariento essere menati dal vento, qandetrae [...]."

83 Damisch (1972), p. 171: "[...] d'emblème [...] épistémologique, dans la mesure où il révèle les limitations du code perspectif [...]. Il fait apparaître la perspective comme une structure d'exclusion, dont la cohérence se fonde sur une série de refus, et qui doit cependant faire place, comme au fond sur lequel elle s'emprime, à cela même qu'elle exclut de son ordre." English translation from Damisch (2002), p. 124.

84 Panofsky (1991), pp. 60-61.

85 Alpers (1983).

86 Panofsky (1991), pp. 68-69 and n. 71, pp. 151-53.

87 Alpers (1983), pp. 51-59.

88 Panofsky (1960), p. 126.

89 Spengler (1972), p. 357, notes the connection and expands it with three other Faustian discoveries: circulation of the blood (the 'inner' continent), gunpowder (long-distance weapons) and printing (long-distance type).

90 Hale (1968), pp. 19-20; Harvey (1991), pp. 51 and 68.

91 Hale (1968), p. 9.

92 Harvey (1991), p. 54.

93 *Ibid.*, pp. 39, 45, 48 and 71.

94 2nd edition of *Conditiones terrae sanctae* (1306-09). See Harvey (1980).

95 Harvey (1991), pp. 16 and 51. The regional maps appeared in series of 26 or 64.

96 On the innovative aspect of Ptolemy's geographical co-ordinates, their conversion into a visual grid and this grid's reception in Florence around 1400, see Edgerton (1975), pp. 91-123; also, Harvey (1991), p. 45.

97 *Ibid.*, p. 60. We know of this map from two later copies, one a manuscript, the other printed.

98 Hale (1968), p. 19.

99 Cited in Edgerton (1975), pp. 121-22.

100 Ovid, *Metamorphoses*, I, 132; Tibullus, *Elegies,* I, 3, 39-30 (cited in Lovejoy and Boas (1935), p. 59).

101 Edgerton (1975), pp. 113-20. Blatt (1984), pp. 216-17, n. 19, similarly notes the connection between the developments of cartography and those of perspective. See also, Jay (1993), p. 63.

102 Despite an aversion to evolutionary thinking, Mitchell observes the contemporaneity of imperialism and the category 'landscape' in such different cultures as China, Japan, Rome, 17th-century Netherlands and France, and 18th-19th-century Britain (Mitchell (1994), pp. 9-10 and 17). See also Cosgrove (1998), p. 20.

103 Leonardo (1956), I, 34.

104 Galassi (1981).

105 *Ibid.*, figs. 8-9.

106 Würtenberger (1958), p. 66.

107 See Rose (1992), no. 22.

108 Le Goff (1977), p. 75.

109 Schöne (1954), pp. 169 and 215.

110 Petrarca (1970), 4, 1, pp. 483-501. Dotti cites, p. 649, G. Billanovitch for the claim that the letter must, for many reasons, be fictive and not written until 1352 or 1353, when Petrarch edited the 4th book of *Le familiari*. Recently, some scholars have even questioned whether the ascent took place at all and, supposing it did, if it happened in 1336 (see Busch (1997), pp. 62-63). In my opinion, the ascent would seem probable, albeit Petrarch has undoubtedly manipulated the details. See also Schama (1995), pp. 419-21.

111 *Ab urbe condita*, 40, 21, 2. Compare also with Apollonius Rhodius, *Argonautica* (1, 1112), in which Jason and his entourage ascend Mount Dindymon on the southern coast of the Sea of Marmara: "And to them the Macrian heights and all the coast of Thrace opposite appeared to view close at hand. And there appeared the misty mouth of Bosporus and the Mysian hills; and on the other side the stream of the river Aesepus and the city and Nepeian plain of Adrasteia."

112 4, 1, 13, Petrarca (1970), p. 489: "Equidem vita, quam beatam dicimus, celso loco sita est; arcta, ut aiunt, ad illam ducit via." English translations from Petrarca (1975-85), vol. 1, pp. 172 and 175.

113 *Confessions*, 10, 8, 15.

114 4, 1, 34, Petrarca (1970), p. 499: "O quanto studio laborandum esset, non ut altiorem terram, sed ut elatos terrenis impulsibus appetitus sub pedibus haberemus!" Translation from Petrarca (1975-85), vol. 1, p. 179.

115 Fabricius Hansen (1996), pp. 87-89 and 102; Fabricius Hansen (1999), pp. 170-72.

116 See, for example, Pietro Lorenzetti, *Birth of the Virgin* (1342), Siena, Museo dell'Opera del Duomo, reproduced in Smart (1978), ill. 117; Barna da Siena, *Betrayal of Judas* (c. 1381 or earlier), San Gimignano, Collegiata, reproduced in *ibid.*, ill. 136.

117 I am grateful to Maria Fabricius Hansen for these important observations.

Chapter 9
Pressure and Counter-Pressure

1 Burckhardt (1926).

2 Panofsky (1960), pp. 19, 30 (with citation), 36-37 and 165.

3 Spengler (1972), pp. 277-78, 290, 300-308 and 330-66. Citation pp. 300-301: "Die Renaissance be-mächtigte sich einiger Künste des Bildes und Wortes, und damit war alles getan. Sie hat die Denkweise Westeuropas, das Lebensgefühl in nichts verändert. Sie drang bis zum Kostüm und zur Gebärde vor, nicht bis zu den Wurzeln des Daseins, denn die Weltanschauung des Barock ist selbst in Italien dem inneren Wesen nach eine Vorsetzung der Gotik." English translation from Spengler (1971), p. 233.

4 Baron (1955), pp. 251-52.

5 See, for example, Villari (1905), pp. vi, 2-11 and 34. Cf. also Cosgrove (1998), p. 82.

6 See, in particular, Villari (1888), especially vol. I, pp. 38-49, 297-305, and vol. II, pp. 418ff.; Baron (1955), p. 251.

7 Russell (1946), pp. 521 and 525. Even so sober-minded a Renaissance scholar as Paul Oskar Kristeller has to note: "In the history of philosophy, the period of the Renaissance must be considered as an age of transition and of fermentation rather than one of synthesis or lasting achievement." See Kristeller (1984), p. 30.

8 Cassirer (1927), pp. 7, 10, 45 and 49-50.

9 Here cited from Jaki (1984), p. 423.

10 Spengler (1972), pp. 216, 234 and 236.

11 Riegl (1931), especially pp. 7-22.

12 Alpers (1983), pp. xix-xxv.

13 On the academic genre hierarchy, see Pevsner (1940), pp. 94-95.

14 Hegel (1970), vol. II, pp. 140 and 139: "Eben deshalb aber läßt die romantische Kunst die Äußerlichkeit sich nun auch ihrerseits wieder frei für sich ergehen und erlaubt in dieser Rücksicht *allem und jedem Stoff*, bis auf Blumen, Bäume und *gewöhnlichste Hausgeräte* herunter, auch in der *natürlichen Zufälligkeit des Daseins ungehindert* in die Darstellung einzutreten." [my italics] And: "den markierten Zügen des Unschönen einen ungeschmälerten Spielraum." English translations from Hegel (1999), vol. II, pp. 295 and 294.

15 Hegel (1970), vol. II, pp. 137-38, 145, 364 and 373; vol. III, pp. 25 and 40.

16 *Ibid.*, vol. III, p. 125. Translation from Hegel (1999), vol. III, p. 331.

17 See Jauss (1968), pp. 143-68, especially p. 168. I am grateful to Joseph Koerner for drawing my attention to this article.

18 Spengler (1972), p. 37: "Es ist ein ehrwürdiges Vorurteil, das wir endlich überwinden sollten, daß die Antike uns innerlich nahesteht, weil wir vermeintlich ihre Schüler und Nachkommen, weil wir tatsächlich ihre Anbeter gewesen sind. Die ganze religionsphilosophische, kunsthistorische,

sozialkritische Arbeit des 19. Jahrhunderts war nötig [...] um uns endlich fühlen zu laßen, wie unermeßlich fremd und fern das alles innerlich ist [...]." Translation from Spengler (1971), p. 27.

19 The most comprehensive and thoughtful discussion of this issue that I have read is in the section "Antique (Ancient)/Modern" in Le Goff (1992), pp. 21-50.

20 See "modus" in Ernout and Meillet (1967), pp. 408-09.

21 *Variae* (finished *c.* 537), 4, 51, 2; Freund (1957), p. 32. See also *ibid.* pp. 23-40 and 111. "Modernus" appears for the first time in writings by Gelasius, 494-95 AD. A synod of 494 issued a ban on giving clerical positions to men who had been born as slaves. When this ban was not adhered to, Gelasius wrote twice to the bishops requesting them to accept the modern rules as opposed to the old rules ("modernus" as opposed to "antiquus"), see Freund (1957), pp. 4-5.

22 Le Goff (1992), pp. 27-29.

23 De Beer (1948), p. 153.

24 Manetti (1887), pp. 103-04; Frankl (1960), p. 255; letter to Leo X, cited in Rowland (1994), p. 101: "Pur, questa architectura ebbe qualche ragione. Però che naque dalli arbori non anchor tagliati, delli quali, piegati li rami e rilegati insieme, fanno li lor terzi acuti." In this letter it is also claimed that Italy with its glorious past "[...] in vero è patria universale di tutti li cristiani [...]" (*ibid.*, p. 100). On bowers, see for example Vitruvius, *De architectura*, 2, 1, 2-3.

25 Filarete (1972), 13, p. 380: "Ancora a me solevano piacere questi moderni, ma poi, ch'io commenciai a gustare questi antichi, mi sone venuti in odio quelli moderni." Englsish translation from Filarete (1965), p. 175.

26 Vasari (1966-87), vol. II, p. 97; vol. III, p. 18 and vol. IV, p. 4. See also Panofsky (1960), pp. 34-35.

27 Ghiberti (1912), II, 1.

28 Sulzer (1792), p. 434: "Die Mahler vor diesem Zeitpunkt zeichneten nach einem Ideal, das nicht eine erhöhete Natur war, wie das Ideal der Griechen, sondern eine in Verhältniss und Bewegung verdorbene Natur." See also "Gotik" (1910), in Schlosser (1927), p. 289.

29 Wood (1993), p. 59.

30 *Ibid.*, p. 65.

31 Alpers (1983).

32 *Poetics*, 23, 1, 1459a.

33 Würtenberger (1958), p. 29. Jay (1993), pp. 51-53, also draws attention to the perspectival space's anti-narrative tendencies and sees very precisely, p. 61, note 129, a zone of conflict in Alpers' idea of the alliance linear perspective/narration.

34 Kant (1974), §14, p. 142: "Selbst was man Zieraten (*parerga*) nennt, d.i. dasjenige, was nicht in die ganze Vorstellung des Gegenstandes als Bastandstück innerlich, sondern nur äußerlich als Zutat gehört und das Wohlgefallen des Geschmacks vergrößert, tut dieses doch auch nur durch seinen Form: wie Einfassungen der Gemälde, oder Gewänder an Statuen, oder Säulengänge um Prachtgebäude. Besteht aber der Zierat nicht selbst in der schönen Form, ist er, wie der goldene Rahmen, bloß um durch seinen Reiz das Gemälde dem Beifall zu empfehlen angebracht: so heißt

er alsdann Schmuck, und tut der echte Schönheit Abbruch." English translation from Kant (2000), pp. 110-11. See also Derrida's comments to this in Derrida (1987), pp. 53ff.

35 Wood (1993), p. 60.

36 Colonna (1964), p. d.iii: "cum gli exquisiti parergi, Acque, fonti, monti, colli, boscheti, animali [...]." English translation from Colonna (1999), p. 61. See also Gombrich (1966), p. 149.

37 Cited in Gombrich (1966), p. 151, n. 33: "Doxi autem Ferrariensis urbanum probatur ingenium cum in justis operibus, tum maxime in illis, quae parerga vocantur. Amoena namque picturae diverticula voluptario labore consectatus, praeruptas cautes, viventia nemora, opacas perfluentium ripas, florentes rei rusticae apparatus, agricolarum laetos fervidosque labores, praeterea longissimos terrarum marisque prospectus, classes, aucupia, venationes et cuncta id genus spectatu oculis jucunda, luxurianti ac festiva manu exprimere consuevit." Translation from *ibid.*, pp. 113-14.

38 Blount (1969). See also Blount's article on "Parergy, Parergon or Parergum": "[...] an addition or access; a thing put unto, though no part of the matter, any thing that is besides the principal question, point, or purpose in hand."

39 Burckhardt (1860), vol. III, p. 796: "Als Gabe des Himmels besaß [die Italienern] [...] den Takt, die äußere Wirklichkeit nicht in alles Detail hinein, sondern nur soweit zu verfolgen, daß die höhere poetische Wahrheit nicht darunter lit."

40 Cited in Panofsky (1953), p. 2, and n. 4, p. 361 (whole text in Latin). Attribution to Rogier van der Weyden comes from Bartolomeo Fazio's reference to the painting in *De viris illustribus* (1456); see Baxandall (1971), p. 108.

41 Cited in *ibid.*, pp. 107 and 166 (Latin).

42 For this and the following, see Olwig (1996), pp. 630-33 and notes 2, 5, 9 and 10, pp. 645-46.

43 *Ibid.*, p. 633.

44 Wood (1993), p. 42; Fechner (1986), p. 21. In two letters of 1508-09 to his customer, Jakob Heller, Dürer refers routinely to the landscapes in two religious pictures (Wood (1993), p. 42).

45 In, respectively, *Della pittura* (1436) and *De re aedificatoria* (c. 1450), chapters 10-11; see Alberti (1966).

46 Leonardo: notebook G, f. 11v, Paris, Institut de France, cited in Leonardo (1939), no. 460: "Il vero modo da pratico nel figurare le ca[m]pagne o vo' dire paesi colle sua piante [...]." Pinturicchio's contract with Santa Maria de' Fossi in Perugia, cited in Baxandall (1972), p. 17.

47 By Marcantonio Michiel. See Frimmel (1888), p. 106: "El paesetto in tela cun la tempesta [...]."

48 One of the first examples of the use of the word in an art context appears in a letter sent from Lüttich (Liège) by Domenicus Lampsonius to Vasari in 1564: "[...] a dipinger' cose piu incerte, che ricercano la mano piu esercitata e sicura, quali sono paesaggi, alberi, acque, nuvole, splendori, fuochj ec." See Frey and Frey (1930), pp. 114-15, no. CDLXVII.

49 According to Osswald (1977), p. 135, the German term *Landschaft* is also the subject of broader usage than either the Italian *paesaggio* or the French *paysage*, as it overlaps the meaning of, respectively, *campagna* and *campagne*.

50 Wood (1993), pp. 38-39.

51 See also *ibid.*, p. 37.

52 For an informative survey of this genre, see Gibson (1989).

53 Cited in Fechner (1986), p. 22.

54 Gombrich (1966), p. 109. Michiel also refers to some works from Cardinal Grimani's collection as: "le molte tavolette de paesi per la maggior parte sono de mano de Alberto de Holanda." Frimmel (1888), p. 102, cited in *ibid.*, p. 109. Gombrich's idea that Italian Renaissance theoreticians were conducive to the development of the Northern landscape image is otherwise sparsely documented and seems to have been instigated by the notion of Renaissance modernity.

55 See also Giulio's pen drawing of a landscape with a watermill (reproduced in Martineau and Hope (1984), p. 252), in which the open space plays an even bigger role.

56 For a more topographical branch of this school, see, for example, Bamberg Master, *View of the Imperial and Episcopal Palace in Bamberg*, before 1487, pen and watercolour on paper, Berlin, Kupferstichkabinett, reproduced in Wood (1993), ill. 148.

57 See Fischer (1989).

58 See Wood (1993), ills. 1, 99-103 and 171-79.

59 *Ibid.*, ills. 1, 101-02 and 171-79. Strangely, Wood does not reflect on the reluctance in terms of materials.

60 *Italienische Reise*, May 13 1787: "[...] daß die Einbildungskraft aller Menchen durchaus Gegenstände, wenn sie solche bedeutend vorstellen will, höher als breiter imaginirt und dadurch dem Bilde mehr Charakter, Ernst und Würde verschafft. [...] Einbildung und Gegenwart verhalten sich wie Poesie und Prosa, jene wird die Gegenstände mächtig und Steil denken, diese sich immer in die Fläche verbreiten. Landschaftsmaler des sechzehnten Jahrhunderts gegen die unsrigen gehalten, geben das auffallendste Beispiel. Eine Zeichnung von Jodocus Momper, neben einen kniepschen Contour würden den ganzen Kontrast sichtbar machen." See Goethe (1992), p. 384. English translation from Goethe (1989), p. 249.

61 Wood (1993), p. 40.

62 *Ibid.*, pp. 36 and 105.

63 See documentation in Brown (1986), especially pp. 132ff.

64 Wölfflin (1963), pp. 273-74: "Was für romanische Empfindung so charakteristisch ist, die gegliederte Schönheit, das durchsichtige System mit klar gesonderten Teilen, ist der deutschen Kunst als Ideal zwar nicht unbekannt, aber alsbald sucht der Gedanke das Eine und Allesfüllende, wo die Systematik aufgehoben und die Selbständigkeit des Teils im ganzen untergegangen ist. [...] Und eben darin liegen auch die Voraussetzungen der nordischen Landschaftsmalerei. Man sieht nicht Baum und Hügel und Wolke für sich, sondern alles ist aufgenommen in den Atemzug der einen grossen Natur." English translation, slightly revised, from Wölfflin (1950), pp. 235-36.

65 Many of the ideas in this and the following section were introduced in Wamberg (1993), pp. 173-211.

66 Some of the first post-antique plant representations based on empirical observation are found in 13th-century British and French cathedral sculptures, for example Southwell; see Pevsner (1945).

67 Spengler (1972), pp. 92 and 508-09.

68 Panofsky (1991), pp. 53-54.

69 *Ansichten vom Niederrhein*, cited in in Frankl (1960), p. 445: "In ungeheurer Länge stehen die Gruppen schlanker Säulen da, wie die Bäume eines uralten Forstes; nur am höchsten Gipfel sind sie in eine Krone von Ästen gespalten, die sich mit ihrem Nachbar im spitzen Bogen wölbt und den Auge das ihnen folgen will, fast unerreichbar ist. Läßt sich auch schon das *Unermeßliche* des Weltalls nicht in beschränktem Raum versinnlichen, so liegt gleichwohl in diesem kühnen Emporstreben der Pfeiler und Mauern das Unaufhaltsame, welches die Einbildungskraft so leicht in das *Grenzenlose* verlängert." [Forster's italics]

70 Burke (1759), *passim*.

71 English translation from Schiller (1966), p. 214.

72 Frankl (1960), pp. 439-46. Milner states his opinions in *Essays on Gothic Architecture by the Rev. T. Warton, Rev. J. Bentham, Captain Grose and the Rev. J. Milner*, London, 1800. Panofsky (1991), pp. 53-54, also remarks on the fundamentally unlimited aspect of the serial repetition in Gothic bays.

73 Goethe, *Über Baukunst*, cited in Schlosser (1927), p. 291.

74 Filarete (1972), XIII, p. 382. English translation from Filarete (1965), p. 176.

75 Cited in Rowland (1994), Appendix 1, p. 101: "E li tedeschi, la maniera delli quali in molti luochi ancor dura, spesso per ornamento pongono un qualche figurino ranichiato e mal fatto et peggio inteso per mensola, a sostenere un travo, et altri strani animali e figure et fogliami fuor d'ogni ragione.". Rowland, who establishes Colocci as the letterwriter, reproduces the letter with philological accuracy.

76 Vasari (1966-87), vol. I, p. 367: "E così per tutte le facce et altri lore ornamanti facevano una maledizione di tabernacolini l'una sopra l'altro, con tante piramidi e punte e foglie, che, non ch'elle possano stare, pare impossibile ch'elle si possino reggere, et hanno più il modo da parer fatte di carta che di pietre o di marmi."

77 In *Le vite de' pittori*, cited in de Beer (1948), p. 153.

78 "Ordine Gottico" in *Vocabulario toscano dell'arte del disegno*, Florence 1681, p. 113: "un'infinità di piccoli tabernacoli" (cited in Schlosser (1927), p. 288) and "sottilisime colonne, e smisuramente lunghe, auuolte, e in più modi snaturate [....]" (cited in Frankl (1960), p. 343). Baldinucci's judgement is echoed in the classically-oriented Jean-François Félibien des Avaux (1658-1733), the man behind the academic genre hierarchy in France. The foreword to Félibien's collection of biographies of major architects (1687) claims that at least the Late Gothic period, influenced as it was by *délicatesse*, was overwhelmed "dans l'amas confus d'une multitude infinie d'ornements et dans une hardiesse de travail démesurée." (See *ibid.*)

79 De Hollanda (1899), pp. 28-29: "A pintura de Frandes, respondeu devagar o pintor, satisfará, senhora, geralmente a qualquer devoto, mais que nenhuma de Italia, que lhe nunca fará chorar uma só lagrima, e a de Frandes muitas; isto não polo vigor e bondade d'aquela pintura, mas pola bondade d'aquele tal devoto. A molheres parecerá bem, principalmente ás muito velhas, ou ás muito moças, e assi mesmo a fradres e a freiras, e a alguns fidalgos desmusicos da verdadeira harmonia. Pintam em Frandes propriamente pera enganar a vista exterior, ou cousas que vos alegrem ou de que não possaes dizer mal, assi como santos e profetas. O seu pintar é trapos, maçonerias, verduras de

campos, sombras d'arvores, e rios e pontes, e que chamam paisagens, e muitas feguras para cá e muitas para acolá. E tudo isto inda que pareça bem a alguns olhos, na verdade é feito sem razão nem arte, sem symetria nem proporção, sem advertencia d'escolher nem despejo, e finalmente sem nenhuma sustancia nem nervo."

80 Burke (1759), pp. 51-54 and 58-59.

81 Kant (1974), §§23-29, pp. 164-207, citation §25, p. 171: "Erhaben is das, mit welchem in Vergleichung alles andere klein ist." English translation from Kant (2000), p. 134.

82 I first presented the following ideas at Joseph Leo Koerner's session on "The Abject in Art History", College Art Association Conference in Boston, February 1996.

83 Kristeva (1982), pp. 11-12.

84 Berenson (1897), p. 47.

85 Panofsky (1946), p. 30. See also the Danish 19th-century art historian Julius Lange, in Lange (1900), pp. 1-9, in which he notes the well-balanced human body in the art of antiquity and contrasts this with the body in the art of modernity, which fluctuates unstably between the 'starved' and the bombastic: "In the one case man conceives of himself in his nothingness in relation to an infinity which lies outside of him; in the other case he gathers the idea of infinity in himself, grows and swells, as if in a feeling of his infinite right and claim. The first is Christianity, the other, for the time being, a titanic humanism; but both parts are equally alien to antiquity which conceives not at all of the human being in relation to the idea of anything infinite, but in relation to the human society in which he lives." (*Ibid.*, p. 6.)

86 The former pairs reproduced in White (1979), ills. 11-12 and 31-32.

87 Antal (1947); Burke (1986), pp. 34-36.

88 The prejudices are even repeated in Jack M. Greenstein's otherwise intriguing and well-documented reinterpretation of Alberti's *De pictura*: Masaccio as the modern visual man, Gentile as the medieval craftsman (Greenstein (1997), pp. 693-96). Greenstein short-circuits again from Gentile's selective use of ornamentation to the *whole* image plane, at the same time as he overestimates the innovation in Masaccio's focus on the external surfaces of bodies in preference to ostensibly, more archaically, bodies in their totality (see later in the present chapter). What he overlooks is, firstly, that these surfaces are indeed used to outline monumental, statuesque bodies and not how the surfaces interplay with space and atmosphere. Secondly, and more gravely, he passes over the more radically modern concept that the image has no need to deal with well-defined surfaces, but could be aimed at more amorphous phenomena such as gravel, mist, night sky, refraction of light in the atmosphere – in short, a number of the phenomena depicted by Gentile.

89 As Spengler regards the Renaissance to be a surface phenomenon, he does not have a determined eye for the conflicts in Italian pictorial art of the time, which he claims to be fundamentally controlled by a Gothic, expansive space (especially Spengler (1972), pp. 330-66). Nonetheless, he is clear about the orientation of this art towards the ideal corporeality and, in particular, he corroborates the closing and proportion-creating effect of Raphael's backgrounds (*ibid.*, p. 356).

90 Baxandall (1971), p. 91.

91 *Ibid.*, pp. 92-93 and 155-56 (Latin).

92 *Ibid.*, pp. 98-109 and 163-67 (Latin).

93 Quintilian, *Institutio Oratoria*, 10, 2, 1: "Ex his ceterisque lectione dignis auctoribus et verborum sumenda copia est et varietas figurarum et compondendi ratio, tum ad exemplum virtutum omnium mens dirigenda."

94 *Ibid.*, 12, 10, 79-80: "Sed et copia habeat, modum [...]. Sic erunt magna non nimia, sublimia non abrupta, fortia non temeraria, severa non tristia, gravia non tarda, laeta non luxuriosa, iucunda non dissoluta, grandia non tumida." See Baxandall (1971), p. 138.

95 In *De rhetorica libri*, 5, cited in Baxandall (1971), pp. 138-39.

96 Alberti (1975), II, 55. English translation from Alberti (1972), p. 90.

97 Alberti (1975), II, 33, 35 and 40. Translation from Alberti (1972), p. 71. Baxandall (1971), pp. 129-33, with citation from Isidore of Seville, *Etymologiae*, 2, 18, and its 3rd-century forerunner, Aquila, *De figuris sententiarum et elocutionis*, 18.

98 Baxandall (1971), p. 132.

99 Greenstein (1997), pp. 671 and 689-97, also stresses the innovative potential of the surface term, in that he understands it as a mediating link where the optical becomes the entrance to knowledge of the objects in the surrounding environment. Greenstein sees, however, no tension between the infinite space and the ideal body, or between the painted surface of the image and the surface of the bodies represented.

100 Alberti (1975), II, 35. Translations from Alberti (1972), p. 71.

101 Alberti (1975), II, 40.

102 This and the following passages: *ibid.*, II, 40. English translation from Alberti (1972), p. 79.

103 *Ibid.*, II, 42. Translation from Alberti (1972), p. 83.

104 For details, see Wamberg (1993), pp. 186-89.

105 Van Veen already noted in 1978 that Ghiberti's reference to the Sienese used Albertian terminology (Veen (1980), pp. 343-48).

106 Ghiberti (1912), II, 22: "[...] le quali istorie molto copiose di figure erano istorie del testamento uecchio: nelle quali mi ingegnai con ogni misura osseruare in esse cercare imitare la natura quanto a me fosse possibile, et con tutti i liniamenti che in essa potessi produrre et con egregij conponimenti et douitosi con moltissimi figure. Missi in alcuna istoria circa di figure cento; in quale istorie meno et in qual più." English translation, slightly revised, from Ghiberti (1979), pp. 66-67.

107 Ghiberti (1912), II, 11-12.

108 Petrarch mentions Simone Martini, partly because they met at the Papal court in Avignon; and in two preaching cycles, held in 1425 and 1427, Saint Bernardino Albizzeschi refers to works of patriotic significance by Simone Martini and Ambrogio Lorenzetti (Ercoli (1980), p. 317; Christiansen et al. (1988), pp. 4-7 and 35-36). In 1459 the Sienese Pope Pius II (Enea Silvio Piccolomini) declares that Simone Martini is not inferior to the Florentine painters (Ercoli (1980), p. 332).

109 Ghiberti (1912), II, 11. English translation from Ghiberti (1979), p. 37.

110 Ghiberti (1912), II, 12. English translation from Ghiberti (1979), p. 40.

111 Ghiberti (1912), II, 11. English translations from Ghiberti (1979, pp. 36-37.

112 Alberti (1975), II, 26. English translation from Alberti (1972), p. 63.

113 For example, in Savonarola, *Sermons on Ezekiel* (1497), cited in Gilbert (1980), p. 159. I am grateful
 to Maria Fabricius Hansen for this reference. The aphorism is, in one tradition, attributed to
 Cosimo de' Medici; it is also found later in Leonardo's writings.

114 Leonardo (1956), vol. 2, 2, 76 (f. 35v): "Non restero di mettere fra questi precetti una nova in-
 ventione di speculatione, la quale, ben che paia pichola e quasi degna di riso, no' di meno è di
 grande uttilità à destare lo ingegnio à varie inventioni. E quest'è, se tu riguarderai in alcuni muri
 imbrattati di varie machie, o' pietre di varij misti, se harai à inventionare qualche sito, potrai li
 vedere similitudini di diversi paesi, hornati di montagne, fiumi, sassi, alberi, pianure grande, valli
 e colli in diversi modi; anchora vi potrai vedere diverse battaglie et atti pronti di figure strane, arie
 di volti, e abitti, et infinite cose, le quali tu potrai ridure in integra e bona forma; ch'interviene
 in simili muri e misti, come del sono delle campane, che ne'loro tocchi vi troverai ogni nome e
 vocabolo, che ti'nmaginerai. Non isprezzare questo mio parere, nel quale ti si ricorda, che nò'ti
 sia grave il fermarti alcuna volta, à vedere nelle machie de muri, o' nella cenere del foco, o'nuvoli,
 o'fanghi, o'altri simili lochi, li quali, se ben fieno da te considerati, tu ti troverai dentro inventioni
 mirabilissimi [...], perche nelle cose confuse l'ingegnio si desta à nove inventioni. Ma fa prima di
 sapere ben fare tutte le membra de quelle cose, che voi figurare, come le membra delli animali,
 come le membra de paesi cioè sassi, painte e simili." English translation, slightly revised, from
 ibid., vol. 1, p. 50.

115 "[...] gli ochii mei acconciamente al piano non pativano riguardare, in tanto che omni cosa infera
 ad me apparea imperfecta." See Colonna (1964), p. 20. I am grateful to Maria Fabricius Hansen
 for having brought this passage to my attention.

116 Jay (1993).

117 Bryson (1983), pp. 89-92.

118 Damisch (1972), especially pp. 26-29 and 32-35.

119 *Ibid.*, especially pp. 29, 48, 183, 197, 206n. and 239-40.

120 *Ibid.*, especially pp. 29, 94, 99 and 201.

121 *Ibid.*, pp. 237-38, 240 and 245-46.

122 Didi-Huberman (1995).

123 *Ibid.*, especially pp. 1-22, 28-44 and 119-23.

124 *Ibid.*, especially pp. 7-8, 36 and 187.

125 Merleau-Ponty (1964), pp. 37, 57 and 72-74; Lacan (1994), pp. 93-97. Allowing for Didi-Huberman's
 and particularly Damisch's scepticism of painting's environmental connection, this influence
 seems somewhat tense, but the influence becomes comprehensible if we accept a common de-
 nominator between body/unconsciousness (Merleau-Ponty/Lacan), the mystery of incarnation
 (Didi-Huberman) and a transcendental, rupturing style (Damisch).

126 See Wölfflin (1963).

127 Cf. Sauerländer (1977), p. 127.

128 On Wölfflin's direct dissociation from Hegel, see Hart (1989), pp. 98-103. Damisch (1972), pp. 23 and 79, also stresses that Riegl's and Wölfflin's theories deal with the same thing, albeit Wölfflin's ideas are purely descriptive, Riegl's more positively theoretical.

129 Wölfflin (1963), p. 273: "Es gibt eine germanische Phantasie, die zwar die allgemeine Entwicklung vom Plastischen zum Malerischen durchmacht, aber doch von allem Anfang an stärker auf malerische Reize reagiert als die südliche. Nicht die Linie, sondern das Liniengeflecht. Nicht die festgelegte Einzelform, sondern die Formbewegung. Man glaubt auch an die Dinge, die sich nicht mit Händen fassen lassen." English translation from Wölfflin (1950), p. 235.

130 Burke (1759), pp. 213ff.; Kant (1974), §23, p. 165.

131 Panofsky (1955).

132 Bryson (1983), pp. 56-66.

133 On the escalation of meaning potentials in 18th-19th-century pictorial art, see Białostocki (1966), pp. 156-80.

Chapter 10
Time, Territory and Wilderness in Early Modern Landscape Images, I

1 Applebaum (1992), p. 253; Rösener (1992), pp. 22-23 and 44; Martines (1979), p. 2.

2 Bloch (1967), pp. 175-81; Ovitt (1987), p. 139; Le Roy Ladurie (1994), pp. 30-31.

3 *Crises agraires en Europe (XIIe-XXe siècle)*, 1973, cited in Braudel (1992), vol. III, p. 546; Rösener (1992), p. 34.

4 The situation points towards Aristotle's prophesy in *Politics* (1, 2, 4-5, 1253b-1254a): "[...] for if every tool could perform its own work when ordered, or by seeing what to do in advance, like the statues of Daedalus in the story, or the tripods of Hephaestus which the poet says 'enter self-moved the company divine,' [...] mastercraftsmen would have no need of assistants and masters no need of slaves." This intelligent obedience is certainly not fulfilled until the computers of our times, but the late medieval use of new forms of energy and new tools already constitutes a different situation from that of antiquity.

5 Ovitt (1987), p. 141; Braudel (1992), vol. II, pp. 232-33.

6 Heitland (1921), p. 456.

7 Rösener (1992), p. 28.

8 Epperlein (1976), p. 191.

9 Cited in Rösener (1992), p. 29.

10 Max Weber remarks, more generally, that the linear and aerial perspectives belong to the capitalist, rational culture, and that both are a speciality of Western culture (Weber (1920), p. 3).

11 Weber (1920), *passim*.

12 Le Goff (1977), p. 110; Rösener (1992), p. 12.

13 Ovitt (1987), pp. 151 and 158.

14 Weber (1920), pp. 63-71 and 98-201.

15 Martines (1979), pp. 17-32.

16 Interestingly, the term fails to appear in the Catholic countries. Its precursor is to be found among the Israelites who in turn took it from the industrious Egyptians (see Weber's thorough etymological discussion, Weber (1920), pp. 63ff.).

17 London, British Library, Royal ms 2B.VII. See Koseleff (1942), pp. 77-88, and Koseleff (1963), pp. 245-53.

18 Webster (1938), pp. 38, 57 and 99-102, plus cat. 53, reproduced pl. 34.

19 London, British Library, Add. ms 42130, ff. 170-173v. Camille (1987).

20 *Ibid.*, pp. 434-36.

21 *Ibid.*, pp. 447-48.

22 On the following, see Feldges (1980), *passim*; Fechner (1986), pp. 209-28; Starn (1992), pp. 11-80; and Norman (1995), vol. II, pp. 145-67.

23 Brunetto Latini: *Il tesoretto* (*c.* 1263) and *Li livres dou tresor* (1260s). Local Sienese texts included, presumably, *Breves officialum communis sienesis* (1250) and the civic constitution in both its original Latin version of 1262 and the extended volgare version of 1309-10. The late medieval source has been deciphered by, in particular, Quentin Skinner (1986) and is quoted in Starn (1992), pp. 33-46, and Norman (1995), pp. 156ff. As Starn notes, however, many of the text fragments do not need to be used directly, but can exemplify traditions which were, to the same extent or more, handed down orally.

24 According to Starn (1992), pp. 43-45, this is the only positively verifiable Aristotelian-Thomistic reference in Lorenzetti's entire programme. Albeit extremely simplified (or misunderstood) it refers to Thomas Aquinas' discussion of the distribution and exchange of material goods in *Summa Theologica*, derived from Robert Grosseteste's translation of Aristotle's *Ethics* (*c.* 1250).

25 Inspired by Pächt, Starn presumes that, in order to make the agricultural scenes harmonise with the personified seasons, only the spring and summer months (March-September) are represented on the east wall, as there is an alleged absence of markedly autumn and winter activities such as wine-making (October), tree pruning and pig fattening (November) and pig slaughtering (December). This would seem to be something of a misrepresentation as at least two of the activities that are actually present – tilling and sowing – are tasks which in Italian calendar images are typically connected with October-November (see Starn (1992), p. 53 and cf. Webster (1938), p. 176).

26 Cited in Huizinga (1990), p. 128.

27 Langland (1992), Passus VII, p. 75. See also Passus VI, especially pp. 68-72.

28 Feldges (1980), p. 63: "daß Ambrogio mit einer tausendjährigen Tradition von Felslandschaften brechen und, im Sinn eines neuzeitlichen Geniebegriffs, eigenständig ganz neue Formen hätte entwickeln können."

29 Norman (1995), vol. I, pp. 135-36, reproduced in *ibid.*, p. 137.

30 Feldges (1980), pp. 30-31; Norman (1995), vol. I, p. 137.

31 Perrig (1987), p. 42, is of course on completely the wrong track when he attributes the bareness of the rocks to a Sienese burning of the Montemassi fields. It is not possible to burn off something that has not previously existed.

32 Norman (1995), vol. I, p. 139. The nail hole and marks of slipping made by the frequently rotated map are still visible on the wall.

33 Le Goff (1977), pp. 67-78. English translations in Le Goff (1980), p. 50.

34 Spengler (1972), p. 175: "Ohne peinlichste Zeitmessung – eine *Chronologie des Geschehenden*, die durchaus unserm ungeheuren Bedürfnis nach Archäologie, das heißt Erhaltung, Ausgrabung, Sammlung alles Geschehenen entspricht – ist der abendländische Mensch nicht denkbar." English translation in Spengler (1971), p. 134.

35 In relation to this and the following, see Le Goff (1977), pp. 67-78; Weber (1920), p. 168, corroborates the conclusion that the capitalist temporal rhythm originated in the monasteries and convents.

36 Spengler (1972), pp. 19 and 175, stresses the symbolic significance of the clock for Western culture as distinct to that of antiquity.

37 "[...] du mestier de draperie et autres mestiers où il convient plusieurs ouvriers ad journee alans et renans à l'oeuvre à certains heures [...]", cited in Le Goff (1977), p. 70. English translation in Le Goff (1980), p. 46.

38 Le Goff (1977), p. 78. English translation in Le Goff (1980), p. 50.

39 Le Goff (1977), p. 78. English translation in Le Goff (1980), p. 52.

40 Ghiberti (1912), II, 11, p. 41: "[...] si muoue una turbatione di tempo scuro con molta grandine saette tuoni tremuoti, pare a uederla dipinta pericoli el cielo e'lla terra [...]." English translation in Ghiberti (1974), p. 37.

41 The latter reproduced in colour in Frugoni (1988), ill. 68.

42 For the following, see Smart (1977).

43 Taddeo's letter is preserved, along with Fra Simone's reply, in the latter's *Epistolarum Fratris Symonis de Cascia*. Cited and discussed in Smart (1977), pp. 404-05. One of Taddeo's lamentations: "For from days not long past I have suffered, and still suffer, from an unendurable infirmity of the eyes, which has been occasioned by my own folly. For while, this year, the sun was in eclipse I looked at the sun itself for a long period of time, and hence the infirmity to which I have just referred. For I constantly have clouds before my eyes which impede the vigor of my sight."

44 *Cronaca* XI, XCIX, cited in *ibid.*, p. 412.

45 See Meiss (1951), pp. 23 and 70-71.

46 Fechner (1986), pp. 242-46.

47 Panofsky (1953) vol. I, pp. 33-34; Le Roy Ladurie (1994), p. 48. *Petites Heures du Duc de Berry*, Paris, Bibliotèque Nationale, ms lat. 18014.

48 Harvey (1991), p. 7.

49 Harvey (1980), p. 72. A more accurate map of Rome after the first in the genre, probably from the 12th century, has been dated to 1280 and is included in three out of four versions of Paolino Veneto's *Magna Chronologia* from the 1320s and 1330s.

50 Fabricius Hansen (1999), pp. 68-74.

51 Feldges (1980), pp. 11-12.

52 Vatican Library, ms Pal. lat. 1993; Feldges (1980), p. 12.

53 Cahn (1991).

54 *Ibid.*, p. 22.

55 Grant (1974), pp. 657-59. The treatise's illustrations of birdlife and hunting scenes were added
 during the reign of Frederick's son Manfred (reigned 1254-66).

56 On the following, see Pächt (1950), pp. 13-47.

57 On the following, see Cogliati Arano (1976).

58 See also, Le Roy Ladurie (1994), p. 56.

59 Paris, Bibliothèque Nationale, ms lat. 6977A, f. 103; Rome, Biblioteca Casanatense, Theatrum
 Sanitatis, ms 4182, f. 45, Cogliati Arano (1976), pls. XLV and 153. Pächt (1950) states, p. 37, that the
 seasons have only been depicted once before in this non-allegorical way: in the two Winchester
 manuscripts from the beginning of the 12th century, with echoes from the Carolingian tradition,
 British Museum, mss Cotton Julius A.VI and Tiberius B.V.

60 See also Cogliati Arano (1976), pls. 202, 236 and 238.

61 Fechner (1986), pp. 179-80.

62 Spengler (1972), pp. 508-09, corroborates the significance of this approach to the forest for the
 Faustian world view, and sees it expressed particularly in Gothic architecture.

63 Fechner (1986), p. 240; Pächt (1950), p. 38; Steingräber (1985), p. 66.

64 On the following, see: Longnon, Cazelles and Meiss (1969); Alexander (1990), pp. 436-52.

65 Alexander (1990), C. 440, with citation from Froissart's *Chronicles* (ed. C. Brereton, 1968).

66 *Ibid.*, pp. 451-52, where it is stressed, however, that the accuracy of the detail only applies to the
 architectural features of the building and not its surroundings.

67 *Ibid.*, p. 440, sees the castles as expressive of the peasants' subjugation to "a gaze that is contemp-
 tuous and not without fear".

68 Avril (1978), pp. 76-79, with colour reproductions.

69 *Ibid.*, pp. 96-99, with colour reproductions.

70 Even though the landscape was in all probability completed by Belbello da Pavia in the 1430s, at
 the same time as the initial-scene of the *Creation of Eve*, the style suggests that the outlines were
 drawn by Giovannino dei Grassi's workshop.

71 The miniature's innovations are excellently described by Gisèle Lambert in Le Roy Ladurie (1994),
 cat. 9, pp. 40-41.

72 *Works by Christine de Pisan*, Paris, Bibliothèque Nationale, ms fr. 606, reproduced in Thomas (1979),
 pl. 18. In the Limbourg brothers *Les Belles Heures de Duc de Berry* (c. 1408-09) half the miniature is
 concluded by a Gothic ornamental sky and half by a blue sky (reproduced in Meiss and Beatson
 (1974)). In their *Les Très Riches Heures* (c. 1410-16) only the small images at the beginning have
 ornamental sky, while the rest have an atmospheric sky.

73 Ruskin (1873), vol. III, p. 261.

74 Breustedt (1966), pp. 5-6 and 53.

75 Painted on the sportello part of a tabernacle containing the head of the local Saint Fina; dated 1402.

76 Cited in Baxandall (1971), pp. 105 and 164-65 (Latin): "Pinxit item en eadem urbe turbinem arbores caeteraque id genus radicitus evertentem, cuius est ea facies, ut vel prospicientibus horrorem ac metum incutiat."

77 Zeri (1987), p. 122.

78 F. 161v.

Chapter 11
Time, Territory and Wilderness in Early Modern Landscape Images, II

1 *Het Schilder-Boeck's* first and theoretical part, *Den Grondt der Edel Vry Schilder-const*, ch. 8, 29 and 30-31, cited in Brown (1986), p. 40.

2 *Den Grondt der Edel Vry Schilder-const*, ch. 8, 41, 44 and 46.

3 Weber (1920), *passim*, particularly pp. 1-37, 84-95 and 164ff.

4 *Ibid.*, pp. 189-90 and 196-99.

5 Of this myth, see Baron (1955).

6 Le Goff (1977), p. 113. Spengler (1972), pp. 349-50, also corroborates the connection between the Italian Renaissance and a court culture weak in development of state.

7 Le Roy Ladurie (1994), pp. 14-18; *ibid.*, p. 18: "Cette immense respiration multiséculaire d'une structure sociale [...]." Braudel (1992), vol. II, pp. 265-72. See also Cosgrove (1998), pp. 52, 70, 76, 80-82 and 87; Coles (1952); and Cipolla (1952).

8 An example: when, in 1913-14, Henry Clay Frick, the American coke and steel industrialist, had a mansion built in New York to house his art collection, the panels were bordered with gilt corn sheaves, a discrete reminder of the labour that had made his collection possible.

9 *Metamorphoses*, 116-20.

10 Carus (1955), p. 38: "Darstellung einer gewissen Stimmung des Gemütslebens (Sinn) durch die Nachbildung einer entsprechenden Stimmung des Naturlebens (Wahrheit)".

11 Panofsky (1955a), p. 85, and Koerner (1993), p. 201; Koerner, pp. 264-73 and 292-316 in *ibid.*, discusses other aspects of the myth of the Fall which, although here applied in relation to Hans Baldung Grien, are of potentially macrohistorical interest.

12 The link between melancholy and imaginative ability is presented in the *Nicomachean Ethics,* 1150b 25 and in *Problems,* 30, 1.

13 See Klibansky, Panofsky and Saxl (1964), especially pp. 15-41 and 338-41.

14 Alberti (1960-73), vol. II (1966), Libro II, p. 87: "Vedi la terra ora vestita di fiori, ora grave di pomi e frutti, ora nuda senza sue fronde e chiome, ora squallida e orrida pe' ghiacci e per la neve canute le fronti e summità de' monti e delle piaggie. E quanto pronto vediamo ora niuna, come dicea

Mannilio poeta, segue mai simile a una altra ora, non agli animi degli uomini solo, quali mo lieti, poi tristi, indi irati, poi pieni di sospetti e simili perturbazioni, ma ancora alla tutta universa natura, caldo el dì, freddo la notte, lucido la mattina, fusco la sera, testé vento, subito quieto, poi sereno, poi pioggie, fulgori, tuoni, e così sempre di varietà in nuove varietà."

15 Spengler (1972), p. 84, emphasises the continuity in Faustian, contrapunctual music.

16 Serres (1989), pp. 333-40.

17 Hegel (1970) vol. II, pp. 140-41: "Das Innere in diesem Verhältnis, so auf die Spitze hinausgetrieben, ist die äußerlichkeitslose Äußerung, unsichtbar gleichsam nur sich selber vernehmend, ein Tönen als solches, ohne Gegenständlichkeit und Gestalt, ein Schweben über den Waßern, ein Klingen über einer Welt, welche in ihren und an ihren heterogenen Erscheinungen nur einen Gegenschein dieses Insichseins der Seele aufnehmen und widerspiegeln kann."

18 Spengler (1972), p. 230: "[...] körperlose Reiche von Tonen, Tonräume, Tonmeere; das Orchester brandet, schlägt Wellen, verebbt; es malt Fernen, Lichter, Schatten, Stürme, ziehende Wolken, Blitze, Farben von vollkommener Jenseitigkeit; man denke an die Landschaften der Instrumentation Glucks und Beethovens." See also *ibid.*, pp. 66, 119 and 298-99. English translation, here slightly revised, from Spengler (1971), p. 177.

19 *De rerum natura*, 6, 1119ff.

20 Boccaccio (1511), 8, 1, f. 61: "Tandem dum sic in pendulo essem; et ecce ex orientali oceano quasi se ab inferis in altum efferens; tardum atque nubilum sidus visum est; Stygia velatum caligine. Quod dum nebulis imixtum intuerer; memor præceptoque venerabilis Andalo: odiosum atque nocivum Saturni astrum fore cognovi." The Genoese traveller, geographer and astronomer Andalò di Negro was Boccaccio's friend and consultant in astrological matters. See also Klibansky, Panofsky and Saxl (1964), pp. 174-76.

21 Carus (1955), p. 92: "Alles, was in des Menschen Brust widerklingt, ein Verhellen und Verfinstern, ein Entwickeln und Auflösen, ein Bilden und Zerstören, alles schwebt in den zarten Gebilden der Wolkenregionen vor unsern Sinnen; und auf die rechte Weise aufgefaßt, durch den Kunstgenius vergeistigt, erregt es wunderbar selbst das Gemüt, an welchem diese Erscheinungen in der Wirklichkeit unbemerkt vorübergleiten." See also Wedewer (1980), p. 39. Also Spengler (1972), pp. 309-10, notes the significance of clouds for the Faustian painting.

22 Cited in Parris and Fleming-Williams (1991), pp. 228-29.

23 *Laws*, 663b.

24 Damisch (1972), especially pp. 14-15, 22-23 and 190-92.

25 For Spengler (1972), pp. 322-23, visible brushwork in particular is a sign of becoming, and thereby of Western, historical sensibility.

26 Panofsky (1953), vol. I, pp. 232-43.

27 Colour reproduction in Hartt (1987), colorpl. 27.

28 Eisler (1989), *passim*, colour reproduction in *ibid.*, Fig. 31.

29 Cited in Baxandall (1963), pp. 320-21.

30 Cited in Baxandall (1971), pp. 97 and 161 (Latin).

31 Cited in *ibid.*, pp. 93 and 156 (Latin).

32 Florence, Museo di San Marco; reproduced in Pope-Hennessy (1974), pl. 25.

33 For other examples, see Christiansen et al. (1989).

34 A Netherlandish parallel to the gaze at the sun could be Rogier van der Weyden's *Saint Columba Altarpiece* (c. 1458-59; Munich, Alte Pinakothek) in which the guiding star shines forth from behind the roof of a stable – the ruins of a church; reproduced in Panofsky (1953), vol. II, pl. 213.

35 See Breustedt (1966), p. 15. Bouts further develops the sunrise motif in *Saint Christopher*, reproduced in *ibid.*, fig. 434.

36 London, National Gallery, reproduced in Panofsky (1953), vol. II, pl. 290. Breustedt (1966) provides a complete catalogue of Netherlandish nocturnal images up until c. 1520/30.

37 Examples of other early Italian nocturnal images: several *Nativity* scenes by Lorenzo Monaco, Giovanni di Paolo and Benozzo Gozzoli (the last two in the Vatican Pinacoteca), but none have a convincing darkness (see Breustedt (1966), pp. 59-65).

38 Predella, Vatican, Pinacoteca. Gentile da Fabriano paints the same motif in the 1420s (also in the Vatican Pinacoteca).

39 Colour reproduction in Hartt (1987), colorpl. 62.

40 A few examples among many: Masaccio, *Rendering of the Tribute Money* (c. 1425; Florence, Brancacci Chapel, Santa Maria del Carmine); Filippo Lippi, *Adoration in the Forest* (c. 1459; Berlin, Staatliche Museen, Gemäldegalerie); Mantegna, *Crucifixion* (1457-59; Paris, Musée du Louvre); Perugino, *Crucifixion with the Virgin, Saint John, Saint Jerome, and Saint Mary Magdalene* (1482-85; Washington, National Gallery).

41 Spengler (1972), pp. 323-27, sees the studio-brown tone typical of so many European paintings from the 16th to the 19th century as being particularly atmospheric and suggestive of infinity, and thereby as an expression congenial to Protestantism. In my opinion, it is more a case of a 'contamination' from the *chiaroscuro*-look of Renaissance nocturnal clouds, a brown colouring that is just as alien to the still Renaissance-free 15th century as it is to 19th-century reactions against the academy: the Pre-Raphaelites and the Impressionists.

42 Damisch (1972), pp. 27-29. In *ibid.*, p. 194, he acknowledges that Leonardo's *sfumato* does not allow space for /cloud/ as an autonomous indication of style.

43 Cited in Hussey (1967), p. 43.

44 Respectively: Paris, Institut de France, B.N. 2038 (Ash. I) (1492), f. 22v, cited in Leonardo (1939), vol. I, 294, p. 235 ("prospettiva del variare e perdere over diminuire la propria essentia de' colori"); B.N. 2038, f. 25v, cited in *ibid.*, 295, p. 235.

45 Of Leonardo's *sfumato*, Spengler (1972), p. 356, states that it is: "das erste Zeichen einer Verleugnung der Körpergrenzen um des *Raumes* zu willen. Von hier geht der Impressionismus aus."

46 See Leonardo (1989), pp. 161-68. Damisch (1972), pp. 215-19, also notes Leonardo's interest in the phenomena of non-linear colour, light and atmosphere.

47 Damisch (1972), p. 192, also notes Leonardo's interest for forceful weather phenomena, which are other challengers to the linear order.

48 Chapter 66: "Come si deve figurar' una fortuna." The observation of the ambiguity of the term is made by Bätschmann (1990), p. 102. A storm is still called *fortunale* in Italian today.

49 Panofsky (1951b), pp. 36ff.; Damisch (1972), pp. 180-83.

50 *Adagia*, 2. Ch., 4. Cent., no. 38, cited in Panofsky (1951b), pp. 41 and 39, respectively. As early as Pliny, Apelles was associated with unpaintable topics such as "thunder, lightning and thunderbolts" (*Naturalis historia*, 35, 96, cited in *ibid.*, p. 36).

51 *De architectura*, 2, 1. Forest fire is also described by Pliny and Lucretius.

52 *Selve*, 1, 6, Lorenzo de' Medici (1939), vol.1, p. 244: "Ma, se dá libertá dalla spelonca/ Eolo a'venti tempestosi e féri,/ non solamente i verdi rami tronca,/ man vanno a terra i vecchi pini interi;/ i miser legni con la prora adonca/ minaccia il mare irato, e par disperi;/ l'aria di folte nebbie prende un velo;/ cosí si duol la terra, il mare e'l cielo." See also Turner (1966), pp. 48-49.

53 Damisch (1972), p. 197, quite appropriately places the "threatening" clouds in this painting (and its 16th-century successors) in inverted commas.

54 Settis (1983), particularly pp. 132ff.

55 Amadeo similarly shows these figures against a background of trees and buildings.

56 Other examples of close juxtaposition of heavens and earth at the beginning of the 16th century include: *Ascensions*: Rosso Fiorentino, *Ascension of the Virgin* (1517), Florence, Santissima Annunziata; Andrea del Sarto, same theme (1526-29), Florence, Palazzo Pitti; Titian, same theme (1516-18), Venice, Santa Maria Gloriosa dei Frari. *Gods manifest in matter*: Titian, *Danaë and the Shower of Gold* (1554), Madrid, Prado. *Witnesses from the heavens*: Beccafumi, *Stigmatisation of Saint Catherine* (c. 1518), Siena, Pinacoteca Nazionale; Perino del Vaga, *Nativity* (1534), Washington, National Gallery; Correggio, *Adoration of the Shepherds* (1522), Dresden, Gemäldegalerie. *Visions*: Parmigianino, *Vision of Saint Jerome* (1526-27), London, National Gallery. *Instances of fall*: Perino del Vaga, *Fall of the Giants* (c. 1529), Genoa, Palazzo del Principe; Beccafumi, *Saint Michael and the Fallen Angels* (c. 1524), Siena, Pinacoteca Nazionale. Also Damisch (1972), p. 113, notes the important function of clouds in 16th-17th-century scenes of revelation, but given that he considers the /cloud/function as allied with a transcendence in relation to that which is visible and physical, he is not inclined to perceive these revelatory clouds as a safeguard against modernity, but on the contrary as the most sophisticated visual sign of the period.

57 Of the rarity and late arrival of tempests in Poussin, see Bätschmann (1990), pp. 97-102. Besides *Winter*, Poussin only executed two paintings with storm scenes, both in 1651: *Landscape with Pyramus and Thisbe* (Frankfurt) and *Landscape with Storm* (Rouen). Bätschmann also observes a growing interest in meteorological phenomena during the 17th century, both in the sciences and the arts.

58 *Het Schilder-Boeck*, I, 8, 3-5, 7-8, 10, 12-15, cited in Brown (1986), pp. 37-38. Van Mander's ideas are later repeated in Joachim von Sandrart's *Teutsche Academie* (1675-79). Here the tired art academy pupil is advised to draw landscapes, aerial perspective and the rising and setting of the sun. Sandrart asks them to note that the landscape's colours are particularly beautiful after rain, during a thunderstorm and in the autumn (see Bramsen (1990), p. 208).

59 Ovid, *Metamorphoses* 1, 123-24 and 135-36.

60 Ernout and Meillet (1967), p. 408. The cognate term *modius* was a spatial measurement for cereal crops, pulses, etc.

61 8, 8, cited in Brown (1986), p. 37.

62 Rösener (1992), pp. 102 and 109. See also Le Roy Ladurie (1994), pp. 30-31.

63 See de Bruyne (1946), pp. 41-42; Pochat (1973), pp. 116-18; Busch (1997), pp. 41-42. In John of Garland's *Parisiana Poetria* we read, for example: "Thus there are three styles in accordance with the three ranks of humankind; the humble style suits the shepherds; the mediocre suits the peasants; the grave suits those who are above shepherds and peasants." ("Item sunt tres styli secundum tres status hominum; pastorali vitae convenit stylus humilis, agricolis mediocris, gravis gravibus personis quae praesunt pastoribus et agricolis.") (Cited in de Bruyne (1946), p. 42.)

64 It is perhaps also telling that *centuria*, the agrimensores' unit of land measurement, has etymological cognation with the English *century*.

65 See Klibansky, Panofsky and Saxl (1964), pp. 204-09; Filedt Kok (1985), pp. 221-22; von Meyenburg (1991), p. 85.

66 Klibansky, Panofsky and Saxl (1964), pp. 333-34.

67 Discussed in *Der Bauer und seine Befreiung* (1975), p. 51.

68 The latter reproduced in Hartt (1987), ill. 265.

69 London, National Gallery; Florence, Uffizi; Paris, Louvre.

70 The same rationale presumably lies behind the yellow, green and brown fields in Roger van der Weyden's version of the theme (*c.* 1432-35), Washington, National Gallery of Art. It is, in addition, hardly immaterial that the saint was martyred at the beginning of the 4th century, the climax of late antique interest in agriculture.

71 Falkenburg (1988), pp. 16 and 42; Meiss (1969), p. 195; Berger (1985), p. 90; Baring and Cashford (1991), pp. 577-78.

72 Otherwise, for example, the following numbers in Gibson (1989): 1, 3 (Patinir, *Flight...*, Antwerp, Koninklijk Museum voor Schone Kunsten); 1, 28 (Workshop of Joachim Patinir, *Rest...*, Antwerp, Museum Ridder Smidt van Gelder); 1, 34 (Master of the Female Half-lengths, *Rest...*, Vienna, Kunsthistorisches Museum; 2, 6 (Lucas Gassel, *Flight...* (1542), Maastricht, Bonnefantenmuseum); 2, 67 (Mathys Cock (?), *Rest...*, Antwerp, Museum Mayer van den Bergh). See also Jean Colombe's *Flight...* in *Les Très Riches Heures* (before 1485), f. 57.

73 Cited in Baxandall (1971), pp. 93 and 155.

74 For the following, see Campbell (1997), pp. 31-36 and 40-42.

75 In Joannes Tzetzes' *scholion* on Hesiod's *Works and Days*, *c.* 1135; see Nigel Wilson in Molfino and Natale (1991), vol. I, p. 83.

76 Letter quoted in Baxandall (1971), pp. 89-90 (English), pp. 158-59 (Latin). Two other muses also change identity on this occasion: Melpomene from tragedy to vocal melody, Erato from lyric poetry to matrimony and the duties of love (Campbell (1997), p. 31).

77 On the Good Government, see Jaynie Anderson in Molfino and Natale (1991), p. 174; on a more general fertility, see Campbell (1997), p. 42.

78 Jaynie Anderson in Molfino and Natale (1991), vol. II, pp. 165-87.

79 See the relevant close-ups in Varese (1989), pp. 376-81. On the astrological iconography of the cycle, see Warburg (1932), vol. II, pp. 459-81.

80 See also the brutally hacked branches in Alesso Badovinetti's *Nativity* (1460-62), Florence, Santissima Annunziata, reproduced in Hartt (1987), ill. 318.

81 Saint Jerome's forest-worker iconography can also be seen in Jacopo del Sellaio's version of the motif (*c*. 1480; Washington, National Gallery) – here the hermit forest worker's axe is still stuck into one of the trees that has yet to be felled by its blade.

82 Le Goff (1977), p. 139.

83 Berlin, Kupferstichkabinett, pen, watercolour and gouache on paper, reproduced in Wood (1993), fig. 1.

84 A prominent example of one such can be seen in the background of the *Sleeping Venus* by Giorgione and Titian (*c*. 1505-10), Dresden, Gemäldegalerie.

85 Epperlein (1976), pp. 200 and 205 and Abb. 6.

86 The observation with regard to the Master of the Housebook and Schongauer is made by Ernst Ullmann in *Der Bauer und seine Befreiung* (1975), p. 27. For illustrations, see *ibid.*, pp. 39-50.

87 On Crescenzi, see Saltini (1979), pp. 51-57; Le Roy Ladurie (1994), p. 44. The popularity of the treatise is demonstrated by, for example, the fact that there are 26 extant illuminated copies (see Le Roy Ladurie (1994), p. 44).

88 III, conclusion, cited in Epperlein (1976), p. 203: "Die Reichen werden herabstürzen, die Armen aber aufsteigen und zu Reichtümern gelangen."

89 See *Der Bauer und seine Befreiung* (1975), pp. 52-53 and Epperlein (1976), pp. 205-06. The edition has 261 woodcuts in all.

90 Smith (1992), p. 8.

91 See also Applebaum (1992), p. 322.

92 On Aertsen, Beuckelaer and Protestantism, see Moxey (1977). On Brueghel's peasants and the reformed Erasmian Catholicism, see Sullivan (1994).

93 Ficino apropos Plotin's *Enneads*, 1, 6, 7, cited in Wind (1958), p. 107: "Animus affectibus ad materiam quasi nubibus procul expulsis ad intellectualis pulchritudinis lumen extemplo convertitur." Boccaccio, *Genealogia deorum gentilium* (12, 62), also refers to Mercury as expelling the clouds of the mind (see Wind (1958)).

94 See also Watson (1979), pls. 30-36 and 38-39.

95 On the following, see *ibid.*, pp. 52-60. See also the garden of vanity in Andrea da Firenze's *Way to Salvation* (1366-68) in the Florentine Santa Maria Novella (Cappella degli Spagnuoli).

96 Clark (1949), p. 3.

97 "O anima, perchè, perchè non pensi/ Che Morte ti torra quel vestimento/ In che tu senti corporal dilecto/ Per la vertù de suoi cinque sensi." Cited in Watson (1979), p. 143.

98 *Il Tesoretto*, 21, see Latini (1788), p. 261: "Come 'n calen di maggio,/ Passati e valli e monti,/ E boschi e selve e ponti,/ I' giunsi 'n un bel prato/ Fiorito d'ogni lato,/ Lo più ricco del mondo./ Ma or mi

parea tondo,/ Or avìa quadratura;/ Or avìa l'aria scura,/ Or è chiara e lucente;/ Or veggio molta gente,/ Or non veggio persone. [...] Così da ogne canto/ Vedea sollazzo e pianto." English translation, slightly modified, from Watson (1979), p. 30.

99 *Epithalamium de nuptiis Honorii Augusti*, 3, 49-85.

100 Lorris: 635-42; Petrarch: 4, 101-5 and 121-23; Boccaccio, *Decameron*: 3; *Teseida*: 7, 51-35; see Watson (1979), pp. 28-33.

101 Tour de la Garde-Robe. See Börsch-Supan (1967), pp. 220-22.

102 See also the animal paddock in Sano di Pietro's *Nativity*, Barbara Piasecka Johnson Collection, reproduced in Christiansen et al. (1989), p. 181.

103 On the following, see Guldan (1966), pp. 36-39.

104 Of Eve's connection to the Great Goddess in general, see Baring and Cashford (1993), pp. 486-546.

105 *Oratio*, 6 (5) from *SS. Deiparae Visitationem*, 16, *Patrologia Graeca*, 127, 675-78, cited in Guldan (1966), p. 37.

106 Of this iconographical tradition, see the excellent survey in Falkenburg (1988), pp. 24-26.

107 The terms are coined in, respectively, Jacob of Serugh (*Carmen de Beata Virgine Maria*) and Andrew of Crete (*Oratio*, 5, *Annuntiationem Beatae Mariae*, *Patrologia Graeca*, 97, 895-96), cited in Guldan (1966), p. 37.

108 Boccaccio (1963), 32, 15-16, p. 124: "O ninfe, abbiate ora compassione alle mie noie! Poi che egli ha gran parte della notte tirata con queste ciance, gli orti di Venere invano si fatica di cultivare; e cercante con vecchio bomere fendere la terra di quelli disiderante i graziosi semi, lavora indarno [...]."

109 *Comento sopra alcuni de' suoi sonetti*, Lorenzo de'Medici (1939), vol. I, p. 42: "Perché 'paradiso', chiunque rettamente vuole diffinire, non vuol dir altro che un giardino amenissimo, abbondante di tutte le cose piacevoli e dilettevoli, d'arbori, di pomi, di fiori, acque vive e correnti, canti d'uccelli, ed in effetto di tutte le amenità che può pensare il cuore dell'uomo; e per questo si verifica che paradiso era ove era sí bella donna, perché qui era copia d'ogni amenità e dolcezza, che un gentil cuore può desiderare."

110 See also Bellini's *Madonna with Blessing Child* (1510), Milan, Brera, and his *Madonna of the Meadow* (c. 1505), London, National Gallery.

111 The territorial markers suppressed in this way also include an aspect of 15th-century painting I have not pursued: references to authentic topography. On this subject, Gibbons (1977) notes that Bellini's topographic references disappear in his post-1500 High Renaissance period (p. 183).

112 9, 4, Alberti (1966), vol. II, p. 805: "Cumque pictura ut poetica varia sit – alia quae maximorum gesta principium dignissima memoratu, alia quae privatorum civium mores, alia quae aratoriam vitam exprimat –, prima illa, quae maiestatem habet, publicis et praestantissimorum operibus adhibebitur; secunda vero privatorum civium parietibus, ornamento ut sit, appingetur; ultima ortis maxime conveniet, quod omnium sit ea quidem iocundissima. Hilarescimus maiorem in modum animis, cum pictas videmus amoenitates regionum et portus et piscationes et venationes

et natationes et agrestium ludos et frondosa." English translation, slightly modified, from Alberti (1988), p. 299.

113 Hay and Law (1989), pp. 53-55.

114 See Maisak (1981), pp. 46-47.

115 *Ibid.*, p. 47.

116 Heitland (1921), pp. 9-10, 50 and 121-23.

117 Maisak (1981), p. 28.

118 Ovid, *Fasti*, 2, 271-89; Schama (1995), pp. 526-29.

119 See Sannazaro (1961). For the following, also Maisak (1981), pp. 59-66.

120 According to Braudel (1992), vol. II, p. 393, the collapse of the Florentine banking empire was already underway after the fall of the Bardi family in 1345.

121 Ficino (1576), vol. I, pp. 843-44. Letter translated into French in Chastel (1959), p. 228.

122 This observation is made in Haaning (1998), p. 50.

123 Pochat (1967), pp. 92-105. Pochat's contribution mainly consists of proof for an interpretation submitted in Brummer (1964), pp. 55-67. Before this, Chastel (1954), *passim*, and Chastel (1959), pp. 226-33, had also presented significant literary material, particularly by Ficino and Lorenzo de' Medici, but without showing how it was used more explicitly in the picture. For a thorough examination of the various readings of this picture, see Hauser (1999). In Brockhaus (1933), pp. 397-416, one of the tarot series is quite unfoundedly linked to the Mantuan princely congress of 1459-60, at which the cards supposedly kept Pius II and Nicholas of Cusa entertained!

124 *Altercazione*, II, 1-40, see Lorenzo il Magnifico (1939), pp. 41-42. Vv. 37-39: "Maraviglia di te, pastor, non aggio/ ché spesso insieme ci troviamo al fonte,/ e talor sotto qualche ombroso faggio." ("I am not surprised, shepherd, to see you here, since we have often met one another by the spring, or sometimes under some shady beech tree.") Chastel already refers to Ficino in the figure of a shepherd, but without connecting the role with this painting (Chastel (1954), pp. 28 and 36, n. 47).

125 Plato, *Phaedrus*, 259d.

126 Hauser (1999), p. 263, maps some, but not all of the lines. My observations on this linear game were first published in Wamberg (1998).

127 Ficino (1576), vol. II, p. 1283 ("In Platonis Ionem [...]"):"Iupiter quidem mens Dei est, ab hac Apollo, mens animæ mundi, & anima totius mundi, octo sphærarum coelestium animæ, quæ novem musæ vocantur, quia dum coelos harmonicæ movent, Musicam pariunt melodiam, quæ in novem distributa sonos, octo scilicet sphærarum tonos, & unum omnium concentum, novem Sirenes Deo canentes producuit." ("Jupiter is God's spirit. From him originates Apollo, the spirit of the world soul and the soul of the whole universe, together with the eight celestial orbs – in total nine souls known as the nine muses, because they, while harmonically moving the heavens, bring forth music and melody which, divided into nine tones (eight sphere tones and the sound of the whole), produce nine sirens who sing in God's honour.") For a French translation, see Chastel (1954), p. 137. Hauser (1999), unconvincingly, reads Calliope as Syrinx and Hermes as Daphnis.

128 In, for example, Franchino Gafurio's *Practica musice*, Milan 1496 (republished in 1518 as *De harmonica musicorum instrumentorum opus*). See Seznec (1953), pp. 135-43, with Gafurio's chart of Apollo, the planets, the muses and musical keys, reproduced *ibid.*, p. 135.

129 Ficino (1576), vol. II, p. 1283 ("In Platonis Ionem [...]"): "Calliope Musa vox est, ex omnibus saltans sphærarum vocibus." ("The muse Calliope is a voice brought forth by all the voices of the spheres.") *Ibid.*, p. 1383 ("In Phædrum [...]": "Allegoria fabulæ de cicadis, musis, dæmonibus"): "Musæ vero ad coelestes sphæras pertinere putantur. Sic modo Calliope quidem fit anima mundi." ("The muses are indeed believed to belong to the celestial spheres. Thus Calliope becomes the world soul.") About the unusual aspect of this, see the brilliant study of Ficino's *Phaedrus* commentary in Allen (1984), pp. 29-30.

130 Hauser (1999) reads the recumbent figure as a close relative: Eros.

131 Observed by Hauser (1999), pp. 256-58, with reference to a 15th-century manuscript of *Trionfi* in Paris, Bibliothèque de l'Arsenal, ms 5056 (reproduced *ibid.*, Fig. 4).

132 *Phaedrus*, 263d: "Upon my word, you rate the nymphs of Achelous and Pan, son of Hermes, much higher as artists in oratory than Lysias, son of Cephalus." Ficino (1576), vol. II, p. 1384 (Cap. 39: "Officium scriptoris, Dionysius, Musæ, Pan, Nymphæ."): "Dionysus, the muses, Pan and the nymphs inspire Socrates. Dionysus supplies the wakening of the mind, the muses poetry, Pan eloquence, the nymphs variation." ("Dionysius, Musæ, Pan, Nymphæ, Socratem afflaverunt: Dionysius præstitit mentis excessum, Musæ Poësim, Pan facundiam, Nymphæ varietatem.") See also Allen (1984), pp. 30-34.

133 Ficino (1576), vol. II, p. 1365 ("In Phædrum", Cap. 4: "De furore poetico [...]"): "Furens autem nullus est simplici sermone contentus. Sed in clamorem prorumpit, & cantus & carmina. Quamobrem furor quilibet, sive fatidicus, sive mysterialis, seu amatorius, dum in cantus procedit & carmina, merito in furorem poeticum videtur absolvi." On *furor divinus* in Plato and Ficino, see also Allen (1984), pp. 41-67.

134 On Ficino and music, see Chastel (1959), pp. 189ff. and Allen (1984), pp. 29-30 and 53-55.

135 *Phaedrus*, 230c. This has seemingly not been observed before.

136 *Ibid.*, 259d.

137 Ficino (1576), vol. II, p. 1383 (Cap. 35): "Sic quidem animæ iam diu Philosophate ad coelestia revocantur." (The citation seems somewhat corrupted in the Basle edition.) On the continuity air-demons-music-cicadas in Ficino, see further Allen (1984), pp. 24-28.

138 Also observed in Hauser (1999), pp. 260-62.

139 Wind (1958), pp. 108-09; Wind here discusses the Neoplatonic idea of the cosmic breath and Hermes' role in it. On Hermes as driving the winds, Boccaccio writes in *Genealogia deorum gentilium* (2, 7): "Ventos agere Mercurii est." (Boccaccio (1511), f. 17v.) And when Jupiter in the *Aeneid* (4, 223) calls upon Mercury to go to the heavens and drive the clouds, he explicitly refers to the winds as "zephyrs": "Vade age, nate, voca zephyros et labere pinnis."

140 Ficino (1576), vol. II, p. 1367 ("Cap. VI: "Quæ fit anima omnis atque tota, & quomodo principium motus [...]"): "Intellectualem vero proprietatem eiusmodi atque multiformem, naturaliter peperit

in se ipso, & in sequentia protulit, quemadmodum varia nubes accepto Solis radio, colores in se varios procreat. Nubes igitur ut simpliciter luceat, efficienter habet a sole, ut autem tali quodam colore refulgeat, habet saltem formaliter ex se ipsa." ("[The soul] naturally gives birth to the intellect's multitude of forms [?], in the same way as the changing cloud, when it catches the radiance of the sun, itself produces various colours. That the cloud shines has its cause in the sun, but that it reflects this light with a certain colour has its cause in itself.")

141 *Ibid.*, pp. 1939-45: "Ex Michaele Psello De Dæmonibus"; on cloud forms, see p. 1942 ("Quomodo dæmones occupent hominem, loquantur, moveant, se transforment."): "[...] corpora vero dæmonum, simplicia sunt ductu, flexuque, facilia, ad omnemque configurationem naturaliter apta, sicut enim nubes suspicimus nunc hominum, nunc ursorum, nunc draconum aliorum ve præferre figuras [...]."("The bodies of the demons are light and simple in movement and suppleness, naturally able to assume all sorts of forms, in the same way as we are led to think that clouds assume the form of humans, bears, dragons and other things.") Psellus' influence on cloud images in 15th-century painting is discussed generally in Janson (1973), pp. 58 and 66, n. 48.

142 Ficino (1576), vol. I, p. 844: "Imitatio ad Rusticandum. Marsilius Ficinus Ioanni Cavalcanti amico unico, S.D." The letter in its totality goes like this (with thanks to Patrick Kragelund's Danish translation):

"I would think you lighter than any breeze, should you perhaps think that I, moved by some breeze or other, had travelled from the city out to the Careggian hills. But nothing would be further from my mind than to have any thought of him as mobile, he who has more weight than the rocks themselves. For, as it has indeed been my opinion that it was not without reason why it would be much preferable if you came up to me on the mountain than if I in these times descended the mountain to you, I have accordingly implored Apollo to prescribe to my lyre the songs of Orpheus and Amphion with which they in days of old moved oaks and rocks, so that I thus could attract you, who in my opinion is such a wooden and rocky man, out to me.

But Apollo replied: 'You are entirely mistaken, my Marsilius, for Giovanni is neither of wood nor stone. Otherwise your citar would long since have enticed him out to you. No, of wood or stone Giovanni is not fashioned. There is here need of more powerful artistry. Now you must endeavour to change the form of this stone rather than its location. Using Zoroaster's art of transformation you must transform the big rock on Monte Vecchio to a magnet, and in so doing draw the iron-man out here.'

That was Apollo's reply to me as I walked at daybreak in Monte Vecchio's forest. So now I am pondering this. See, my friend – I entreat you – what great matters I ponder for your sake. See, how you force me to exert myself to no avail. O how it would be better and easier if you changed voluntarily, rather than the rocks having to be changed by me. When first you cease to be as unyielding as iron, then I shall indeed cease to exert myself in vain."

143 "[...] quadam commotum aura [...]"; "[...] qui vel saxis est gravior."

144 "[...] Orphei Amphionisque dictaret carmina, quibus illi quondam quercus et saxa movebant, quo ipse te arboreum, meo iudicio, saxeumque tra herem."

145 "Ingens istud Vecchiij montis saxum, (si potes) metamorphosea Zoroastris arte transferas in magnetem [...]."

Chapter 12
The Architecture of the Underworld

1 Clark (1949), p. 21.

2 Martines (1979), p. 267.

3 The ground plan for the following is outlined for the first time in Wamberg (1990).

4 Fore more miniatures by de' Russi and Giraldi, see Michelini Tocci (1965); for another example by Guindaleri, see Salmi (1956), Tf. 469.

5 Pennick (1979), pp. 21-22.

6 Friis Johansen (1955), pp. 96-99.

7 Jerome, *Letters*, XXII, 7.

8 Colour reproduction in Giovannucci Vigi (1993), p. 174. See Russo (1987); Meiss (1974), pp. 134-40.

9 For the following, see Pieper (1987), pp. 140-45; Rossi-Osmida (1974), pp. 17-18.

10 *De architectura*, 2,1.

11 See also *Centaur attacked by Tigers*, Berlin, Staatliche Museen, reproduced in Jahn (1975), Abb. 1; and *Scene by the Sea with Galathea*, from House of Livia, reproduced in Pfuhl, vol. III (1923), Abb. 730.

12 See also Sellaio's religious scenes in Milan, Contessa Rasini Collection, reproduced in Berenson (1963), vol. II, fig. 826, and in University of Göttingen (reproduced in *Katalog der Gemäldesammlung der Universität Göttingen* (1926), No. 164 – here there are also oblique bridging blocks and a perfectly formed natural arch); Pinturicchio, *Saint Bernardino Liberating a Prisoner*, panel, Perugia, Galleria Nazionale dell'Umbria, reproduced in Zeri (1987), Ill. 528; Luca Signorelli and Bartolomeo della Gatta, *Moses' Testament and Death*, fresco, Vatican, Sistine Chapel, reproduced in *ibid.*, Ill. 606; Domenico Ghirlandaio, *Adoration of the Shepherds* (1485), Florence, Santa Trinità.

13 Martineau (1992), cat. 65.

14 Lightbown (1986), p. 36.

15 *Sophist*, 265e.

16 Pochat (1973), pp. 101-02.

17 Ficino (1964), XIII, 3, vol. 2, p. 223: "Denique homo omnia divinae naturae opera imitatur et naturae inferioris opera perficit, corrigit et emendat." English translation in Ficino (2004), Book XIII, ch. 3.1.

18 Alberti (1966), pp. 93-94: "Nascose la natura e' metalli, nascose l'oro e l'altre minere sotto grandissimi monti e ne' luoghi desertissimi. Noi frugoli omicciuoli lo producemmo in luce e ponemmolo fra' primi usi. Ella disperse le gemme lucidissime e in forma quanto a lei ottima maestra parse attissima. Noi le raccoglemmo persino dalle ultimi ed estremissime regioni, e cincischiànle diamoli nuova lima e forma. [...] Stavansi e' marmi giacendo in terra: noi li collocammo sulle fronti de'templi e sopra a'nostri capi. E tanto ci dispiace ogni naturale libertà di qualunque cosa

procreata, che ancora ardimmo soggiogarci a servitù noi istessi. E a tutte queste inezie nacquero e crebbero artefici innumerabili, segni e argomenti certissimi di nostra stoltizia. Aggiungi ancora la poca concordia dell'uomo quale egli ha con tutte le cose create e seco stessi, quasi come giurasse in sé osservare ultima crudeltà e immanità. Volle el suo ventre essere publica sepultura di tutte le cose, erbe, piante, frutti, uccelli, quadrupedi, vermi, pesci; nulla sopra terra, nulla sotto terra, nulla che esso non divori.".

19 Eliade (1962), pp. 47-49; Sébillot (1894), pp. 392-96.

20 Discussed in Camille (1996), pp. 139-40.

21 Eliade (1962), p. 51.

22 Another depiction of the coupling cave/work is found in Theophilius Schweighart's *Speculum sophicum rhodostauroticum* (1604), reproduced in Roob (1997), p. 333.

23 Roob (1997), p. 31.

24 *Summa theologica*, I, 115, 1, see Aquinas (1949ff.).

25 See Ross (1971), pp. 110, 137-41 and 250-55.

26 Thomas Aquinas, *Summa theologica*, I, 115, 1: "[...] sed tamen unum corpus est infra alterum, inquantum est in potentia ad id quod habet aliud in actu." ("[...] but one body is under another, as much as it has potential for that which another body already possesses in action.")

27 Biedermann (1986), vol. II, pp. 294-96.

28 Klossowski de Rola (1988), p. 44.

29 Cited in *Eröffnete Geheimnisse des Steins der Weisen oder Schatz-Kammer der Alchymie* (1718), p. 361: "Es ist ein Stein, und doch kein Stein,/ In disem ligt die Kunst allein:/ Die Natur hats also gemacht,/ Doch zur Volkommenheit nicht bracht:/ Seins gleichen wirdt auff Erd nicht funden,/ Es wechst auff Bergen und in Gründen,/ Materiam Primam thuts mans nennen:/ Der ist gar Weiss, der solches mag kennen." This text builds upon *Aureum vellus* (*Goldene Vlies*), one of the first German-language alchemy books, originally published 1598 in Rorschach near Bodensee. The publisher is unknown and the source originals were mainly Latin manuscripts.

30 *Physics*, 2, 199a 10ff.

31 Woodbridge (1965), p. 52.

32 Pieper (1987), p. 154; Dixon (1981), p. 23 and figs. 160-62 (16th-century illustrations of *domus*).

33 In Girolamo dai Libri's *Nativity with Rabbits* (c. 1500), Verona, Museo di Castelvecchio, the fertility symbolism is also explicit: rabbits by a cave entrance, reproduced in Levi d'Ancona (1977a), p. 309. Architectonic features are also coupled with organic features in Ferrarese Jacopo Filippo d'Argenta's chorale manuscripts for Ferrara Cathedral (1481ff.; PLATE 40), Ferrara, Museo della Cattedrale. See Giuvannucci Vigi (1983), pp. 201-22. Many of the miniatures have echoes in the chorales for San Francesco d'Assisi in Brescia, now in Pinacoteca Tosio e Martinengo, see Calabi (1938), pp. 57-67.

34 *Metamorphoses*, 3, 159-60.

35 *De re aedificatoria*, 2, 9.

36 In *De re aedificatoria*, 9, 4 Alberti states, furthermore, that travertine foam was used in the garden grottos of antiquity, what Ovid called "living rock" ("pumice vivo", see *Metamorphoses*, 3, 159-60; also *Fasti*, 2, 315).

37 Leonardo (1939), vol. II, 980, p. 166: "le falde delle pietre vive".

38 Cited in Hope (1980), p. 112.

39 See the red and blue pebbles in, for example, Gratian's *Decretum*, printed in Venice 1473 and illuminated by Giraldi 1474, Museo Civico di Schifanoia, f. 91; or the Giraldi studio's chorales for Ferrara's Certosa, no. 2 and L/A (after 1468), also Museo Civico di Schifanoia. See Herrmann (1900), pp. 117ff. A similar rock landscape, sprinkled with glinting stones and studded with ferocious peaks, can be seen in a West French manuscript of c. 1440 (from Angers?) of Batholomeus Anglicus' *Propriété des Choses*, but here the subject is due to a specific iconography - the author's list of precious stones and metals - and not, as in the aforementioned case, the paradigm (Paris, Bibliothèque Nationale, ms fr. 136, f. 73., reproduced and discussed in Cahn (1991), pp. 22-23).

40 For the following, see: Pochat (1990), pp. 203-04; Campbell (1997), p. 126.

41 The codex title is *Ordine de le Noze de lo illustrissimo Signor Misir Costantino Sforza de Aragonia: et de la illustrissima Madona Camilia de Aragonia sua consorte nel anno MCCCCLXXV infrascripto.*

42 *Alchemie*, Freiburg 1960, pp. 10ff., cited in Pochat (1990), p. 204: "eine unermessliche Sammlung unerschaffener Dinge".

43 Eliade (1971), p. 54; Sébillot (1894), pp. 415-17.

44 See Fabricius (1976), p. 38.

45 This information is provided in Trismosin's treatise *Wanderschafft*, p. 4, in *Aureum Vellus*, the collection of tracts published in Rorschach 1598. The collection also included the first publication of *Splendor Solis*. See Fabricius (1976), p. 243. However, Trismosin might be an invention.

46 Hartt (1952), pp. 340-41; Kern (1982), pp. 268 and 279-81.

47 Reproduced in Kern (1982), fig. 344.

48 Ziggurat-like terrassed rocks also feature in Lorenzo de' Medici's library. See, for example, *All'ombra del Lauro* (1992), pp. 136 (Plut. 16, 4, f. 1), and p. 137 (Plut. 63. 2, f. 3), where there are water canals on the plateaus and, uppermost, a plant with a bird on it. Moreover, *ibid.* pp. 144 (Plut. 13, 6, f. 1), 136 (Plut. 16, 4, f. 1), 129 (Plut. 82, 6, f. 1), where bees swarm around a beehive shaped exactly like the underlying cylindrical rocks.

49 See, for example, Augustine, *De civitate Dei*, 7, 24, with citation from Varro.

50 See also his Vatican *Deposition*, reproduced in Christiansen, Kanter and Strehlke (1988), p. 189.

51 *Bible of Borso d'Este*, illuminated by, *inter alios*, Taddeo Crivelli and Franco de' Russi: Modena, Biblioteca Estense, ms V. G. 12=Lat. 429, reproduced facsimile in Treccani Degli Alfieri (1961). See also the Ferrarese chorale miniatures from the second half of the 15th century in Collezione Hoepli, reproduced in Toesca (1930), tav. CXVI and CXVIII. Pietro Guindaleri's Pliny miniatures: especially ff. 45v (min. 25; reproduced in Bovero (1957), fig. 4), and 82 (min. 12).

52 On the stone images, see Daston (1998) and Baltrušaitis (1983), pp. 87-149. See also the final section of the current chapter.

53 A similar border illustration, in which the river systems are also included, can be seen in a second copy of the same work (after 1321), Oxford, ms Tanner 190, f. 175v, reproduced in Degenhart-Schmitt (1980), vol. II-1, Abb. 23, p. 16.

54 A slightly earlier manuscript, a northeast French edition of Moses ben Abraham's *Chroniques de la Bible* from *c*. 1300 (The Hague, Koninklijke Bibliothek, ms 131 A 3), there is a related border miniature describing one of Daniel's dream visions: four beasts forced from the sea by the four winds (Daniel 7: 1-27; reproduced in Cahn (1991), p. 17). Rather than depicting the usual medieval personifications of winds (cf. chapter 7), the illuminator has here released the actual winds (*tourbillons de vent*): chaotic wave formations which, like the rocks in the Sanudo manuscript, float in a strangely independent way around the border. Naturalism is obviously born of a semantic licentiousness in the periphery.

55 F. Mercier, the only scholar to have addressed the phenomenon (in Mercier (1968), pp. 82-84), writes pertinently of "expérimentations spatiales uniques en Quattrocento".

56 See Baltrušaitis (1954), pp. 31-40; Fabricius Hansen (1996b), pp. 99-100.

57 Clark (1949), p. 87.

58 Perrig (1980), p. 51: "ohne […] die Vorstellung eines unsichtbaren Gärtners".

59 *Ibid.*, pp. 59-60; Leonardo (1939), vol. II, 981 and 983, pp. 166-67.

60 Snow-Smith (1987); Stefaniak (1997). These two articles provide the basis for the following.

61 Stefaniak (1997), pp. 4-5.

62 Snow-Smith (1987), p. 94.

63 Sermo II: "De nominatione Mariae", Mariale, f. M 5, cited in Stefaniak (1997), p. 8.

64 The narcissus are noted by Stefaniak (1997), p. 24, and linked to the Madonna's mirror-like brooch. The idea that Mary is looking down into the water was suggested by Mary Garrard in 1992.

65 Stefaniak (1997), pp. 18-25.

66 Alberti (1975), II, 26. Translation from Alberti (1972), p. 63.

67 *Trattato della pittura*, Leonardo (1956), I, 34; cf. also the present chapter 8.

68 This idea of self-referentiality in Leonardo's painting has, as far as I am aware, never been presented before.

69 *Aeneid*, I, 166-68, see chapter 2.

70 Stefaniak (1997), p. 22.

71 Luke I: 41.

72 Song of Songs 2: 13-14. Robertson (1954), pp. 92-95, suggests a connection to this passage, albeit with no mention of the hand.

73 *Timaeus*, 50 a-c.

74 Stefaniak (1997), p. 34, n. 102.

75 Pseudo-Cavalca's description in *La vita di San Giovanni Battista*, cited in Snow-Smith (1987), pp. 52-53. Gabriel's pointing hand has been left out of the later London version of *Virgin of the Rocks*, presumably because it made for too blatant an accentuation of John the Baptist in the role of Saint Francis (Snow-Smith (1987), p. 63) (see also below).

76 See, for example, Domenico Veneziano's *Santa Lucia Altarpiece* in Florence, Uffizi.

77 Dante (1994), 32, 24-30, p. 354 (although, in this 1994 edition, the translator has changed the order between Augustine and Francis).

78 *Vita secunda*, I, 3, in Habig (1973), p. 364; see also Snow-Smith (1987), p. 59.

79 Matthew 27: 51.

80 *Gospel of Nicodemus*, 13: 11-14, cited in Snow-Smith (1987), p. 75. Nicodemus' ideas were spread from the 13th century onwards through the popular writings of Vincent of Beauvais and Jacobus de Voragine (*ibid.*, p. 93, n. 117).

81 Habig (1973), p. 1438; see also Snow-Smith (1987), p. 69, and Schama (1995), pp. 436-39.

82 Cited in Snow-Smith (1987), p. 69. The work is used again by the Franciscan preacher Saint Bernardino of Siena in the first half of the 15th century in his many sermons on the theme Franciscus alter Christus.

83 Perrig (1980), p. 67.

84 Leonardo's two drawings were executed as directions for Charles d'Amboise *c.* 1506-08 and are now in the British Library, Codex Arundel, ff. 231v and 224. On Poliziano's play and Leonardo's scenery, see Pedretti (1964), pp. 25-34; Marinoni (1957), pp. 273-87; Pochat (1990), pp. 226-28. On *sacre rappresentazioni* of the Nativity, see Pochat (1990), p. 228.

85 The whole passage: "E tirato dalla mia bramosa voglia, vago di vedere la gran copia delle varie e strane forme dalla artifiziosa natura, raggiratomi alquanto infra gli ombrosi scogli, pervenni all'entrata d'una gran caverna; dinanzi alla quale, restato alquanto stupefatto e ignorante di tal cosa, pegato le mie reni in arco, e ferma la stanca mano sopra il ginocchio, e colla destra mi feci ten[ebre] alle abbassate e chiuse ciglia; e spesso piegandomi in qua e in là per [ve]dere se dentro vi discernessi alcuna cosa; e questo vietatomi [per] la grande oscuri[t]à che là entro era. E stato alquanto, subito sa[l]se in me due cose, paura e desiderio; paura per la minac[cian]te e scura spilonca, desiderio per videre se là entro fusse alcu[na] miracolosa cosa." Cited in Leonardo (1974), pp. 184-85.

86 Leonardo (1974), p. 133: "De' denari e oro. Uscirà delle cavernose spelonche chi farà con sudore affaticare tutti i popoli del mondo, con grandi affanni, ansietà, sudori, per essere aiutato da lui." *Ibid.*, p. 74: "Salvatico è quel che si salva." See also Emison (1993), p. 117.

87 Cited in Pochat (1973), p. 129.

88 Ficino (1964), 13, 3, 6, vol. 2, p. 225. English translation in Ficino (2004).

89 Pochard (1973), p. 292, n. 189, and p. 319.

90 Martines (1979), p. 267.

91 *Diario ferrarese dall'anno 1409 sino al 1502 di autori incerti* (ed. G. Pardi), in *Rerum Italicarum Scriptores*, rev. ed. vol. 24, pt. VII, Bologna, 1928, here cited from Gundesheimer (1973), pp. 155-56: "(MCCCCLXXI, de Zenaro, lo illustrissimo duca Borso cominciò dare principio a fare una montagna de terra per forza de carri, navi et brozi et de opere manuali, che era una grande facenda;) del che tutto il populo se ne redoleva molto, perchè non era utile alcuno et li contadini non poteano lavorare le possessione per cagione de dicto lavoriero; et faceva fare questa montagna dove se chiama Monte

Sancto; et di questo il populo mor'morava molto." See also Gibbons (1966), p. 410. No. 76 of an engraved view of Ferrara from c. 1600 is designated "Montagna grande", reproduced in Walker (1956), fig. 15, p. 30.

92 See Sannazaro (1961), X (prose), 5, pp. 79-80: "Et intrati nel santo pineto, trovammo sotto una pendente ripa, fra ruinati sassi una spelunca vecchissima e grande, non so se naturalmente o se da manuale artificio cavata nel duro monte [...]."

93 Damisch (1972), p. 184 (English translation in Damisch (2002), p. 132), refers similarly to "the vanishing lines of the ground, treated in curvilinear perspective". Also, of Mantegna's rock, he synthesises interestingly, albeit only in part correctly, that with its phantasmagorical folds it fulfils a similar function to Correggio's cloud, stretched out as it is in the indeterminate area between depictable and non-depictable. Although it would seem plausible that both Mantegna's rocks and Correggio's clouds deal with the relationship between representation and nature, the proper phantasmagorical dimension - i.e. the indeterminacy of artificiality expanding so far as to the surroundings, flickering between interpretant, representamen and object - is still a speciality of Mantegna.

94 See Prager and Scaglia (1972), pp. 3-4.

95 *De ingeneis* is divided between Munich, Bayerische Staatsbibliothek, ms lat. 197 (books I-II) and Florence, Biblioteca Nazionale, ms Palatino 766 (books III-IV). *De machinis*: Munich, Bayerische Staatsbibliothek, ms Clm. 28800, reproduced in Scaglia (1971).

96 Scaglia (1971), vol. 1, p. 19.

97 *Naturalis historia*, 36, 1-2.

98 Fabricius Hansen (1996b).

99 Winkelmann et al. (1958), pp. 69-72; p. 69: "Neither the Earlier not the High Middle Ages know of mining representations."

100 Vienna, Nationalbibliothek. For a detailed survey, see Winkelmann et al. (1958), pp. 72-79.

101 Pen and watercolour, Aulendorf, Fürstlich zu Waldburg-Wolfeggsches Kupferstichkabinett; see Filedt Kok (1985), p. 17.

102 Cited in Bromehead (1956), vol. 2, p. 25.

103 See also Wood (1993), figs. 35 and 70.

104 *Ibid.*, p. 119.

105 The woodcut, with no explanatory remarks, is reproduced in Winkelmann et al. (1958). I have not had access to Palz's treatise and therefore cannot support my interpretation of the woodcut with written evidence - if, that is, such testimony exists.

106 Forbes (1966), p. 145.

107 See Bucci (1965).

108 Compare, for example, Herri met de Bles' *Landscape with Mining Scenes* (*fig. 12.49*) with his *Landscape with Saint John the Baptist Preaching* (Brussels, Musées Royaux des Beaux-Arts de Belgique), reproduced in Gibson (1989), fig. 2.46.

109 Ruhmer (1959), p. 8. Cossa's grandfather, great-grandfather, uncle and great-uncle were also employed in this occupation.

110 See Roob (1997), p. 516.

111 See also the two watercourses flanking the diagram of the alchemical transformation in A.T. de Limojon de Saint-Didier's *Le triomphe hermétique* (1689), in Christopher Love Morley and Theodorus Muykens' *Collectanea chymica* (Leiden: Cornelius Boutesteyn and Frederik Haaring 1693), reproduced in Klossowski de Rola (1988), p. 304. The text of the German-language edition of *Le triomphe hermétique* (Frankfurt, 1765), which includes a redrawing of the same illustration, refers to "two parabolic streams [...] which together yield the mysterious triangular stone [i.e. the Philosophers' Stone, the instrument for the alchemical transformation]" (see Roob (1997), p. 411). On a different level, Gentili (1982), p. 574, suggests that the sewer entrances in the *Miracles of Saint Vincent Ferrer* refer to Borso's hydraulic works in Ferrara.

112 For the following, see Signorini (1985), pp. 153-69.

113 *Geography*, 5, 3, 11.

114 On Valla (with citation), see Baxandall (1971), pp. 118-19. In Goldthwaite (1980), pp. 212-37, there is an instructive historical summary of quarrying in Western Late Middle Ages; Goldthwaite is, however, silent on its attitudinal implications.

115 The dating is apparent from Guindaleri's complaint in 1489 to Francesco Gonzaga that he has not been paid for the completion of "quello Plinio opera di certo superba, che rappresenta la fatica di qualche decennio." See Luzio (1908), pp. 59-60.

116 See Bovero (1957), pp. 261-65.

117 Signorini (1985), p. 155. Mantegna possibly also illuminates the abovementioned coupling of hermit plus mining and quarrying milieus. Not only had the area around Tivoli been the main supplier of stone for the art works of Rome, but the area by the Anio river was also particularly abundant in monks and anchorites. See the cave by the natural arch above the grooms, where two praying figures feature in front of two cowl-clad monks, one standing and one sitting (Signorini (1985), p. 158, detail reproduced in *ibid.*, fig. 67).

118 Sachs (s. a.), pp. 51-52; Ferguson (1954), p. 107.

119 Panofsky (1953), vol. I, p. 186, makes no mention of Barbara's connection to mine-work.

120 It was recently discovered that the Copenhagen painting was in the collection of the Italian-born Briton Ignazio Hugford, before being sold in 1753 to the Roman Cardinal and Papal Secretary of State, Silvio Valenti Gonzaga. After Valenti Gonzaga's death in 1756, it came in 1763 to its permanent home in the collection of the Danish king (now the Danish state). Despite the Mantuan origins of the Valenti Gonzaga family, Hugford's earlier ownership of the painting thus disproves any certainty about a possible Mantuan provenance (see Perini (1993), p. 551). I am indebted to Chris Fischer and Charles Dempsey for this reference. For the following, see Wamberg (1991).

121 Hartt (1952).

122 "Qui natus olim ex virgine nunc e sepulcro nasceris." Cited in Hirn (1912), p. 337.

123 Migne, *Patrologia Latina*, 112, col. 887.

124 See Wamberg (1991) and Andreas Hauser's well-argued reading of the painting in Hauser (2000b), pp. 450-59.

125 *Naturalis historia*, 33, 1, 1. In her short, astute article (Emison (1993)), Patricia Emison links the related passages from Alberti's *Theogenius* cited above with both Leonardo's painting and Mantegna's *Madonna of the Stonecutters*. She very precisely submits that Mantegna's rock is profaned by the stonemasons, whereas Leonardo's is virginal. However, as she is not aware of Alberti's use of the Golden Age topos, she presumes that Mantegna's agricultural activities on the left, including pastoralism, are also part of the rape on equal terms with the quarrying. This, as we have seen, is unlikely. On Leonardo, see later in the current chapter.

126 Isaiah 14: 18-19. See also 2 Kings 9: 30-37.

127 Hartt (1952), p. 338, identifies the harvest as wheat, but ripe wheat is not green.

128 For the linking of lust and idolatry, see for instance Colossians 3: 5.

129 On the column's connotations to antiquity, see Bandmann (1970), n. 75, p. 148.

130 See also the Louvre *Sketchbook*, f. 19v (*Saint Jerome in the Wilderness*). This and the following mentioned folios are reproduced in Eisler (1989).

131 An equivalent scene, in which only the actual statue is being worked on, can be seen in the *British Museum Sketchbook*, f. 69v.

132 As free-standing basins with conical base: British Museum, f. 70v. With column and idol: British Museum, ff. 66v and 75; Louvre, ff. 7 and 17.

133 Degenhart and Schmitt (1968-90), vol. II, 6 (1990), p. 370.

134 Fabricius Hansen (1994), pp. 12-13.

135 Hauser (2000b), the first to comment on the erection, pursues a similar interpretation (pp. 458-79).

136 Camille (1989), p. 33.

137 Book of Wisdom 15: 7-17.

138 Book of Daniel 2: 31-35. The modern English Bible merely states that "a stone was cut out" and not, as in the Latin *Vulgata*, that it was from the mountain. This is first specified in verse 45: "a stone was cut from a mountain".

139 *Monitum in Homilias de S. Virginis Deiparae Mysteriis*, 16, Migne, *Patrologia Graeca*, 98, col. 307, here cited from Snow-Smith (1987), p. 35: "Ave, Dei mons praepinguis et umbrosus: in quo enutritus [...]. Agnus peccata atque infirmitates nostras portavit; mons e quo devolutus ille, nulla manu praecisus, lapis, contrivit aras idolorum, et factus est 'incaput anguli, mirabilis in oculis nostris'." Snow-Smith links this passage to Leonardo's *Virgin of the Rocks*.

140 Migne, *Patrologia Latina*, 112, col. 980: "*Lapis* [...]. Hunc lapidem et Daniel de monte sine manibus intellexit, ut hic est Christum de populo Judæorum sine opere conjugali progenitum, qui postea in montem magnum factus implevit universam faciem terræ: quod tam gentes, quam Judæos fecundaverat verbo doctrinæ suæ." *Ibid.* col. 1001: "*Mons*, virgo Maria ut in Daniele: 'Abscissus lapis de monte sine manibus', quod Christus de Maria natus est sine virili semine."

141 Hauser convincingly observes that these crystals can, furthermore, be seen as the wildly bristling hair of a monstrous, proto-Arcimboldean profile whose eye, nose and jutting under-jaw are evoked by the left side of the mountain (Hauser (2001), p. 149).

142 Eliade (1971), p. 43.

143 See 1 Peter 2: 4; 1 Corinthians 10: 4. According to, for example, Pseudo-Albertus Magnus's *De occultis naturae* (13th century) alchemy's *lapis* should be understood as the Infant Christ in Bethlehem; this stone possesses a wonderful power [*effectus mirabilis virtutis*]; see Haaning (1993), p. 178.

144 "simil cose non sono tutte della natura nè tutte dell'arte, ma vi hanno ambedue parte, aiutandosi l'una l'altra – come per dare un esempio, la natura da il suo diamante ò carbonchio ò cristallo et simile altra materia rozza et informe, et l'arte gli pulisce, riquadra, intagli etc. [...]." Cited in Berti (1967), p. 63.

145 First noted by Christiansen in Martineau (1992), p. 394.

146 I am indebted to Maria Fabricius Hansen for this idea. See also Fabricius Hansen (1996b), pp. 128-30 and 242-44.

147 Hauser (2000b), pp. 484ff., also notes the marble-like aspect of Christ's body and similarly links it to the paragone between painting and sculpture.

148 Camille (1989), p. 30; Koerner (1993), pp. 80-126.

149 *Della pittura*, II, 1.

150 *Trattato di architettura*, f. 181, cited in Gilbert (1980), p. 90.

151 I am indebted to Maria Fabricius Hansen for this observation.

152 *Elegies*, 3, 2, 8: "[...] saxa Cithaeronis Thebas agitata per artem sponte sua in muri membra coisse ferunt [...]."

153 Lucian, *Astrology*, 22; *Odyssey*, 8, 265ff. On Mantegna's use of these texts, see Wind (1948), pp. 9ff. and Wind (1949), p. 229, n. 47. For a synthesising, albeit deficient, outline of previous interpretations, see Lightbown (1986), pp. 189-201.

154 Hauser (2000a), pp. 23-25.

155 On Apollo's identification with Orpheus, see *ibid.*, pp. 35-39.

156 Wind (1948), p. 10.

157 "Pegaso novo, al cui un fluente/ Fonte risorge in arrido terreno", cited in Luzio and Renier (1902), p. 247, n. 3. Ariosto later said of the same poet (*Orlando furioso*, 42, 91, cited in *ibid.*, p. 247): "And a Marco Cavallo, who will cause such a fount of poetry to spring from Ancona,/ just like the winged horse did from the mountain/ I do not know if it was from Parnassus or Helicon." ("Et un Marco Cavallo, che tal fonte/ Farà di poesia nascer d'Ancona,/ Qual fè il cavallo alato uscir dal monte/ Non so se di Parnaso o d'Elicona.")

158 "[...] è doctissima, che è stata al monte de Parnaso et a la fonte pegasea [...]"; and "[...] tucta dedita a le Muse [...]". Cited in *ibid.*, p. 246.

159 Hauser (2000a), pp. 29-32.

160 This and the following play of lines are observed in Jones (1981), pp. 193-98.

161 A similar conclusion is reached by Hauser (2000a, p. 37), who, moreover, observes a line going from Vulcan's eye through his left curved hand and up to Venus' genitals, also a sign of his cleansing. Hauser also convincingly detects a geometry emphasising the link between Venus' and Mars' love and the sources of poetry: a line linking the floor of the natural arch with the right waterfall, and a line going from this waterfall through Venus' genitals and on to the left waterfall (Hauser (2000a), p. 31).

162 On *Harmonia* and the love between Mars and Venus, see Panofsky (1939), pp. 163-64.

163 Wind (1948), p. 86.

164 The reference to Nicander (handed down in Antonius Liberalis' *Metamorphoses*) is found in E. Tietze-Conrat's attack on Wind's book, Tietze-Conrat (1949), pp. 127-28, albeit the author links the citation with Vulcan's rocks. In his response to this attack, Wind (1949), p. 229, Wind remarks, quite rightly, that Pegasus is situated too far away from the volcanic formations for it to be their growth he has to stop. Neither Tietze-Conrat nor Wind observe, however, the Hippocrene spring's crystals.

165 Ovid, *Metamorphoses,* I, 313-19.

166 *Ibid.,* I, 383 and 388-415.

167 *Naturalis historia*, 37, 3, 5-6: "Post hunc anulum regis alterius in fama est gemma, Pyrrhi illius, qui adversus Romanos bellum gessit. Namque habuisse dicitur achaten in qua novem Musae et Apollo citharem tenens spectarentur, non arte, sed naturae sponte ita discurrentibus maculis ut Musis quoque singulis sua redderentur insignia." Baltrušaitis (1983), pp. 111-13, pursues the fate of the Pyrrhus agate in the various versions of Marbodus' *Lapidarium* (Migne, *Patrologia Latina*, 171) between the 11th and 15th centuries. See also Alberti (1975), II, 28, pp. 64-65.

168 "Über den Begriff der Geschichte IX" (1940), Benjamin, vol. I, 2 (1974), pp. 697-98: "Es gibt ein Bild von Klee, das Angelus Novus heißt. Ein Ángel ist darauf dargestellt, der aussieht, als wäre er im Begriff, sich von etwas zu entfernen, worauf er starrt. Seine Augen sind aufgerißen, sein Mund steht offen undseine Flügel sind ausgespannt. Der Engel der Geschichte muß so aussehen. Er hat das Antlitz der Vergangenheit zugewendet. Wo eine Kette von Begebenheiten vor *uns* erscheint, da sieht *er* eine eintzige Katastrophe, die unabläßig Trümmer auf Trümmer häuft und sie ihm vor die Füße schleudert. Er möchte wohl verweilen, die Toten wecken und das Zerschlagene zusammenfügen. Aber ein Sturm weht vom Paradiese her, der sich in seinen Flügeln verfangen hat und so stark ist, dass der Engel sie icht mehr schließen kann. Dieser Sturm treibt ihn unaufhaltsam in die Zukunft, der er den Rücken kehrt, während er Trümmerhaufen, vor ihn zum Himmel wächst. Das, was wir den Fortschritt nennen, ist *dieser* Sturm."

169 *Het Schilder-Boeck*, I, 8, 32, cited in Brown (1986), p. 41.

170 "Vetustas omnia deformavit", Piccolomini (1984), 5, 27, pp. 986-87. For drawing my attention to this and several other passages concerning the ruin in early modernity, and also for many inspiring discussions since 1991 about this and related topics, I am indebted to Maria Fabricius Hansen. Fabricius Hansen's extensive account of the significance of the ruin in late medieval Italy

is published in Fabricius Hansen (1996) and *idem* (1999). My own thoughts on the iconological significance of the ruin were first presented in my unpublished MA dissertation (1990).

171 "invidioso della gloria delli mortali" and "edace lima: e venenoso morso", cited in Rowland (1994), p. 100.

172 Cited in Gibson (1989), p. 55.

173 Nicolson (1959).

174 Grant (1974), pp. 619-20.

175 Leonardo (1939), Nos. 983 (first citation from Milan, Biblioteca Ambrosiana, ms C.A. (*c.* 1483-1518), f. 126v) and 953 (previously Norfolk, Holkham Hall, Leicester Library (*c.* 1504-06), f. 20): "Come li scogli e promontori de'mari al continuo ruinano e si consumano". See also *ibid.*, Nos. 954, 976 and 979-81, and Perrig (1980), p. 59.

176 *Het Schilder-Boeck*, I, 8, 34, cited in Brown (1986), p. 41.

177 Spengler (1972), pp. 328-29, also notes the significance of the ruin to the Faustian culture and its corresponding absence prior to this culture.

178 Troy, for example: *Troy Being Plundered and Destroyed by the Greeks, Roman de Troye* (Naples, 1300-1310), Tours, Bibliothèque Municipale, ms 953, reproduced in Degenhart and Schmitt, vol. II-3 (1980), Tf. 114 (cat. 679).

179 The effect is described precisely by Heckscher (1937-38), pp. 210-12. Strangely, Heckscher's observations have long had no follow-up. See Fabricius Hansen (1999), pp. 42-47.

180 Camille (1989), p. 5.

181 Heckscher (1937-38), p. 211. The phenomenon is also discussed in Fabricius Hansen (1999), who notes, in addition, a similar unbrokenness in pre-modern depictions of buildings under construction (pp. 42-47).

182 As an argument to explain the intact appearance of medieval buildings, Heckscher similarly turns to contemporaneous ideas of beauty being identical with completeness (Heckscher (1937-38), pp. 210-12).

183 Isaiah 34: 13-14; 13: 19-22.

184 *Adoration of the Magi, Strozzi Altarpiece*, Florence, Galleria degli Uffizi.

185 Panofsky (1953), pp. 133-34.

186 Panofsky (1960), p. 113.

187 Fabricius Hansen (1996), pp. 104-08; *idem* (1999), pp. 216-18 and 231-36.

188 Alberti (1988), 3, 14, p. 86: bone, flesh, nerves; *ibid.*, 3, 8, p. 73: muscles; *ibid.*, 9, 5, p. 301: animals; *ibid.*, 9, 5, p. 303: the body; *ibid.*, 9, 8, p. 310: animals. Apropos this and the following comments, see also Fabricius Hansen (1999), pp. 164-77.

189 Manetti (1970), p. 51.

190 Pius II: "porta [...] nudata marmoribus", in Piccolomini (1984), 9, 19; letter to Leo X: "Cadavero" and "l'ossa del corpo senza carne", cited in Rowland (1994), p. 100; Poggio: "[...] ut nunc omni decore nudata, prostrata iaceat instar gigantei cadaveris corrupti [...]", in *De varietate fortunae*, cited

in Valentini and Zucchetti (1953), p. 231. I am indebted to Maria Fabricius Hansen for drawing my attention to these passages.

191 Cf. also Joseph Koerner's remark about the human corpse generated by 16th-century South German art: "First, as body image, it overturns the Renaissance fiction of the closed and finished person, replacing it with an admonishing vision of the physical dissolution of all boundaries." (Koerner (1993), p. 266.)

192 2 Kings 8: 30-37.

193 *Epistola*, Valentini and Zucchetti (1953), p. 93: "Dici solet, et habet certam res ipsa rationem, in ruinosis urbibus, quas aut violentus casus diruit aut vetustas exedit, esse aerem parum salubrem [...]." See also Fabricius Hansen (1999), p. 175.

194 Piccolomini (1984), 6, 22, p. 1184: "[...] et murorum quadrati lapides vix credibilis magnitudinis."

195 Alberti (1988), 7, 2, p.192. Cf. also Giovanni Dondi, a learned Paduan and Petrarch's friend, who writes in his treatise *Iter romanum* (c. 1375): "In Coliseo [...] fuerunt pilastri 800, omnes de saxis magnis quadratis et magno ingenio laboratis et compositis [...]", cited in Günther (1988), p. 15.

196 *Naturalis historia*, 35, 10. The same story is told of Nealces or Apelles and a horse: Dio Chrysostom, *Discourses*, 64. See Janson (1973), p. 56.

197 Cf. Damisch (1972), pp. 53 and 55.

198 Janson (1973), p. 64.

199 Didi-Huberman (1995), cf. chapter 9.

200 See the extensive documentation in Baltrušaitis (1983).

201 The phenomenon has been thoroughly investigated in an unpublished study by Christopher S. Wood, "Dürer's Hidden Faces" (1987). I am indebted to Christopher Wood for allowing me access to this text.

202 The same notion is seen later in A.-J. Dézallier d'Argenville's engraving of a skull-shaped stone (1755), reproduced in Baltrušaitis (1983), p. 134. Hauser, among other instances, also points to a mummy-like figure underneath Christ, hinting at his imminent burial, in the *Agony in the Garden* (fig. 11.42), and to several rock faces in the Camera degli Sposi (Hauser (2001), p. 149).

203 Campbell (1997), pp. 155-57.

204 In Cap. IX, Ficino (1576), vol. II, pp. 1865-66. This and other passages from *Asclepius* are also quoted in Augustine's *De civitate Dei*, 8, 23-24.

205 Book Two. Taking Pliny as his source (*Naturalis historia*, 35, 15-16), Alberti has earlier stated that painting was in use among the Egyptians 6,000 years before it reached Greece.

206 *Naturalis historia*, 36, 17, 77: "est autem saxo naturali elaborata."

207 Cited in Janson (1973), p. 55.

208 Cited in *ibid.*, p. 62.

209 Alberti (1975), II, 28, pp. 64-65).

210 *Naturalis historia*, 36, 5; *Natural History of Stones*, 2, 3, 1. Albertus Magnus himself states that he has seen the picture in the block of marble which everyone agreed had been painted by nature. See Janson (1973), pp. 56-58; also, Baltrušaitis (1983), pp. 114-15.

211 Fabricius Hansen (2000).

212 Cicero, *De divinatione*, 1, 13, cited in Janson (1973), p. 57.

213 *De meteorologica*, 3, 3, 23, cited in Janson (1973), p. 58, n. 16.

214 *Apollonios of Tyana*, 2, 22; see Janson (1973), pp. 58-60 and Damisch (1972), pp. 53-54.

215 Petrarca (1996), 129, vv. 27-29, p. 625: "Ove porge ombra un pino alto od un colle/ talor m'arresto, et pur nel primo sasso/ disegno co la mente il suo bel viso." Vv. 49-51, *ibid.*, p. 626: "Poi quando il vero sgombra/ quel dolce error, pur lì medesmo assido/ me freddo, pietra morta in pietra viva [...]." In the closing hymn to the Virgin Mary, *canzone* 366, v. 111, *ibid.*, p. 1400, Laura is referred to explicitly as Medusa: "Medusa et l'error mio m'àn fatto un sasso/ d'umor vano stillante [...]." English translation in Petrarca (1999). I am indebted to the Petrarch scholar Unn Falkeid for reference to these passages and their interpretation.

216 Daniel Arasse has spotted, furthermore, a cloudy profile in the *trompe l'oeil* oculus of Camera degli Sposi, and, apart from lesser human faces in the Pallas clouds, Hauser also mentions a panther-like face in the San Zeno *Agony in the Garden* (see Hauser (2001), p. 148).

217 Leonardo (1939), vol. 2, 1021, p. 187. The reverse effect, that distant mountains look like clouds, is discussed by van Mander in *Het Schilderboeck* (1604), 1, 8, 8 (cited in Brown (1986), p. 37: "See how that hazy landscape in the distance begins to look like the sky, and almost merges into it. Solid mountains seem to be moving clouds."

218 *De rerum natura*, 4, 133-42: "[Simulacra] quae multis formata modis sublime feruntur nec speciem mutare suam liquentia cessant et cuiusque modi formarum vertere in oras; ut nubes facile inderdum concrescere in alto cernimus et mundi speciem violare serenam aera mulcentes motu. Nam saepe Gigantum ora volare videntur et umbram ducere late, interdum magni montes avolsaque saxa montibus anteire et solem succedere praeter, inde alios trahere atque inducere belua nimbos." The connection is noted by Damisch (1972), p. 54.

219 See Lightbown (1986), pp. 201-08.

220 "ET MIHI VIRTUTUM MATRI SUCCURRITE DIVI" ("And you, O Gods, help me, Mother of Virtues").

221 See Battista Spagnoli Mantuano (1499), Lib. 1, ff. 5v and 7: "Totam pudicitiam veram poesis amat." And: "Est Helicon virgo; virgo peneia Daphne; Castalidasque aiunt virgine matre satas. Ite procul veneris vates Heliconis ab amne; Virgeneus vestro laeditur ore liquor." English translation in Lightbown (1986), p. 208.

222 For example, *Iliad*, 2, 42-54.

223 On this and the following, see Levi d'Ancona (1977b), pp. 98ff. Levi d'Ancona's deliberations are in principle excellent, but when articulated in a polemic with Janson (1973) – cf. the title of her article – they seem to be unnecessarily categoric. That the cloud images have an iconographical stratum does not, of course, preclude other interpretations, including the one proposed by Janson.

224 Boccaccio (1511), 8, 1, f. 61.

225 Cartari (1571), p. 20. Levi d'Ancona (1977b) claims mistakenly, p. 104, that according to Cartari, the Saturn legend actually ends with an image of a god on horseback in the sky.

226 Isaiah 14: 12-14.

227 Job 39: 18.

228 *Moralium libri*, Migne, *Patrologia Latina*, 76, 596-97.

229 Damisch (1972), p. 54, similarly notes the correspondence between cloud-horseman and sculpture
 fragments; however, he connects them with Foucault's Renaissance *episteme* relating to the homo-
 geneity of things.

230 Hauser (2001).

231 *Ibid.*, pp. 164-71. Hauser does not, however, involve melancholy in this reading.

232 Vasari, vol. III (1878), p. 389. English translation from Vasari (1996), p. 559. The source is presum-
 ably a letter from Girolamo Campagnola (*c.* 1433/35-1522) to Leonico Tomeo (1456-1531). The letter
 is also reflected in Bernardino Scardeone's *De Antiquitate Urbis Patavii, & claris ciuibus Patauinis libri
 tres*, Basle, 1560, p. 373; see Lightbown (1986), pp. 392-93.

233 See Christiansen in Martineau (1992), pp. 94-114.

234 Amstrong Anderson (1976), pp. 13-14.

235 Lohr (1969), p. 429; Kristeller (1960), p. 149.

236 Levi d'Ancona (1977b), p. 98.

237 de' Thiene (1487), f. 45. The debate was sparked off by Burley (1482) (f. 70). That the relationship
 between art and nature really was a concern is apparent from the fact that the later version of
 Burley's Aristotle commentary was supplemented by his *De deo, natura et arte*, see Shapiro (1963),
 pp. 88-90.

Bibliography

The bibliography includes all sources used and referred to in the text. When not otherwise specified, the English translations are mine; exceptions being translations from classical sources and the Bible, which derive from the translations mentioned in the first two paragraphs of the bibliography. I am grateful to the Director of the Danish National Art Library, dr. phil. Patrick Kragelund, for his expert assistance with translations from the Latin.

Pre-antique and antique sources

Loeb Classical Library: Cambridge (Mass.): Harvard University Press; London: William Heinemann; New York: G.P. Putnam's Sons and/or New York: Macmillan.

Achilles Tatius, *The Adventures of Leucippe and Clitophons* (trl. S. Gaselee), Loeb Classical Library, 1917.

Aeschylus, *Danaïds* (trl. Herbert Weir Smyth), Loeb Classical Library, 1926.

Aeschylus, *Prometheus Bound* (trl. Herbert Weir Smyth), Loeb Classical Library, 1926.

Aeschylus, *Fragments* (ed. Hugh Lloyd-Jones, trl. Herbert Weir Smyth), Loeb Classical Library, 1957.

Apollonius Rhodius, *Argonautica* (trl. R.C. Seaton), Loeb Classical Library, 1912.

Apuleius, *The Golden Ass* (trl. W. Adlington), Loeb Classical Library, 1935.

Aristophanes, *Clouds* (ed. and trl. Jeffrey Henderson), Loeb Classical Library, 1998.

Aristotle, *The "Art" of Rhetoric* (trl. J.H. Freese), Loeb Classical Library, 1926.

Aristotle, *Generation of Animals* (trl. A.L. Peck), Loeb Classical Library, 1953.

Aristotle, *Meteorologica* (trl. E.W. Webster), in *The Complete Works of Aristotle: The Revised Oxford Translation* (ed. Jonathan Barnes), Princeton: Princeton University Press, 1991 (1984).

Aristotle, *Nicomachean Ethics*, (trl. H. Rackham), Loeb Classical Library, 1934.

Aristotle, *On Coming-To-Be and Passing-Away* (trl. E.S. Forster), Loeb Classical Library, 1955.

Aristotle (attributed), *On the Cosmos* (trl. D.J. Furley), Loeb Classical Library, 1955.

Aristotle, *On the Heavens* (trl. W.K.C. Guthrie), Loeb Classical Library, 1939.

Aristotle, *Sense and Sensibilia* (trl. J.I. Beare), in *The Complete Works of Aristotle: The Revised Oxford Translation* (ed. Jonathan Barnes), Princeton: Princeton University Press, 1991 (1984).

Aristotle, *On the Soul* (trl. W.S. Hett), Loeb Classical Library, 1957.

Aristotle, *Parts of Animals* (trl. A.L. Peck), Loeb Classical Library, 1961.

Aristotle, *The Physics* (trl. Philip H. Wicksteed and Francis M. Cornford), Loeb Classical Library, 1929-34.

Aristotle, *Poetics* (ed. and trl. Stephen Halliwell), Loeb Classical Library, 1995.

Aristotle, *Politics* (trl. H. Rackham), Loeb Classical Library, 1944.

Aristotle, *Problems* (trl. W. S. Hett), Loeb Classical Library, 1957-1961.

Aristotle, *Rhetoric* (trl. W. Rhys Roberts), in *The Complete Works of Aristotle: The Revised Oxford Translation* (ed. Jonathan Barnes), Princeton: Princeton University Press, 1991 (1984).

Athenaeus, *Deipnosophists* (trl. Charles Burton Gulick), Loeb Classical Library, 1928-61.

Callistratus, *Descriptions* (trl. Arthur Fairbanks), Loeb Classical Library, 1931.

Cassiodorus, *Variae* (trl. and intr. S.J.B. Barnish), Liverpool: Liverpool University Press, 1992.

Cassius Dio, *Roman History* (trl. E. Cary), Loeb Classical Library, 1914-27.

Cato, *On Agriculture* (trl. W.D. Hooper), Loeb Classical Library, 1934.

Catullus, *Carmina* (trl. F.W. Cornish), Loeb Classical Library, 1913.

Cicero, *Brutus* (trl. G.L. Hendrickson), Loeb Classical Library, 1939.

Cicero, *De natura deorum* (trl. H. Rackham), Loeb Classical Library, 1933.

Cicero, *De officiis* (trl. Walter Miller), Loeb Classical Library, 1913.

Cicero, *De oratore* (trl. E.W. Sutton and H. Rackham), Loeb Classical Library, 1942.

Cicero, *Tusculanae disputationes* (J.E. King), Loeb Classical Library, 1927.

Claudian, *Epithalamium of Honorius and Maria* (trl. Maurice Platnauer), Loeb Classical Library, 1922.

Claudian, *Rape of Proserpine* (trl. Maurice Platnauer), Loeb Classical Library, 1922.

Columella, *On Agriculture and Trees* (trl. E.S. Forster), Loeb Classical Library, 1941-55.

Dalley, Stephanie (ed. and intr.), *Myths from Mesopotamia*, Oxford and New York: Oxford University Press, 1989.

Diodorus Siculus, *Bibliotheca historica* (trl. C.H. Oldfather, C.L. Shepman, C. Bradford Welles, Russel M. Geer and Francis R. Walton), Loeb Classical Library, 1933-67.

Euclid, *L'optique et la catoptrique* (ed. Paul Ver Eecke), Paris and Bruges: Desclée et De Brouwer, 1938.

The Epic of Gilgamesh: The Babylonian Epic Poem and Other Texts, (trl. and intr. Andrew George), London: Penguin Books, 1999.

Euripides, *Bacchanals* (trl. Arthur Sandars Way), Loeb Classical Library, 1920.

Euripides, *Ion* (ed. and trl. David Kovacs), Loeb Classical Library, 1999.

The Greek Anthology (trl. W.R. Paton), Loeb Classical Library, 1916-18.

Herodotus, *The Persian Wars* (trl. A.D. Godley), Loeb Classical Library, 1921-25.

Hesiod, *Homeric Hymns and Homerica* (trl. Hugh G. Evelyn-White), Loeb Classical Library, 1914.

Hesiod, *Theogony* (trl. Hugh G. Evelyn-White), Loeb Classical Library, 1914.

Hesiod, *Works and Days* (trl. Hugh G. Evelyn-White), Loeb Classical Library, 1914.

Homer, *The Iliad* (trl. A.T. Murray); revised by William Wyatt, Loeb Classical Library, 1924-25.

Homer, *The Odyssey* (trl. A.T. Murray); revised by Georg E. Dimock) Loeb Classical Library, 1919.

Horace, *Odes and Epodes* (trl. C.E. Bennett), Loeb Classical Library, 1968.

Livy, *Ab Urbe Condita*, vols. 2-3 (trl. B.O. Foster) and 12 (trl. Evan T. Sage), Loeb Classical Library, 1922, 1924 and 1938.

Lucian, *Astrology* (trl. A.M. Harmon), Loeb Classical Library, 1936.

Lucretius, *On the Nature of Things* (trl. W.H.D. Rouse), Loeb Classical Library, 1924.

Martial, *Epigrams* (ed. and trl. D.R. Shackleton Bailey), Loeb Classical Library, 1993.

Nonnos, *Dionysiaca* (trl. W.H.D. Rouse), Loeb Classical Library, 1940.

Orphic Hymns (trl. and notes A.N. Athnassakis), Missoula (Montana): Scholars Press, 1977.

Ovid, *Fasti* (trl. James George Frazer), Loeb Classical Library, 1931.

Ovid, *Metamorphoses* (trl. Frank Justus Miller), Loeb Classical Library, 1916.

Pausanias, *Description of Greece* (trl. W.H.S. Jones, H. A. Ormerod and R.E. Wycherley), Loeb Classical Library, 1918-35.

Philo, *On the Eternity of the World* (trl. F.H. Colson), Loeb Classical Library, 1941.

Philo, *Questions and Answers on Genesis* (trl. Ralph Marcus), Loeb Classical Library, 1953.

Philostratus, *Imagines* (trl. Arthur Fairbanks), Loeb Classical Library, 1931.

Pindar, *Olympian Odes* (ed. and trl. William R. Race), Loeb Classical Library, 1997.

Plato, *Critias* (trl. A.E. Taylor), in *The Collected Dialogues of Plato* (1989).

Plato, *Laws* (trl. A.E. Taylor), in *The Collected Dialogues of Plato* (1989).

Plato, *Parmenides* (trl. F.M. Cornford), in *The Collected Dialogues of Plato* (1989).

Plato, *Phaedo* (trl. Hugh Tredennick), in *The Collected Dialogues of Plato* (1989).

Plato, *Phaedrus* (trl. R. Hackforth), in *The Collected Dialogues of Plato* (1989).

Plato, *Sophist* (trl. F.M. Cornford), in *The Collected Dialogues of Plato* (1989).

Plato, *The Republic* (trl. Paul Shorey), in *The Collected Dialogues of Plato* (1989).

Plato, *Symposium* (trl. Michael Joyce), in *The Collected Dialogues of Plato* (1989).

Plato, *Theaetetus* (trl. F.M. Cornford), in *The Collected Dialogues of Plato* (1989).

Plato, *Timaeus* (trl. Benjamin Jowett), in *The Collected Dialogues of Plato* (1989).

Plato, *The Collected Dialogues of Plato including the Letters* (eds. Edith Hamilton and Huntington Cairns), Bollingen series LXXI, Princeton: Princeton University Press, 1989 (1938).

Pliny the Elder, *Natural History* (trl. H. Rackham, W.H.S. Jones and D.E. Eichholz), Loeb Classical Library, 1938-62.

Pliny the Younger, *Letters* (trl. William Melmoth; revised by W.M.L. Hutchinson), Loeb Classicial Library, 1915.

Plotinus, *Enneads* (trl. A.H. Armstrong), Loeb Classical Library, 1966-88.

Plutarch, *Alcibiades and Coriolanus* (trl. Bernadotte Perrin), Loeb Classical Library, 1916.

Plutarch, *Aratus* (trl. Bernadotte Perrin), Loeb Classical Library, 1921.

Plutarch, *De gloria atheniensum (Were the Athenians more Famous in War or in Wisdom?)* (trl. Frank Cole Babbitt), Loeb Classical Library, 1936.

Plutarch, *Pericles and Fabius Maximus* (trl. Bernadotte Perrin), Loeb Classical Library, 1916.

Propertius, *Elegies* (trl. H.E. Butler), Loeb Classical Library, 1912.

Quintilian, *The Orator's Education* (ed. and trl. Donald A. Russel), Loeb Classical Library, 2002.

Sandars, N.K. (ed. and trl.), *Poems of Heaven and Hell from Ancient Mesopotamia*, Harmondsworth: Penguin, 1971.

Sandars, N.K. (ed. and intr.), *The Epic of Gilgamesh*, Harmondsworth: Penguin, 1972.

Seneca, *Naturales quaestiones* (trl. T.H. Corcoran), Loeb Classical Library, 1971-72.

Seneca, *Oedipus* (trl. Frank Justus Miller), Loeb Classical Library, 1917.

Servius, *Servianorum in Vergilii carmina commentariorum, editionis Harvardianae:* Vol. II: *Quod in Aeneidos libros I et II explanationes continent,* Lancaster (Pa.): American Philological Association, 1946.

Sextus Empiricus, *Outlines of Pyrrhonism* (trl. R.G. Bury), Loeb Classical Library, 1933.

Sophocles, *Oedipus the King* (trl. F. Storr), Loeb Classical Library, 1912.

Statius, *Silvae and Thebaid* (ed. and trl. D.R. Shackleton Bailey), Loeb Classical Library, 2003.

Strabo, *The Geography of Strabo* (trl. Horace Leonard Jones), Loeb Classical Library, 1917-32.

Suetonius, *The Lives of the Caesars* (trl. J.C. Rolfe), Loeb Classical Library, 1914.

Tacitus, *The Annals* (trl. John Jackson), Loeb Classical Library, 1931-37.

Tacitus, *The Histories* (trl. Clifford H. Moore), Loeb Classical Library, 1925-31.

Theocritus (ed. and trl. A.S.F. Gow), Cambridge: Cambridge University Press, 1950.

Theophrastus, *De lapidibus* (ed. and trl. D.E. Eichholz), Oxford: Clarendon Press, 1965.

Valerius Maximus, *Memorable Doings and Sayings* (ed. and trl. D.R. Shackleton Bailey), Loeb Classical Library, 2000.

Varro, *On the Latin Language* (trl. Roland G. Kent), Loeb Classical Library, 1938.

Varro, *On Agriculture* (trl. William Davis Hooper), Loeb Classicial Library, 1934.

Virgil (attributed), *Culex* (trl. H. Rushton Fairclough, Loeb Classical Library, 1918.

Virgil, *Eclogues* (trl. H. Rushton Fairclough; revised by G.P. Goold), Loeb Classical Library, 1916.

Virgil, *Georgics* (trl. H. Rushton Fairclough; revised by G.P. Goold), Loeb Classical Library, 1916.

Virgil, *Aeneid* (trl. H. Rushton Fairclough; revised by G.P. Goold), Loeb Classical Library, 1916-18.

Virgil's Works (trl. J.W. Mackail and intr. W.C. McDermott), New York: Modern Library, 1950.

Vitruvius, *On Architecture* (trl. Frank Granger), Loeb Classical Library, 1931-34.

Xenophon, *Oeconomicus* (trl. E.C. Marchant and O.J. Todd), Loeb Classical Library, 1923.

Medieval and biblical sources

Unless otherwise stated, references are from Jacques-Paul Migne (ed.), *Patrologiae cursus completus, Series latina (Patrologia Latina)*, Paris, 1844-1905 or *Series graeca (Patrologia Graeca)*, Paris, 1857-85.

Alberti Magni Opera Omnia (ed. Wilhelm Kübel), vol. 5, II, Aschendorff: Monasterii Westfalorum, 1980.

Aquinas, Thomas, *La Somma Teologica*, Florence: Casa editrice Adriano Salani, 1949ff.

Saint Augustine, *Confessions* (trl. W. Watts), Loeb Classical Library, London: William Heinemann and Cambridge (Mass.): Harvard University Press 1912.

Saint Augustine, *Concerning the City of God against the Pagans* (trl. H. Bettenson), Harmondsworth: Penguin Books, 1972.

Saint Augustine, *De civitate Dei*.

Saint Augustine, *De trinitate*.

Saint Augustine (attributed), *In Vigilia paschae*.

Avitus, *Genesis*.

Beda Venerabilis, *De Genesi ad Literam*.

Beda Venerabilis, *De natura rerum*.

Beda Venerabilis (attributed), *De Sex Dierum Creatione Liber*.

Beda Venerabilis, *De templo Salomonis*.

Beda Venerabilis, *Enerratio in Psalmum LXXXIX*.

Boccaccio, Giovanni, *Comedia delle ninfe fiorentine (Ameto)* (ed. A.E. Quaglio), Florence: G. C. Sansoni, 1963.

Boccaccio, Giovanni, *Genealogia Deorum*, Paris: Lodowici Hornken, 1511.

Bruno of Segni, *Expositio in Exodum*.

Bruno of Segni, *Sententiae*.

Cennini, Cennino, *The Craftsman's Handbook: The Italian "Il libro dell'arte"* (trl. D.V. Thompson, Jr.), New Haven: Yale University Press, 1933.

Dante Alighieri, *The Divine Comedy: The Vision of Dante* (trl. Henry Cary), The Everyman Library, London: J.M. Dent and Vermont: Charles E. Tuttle, 1994 (1814).

Saint Ephrem the Syrian, *Hymns on Paradise* (intr. and trl. Sebastian Brock), Crestwood (NY): St. Vladimir's Seminary Press, 1990.

Friis Johansen, Holger (trl.), *Den hellige Antonius' liv og andre skrifter om munke og helgener i Ægypten, Palæstina og Syrien*, Copenhagen: Munksgaard, 1955.

Ginzberg, Louis, *The Legends of the Jews* (trl. from German: Henrietta Szold), Philadelphia: The Jewish Publication Society of America, 1909-38 (7 vols.).

Godman, Peter (ed.), *Poetry of the Carolingian Renaissance*, Norman (Okl.): University of Oklahoma Press, 1985.

Gregory the Great, *In Ezechielem*.

Habig, Marion A. (ed.), *St. Francis of Assisi: Writings and Early Biographies. English Omnibus of the Sources for the Life of St. Francis*, London: The Society for Promoting Christian Knowledge, 1973.

The Holy Bible, English standard version, containing the Old and the New Testament, Wheaton (Il.): Crossway Bibles, 2001.

Honorius of Autun, *Elucidarium.*

Hrabanus Maurus, *Allegoriæ in sacram scripturam.*

Isidore of Seville, *Traité de la nature* (ed. Jacques Fontaine), Bordeaux: Féret, 1960.

Isidore of Seville, *Etymologiarum sive originum libri XX* (ed. W.M. Lindsay), Oxford: Clarendon Press, 1962 (1911).

Isidore of Seville, *The* Etymologies *of Isidore of Seville* (eds. Stephen A. Barney, W.J. Lewis, J.A. Beach, Oliver Berghof, with the collaboration of Muriel Hall), Cambridge: Cambridge University Press, 2006.

Jerome, *Select Letters* (trl. F.A. Wright), Loeb Classical Library, London: Heinemann and Cambridge (Mass.): Harvard University Press, 1999 (1933).

Johannes Scotus Erigena, *De divisione naturae.*

Langland, William *Piers Plowman* [1378-79]: *A New Translation of the B-Text* (trl. and intr. A.V.C. Schmidt), Oxford: Oxford University Press, 1992.

Latini, Brunetto, *Pataffio e Il Tesoretto*, Naples: T. Chiappari, 1788. .

Michaelis, Wilhelm, *Die Apokryphen Schriften zum Neuen Testament*, Bremen: Schünemann, 1958 (1956).

The New Interpreter's Bible (ed. Leander E. Keck et al.), Nashville: Abingdon Press, 1994-2004, vol. 5 (1997).

Petrarca, Francesco, *Le familiari* (ed. Ugo Dotti), Urbino: Argalia, 1970.

Petrarca, Francesco, *Rerum familiarium libri* (trl. Aldo S. Bernardo), Baltimore: Johns Hopkins University Press, 1975-85 (3 vols).

Petrarca, Francesco, *Canzoniere* (ed. Marco Santagata), Milan: A. Mondadori, 1996.

Petrarca, Francesco, *Selections from the 'Canzoniere' and other Works* (trl., ed., intr. and notes Mark Musa), New York: Oxford University Press, 1999 (1985).

Restoro d'Arezzo, *La composizione del mondo colle sue cascioni* [1282] (ed. Alberto Morino), Florence: Presso l'Accademia della Crusca, 1976.

Tertullian, *Apologeticus adversus gentes pro christianis* (trl. T. R. Glover), Loeb Classical Library, London: William Heinemann and New York: G.P. Putnam's Sons, 1931.

Tertullian, *Adversus Marcionem.*

Post-medieval sources

Abraham, Ralph, "Vibrations and the Realization of Form", in Jantsch and Waddington (1976), pp. 134-49.

Ahlqvist, Agneta, *Tradition och rörelse. Nimbusikonografin i den romerskantika och fornkristna konsten*, Helsinki: SHS, 1990.

Alberti, Leon Battista, *On Painting and On Sculpture: The Latin Texts of* De Pictura *and* De Statua (ed. and trl. Cecil Grayson), London: Phaidon, 1972.

Alberti, Leon Battista, *De pictura* (1435), with Alberti's own translation into Italian, *Della pittura* (1436), (ed. Cecil Grayson), Rome and Bari: Laterza, 1975.

Alberti, Leon Battista, *L'architettura [De re aedificatoria]* (Lat. and Ital. trl. Giovanni Orlandi; intr. and notes Paolo Portoghesi), Milan: Edizioni il Polifilo, 1966.

Alberti, Leon Battista, *On the Art of Building in Ten Books* (trl. J. Rykwert, N. Leach and R. Tavernor), Cambridge (Mass.) and London: MIT Press, 1988.

Alberti, Leon Battista, *Opere Volgari* (ed. Cecil Grayson), Bari: Laterza, 1960-73 (3 vols.).

Alexander, Jonathan, "*Labeur* et *Paresse*: Ideological Representations of Medieval Peasant Labor", *Art Bulletin*, 72, 1990, pp. 436-52.

Allen, Michael J.B., *The Platonism of Marsilio Ficino: A Study of His* Phaedrus Commentary, *Its Sources and Genesis*, Berkeley, Los Angeles and London: University of California Press, 1984.

All'ombra del Lauro (exhibition catalogue), Florence: Silvana Editoriale, 1992.

Alpers, Svetlana, *The Art of Describing: Dutch Art in the Seventeenth Century*, Chicago: University of Chicago Press and John Murray, 1983.

Amouretti, Marie-Claire, *Le pain et l'huile dans la Grèce antique*, Paris: Les Belles Lettres, 1986.

Anati, Emmanuel, *La civilisation du Val Camonica*, Paris: Arthaud, 1960.

Antal, Frederick, "Gedanken zur Entwicklung der Trecento- und Quattrocentomalerei in Siena und Florenz", *Jahrbuch für Kunstwissenschaft*, 2, 1924/25, pp. 207-39.

Antal, Frederick, *Florentine Painting and Its Social Background: The Bourgeois Republic before Cosimo de' Medici's Advent to Power. XIV and Early XV Centuries*, London: Kegan Paul, 1947.

Applebaum, Herbert, *The Concept of Work: Ancient, Medieval and Modern*, Albany: State University of New York Press, 1992.

Armstrong Anderson, Lilian, *The Paintings and Drawings of Marco Zoppo*, New York: Garland, 1976.

Arnott, Peter, *Greek Scenic Conventions in the Fifth Century B.C.*, Oxford: Clarendon, 1962.

Avril, François, *Manuscript Painting at the Court of France: The Fourteenth Century (1310-80)*, New York: G. Braziller, 1978.

Bätschmann, Oskar, *Nicolas Poussin: Dialectics of Painting*, London: Reaktion Books, 1990.

Bal, Mieke and Bryson, Norman, "Semiotics and Art History", *Art Bulletin*, 73, 1991, pp. 174-208.

Baltrušaitis, Jurgis, "Villes sur arcatures", in *Urbanisme et architecture. Études [...] en l'honneur de Pierre Lavedan*, Paris: H. Laurens, 1954, pp. 31-40.

Baltrušaitis, Jurgis, "Pierres imagées", in Jurgis Baltrušaitis (ed.), *Aberrations. Essai sur la légendes des formes*, Paris: Flammarion, 1983 (1957), pp. 87-149.

Bandmann, Günther, "Höhle und Säule auf Darstellungen Mariens mit dem Kinde", in *Festschrift für Gert von der Osten*, Cologne: M. DuMont Schauberg, 1970, pp. 148ff.

Baring, Anne and Cashford, Jules, *The Myth of the Goddess: Evolution of an Image*, London and New York: Viking, 1991.

Barlow, Connie (ed.), *Evolution Exended: Biological Debates on the Meaning of Life*, Cambridge (Mass.): MIT Press, 1994.

Barnett, R.D., *Assyrische Skulpturen in British Museum*, Recklinghausen: Aurel Bongers, 1975.

Barnett, R.D., *Assyrische Palastreliefs*, Prague: Artia, 1960.

Baron, Hans, *The Crisis of the Early Italian Renaissance: Civic Humanism and Republican Liberty in an Age of Classicism and Tyranny*, Princeton: Princeton University Press, 1955.

Battista Spagnoli Mantuano, *Contra impudice scribentes*, Paris: Thielmann Kerver, 1499.

Der Bauer und seine Befreiung. Kunst vom 15. Jahrhundert bis zur Gegenwart. Ausstellung aus Anlass des 450. Jahrestages des deutschen Bauernkrieges und des 30. Jahrestages der Bodenreform im Albertinum September 1975 bis Januar 1976, Dresden: Ministerium für Kultur, Staatliche Kunstsammlungen Dresden, 1975.

Baxandall, Michael, "A Dialogue on Art from the Court of Leonello d'Este", *Journal of the Warburg and Courtauld Institutes*, 26, 1963, pp. 304-26.

Baxandall, Michael, *Giotto and the Orators: Humanist Observers of Painting in Italy and the Discovery of Pictorial Composition 1350-1450*, Oxford: Clarendon, 1971.

Baxandall, Michael, *Painting and Experience in Fifteenth Century Italy*, Oxford and New York: Oxford University Press, 1972.

Beckwith, John, *Early Christian and Byzantine Art*, Harmondsworth: Penguin Books, 1979.

Beer, E.S. de, "Gothic: Origin and Diffusion of the Term: The Idea of Style in Architecture", *Journal of the Warburg and Courtauld Institutes*, 11, 1948, pp. 143-62.

Benjamin, Walter, *Gesammelte Schriften* I, 2 (eds. R. Tiedemann and H. Schweppenhäuser), Frankfurt a.M.: Suhrkamp, 1974.

Benjamin, Walter, *Selected Writings*, vol. 4: *1938-40* (ed. Howard Eiland and Michael W. Jennings, trl. Edmund Jephcott, Howard Eiland et al.), Cambridge (Mass.) and London: Harvard University Press, 2003.

Benko, Stephen, *The Virgin Goddess: Studies in the Pagan and Christian Roots of Mariology*, Leiden: E.J. Brill, 1993.

Benz, Ernst, "Die heilige Höhle in der alten Christenheit und in der östlich-ortodoxen Kirche", *Eranos-Jahrbuch*, 22, 1953, pp. 365-432.

Berchem, Marguerite van and Clouzot, Etienne, *Mosaiques chrétiennes du IVme au Xme siècle*, Geneva: Les presses de l'Imprimerie du "Journal de Genève", 1924.

Berenson, Bernard, *The Central Italian Painters of the Renaissance*, New York and London: G.P. Putnam's Sons, 1897.

Berenson, Bernard, *Italian Pictures of the Renaissance: Florentine School*, London: Phaidon, 1963.

Berger, Pamela, *The Goddess Obscured: Transformation of the Grain Protectress from Goddess to Saint*, Boston: Beacon Press, 1985.

Bergmann, Bettina, "Exploring the Grove: Pastoral Space on Roman Walls", in Hunt (1992), pp. 20-46.

Berman, Marshall, *All That Is Solid Melts Into Air: The Experience of Modernity*, London and New York: Verso, 1983 (1982).

Bernheimer, Richard, *Wild Men in the Middle Ages: A Study in Art, Sentiment, and Demonology*, Cambridge (Mass.): Harvard University Press, 1952.

Bertalanffy, Ludwig von, "General System Theory" (1955), in H.J. Demerath III and Richard A. Peterson (eds.), *System, Change and Conflict: A Reader on Contemporary Sociological Theory and the Debate over Functionalism*, London: Collier-Macmillian and New York: The Free Press, 1967, pp. 115-29.

Bertalanffy, Ludwig von, *General System Theory: Foundations, Development, Applications*, New York: G. Braziller, 1968.

Berti, Luciano, *Il Principe dello Studiolo: Francesco I dei Medici e la fine del Rinascimento fionrentino*, Florence: Editrice Edam, 1967.

Beyen, H.G., *Die pompejanische Wanddekoration vom Zweiten bis zum Vierten Stil*, The Hague: M. Nijhoff, 1938-60 (2 vols.).

Białostocki, Jan, "Romantische Ikonographie", in Jan Białostocki (ed.), *Stil und Ikonographie*, Dresden: VEB Verlag der Kunst, 1966, pp. 156-80.

Biedermann, Hans, *Handlexikon der magischen Künste von der Spätantike bis zum 19. Jahrhundert*, Graz: Akademische Druck- und Verlagsanstalt, 1968.

Bihalji-Merin, Oto, *Byzantine Frescoes and Icons in Yugoslavia*, London: Thames & Hudson, 1960.

Black, Jeremy and Green, Anthony, *Gods, Demons and Symbols of Ancient Mesopotamia: An Illustrated Dictionary*, Austin: University of Texas Press, 1992.

Blackmore, Susan, *The Meme Machine* (preface: Richard Dawkins), Oxford: Oxford University Press, 1999.

Blatt, Sidney J. (in collaboration with Ethel S. Blatt), *Continuity and Change in Art: The Development of Modes of Representation*, Hillsdale (NJ) and London: L. Erlbaum, 1984.

Blatt, Sidney J., "On Development in the History of Art", in M.B. Franklin and B. Kaplan (eds.), *Development and the Arts: Critical Perspectives*, Hillsdale (NJ): L. Erlbaum, 1994, pp. 195-226.

Blatt, Sidney J., "A Psychoanalytic Appreciation of Giotto's Mode of Artistic Representation and Its Implications for Renaissance Art and Science", *The Psychoanalytic Study of the Child*, 49, 1994, pp. 365-93.

Bloch, Marc, *Land and Work in Medieval Europe* (trl. J.E. Anderson), London: Routledge & K. Paul, 1967 (Fr. 1st ed. 1966).

Blount, Thomas, *Glossographia: or a Dictionary Interpreting all such Hard Words, Whether Hebrew, Greek, Latin, Italian [...], as are now used in our refined English Tongue [...]*, London: Thomas Newcombe for Humphrey Moseley and George Sawbridge, 1656; reprint (facsimile): Menston: Scolar Press, 1969.

Blume, Bernhard, "Lebendiger Quell und Flut des Todes. Ein Beitrag zu einer Literaturgeschichte des Wassers", *Arcadia*, 1, 1966, pp. 18-30.

Blumenberg, Hans, *Höhlenausgänge*, Frankfurt a.M.: Suhrkamp 1989.

Boardman, John, *Athenian Black Figure Vases: A Handbook*, New York: Oxford University Press, 1974.

Boardman, John, *The History of Greek Vases: Potters, Painters and Pictures*, London: Thames & Hudson, 2001.

Börsch-Supan, Eva, *Garten-, Landschafts- und Paradiesmotive im Innenraum*, Berlin: Hessling, 1967.

Bogh, Mikkel, "Formalitet og figurativitet. Fænomenlogiske perspektiver i nyere kunstteori", in Hans Dam Christensen, Anders Michelsen and Jacob Wamberg (eds.), *Kunstteori. Positioner i nutidig kunstdebat*, Copenhagen: Borgen, 1999, pp. 215-50.

Bourdieu, Pierre, *Zur Soziologie der symbolischen Formen* (trl. W.F. Fietkau), Frankfurt a.M.: Suhrkamp, 1970.

Bourdieu, Pierre, *Outline of A Theory of Practice* (trl. R. Nice), Cambridge: Cambridge University Press, 1977 (Fr. 1st ed. 1972).

Bourdieu, Pierre, *The Logic of Practice* (trl. R.Nice), Stanford: Stanford University Press, 1990 (Fr. 1st ed. 1980).

Bourdieu, Pierre, *The Field of Cultural Production: Essays on Art and Literature* (ed. and intr. Randal Johnson), New York: Columbia University Press, 1993.

Bovero, Anna, "Ferrarese Miniatures in Turin", *Burlington Magazine*, 99, 1957, pp. 261-65.

Bowler, Peter J., *Evolution: The History of an Idea*, Berkeley, Los Angeles and London: University of California Press, 1984.

Braidwood, Robert J., *Prehistoric Men*, Glenview (Ill.): Scott, Foresman, 1967.

Bramsen, Henrik, *Kunst i enevældens sidste hundrede år, sådan set*, Copenhagen: Fogtdal, 1990.

Braudel, Fernand, *The Mediterranean and the Mediterranean World in the Age of Philip II*, London: Collins, 1972.

Braudel, Fernand, *Civilization and Capitalism, 15th-18th Century* (trl. S. Reynolds), Berkeley and Los Angeles: University of California Press, 1992 (Fr. 1st ed. 1979).
Vol. II: *The Wheels of Commerce.*
Vol. III: *The Perspective of the World.*

Braunfels, Wolfgang, *Die Welt der Karolinger und ihre Kunst*, Munich: Georg D.W. Callwey, 1968.

Breustedt, Renate, *Die Entstehung und Entwicklung des Nachtbildes der abenländischen Malerei und seine Ausbreitung in den Niederländern (bis ca. 1520/30)* (Diss.), Göttingen, 1966.

Brockhaus, Heinrich, "Ein edles Geduldspiel: "Die Leitung der Welt oder die Himmelsleiter" die sogenannten Taroks Mantegnas vom Jahre 1459-60", in *Miscellanea di storia dell'arte in onore di Igino Benvenuto Supino* (a cura della Rivista d'arte), Florence: Olschki, 1933, pp. 397-416.

Bromehead, C.N., "Mining and Quarrying in the Seventeenth Century", in S. Singer, E.J. Holmyard, E.J. Hall and T.I. Williams (eds.), *A History of Technology*, Oxford: Clarendon, 1956.

Brown, Christopher, *Dutch Landscape: The Early Years. Haarlem and Amsterdam, 1590-1650* (exhibition catalogue), London: National Gallery, 1986.

Brubaker, L. and Littlewood, R., "Byzantinische Gärten", in Maureen Carroll-Spillecke (ed.), *Der Garten von der Antike bis zum Mittelalter*, Mainz a.R.: Philipp von Zabern, 1992.

Brummer, Hans Henrik, "Pan Platonicus", *Konsthistorisk tidskrift*, 33, 1964, pp. 55-67.

Bruyne, Edgar de, *Études d'esthétique médievale*, Bruges: De Tempel, 1946.

Bryson, Norman, *Vision and Painting: The Logic of the Gaze*, New Haven: Yale University Press, 1983.

Bryson, Norman, *Looking at the Overlooked: Four Essays on Still Life Painting*, Cambridge (Mass.): Harvard University Press, 1990.

Bucci, Mario, *Lo Studiolo di Francesco I*, Florence: Sadea/G.C. Sansoni, 1965.

Buchtal, Hugo, "Early Fourteenth Century Illuminations from Palermo", *Dumbarton Oaks Papers*, 20, 1966, pp. 103-18.

Bultmann, Rudolf, "Zur Geschichte der Lichtsymbolik in Altertum", *Philologus*, 97, 1948, pp. 1-36.

Bunim, Miriam Schild, *Space in Medieval Painting and the Forerunners of Perspective*, New York: Columbia University Press, 1940.

Burckhardt, Jacob, *Der Cicerone. Eine Anleitung zum Genuss der Kunstwerke Italiens*, Basle: Schweighause-rische Verlagsbuchhandlung, 1860.

Burckhardt, Jacob, *Die Cultur der Renaissance in Italien. Ein Versuch*, Stuttgart: Alfred Kröner, 1926 (1860).

Burford, Alison, *Land and Labor in the Greek World*, Baltimore and London: Johns Hopkins University Press, 1993.

Burke, Edmund, *A Philosophical Enquiry into the Origin of Our Ideas of the Sublime and Beautiful*, London: R. and J. Dodsley, 1759 (1757).

Burke, Peter, *The Italian Renaissance: Culture and Society in Italy*, Cambridge: Cambridge University Press, 1986.

Burley, Walter, *Expositio in libros octo de physicorum audito Aristotelis Stagerite* (ed. Nicoletto Vernia), Ven-ice, 1482.

Busch, Werner (ed.), *Landschaftsmalerei*. Geschichte der klassischen Bildgattungen in Quellentexten und Kommentaren, Band 3, Berlin: Reimer, 1997.

Cahn, Walter, "Medieval Landscape and the Encyclopedic Tradition", in Daniel Poirion and Nancy Freeman Regalado (eds.), *Contexts: Style and Values in Medieval Art and Literature*, Yale French Stud-ies Special Edition, New Haven: Yale University Press, 1991, pp. 11-24.

Calabi, Emma, "I corali miniati del convento di S. Francesco di Brescia", *La critica d'Arte*, 3, 1938, pp. 57-67.

Camille, Michael, "Labouring for the Lord: The Ploughman and the Social Order in the Luttrell Psal-ter", *Art History*, 10, 1987, pp. 423-54.

Camille, Michael, *The Gothic Idol: Ideology and Image-making in Medieval Art*, Cambridge: Cambridge University Press, 1989.

Camille, Michael, *Gothic Art: Visions and Revelations of the Medieval World*, London: Everyman Art Li-brary, 1996.

Campbell, Stephen J., *Cosmè Tura of Ferrara: Style, Politics and the Renaissance City (1450-1495)*, New Haven and London: Yale University Press, 1997.

Carrol, Lewis, "Sylvie and Bruno Concluded", in *The Complete Works of Lewis Carroll*, London: None-such Press, 1939.

Carroll-Spillecke, Maureen, *Landscape Depictions in Greek Relief Sculptures: Development and Conventionalization*, Frankfurt a.M, Bern and New York: Peter Lang, 1985.

Cartari, Vincenzo, *Le imagini de i dei degli antichi nelle qvali si contengono gl'idoli, riti, ceremonie, e altre cose appartenenti alla religione de gli antichi*, Venice: Vincentio Valgrisi, 1571 (reprint: New York and London: Garland Publishing, 1976).

Cassirer, Ernst, *Individuum und Kosmos in der Philosophie der Renaissance. Die platonische Renaissance in England und die Schule von Cambridge,* Studien der Bibliothek Warburg (ed. F. Saxl), Leipzig and Berlin: B.G. Teubner, 1927.

Castleden, Rodney, *Minoans: Life in Bronze Age Crete*, London and New York: Routledge, 1990.

Cavendish, Richard, *Visions of Heaven and Hell*, London: Orbis, 1977.

Chastel, André, *Marsile Ficin et l'art*, Geneva: E. Droz. and Lille: R. Giard, 1954.

Chastel, André, *Art et humanisme à Florence au temps de Laurent le Magnifique: Études sur la Renaissance et l'humanisme platonicien*, Paris: Presses universitaires de France, 1959.

Cherry, John F., "Pastoralism and the role of animals in pre- and protohistoric economies of the Aegean", in Whittaker (1988).

Chouquer, Gérard and Favory, François, *Les paysages de l'antiquité: Terres es cadastres de l'Occident romain (IVe siècle avant J.-C./ IIIe siècle après J.-C.)*, Paris: Errance, 1991.

Christiansen, Keith, Kanter, Laurence B. and Strehlke, Carl Brandon, *Painting in Renaissance Siena 1420-1500* (exhibition catalogue), New York: Metropolitan Museum of Art, distributed by Harry N. Abrams, 1988.

Cipolla, Carlo M., "The Decline of Italy: The Case for a Fully Matured Economy", *Economic History Review*, 5, 1952, pp. 178-87.

Clagett, Marshall (ed., intr. and trl.), *Nicole Oresme and the Medieval Geometry of Qualities and Motions: A Treatise on the Uniformity and Difformity of Intensities Known as Tractatus de configurationibus qualitatum et motuum*, Madison, Milwaukee and London: University of Wisconsin Press, 1968.

Clark, Kenneth, *Landscape into Art*, London: John Murray, 1949.

Clarke, John R., *Art in the Lives of Ordinary Romans: Visual Representation and Non-Elite Viewers in Italy, 100 B.C. – A.D. 315*, Berkeley, Los Angeles and London: University of California Press, 2003.

Clottes, Jean and Lewis-Williams, David, *The Shamans of Prehistory: Trance and Magic in the Painted Caves* (trl. Sophie Hawkes), New York: Harry N. Abrams, 1998 (Fr. 1st ed. 1996).

Cogliati Arano, Luisa, *The Medieval Health Handbook: Tacuinum Sanitatis* (trl. and ed. O. Ratti and A. Westbrook), New York: G. Braziller, 1976.

Cohn, Jonas, *Geschichte des Unendlichkeitsproblems im abendländischen Denkens bis Kant*, Hildesheim: G. Olms, 1960 (1896).

Coles, Paul, "A note on the arrest of pre-Capitalism in Italy", *Past and Present*, 2, 1952, pp. 51-54.

Colonna, Francesco, *Hypnerotomachia Poliphili* (eds. Giovanni Pozzi and Lucia A. Ciapponi), Padua: Editrice Antenore, 1964 (facsimile of orig. ed., Venice 1499).

Colonna, Francesco, *Hypnerotomachia Poliphili: The Strife of Love in a Dream* (trl. Joscelyn Godwin), London: Thames & Hudson, 1999 (Latin 1st ed. 1499).

Comoretto, Achille, *Le miniature del sacramentario fuldense di Udine*, Udine: Artu grafiche friulane, 1988.

Conti, Giovanni, *Rapporti tra egiziano e semitico nel lessico egiziano dell'agricoltura*, Florence: Istituto di linguistica e di lingue orientali, Università di Firenze, 1978.

Cosgrove, Denis E., *Social Formation and Symbolic Landscape*, Madison: University of Wisconsin Press, 1998 (1984).

Crawford, Harriet, *Sumer and the Sumerians*, Cambridge: Cambridge University Press, 1991.

Crawford, Vaughn Emerson, et al., *Ancient Near Eastern Art: The Metropolitan Museum of Art. Guide to the Collections*, New York: Metropolitan Museum of Art, 1966.

Curtius, Ernst Robert, *Europäische Literatur und Lateinisches Mittelalter*, Bern: Francke, 1954.

Curtius, Ludwig, *Die Wandmalerei Pompejis. Eine Einführung in ihr Verständnis*, Hildesheim: G. Olms, 1960.

Cusano, Nicolò, *Scritti filosofici* (ed. G. Santinello), Bologna: Zanichelli, 1965-80.

Damisch, Hubert, *Théorie du /nuage/: Pour une histoire de la peinture*, Paris: Seuil, 1972.

Damisch, Hubert, *L'Origine de la perspective*, Paris: Flammarion, 1987.

Damisch, Hubert, *A Theory of /Cloud/: Toward a History of Painting* (trl. Janet Lloyd), Stanford: Stanford University Press, 2002 (Fr. 1st ed. 1972).

Daniélou, Jean, "Terre et paradis chez les pères de l'église", *Eranos-Jahrbuch*, 22, 1953, pp. 433-72.

Danto, Arthur C., *The Philosophical Disenfranchisement of Art*, New York: Columbia University Press, 1986.

Daston, Lorraine, "Nature by Design", in Lorraine Daston and Katherine Park, *Wonders and the Order of Nature 1150-1750*, New York: Zone Books, 1998, pp. 232-53.

Degenhart, Bernhard and Schmitt, Annegrit, *Corpus der italienischen Zeichnungen 1300-1450*, Berlin: Mann, 1968-90 (6 vols.).

Deichman, Friedrich Wilhelm (ed.), *Repertorium der christlich-antiken Sarkofage*, vol. 1: *Rom und Ostia*, Wiesbaden: Franz Steiner Verlag, 1967.

Demus, Otto, *Mosaics of Norman Sicily*, London: Routledge & Paul, 1950.

Demus, Otto, *Byzantine Art and the West*, New York: New York University Press 1970.

Demus, Otto, *Corpus der byzantinischen Miniaturenhandschriften*, Stuttgart: Anton Hiersemann, 1977f.

Demus, Otto, *The Mosaics of San Marco in Venice*, Chicago and London: University of Chicago Press, 1984.

Derrida, Jacques, *The Truth in Painting* (trl. G. Bennington and I. McLeod), Chicago: University of Chicago Press, 1987 (Fr. 1st ed. 1978).

Descartes, René, "Discourse on the Method of Rightly Conducting the Reason and Seeking Truth in the Sciences" [1637] (trl. J. Veitch), in *The Rationalists*, New York: Doubleday, 1960, pp. 35-96.

Deshman, Robert, *The Benedictional of Æthelwold*. Studies in Manuscript Illumination 9 (ed. Herbert L. Kessler), Princeton: Princeton University Press, 1995.

Didi-Huberman, Georges, *Fra Angelico: Dissemblance and Figuration* (trl. J.M. Todd), Chicago and London: University of Chicago Press, 1995 (Fr. 1st ed. 1990).

Dieterich, Albrecht, *Mutter Erde. Ein Versuch über Volksreligion*, Leipzig and Berlin: B.G. Teubner, 1905.

Dilke, O.A.W., *The Roman Land Surveyors: An Introduction to the Agrimensores*, Newton Abbot: David and Charles, 1971.

Dilke, O.A.W., *Greek and Roman Maps*, London: Thames & Hudson, 1985.

Dixon, Laurinda S., *Alchemical Imagery in Bosch's Garden of Delights* (diss.), Ann Arbor (Michigan): University Microfilms International, 1981.

Dodge, Barbara Kathlyn, *Tradition, Innovation and Technique in Trecento Mural Painting: The Frescoes and Sinopie Attributed to Francesco Traini in the Camposanto in Pisa* (diss.), Ann Arbor (Michigan): University Microfilms International, 1979.

Döbert, Rainer, "Methodologische und forschungsstrategische Implikationen von evolutionstheoretischen Stadienmodellen", in Urs Jaeggi and Axel Honneth (eds.), *Theorien des Historischen Materialismus*, Frankfurt a.M.: Suhrkamp, 1977, pp. 524-60.

Döbert, Rainer, "The Role of Stage Models within a Theory of Social Evolution, Illustrated by the European Witch Craze", in U.J. Jensen and R. Harré (eds.), *The Philosophy of Evolution*, Brighton: Harvester Press, 1981, pp. 91-119.

Döbert, Rainer, Habermas, Jürgen and Nunner-Winkler, Gertrud (eds.), *Entwicklung des Ichs*, Cologne: Kiepenheuer & Witsch, 1977.

Donne, John, *The Works of John Donne: With an Introduction and Bibliography*, Ware: Wordsworth Poetry Library, 1994.

Dorigo, Wladimiro, *Late Roman Painting: A Study of Pictorial Records 30 BC-AD 500* (trl. James Cleugh and John Warrington), London: Dent, 1971.

Dronke, Peter, "Tradition and Innovation in Medieval Western Colour-Imagery", *Eranos*, 41, 1972, pp. 51-107.

Dufrenne, Suzy, *Les illustrations du Psautier d'Utrecht: sources et apport carolingien*, Paris: Ophrys, 1978.

Duhem, Pierre, *Le système du monde: Histoire des doctrines cosmologiques de Platon à Copernic*, Paris: A. Hermann, 1913-59 (10 vols.).

Durand, Jean-Luis, *Sacrifice et labour en Grèce ancienne: Essai d'anthropologie religieuse*, Paris: Découverte and Rome: Ecole française de Rome, 1986.

Eagleton, Terry, *Literary Theory: An Introduction*, Oxford: Basil Blackwell, 1983.

Ebeling, Erich, et al. (eds.), *Reallexikon der Assyrologie*, Berlin and Lepizig: W. de Gruyter, 1928ff.

Edgerton, Samuel Y., *The Renaissance Rediscovery of Linear Perspective*, New York: Basic Books, 1975.

Edinger, Edward F., *The New God-Image: A Study of Jung's Key Letters Concerning the Evolution of the Western God-Image*, Wilmette (Ill.): Chiron, 1996.

Ehrenberg, Margaret, *Women in Prehistory*, Norman (Okl.) and London: University of Oklahoma Press, 1989.

Eisler, Colin, *The Genius of Jacopo Bellini: The Complete Paintings and Drawings*, New York: Harry N. Abrams, 1989.

Eisler, Robert, *Weltenmantel und Himmelszelt. Religionsgeschichtliche Untersuchungen zur Urgeschichte des antiken Weltbildes*, Munich: C.H. Beck'sche Verlagsbuchhandlung, Oskar Beck, 1910.

Elers Koch, Kirsten, "Da ørkenen blomstrede", *Sfinx*, 8, 1985, pp. 18-23

Eliade, Mircea, *Myths, Dreams and Mysteries: The Encounter between Contemporary Faiths and Archaic Realities* (trl. P. Mairet), New York: Harper & Row, 1960 (Fr. 1st ed. 1957).

Eliade, Mircea, *The Forge and the Crucible* (trl. S. Corrin), Chicago and London: Chicago University Press, 1962 (Fr. 1st ed. 1956).

Elsner, Jaś, *Art and the Roman Viewer: The Transformation of Art from the Pagan World to Christianity*, Cambridge: Cambridge University Press, 1995.

Emison, Patricia, "Leonardo's Landscape in the *Virgin of the Rocks*", *Zeitschrift für Kunstgeschichte*, 56, 1993, pp. 116-18.

Emmeche, Claus, *Det levende spil. Biologisk form og kunstigt liv*, Copenhagen: Nysyn, 1991.

Enciclopedia Italiana di scienze, lettere ed arti: Pubblicata sotto l'alto patronato di S. M. il Re d'Italia, vol. 13, Rome: Istituto della Enciclopedia Italiana, 1932.

Epperlein, Siegfried, "Bäuerliche Arbeitsdarstellungen auf mittelalterlichen Bildzeugnissen. Zur geschichtlichen Motivation von Miniaturen und Graphiken vom 9. bis 15. Jahrhundert", *Zeitschrift für Wirtschaftsgeschichte*, 1976, pp. 181-208.

Ercoli, Giuliano, "Il Trecento senese nei *Commentarii* di Lorenzo Ghiberti", in *Lorenzo Ghiberti nel suo tempo*, pp. 317f.

Ernout, A. and Meillet, A., *Dictionnaire étymologique de la langue latine: histoire des mots*, Paris: C. Klincksieck, 1967.

Eröffnete Geheimnisse des Steins der Weisen oder Schatz-Kammer der Alchymie, Salzburg 1718 (reprint Graz: Akademische Druck- und Verlagsanstalt, 1976).

Evans, Arthur J., *The Mycenean Tree and Pillar Cult and Its Mediterranean Relations. With Illustrations from Recent Cretan Finds*, London: Macmillan, 1901.

Evans, Arthur J., *The Palace of Minos: A Comparative Account of the Successive Stages of the Early Cretan Civilization as Illustrated by the Discoveries at Knossos*, London: Macmillan, 1921-35 (4 vols.).

Fabricius, Johannes, *Alchemy: The Medieval Alchemists and their Royal Art*, Copenhagen 1976.

Fabricius Hansen, Maria, "Representing the Past: The Concept and Study of Antique Architecture in 15th-century Italy", *Analecta Romana Instituti Danici*, 23, 1996, pp. 83-116.

Fabricius Hansen, Maria, *Ruinbilleder. Arkitekturfremstillinger og metaforiske brud i 1400-tallets kunst*, unpubl. ph.d. dissertation, Copenhagen: University of Copenhagen, 1996.

Fabricius Hansen, Maria, *Ruinbilleder. Antikfascinationens baggrunde i 1400-tallets italienske maleri*, Copenhagen: Tiderne Skifter, 1999.

Fabricius Hansen, Maria, "La fureur du grotesque: Alberti, Mantegna et l'auto-représentation artistique", in Francesco Furlqan (ed.), *Leon Battista Alberti*. Actes du congrès international de Paris, 10-15 avril 1995, Turin: Nino Aragno and Paris: J. Vrin, 2000, pp. 575-87.

Falkenburg, Reindert L., *Joachim Patinir: Landscape as an Image of the Pilgrimage of Life* (trl. M. Hoyle), Amsterdam and Philadelphia: J. Benjamins, 1988.

Fauré, P., *Fonctions des cavernes crétoises*, Paris: E. de Boccard, 1964.

Fechner, Renate, *Natur als Landschaft. Zur Entstehung der ästhetischen Landschaft*, Frankfurt a.M.: P. Lang, 1986.

Feder, Theodore H., *Great Treasures of Pompeji and Herculaneum*, New York: Abbeville Press, 1978.

Feldges, Uta, *Landschaft als topographisches Porträt. Der Wiederbeginn der europäischen Landschaftsmalerei in Siena*, Berne: Benteli, 1980.

Ferguson, George, *Signs and Symbols in Christian Art. With Illustrations from Paintings of the Renaissance*, London and New York: Oxford University Press, 1954.

Ficino, Marsilio, *Opera omnia*, Basle: Heinrich Petri, 1576 (2 vols.).

Ficino, Marsilio, *Théologie platonicienne de l'immortalité des Âmes* (with trl. by Raymond Marcel), Paris: Société d'édition "Les Belles Lettres", 1964.

Ficino, Marsilio, *Platonic Theology* (trl. Michael J.B. Allen), The I Tatti Renaissance Library, Cambridge (Mass.) and London: Harvard University Press, 2004.

Filarete, Antonio, *Filarete's Treatise on Architecture* (trl. and intr. John Spencer), New Haven and London: Yale University Press, 1965.

Filarete, Antonio, *Trattato di architettura* (eds. A.M. Finoli and L. Grassi), Milan: Edizioni il Polifilo, 1972.

Filedt Kok, J.P. (ed.), *Livelier than Life: The Master of the Amsterdam Cabinet or the Housebook Master ca.1470-1500* (exhibition catalogue), Amsterdam: Rijkspretenkabinet/Rijksmuseum, in association with G. Schwartz, Maarssen, 1985.

Fischer, Chris, "Fra Bartolommeo's Landscape Drawings", *Mitteilungen des kunsthistorischen Instituts in Florenz*, 33, 1989, pp. 301-42.

Folsom, Robert, *Attic Red-Figured Pottery*, Park Ridge (NJ): Noyes Press, 1976.

Forbes, R.J., *Studies in Ancient Technology*, vol. 7, Leiden: E.J. Brill, 1966.

Foucault, Michel, *Les Mots et les Choses: Une archéologie des sciences humaines*, Paris: Gallimard, 1966.

Francisco de Hollanda, *Vier Gespräche über die Malerei geführt zu Rom 1538* (ed. Joaquim de Vasconcellos), Quellenschriften für Kunstgeschichte und Kunsttechnik des Mittelalters und der Neuzeit, vol. 9, Vienna: C. Graeser, 1899.

Frankl, Paul, *The Gothic: Literary Sources and Interpretations through Eight Centuries*, Princeton: Princeton University Press, 1960.

Frazer, Alfred, "The Roman Villa and the Pastoral Ideal", in Hunt (1992), pp. 49-61.

Frazer, James George, *The Golden Bough: A Study in Magic and Religion. Abridged Edition*, New York: Macmillan: 1922.

Freund, Walter, *Modernus und andere Zeitbegriffe des Mittelalters*, Cologne: Böhlau, 1957.

Frey, Karl and Frey, Herman-Walther (eds.), *Der literarische Nachlass Giorgio Vasaris*, vol. 2, Munich: Georg Müller, 1930.

Friedländer, Max J., *Essays über die Landschaftsmalerei und andere Bildgattungen*, The Hague: A.A.M. Stols, 1947.

Frimmel, Theodor (ed.), *Der anonimo Morelliano (Marcanton Michiel's Notizia d'opere del disegno)*, Vienna: C. Graeser, 1888.

Fronzaroli, Pelio, "Studi sul lessico comune semitico. V. – La natura selvatica", *Atti della Accademia Nazionale dei Lincei. Rendiconti*, 23, 1968, pp. 267-303.

Frugoni, Chiara, *Pietro and Ambrogio Lorenzetti*, Florence: Scala, 1988.

Furley, David, "Aristotle and the Atomists on Infinity", in David Furley (ed.), *Cosmic Problems: Essays on Greek and Roman Philosophy of Nature*, Cambridge: Cambridge University Press, 1989, pp. 103-14.

Gablik, Suzi, *Progress in Art*, London: Thames & Hudson, 1976.

Gaetano de' Thiene, *Recollecta super octo libros physicorum Aristotelis*, Vicenza: Henricus de Sancto Ursio, Zenus, 1487.

Gage, John, *Color and Culture: Practice and Meaning from Antiquity to Abstraction*, Berkeley and Los Angeles: University of California Press, 1993.

Galassi, Peter, *Before Photography: Painting and the Invention of Photography*, New York: Museum of Modern Art, 1981.

Garnsey, Peter, "Mountain Economies in Southern Europe: Thoughts on the Early History, Continuity and Individuality of Mediterranean Upland Pastoralism", in Whittaker (1988), pp. 196-209.

Garrison, E.B., *Studies in the History of Medieval Italian Painting*, Florence: L'Impronta, 1953-56 (4 vols.).

Gauckler, P., "Le domaine des Laberii à Uthina", *Monuments et Mémories, Fondation Eugène Piot*, vol. III, 1896, pp. 177-229.

Gelfer-Jørgensen, Mirjam, *Medieval Islamic Symbolism and the Paintings in the Cefalù Cathedral*, Leiden: E.J. Brill, 1986.

Gentili, Augusto, "Mito cristiano e storia ferrarese nel Polittico Griffoni", in Giuseppe Papagno and Amedeo Quondam (eds.), *La corte e lo spazio: Ferrara Estense*, Rome: Bulzoni, 1982, pp. 574ff.

Ghiberti, Lorenzo, *Lorenzo Ghibertis Denkwürdigkeiten (I Commentarii)* (ed. Julius von Schlosser), Berlin: Julius Bard, 1912.

Ghiberti, Lorenzo, *Second Commentary: The Translation and Interpretation of a Fundamental Renaissance Treatise on Art* (ed. and trl. Christie Knapp Fengler) (diss., University of Wisconsin, 1974), Ann Arbor: University Microfilms International, 1979.

Gibbons, Felton, "Ferrarese Tapestries of Metamorphoses", *Art Bulletin*, 48, 1946, pp. 409-11.

Gibbons, Felton, "Giovanni Bellini's Topographical Landscapes", in Irving Lavin and John Plummer (eds.), *Studies in Late Medieval and Renaissance Painting in Honor of Millard Meiss*, New York: New York University Press, 1977, pp. 174-84.

Gibson James J., *The Perception of the Visual World*, Boston: Houghton Mifflin, 1950.

Gibson, Walter S., *"Mirror of the Earth": The World Landscape in Sixteenth Century Flemish Painting*, Princeton: Princeton University Press, 1989.

Gilbert, Creighton E. (ed.), *Italian Art 1400-1500: Sources and Documents*, Evanston (Ill.): Northwestern University Press, 1980.

Gilbert, Otto, *Die meteorologischen Theorien des griechischen Altertums*, Leipzig: B.G. Teubner, 1907.

Gimbutas, Marija, *The Gods and Goddesses of Old Europe. 7000 to 3500 B.C.: Myths, Legends and Cult Images*, Berkeley and Los Angeles: University of California Press, 1974.

Ginsburg, Herbert and Opper, Sylvia, *Piaget's Theory of Intellectual Development: An Introduction*, Englewood Cliffs: Prentice-Hall, 1969.

Giovanucci Vigi, Berenice, "Jacopo Filippo d'Argenta, il maggior miniatore dei Corali della Cattedrale di Ferrara", *La Bibliofila*, 85, 1983, pp. 201-22.

Giovanucci Vigi, Berenice (ed.), *Marco Zoppo. Cento 1433-1478 Venezia*. Atti del convegno internazionale di studi sulla pittura del Quattrocento padano, Cento 8-9 ott. 1993, Bologna: Nuova Alfa, 1993.

Glob, P. V., *Helleristninger i Danmark*, Jysk Arkæologisk Selskabs Skrifter 7, Copenhagen: Gyldendal, 1969.

Goethe, Johann Wolfgang von, *Faust. Gesamtausgabe*, Frankfurt a.M.: Insel-Verlag, 1962.

Goethe, Johann Wolfgang von, *Faust* (trl. Walter Arndt, ed. Cyrus Hamlin), New York: W. W. Norton, 1976.

Goethe, Johann Wolfgang von, *Italian Journey* (ed. Thomas P. Saine and Jeffrey L. Sammons, trl. Robert R. Heitner), New York: Suhrkamp, 1989 (German 1st ed. 1787).

Goethe, Johann Wolfgang von, *Italienische Reise* (eds. A. Beyer and N. Miller), Sämtliche Werke nach Epochen seiner Schaffens, Münchner Ausgabe, Bd. 15, Munich: C. Hanser, 1992 (1787).

Goldthwaite, Richard, *The Building of Renaissance Florence: An Economic and Social History*, Baltimore and London: Johns Hopkins University Press, 1980.

Golowin, Sergius, *Magier der Berge. Lebensenergie aus dem Ursprung*, Basel: Sphinx, 1984.

Gombrich, Ernst H., *Art and Illusion: A Study in the Psychology of Pictorial Representation*, London: Phaidon, 1960.

Gombrich, Ernst H., "The Renaissance Theory of Art and the Rise of Landscape", in Ernst H. Gombrich, *Norm and Form: Studies in the art of the Renaissance*, London: Phaidon, 1966, pp. 107-21.

Gougaud, Louis, *Dévotions et pratiques ascétiques du Moyen Âge*, Paris: Desclée, De Brouwer & Cie and P. Lethielleux, 1925.

Grabar, André, *Byzantine Painting: Historical and Critical Study*, Geneva: Skira, 1953.

Grabar, André, *Christian Iconography: A Study of Its Origins*. The A.W. Mellon Lectures in the Fine Arts, 1961, Princeton: Princeton University Press, 1968.

Grabes, Herbert, *Speculum, Mirror und Looking-Glas. Kontinuität und Originalität der Spiegelmetapher in den Buchtiteln des Mittelalters und der englischen Literatur des 13. bis 17. Jahrhunderts*, Tübingen: M. Niemeyer, 1973.

Grant, Edward, *A Source Book in Medieval Science*, Cambridge (Mass.): Harvard University Press, 1974.

Greenstein, Jack M., "On Alberti's "Sign": Vision and Composition in Quattrocento Painting", *Art Bulletin*, 79, 1997, pp. 669-98.

Groenewegen-Frankfort, H.A., *Arrest and Movement: An Essay on Space and Time in the Representational Art of the Ancient Near East*, London: Faber, 1951.

Günther, Hubertus, *Das Studium der antiken Architektur in den Zeichnungen der Hochrenaissance*, Tübingen: E. Wasmuth, 1988.

Guldan, Ernst, *Eva und Maria. Eine Antithese als Bildmotiv*, Graz and Cologne: Böhlaus, 1966.

Gundersheimer, Werner, *Ferrara: The Style of a Renaissance Despotism*, Princeton: Princeton University Press, 1973.

Haaning, Aksel, *Middelalderens naturfilosofi. En indføring i grundlaget for Vestens religiøse kosmologi og natursyn*, Copenhagen: C.A. Reitzel, 1993.

Haaning, Aksel, *Naturens Lys. Vestens naturfilosofi i højmiddelalder og renæssance 1250-1650*, Copenhagen: C.A. Reitzel, 1998.

Haas, Volkert, *Hethitische Berggötter und hurritische Steindämonen. Riten, Kulte und Mythen. Eine Einführung in die altkleinasiatischen religiösen Vorstellungen*, Mainz a.R.: P. von Zabern, 1982.

Habermas, Jürgen, *Zur Rekonstruktion des Historischen Materialismus*, Frankfurt a.M.: Suhrkamp, 1976.

Habermas, Jürgen, *Theorie des kommunikativen Handelns*, Frankfurt a.M.: Suhrkamp, 1987 (1981) (2 vols.).

Habermas, Jürgen, *Communication and the Evolution of Society* (trl. and introd. Thomas McCarthy), Cambridge: Polity Press, 1991 (1979; German 1st ed. 1976).

Haeberlein, Fritz, "Grundzüge einer nachantiken Farbenikonographie", *Römisches Jahrbuch für Kunstgeschichte*, 3, 1939, pp. 75-140.

Hale, J.R., *Renaissance Exploration*, New York, Norton and London: British Broadcasting Corporation, 1968.

Halleux, Pierre, "Fécondité des mines et sexualité des pierres dans l'Antiquité gréco-romaine", *Revue d'histoire et de philologie belge*, 48, 1970, pp. 16-25.

Hammond, John H., *The Camera Obscura: A Chronicle*, Bristol: Hilger, 1981.

Hammond, N.G.L. and Scullard, H.H. (eds.), *The Oxford Classical Dictionary*, Oxford: Clarendon, 1979.

Hansen, Mogens Herman, *The Triumph of Time: Reflections of a Historian on Time in History* (trl. J.A. Crook), Copenhagen: Museum Tusculanum Press, 2002.

Hanfmann, George M.A., *The Season Sarcophagus in Dumbarton Oaks*, Cambridge (Mass.): Harvard University Press, 1951.

Harris, Marvin, *Cannibals and Kings: The Origins of Cultures*, New York: Random House, 1977.

Harrison, Charles and Wood, Paul (eds.), *Art in Theory 1900-1990: An Anthology of Changing Ideas*, Oxford and Cambridge (Mass.): Blackwell, 1992.

Harrison, Charles and Wood, Paul with Geiger, Jason (eds.), *Art in Theory 1815-1900: An Anthology of Changing Ideas*, Oxford and Malden (Mass.): Blackwell, 1998.

Hart, Joan, "The Origins of Heinrich Wölfflin's Art History", in M. Harbsmeier and M. Trolle Larsen (eds.), *The Humanities Between Art and Science: Intellectual Developments 1880-1914*, Copenhagen: Akademisk Forlag, 1989, pp. 91-109.

Hartt, Frederick, "Mantegna's Madonna of the Rocks", *Gazette des Beaux-Arts*, 40, 1952, pp. 329-42.

Hartt, Frederick, *History of Italian Renaissance Art: Painting, Sculpture, Architecture*, New York: Harry N. Abrams, 1987 (3rd ed.).

Harvey, P.D.A., *The History of Topographical Maps: Symbols, Pictures and Surveys*, London: Thames & Hudson, 1980.

Harvey, P.D.A., *Medieval Maps*, London: British Library, 1991.

Hauser, Andreas, "Luca Signorellis *Pan*. Kunst als Sublimierung von Liebe", *Konsthistorisk Tidskrift*, 68, 1999, pp. 250-69.

Hauser, Andreas, "Andrea Mantegnas 'Parnass': Ein Programmbild orphischen Künstlertums", *Pantheon*, 58, 2000, pp. 23-43.

Hauser, Andreas, "Andreas Mantegnas 'Pietà': Ein ikonoklastisches Andachtsbild", *Zeitschrift für Kunstgeschichte*, 63, 2000, pp. 449-93.

Hauser, Andreas, "Andreas Mantegnas 'Wolkenreiter': Manifestation von kunstloser Natur oder Ursprung von vexierbildhafter Kunst?", in Gerhart von Graevenitz, Stefan Rieger and Felix Thürlemann (eds.), *Die Unvermeidlichkeit der Bilder*, Tübingen: Gunter Narr, 2001, pp. 147-72.

Hauttmann, Max, *Die Kunst des frühen Mittelalters*, Berlin: Propyläen Verlag, 1929.

Hawkes, Jacquetta, *The Atlas of Early Man*, New York: St. Martin's Press, 1976.

Hay, D. and Law, J., *Italy in the Age of the Renaissance 1380-1530*, London: Longman, 1989.

Hayles, N. Katherine, *How We Became Posthuman: Virtual Bodies in Cybernetics, Literature, and Informatics*, Chicago and London: University of Chicago Press, 1999.

Heckscher, W.S., "Relics of Pagan Antiquity in Medieval Settings", *Journal of the Warburg and Courtauld Institutes*, 1, 1937-38, pp. 204-20.

Hegel, Georg Wilhelm Friedrich, *Phänomenologie des Geistes* [1807], Hamburg: F. Meiner Verlag, 1988.

Hegel, Georg Wilhelm Friedrich, *Vorlesungen über die Ästhetik I-III. Werke, 13-15* [delivered 1820-29; edited posthumously by H.G. Hotho, 1835, on the basis of Hegel's own and his students' lecture notes], Frankfurt a.M.: Suhrkamp, 1970.

Hegel, Georg Wilhelm Friedrich, *The Philosophy of Fine Art* (trl. F.P.B. Osmaston), Bristol: Thoemmes Press, 1999 (1920; German 1st ed. 1835) (4 vols.).

Heinberg, Richard, *Memories and Visions of Paradise: Exploring the Universal Myth of a Lost Golden Age*, Los Angeles: J.P. Tarcher, 1989.

Heitland, W.E., *Agricola: A Study of Agriculture and Rustic Life in the Greco-Roman World from the Point of View of Labour*, Cambridge: Cambridge University Press, 1921.

Helbig, Wolfgang, et al., *Führer durch die öffentlichen Kunstsammlungen Klassischer Altertümer in Rom*, vol. 3, Tübingen: E. Wasmuth, 1969.

Helck, Wolfgang, et al. (eds.), *Lexikon der Ägyptologie*, Wiesbaden: O. Harrassowitz, 1973-92.

Hermann, Hermann Julius, "Zur Geschichte der Miniaturemalerei am Hofe der Este in Ferrara", *Jahrbuch der Kunsthistorischen Sammlungen des Allerhöchsten Kaiserhauses*, 21, 1900, pp. 117ff.

Herrmann, Paul, *Denkmäler der Malerei des Altertums*, Munich: F. Bruckmann, 1904-31.

Hillman, James, *The Dream and the Underworld*, New York: Harper & Row, 1979.

Hirn, Yrjö, *The Sacred Shrine: A Study of the Poetry and Art of the Catholic Church*, London: Macmillan, 1912.

Hoffmeyer, Jesper, *En snegl på vejen. Betydningens naturhistorie*, Copenhagen: Munksgaard/Rosinante, 1993.

Holly, Michael Ann, *Panofsky and the Foundations of Art History*, Ithaca and London: Cornell University Press, 1984.

Hope, Charles, *Titian*, New York: Harper & Row, 1980.

Hoppe, Edmund, *Geschichte der Optik*, Leipzig: J.J. Weber, 1926.

Hoppin, Joseph Clark, *A Handbook of Attic Red-Figured Vases*, Cambridge (Mass.): Harvard University Press, 1919 (2 vols.).

Hughes, Robert, *Heaven and Hell in Western Art*, New York: Stein and Day, 1968.

Huizinga, Johan, *The Waning of the Middle Ages: A Study of the Forms of Life, Thought, and Art in France and the Netherlands in the Fourteenth and Fifteenth Centuries* (trl. F. Hopman), London: Penguin, 1990 (1924; 1st Dutch ed. 1919).

Hunt, John Dixon (ed.), *The Pastoral Landscape*, Hanover (NH): University Press of New England, 1992.

Husband, Timothy, *The Wild Man: Medieval Myth and Symbolism* (exhibition catalogue), New York: Metropolitan Museum of Art, 1980.

Hussey, Christopher, *The Picturesque: Studies in a Point of View*, London: F. Cass, 1967 (1927).

Immerwahr, Sara A., *Aegean Painting in the Bronze Age*, University Park and London: Pennsylvania State University Press, 1990.

Inhelder, Bärbel and Chipman, Harold B. (eds.), *Piaget and His School: A Reader in Developmental Psychology*, New York, Heidelberg and Berlin: Springer, 1976.

Isager, Signe and Skydsgaard, Jens Erik, *Ancient Greek Agriculture: An Introduction*, London and New York: Routledge, 1992.

Iversen, Margaret, *Alois Riegl: Art History and Theory*, Cambridge (Mass.) and London: MIT Press, 1993.

Jacoby, Mario, *The Longing for Paradise: Psychological Perspectives of an Archetype*, Boston: Sigo Press, 1985.

Jahn, Johannes, *Antike Tradition in der Landschaftsdarstellung bis zum 15. Jahrhundert*, East Berlin: Akademie-Verlag, 1975.

Jaki, Stanley L., *Uneasy Genius: The Life and Work of Pierre Duhem*, The Hague, Boston and Lancaster: Nijhoff, 1984.

Jaki, Stanley L., *The Only Chaos and Other Essays*, Lanham (MD): University Press of America, 1990.

James, E.O., *The Cult of the Mother-Goddess: An Archaeological and Documentary Study*, London: Thames & Hudson, 1959.

Janson, H.W., "The 'Image Made by Chance' in Renaissance Thought" [1961], in H.W. Janson, *Sixteen Studies*, New York: Abrams, 1973, pp. 53-74.

Jantsch, Erich and Waddington, Conrad Hall (eds.), *Evolution and Consciousness: Human Systems in Transition*, Reading (Mass.): Addison-Wesley, 1976.

Jauss, Hans Robert, "Die klassische und die christliche Rechtfertigung des Hässlichen in mittelalterlicher Literatur", in H.R. Jauss (ed.), *Die nicht mehr schönen Künste. Grenzphänomene des Ästhetischen*, Munich: W. Fink, 1968 pp. 143-68.

Jay, Martin, *Downcast Eyes: The Denigration of Vision in Twentieth-Century French Thought*, Berkeley, Los Angeles and London: University of California Press, 1993.

Jeanmaire, H., *Historie de culte de Bacchus*, Paris: Payot, 1951.

Jensen, Peter, *Die Kosmologie der Babylonier. Studien und Materialen*, Strassburg: Karl J. Trübner, 1890 (reprint New York and Berlin: Walter de Gruyter, 1974).

Johnston, William M., "Von Bertalanffy's Place in Austrian Thought: Strategies of Integrative Thinking among Leibnizians and Impressionists", in William Gray and Nicholas D. Rizzo (eds.) *Unity*

Through Diversity: A Festschrift for Ludwig von Bertalanffy, New York, London and Paris: Gordon and Breach Science Publishers, 1973, pp. 21-30.

Jones, Roger, "What Venus did with Mars: Battista Fiera and Mantegna's *Parnassus*", *Journal of the Warburg and Courtauld Institutes*, 44, 1981, pp. 193-98.

Jung, Carl Gustav, *Psychology and Alchemy* (trl. R.F.C. Hull), in Herbert Read et al. (eds.), *The Collected Works of C.G. Jung*, vol. 12, Princeton: Princeton University Press, 1968 (1953).

Jung, Carl Gustav, *Alchemical Studies* (trl. R.F.C. Hull), in Herbert Read et al. (eds.), *The Collected Works of C.G. Jung*, vol. 13, Princeton: Princeton University Press, 1967.

Jørgensen, Hans Henrik Lohfert, "Arkitekturens mystiske blik. Hagioskopisk rumopfattelse og -reception på Den iberiske Halvø", *Passepartout. Skrifter for kunsthistorie*, 12, 1998, pp. 81-III.

Jørgensen, Hans Henrik Lohfert, "*Velatio* and *Revelatio*: Hagioscopic Vision in Early Medieval Architecture on the Iberian Peninsula", in Antoinette Roesler-Friedenthal and Johannes Nathan (eds.), *The Enduring Instant: Time and the Spectator in the Visual Arts*. A Section of the XXXth International Congress for the History of Art, London, Sept. 2000, Berlin: Gebr. Mann, 2003, pp. 177-91.

Kallab, Wolfgang, "Die toscanische Landschaftsmalerei im XIV. und XV. Jahrhundert, ihre Entstehung und Entwicklung", *Jahrbuch der kunsthistorischen Sammlungen des allerhöchsten Kaiserhauses*, 21, 1900, pp. 1ff.

Kant, Immanuel, *Kritik der Urteilskraft*, Frankfurt a.M.: Suhrkamp, 1974 (1793).

Kant, Immanuel, *Critique of the Power of Judgment* (trl. Paul Guyer and Eric Matthews), Cambridge: Cambridge University Press, 2000 (German 1st ed. 1793).

Kauffman, Stuart, *At Home in the Universe: The Search for Laws of Self-Organization and Complexity*, London: Viking, 1995.

Katalog der Gemäldesammlung der Universität Göttingen, Göttingen: W.H. Lange, 1926.

Kazhdan, Alexander, "Byzantine Hagiography and Sex in the Fifth to the Twelfth Centuries", *Dumbarton Oaks Papers*, 44, 1990, pp. 131-43.

Kérenyi, Karoly, *Dionysos: Archetypical Image of Indestructible Life*, London: Routledge and Kegan Paul, 1976.

Kern, Hermann, *Labyrinthe. Erscheinungsformen und Deutungen 5000 Jahre Gegenwart eines Urbilds*, Munich: Prestel-Verlag, 1982.

Kessler, Herbert L., *The Illustrated Bibles from Tours*, Princeton: Princeton University Press, 1977.

Kessler, Herbert L., "Medieval Art as Argument", in Brendan Cassidy (ed.), *Iconography at the Crossroads*. Papers from the Colloquium Sponsored by the Index of Christian Art, Princeton University 23-24 March 1990, Princeton: Princeton University Press, 1993, pp. 59-70.

Kessler, Herbert L., "'Facies bibliothecae relevata': Carolingian Art as Spiritual Seeing", in *Testo e immagine nell'alto medioevo*. Settimane di studio del centro italiano di studi sull'Alto Medioevo, Spoleto 15-21 aprile 1993, Spoleto: Presso la sede del centro, 1994, pp. 533-94.

Kessler, Herbert L., *Seeing Medieval Art*, Toronto: Broadview Press, 2004.

Kessler, Herbert L., "'Hoc visibile imaginatum figurat illud invisibile verum': Imagining God in Pictures of Christ," in G. De Nie, K. Morrison and M. Mostert (eds.), *Seeing the Invisible in Late*

Antiquity and the Early Middle Ages. Papers from "Verbal and Pictorial Representations of the Invisible 400 to 1000", Utrecht, 11-13 December 2003, Turnhout: Brepols, 2005, pp. 291-326.

Kierkegaard, Søren, *The Concept of Anxiety: A Simple Psychologically Orienting Deliberation on the Dogmatic Issue of Hereditary Sin* (ed. and trl. Reidar Thomte, in collab. with Albert B. Anderson), Princeton: Princeton University Press, 1980 (Danish 1st ed. 1855).

King, L.W. (ed.), *Bronze Reliefs from the Gates of Shalmaneser, King of Assyria B.C. 860-25*, London: Longmans & Co., 1915.

Kircher, Athanasius, *Mundus subterraneus*, Amsterdam: Johannes Jansonius and Elizeus Weyerstraten, 1664.

Kirschbaum, Engelbert (ed.), *Lexicon der christlichen Iconograhie*, Rome: Herder, 1970.

Klibansky, Raymond, Panofsky, Erwin and Saxl, Fritz, *Saturn and Melancholy: Studies in the History of Natural Philosophy, Religion, and Art*, London: Nelson, 1964.

Klossowski de Rola, Stanislas, *The Golden Game: Alchemical Engravings of the Seventeenth Century*, London: Thames & Hudson, 1988.

Koehler, Wilhelm, *Die karolingischen Miniaturen* I: *Die Schule von Tours*, Berlin: Deutscher Verein für Kunstwissenschaft, 1963 (1930).

Koehler, Wilhelm, *Die karolingischen Miniaturen* II: *Die Hofschule Karls des Grossen*, Berlin: Deutscher Verein für Kunstwissenschaft, 1958.

Koehler, Wilhelm, *Die karolingischen Miniaturen* III: *Die Gruppe des Wiener Krönungs-Evangeliars; Metzer Handschriften*, Berlin: Deutscher Verein für Kunstwissenschaft, 1960.

Koehler, Wilhelm and Mütherich, Florentine, *Die karolingischen Miniaturen* V: *Die Hofschule Karls des Kahlen*, Berlin: Deutscher Verein für Kunstwissenschaft, 1982.

Koerner, Joseph Leo, *The Moment of Self-Portraiture in German Renaissance Art*, Chicago and London: University of Chicago Press, 1993.

Kojève, Alexandre, *Introduction to the Reading of Hegel: Lectures on the Phenomenology of Spirit* (collected by Raymond Queneau, ed. Allan Bloom, trl. J.H. Nichols, Jr.), Ithaca and London: Cornell University Press, 1980 (Fr. 2. ed. 1947).

Koseleff, Olga, "Representations of the Months and Zodiacal Signs in *Queen Mary's Psalter*", *Gazette des Beaux-Arts*, 22, 1942, pp. 77-88.

Koseleff Gordon, Olga, "Two Unusual Calendar Cycles of the Fourteenth Century", *Art Bulletin*, 45, 1963, pp. 245-53.

Koyré, Alexandre, *From the Closed World to the Infinite Universe*, Baltimore and London: Johns Hopkins University Press, 1957.

Kramer, Samuel Noah, *The Sumerians: Their History, Culture, and Character*, Chicago: University of Chicago Press, 1963.

Kranz, Peter, *Jahreszeiten-Sarkophage. Entwicklung und Ikonographie des Motivs der vier Jahreszeiten auf kaiserzeitlichen Sarkophagen und Sarkophagdeckeln*, Berlin: Mann, 1984.

Krautheimer, Richard, *Rome: Profile of a City, 312-1308*, Princeton: Princeton University Press, 1980.

Kristeller, Paul Oskar, "Paduan Averroism and Alexandrism in the Light of Recent Studies", in *Aristotelismo padovano e filosofia aristotelica*. Atti del XII congresso internazionale di filosofia, Venezia 12-18 sett. 1958, Florence: G.C. Sansoni, 1960, pp. 149ff.

Kristeller, Paul Oskar, *Studies in Renaissance Thought and Letters*, Rome: Edizioni di Storia e Letteratura, 1984.

Kristeva, Julia, *Powers of Horror: An Essay on Abjection* (trl. L.S. Roudiez), New York: Columbia University Press, 1982 (Fr. 1st ed. 1980).

Kristeva, Julia, *Revolution in Poetic Language* (trl. M. Waller, intr. L.S. Roudiez), New York: Columbia University Press, 1984 (Fr. 1st ed. 1974).

Kristeva, Julia, "A Question of Subjectivity – an Interview" [1986], in Philip Rice and Patricia Waugh (eds.), *Modern Literary Theory: A Reader*, London: Arnold, 1989, pp. 128-33.

Kubovy, Michael, *The Psychology of Perspective and Renaissance Art*, Cambridge: Cambridge University Press, 1986.

Kühn, Herbert, *Die Felsbilder Europas*, Stuttgart: W. Kohlhammer, 1952.

Kuhn, Thomas S., *The Structure of Scientific Revolutions*, Chicago: University of Chicago Press, 1962.

Kuhn, Thomas S., *The Copernican Revolution: Planetary Astronomy in the Development of Western Thought*, Cambridge (Mass.) and London: Harvard University Press, 1985 (1st ed. 1957).

Laubscher, H.P., *Fischer und Landleute. Studien zur hellenistischen Genreplastik*, Mainz a.R.: von Zabern, 1982.

Lacan, Jacques, "The Mirror Stage as Formative of the Function of the I as revealed in Psychoanalytic Experience" [1949], in Philip Rice and Patricia Waugh (eds.), *Modern Literary Theory: A Reader*, London: Arnold, 1989, pp. 122-27.

Lacan, Jacques, *The Four Fundamental Concepts of Psycho-Analysis* (ed. Jacques-Alain Miller, trl. Alan Sheridan, intr. David Macey), Harmondsworth: Penguin, 1994 (Fr. 1st ed. 1973).

Laming-Emperaire, A., *La signification de l'art rupestre paléolithique: Methodes et applications*, Paris: A. & J. Picard, 1962.

Lang, Mabel L., *The Palace of Nestor at Pylos in Western Messenia*, Princeton: Princeton University Press, 1969 (2 vols.).

Lange, Julius, "Til Sammenligning mellem antik og modern Figurstil", in *Udvalgte Skrifter af Julius Lange* (eds. Georg Brandes and P. Købke), Copenhagen: Det Nordiske Forlag, 1900, vol. II, pp. 1-9.

Lazarev, Viktor, *Storia della pittura bizantina*, Turin: G. Einaudi, 1967 (Russ. 1st ed. 1947-48).

Le Goff, Jacques, *Pour un autre Moyen Age: Temps, travail et culture en Occident. 18 essais*, Paris: Gallimard, 1977.

Le Goff, Jacques, *Time, Work and Culture in the Middle Ages* (trl. Arthur Goldhammer), Chicago and London: University of Chicago Press, 1980.

Le Goff, Jacques, *History and Memory* (trl. Steven Rendall and Elizabeth Claman), New York: Columbia University Press, 1992 (Fr. 1st ed. 1988).

Le Goff, Jacques, *The Medieval Imagination* (trl. A. Goldhammer), Chicago and London: University of Chicago Press, 1992 (Fr. 1st ed. 1985).

Le Roy Ladurie, Emmanuel, *Montaillou, village occitan de 1294 à 1324*, Paris: Gallimard, 1975.

Le Roy Ladurie, Emmanuel (ed.), *Paysages, paysans: L'art et la terre en Europe du Moyen Age au XX siècle* (exhibition catalogue), Paris: Bibliothèque nationale de France, Réunion des musées nationaux, 1994.

Leach, Eleanor Winsor, *The Rhetoric of Space: Literary and Artistic Representations of Landscape in Republican and Augustan Rome*, Princeton: Princeton University Press, 1992 (1988).

Lee, Sherman E., *Chinese Landscape Painting*, New York: Harper & Row, s.a. (after 1954).

Lehmann, Karl, "The Dome of Heaven", in W. Eugene Kleinbauer (ed.), *Modern Perspectives in Western Art History: An Anthology of 20th-century Writings on the Visual Arts*, New York: Holt, Rinehart and Winston, 1971, pp. 228-70 (reprint from *Art Bulletin*, 27, 1945, pp. 1-27).

Lehmann, Phyllis Williams, *Roman Wall Paintings from Boscoreale in the Metropolitan Museum of Art*, Cambridge (Mass.): Archaelogical Institute of America, 1953.

Lehmann-Hartleben, Karl and Olsen, Erling C., *Dionysiac Sarcophagi in Baltimore*, New York and Baltimore: Institute of Fine Arts, New York University, and the Trustees of the Walters Art Gallery, 1942.

Lenski, Gerhard, *Human Societies: A Macrolevel Introduction to Sociology*, New York: McGraw-Hill, 1970.

Leonardo da Vinci, *Leonardo on Painting: An anthology of writings by Leonardo da Vinci with a selection of documents relating to his career as an artist* (ed. Martin Kemp), New Haven and London: Yale University Press, 1989.

Leonardo da Vinci, *The Literary Works of Leonardo da Vinci* (ed. Jean Paul Richter), London: Oxford University Press, 1939 (2 vols.).

Leonardo da Vinci, *Scritti letterari* (ed. Augusto Marinoni), Milan: Biblioteca universale Rizzoli, 1974.

Leonardo da Vinci, *Treatise on Painting [Codex Urbinas Latinus 1270]* (ed. with trl. A. Philip McMahon), Princeton: Princeton University Press, 1956 (2 vols.).

Leroi-Gourhan, André, *Treasures of Prehistoric Art* (trl. N. Guterman), New York: Harry N. Abrams, 1967.

Lessing, Gotthold Ephraim, *Laocoön: An Essay on the Limits of Painting and Poetry* (trl. Edward Allen McCormick), Baltimore and London: Johns Hopkins University Press, 1984 (1962; German 1st ed. 1766).

Levi, Doro, "The Allegories of the Months in Classical Art", *Art Bulletin*, 23, 1941, pp. 251-91.

Levi d'Ancona, Mirella, *The Garden of the Renaissance: Botanical Symbolism in Italian Painting*, Florence: Olschki, 1977.

Levi d'Ancona, Mirella, "An Image Not Made by Chance: The Vienna *St. Sebastian* by Mantegna", in Irving Lavin and John Plummer (eds.), *Studies in Late Medieval and Renaissance Painting in Honor of Millard Meiss*, New York: New York University Press, 1977, pp. 98ff.

Lévi-Strauss, Claude, *Structural Anthropology* (trl. C. Jacobson and B.G. Schoepf), London: Penguin, 1968 (Fr. 1st ed. 1958).

Lévi-Strauss, Claude, *The Raw and the Cooked: Introduction to a Science of Mythology*, vol. 1 (trl. J. and D. Weightman), New York: Harper & Row, 1969 (Fr. 1st ed. 1964).

Lightbown, Ronald W., *Mantegna. With a complete Catalogue of the Paintings, Drawings and Prints*, Oxford: Phaidon Christie's, 1986.

Ling, Roger, *Roman Painting*, Cambridge: Cambridge University Press, 1991.

Little, Alan M.G., *Roman Perspective Painting and the Ancient Stage*, Wheaton (Md.): The Author, 1971.

Lohr, Charles H., "Aristotle in the West: Some Recent Books", *Traditio*, 25, 1969, pp. 429ff.

Longnon, Jean; Cazelles, Raymon (intr. and ed.); and Meiss, Millard (preface), *The Très Riches Heures of Jean, Duke of Berry, Musée Condé, Chantilly*, Secaucus (NJ): Wellfleet Press, 1969.

Lorenzo Ghiberti nel suo tempo. Atti del Convegno internazionale di studi, Firenze 18-21 ottobre 1978, Florence: Olschki, 1980.

Lorenzo de' Medici, *Opere* (ed. Attilio Simioni), Bari: Laterza & figli, 1939 (2 vols.).

Lovejoy, Arthur Ochden and Boas, George, *A Documentary History of Primitivism and Related Ideas in Antiquity*, Baltimore: Johns Hopkins University Press, 1935.

Luzio, Alessandro and Renier, Rodolfo, "La coltura e le relazioni letterarie di Isabella d'Este Gonzaga", *Giornale storico della letteratura italiana*, 39, 1902, pp. 193-251.

Luzio, Alessandro, "Isabella d'Este e Francesco Gonzaga promessi sposi", *Archivio storico lombardo*, 35, 9, 1908, pp. 34-69.

Lyotard, Jean-François, *The Postmodern Condition: A Report on Knowledge* (trl. Geoff Bennington and Brian Massumi, preface: Fredric Jameson), Manchester: Manchester University Press, 1984 (Fr. 1st ed. 1979).

Magi, Filippo, "Il calendario dipinto sotto Santa Maria Maggiore", *Atti della pontificia Accademia Romana di Archeologia, Memorie*, 11, 1972, pp. 23-35.

Maguire, Henry, *Earth and Ocean: The Terrestrial World in Early Byzantine Art*, University Park and London: Pennsylvania State University Press, 1987.

Maisak, Petra, *Arkadien. Genese und Typologie einer idyllischen Wunschwelt*, Frankfurt a.M. and Bern: Lang, 1981.

Maiuri, A., *Roman Painting*, Geneva: Skira, 1953.

Manetti, Antonio di Tuccio, *Operette istoriche* (ed. G. Milanesi), Florence: Le Monnier, 1887.

Manetti, Antonio di Tuccio, *The Life of Brunelleschi* (intr. and ed. Howard Saalman, trl. C. Enggass), University Park and London: Pennsylvania State University Press, 1970.

Maor, Eli, *To Infinity and Beyond: A Cultural History of the Infinite*, Boston, Basel and Stuttgart: Birkhäuser, 1987.

Marcussen, Lars, "Om rummets arkitektur", in Anders Michelsen and Frederik Stjernfelt (eds.), *Rum og Fænomenologi. Filosofi, æstetik, arkitektur, historie*, Hellerup: Spring, 2000, pp. 139-72.

Marcussen, Lars, *Rummets arkitektur – arkitekturens rum*, Copenhagen: Arkitektens Forlag, 2002.

Marinatos, Nannò, *Art and Religion in Thera: Reconstructing a Bronze Age Society*, Athens: Mathioulakis, 1984.

Marinoni, Augusto, "Il Regno e il Sito di Venere", *Il Poliziano e il suo tempo*. Atti del IV convegno internazionale di studi sul Rinascimento – Palazzo Strozzi 23-26 settembre 1954, Firenze: Florence: G.C. Sansoni, 1957, pp. 273-87.

Martineau, Jane and Hope, Charles (eds.), *The Genius of Venice 1500-1600* (exhibition catalogue), New York: Harry N. Abrams, 1984.

Martineau, Jane (ed.), *Andrea Mantegna* (exhibition catalogue), London and New York: Metropolitan Museum of Art, distributed by Harry N. Abrams, 1992.

Martines, Lauro, *Power and Imagination: City States in Renaissance Italy*, Harmondsworth: Penguin, 1979.

Matt, Leo von, *Die Kunstsammlungen der Biblioteca Apostolica Vaticana Rom*, Cologne: M. DuMont Schauberg, 1969.

May, Michael and Stjernfelt, Frederik, "Measurement, diagram, art – reflections on the role of the icon in science and aesthetics", in Anders Michelsen and Frederik Stjernfelt (eds.), *Billeder fra det fjerne / Images from afar*, Copenhagen: Kulturby 96 and Oslo: Universitetsforlaget, 1996, pp. 191-203.

Mayr-Harting, Henry, *Ottonian Book Illumination: An Historical Study*, London: Harvey Miller, 1991 (2 vols.).

McCann, Anne Marguerite, *Roman Sarcophagi in the Metropolitan Museum of Art*, New York: The Metropolitan Museum of Art, 1978.

McClung, William Alexander, *The Architecture of Paradise: Survivals of Eden and Jerusalem*, Berkeley, Los Angeles and London: University of California Press, 1983.

McDannell, Colin and Lang, Bernhard, *Heaven: A History*, New Haven and London: Yale University Press, 1988.

Meer, Frederick van der, *Apocalypse: Visions from the Book of Revelation in Western Art*, Antwerp: Mercatorfonds, 1978.

Meier, Christel and Suntrup, Rudolf, "Zum Lexikon der Farbendeutungen im Mittelalter. Einführung zu Gegenstand und Methoden sowie Probeartikel aus dem Farbenbereich 'Rot'", *Frühmittelalterliche Studien. Jahrbuch des Instituts für Frühmittelalterforschung der Universität Münster*, 21, 1987, pp. 390-478.

Meiss, Millard, *Painting in Florence and Siena after the Black Death: The Arts, Religion, and Society in the Mid-Fourteenth Century*, Princeton: Princeton University Press, 1951.

Meiss, Millard and Beatson, Elisabeth H., *Les Belles Heures de Jean Duc de Berry*, London: Thames & Hudson, 1974.

Meiss, Millard, "Scholarship and Penitence in the Early Renaissance: The Image of St. Jerome", *Pantheon*, 32, 1974, pp. 134-40.

Meissner, Bruno, *Babylonien und Assyrien*, Heidelberg: C. Winter, 1920-1925 (2 vols.).

Mellink, Machteld J. and Filip, Jan, *Frühe Stufen der Kunst*. Propyläen Kunstgeschichte 13, Berlin: Propyläen Verlag, 1974.

Menzel, Wolfgang, *Christliche Symbolik*, Regensburg: G.J. Manz, 1854.

Merchant, Carolyn, *The Death of Nature: Women, Ecology, and the Scientific Revolution*, New York: Harper & Row, 1980.

Mercier, F., "L'organisation de l'espace dans les fresques du palais Schifanoia à Ferrare", *L'Information d'histoire de l'art*, 13, 1968, pp. 82-84.

Merkelbach, Reinhold, *Mithras. Ein persisch-römischer Mysterienkult*, Wiesbaden: Albus im VMA-Verlag, 1984.

Merleau-Ponty, Maurice, *L'Oeil et l'Esprit* [1960], Paris: Gallimard, 1964.

Merleau-Ponty, Maurice, "Eye and Mind" (trl. Carleton Dallery), in *The Primacy of Perception and Other Essays* (ed. James M. Edie), Chicago: Northwestern University Press, 1964, pp. 159-190.

Meyenburg, Bettina von, "Lukas Cranachs 'Melankoli' og renæssancens melankoliopfattelse", *Kunstmuseets Årsskrift*, 69, 1991, pp. 82-101.

Michelini Tocci, Luigi, *Il Dante Urbinate della Biblioteca Vaticana*, the Vatican: Biblioteca Apostolica Vaticana, 1965.

Middleton, John and Waltham, Tony, *The Underground Atlas: A Gazetteer of the World's Cave Regions*, London: Hale, 1986.

Miller, Jonathan, *On Reflection* (exhibition catalogue, National Gallery), London: Yale University Press, 1998.

Mitchell, W.J.T., "Imperial Landscape", in W.J.T. Mitchell (ed.), *Landscape and Power*, Chicago and London: University of Chicago Press, 1994, pp. 5-34.

Molfino, Alessandra Mottola and Nattale, Mauro (eds.), *Le Muse e il Principe. Arte di corte nel Rinascimento Padano* (exhibition catalogue), Modena and Milan: F.C. Panini, 1991.

Montmarquet, James A., *The Idea of Agrarianism: From Hunter-Gatherer to Agrarian Radical in Western Culture*, Moscow (Idaho): University of Idaho Press, 1989.

Moore, A.W., *The Infinite*, London: Routledge, 1990.

Moretti, Mario, *Il Museo nazionale di Villa Giulia*, Rome: Tipografia Artistica Editrice, 1967.

Morgan, Lyvia, *Miniature Wall Paintings of Thera: A Study of Aegaean Culture and Iconography*, Cambridge: Cambridge University Press, 1988.

Morris, Colin, *The Discovery of the Individual 1050-1200*, Toronto, Buffalo and London: SPCK, 1972.

Mounod, Pierre, "The Development of Systems of Representation and Treatment in the Child", in Inhelder and Chipman (1976), pp. 166-85.

Moxey, Keith K., *Pieter Aertsen, Joachim Beuckelaer, and the Rise of Secular Painting in the Context of the Reformation* (diss. 1974), New York and London: Garland, 1977.

Mühlhäusser, Anna, *Die Landschaftsschilderung in Briefen der italienischen Frührenaissance*, Berlin and Leipzig: Rothschild, 1914.

Mulvey, Laura, "Visual Pleasure and Narrative Cinema" [1975], in *Visual and other Pleasures*, Bloomington (In.): Indiana University Press, 1989, pp. 14-26.

Mütherich, Florentine and Gaehde, Joachim, *Carolingian Painting*, New York: G. Braziller, 1976.

Nardi, Bruno, "Sguardo panoramico alla filosofia nel Medioevo", *La filosofia della natura nel Medioevo. Atti del terzo congresso internazionale di filosofia medioevale, 31 agosto-5 sett. 1964*, Milan: Società Editrice Vita e Pensiero, 1966, pp. 3-23.

Naumann, Rudolph, *Die Ruinen von Tacht-e Suleiman und Zendan-e Suleiman*, Berlin: Dietrich Reimer, 1977.

Neumann, Erich, *Ursprungsgeschichte des Bewusstseins*, Zurich: Rascher, 1949.

Neumann, Erich, *The Origins and History of Consciousness* (trl. R.F.C. Hull), Princeton: Princeton University Press, 1954 (German 1st ed. 1949).

Neumann, Erich, *The Great Mother: An Analysis of the Archetype* (trl. R. Manheim), Princeton: Princeton University Press, 1963 (1955).

Niccolini, Fausto e Felice, *Le case ed i monumenti di Pompeji*, vol. III, 1, Naples, 1890.

Nicolson, Marjorie Hope, *Mountain Gloom and Mountain Glory: The Development of the Aesthetics of the Infinite*, New York: Cornell University Press, 1959.

Nilsson, Martin P., *Primitive Time-Reckoning: A Study in the Origins and First Development of the Art of Counting Time among the Primitive and Early Culture Peoples*, Lund: C.W.K. Gleerup, 1920.

Norberg-Schulz, Christian, *Intentions in Architecture*, Cambridge (Mass.): MIT Press, 1965.

Nordenfalk, Carl, *Early Medieval Book Illumination*, Geneva: Skira, 1957.

Norman, Diana (ed.), *Siena, Florence and Padua: Art, Society and Religion 1280-1400*, New Haven and London: Yale University Press in association with the Open University, 1995 (2 vols.).

Nougier, Louis-René, *L'Art de la préhistoire*, Paris: Livre de Poche, 1993.

Oertel, Robert, *Early Italian Painting to 1400*, London: Thames & Hudson, 1968.

Olwig, Kenneth R., "Recovering the Substantive Nature of Landscape", *Annals of the Association of American Geographers*, 86, 1996, pp. 630-53.

Onians, John, *Art and Thought in the Hellenistic Age: The Greek World View 350-50 BC*, London: Thames & Hudson, 1979.

Osborne, Robin, *Classical Landscape with Figures: The Ancient Greek City and Its Countryside*, London: Philips, 1987.

Osswald, Paul, *Wortfeldtheorie und Sprachenvergleich. Französisch* campagne *und deutsch* Landschaft, Tübingen: TBL-Verlag Narr, 1977.

Outhwaite, William, *Habermas: A Critical Introduction*, Cambridge: Polity Press, 1994.

Ovitt, George, *The Restauration of Perfection: Labor and Technology in Medieval Culture*, New Brunswick and London: Rutgers University Press, 1987.

Pächt, Otto, "Early Italian Nature Studies and the Early Calendar Landscape", *Journal of the Warburg and Courtauld Institutes*, 13, 1950, pp. 13-37.

Paglia, Camille, *Sexual Personae: Art and Decadence from Nefertiti to Emily Dickinson*, New York: Vintage Books, 1991 (1990).

Panofsky, Erwin, "Die Perspektive als 'symbolische Form'", *Vorträge der Bibliothek Warburg 1924-25*, Leipzig and Berlin, 1927, pp. 258-330.

Panofsky, Erwin, *Studies in Iconology: Humanistic Themes in the Art of the Renaissance*, New York: Oxford University Press, 1939.

Panofsky, Erwin, *Abbot Suger on the Abbey Church of St.-Denis and Its Art Treasures*, Princeton: Princeton University Press, 1946.

Panofsky, Erwin, *Gothic Architecture and Scholasticism: An inquiry into the analogy of the arts, philosophy, and religion in the Middle Ages*, Latrobe (Pa.): Archabbey Press, 1951.

Panofsky, Erwin, "'Nebulae in pariete'; Notes on Erasmus' Eulogy on Dürer", *Journal of the Warburg and Courtauld Institutes*, 14, 1951 pp. 34-41.

Panofsky, Erwin, *Early Netherlandish Painting: Its Origin and Character*, Cambridge (Mass.): Harvard University Press, 1953.

Panofsky, Erwin, *The Life and Art of Albrecht Dürer*, Princeton: Princeton University Press, 1955 (1943).

Panofsky, Erwin, *Meaning in the Visual Arts*, Garden City (NY): Doubleday, 1955.

Panofsky, Erwin, *Renaissance and Renascenses in Western Art*, Stockholm: Almqvist & Wiksell, 1960.

Panofsky, Erwin, *Tomb Sculpture: Four Lectures on Its Changing Aspects from Ancient Egypt to Bernini*, New York: Harry N. Abrams, 1964.

Panofsky, Erwin, *Perspective as Symbolic Form* (trl. Christopher S. Wood), New York: Zone Books, 1991 (German 1st ed. 1927).

Parris, Leslie and Fleming-Williams, Ian, *Constable*, Tate Gallery (exhibition catalogue,) London: Tate Gallery, 1991.

Parrish, David, *Season Mosaics of Roman North Africa*, Rome: Bretschneider, 1984.

Parsons, Talcott, *The Evolution of Societies* (ed. and intr. Jackson Toby) [fusion of Parsons' *Societies: Evolutionary and Comparative Perspectives*, Englewood Cliffs (NJ), 1966 and *The System of Modern Societies*, Englewood Cliffs, 1971], Englewood Cliffs (NJ): Prentice-Hall, 1977.

Pauly-Wissowa, *Real-Encyklopädie der classischen Altertumswissenschaft*, Stuttgart: J.B. Metzler, 1884-1980.

Pearsall, Derek and Salter, Elisabeth, *Landscapes and Seasons of the Medieval World*, London: Elek, 1973.

Peat, F. David, *The Philosopher's Stone: Chaos, Synchronicity, and the Hidden Order of the World*, New York: Bantam Books, 1992 (1991).

Pedretti, Carlo, "Dessins d'une scène exécutés par Léonard de Vinci pour Charles d'Amboise (1506-07)", in Jean Jacqout (ed.), *Le lieu théâtral à la Renaissance*, Paris: Éditions du Centre national de la recherche scientifique, 1964, pp. 25-34.

Peirce, Charles Sanders, *Collected Papers*, vol. II: *Elements of Logic* (eds. C. Hartshorne and P. Weiss), Cambridge (Mass.): Bellknap Press of Harvard University Press, 1965.

Pennick, Nigel, *The Ancient Science of Geomancy: Man in Harmony with the Earth*, London: Thames & Hudson, 1979.

Perini, Giovanna, "Dresden and the Italian art market in the eighteenth century: Ignazio Hugford and Giovanni Ludovico Bianconi", *Art Bulletin*, 75, 1993, pp. 550-58.

Perrig, Alexander, "Leonardo: Die Anatomie der Erde", *Jahrbuch der Hamburger Kunstsammlungen*, 25, 1980, pp. 51-80.

Perrig, Alexander, "Die theoriebedingten Landschafsformen in der italienischen Malerei des 14. und 15. Jahrhunderts", in Wolfram Prinz and Andreas Beyer (eds.), *Die Kunst und das Studium der Natur vom 14. bis 16.Jahrhundert*, Weinheim: Acta Humaniora, 1987, pp. 41-60.

Peters, W.J.T., *Landscape in Romano-Campanian Mural Painting*, Assen: Van Gorcum, 1963.

Pevsner, Nikolaus, *Academies of Art, Past and Present*, Cambridge: Cambridge University Press, 1940.

Pevsner, Nikolaus, *The Leaves of Southwell*, London: The King Penguin Books, 1945.

Pfister, Friedrich, *Die Reliquienkult im Altertum*, Giessen: Alfred Töpelmann, 1909.

Pfuhl, E., *Malerei und Zeichnung der Griechen*, Munich: F. Bruckmann, 1923.

Piaget, Jean, *The Child's Conception of the World* (trl. J. & A. Tomlinson), London: Routledge & Kegan Paul, 1929.

Piaget, Jean and Inhelder, Bärbel, *The Child's Conception of Space* (trl. F.J. Langdon and J.L. Lunzer), London: Routledge & Kegan Paul, 1956 (Fr. 1st 1948).

Piaget, Jean, "Piaget's Theory" and "Need and Significance of Cross-Cultural Studies in Genetic Psychology", in Inhelder and Chipman (1976), pp. 11-23 and 259-68.

Picard, Gilbert, *Roman Painting*, New York: New York Graphic Society, 1968.

Piccolomini, Enea Silvio (Pius II), *I Commentarii* (ed. Luigi Totaro), Milan: Adelphi, 1984.

Pickard-Cambridge, A.W., *The Theatre of Dionysus in Athens*, Oxford: Clarendon, 1946.

Pieper, Jan, *Das Labyrinthische. Über die Idee des Verborgenen, Rätselhaften, Schwierigen in der Geschichte der Architektur*, Braunschweig and Wiesbaden: F. Vieweg, 1987.

Pipili, Maria, "Wearing an Other Hat: Workmen in Town and Country", in Beth Cohen (ed.), *Not the Classical Ideal: Athens and the Construction of the Other in Greek Art*, Leiden, Boston and Cologne: E.J. Brill, 2000, pp. 153-79.

Pittman, Holly, *Ancient Art in Miniature: Near Eastern Seals from the Collection of Martin and Sarah Cherkasky*, New York: Metropolitan Museum of Art, 1987.

Plumpe, J.C., "Vivum saxum, vivi lapides: The Concept of 'Living Stone' in Classical and Christian Antiquity", *Traditio*, 1, 1943, pp. 1-14.

Pochat, Götz, "Luca Signorelli's 'Pan' and the so-called 'Tarocchi di Mantegna'", *Konsthistorisk tidskrift*, 36, 1967, pp. 92-105.

Pochat, Götz, *Figur und Landschaft. Eine historische Interpretation der Landschaftsmalerei von der Antike bis zur Renaissance*, Berlin and New York: De Gruyter, 1973.

Pochat, Götz, "Mensch und Natur im Spiegel der prähistorischen Kunst. Gedanken über die Anfänge einer ästhetischen Verhaltensweisse", *Natur und Kunst. Kunsthistorisches Jahrbuch Graz*, 23, 1987, pp. 7-37.

Pochat, Götz, *Theater und bildende Kunst im Mittelalter und in der Renaissance in Italien*, Graz: Akademische Druck- u. Verlagsanstalt, 1990.

Pollitt, Jerome Jordan (ed.), *The Art of Ancient Greece: Sources and Documents*, Cambridge: Cambridge University Press, 1990.

Pope-Hennessy, John, *Fra Angelico*, London: Phaidon, 1974.

Popper, Karl R., *The Logic of Scientific Discovery*, London and New York: Routledge, 1995 (1959).

Prager, Frank D. and Scaglia, Giustino, *Mariano Taccola and His Book De Ingeneis*, Cambridge (Mass.) and London: MIT Press, 1972.

Précheur-Canonge, Thérèse, *La vie rurale en Afrique romaine d'après les mosaïques*, Paris: Presses Universitaires de France, 1962.

Prigogine, Ilya, "Order through Fluctuation: Self-Organization and Social System", in Jantsch and Waddington (1976), pp. 93-126.

Prigogine, Ilya and Stengers, Isabelle, *Order out of Chaos: Man's New Dialogue with Nature*, New York: Bantam Books, 1984.

Pulaski, Mary Ann Spencer, *Understanding Piaget: An Introduction to Children's Cognitive Development*, New York: Harper & Row, 1971.

Reid, Robert G.B., *Evolutionary Theory: The Unfinished Synthesis*, London and Sydney: Croom Helm, 1985.

Reinach, Salomon, *Repertoire de reliefs grecs et romains*, Paris: Ernest Leroux, 1909-12 (3 vols.).

Richter, Gisela M.A., *Perspective in Greek and Roman Art*, London and New York: Phaidon, 1970.

Riegl, Aloïs, *Die Spätrömische Kunst-Industrie nach den Funden in Österreich-Ungarn, im Zusammenhange mit der Gesammtentwicklung der bildenden Künste bei den Mittelmeervölkern*, Vienna: Druck und Verlag der Kaiserlich-Königlichen Hof- und Staatsdruckerei, 1901.

Riegl, Alois, *Gesammelte Aufsätze* (ed. Karl M. Swoboda), Vienna: Dr. Benno Filser Verlag, 1929.

Riegl, Alois, *Das Holländische Gruppenporträt*, Vienna: Druck und Verlag der Österreichischen Staats-druckerei, 1931 (1st ed.: *Jahrbuch der kunsthistorischen Sammlungen des Allerhöchsten Kaiserhauses*, 23, 1902, pp. 71-278).

Ringbom, Lars-Ivar, *Paradisus Terrestris. Myt, Bild och Verklighet*, Helsinki: Akademiska Bokhandeln, 1958.

Ritter, Joachim, "Landschaft. Zur Funktion des ästhetischen in der modernen Gesellschaft" [1963], in Joachim Ritter (ed.), *Subjektivität. Sechs Aufsätze*, Frankfurt a.M.: Suhrkamp, 1989 (1979), pp. 141-90.

Robb, David M., *The Art of the Illuminated Manuscript*, South Brunswick and New York: Barnes, 1973.

Robertson, D.W., "In Foraminibus Petrae: A Note on Leonardo's 'Virgin of the Rocks'", *Renaissance News*, 7, 1954, pp. 92-95.

Rösch, Siegfried, "Der Regenbogen in der Malerei", *Studium Generale*, 13, 1960, pp. 418-26.

Rösener, Werner, *Peasants in the Middle Ages* (trl. A. Stützer), Urbana and Chicago: University of Illinois Press, 1992 (German 1st ed. 1985).

Rohde, Peter P., *Den græske kulturs historie, I: Den store moder*, Copenhagen: Thaning & Appel, 1964.

Romm, James S., *The Edges of the Earth in Ancient Thought: Geography, Exploration and Fiction*, Princeton: Princeton University Press, 1992.

Roob, Alexander, *The Hermetic Museum: Alchemy and Mysticism*, Cologne: Taschen, 1997.

Rose, Andrea, *The Pre-Raphaelites*, London: Phaidon, 1992.

Rosenmeyer, Thomas, *The Green Cabinet: Theocritus and the European Pastoral Lyric*, Berkeley and Los Angeles: University of California Press, 1969.

Ross, David, *Aristote* (trl. J.Samuel), Paris, London and New York: Publications Grammo, 1971 (1930; Engl. 1st ed. 1923).

Rossi-Osmida, G., *Le caverne e l'uomo. Dal culto della Dea Madre alla speleologia*, Milan: Longanesi, 1974.

Rostovtzeff, M., "Die hellenistisch-römische Figurlandschaft", *Mitteilungen des königlich deutschen archäologischen Instituts, Römische Abteilung*, 26, 1911, pp. 1-186.

Rowland, Ingrid D., "Raphael, Angelo Colocci, and the Genesis of the Architectural Orders", *Art Bulletin*, 76, 1994, pp. 81-104.

Ruhmer, Eberhard, *Francesco del Cossa*, Munich: F. Bruckmann, 1959.

Ruskin, John, *Modern Painters*, Boston: Dana Estes, 1873 (1856) (5 vols.).

Russell, Bertrand, *History of Western Philosophy and Its Connection with Political and Social Circumstances from the Earliest Times to the Present Day*, London: George Allen & Unwin, 1946.

Russo, Daniel, *Saint Jérôme en Italie: Étude d'iconographie et spiritualité (XIIIe-XVe siècle)*, Paris and Rome: La Découverte, 1987.

Rutkowski, Bogdan, *The Cult Places of the Aegean*, New Haven and London: Yale University Press, 1986.

Sachs, Hannelore, et al., *Erklärendes Wörterbuch zu christlichen Kunst*, Hanau: W. Dausien, s.a.

Sahlins, Marshall David, *Islands of History*, Chicago and London: University of Chicago Press, 1985.

Salmi, Mario, *Italienische Buchmalerei*, Munich: Hirmer, 1956.

Salonen, Armas, *Agricultura mesopotamica nach sumerisch-akkadischen Quellen. Eine lexikalische und kulturgeschichtliche Untersuchung*, Helsinki: Suomalaisen Tiedeakatemian Toimituksia, 1968.

Saltini, Antonio, *Storia delle scienze agrarie. Venticinque secoli di pensiero agronomico*, Bologna: Edagricole, 1979.

Sandars, N.K., *Prehistoric Art in Europe*, Harmondsworth: Penguin, 1968.

Sanderson, Stephen K., *Social Evolutionism: A Critical History*, Oxford and Cambridge (Mass.): Blackwell, 1990.

Sannazaro, Iacobo, *Opere volgari* (ed. Alfredo Mauro), Bari: Laterza, 1961.

Sauerländer, Willibald, "Alois Riegl und die Entstehung der autonomen Kunstgeschichte am Fin de siècle", in Roger Bauer et al. (eds.), *Fin de siècle. Zu Literatur und Kunst der Jahrhundertwende*, Frankfurt a.M.: Klostermann, 1977, pp. 125-39.

Scaglia, Giustino (ed.), *De Machinis: The Engineering Treatise of 1449*, Wiesbaden: Reichert, 1971.

Schäfer, Godehard (trl.), *Malerhandbuch des Malermönchs Dionysios vom Berge Athos*, Munich: Slavisches Institut München, 1960.

Schama, Simon, *Landscape and Memory*, New York: Alfred A. Knopf, 1995.

Schapiro, Meyer, review of Webster (1938), *Speculum*, 16, 1941, pp. 131-37.

Schapiro, Meyer, "On Some Problems in the Semiotics of Visual Art: Field and Vehicle in Image-Signs", *Semiotica*, 1, 1969, pp. 223-42.

Schefold, Karl, *Pompejanische Malerei. Sinn- und Ideengeschichte*, Basel: Benno Schwabe, 1952.

Schefold, Karl, "Origins of Roman Landscape Painting", *Art Bulletin*, 42, 1960, pp. 87-96.

Schiller, Friedrich, "Über naïve und sentimentalische Dichtung" [1795], in *Gesammelte Werke*, vol. 8: *Philosophische Schriften*, Berlin: Aufbau-Verlag, 1959, pp. 547-631.

Schiller, Friedrich, "On Naive and Sentimental Poetry" [1795] (trl. Julius A. Elias), in H.B. Nisbet (ed.), *German Aesthetic and Literary Criticism: Winckelmann, Lessing, Hamann, Herder, Schiller, Goethe*, Cambridge: Cambridge University Press, 1985.

Schlosser, Julius von, *Präludien. Vorträge und Aufsätze*, Berlin: J. Bard, 1927.

Schmid, Michael, "Habermas' Theory of Social Evolution", in John B. Thompson and David Held (eds.), *Habermas: Critical Debates*, London and Basingstoke: Macmillan, 1982, pp. 162-80.

Schmitt, Charles B. (ed.), *The Cambridge History of Renaissance Philosophy*, Cambridge: Cambridge University Press, 1988.

Schneider, Lambert, *Die Domäne als Weltbild. Wirkungsstrukturen der spätantiken Bildersprache*, Wiesbaden: F. Steiner, 1983.

Schönbeck, Gerhard, *Der locus amoenus von Homer bis Horaz* (Diss., Heidelberg), Cologne: Gerd Wasmund, 1962.

Schöne, Wolfgang, *Über das Licht in der Malerei*, Berlin: Mann, 1954.

Sébillot, Paul, *Les travaux publics et les mines dans les traditions et les superstitions de tous les peuples*, Paris: J. Rothschild, 1894.

Serres, Michel, *Statues: Le second livre des fondations*, Paris: Flammarion, 1989 (1987).

Settis, Salvatore, *Giorgiones 'Gewitter'. Auftraggeber und verborgenes Sujet eines Bildes in der Renaissance* (trl. M. Pflug), Berlin: Klaus Wagenbach, 1983 (It. 1st ed. 1978).

Seznec, Jean, *The Survival of the Pagan Gods: The Mythological Tradition and Its Place in Renaissance Humanism and Art* (trl. B.F. Sessions), New York: Pantheon Books, 1953 (Fr. 1st ed. 1940).

Shapiro, Herman, "Walter Burley's De Deo, natura et arte", *Medievalia et Humanistica*, 15, 1963, pp. 88-90.

Shaw, Brent D., "'Eaters of Flesh, Drinkers of Milk': The Ancient Mediterranean Ideology of the Pastoral Nomad", *Ancient Society*, 13/14, 1982/83, pp. 5-31.

Sheldrake, Rupert, *The Rebirth of Nature: The Greening of Science and of God*, London: Century, 1990.

Signorini, Rodolfo, *Opus hoc tenue: La camera dipinta di Andrea Mantegna. Lettura storica iconografica iconologica*, Mantua: Sintesi, 1985.

Silberberg, Susan Rose, *A Corpus of the Sacred-Idyllic Landscape Painting in Roman Art* (diss.), Ann Arbor: University Microfilms International, 1980.

Sinibaldi, Giulia and Brunetti, Giulia, *Pittura italiana del duecento e trecento: Catalogo della Mostra Giottesca de Firenze del 1937* (exhibition catalogue), Florence: G.C. Sansoni, 1937 (reprint: 1981).

Smart, Alastair, "Taddeo Gaddi, Orcagna, and the Eclipses of 1333 and 1339", in Irving Lavin and John Plummer (eds.), *Studies in Late Medieval and Renaissance Painting in Honor of Millard Meiss*, New York: New York University Press, 1977, pp. 403-14.

Smart, Alastair, *The Dawn of Italian Painting 1250-1400*, Oxford: Phaidon, 1978.

Smith, Christine, *Architecture in the Culture of Early Humanism: Ethics, Aesthetics and Eloquence 1400-1470*, New York and Oxford: Oxford University Press, 1992.

Smith, R.R.R., *Hellenistic Sculpture*, London: Thames & Hudson, 1991.

Snow-Smith, Joanne, "Leonardo's *Virgin of the Rocks* (Musée du Louvre): A Franciscan Interpretation", *Studies in Iconography*, 11, 1987, pp. 35-94.

Somit, Albert and Peterson, Steven A. (eds.), *The Punctuated Equilibrium Debate in the Natural and Social Sciences: Scientific Issues and Implications*, Ithaca and London: Academic Press, 1989.

Soutar, George, *Nature in Greek Poetry*, London: H. Milford, 1939.

Spaeth, Barbette Stanley, *The Roman Goddess Ceres*, Austin: University of Texas Press, 1996.

Spengler, Oswald, *Decline of the West* (trl. Charles Francis Atkinson), London: George Allen & Unwin, 1971 (German 1st ed. 1923).

Spengler, Oswald, *Der Untergang des Abendlandes. Umrisse einer Morphologie der Weltgeschichte*, Munich: Deutscher Taschenbuch-Verlag, 1972 (1923).

Starn, Randolph, "The Republican Regime of the Sala dei Nove in Siena, 1338-1340", in Randolph Starn and Loren Partridge (eds.), *Arts of Power: Three Halls of State in Italy, 1300-1600*, Berkeley, Los Angeles and London: University of California Press, 1992, pp. 11-80.

Stefaniak, Regina, "On Looking into the Abyss: Leonardo's *Virgin of the Rocks*", *Konsthistorisk tidskrift*, 65, 1997, pp. 3-36.

Steingräber, Erich, *Zweitausend Jahre Europäische Landschaftsmalerei*, Munich: Hirmer, 1985.

Stevenson, Thomas B., *Miniature Decoration in the Vatican Virgil: A Study in Late Antique Iconography*, Tübingen: Ernst Wasmuth, 1983.

Stevenson Smith, William, *A History of Egyptian Painting and Sculpture in the Old Kingdom*, Oxford: Oxford University Press, 1951 (1946).

Stevenson Smith, William, *The Art and Architecture of Ancient Egypt*, Harmondsworth: Penguin, 1958.

Straus, Erwin, *Von Sinn der Sinne. Ein Beitrag zur Grundlegung der Psychologie*, Berlin: Springer, 1956.

Sullivan, Margaret A., *Bruegel's Peasants: Art and Audience in the Northern Renaissance*, Cambridge: Cambridge University Press, 1994.

Sulzer, Johann George, *Allgemeine Theorie der Schönen Künste in einzeln, nach alphabetischer Ordnung der Kunstwörter auf einander folgenden*, vol. II, Leipzig: Weidmann, 1792.

Talbot Rice, David, *The Byzantines*, London: Thames & Hudson, 1962.

Taylor, Alastair M., "Process and Structure in Sociocultural Systems", in Jantsch and Waddington (1976), pp. 169-84.

Thomas, Marcel, *The Golden Age: Manuscript Painting at the Time of Jean, Duke of Berry*, New York: G. Braziller, 1979.

Thompson, Dorothy, *Garden Lore of Ancient Athens*, Princeton: American School of Classical Studies at Athens, 1963.

Tietze-Conrat, E., "Mantegna's *Parnassus*: A Discussion of a Recent Interpretation", *Art Bulletin*, 31, 1949, pp. 126-30.

Toesca, Pietro, *La collezione di Ulrico Hoepli*, Milan: U. Hoepli, 1930.

Tooley, R.V. and Bricker, Charles, *A History of Cartography: 2500 Years of Maps and Mapmakers*, London: Thames & Hudson, 1969.

Torelli, Mario, *Typology and Structure of Roman Historical Reliefs*, Ann Arbor: University of Michigan Press, 1982.

Toulmin, Stephen and Goodfield, June, *The Ancestry of Science*.

 Vol. I: The Fabric of the Heavens, London: Hutchinson, 1960.

 Vol. III: The Discovery of Time, London: Hutchinson, 1965.

Treccani Degli Alfieri, Giovanni (ed.), *La Bibbia di Borso d'Este*, Bergamo: Banca popolare di Bergamo, 1961.

Tromp, Nicholas, *Primitive Conceptions of Death and the Netherworld in the Old Testament*, Rome: Pontifical Biblical Institute, 1969.

Turner, A. Richard, *The Vision of Landscape in Renaissance Italy*, Princeton: Princeton University Press, 1966.

Tylor, Edward Burnett, *Researches into the Early History of Mankind and the Development of Civilization*, London: J. Murray, 1870 (1865).

Tyree, E. Loeta, *Cretan Sacred Caves: Archaeological Evidence* (diss. 1975), Ann Arbor: University Microfilms International, 1977.

Ueberwasser, Walter, "Deutsche Architekturdarstellung um das Jahr 1000", in Kurt Bauch (ed.), *Festschrift für Hans Jantzen*, Berlin: Mann, 1951, pp. 45-70.

Underwood, Paul A., *The Kariye Djami*, London: Routledge & Kegan Paul, 1969.

Valentini, R. and Zucchetti, G. (ed.), *Codice Topografico della Città di Roma*, IV, Rome: Tipografia del Senato, 1953.

Varese, Ranieri (ed.), *Atlante di Schifanoia*, Modena: Panini, 1989.

Vasari, Giorgio, *Le vite de' più eccellenti pittori scultori ed architettori* (ed. Gaetano Milanesi), vol. 3, Florence: G.C. Sansoni, 1878.

Vasari, Giorgio, *Le vite de' più eccelenti pittori scultori e architettori* (synoptic double edition of the versions 1550 and 1568; eds. R. Bettarini and P. Barocchi), Florence: Sansoni, 1966-87 (9 vols.).

Vasari, Giorgio, *Lives of the Painters, Sculptors and Architects* (trl. Gaston de Vere, intr. David Ekserdijan), Everyman's Library, New York and Toronto: Alfred A. Knopf, 1996 (1927).

Vasey, Daniel A., *An Ecological History of Agriculture*, Ames (Iowa) 1992.

Veen, Henk van, "L.B. Alberti and a Passage from Ghiberti's Commentaries", in *Lorenzo Ghiberti nel suo tempo*, pp. 343-48.

Veldman, Ilja M., *Maarten van Heemskerck and Dutch Humanism in the Sixteenth Century* (trl. Michael Hoyle), Amsterdam: Meulenhoff, 1977.

Vermaseren, Maarten H., *Cybele and Attis: The Myth and the Cult*, London: Thames & Hudson, 1977.

Vernant, Jean-Pierre, "Arbeit und Natur in der griechischen Antike", in *Seminar: Die Entstehung von Klassengesellschaften*, Frankfurt a.M.: Suhrkamp, 1973, pp. 246-70.

Vernant, Jean-Pierre, *The Origins of Greek Thought*, Ithaca (NY): Cornell University Press, 1982 (Fr. 1st ed. 1962).

Vernant, Jean-Pierre, *Myth and Thought among the Greeks*, London: Routledge & Kegan Paul, 1983.

Villari, Pasquale, *The Life and Times of Girolamo Savonarola* (trl. Linda Villari), New York: Scribner, 1888 (reprint: St. Clair Shores (Mi), 1972).

Villari, Pasquale, *The Two First Centuries of Florentine History: The Republic and Parties at the Time of Dante* (trl. Linda Villari), London: T. Fisher Unwin, 1905 (1894-95).

Vosniadou, Stella, "Universal and Culture-Specific Properties of Children's Mental Models of the Earth", in Lawrence A. Hirschfeld and Susan A. Gelman (eds.), *Mapping the Mind: Domain Specificity in Cognition and Culture*, Cambridge and New York: Cambridge University Press, 1994, pp. 412-30.

Waddington, Conrad Hall, "Concluding Remarks", in Jantsch and Waddington (1976), pp. 243-49.

Waddington, Conrad Hall, *The Evolution of an Evolutionist*, Edinburgh: Edinburgh University Press, 1975.

Walker, John, *Bellini and Titian at Ferrara: A Study of Styles and Taste*, London: Phaidon, 1956.

Walker Bynum, Caroline, *Fragmentation and Redemption: Essays on Gender and the Human Body in Medieval Religion*, New York: Zone Books, 1991.

Wamberg, Jacob, "Art as the Fulfilment of Nature: Rock Formations in Ferrarese Quattrocento Painting", in M.Pade, L. Waage Petersen and D. Quarta (eds.), *La corte di Ferrara e il suo mecenatismo 1441-1598. Atti del convegno internazionale, Copenaghen maggio 1987*, Copenhagen: Museum Tusculanum Press and Modena: Panini, 1990, pp. 129-49.

Wamberg, Jacob, "Smertensmanden og idolet. Omkring Mantegnas 'Kristus som den lidende Forsoner'", *Kunstmuseets Årsskrift*, 69, 1991, pp. 46-69.

Wamberg, Jacob, "Ghiberti, Alberti, and the Modernity of Gothic", *Analecta Romana Instituti Danici*, 21, 1993, pp. 173-211.

Wamberg, Jacob, "En ikonologi uden ikonografi?", *Bulletinen. Meddelelser fra Dansk Kunsthistoriker Forening*, 23, October 1995, pp. 15-19.

Wamberg, Jacob, "Locus amoenus som magtens sted: Om Signorellis *Pans Hof*", *Passepartout. Skrifter for kunsthistorie*, 11, 1998, pp. 207-18.

Wamberg, Jacob, "Kunstbegrebets forældelse? Evolutionen som vilkår – og udfordring", in Hans Dam Christensen, Anders Michelsen and Jacob Wamberg (eds.), *Kunstteori. Positioner i nutidig kunstdebat*, Copenhagen: Borgen, 1999, pp. 181-211.

Wamberg, Jacob, "Abandoning Paradise: The Western Pictorial Paradigm Shift around 1420", in David E. Nye (ed.), *Technologies of Landscape: From Reaping to Recycling*, Amherst (Mass.): University of Massachusetts Press, 1999, pp. 69-86.

Wamberg, Jacob, "Rummet og malerens øje. Landskabsbilledets evolution i kosmologisk lys", in Anders Michelsen and Frederik Stjernfelt (eds.), *Rum og Fænomenologi. Filosofi, æstetik, arkitektur, historie. Urbanitet og Æstetik*, Hellerup: Spring, 2000, pp. 108-38.

Wamberg, Jacob, "Hvor kunsten vil hen. Plaidoyer for en (post)evolutionistisk historiografi", *Periskop. Forum for kunsthistorisk debat*, 11, 2003, pp. 11-38.

Wamberg, Jacob, "Mellem æter og afgrund. Middelalderens dualistiske landskabsbillede", in Mette Birkedal Bruun and Britt Istoft (eds.), *Undervejs mod Gud. Rummet og rejsen i middelalderlig religiøsitet*, Copenhagen: Museum Tusculanum Press, 2004, pp. 89-114.

Warburg, Aby, "Italienische Kunst und internationale Astrologie im Palazzo Schifanoja zu Ferrara" [1912], in Aby Warburg, *Gesammelte Schriften*, vol. II, Berlin: Teubner, 1932, pp. 459-81.

Warnke, Martin, *Political Landscape: The Art History of Nature* (trl. D. McLintock), London: Reaktion Books, 1994 (German 1st ed. 1992).

Watson, Paul F., *The Garden of Love in Tuscan Art of the Early Renaissance*, London: Associated University Press, 1979.

Weber, Max, "Die protestantische Ethik und der Geist der Kapitalismus" [1904-05], in *Gesammelte Aufsätze zur Religionssoziologie I*, Tübingen: J.C.B. Mohr, 1920, pp. 1-206.

Webster, James Carson, *The Labors of the Months in Late Antique and Medieval Art. To the End of the Twelfth Century*, Princeton: Princeton University Press, 1938.

Wedewer, Rolf, *Landschaftsmalerei zwischen Traum und Wirklichkeit. Idylle und Konflikt*, Cologne: DuMont, 1980 (1978).

Weidinger, Erich (ed.), *Legenda aurea. Das Leben der Heiligen*, Aschaffenberg: Pattloch, 1986.

Weigall, Arthur, *Ancient Egyptian Works of Art*, London: T.F. Unwin, 1924.

Weitzmann, Kurt, *Late Antique and Early Christian Book Illumination*, New York: G. Braziller, 1977.

Weitzmann, Kurt, *Byzantine Book Illumination and Ivories*, London: Variorum, 1980.

Weitzmann, Kurt, et al., *The Icon*, London: Evan Bros., 1982.

White, John, *The Birth and Rebirth of Pictorial Space*, London: Faber and Faber, 1967.

White, John, *Duccio: Tuscan Art and the Medieval Workshop*, London: Thames & Hudson, 1979.

White, Leslie E., *The Evolution of Culture: The Development of Civilization to the Fall of Rome*, New York, Toronto and London: McGraw-Hill, 1959.

Whittaker, C.R. (ed.), *Pastoral Economies in Classical Antiquity*, Cambridge: Cambridge Philological Society, 1988.

Widengren, Geo, "The King and the Tree of Life in Ancient Near Eastern Religion", *Uppsala Universitets Årsskrift*, 4, 1951.

Wilkinson, Richard H., *Reading Egyptian Art: A Hieroglyphic Guide to Ancient Egyptian Painting and Sculpture*, London: Thames & Hudson, 1992.

Wilpert, Joseph, *Le pitture delle catacombe romane*, Rome: Desclée, Lefebvre et Sociorum, 1903.

Wilpert, Joseph, *Die römischen Mosaiken und Malereien der kirchlichen Bauten vom IV. bis XIII. Jarhundert*, Freiburg am Bresgau: Herder, 1916-1917 (4 vols.).

Wind, Edgar, *Bellini's Feast of the Gods: A Study in Venetian Humanism*, Cambridge (Mass.): Harvard University Press, 1948.

Wind, Edgar, "Mantegna's *Parnassus*: A Reply to Some Recent Reflections", *Art Bulletin*, 31, 1949, pp. 224-30.

Wind, Edgar, *Pagan Mysteries in the Renaissance*, London: Faber, 1958.

Winkelmann, Heinrich et al., *Der Bergbau in der Kunst*, Essen: Glückauf, 1958.

Witt, Antony de, *I mosaici del Battistero di Firenze*, Florence: Cassa di Risparmio di Firenze, 1954-1959 (5 vols.).

Wölfflin, Heinrich, *Principles of Art History: The Problem of the Development of Style in Later Art*, (trl. M.D. Hottinger), New York: Dover Publications, 1950 (1932; German 1st ed. 1915).

Wölfflin, Heinrich, *Kunstgeschichtliche Grundbegriffe. Das Problem der Stilentwicklung in der neueren Kunst*, Basel and Stuttgart: B. Schwabe, 1963 (1915).

Woermann, Karl, *Die Landschaft in der Kunst der alten Völker. Eine Geschichte der Vorstufen und Anfänge der Landschaftsmalerei*, Munich: T. Ackermann, 1876.

Wolf, Walther, *The Origins of Western Art*, London: Weidenfeld and Nicholson, 1971.

Wood, Christopher S., *Albrecht Altdorfer and the Origins of Landscape*, London: Reaktion Books, 1993.

Woodbridge, Frederick J.E., *Aristotle's Vision of Nature* (lectures given in 1930 at Union College, Schekertady, ed. and intr. John Herman Randall Jr., with ass. of C.H. Kahn and H.A. Larrabee), New York and London: Columbia University Press, 1965.

Wright, M.R., *Cosmology in Antiquity*, London and New York: Routledge, 1995.

Würtenberger, Franzsepp, *Weltbild und Bilderwelt von der Spätantike bis zur Moderne*, Vienna and Munich: Schroll, 1958.

Yacoub, Mohamed, *Splendeurs des mosaïques de Tunisie*, Tunis: Ministère de la Culture, 1995.

Young, Dudley, *Origins of the Sacred: The Ecstasies of Love and War*, New York: St. Martin's Press, 1991.

Zahlten, Johannes, *Creatio mundi. Darstellungen der Sechs Schöpfungstage und das naturwissenschaftlichen Weltbild im Mittelalter*, Stuttgart: Klett-Cotta, 1979.

Zanker Paul, *The Power of Images in the Age of Augustus* (trl. Alan Shapiro), Ann Arbor: University of Michigan Press, 1988 (German 1st ed. 1987).

Zeri, Federico (ed.), *La pittura in Italia: Il Quattrocento*, Milan: Electa, 1987.

Ziomecki, Juliusz, *Les représentations d'artisans sur les vases attiques*, Wrocław: Zakład Narodowy im. Ossolińskich, 1975.

Åkerström-Hougen, Gunilla, *The Caldendar and Hunting Mosaics of the Villa of the Falconer in Argos: A Study in Early Byzantine Iconography*. Skrifter utgivna av svenska Institutet i Athen, 4, 23, Stockholm, 1974.

List of terms

The list covers three types of recurrent words and terms: [1] neologisms, [2] highly specialised terminology, and [3] common words and terms defined and used in the text in a specific way.

advanced intermediate
Talcott Parsons' term for a cultural evolutionary stage characterised by a hierarchical urban society with a detached quasi-autonomous literate upper class. Corresponds to Marx's *antique* stage and is equivalent to Piaget's concrete operational stage. Western examples: Greek and Roman antiquity.

advanced primitive
Talcott Parsons' term for a cultural evolutionary stage characterised by a clan-controlled village community, based on the slash-and-burn method, with incipient social hierarchy. Corresponds partially to Piaget's preoperational stage. Western examples: the Neolithic cultures.

archaic intermediate
Talcott Parsons' term for a cultural evolutionary stage characterised by a plough-based urban society and a pyramidal, still clan-controlled social structure in which the ruling class comprises a monarch surrounded by a literary priesthood and war-riors. Corresponds to Marx's *Asiatic* stage and is equivalent to Piaget's preoperational stage, albeit bordering on the concrete operational stage. Western examples: Egypt and Mesopotamia.

attractor
Term taken from the interdisciplinary general systems theory. Describes an ac-cumulation of forces which attract the elements of a complex system regardless of position of departure of these elements. Formally described in a multi-dimensional phase space, but can be compared to counter-sinking in a terrain within which rolling balls are held regardless of their more precise routes. Synonymous with Waddington's term *chreode*.

chora
Besides referring to the ground and the land outside the urban area, *chora* signi-fies the primeval container referred to in Plato's myth of creation in *Timaeus* and

is re-used by Kristeva as a reference to the child's pre-language symbiosis with the mother. Both writers exemplify *chora* by fluctuating movements on the brink of chaos, and in this book it is therefore used to identify the specific dynamics which characterise many of the pictorial rocks, particularly from the High Middle Ages.

chreode
See attractor.

chthonic
Concerning things subterranean (from Greek *chthon* = under the earth).

concrete operational
Piaget's term for the third stage of child development (7-11 years), during which differentiation is made between mental representations and the surrounding environment, albeit still in a conformist belief in the truth value of the symbolic world. Also used here of cultural evolution, covering the advanced intermediate and feudal stages.

consciousness
Internalised, mental representations, which combine to produce a sensation of an 'I' differentiated from the surrounding world. Consciousness is here understood to have developed in close correlation with culture.

Copernican world picture
The post-medieval, by now infinite world picture with the sun as local centre of the planets. Has forerunners in the 14th-15th centuries, but assumes a definite theory in 1543 with Copernicus' *De revolutionibus orbium coelestium*.

covering
Depth-producing pictorial effect occurring when bodies closer to the observer partially cover bodies further away from the observer. Emerges in Egypt and Mesopotamia.

culture
That part of the material world structured by humankind.

depth of field
Photographic term denoting how much of what is seen in front of and behind focus is in high-definition. In the current context, depth of field refers to how far

the pictorial view stretches into the surrounding environment in relation to the motif at the centre of attention.

depth of field, actual
Signifies depth of field in an image in so far as this depth of field is clearly executed and shows, for the given evolutionary stage, visualisation of the most distant possible spatial depths.

depth of field, potential
Signifies depth of field in an image when the insertion of an impenetrable visual barrier – a wall, a thicket, a rock, for example – prevents it from reaching out to the depths which, in principle, are possible at the given evolutionary stage.

distant sight
Riegl's term for a pictorial gaze directed towards the infinite environment, with body and space forming part of an indissoluble web. Commences in late antiquity, culminates in Impressionism.

dualistic world picture
A world picture divided into two: an indestructible, impregnating heaven and a chaotic, recipient earth. Characterises the eras between Mesopotamia and the Late Middle Ages.

epistemic *field*
An overarching hyper-*field* assembling all the *fields* of a culture and affecting them with homologous paradigms. The term epistemic is derived from Foucault's *episteme*, a basic structure moulding every cultural manifestation of an era. Examples of epistemic *fields* are historical eras such as antiquity and the Middle Ages or an additionally overarching *field* such as the Golden Age *field*.

ergon
Greek = work. Antique term for the actual motif of a work of art, in contrast to *parergon*, the secondary work.

Euclidian space
Piaget's (somewhat unfortunate) term for a representation of space characterised by metric relations and abstract coordinates independent of the body. Projective images are an element of this spatial form. Commences, according to Piaget, in the concrete operational stage and concludes in the formal operational stage. In

terms of cultural history, this corresponds to a span from classical antiquity to modernity pre-1900.

evolution
Here: developmental process, the phases of which can be recognised as continuation of earlier phases and which are, moreover, directional.

feudal
Term for the social structure in the Middle Ages, which might be hierarchical but which nonetheless affords the underclass greater worth than the slave status they often held in Greco-Roman antiquity.

field
Bourdieu's term for a system of forces – rules, practices, traditions – which influence a culturally-determined action. The *field* comprises a space of potential determining what can be realised at a particular moment in history in a particular social context. Despite the autonomy of the *fields*, they sometimes display mutual morphological correspondences. The 'surface' of a *field* is what I term the paradigm.

formal operational
Piaget's term for the fourth and final stage of child development (12 years +), in which internalisation of the mental representations are accomplished to a degree that allows for self-consciousness and cognition of the subjectively-determined nature of thought. Also used here of cultural evolution, where it corresponds to modernity between 1400 and 1900.

geocentric world picture
The part of the dualist world picture that places a round earth at the centre of concentric celestial spheres. Originated in Greece *c.* 500 BC and operated until the Late Middle Ages when it was gradually replaced by a heliocentric, Copernican world picture.

Golden Age *field*
Overarching epistemic *field* spanning the epistemic *fields* from Mesopotamia to the Late Middle Ages. Characterised by a primitivist tendency attempting to reconstruct work-free Golden Age and Paradise for a privileged ruling class. Accordingly, the work necessary for this reconstruction, but belonging to the post-Golden Age or post-expulsion from Paradise period, is degraded and repressed.

Golden Age myth

Greco-Roman parallel to the Paradise myth, similarly telling of the genesis of civilisation. Originates with the Golden Age, the ideal era of perpetual blossoming, abundance and freedom from work, but in the sequence from Silver to Bronze and Iron Age, parallel to the Fall, changeable seasons emerge and nature loses its fertility, while agriculture, trade and, eventually, mining become established.

Golden Age paradigm

The Golden Age *field*'s imprint in pictorial art. A structural equivalent to the first stage of the Golden Age myth, the Golden Age, through the following four limits: [1] space (absence of infinity), [2] time (perpetual blossoming), [3] cultivation (no trace of the territory's cultivated nature) and [4] ground (mountains).

Gothic

North European style which influenced all visual arts between 1100 and 1500. Generally characterised by myriads of details, extensive spaces and a combination of stylisation and intimate, unadorned naturalism. Here seen as an essential precondition for the emergence of modernity in art.

haptic

Synonym for tactile.

homology

Correspondence of form.

icon

Peirce's term for a sign relation by means of which large or small parts of an object's structure are preserved in the sign (representamen). Encompasses images, diagrams and metaphors.

iconography

The second level of Panofsky's interpretation of images, beyond simple identification of pictorial elements and their stylistic representation (the pre-iconographic level). Signifies a well-defined and intentional symbolic content.

iconology

The third level of Panofsky's interpretation of images, beyond iconography, and here understood as being to some extent detached from iconography. Signifies a more scattered and often unintentional symbolic content associated with basic

attitudes in a culture, of which I deal in particular with issues of consciousness, society and cosmology. Iconology is here pinned down by means of two approaches: [1] a worm's-eye view, which assembles a space of iconographies, and [2] a bird's-eye perspective, which in other cultural domains spots paradigms homologous to the images' paradigms. The more the paradigms can be established to be imprints of *fields*, the more iconological is the analysis.

index
Peirce's term for a sign relation by means of which the object has physically affected the sign (representamen): for example, footprints or photographs.

interpretant
Peirce's term for the mental image called forth upon encountering the sign, or representamen.

intuitive perspective
Perspective not produced by a systematic, linear construction of the pictorial space, but originating in a purely empirical reconstruction of visual impression. Is in particular honed by the pictorial tradition North of the Alps.

isomorphism
Similarity of form.

landscape
Signifies in the strictest sense, i.e. after the emergence of the term in the Late Middle Ages, a panoramic section of cultivated or non-cultivated nature. Here, however, the term is also used more loosely of elements in nature generally, i.e. not necessarily in connection with panoramas.

landscape image
Here: a term for the representation of landscape in a single or several images. Not to be confused with the autonomous landscape image, the depiction of landscape for its own sake.

linear perspective
Perspective based on linear, mathematical principles, in contrast to intuitive perspective (see entry). Originally developed in 15th-century Italy, but in the 16th century becomes common throughout Europe.

macrohistory
History based on analytical units spanning larger geographical and chronological stretches, as a rule several nations at once and durations of several hundred years – termed *longues durées* by Braudel.

mapping gaze
Pictorial view which, like the cartographic map, beholds the surface of the earth from above and downwards. In prehistoric times and Egypt, the mapping gaze is mixed together with the panoramic gaze (see entry), after which, in the period of the Golden Age paradigm, it is largely reserved for cartographic depictions of the cultivated and surveyed land, the territory. Again merged with the panoramic gaze in the pictorial view of the post-1420 modern paradigm.

Mesolithic period
Transitional period between the Palaeolithic and Neolithic periods, from *c.* 10,000 BC to *c.* 2000 BC. Characterised by the beginning of settled communities.

Middle Ages
The zenith of Christianity in Europe, *c.* 300-1400. Here: Early Middle Ages: *c.* 300-700; High Middle Ages: *c.* 700-1100; Late Middle Ages: *c.* 1100-1400.

middle distance
The middle of the three key positions of landscape according to which my analytical apparatus is structured. Facilitates a structuralist comparison between the landscape image's degree of cultivation and the socially-determined perception of nature in a given era.

modernity
Here understood as the period in Western culture between *c.* 1400 and *c.* 1900, but with forerunners in late antiquity. Characterised in its mature form by secularisation, development of bourgeois society, Protestantism and nominalism.

nature
The part of the material world that has not been structured by humankind. In the dualist world picture, nature comprises the world beyond sheer spirit, i.e. everything below the uppermost celestial sphere that is not cultivated by humankind.

near sight

Riegl's term for a pictorial view directed head-on towards bodies in seclusion. Typical in Egypt.

Neolithic period

New Stone Age, from *c.* 10,000 BC until *c.* 2000 BC. Characterised by settlement in village communities and the invention of agricultural farming. Corresponds to Talcott Parsons' advanced primitive stage.

normal sight

Riegl's term for a pictorial view directed towards bodies in interaction with their immediate environment. Culminates in classical antiquity.

***numen*, numinous force**

The unity of natural power preceding the dualisation of the world picture into masculine heaven and feminine earth. Corresponds to Neumann's *uroboros*.

object

Peirce's term for the imaginary or physical object to which the sign (representamen) refers.

ontogenesis

Process of individual evolution, in contrast to that of the species (phylogenesis). A biological term used here of the individual's cultural development.

Palaeolithic period

Early Stone Age up until *c.* 10,000 BC, characterised by hunter-gatherer cultures. Corresponds to Talcott Parsons' primitive stage.

panoramic gaze

Pictorial view which beholds outwards, by which the direction of gaze is more or less parallel with the surface of the earth. Dominates the pictorial view from Mesopotamia to modernity, until the Late Middle Ages clearly separated from mapping gaze.

paradigm

Thomas Kuhn's term for the often unwritten set of rules characterising a given science. Here used generally of the sets of rules characterising a cultural domain in a given period, especially pictorial art. Can be understood as the surface of Bourdieu's *field*.

parergon

Greek = secondary work. Antique term for the subordinate parts of a work of art, its environment as opposed to the actual motif, *ergon*. Far into modernity, landscape as a category comes under *parergon*.

perspective

Here: general term for depth-effect in images involving specification of a viewing position, foreshortening and reduction with distance, and possibly horizon and vanishing point. Perspectival depiction can be understood as a monocular, level reconstruction of the instantaneous visual impression, be it linearly constructed or intuitive (see linear perspective, intuitive perspective). Has forerunners in classical antiquity, but is first developed fully during the period between 1420 and 1900. Corresponds to Piaget's formal operational stage.

phylogenesis

Process of species evolution, in contrast to that of the individual (ontogenesis). A biological term used here of humankind's cultural development.

pictorial view

The representation of a gaze in images.

pole of remoteness

One of the three key positions of landscape, according to which my analytical apparatus is structured. Allows for a structuralist comparison between the depth of pictorial space and the world picture of cosmology.

pole of vantage point

The innermost of the three key positions of landscape, according to which my analytical apparatus is structured. Allows for a structuralist comparison between specification of vantage position in the pictorial space and the developmental stage of self-consciousness in a given era.

postmodernity

Used here of post-1900 culture in general.

power of conception

The cosmological power thought to initiate the creation of the world's objects and organisms. In prehistoric times and Egypt, the power of conception is seen as originating from the female earth, but is gradually displaced to the celestial domain,

which then holds the monopoly on it from Mesopotamia to the Late Middle Ages, the period of the Golden Age *field*.

preoperational
Piaget's term for the second stage of child development (2-7 years), during which mental representations are generated, but with no differentiation between symbol and reality. Also used here of cultural evolution, where it corresponds to the advanced primitive and archaic intermediate stages and borders on the primitive stage.

primitive
Talcott Parsons' term for a cultural evolutionary stage characterised by non-settled hunter-gatherers. Western examples: Palaeolithic cultures. Corresponds to the threshold between Piaget's sensorimotor and preoperational stages.

primitivism
Tendency in the advanced intermediate and feudal stages which, based on a notion of the contemporary culture's decadence, seeks to reconstruct aspects of the origin of the culture: Golden Age or Paradise. Hence the collective term *Golden Age field* for these cultures. Primitivism must on no account be confused with primitiveness.

Renaissance
Used here specifically of the movement which, from the 14th to 16th centuries and originating in Italy, sought to re-institute the ideals of antique culture. Understood as a partially conservative tendency which, in pictorial art, beautifies and subdues the radical naturalism of the Gothic culture.

representamen
Peirce's term for the sign in the triadic semiotic relation, the other elements of which are object (referent) and interpretant (mental image). The representamen could be, for example, a painted canvas or spoken word.

self-consciousness
Consciousness of the very fact of having a consciousness, i.e. a collection of internalised mental representations generating an 'I' distinct from the surrounding environment. Develops gradually over the course of cultural history, culminating in modernity.

sensorimotor
Piaget's term for the first stage of child development (0-2 years), during which the surrounding environment is experienced directly through senses and body movements, and in which mental representations have yet to be generated. Also used here in connection with cultural evolution, where it corresponds to the earliest, pre-cultural phases.

spirit
Synonym for consciousness. Here used particularly in a cosmological sense of the imperishable intelligence which, from Mesopotamia to the Late Middle Ages, is ascribed to the heavens and which endows the underlying matter with life.

symbol
Peirce's term for a sign relation in which the relation between object and sign (representamen) is arbitrary and conventional: for example, spoken or written words.

terra
Latin = earth. Here understood in three often overlapping meanings: [1] the element earth, [2] the dry ground, and [3] the virgin soil in contrast to the cultivated soil, territory.

terraced rock
Prevalent rock type in landscape images of antiquity and the Middle Ages, particularly in the Byzantine tradition. Consists of plateaus linked vertically by jagged edges ('abyss effect').

territory
A terrain that is cultivated, divided up and consumed. Characterised by farmed fields and demarcation lines such as roads, paths, fences, hedges, bridges and watercourses, and perhaps, on the periphery, by mines and quarries. Has its fulcrum in the flat plain.

topological space
Term for a spatial representation without metric invariables, but orientated according to qualitative relations such as proximity, separation, succession, inclusion and continuity. Can be compared to distorted drawings on a rubber tablecloth, where closed forms such as squares and circles become identical. Characterises, according to Piaget, the preoperational stage, i.e. in terms of cultural history, the advanced primitive and to some extent the archaic intermediate stage.

uroboros

Originally: the snake eating its own tail. Neumann's term for the continuum that, at the pre-conscious stage, flows between mind and environment.

world picture

A period's concept of cosmos in its entirety and of the position of the human body and gender in this entirety.

Index

point of view vol. I 18, 22, 54, 80, 97, 128, 139, 142,
 397, 399, 430, vol. II 5, 24-25, 28, 32, 39, 64,
 112, 142, 177, 195

pole of remoteness vol. I 7, 43-44, 47, 139, 161,
 195, 332, vol. II 6, 18-19, 117-18, 367, 370, 374,
 380,473

pole of vantage point vol. I 7, 43-45, 138, 332,
 vol. II 6, 8, 17, 19, 118, 367, 370, 473

polis vol. I 396, 558n, vol. II 182, 264, 323

politics vol. I 73, 81-85, 87-89, 134, 144, 338, 357,
 386, 392, 395-97, 400, 414, 477, 529n, 535n,
 564n, 565n, vol. II 55, 70, 94, 129-30, 170-71,
 307, 370, 378, 397n

Poliziano, Angelo vol. II 289, 415n

Pollaiuolo, Antonio vol. II 223, 339

Polo family vol. II 35

Polyhymnia vol. II 214

Polyphemus vol. I 274, 425, 452

Sacrifice of Iphigenia vol. I 16, 292, 298, 448-49

Pomponius Mela vol. I 244, 546n

Popper, Sir Karl vol. I 74, 78-79, 531n

Porphyry vol. I 170, 538n, vol. II 320

Poseidon vol. I 247, 391

positivism vol. I 6, 73, 78, 81

possest vol. II 12-13, 83, 384n

postcolonialism vol. I 33, 73

post-evolutionary epoch vol. I 86

post-Golden age vol. I 398, 475, vol. II 38, 468

posthuman, the vol. II 10

postmodernism vol. I 6, 33, 86

postmodernity vol. I 10, 25, 34, vol. II 365-66, 473

post-structuralism vol. I 33, 73, 79-80, 82, 84, 86,
 532n

Poussin, Nicolas, vol. II 178, *202*, 404n

power of conception vol. I 163-64, 166, 179, 197,
 332-34, 336, 339, 341, 346, 366, 393, vol. II 329,
 375-76, 473n

power elite vol. I 120, 334, 414

praxis vol. I 253, 395-97, 399, vol. II 378

Praxiteles vol. I 564n

preoperational stage vol. I 40, 46, 140-42, 146-49,
 160, 164, 166, 333, 339, 345-46, vol. II 369-70,
 376, 465, 474, 475

Pre-Raphaelites vol. II 43, 403n

Priapus vol. I 452, 460-62, 467-68

Prigogine, Ilya vol. I 66, 530n

prima materia vol. I 232, 235-36, vol. II 248, 267-69,
 273-74, 278, 323-24

prime symbol vol. I 63

primeval qualities vol. I 22, 48, 163-64, 212, vol. II
 248, 282, 352, 377, 465n

primitive cultures vol. I 22, 72, 100, 109, 117, 124,
 181, 199-200, 217, 277, 346, 351, 361, 366, 368,
 372, 375, 386, 393, 395, 411, 466, 468, 480, 523,
 vol. II 61-62, 197, 217, 234, 378

primitive stage vol. I 39, 41-42, 366, vol. II 369,
 472, 474

primitivism vol. I 50-51, 330, 336-37, 357, 373, 389,
 vol. II 82, 227, 298, 377, 468, 474
 hard vol. I 371, vol. II 197
 soft vol. I 371, vol. II 237

primordial qualities vol. I 15, 22, 70, 171, 179,
 185, 196-97, 201-02, 230, 232, 290, 334, 357-58,
 372-73, 411, 414, 429, 439-40, vol. II 7, 83, 118,
 132, 234, 241, 244, 256-57, 280, 283, 286, 290,
 326, 371-72, 377-78

primum mobile vol. I 168, 183, 196, vol. II 266

progression vol. I 6, 20, 35, 44, 71, vol. II 10, 139,
 244

Prometheus vol. I 368, 372, 546n, 562n

Propertius, Sextus Aurelius vol. I 466, 468, vol. II
 324

Protestantism vol. I 51, vol. II 5, 11, 13, 19, 81, 170,
 172, 201, 220, 403n, 406n, 471

Protogenes vol. I 180, vol. II 346

Psellus, Michael vol. II 245, 410n

Pseudo-Albertus vol. II 419n

Pseudo-Dionysus vol. I 183